PABLO PICASSO
A RETROSPECTIVE

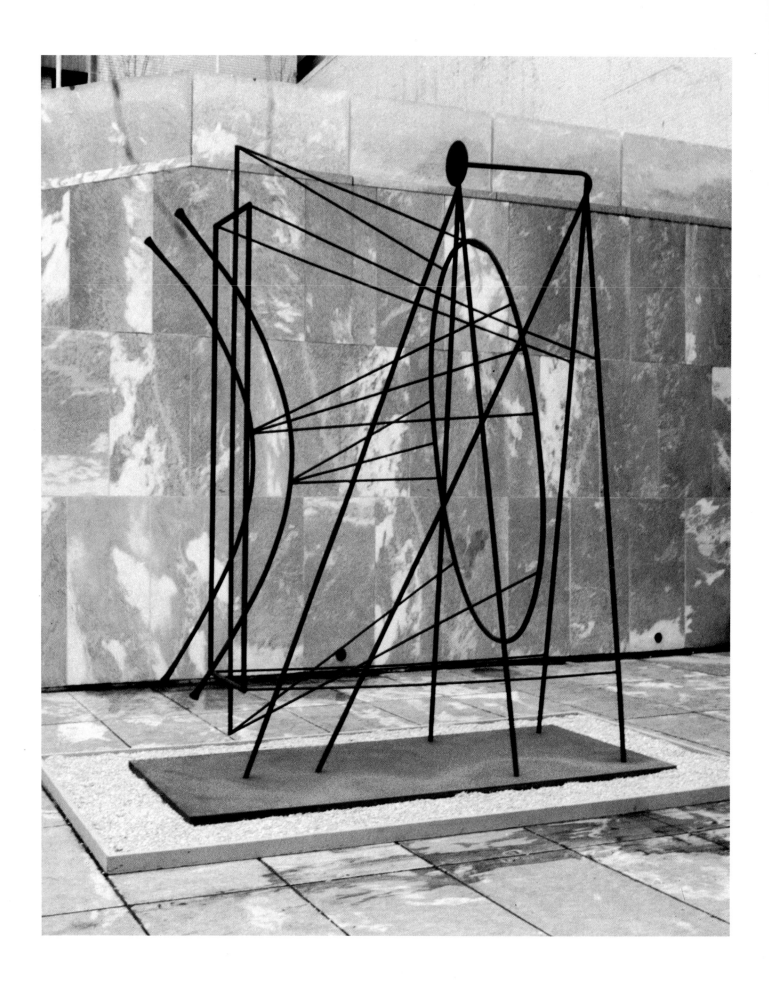

PABLO PICASSO
A RETROSPECTIVE

EDITED BY WILLIAM RUBIN

Chronology by Jane Fluegel

THE MUSEUM OF MODERN ART, NEW YORK
Distributed by New York Graphic Society, Boston

Published on the occasion of the exhibition "Pablo Picasso: A Retrospective," May 22–September 16, 1980, organized by The Museum of Modern Art, New York, with the collaboration of the Réunion des Musées Nationaux de France and directed by William Rubin, Director of the Department of Painting and Sculpture, The Museum of Modern Art, and Dominique Bozo, Curator-in-Charge, Musée Picasso, Paris.

Both exhibition and publication have been made possible by a generous grant from the IBM Corporation. Additional support has been provided by the Robert Wood Johnson Jr. Charitable Trust and the National Endowment for the Arts; an indemnity for the exhibition has been provided by the Federal Council on the Arts and the Humanities.

Designed by Christopher Holme
Design staff: Steven C. Coppolino,
Lisa Hirsh, and J. Richard Hsu
Production by Tim McDonough
Type set by Boro Typographers, Inc., New York
Printed and bound by The Arts Publisher, Inc.,
Richmond and New York

The Museum of Modern Art
11 West 53 Street
New York, New York 10019

Printed in the United States of America
Second printing, revised, 1980

FRONTISPIECE: *Monument*. New York, 1972. Constructed after an enlargement, supervised by the artist, of a 19⅞" (50.5 cm) high wire maquette (p. 268) from late 1928 of a monument to Guillaume Apollinaire. Cor-ten steel, 155⅝" (395.3 cm) high, including base, 1⅞ x 58¾ x 132" (4.7 x 149.2 x 319.3 cm). The Museum of Modern Art, New York. Gift of the artist

CONTENTS

FOREWORD

As The Museum of Modern Art celebrates the fiftieth anniversary of its founding, it seems very fitting to present a retrospective of Picasso, whose work stylistically and chronologically encompasses more of twentieth-century art than that of any other artist. It is also a privilege to mark our anniversary with a tribute to this great modern master.

Especially gratifying in the organization of this retrospective has been our collaboration with the Réunion des Musées Nationaux de France. As the second coproduced exhibition in a series projected by an accord signed between the Réunion and The Museum of Modern Art in 1975, it extends a cooperative effort that significantly benefits the museum-going public of both our countries. The support of the Réunion represents on a symbolic level a gracious recognition of our fiftieth anniversary; on a practical level, it has been crucial to the realization of this project. Of the more than nine hundred works in this exhibition, some three hundred are being loaned under the aegis of the Réunion by the future Musée Picasso of Paris, whose holdings comprise those works selected by the French Government from the Picasso estate in lieu of a fiscal settlement of inheritance taxes. Despite the special relationship between The Museum of Modern Art and the Réunion, the scope of the latter's loans is so great that without the generous assistance and far-reaching vision of Jean-Philippe Lecat, Ministre de la Culture et de la Communication, Maurice Aicardi, Président de la Commission Interministérielle d'Agrément, and Hubert Landais, Directeur des Musées de France, we could not have hoped to present such an extraordinary group of works from this essential resource.

In the early seventies, when this exhibition was conceived, Picasso himself favored its realization and was prepared to make the required extensive loans from his personal collection. That we have been able to mount this retrospective after his death is due not only to the sympathetic cooperation of the French authorities but also to the great good will of Picasso's heirs. Claude Picasso's assistance has been vital in the complicated logistics of preparation, both for the exhibition and for the catalog, and he is also a generous lender. We are profoundly grateful as well to Jacqueline Picasso and to Bernard Picasso, Marina Picasso, Maïa Widmaier-Picasso, and Paloma Picasso Lopez for their willingness to part for the duration of this exhibition with works that have such special meaning to them.

Very near to Picasso's heart was the Museo Picasso of Barcelona; its collection, uniquely rich in early works, was largely donated either by the artist himself or by his close friend Jaime Sabartés. To a small museum devoted exclusively to the work of one artist, extensive loans constitute a special deprivation; nevertheless, in recognition of Picasso's desire that his early work be well represented in this retrospective, Barcelona has been a generous participant. Without the Barcelona loans a coherent account of Picasso's early development would scarcely have been possible; its presentation here owes much to the efforts of Narcis Serra, Mayor of Barcelona, and Rafael Pradas, Regidor de Cultura of Barcelona, for which we are most appreciative.

Acknowledging its gratitude to certain individuals and museum directors whose aid has been instrumental in assembling this exhibition, the Museum has constituted an "Honorary Committee for 'Pablo Picasso: A Retrospective.'" Its members are Pierre Daix and Roland Penrose, both friends of Picasso and scholars of his work; Mme Irina Aleksandrovna Antonova, Director, Pushkin State Museum of Fine Arts, Moscow; K. G. Pontus Hultén, Director, Musée National d'Art Moderne, Centre National d'Art et de Culture Georges

Pompidou, Paris; Dr. Jiri Kotalik, Director, National Gallery, Prague; Hubert Landais, Director, Musées de France; Dr. Franz Meyer, Director, Kunstmuseum, Basel; Boris Borisovich Piotrovsky, Director, The Hermitage Museum, Leningrad; Sir Norman Reid, former Director, The Tate Gallery, London; Sra. Rosa-Maria Subirana, Director, Museo Picasso, Barcelona.

The extraordinary size and scope of this exhibition has made it a very costly endeavor—one which could never have been translated from dream to reality were it not for a most generous grant from the IBM Corporation and additional support provided by the Robert Wood Johnson Jr. Charitable Trust and the National Endowment for the Arts. The Federal Council on the Arts and the Humanities, through the Art and Artifacts Indemnity Act, provided insurance coverage for foreign loans that was essential to the realization of the full compass of this exhibition. To these several sources of support, we are deeply grateful not only for financial aid but for the active interest and encouragement they lent to the project.

In conclusion and most personally, I should like very warmly to thank the staff of The Museum of Modern Art, virtually all of whom contributed in one way or another to bringing into being "Pablo Picasso: A Retrospective." Deep appreciation is also due to the Museum's President, Mrs. John D. Rockefeller 3rd, and to the other members of its Board of Trustees for the constancy and strength of their commitment to this ambitious undertaking. Finally very special thanks must go to William Rubin, Director of the Department of Painting and Sculpture, whose vision, initiative, and energy were the driving forces behind this project. As codirectors of the exhibition, he and Dominique Bozo, Curator-in-Charge of the Musée Picasso, Paris, deserve not only our gratitude but our admiration.

Richard E. Oldenburg
Director of The Museum of Modern Art

FOREWORD

"In short, it's the inventory of someone with the same name as mine," Picasso said to Jean Leymarie when the latter discussed with him his plans for the 1966 exhibition in Paris.

Inventory, retrospective, balance sheet, homage—what term should be used for the present exhibition, the exceptional nature of which will escape no one? Homage would probably be the most appropriate: homage paid to Picasso, of course, but even more perhaps, homage paid by Picasso to his times—to our times—homage by a man "seizing hold of whatever comes within his reach, hailing and ensnaring it with a gesture, with an instant irrepressible cry, according to his angle of vision and the mood of the moment" (Gaëtan Picon).

Even if it was indeed fitting to celebrate the fiftieth anniversary of The Museum of Modern Art with brilliance, the very idea of an undertaking like this one could be taken for madness. But in what other place and for what other occasion could such madness be attempted?

The circumstances are favorable: the Musée Picasso in Paris is not ready to install its collections, *Guernica* has not yet reached its permanent home port, and "MoMA" itself has not completed its architectural transformation.

Messrs. Oldenburg and Rubin had, besides, a certain number of good arguments to offer the French custodians in order to obtain the loan of what we in France call the "*dation Picasso*." The list of works borrowed both by the Réunion des Musées Nationaux and the Centre National d'Art et de Culture Georges Pompidou from MoMA's collections is indeed a long one.

So true is this that it can be said that no large exhibition of modern art has been held in Paris during the last ten years without the Museum's having been solicited—abundantly solicited—whether it had to do with Chagall, Léger, Matisse, or Paris–New York. Furthermore, certain exhibitions, such as "Cézanne: The Late Work," were in their entirety organized jointly by New York and Paris.

Beyond this, how can one help wishing that some solid basis be established for future cooperation that would make it possible, say, to see once again in Paris this or that masterpiece, such as the *Demoiselles d'Avignon,* temporarily displayed along with its preparatory studies?

Picasso's estate having finally been settled, the Ministre de la Culture et de la Communication having given his approval, there was no longer anything to prevent the dream from becoming reality.

May the Director of the Musées de France take this opportunity to express his pride at seeing the youngest of the French national museums, the Musée Picasso, and its Curator-in-Charge, Dominique Bozo, associated from the outset with the accomplishing of a project of such quality and scope—with an undertaking that will never again be possible?

Few professions will have matched ours—I mean the museum profession—in the creation of such a network of cooperation, trust, and friendship, placed at the service of an increasingly demanding public, ever more eager to see, to know, to understand. Museum cooperation on the international level is no longer an empty word.

Picasso would probably have been much amused had anyone predicted to him that he would hallow with such brilliance the "age of the museums."

Hubert Landais
Director of the Musées de France
President of the International Council of Museums

INTRODUCTION

As the Director of the Musées de France rightly remarks, the Musée Picasso is a very young museum. Still in the process of being set up, its holdings have scarcely been revealed to the public. Yet, with this exhibition it begins a promising collaboration with The Museum of Modern Art. From the beginning, the undertaking of this exhibition was something of a gamble. At the time of our first contact with William Rubin, in 1975, the Picasso museum project was in gestation, and although the collection was not yet available to us, we became convinced that it was our duty to do everything possible to share in and achieve this retrospective. About the same time, our colleague Martin Friedman, Director of the Walker Art Center in Minneapolis, asked that his city be the first in America to play host to the cream of Picasso's own collection of his work. Before the two American exhibitions could be held, the collection received by France had first to be shown in Paris. Thus in 1979 and 1980, in advance of the centenary of the artist's birth in 1981, three exhibitions, differing in their content and purpose, have inaugurated the grand homage to be paid by our century to the artist who has expressed our time most completely.

The exhibition in Paris was arranged with the understanding that it would not be a retrospective in the usual sense, in which a selection of works is presented and analyzed in a developed and scientific fashion; rather, it would be a display of the works "in the raw state," simply hung on temporary walls within the space of the Grand Palais in Paris. Therefore we did not try to reconstruct a specific milieu or establish a given point of view. That would have been premature and would have required much more lengthy preparations than time allowed.

The Minneapolis exhibition, on the other hand, involved other criteria. It was a selection of significant works of exceptional quality, taken from the immense collection that will form the Musée Picasso. A nondiscursive retrospective, without anecdote, in which each work was chosen on its own merits, it was based on no other judgment but the individual effectiveness of each object. A "collector's choice," it might be called, excluding documentation and reference or supporting works, but showing the essential development of Picasso's oeuvre: a small, ideal museum devoted to contemplation, in which the public had the time to look and to see.

The aim of the present retrospective is, again, quite different. M. Landais emphasizes not only the exceptional circumstances that make it possible, but also the "mad" aspect of the undertaking, that is to say, the "luxury" of bringing together such an assemblage, which has only been made possible by a driving strength of passion for Picasso's work. What are the reasons for holding this exhibition? First of all, because it can never have an equivalent in the future. After Picasso's collection has reached its permanent home in the new Musée Picasso, it can never travel in such numbers again. Second, in order to pay Picasso the unique homage we owe him on the eve of the hundredth anniversary of his birth. This homage, exceptional in its magnitude, had to be the work of an exceptional museum. More than any other, The Museum of Modern Art, throughout its fifty years, has brilliantly, and whenever occasion demanded, brought together major assemblages of Picasso's oeuvre. This exhibition is intended also for scholars and art historians, who will find in this "album"—perhaps the richest and most complete ever devoted to Picasso—the groundwork for new studies, new analyses, and new syntheses based on data previously unknown or hitherto inaccessible. Although it was agreed that this catalog would not offer any new studies, the exhibition itself will present whole constellations of themes, offering them for imme-

diate comparison and dialogue in the space of the museum.

For those in charge of a museum in the process of being conceived and developed, this exhibition offers a valuable opportunity for measuring the response to such a presentation. The experience of the New York retrospective will unquestionably contribute to the shaping of exhibition space and to the subsequent placing of works at the hôtel Salé, the new home of the Musée Picasso in Paris. It is a rehearsal whose timeliness we appreciate, since it allows us to have a new relationship with the great milestones of Picasso's oeuvre, and these, with their surroundings; to experience the confrontation between his painting and sculpture, so important to the endeavors of artists of this century; and to display Picasso's experiments: the appearances, the renunciations (most often temporary), the abiding signs and themes. Only in the future installation at the hôtel Salé will one be able to see as clearly how Picasso's work—ordinarily judged by his single masterpieces or in relation to his contemporaries'—was developed, nourished, and continually restored from its own fundamental resources, from its own gestures.

This is the last joint manifestation before the opening of the Musée Picasso in Paris. That event will be, we hope, the extension or, rather, the "completion" of this retrospective. A unique feature offered by the new museum will be the opportunity of confronting Picasso with himself and with his time, thanks to the extraordinary wealth of documentation in our archives and to the presence of Picasso's personal collection (now being shown at the Louvre), which includes works by Cézanne, Matisse, Derain, Degas, Renoir, and the *Douanier* Rousseau.

It is a collection, moreover, that has since been enriched by other examples of primitive and modern art. The hôtel Salé will thus devote some of its rooms to the life and society in which Picasso moved—for example, to the Bateau-Lavoir, to Picasso's relations with the writers and poets of his time, and to the Ballets Russes. Hundreds of studies (some fifteen hundred sheets of drawings and almost as many contained in the 33 notebooks of the collection), like the various documents assembled, will make the Musée Picasso a unique research center.

There is no space here to dwell on the importance of its holdings, to enumerate its masterpieces, its exceptional groupings and series, the treasures of its sculpture collection; or to speak of the program and activities planned by the new museum around major works; nor to mention future collaborations already envisaged. Rather, let us say only that it is our ambition to make it not a museum in the classical sense of the word but a place that will be close in spirit to those studio-houses where Picasso's work and life mingled and combined.

Dominique Bozo
Curator-in-Charge of the Musée Picasso, Paris

GENESIS OF AN EXHIBITION

The idea for the present exhibition emerged from my visits with Picasso during the last years of his life. I had the good fortune not only to observe how Picasso lived but to see many works he had kept near him. Some I had seen in exhibitions; most I knew only through photographs, and still others were entirely new to me. Studying them all in Picasso's own surroundings altered my image of the man and his work even as it expanded it. My desire to share that experience and perception was the genesis of this exhibition.

The works Picasso retained for himself evoke a very different artist from the one we see in monographs and major museum collections, which depend perhaps disproportionately on paintings and tend to be organized according to received ideas. While Picasso held on to a number of his important paintings, the preponderant weight of his own holdings lay in those areas of his art most associated with experiment and process—his sketches and drawings, constructed sculptures, and works in mixed media. Among his paintings he not infrequently kept the unusual or unique, such as *Still Life with Chair Caning* of 1912 and *Crucifixion* of 1930.

Picasso needed to stay in contact with his own work; he frequently "vegetated," as he put it, in the forest of sculptures that filled the lower studio of his villa Notre-Dame-de-Vie. He prized above all his Cubist constructions, of which only two—both gifts—were allowed to depart his studio during his lifetime. (Almost all the rest have been selected for the Musée Picasso.) In retaining virtually his entire output of Cubist sculpture, Picasso confirmed his recognition of its unique position within his oeuvre. By making sculpture through construction and assemblage rather than through carving and modeling, the methods employed since ancient times, he changed the art more radically than any other artist in history. In painting, his revolutionary Cubism had been developed in concert with Braque and had been adumbrated by Cézanne; the radicality of his sculpture owed nothing to forerunners or contemporaries.

In addition to a comprehensive representation of sculpture, I wanted to exhibit sufficient numbers of the works I saw in the many studios distributed throughout Picasso's villa to communicate their cumulative effect of restless, proliferating inventiveness, their revelations of the eddies and backwaters of his mind, as well as its major currents. But I also wanted to situate the best of his collection in the context of the panorama of the even larger number of key works that, over a period of more than seventy years, had left his studio, some of them in out-of-the-way museums or inaccessible collections. This combination, I felt, would make clear the continuity and unity of Picasso's work as never before.

As I began to contemplate (or, if you wish, fantasize about) the kind of show that would do justice to Picasso, that would show his career not in terms of discrete and recognizable segments—the various "periods" —but in its one long, continuous flow, it became clear not only that our Museum's temporary exhibition space would be entirely inadequate, but that we would be lucky to be able to "contain" the essential Picasso within the whole of the Museum. Indeed, although the Museum has given over virtually the entire building to this exhibition, my codirector Dominique Bozo and I have had to make unwilling sacrifices in our selection because of lack of space.

Because Picasso's oeuvre, in its multiplicity of styles, variety, and inventiveness, epitomizes twentieth-century art as a whole, this appeared to me a fitting exhibition to celebrate the Museum's first fifty years. After clearing the idea with our President and Director, I broached it to Picasso, who was pleased, bemused, and promised his help. Hardly had I reported the results of

my conversation with him when he died—and a maze of litigation made his work inaccessible.

The progress in the past few years in the settlement of Picasso's estate reopened the way for such an exhibition and gave it a special urgency, since it was evident that once many of the best of Picasso's holdings were settled in Paris's Picasso museum, these works could never leave in such numbers as to make possible the exhibition I had envisioned. Another cause for urgency was the approaching departure of *Guernica* and its studies. Once in Spain, the mural would never move again from its home in the Prado, and its absence would constitute an unfillable lacuna in any future Picasso retrospective.

When I proposed this exhibition to Dominique Bozo, the curator designate of the future Picasso museum, he was enthusiastic, realizing immediately how beneficial it would be to everyone interested in Picasso's work if such a retrospective could be brought off. We agreed that the many important loans necessary from the Musée Picasso could be considered the basis of a special reciprocal relationship between our two museums; The Museum of Modern Art has pledged to collaborate in, and to make those loans necessary for, a program of small but highly focused and scholarly exhibitions envisioned by M. Bozo. The first of these will unite all the studies and postscripts for *Les Demoiselles d'Avignon*—a type of concentrated approach to a single work not possible in the context of even the largest retrospective. These exhibitions will be the centerpieces of a program involving all forms of bibliographic and scholarly exchange.

With these agreements, the project for the retrospective became a collaborative one, the participation of the Réunion des Musées Nationaux (under whose aegis the Musée Picasso operates) serving as a much appreciated salute to The Museum of Modern Art on its fiftieth anniversary. Beginning with the earliest selections made two years ago, Dominique Bozo and I have shared the task of organizing and will share that of installing the exhibition. A man of superb sensibility, of an amiabil-

ity and diplomacy matched only by the firmness of his convictions, Dominique Bozo made it a great pleasure to work with him. Our collaboration has certainly been to the benefit of ourselves and our respective museums; I hope it will prove equally rewarding to the public.

As the unusual element in the show will be the presence of many unfamiliar works, and given the already vast body of literature available on Picasso, we decided to place our emphasis on the purely visual aspect of the catalog, choosing a generous format and reproducing every painting, sculpture, work on paper, and ceramic in the exhibition—over two hundred of them in color. With a few exceptions—made to emphasize iconographic, formal, or typological relationships and, occasionally, as the aesthetics of book design demanded—I have adhered closely to chronological order in laying out the catalog. Within this framework, however, I have attempted to communicate ideas about Picasso's development through the juxtaposition of particular works. Indeed, few texts I have written have been given more thought than the layout of this catalog, which, in the issues it raises in certain juxtapositions, at least, aspires to a kind of art history without words. Despite the vastness of the Picasso literature, there exists no up-to-date biographical sketch of Picasso's life—hence, our decision to introduce each group of plates with a chronology supplemented by documentary photographs. We hope that this, in combination with the plates, will make this volume a useful reference for the student and scholar as well as the layman.

Because this catalog went to press in the first week of February 1980, formal agreement to a few verbally committed loans was still outstanding. Hence some differences might exist between exhibition and catalog. To satisfy documentary needs, the Museum will make available at the time of the opening of the exhibition a precise checklist of its contents.

William Rubin
Director of Painting and Sculpture
The Museum of Modern Art

CHRONOLOGY
AND PLATES

Editor's Note:

The photographs accompanying the Chronology are intended to document events in Picasso's life. For the most part, works reproduced in this section are not in the exhibition. Where exceptions do occur, they are indicated in the caption by a dagger following the title.

In plate captions, height precedes width, followed, in the case of sculpture, by depth. Unless otherwise specified, drawings, watercolors, and *papiérs collés* are works on paper, for which sheet sizes are given. For prints, plate or composition sizes appear. Dates for sculptures in bronze refer to the original facture, whether in clay, plaster, or any material in the wide range used by the artist. Dates marked with an asterisk differ from those accepted by respected authorities on Picasso's oeuvre. A key to variant dates and their sources can be found on page 459. If information is in doubt, the date or place of execution is placed in brackets. Where possible, captions refer to entry numbers in the appropriate catalogue raisonné. Full titles of the catalogues raisonnés can be found on page 459.

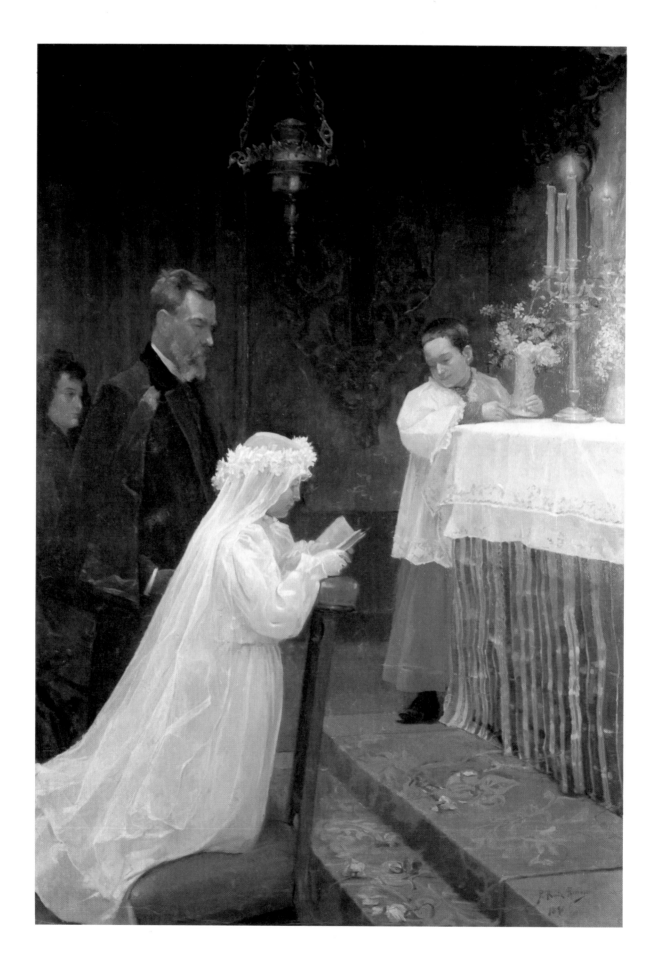

1881-1899

First Communion. Barcelona, Winter 1895–96
Oil on canvas, 65⅜ x 46½″ (166 x 118 cm)
Zervos XXI, 49. Museo Picasso, Barcelona

School of Fine Arts and Crafts (San Telmo), Málaga

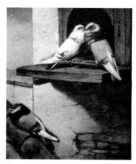

José Ruiz Blasco: *Pigeons.* n.d. Oil

Pigeons. Málaga, 1890. Pencil, 4⅜ x 8¾″ (11 x 22 cm). Museo Picasso, Barcelona

1881

OCTOBER 25: Birth of Pablo Ruiz Picasso at Málaga, the first child of Don José Ruiz Blasco and his wife, Doña María Picasso y López. Don José, a painter, teaches drawing at the School of Fine Arts and Crafts and is curator of the local museum. Described as "having the air of an Englishman," he is tall and blond, his wife small and dark.

1884

DECEMBER 15: Birth of Pablo's first sister, Lola.

1887

Birth of Pablo's second sister, Concepción (Conchita).

1888–1890

Pablo begins to draw and paint. Attends bullfights with his father; completes a bullfight painting, *Picador*, his earliest known picture.

1891

SEPTEMBER: Don José accepts a position as art teacher in a secondary school in La Coruña, on the Atlantic coast of Spain, where he moves with his family.

Sister Conchita dies of diphtheria.

Pablo studies drawing and painting under his father, who allows him to finish details of his own paintings.

1892

Don José enrolls his son in the School of Fine Arts in La Coruña, where he enters the Drawing and Ornament class.

1893

Progresses to the Life Drawing class. In addition, draws and paints battle scenes, portraits of his father and mother, and sketches of the local landscape.

1894

Thirteen years old, keeps journals which he calls *La Coruña* and *Asul y Blanco* (*Blue and White*), illustrating them with portraits and caricatures; signs his work "P. Ruiz." Enters a new class at the academy, drawing from plaster casts (pp. 20, 21). Becomes so accomplished that his father, overwhelmed by his son's talent, is said to have given Pablo his own palette, brushes, and colors, declaring that he will never paint again.

Picador. Málaga, 1889–90. Oil on panel. Collection Claude Picasso, Paris

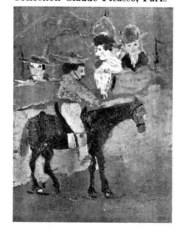

1895

SPRING: Don José accepts post at the School of Fine Arts in Barcelona (popularly called La Lonja) and moves immediately, leaving his family in La Coruña until the end of the school year.

JULY: Family leaves for Málaga, stopping first in Madrid. Pablo sketches the Prado in the rain; sees paintings of Velázquez, Zurbarán, and Goya for the first time.

Vacations in Málaga and travels to Barcelona by sea; paints a small canvas of Cartagena and seascapes of Alicante and Valencia.

SEPTEMBER: Family moves to calle Cristina, near School of Fine Arts. Pablo applies to the school and is allowed to skip the early classes and take the entry examination for advanced classes in classical art and still life. Completes the exam in one day and is admitted.

Asul y Blanco. La Coruña, 1894. Pen and ink, 8 x 10½″ (20.3 x 26.5 cm). Museo Picasso, Barcelona

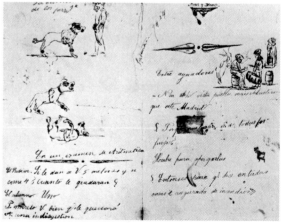

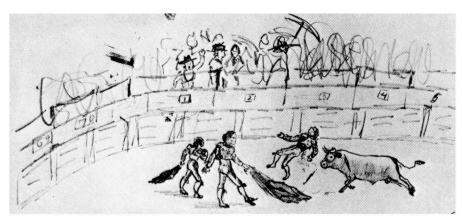

Bullfight. Málaga, 1890. Pencil, 5⅜ x 8″ (13.5 x 20.2 cm) (sheet). Museo Picasso, Barcelona

Diploma drawing for entry to School of Fine Arts, Barcelona. 1895. Lead pencil

Family moves to calle de la Merced, n. 3, and father finds Pablo a studio nearby.

WINTER 1895–96: Makes sketches of nearby landscape (p. 22), and paints first large "academic" canvas, *First Communion* (p. 14). His father is model for male figure.

1896

APRIL: *The First Communion* appears in exhibition in Barcelona, along with paintings by Santiago Rusiñol, Ramón Casas, and Isidro Nonell.

Paints portraits of his family—his father (pp. 21, 23, 24), mother, aunt Pepa (p. 23), grandmother Doña Iñes, and sister Lola.

Meets Manuel Pallarés, a Catalan painter from Horta, in the Ebro valley, who becomes his "guide to Barcelona." Paints several portraits of the young Catalan.

SUMMER: Vacations in Málaga. Paints *Mountain Landscape* (p. 22).

1897

BEGINNING OF YEAR: Paints second large academic work, *Science and Charity* (p. 24), his father modeling for figure of doctor; it receives honorable mention in the national exhibition of fine arts in Madrid in June (later receives gold medal in competition at Málaga). This student picture is shown alongside work by the portraitist Antonio Caba, director of School of Fine Arts.

SUMMER: Vacations again in Málaga. Courts his young cousin. Don José asks his brothers for money to send Pablo to Madrid.

SEPTEMBER: Leaves for Madrid, his first trip there on his own.

OCTOBER: Completes admission drawings for the Royal Academy of San Fernando in one day, equaling his brilliant performance in Barcelona. Finds lodgings at calle San Pedro Martir, n. 5.

Portrait of the Artist's Grandmother. Barcelona, 1895–96. Pencil, 5 x 4″ (12.7 x 10 cm). Museo Picasso, Barcelona

The Artist's Sister Lola. Barcelona, 1899–1900. Conté crayon, 17½ x 12¾ (48.5 x 32.3 cm). Museo Picasso, Barcelona

17

Portrait of the Artist's Father.† Barcelona. 1895–96. Pen and ink, 8¼ x 6⅛″ (20.7 x 15.4 cm). Museo Picasso, Barcelona

Portrait of the Artist's Mother. Barcelona, 1896. Pastel, 19⅝ x 15⅜″ (49.8 x 39 cm). Zervos XXI, 40. Museo Picasso, Barcelona.

NOVEMBER: Writes to a friend, Bas, in Barcelona that Spanish painters are badly educated: "If I had a son who wanted to be a painter, I would not let him live in Spain [or] . . . send him to Paris . . . but [I would] send him to Munich where one studies painting seriously without paying attention to fashions such as pointillism and others. . . .

I am not in favor of following any determined school because that only brings about a similarity among adherents." Assesses what he has seen at the Prado: "The museum of painters is beautiful. Velázquez is first class. Some of Greco's heads are magnificent. Murillo is not always convincing. Titian's 'Dolorosa' is good; there are some beautiful Van Dyck portraits. Rubens has some snakes of fire as his prodigy, Teniers some very good small paintings of drunkards, and everywhere 'Madrileñitas' so beautiful that no Turkish woman could compare. . . . Your good friend, P. Ruiz Picasso. . . ."

WINTER: Abandons the Academy. Has falling-out with his father.

Self-Portrait.† Barcelona, 1897. Conté crayon, 12⅝ x 9¾″ (32 x 24.7 cm). Zervos VI, 114. Collection Paloma Picasso Lopez, Paris

1898

LATE SPRING: Ill with scarlet fever, returns home to Barcelona to convalesce.

MID-JUNE: Visits his friend Pallarés at his home in Horta for the first time. Regains his health and spends eight months there, he and Pallarés living for part of the time in a cave in the mountains. Makes sketches of the pine forests, the mountain of Santa Bárbara, and the houses of the village.

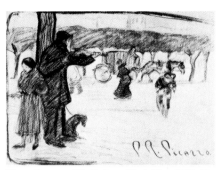

The Street Violinist. Madrid, 1897–98. Conté crayon and watercolor, 9¼ x 13¼″ (23.5 x 33.5 cm). Museo Picasso, Barcelona

1899

FEBRUARY: Returns to Barcelona. Establishes himself in studio belonging to the brother of his friend Josep Cardona, at calle de Escudillers Blancs, n. 2.

Begins to frequent Els Quatre Gats, a café founded by Pere Romeu two years before. Designs Quatre Gats menus (p. 25). Meets the painters Sebastián Junyer-Vidal, Isidro Nonell, Joaquín Sunyer, and Carlos Casagemas (shortly to go with him to Paris), the collector Carlos Junyer-Vidal, the sculptor Manolo Hugué, the brothers Fernández de Soto (Angel and Mateu), the writer Ramón Reventos, and the poet Jaime Sabartés (later to be his secretary and lifelong close friend). Among the older men he meets at the café are the philosopher and critic Eugenio d'Ors, the painter-playwright Santiago Rusiñol, the art historian Miguel Utrillo, and the painter Ramón Casas.

Through Casas, becomes acquainted with the work of Théophile Steinlen and Henri de Toulouse-Lautrec.

JUNE: Utrillo and Casas found *Pél i Ploma* (*Brush and Pen*), publishing articles on El Greco as well as reevaluations of Romanesque and Gothic Art.

With help of Ricardo Canals, makes first etching, *El Zurdo*, representing a picador.

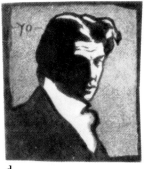
a

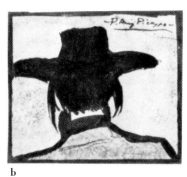
b

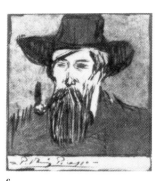
c

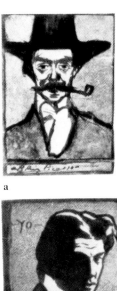
d

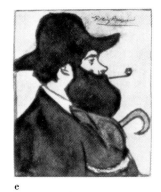

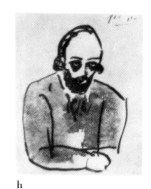
e

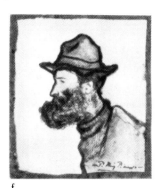
f

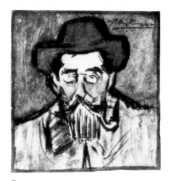
g

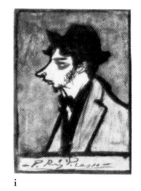
h

i

Portraits of Els Quatre Gats friends and acquaintances. Barcelona, c. 1899. Present whereabouts unknown. (a) *Pujolá y Vallés,* (b) *Pere Romeu,* (c) *Santiago Rusiñol,* (d) *Self-Portrait,* (e) *Hermen Anglada Camarasa,* (f) *Ramón Pichot,* (g) *Ramón Casas,* (h) *Manolo Hugué,* (i) *Carlos Casagemas*

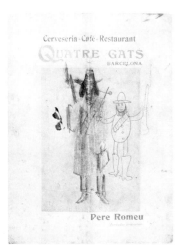

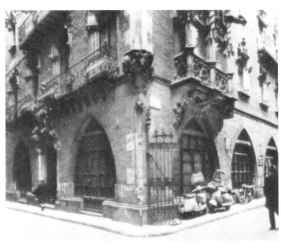

Pere Romeu as "Boer."† Barcelona, 1899. Lead pencil on printed menu of Els Quatre Gats (also designed by Picasso, p. 25), 8⅝ x 6½″ (21.8 x 16.4 cm). Museo Picasso, Barcelona

Building that housed Els Quatre Gats, Barcelona

19

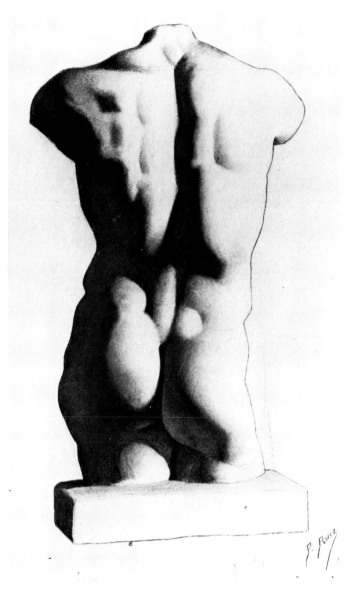

Study of a Torso, after a Plaster Cast. La Coruña, 1894–95
Charcoal, 19⅜ x 12⅜″ (49 x 31.5 cm)
Zervos VI, 1. Musée Picasso, Paris

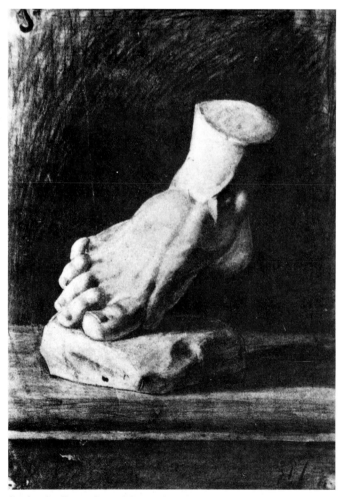

Study of a Foot, after a Plaster Cast. La Coruña, 1894–95
Charcoal, 20½ x 14½″ (52.2 x 36.7 cm)
Zervos VI, 7. Private collection

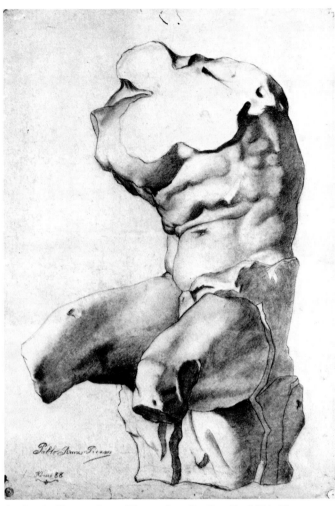

Self-Portrait. Barcelona, 1896
Pencil, 5⅜ x 4⅛″ (13.5 x 10.5 cm)
Zervos VI, 50. Collection Paloma
Picasso Lopez, Paris

Study of a Torso, after a Plaster Cast. La Coruña, 1894–95
Charcoal and conté crayon, 20⅝ x 14½″ (52.4 x 36.7 cm)
Not in Zervos. Museo Picasso, Barcelona

Portrait of José Ruiz Blasco, the Artist's Father
Barcelona, 1896
Watercolor, 7⅛ x 4⅝″ (18 x 11.8 cm)
Not in Zervos. Museo Picasso, Barcelona

21

Landscape Study. Barcelona, c. 1895–96
Lead pencil, 14⅜ x 10½″ (36.5 x 26.5 cm)
Not in Zervos. Museo Picasso, Barcelona

Landscape. Barcelona, c. 1895–96
Conté crayon, 12½ x 9½″ (31.5 x 24 cm)
Not in Zervos. Museo Picasso, Barcelona

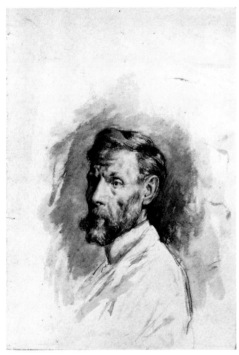

*Portrait of José Ruiz Blasco, the Artist's
Father.* Barcelona, 1896
Watercolor, 10⅛ x 7″ (25.5 x 17.8 cm)
Zervos XXI, 28. Museo Picasso, Barcelona

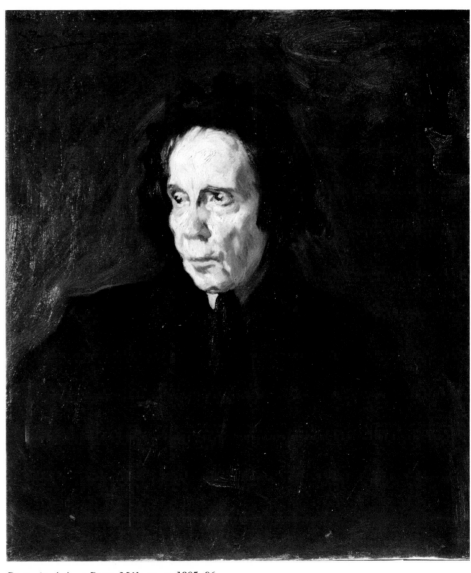

Portrait of Aunt Pepa. Málaga, c. 1895–96
Oil on canvas, 22⅝ x 19⅞″ (57.5 x 50.5 cm)
Zervos XXI, 38. Museo Picasso, Barcelona

OPPOSITE:
Mountain Landscape. Málaga, c. 1896
Oil on canvas, 23⅞ x 32½″ (60.7 x 82.5 cm)
Not in Zervos. Museo Picasso, Barcelona

The Artist's Father. Barcelona, 1895–96
Pen and ink and aquatint, 6½ x 5⅞″ (16.5 x 15 cm)
Zervos XXI, 39. Museo Picasso, Barcelona

Science and Charity. Barcelona, early 1897
Oil on canvas, 77⅝ x 98¼″ (197 x 249.5 cm)
Zervos XXI, 56. Museo Picasso, Barcelona

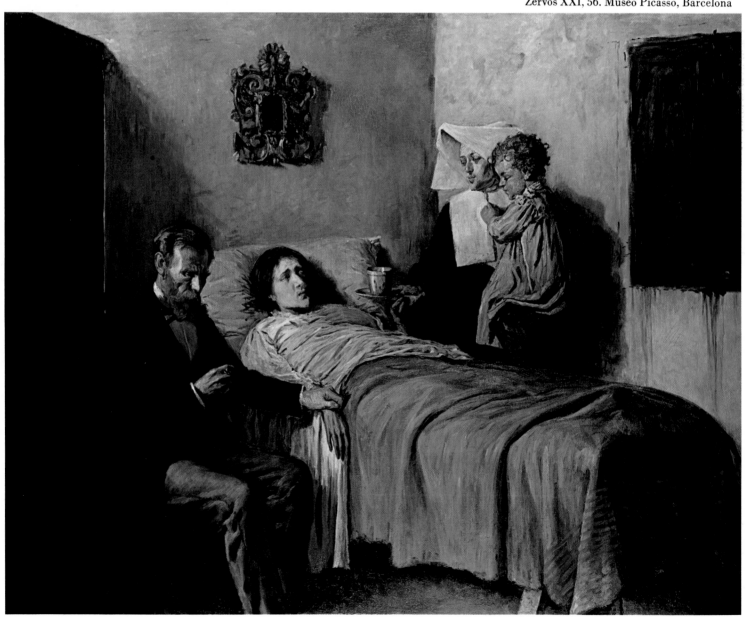

Studies for Menu of Els Quatre Gats
(recto and verso of one sheet; in left panel, caricature of Mateu Fernández de Soto) Barcelona, 1899
Pen and ink and pencil, 12⅝ x 9″ (32.1 x 22.7 cm)
Not in Zervos. Museo Picasso, Barcelona

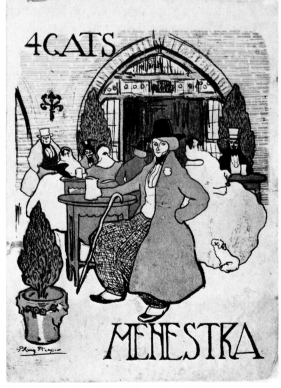

Studies for Menu of Els Quatre Gats. Barcelona, 1899
Pen and ink, 12⅝ x 8⅞″ (32 x 22.3 cm)
Not in Zervos. Museo Picasso, Barcelona

Menu of Els Quatre Gats. Barcelona, 1899
Printed, 8⅝ x 6½″ (22 x 16.5 cm)
Zervos VI, 193. Museo Picasso, Barcelona

25

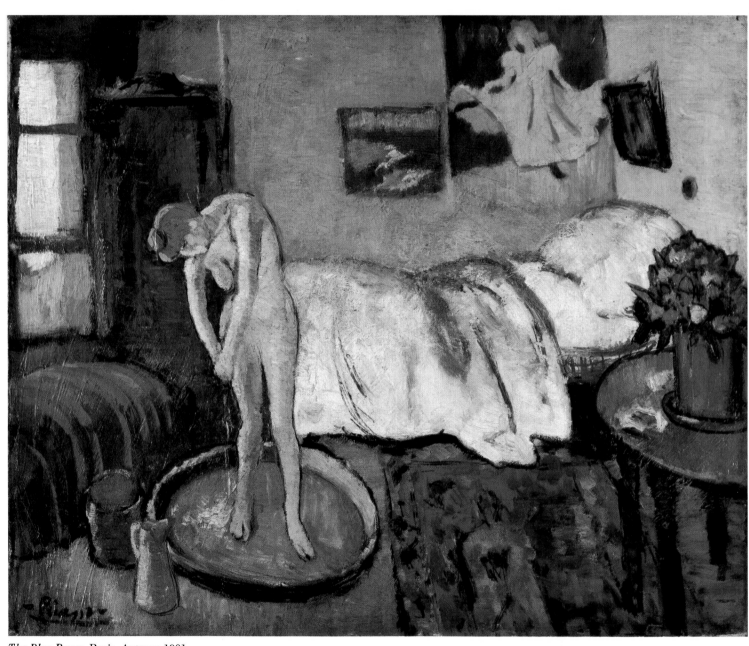

The Blue Room. Paris, Autumn 1901
Oil on canvas, 20 x 24½" (50.8 x 62 cm)
Zervos I, 103. D.B. VI, 15. The Phillips Collection, Washington, D.C.

1900-1901

1900

BEGINNING OF YEAR: Shares studio with Carlos Casagemas on calle Riera de San Juan, n. 17, Barcelona.

FEBRUARY 1: Group of Picasso's drawings, mainly portraits of his friends, writers, and painters (p. 19), exhibited at Quatre Gats, along with a painting called *The Last Moments* (possibly *Science and Charity*). Account of exhibition appears in *La Vanguardia*.

FEBRUARY 24: *La Vanguardia* publishes list of artists whose work has been submitted for exhibition at the Paris Universal Exposition, including several paintings by "Pablo Ruiz." *The Last Moments* is selected for the exhibition, which opens May 1.

JULY 12: *Joventut*, an avant-garde Catalonian review, publishes a drawing; a second is published in August.

SEPTEMBER 6: *Catalunya Artistica* publishes a drawing.

OCTOBER: Picasso and Casagemas leave for Paris and install themselves in Nonell's studio at 49, rue Gabrielle, in Montparnasse. They become part of Spanish colony, which includes the sculptors Paco Durio and Manolo. They visit the Exposition and picture dealers, where they see works by Cézanne, Lautrec, Degas, Signac, Bonnard, and Vuillard.

Paints first Paris picture, *Le Moulin de la Galette* (p. 32); shows interest in Toulouse-Lautrec. Features Commedia dell'Arte figure Pierrot in *The Blue Dancer* (p. 31), having introduced him in a carnival handbill in Barcelona early in year (p. 30). Beginning of lifelong interest in the theater.

Meets dealers Berthe Weill and Pedro Mañach. Mañach offers him 150 francs a month in exchange for paintings. Berthe Weill buys three pastels of bullfights (p. 31).

Casagemas falls in love with model Germaine (real name Laure Gargallo).

DECEMBER 20: With Casagemas, departs for Barcelona and then Málaga. Casagemas, who cannot forget his new love, returns to Paris, and Picasso goes on to Madrid.

1901

FEBRUARY 17: Disappointed in his love

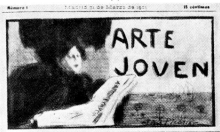

First issue of *Arte Joven* (Madrid), March 31, 1901. Illustrated below: *Woman in a Large Hat*, 1901. Musée des Beaux-Arts, Reims

"Notas de Arte, 'Madrid.'" Advertisement in *Arte Joven* for new publication planned by Picasso and Francisco de Asís Soler, 1901

for Germaine, Casagemas commits suicide in a Paris café.

FEBRUARY 28: *Catalunya Artistica* carries an obituary of Casagemas, accompanied by a drawing by Picasso.

MARCH 31: First issue of the review *Arte Joven* is published with funds provided by Francisco de Asís Soler, a young Catalan writer; Picasso is art editor and illustrator. Only four issues appear. Second includes announcement of new review "Madrid," which is never published.

LATE APRIL: Leaves for Barcelona to prepare for return to Paris. Paints several canvases using divisionist brushwork and pure color.

MAY: Leaves for Paris with Jaime Andreu Bonsons and installs himself at 130ter, boulevard de Clichy, in his late friend Casagemas's studio. During next few months turns frequently to theme Paris by Night: *The Absinth Drinker* and *Picasso in a Top Hat* (both, p. 33);

Parody of Manet's Olympia (Sebastián Junyer-Vidal and Picasso).† Barcelona, 1901. Pen and ink and colored crayon, 6 x 9⅛" (15.3 x 23 cm). Zervos VI, 343. D.B. D. IV, 7. Collection Léon Bloch, Paris

Illustration for "El Clam de las Verges" ("The Virgins' Clamor"), poem by Juan Oliva Bridgman. Published in *Joventut* (Barcelona), July 12, 1900

Self-Portrait. Barcelona or Paris, 1900. Charcoal on gray paper, 8⅞ x 6½" (22.5 x 16.5 cm). Museo Picasso, Barcelona

Self-Portrait and Sketches of Fuentes, Martí, Pompeu Gener, and Others.† Barcelona, 1900. Pen and ink, 12⅝ x 8¾" (32 x 22 cm). Museo Picasso, Barcelona

French Cancan (p. 35); and *At the Moulin Rouge* (p. 36).

JUNE: Miguel Utrillo shows Picasso's pastels at the Sala Parés in Barcelona. The catalog is published in *Pél i Ploma,* with Casas's drawing of Picasso as the frontispiece. The text, written by Utrillo

under the pen name "Pincell," refers to the artist throughout as Picasso. Until just before his first trip to Paris, the artist has signed most paintings "P. Ruiz Picasso," then simplifying the signature to "P. R. Picasso." Upon his return to Barcelona, he apparently has abbreviated it further to "Picasso."

JUNE 24: With Basque painter Iturrino, has exhibition in Paris at Galeries Vollard on rue Laffitte; show is mounted by Mañach, and critic Gustave Coquiot writes the catalog preface. Picasso paints portraits of both Mañach and Coquiot (p. 37), including the former in exhibition. Also shows *Self-Portrait: Yo Picasso* (p. 36), *At the Moulin Rouge, Blue Roofs* (p. 39), and perhaps *La Madrilène* (p. 35).

Despite Vollard's later assertion that the show is unsuccessful, 15 works are sold even before the exhibition opens; and the critic Félicien Fagus writes in a laudatory review in *La Revue blanche:* "[Picasso] is the brilliant newcomer. . . . Like all pure painters, he adores

Self-Portrait.† Paris, [Summer] 1901. Oil on cardboard mounted on wood, 20¼ x 14½" (51.4 x 36.8 cm). Zervos I, 113. D.B. V, 1. Collection Mr. and Mrs. John Hay Whitney, New York

color for itself and each substance has its proper color." Fagus traces not only Picasso's Spanish ancestry but also his French antecedents and concludes: "Each influence is transitory. . . . One sees that Picasso's haste has not yet given him time to forge a personal style; his personality is in this haste, this youthful impetuous spontaneity (I understand he is not yet twenty, and covers as many as three canvases a day)."

Mañach introduces Picasso to Max Jacob during the course of the show.

LATE SUMMER: Paints *Evocation* (*The Burial of Casagemas*) (p. 40), which recalls El Greco's *Burial of the Count of Orgaz*; two other canvases follow on the theme of his friend's death (p. 40).

SEPTEMBER–OCTOBER: Canvases tend more and more to blue: *The Blue Room* (p. 26), painted in his studio on the boulevard de Clichy, and portraits of his friends Sabartés and Mateu Fernández de Soto, newly arrived in Paris.

Introduces Circus and Harlequin themes with the paintings *The Two Saltimbanques* and *Harlequin* (both, p. 41). Also executes a series of *Maternités*.

WINTER: Paints three more portraits: another of Sabartés and of F. de Soto (p. 43) and one of himself (p. 43).

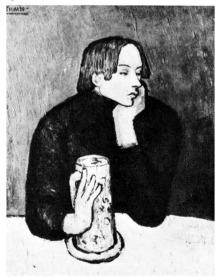

Portrait of Sabartés (The Glass of Beer). Paris, September–October 1901. Oil on canvas, 32¼ x 26" (82 x 66 cm). The Pushkin State Museum of Fine Arts, Moscow

Pierrot Celebrating the New Year (Carnival handbill)
Barcelona, January 1, 1900
Watercolor and charcoal, 19 x 12⅜″ (48.3 x 31.4 cm)
Zervos XXI, 127. Musée Picasso, Paris

Study for Pierrot Celebrating the New Year
Barcelona, January 1, 1900
Charcoal and conté crayon, 24½ x 16⅞″ (62 x 42.7 cm)
Not in Zervos. Museo Picasso, Barcelona

OPPOSITE:
Bullfight. Barcelona, 1900
Pastel and gouache on canvas, 18 x 27″ (45.8 x 68.6 cm)
Zervos XXI, 148. D.B. II, 6. Private collection

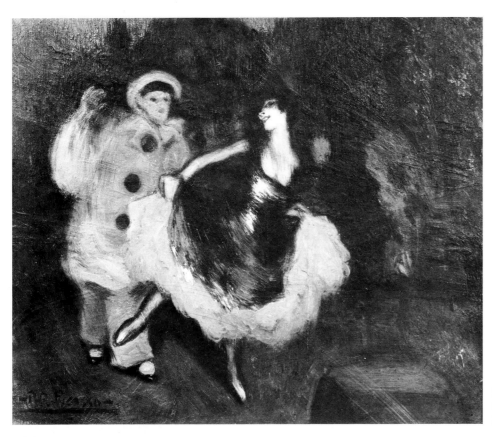

The Blue Dancer. Paris, Autumn 1900
Oil on canvas, 15 x 18⅛″ (38 x 46 cm)
Zervos XXI, 224. D.B. II, 23. Private collection

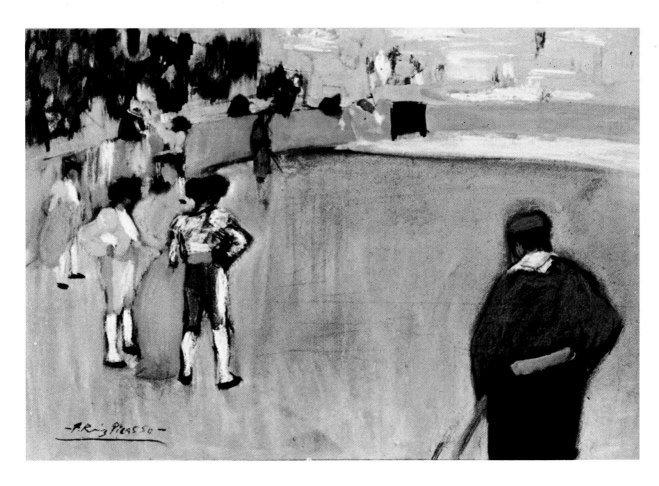

Angel Fernández de Soto with a Woman. Barcelona, c. 1901
Watercolor and ink, 8¼ x 6″ (21 x 15.2 cm)
Not in Zervos. Museo Picasso, Barcelona

Le Moulin de la Galette. Paris, Autumn 1900
Oil on canvas, 34¾ x 45¼″ (88.2 x 115 cm)
Zervos I, 41. D.B. II, 10. The Solomon R. Guggenheim Museum, New York. Gift of Justin K. Thannhauser

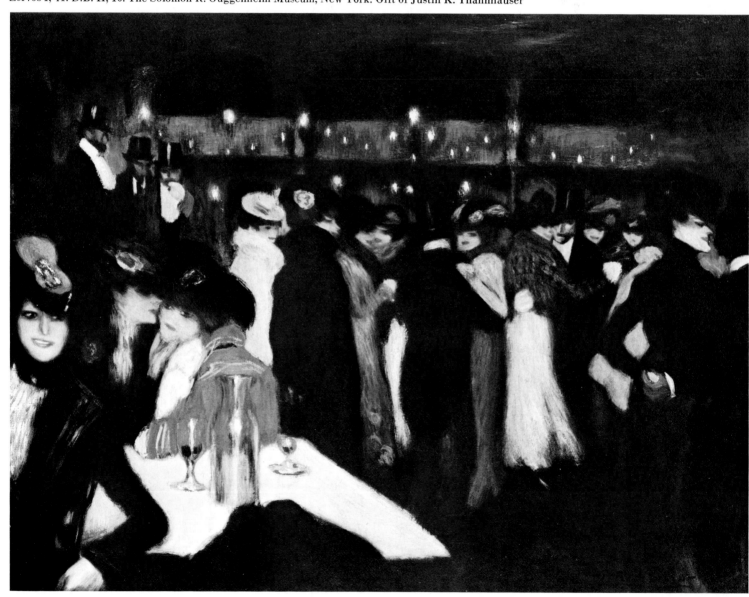

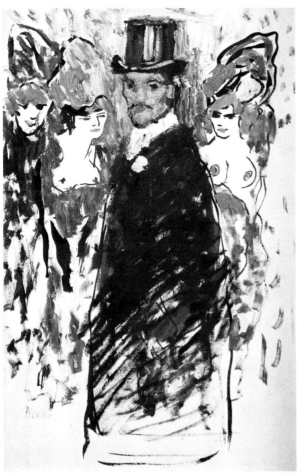

Picasso in a Top Hat. Paris, 1901
Oil and India ink on paper, 19¾ x 13″ (50 x 33 cm)
Zervos XXI, 251. D.B. V, 41. Private collection

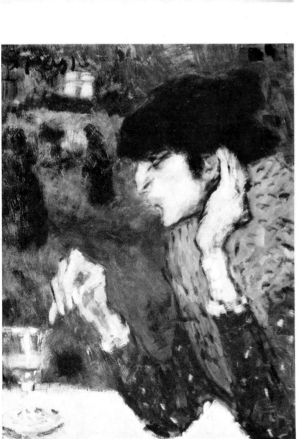

Woman with Furs. [Barcelona or Paris], 1901
Pen and ink, 19½ x 12¾″ (49.5 x 32.4 cm)
Not in Zervos. E. V. Thaw and Co., Inc., New York

The Absinth Drinker. Paris, 1901
Oil on cardboard, 25⅞ x 20″ (65.8 x 50.8 cm)
Zervos I, 62. D.B. V, 12. Collection Mrs. Melville Hall, New York

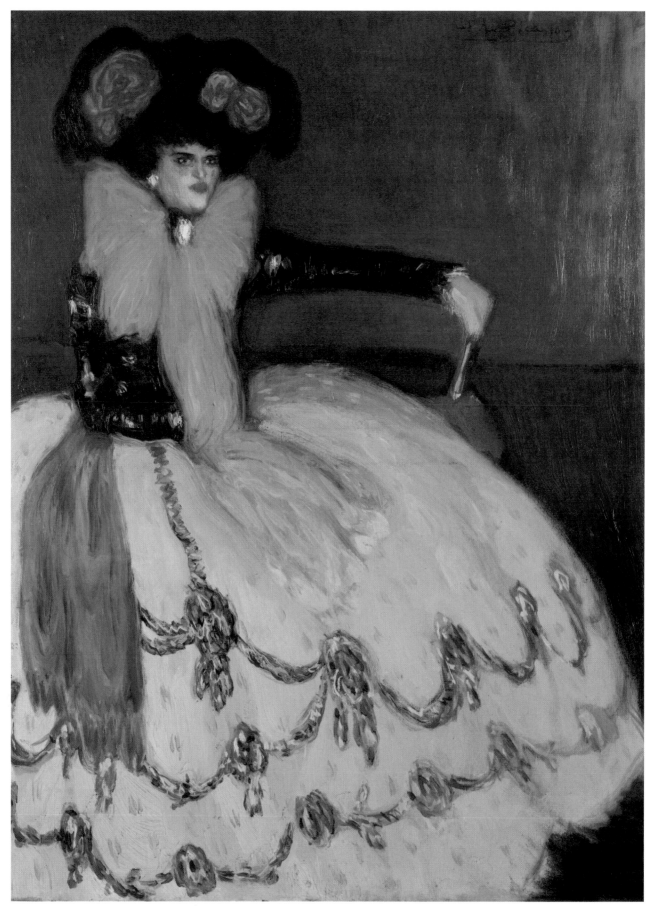

34

Woman in Blue. Madrid, early 1901
Oil on canvas, 52⅝ x 39¾″ (133.5 x 101 cm)
Zervos XXI, 211. D.B. III, 5. Museo Nacional de Arte Moderno, Madrid

La Madrilène (*Head of a Young Woman*)
Madrid or Paris, early 1901
Oil on wood, 20½ x 13″ (52 x 33 cm)
Zervos I, 64. D.B. V, 57. Rijksmuseum
Kröller-Müller, Otterlo

French Cancan. Paris, 1901
Oil on canvas, 18⅛ x 24″ (46 x 61 cm)
Zervos XXI, 209. D.B. V, 55. Collection Raymond Barbey, Geneva

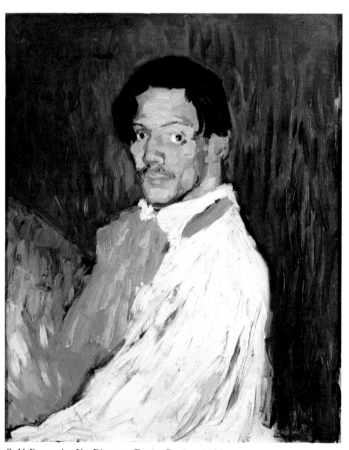

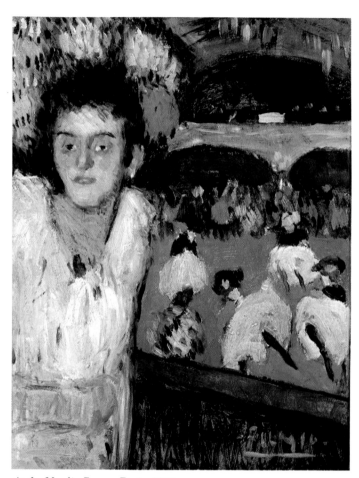

At the Moulin Rouge. Paris, 1901
Oil on canvas mounted on panel, 27½ x 20½″ (69.9 x 52 cm)
Zervos I, 69. D.B. V, 13. Private collection

Self-Portrait: Yo Picasso. Paris, Spring 1901
Oil on canvas, 29 x 23⅞″ (73.5 x 60.5 cm)
Zervos XXI, 192. D.B. V, 2. Private collection

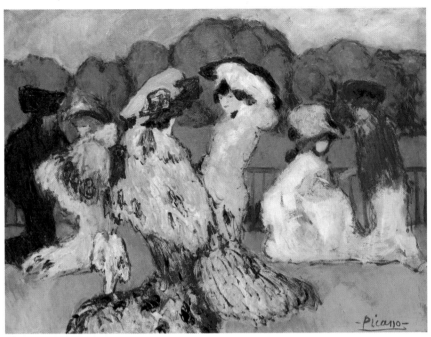

Enclosure at Auteuil. Paris, 1901
Oil on cardboard, 18⅛ x 24″ (46 x 61 cm)
Zervos I, 71. D.B. V, 32. Collection
Joseph H. Hazen, New York

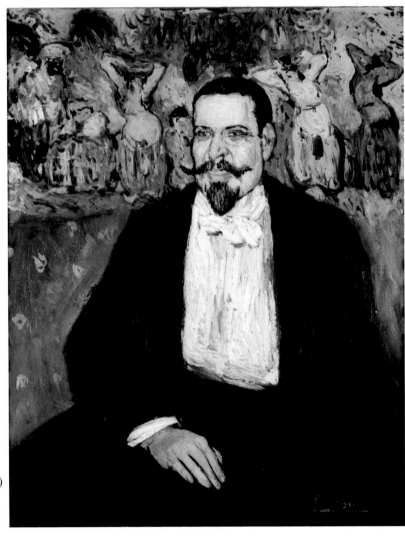

Portrait of Gustave Coquiot. Paris, 1901
Oil on canvas, 39⅜ x 31½″ (100 x 80 cm)
Zervos I, 84. D.B. V, 64. Musée National
d'Art Moderne, Centre National d'Art et
de Culture Georges Pompidou, Paris

37

Chrysanthemums. Paris, 1901
Oil on canvas, 32 x 25¾″ (81.2 x 65.3 cm)
Zervos VI, 647. D.B. V, 29. Collection
Mrs. John Wintersteen, Haverford, Pennsylvania

Montmartre Brasserie: The Flower Vendor. Paris, 1901
Oil on cardboard, 17½ x 21⅛″ (44.5 x 53.5 cm)
Zervos XXI, 281. Galerie Rosengart, Lucerne

Blue Roofs. Paris, 1901
Oil on cardboard, 15¾ x 23⅝″ (40 x 60 cm)
Zervos I, 82. D.B. V, 21. The Visitors of
the Ashmolean Museum, Oxford

On the Upper Deck (*The Omnibus*). Paris, 1901
Oil on cardboard mounted on panel, 19⅜ x 25¼″ (49.2 x 64.1 cm)
Zervos XXI, 168. D.B. V, 61. The Art Institute of Chicago.
Mr. and Mrs. Lewis L. Coburn Memorial Collection

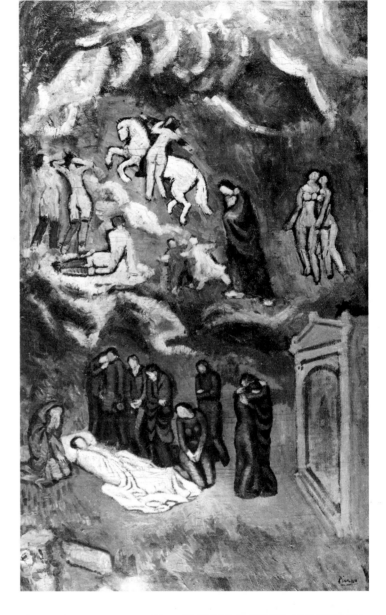

Portrait of the Dead Casagemas. Paris, Summer 1901
Oil on cardboard, 20½ x 13⅜″ (52 x 34 cm)
Zervos XXI, 177. D.B. A. 6
Collection Bernard Picasso, Paris

ABOVE RIGHT:
Evocation (*The Burial of Casagemas*)
Paris, Summer 1901
Oil on canvas, 59⅛ x 35½″ (150 x 90 cm)
Zervos I, 55. D.B. VI, 4
Musée d'Art Moderne de la Ville de Paris

The Death of Casagemas. Paris, Summer 1901
Oil on wood, 10⅝ x 13¾″ (27 x 35 cm)
Zervos XXI, 178. D.B. VI, 5. Musée Picasso, Paris

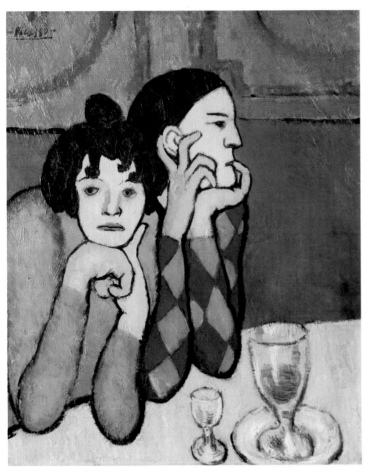

The Two Saltimbanques
(*Harlequin and His Companion*). Paris, Autumn 1901
Oil on canvas, 28¾ x 23⅝″ (73 x 60 cm)
Zervos I, 92. D.B. VI, 20
The Pushkin State Museum of Fine Arts, Moscow

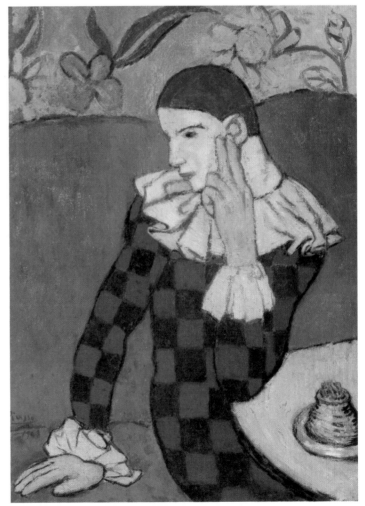

Harlequin. Paris, Autumn 1901
Oil on canvas, 32⅝ x 24⅛″ (82.7 x 61.2 cm)
Zervos I, 79. D.B. VI, 22. The Metropolitan Museum of Art,
New York. Purchase, Gift of Mr. and Mrs. John L. Loeb

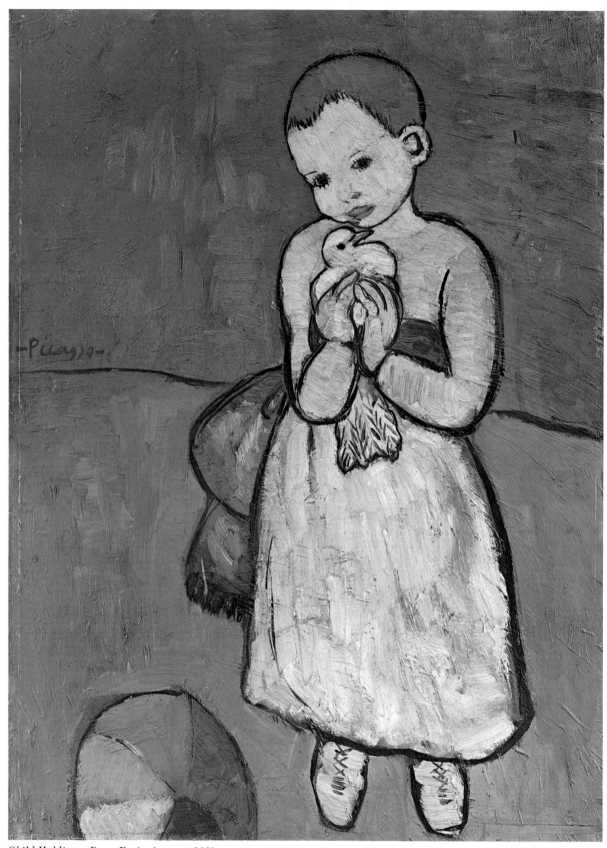

Child Holding a Dove. Paris, Autumn 1901
Oil on canvas, 28¾ x 21¼" (73 x 54 cm)
Zervos I, 83. D.B. VI, 14. Anonymous loan to the National Gallery, London

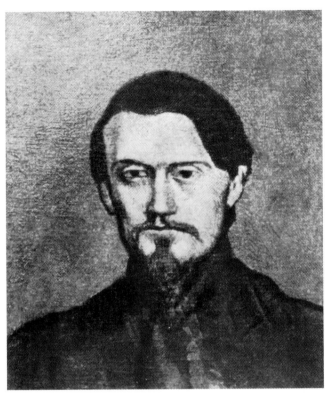

Portrait of Mateu Fernández de Soto. Paris, late 1901
Oil on canvas, 17¾ x 14⅝″ (45 x 37 cm)
Zervos I, 86. D.B. VI, 33. Collection Bernard Picasso, Paris

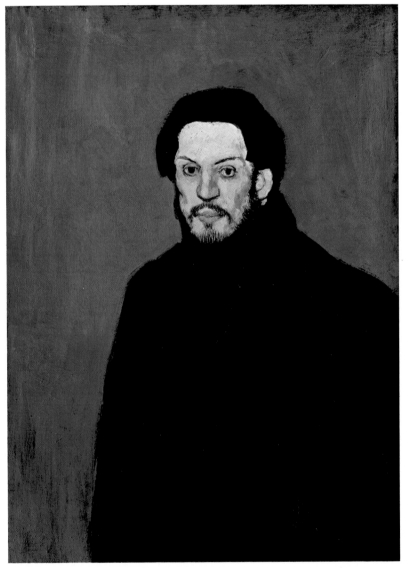

Self-Portrait. Paris, late 1901
Oil on canvas, 31½ x 23⅝″ (80 x 60 cm)
Zervos I, 91. D.B. VI, 35. Musée Picasso, Paris

Study for La Vie, Barcelona, May 2, 1903
Pen and ink, 10½ x 7⅞" (26.7 x 19.7 cm)
Zervos XXII, 44. D.B. D. IX, 5
Private collection, London

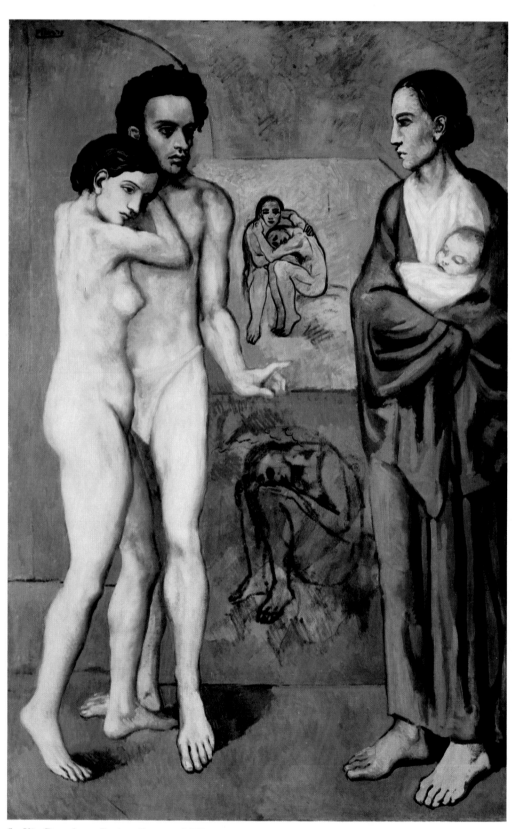

La Vie. Barcelona, Spring–Summer 1903
Oil on canvas, 77⅜ x 50⅝" (196.5 x 128.5 cm)
Zervos I, 179. D.B. IX, 13. The Cleveland Museum of Art. Gift of Hanna Fund

1902-1903

Self-Portrait with Dog.† Barcelona or Paris, c 1902. Pen and ink, 4½ x 5⅛" (11.5 x 13 cm). Not in Zervos. Museo Picasso, Barcelona

Self-Portrait.† Barcelona or Paris, c. 1902. Purple ink, 12⅞ x 7½" (32.5 x 19 cm). Not in Zervos. Museo Picasso, Barcelona

Announcement of exhibition at Galerie Berthe Weill, April 1–15, 1902

1902

JANUARY: Receives money from home and returns to Barcelona. Moves into studio rented by Angel Fernández de Soto at calle Nueva, n. 6 (today Conde del Asalto), sharing it with another artist.

Using a near monochromatic blue-green palette, paints canvases dealing with the miseries of poverty and psychological depression, as in *Woman with a Scarf* and *Two Women at a Bar* (both, p. 48). Subjects are often devoted mothers with downcast eyes or life-saddened harlots — sometimes a combination of the two, as in *Two Sisters*, about which he has previously written to Max Jacob in Paris: "I want to make a picture of this drawing that I send you [*Two Sisters*]. It is a picture that I am making of a whore of St. Lazare and a mother."

Takes up again with Barcelona friends at Els Quatre Gats. About this time meets Julio Gonzalez.

APRIL 1–15: Berthe Weill exhibition in Paris. Includes *The Blue Room, Courtesan with a Jeweled Collar,* and *Virgin with Golden Hair.*

MAY 12: Designs birth announcement for Corina and Pere Romeu's son; later makes portrait of Corina (p. 48).

OCTOBER: With Sebastián Junyer-Vidal, returns to Paris, where he makes an *aleluya* series depicting the trip. Shares Max Jacob's small room at 87, boulevard Voltaire. Picasso works at night and sleeps until mid-day, which will remain a frequent pattern for the rest of his life. He and Jacob are so poor that Picasso cannot buy canvas and must confine activity to drawing.

NOVEMBER 15: Mañach arranges another exhibition at Berthe Weill's, this

Study for Two Sisters. Barcelona, 1902. Pencil, 17½ x 12⅞" (45.5 x 32.8 cm). Zervos XXI, 369. Musée Picasso, Paris

Two Sisters. Barcelona, 1902. Oil on canvas, 59⅞ x 39⅜" (152 x 100 cm). Zervos I, 163. D.B. VII, 22. The Hermitage Museum, Leningrad

Sketches from Picasso's second trip to Paris, in company of Sebastián Junyer-Vidal, 1902. Pen and ink and colored pencil, each 8⅝ x 6¼″ (22 x 16 cm). Museo Picasso, Barcelona. Inscriptions: (1) "On the way to the border in a third-class carriage." (2) "At one o'clock they've arrived and say 'Cony, qué salado.'" (3) "They arrive at Montauban wrapped in their overcoats." (4) "At nine in the morning, arrive in Paris at last." (6) "Duran-Rouel [Durand-Ruel] calls and gives him a lot of bucks."

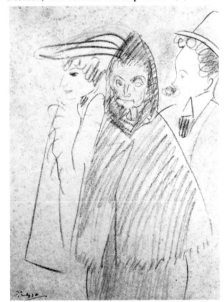

Study for Celestina (Sebastián Junyer-Vidal at right). Barcelona, Summer 1903. Colored pencil, 5¼ x 3½″ (27 x 23.5 cm). Private collection, Geneva

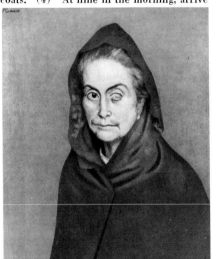

Celestina. Barcelona, Summer 1903 (color-plate, p. 52)

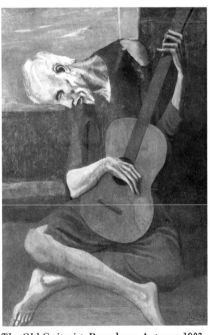

The Old Guitarist. Barcelona, Autumn 1903. Oil on panel, 47¾ x 32½″ (121.3 x 82.5 cm). Zervos I, 202. D.B. IX, 34. The Art Institute of Chicago. Helen Birch Bartlett Memorial Collection

one with a Barcelona friend, Ramón Pichot, and two Frenchmen, Girieud and Launay. Several blue canvases are shown. Symbolist poet Charles Morice reviews the show in *Mercure de France* (December), noting its "stark sadness," but writes that despite the work's negative quality, the young painter has "a force, a gift, a talent."

Perhaps also included in exhibition is *Enclosure at Auteuil* of 1901 (p. 37).

1903

JANUARY: Returns to Barcelona, again moving into studio on calle Riera de San Juan that he had shared with Casagemas. One of his most fruitful periods in Barcelona; produces some fifty works over next 14 months.

SPRING: Makes sketches (p. 50) for large allegorical work to be called *La Vie*, some showing himself in role of male protagonist (pp. 44, 50); final composition, set in an artist's studio, places his friend Casagemas in that role.

SPRING–SUMMER: Completes *La Vie* (p. 44) and the portrait of his tailor, Soler (p. 49).

Paints Celestina (p. 52), the one-eyed procuress in Fernando de Rojas's play; a pencil study casts his friend Sebastián Junyer-Vidal as one of her clients.

AUTUMN: Completes series of "Mannerist" pictures reminiscent of El Greco, including *The Old Guitarist* and *The Blindman's Meal* (p. 53).

Series of caricatures (1902–03) with brothel theme (p. 51).

47

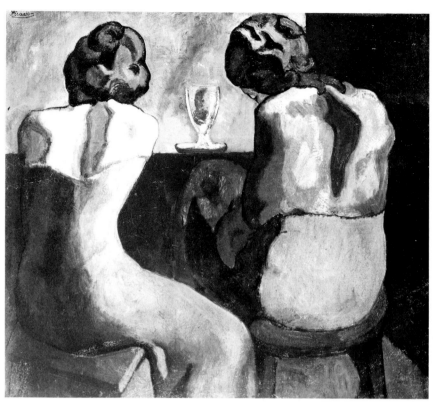

Two Women at a Bar. Barcelona, 1902
Oil on canvas, 31½ x 35⅝" (80 x 91.4 cm)
Zervos I, 132. D.B. VII, 13. Hiroshima Museum of Art

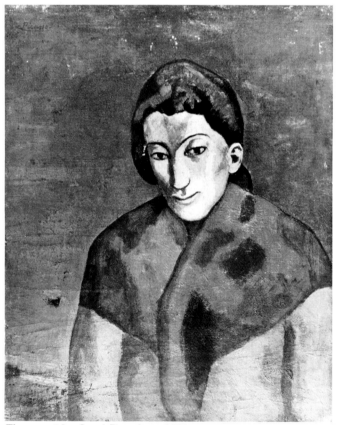

Woman with a Scarf. Barcelona, 1902
Oil on canvas. 24⅞ x 20⅝" (63 x 52.4 cm)
Zervos I, 155. D.B. VII, 9. Marina Picasso Foundation

Corina Pere Romeu. Barcelona, Spring 1902
Oil on canvas, 23¼ x 19¼" (59 x 48.8 cm)
Zervos I, 130. D.B. VII, 15. Collection Jacqueline Picasso, Mougins

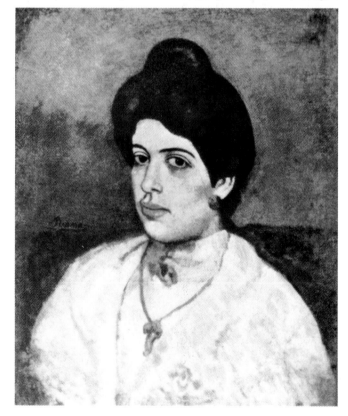

Roofs of Barcelona. Barcelona, 1903
Oil on canvas, 27⅜ x 43⅛″ (69.5 x 109.6 cm)
Zervos I, 207. D.B. IX, 2. Collection Jacqueline Picasso, Mougins

Portrait of a Man. 1902
Oil on canvas, 28¾ x 23⅝″ (73 x 60 cm)
Not in Zervos. Museo Picasso, Barcelona

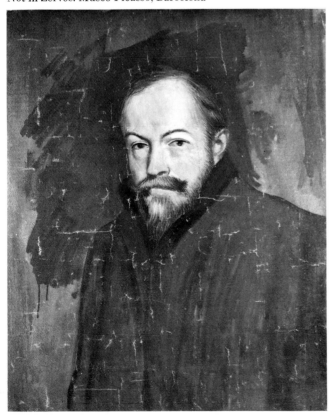

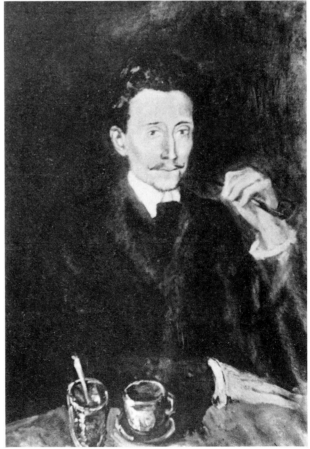

Portrait of Soler. Barcelona, Summer 1903
Oil on canvas, 39⅜ x 27⅝″ (100 x 70 cm)
Zervos I, 199. D.B. IX, 22. The Hermitage Museum, Leningrad

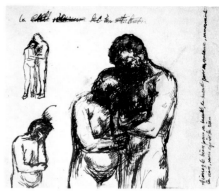

Study for La Vie. Barcelona, [April] 1903
Pen and ink, 6 x 7¼" (15.3 x 18.5 cm)
Not in Zervos. Museo Picasso, Barcelona

Nude Couple (Study for La Vie)
Barcelona, March 1903
Conté crayon, 9⅛ x 7" (23 x 17.8 cm)
Not in Zervos. Museo Picasso, Barcelona

Nude Couple (Study for La Vie)
Barcelona, March 1903
Conté crayon, 9⅛ x 7⅛" (23 x 18 cm)
Not in Zervos. Museo Picasso, Barcelona

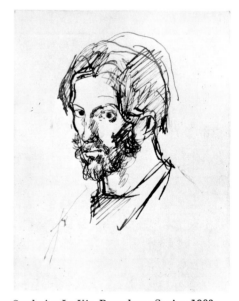

Study for La Vie. Barcelona, Spring 1903
Pen and ink on pasteboard, 5⅛ x 3⅞"
(12.8 x 9.8 cm)
Not in Zervos. Museo Picasso, Barcelona

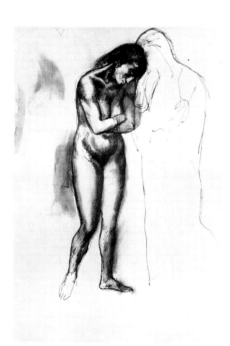

Study for Two Sisters. Barcelona, [1902]
Pen and ink and aquatint on graph paper,
13¼ x 9" (33.5 x 22.8 cm)
Not in Zervos. Museo Picasso, Barcelona

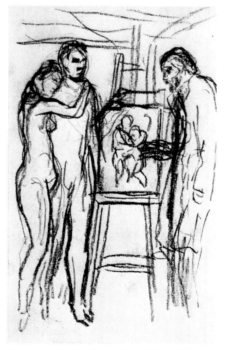

Study for La Vie. Barcelona, May 1903
Conté crayon, 5¾ x 3¾" (14.5 x 9.5 cm)
Not in Zervos. Museo Picasso, Barcelona

Study for La Vie. Barcelona, May 1903
Conté crayon, 6¾ x 3¾" (17.1 x 9.5 cm)
Not in Zervos. Museo Picasso, Barcelona

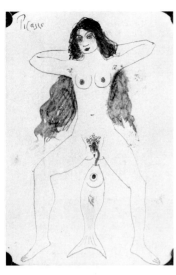

The Mackerel (Allegorical Composition)
Barcelona, c. 1902. Color wash on pasteboard,
5½ x 3½" (13.9 x 9 cm)
Not in Zervos. Museo Picasso, Barcelona

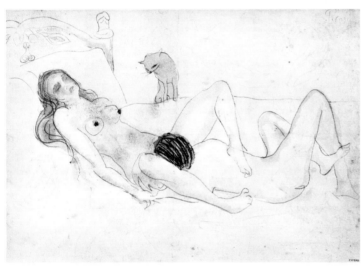

Two Figures and a Cat. Barcelona, c. 1902
Watercolor and pencil, 7⅛ x 10½" (18 x 26.5 cm)
Not in Zervos. Museo Picasso, Barcelona

Caricature of the Artist. Barcelona, 1903
Pen and ink, 4⅝ x 4¼" (11.8 x 10.7 cm)
Not in Zervos. Museo Picasso, Barcelona

Isidro Nonell and a Female Figure. Barcelona, c. 1902
Watercolor and ink, 9¾ x 6¼" (24.8 x 16 cm)
Not in Zervos. Museo Picasso, Barcelona

51

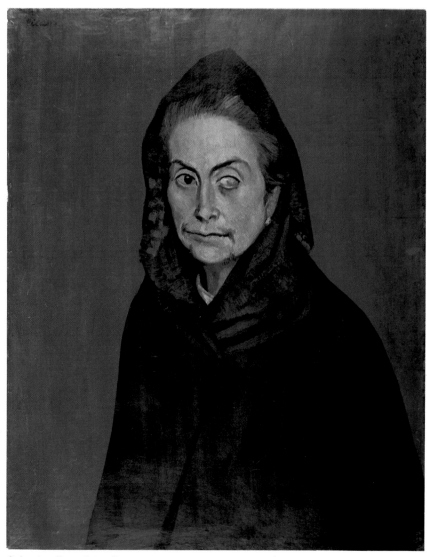

Celestina. Barcelona, Summer 1903
Oil on canvas, 31⅞ x 23⅝″ (81 x 60 cm)
Zervos I, 183. D.B. IX, 26. Private collection

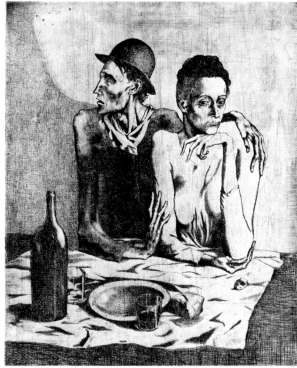

The Frugal Repast. Paris, Autumn 1904
Etching, 18³⁄₁₆ x 14¹³⁄₁₆″ (46.5 x 37.6 cm)
Geiser 2, IIb. The Museum of Modern Art, New York.
Gift of Abby Aldrich Rockefeller

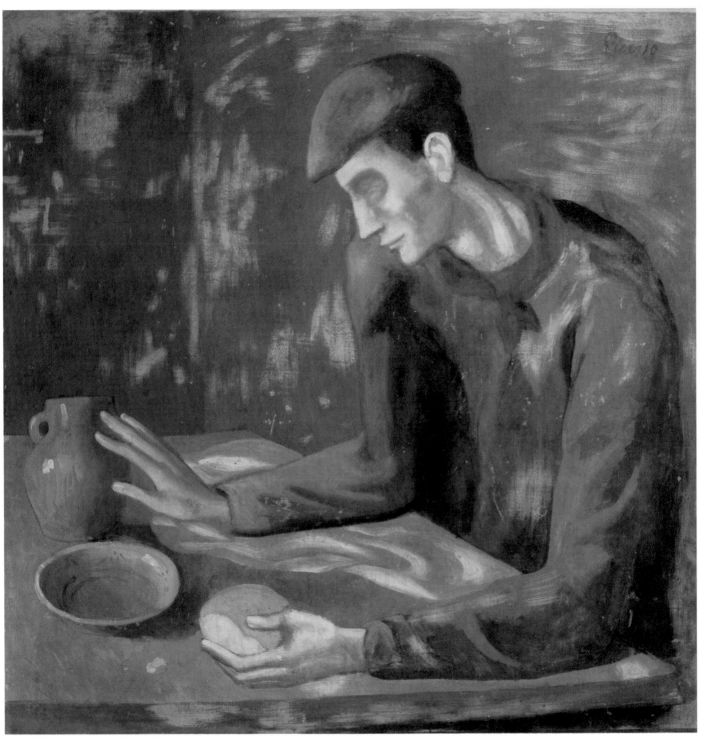

The Blindman's Meal. Barcelona, Autumn 1903
Oil on canvas, 37½ x 37¼″ (95.3 x 94.6 cm)
Zervos I, 168. D.B. IX, 32. The Metropolitan Museum of Art,
New York. Gift of Mr. and Mrs. Ira Haupt

Study for The Actor (with two profiles of
Fernande). Paris, Winter 1904–05
Pencil, 19 x 12½″ (48.3 x 31.7 cm)
Zervos VI, 681. D.B. XII, 2. Collection
Mr. and Mrs. Sidney E. Cohn, New York

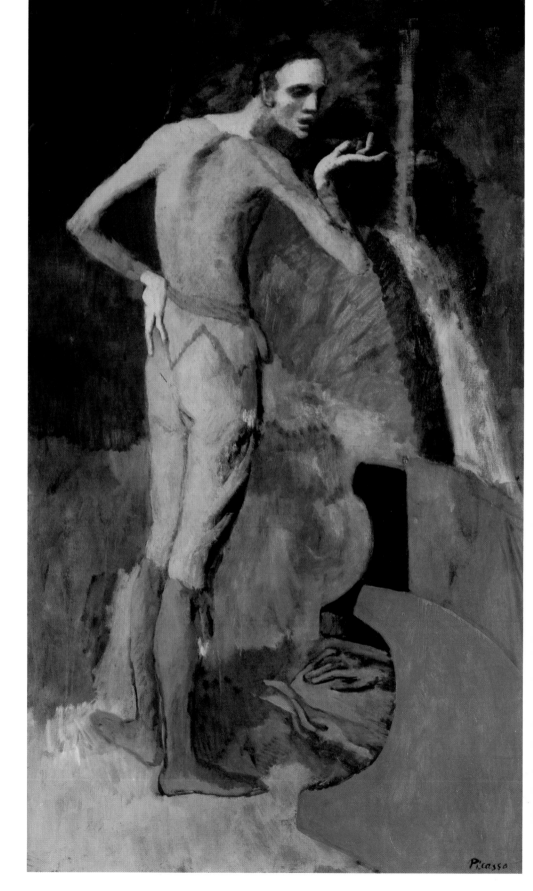

The Actor. Paris, Winter 1904–05
Oil on canvas, 76⅜ x 44⅛″ (194 x 112 cm)
Zervos I, 291. D.B. XII, 1
The Metropolitan Museum of Art,
New York. Gift of Thelma Chrysler Foy

1904-1906

Picasso in photograph by Ricardo Canals. Paris, 1904. Inscribed: "To my friends Suzanne and Henri [Bloch]"

Bateau-Lavoir, 13 rue Ravignan, Paris; arrows point to Picasso's studio

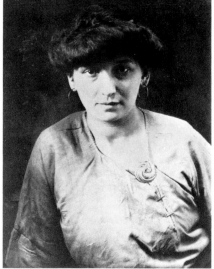

Fernande Olivier, 1905

1904

JANUARY: Takes a studio on calle del Commercio in Barcelona.

SPRING: Leaves Barcelona for Paris with painter Sebastián Junyent. Never returns to live in Catalonia. Moves into dilapidated studio building at 13, rue Ravignan, christened the "Bateau-Lavoir" ("Laundry Barge") by poet Max Jacob. Takes over top-floor studio vacated by fellow Spaniard Paco Durio. His close friends are Ricardo Canals and his wife (who also live in the Bateau-Lavoir); Manolo Hugué and his wife Totote; and Ramón Pichot and Germaine, the woman for whom Casagemas committed suicide.

Nearby, at the foot of Montmartre, is the Cirque Médrano, which Picasso and his friends visit three or four times a week.

SPRING–SUMMER: Paints last "blue" works, among them *Woman Ironing* and the gouache *Woman with Helmet of Hair* (both, p. 60).

In summer, liaison with woman named Madeleine, about whom little is known, although she is probably model for *Woman with Helmet of Hair*. She inspires the *Maternité* theme that appears repeatedly in his drawings and gouaches and leads finally to the theme of the Family of Harlequin (pp. 62, 63).

AUTUMN: Meets Fernande Olivier in the Bateau-Lavoir; she will be his mistress

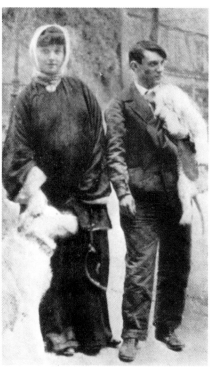

Fernande Olivier and Picasso in Montmartre, c. 1906

for the next seven years. Another resident is poet André Salmon, introduced to Picasso by Max Jacob. Soon meets Guillaume Apollinaire.

Makes second etching, *The Frugal Repast* (p. 52), possibly with assistance of Canals, but more likely that of Eugène Delâtre, who prints a small edition for Clovis Sagot and Père Soulier, dealers in pictures and secondhand goods.

Head of a Woman (Fernande Olivier). 1905. Etching and drypoint, 6⅜ x 4⅝" (16.2 x 11.8 cm). The Baltimore Museum of Art. The Cone Collection

Paints the watercolor *Meditation (Contemplation)* (p. 61), in which Fernande first appears in his work; the artist himself is the observer. Tonalities brightening.

OCTOBER 24: Final exhibition at Galerie Berthe Weill, showing a dozen works mostly dating from previous three years.

WINTER: Paints *The Actor* (p. 54), transitional work between blue and rose tonalities.

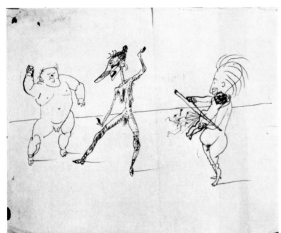

Caricature.† [Paris, 1904]. India ink, 10 x 13″ (25.5 x 33 cm). Not in Zervos. Musée Picasso, Paris

Guillaume Apollinaire.† [Paris], 1905. Pen and ink, 12¼ x 9⅛″ (31 x 23 cm). Zervos XXII, 294. Collection Henry Brandon, Washington, D.C.

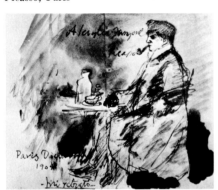

Self-Portrait with a Pipe. Paris, December 1904. Pen and ink and wash. Present whereabouts unknown. Inscribed: "To Sebastiá Junyent, My Portrait, Picasso, Paris, December 1904"

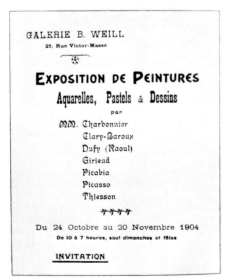

Invitation to exhibition at Galerie Berthe Weill, October–November 1904

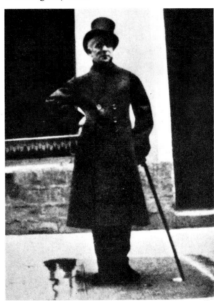

Max Jacob in front of his house in Montmartre

1905

FEBRUARY 25–MARCH 6: Exhibition with Albert Trachsel and Auguste Gérardin at Galeries Serrurier on boulevard Haussmann. Shows first Rose-period paintings. Eight Saltimbanques are listed in the catalog, his initial exhibition of paintings on the Circus theme. Charles Morice writes catalog preface, and Apollinaire reviews show for two publications, La Revue immoraliste (April) and La Plume (May 15). The latter illustrates five works.

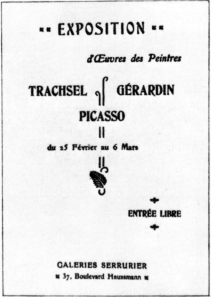

Announcement of exhibition at Galeries Serrurier, February–March 1905

SPRING: Continues to be attracted to Circus theme. Paints Two Acrobats with a Dog (p. 62), The Harlequin's Family (p. 63), The Acrobat's Family with a Monkey (p. 62), Young Acrobat on a Ball, and The Family of Saltimbanques (p. 58). Completes series of 14 drypoints and etchings of Saltimbanques (Salomé, p. 58), again with Delâtre (Ambroise Vollard will print deluxe edition in 1913). Makes sculpture The Jester (p. 64), which Vollard casts in bronze.

Frequents the bistro Lapin Agile, owned by a man named Frédé; his daughter Margot and her tame crow are the subjects of a drawing and a pastel, Woman with a Crow (p. 60), done the previous year. Gives Frédé a painting, At the Lapin Agile, to hang in the café. In it, casts himself as Harlequin and Pichot's wife, Germaine, as his companion; Frédé plays the guitar.

SUMMER: Goes to Holland at the invitation of a young writer, Tom Schilperoort; visits for a month at his home in Schoorl.

Paints Dutch Girl (La Belle Hollandaise) (p. 65).

AUTUMN: Air of detachment enters his subject matter; seen in such paintings

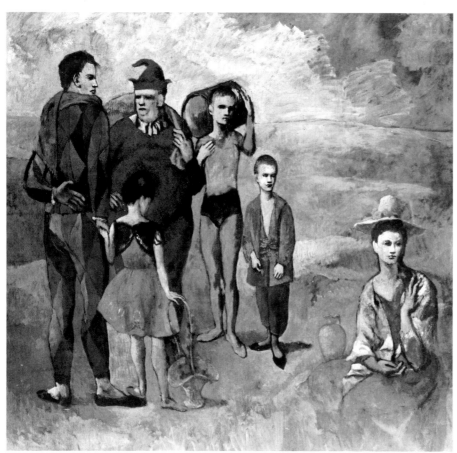

The Family of Saltimbanques. Paris, 1905. Oil on canvas, 83¾ x 90⅜" (212.8 x 229.6 cm). Zervos I, 285. D.B. XII, 35. National Gallery of Art, Washington, D.C. Chester Dale Collection

Portrait of Leo Stein.† Paris, Spring 1906. Gouache, 9¾ x 6¾" (24.7 x 17 cm). Zervos I, 250. D.B. XIV, 1. The Baltimore Museum of Art. The Cone Collection

Portrait of Allan Stein.† Paris, Spring 1906. Gouache on cardboard, 29⅛ x 23½" (74 x 59.7 cm). Zervos I, 353. D.B. XIV, 2. The Baltimore Museum of Art. The Cone Collection

Salomé. Paris, 1905. Drypoint, 15⅞ x 13¾" (40.3 x 34.9 cm). The Museum of Modern Art, New York. Lillie P. Bliss Collection

as *Portrait of Madame Canals* (p. 66), *Boy with a Pipe* (p. 66), *Woman with a Fan* (p. 67), and *Young Girl with a Basket of Flowers* (p. 67). Latter two paintings are bought by Gertrude Stein and her brother Leo, who has previously purchased *The Acrobat's Family with a Monkey*. They are introduced to the artist by the dealer Sagot, and Picasso becomes a frequent visitor at the Steins' salons. Some months later he makes portraits of Leo Stein and of his brother Michael's son, Allan.

OCTOBER 18: Opening of Salon d'Automne, at which the "scandal" of the Fauves erupts. Salon also includes an Ingres retrospective, at which the *Bain Turc* is shown; a gallery of ten paintings by Cézanne; and a group of three paintings by the *Douanier* Rousseau, one of them *The Hungry Lion*.

WINTER: Paints *The Death of Harlequin*. Begins portrait of Gertrude Stein.

1906

BEGINNING OF YEAR: Paints *Boy Leading a Horse* (p. 68), which shifts large-

ly rose tonality of his recent works to terra-cotta and gray; reflects his interest in Greek art and Cézanne bathers. It is one of a series of drawings, watercolors, and paintings leading to a large canvas to be called "The Watering Place." Although never executed, a gouache study of the complete composition exists (p. 69).

Exhibition at the Louvre of Iberian sculptures recently excavated from Osuna. Seen by the artist sometime before May.

Vollard buys most of his Rose-period canvases.

APRIL: Opening of Salon des Indépendants. Matisse shows *Bonheur de Vivre,* and about this time Gertrude Stein introduces the two painters to each other. Picasso soon meets Derain.

SPRING: Continues work on Stein portrait, for which she sits some eighty or ninety times. Shortly before departing for vacation in Spain, Picasso becomes dissatisfied with the head and paints it out.

First work on Coiffure theme. Begins painting of that title and models sculpture *Woman Combing Her Hair* (p. 74).

MAY: Leaves with Fernande for Barcelona, where he introduces her to his family. They continue on to Gosol in the Pyrenees.

SUMMER: In Gosol, paints *Two Brothers* (p. 69) and *La Toilette* (p. 70). The latter is one of a series of works on the theme of the Coiffure, also explored in the large canvas *The Harem* (p. 71). Here, nudes are grouped in attitudes recapitulating poses seen in his contemporary work but not yet demonstrating the depersonalized features nor radical stylization of his post-Gosol figures.

Makes sketches of landscape and peasants. Paints *Young Man from Gosol* and *Reclining Nude* (Fernande) (both, p. 72), and begins *Woman with Loaves* (p.72), which is completed in Paris in autumn; the "Iberian" stylization of the heads is influenced by Osuna figures. Gosol visit ends abruptly in late summer as Picasso learns of outbreak of typhoid nearby.

AUTUMN: Completes portrait of Gertrude Stein (p. 73) without further sittings; the masklike, conceptualized face reflects continued interest in Iberian sculpture.

Completes *La Coiffure* (p. 74) and *Woman Combing Her Hair* (p. 75). Latter, begun in Gosol, has sculptural and abstract head similar to the masklike heads in two self-portraits (p. 79)

Self-Portrait.† 1906. Charcoal, 9⅞ x 9⅛″ (25 x 23 cm). Zervos XXII, 450. Collection Jacqueline Picasso, Mougins

painted slightly later; reflects increasing influence of Iberian sculpture.

OCTOBER: Death of Cézanne. Ten of his paintings are shown at the Autumn Salon.

END OF YEAR: Paints *Two Nudes* (p. 83), in which Iberian stylization and sculptural, bas-relief modeling are pushed to furthest extreme. Influence of Cézanne apparent in monumental figure types and in autonomous patterning of light and dark.

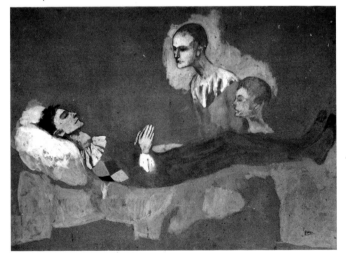

The Death of Harlequin. Paris, 1905. Gouache on cardboard, 26 x 36½″ (66 x 92.7 cm). Zervos I, 302. D.B. XII, 27. Collection Mr. and Mrs. Paul Mellon, Upperville, Virginia

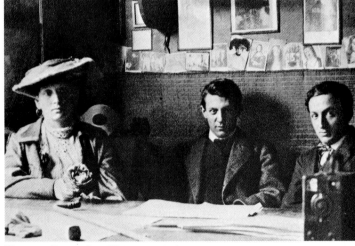

Picasso, Fernande Olivier, and Ramón Reventos, Barcelona, Summer 1906. Photograph taken by Juan Vidal y Ventosa in his studio "El Guayaba" the day before Picasso and Fernande leave for Gosol

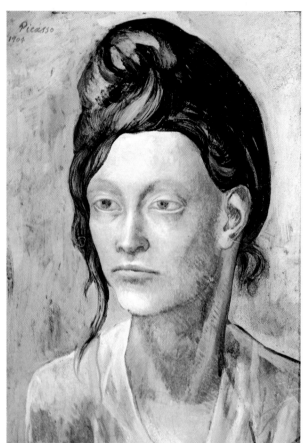

Woman with Helmet of Hair. Paris, Summer 1904
Gouache on board, 16⅞ x 12¼" (42.8 x 31 cm)
Zervos I, 233. D.B. XI, 7. The Art Institute of Chicago.
Gift of Kate L. Brewster

Woman Ironing. Paris, Spring 1904
Oil on canvas, 45¾ x 28¾" (116.2 x 73 cm)
Zervos I, 247. D.B. XI, 6. The Solomon R. Guggenheim Museum,
New York. Gift of Justin K. Thannhauser

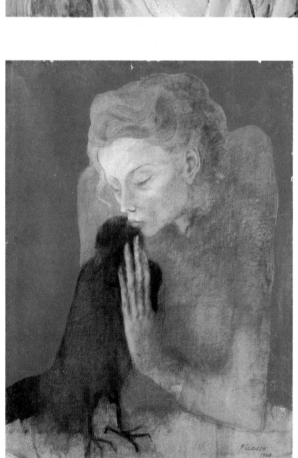

Woman with a Crow. Paris, 1904
Charcoal, pastel, and watercolor on paper,
25½ x 19½" (64.6 x 49.5 cm)
Zervos I, 240. D.B. XI, 10. The Toledo Museum of Art.
Gift of Edward Drummond Libbey

Study for Woman Ironing. Paris, Spring 1904
Pen and India ink, 14¾ x 10⅝″ (37.3 x 27 cm)
Zervos XXII, 48. Musée Picasso, Paris

Meditation (Contemplation). Paris, late 1904
Watercolor and pen, 13⅝ x 10⅛″ (34.6 x 25.7 cm)
Zervos I, 235. D.B. XI, 12. Collection Mrs. Bertram Smith, New York

Sleeping Nude. Paris, late 1904
Watercolor and pen, 14⅛ x 10¼″ (36 x 26 cm)
Zervos I, 234. D.B. XI, 11. Collection Mr. and Mrs. Jacques Helft, Paris

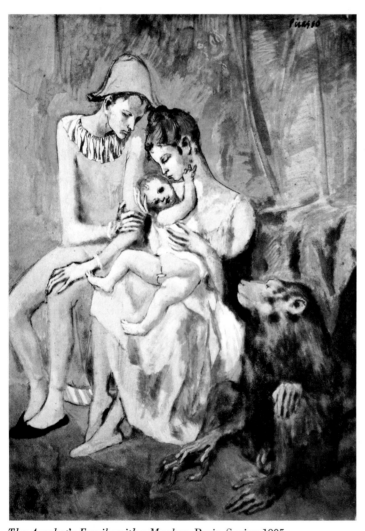

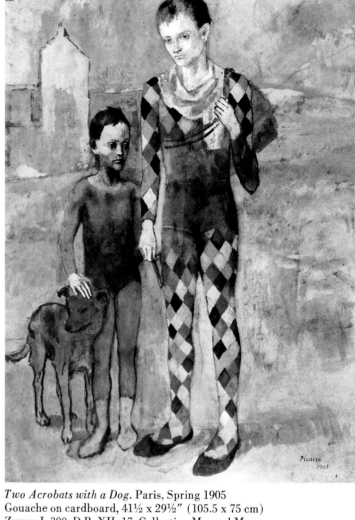

Two Acrobats with a Dog. Paris, Spring 1905
Gouache on cardboard, 41½ x 29½" (105.5 x 75 cm)
Zervos I, 300. D.B. XII, 17. Collection Mr. and Mrs.
William A. M. Burden, New York

The Acrobat's Family with a Monkey. Paris, Spring 1905
Gouache, watercolor, pastel, and India ink on cardboard,
41 x 29½" (104 x 75 cm)
Zervos I, 299. D.B. XII, 7. Göteborgs Konstmuseum, Göteborg, Sweden

Mother and Child. Paris, 1904
Black crayon on cream-colored paper, 13½ x 10½" (34.2 x 26.6 cm)
Zervos I, 220. D.B. D. XI, 26. Fogg Art Museum, Harvard University,
Cambridge, Massachusetts. Bequest of Meta and Paul J. Sachs

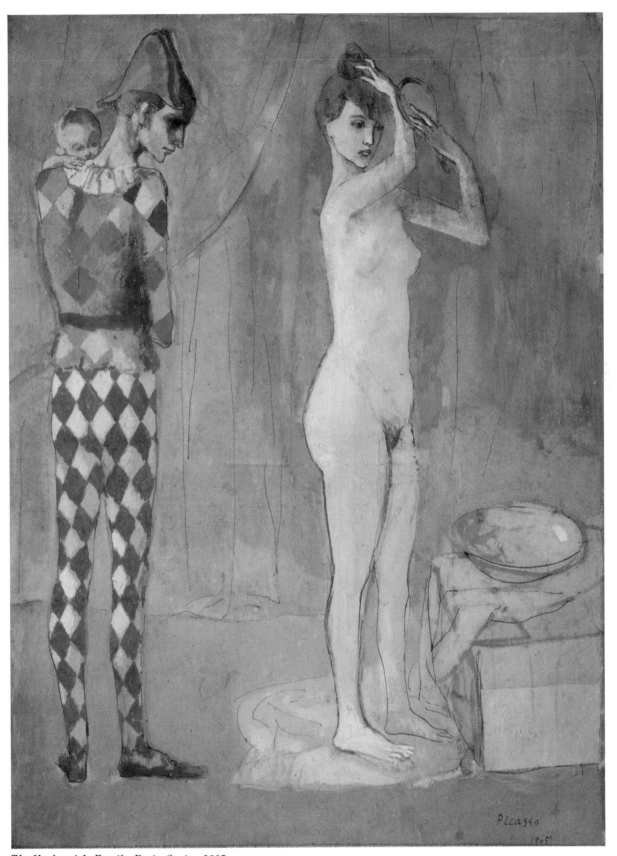

The Harlequin's Family. Paris, Spring 1905
Gouache and India ink, 22⅝ x 17″ (57.5 x 43 cm)
Zervos I, 298. D.B. XII, 6. Private collection, from the Sam A. Lewisohn Collection

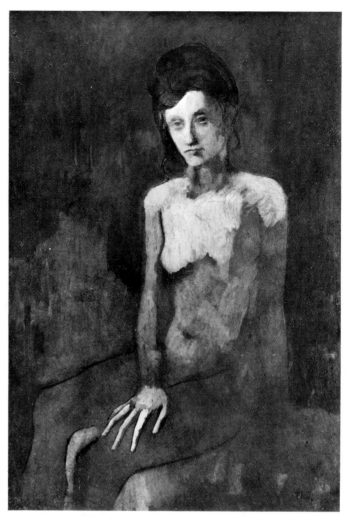

Seated Nude. Paris, early 1905
Oil on cardboard mounted on panel, 41¾ x 30″ (106 x 76 cm)
Zervos I, 257. D.B. XII, 3. Musée National d'Art Moderne,
Centre National d'Art et de Culture Georges Pompidou, Paris

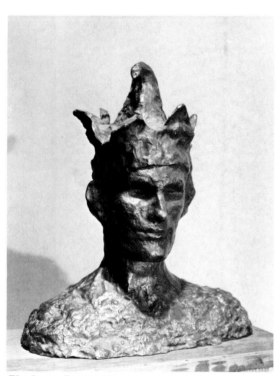

The Jester. Paris, 1905
Bronze, 15¾ x 13¾ x 8⅝″ (40 x 35 x 22 cm)
Zervos I, 322. Spies 4
Collection Mrs. Bertram Smith, New York

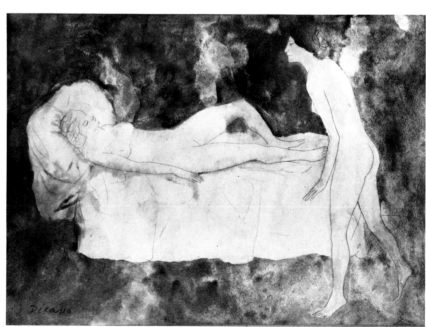

The Two Friends. Paris, 1904
Watercolor, 10⅝ x 14⅝″ (27 x 37 cm)
Zervos XXII, 63. D.B. XI, 9. Private collection, Paris

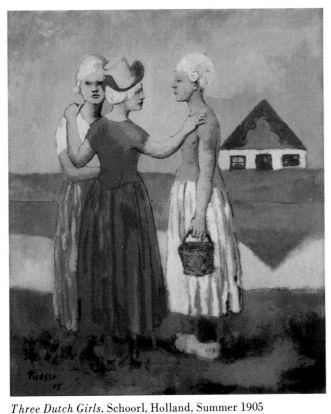

Three Dutch Girls. Schoorl, Holland, Summer 1905
Gouache and India ink on paper mounted on cardboard,
30⅜ x 26⅜″ (77 x 67 cm)
Zervos I, 261. D.B. XIII, 2. Musée National d'Art Moderne,
Centre National d'Art et de Culture Georges Pompidou, Paris

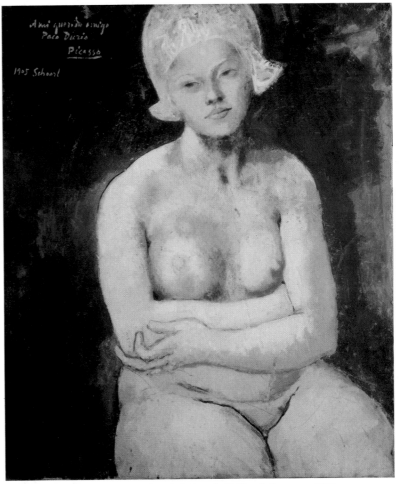

Dutch Girl (La Belle Hollandaise). Schoorl, Holland, Summer 1905
Oil, gouache, and blue chalk on cardboard mounted on panel,
30⅜ x 26″ (77 x 66 cm)
Zervos I, 260. D.B. XIII, 1. Queensland Art Gallery, Brisbane

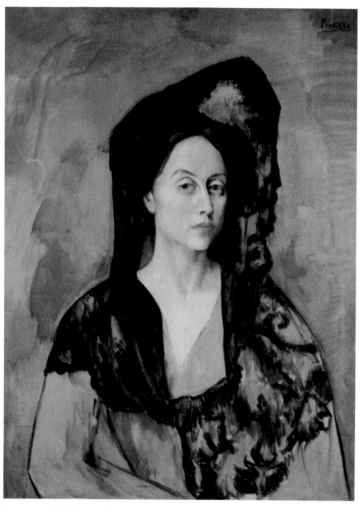

Portrait of Madame Canals. Paris, Autumn 1905
Oil on canvas, 34¾ x 26⅞″ (88 x 68 cm)
Zervos I, 263. D.B. XIII, 9. Museo Picasso, Barcelona

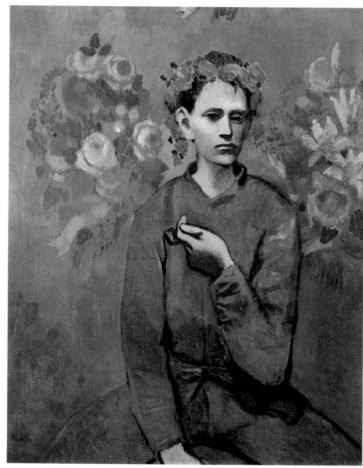

Boy with a Pipe. Paris, late 1905
Oil on canvas, 39⅜ x 32″ (100 x 81.3 cm)
Zervos I, 274. D.B. XIII, 13. Collection
Mr. and Mrs. John Hay Whitney, New York

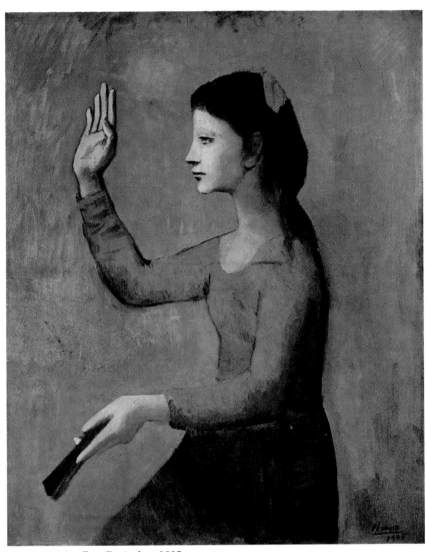

Woman with a Fan. Paris, late 1905
Oil on canvas, 39½ x 32" (100.3 x 81.2 cm)
Zervos I, 308. D.B. XIII, 14. National Gallery of Art, Washington, D.C.
Gift of the W. Averell Harriman Foundation in memory of Marie N. Harriman

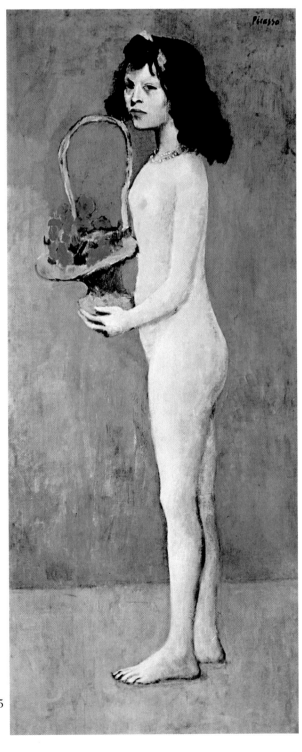

Young Girl with a Basket of Flowers. Paris, Autumn 1905
Oil on canvas, 61 x 26" (155 x 66 cm)
Zervos I, 256. D.B. XIII, 8. Private collection, New York

67

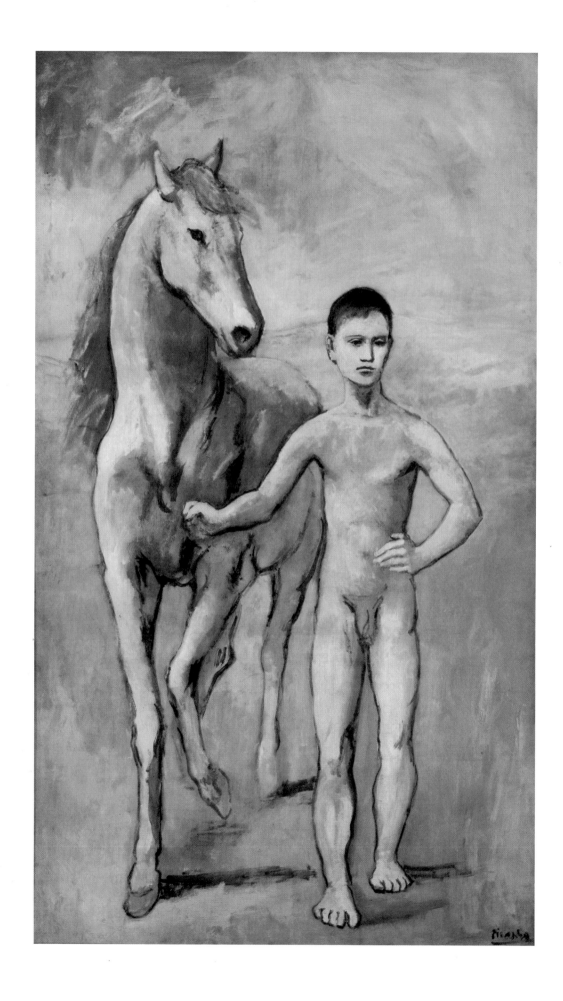

68

The Watering Place. Paris, early 1906
Gouache on pulp board, 14⅞ x 22⅞″ (37.7 x 57.9 cm)
Zervos I, 265. D.B. XIV, 16. The Dial Collection,
through Worcester Art Museum, Worcester, Massachusetts

The Two Brothers. Gosol, early Summer 1906
Oil on canvas, 55⅞ x 38¼″ (142 x 97 cm)
Zervos I, 304. D.B. XV, 9. Kunstmuseum, Basel

OPPOSITE:
Boy Leading a Horse. Paris, early 1906
Oil on canvas, 86¾ x 51½″ (220.3 x 130.6 cm)
Zervos I, 264. D.B. XIV, 7. The Museum of Modern
Art, New York. Gift of William S. Paley, the donor
retaining life interest

Femme Complaisante. [Paris], late 1905
India ink, 8¼ x 5⅜″ (21 x 13.5 cm)
Zervos XXII, 296. Musée Picasso, Paris

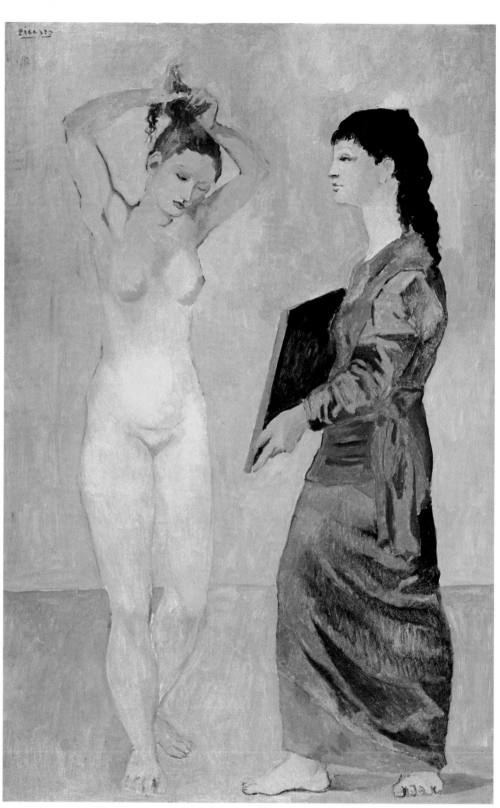

La Toilette. Gosol, early Summer 1906
Oil on canvas, 59½ x 39″ (151 x 99 cm)
Zervos I, 325. D.B. XV, 34. Albright-Knox Art Gallery, Buffalo, New York. Fellows for Life Fund

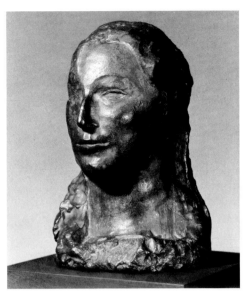

Head of a Woman (Fernande). Paris, 1906
Bronze with green patina, 13⅜ x 9⅞ x 9⅝″ (34 x 25 x 24.5 cm)
Zervos VI, 323. Spies 6. Allen Memorial Art Museum,
Oberlin College, Oberlin, Ohio. R. T. Miller, Jr., Fund

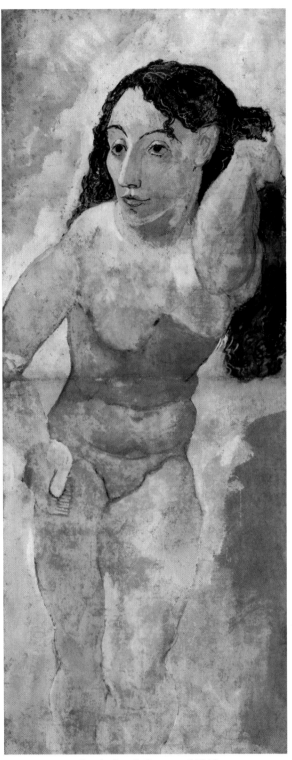

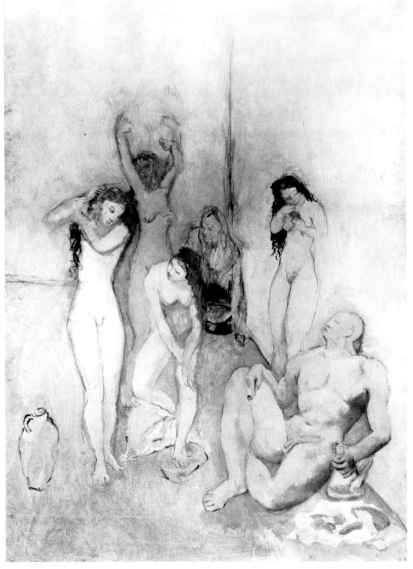

Woman with a Comb. Gosol, Summer 1906*
Gouache, 54¾ x 22½″ (139 x 57 cm)
Zervos I, 337. D.B. XVI, 5. Musées Nationaux, Paris.
Ancienne Collection Walter-Guillaume

The Harem. Gosol, early Summer 1906
Oil and charcoal on canvas, 60¾ x 43⅛″ (154.3 x 109.5 cm)
Zervos I, 321. D.B. XV, 40. The Cleveland Museum of Art.
Leonard C. Hanna, Jr., Collection

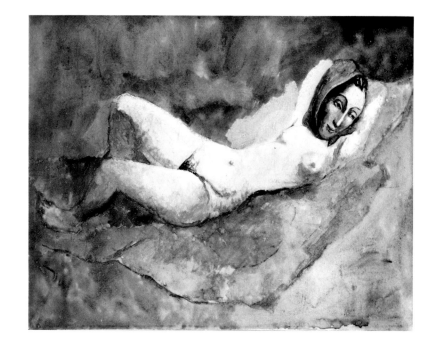

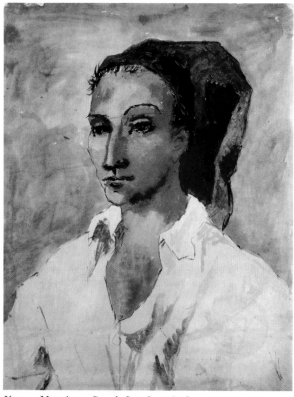

Young Man from Gosol. Gosol, early Summer 1906
Gouache and watercolor, 24¼ x 18⅞" (61.5 x 48 cm)
Zervos I, 318. D.B. XV, 37. Göteborgs Konstmuseum,
Göteborg, Sweden

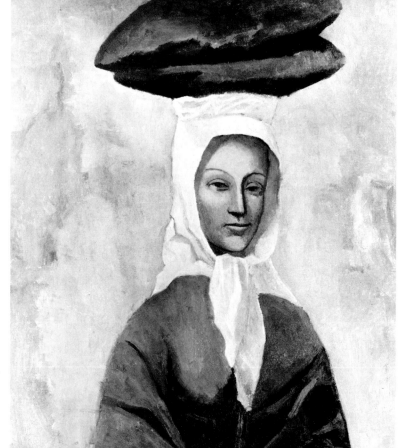

ABOVE RIGHT:
Reclining Nude (Fernande). Gosol, late Summer 1906
Gouache, 18⅝ x 24⅛" (47.3 x 61.3 cm)
Zervos I, 317. D.B. XV, 47. The Cleveland Museum of Art.
Gift of Mr. and Mrs. Michael Straight

RIGHT:
Woman with Loaves. Gosol, late Summer 1906;
partially reworked Paris, Autumn 1906*
Oil on canvas, 39⅜ x 27½" (100 x 69.8 cm)
Zervos VI, 735. D.B. XV, 46. Philadelphia Museum of Art.
Gift of Charles E. Ingersoll

72

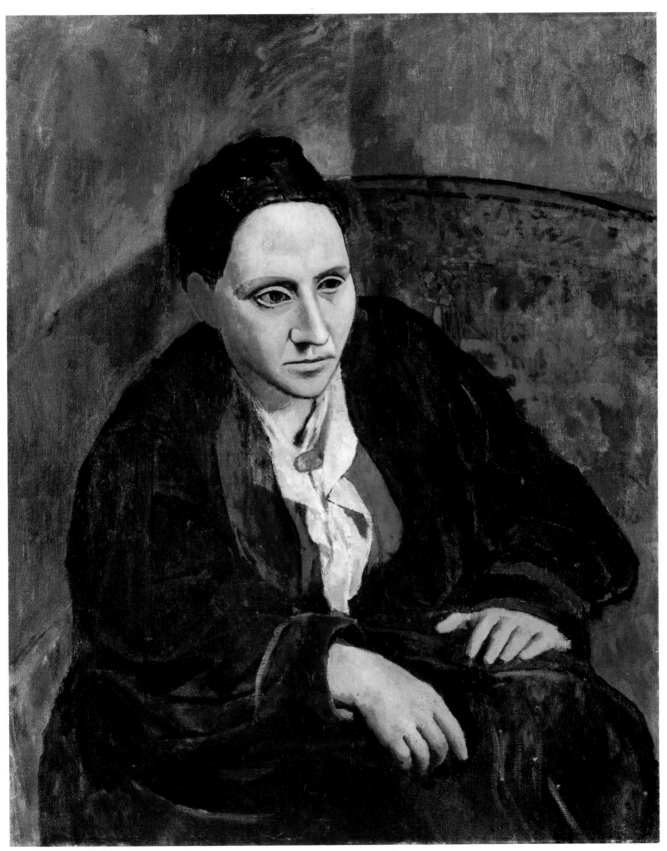

Portrait of Gertrude Stein. Paris, begun Winter 1905–06; partially reworked Paris, Autumn 1906
Oil on canvas, 39¼ x 32″ (99.6 x 81.3 cm)
Zervos I, 352. D.B. XVI, 10. The Metropolitan Museum of Art, New York. Bequest of Gertrude Stein

La Coiffure. Paris, begun Spring, completed early Autumn 1906
Oil on canvas, 68⅞ x 39¼″ (175 x 99.7 cm)
Zervos I, 313. D.B. XIV, 20. The Metropolitan Museum of Art,
New York. Purchase, Anonymous gift

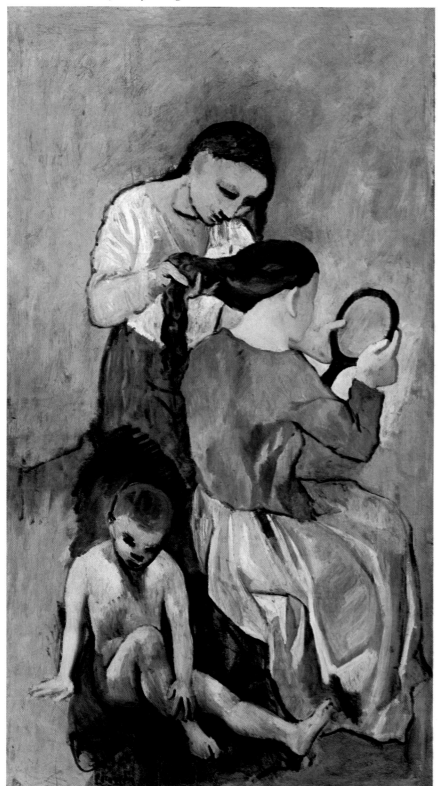

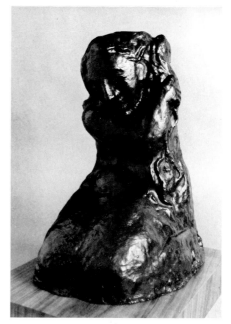

Woman Combing Her Hair
Paris, early Spring 1906
Bronze, 16½ x 10¼ x 12⅝″
(42 x 26 x 32 cm)
Zervos I, 329. Spies 7. The Baltimore
Museum of Art. The Cone Collection,
formed by Dr. Claribel Cone and Miss
Etta Cone of Baltimore, Maryland

Study for Woman Combing Her Hair
Gosol, Summer 1906
Pencil, 11⅞ x 8⅝″ (30.2 x 22 cm)
Zervos VI, 751. Collection Mr. and Mrs.
Georges E. S.

Study for Woman Combing Her Hair
Paris, [Autumn 1906]
Crayon and charcoal, 22 x 16″
(55.8 x 40.7 cm)
Zervos I, 341. University of East Anglia,
Norwich, England.
Robert and Lisa Sainsbury Collection

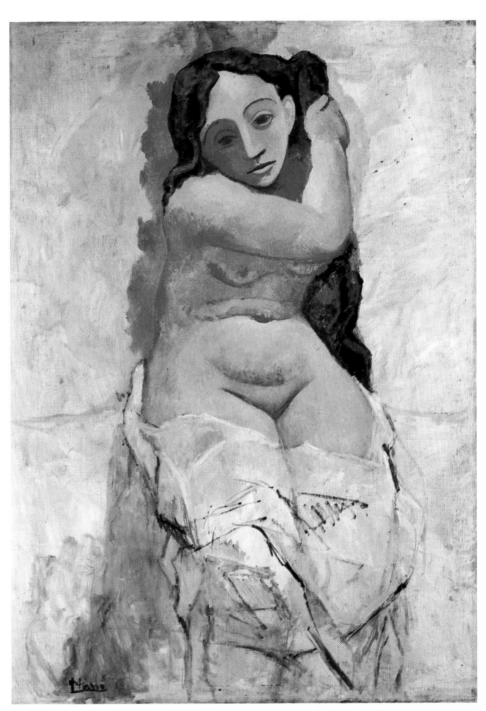

Woman Combing Her Hair. Gosol and Paris, late Summer and Autumn 1906
Oil on canvas, 49⅝ x 35¾″ (126 x 90.7 cm)
Zervos I, 336. D.B. XVI, 7. Private collection

Two Nudes. Paris, Autumn 1906
Ink and wash, 19 x 12⅝" (48 x 32 cm)
Zervos I, 359. D.B. D. XVI, 21
Private collection, Switzerland

Two Nudes. Paris, Autumn 1906
Gouache, charcoal, and watercolor,
25¼ x 18⅞" (64 x 48 cm)
Zervos XXII, 411. D.B. XVI, 12. The Baltimore Museum
of Art. The Cone Collection, formed by Dr. Claribel Cone
and Miss Etta Cone of Baltimore, Maryland

Two Nudes. Paris, Autumn 1906
Gouache on paper mounted on cloth,
23 x 17" (58.5 x 43.2 cm)
Zervos I, 361. D.B. XVI, 14. Collection Walter D.
Floersheimer, Locarno, Switzerland

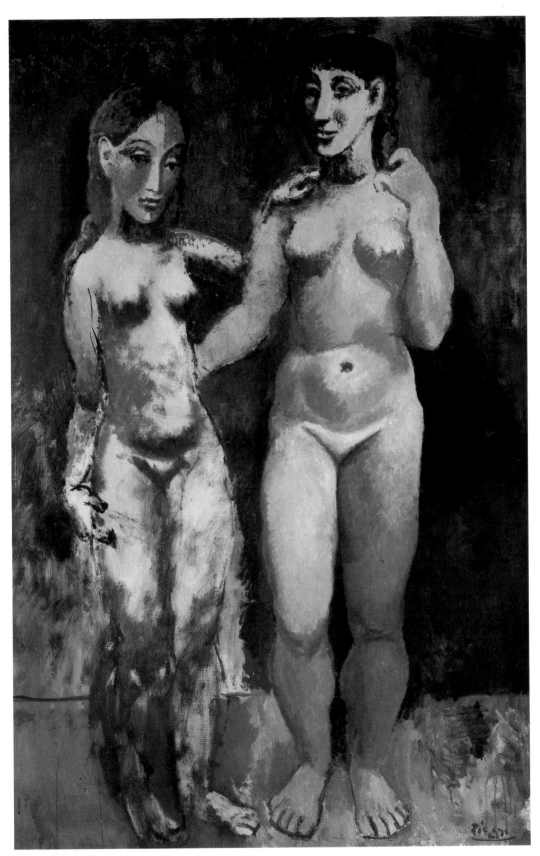

Two Nudes. Paris, Autumn 1906
Oil on canvas, 59½ x 39⅜″ (151 x 100 cm)
Zervos I, 360. D.B. XVI, 13. Private collection, Switzerland

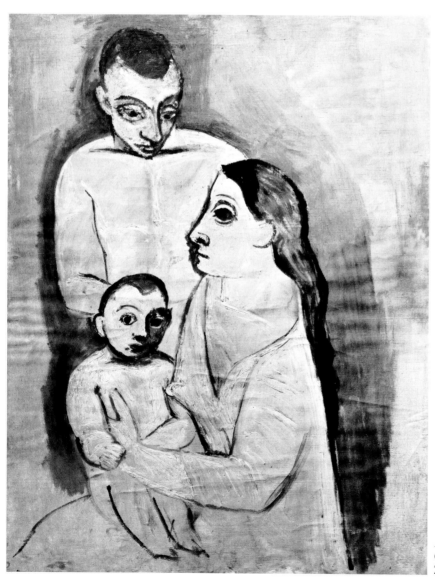

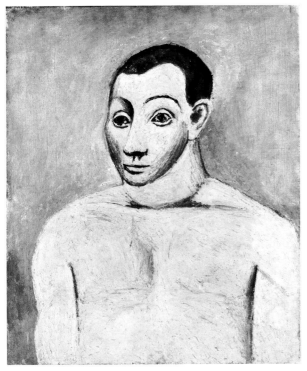

Self-Portrait. Paris, Autumn 1906
Oil on canvas, 25⅝ x 21¼" (65 x 54 cm)
Zervos II,¹ 1. D.B. XVI, 26. Musée Picasso, Paris

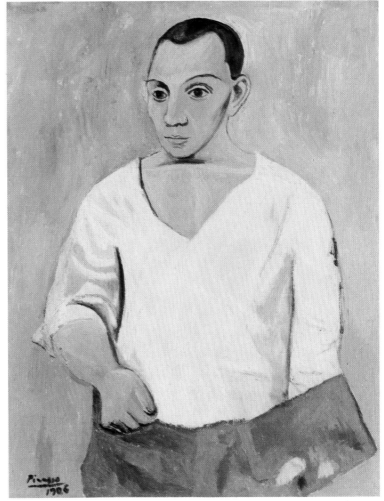

Self-Portrait with a Palette. Paris, Autumn 1906
Oil on canvas, 36¼ x 28¾" (92 x 73 cm)
Zervos I, 375. D.B. XVI, 28. Philadelphia Museum of Art.
A. E. Gallatin Collection

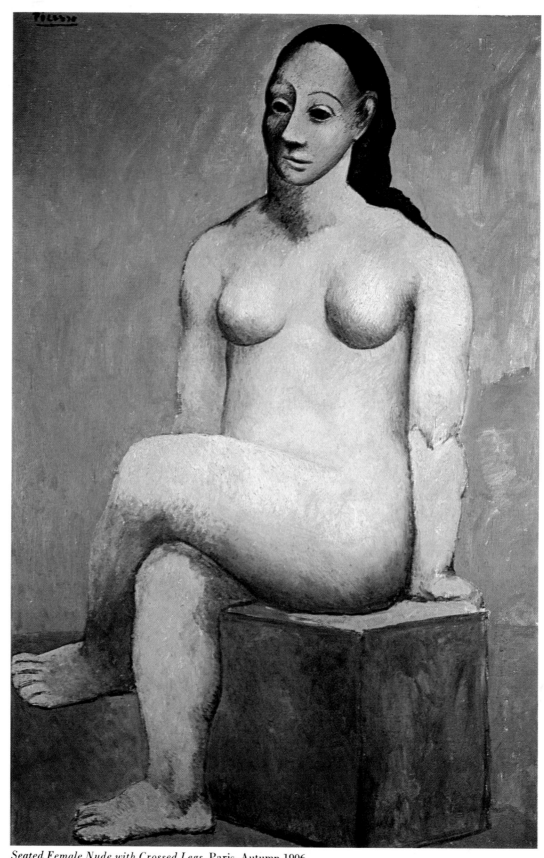

Seated Female Nude with Crossed Legs. Paris, Autumn 1906
Oil on canvas, 59½ x 39⅜″ (151 x 100 cm)
Zervos I, 373. D.B. XVI, 25. National Gallery, Prague

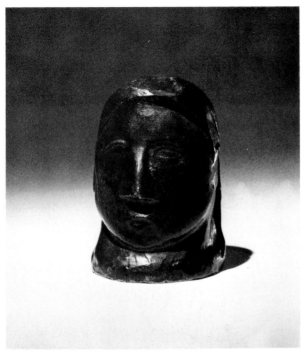

Head of a Woman. Paris, 1906–07
Bronze, 4½ x 3⅜ x 3¼″ (11.5 x 8.4 x 8.2 cm)
Zervos II,² 574. Spies 12. Hirshhorn Museum and Sculpture
Garden, Smithsonian Institution, Washington, D.C.

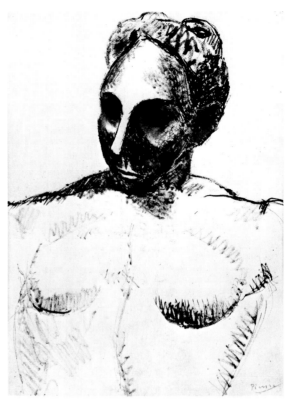

Bust of a Woman. Paris, Autumn 1906
Ink and red gouache, 24⅞ x 18½″ (63 x 47 cm)
Zervos XXII, 470. D.B. D. XVI, 24
Musée National d'Art Moderne, Centre National
d'Art et de Culture Georges Pompidou, Paris

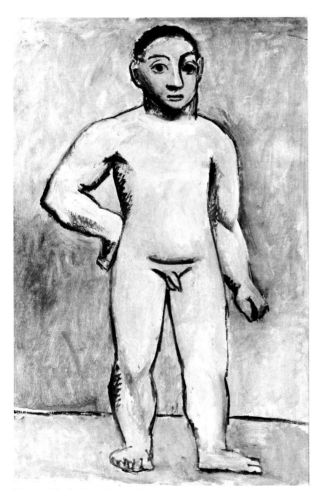

Young Nude Boy. Paris, Autumn 1906
Oil on canvas, 26⅜ x 17⅜″ (67 x 44 cm)
Not in Zervos. Musée Picasso, Paris

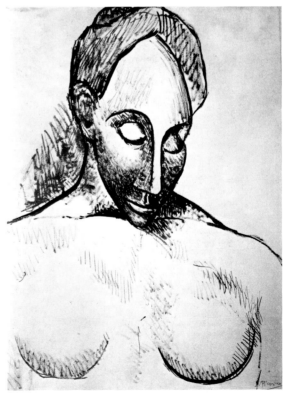

Bust of a Woman. Paris, Autumn 1906
Ink and red gouache, 24½ x 18½″ (62 x 47 cm)
Zervos VI, 856. D.B. D. XVI, 23. Collection
Gustav Zumsteg, Zurich

81

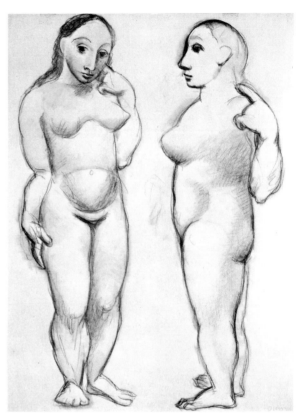

Two Nudes. Paris, Autumn 1906
Charcoal, 24⅜ x 18½″ (61.9 x 46. 9 cm)
Zervos I, 365. The Museum of Modern Art, New York.
Extended loan from the Joan and Lester Avnet Collection

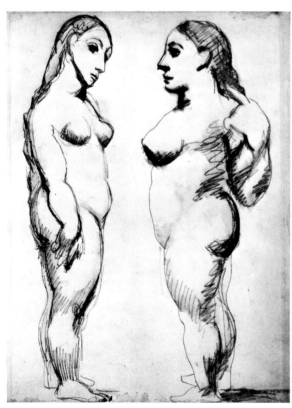

Two Nudes. Paris, Autumn 1906
Pencil, 24½ x 18⅜″ (62.2 x 46.7 cm)
Zervos XXII, 465. D.B. XVI, 18.
The Art Institute of Chicago. Gift of Mrs. Potter Palmer

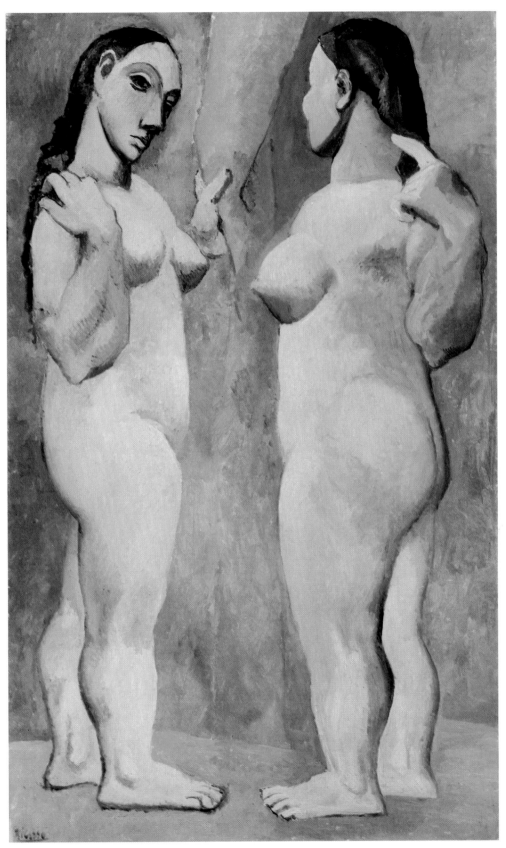

Two Nudes. Paris, late 1906
Oil on canvas, 59⅝ x 36⅝″ (151.3 x 93 cm)
Zervos I, 366. The Museum of Modern Art, New York.
Gift of G. David Thompson in honor of Alfred H. Barr, Jr.

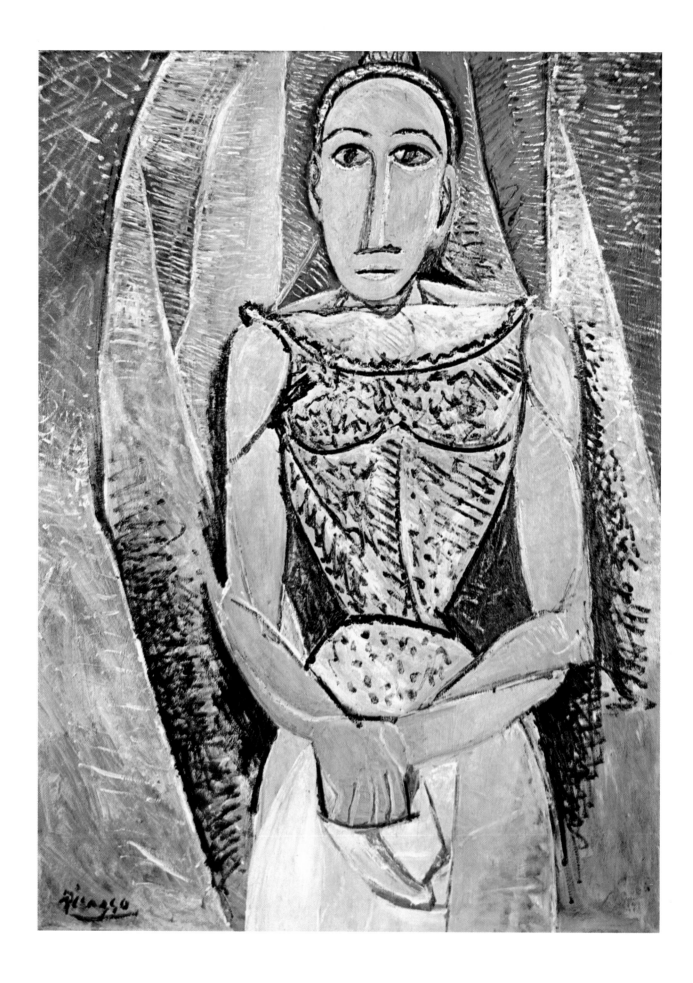

1907-1908

Woman in Yellow. Paris, Spring 1907
Oil on canvas, 51¼ x 38¼″ (130 x 97 cm)
Zervos II,¹ 43. Daix 51. Private collection

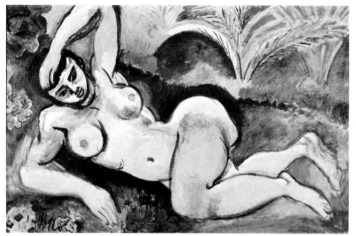

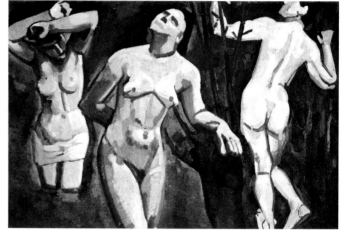

LEFT: Henri Matisse: *Blue Nude (Souvenir de Biskra)*. 1907. Oil on canvas, 36¼ x 55¾" (92.1 x 141.6 cm). The Baltimore Museum

of Art. The Cone Collection. RIGHT: André Derain: *Bathers*. 1907. Oil on canvas, 51¼ x 75⅞" (130.2 x 192.7 cm). On loan to Musée

National d'Art Moderne, Centre National d'Art et de Culture Georges Pompidou, Paris

1907

WINTER: Nude continues to be dominant subject in his work. Partially spurred on by Matisse's *Bonheur de vivre*, begins sketches intended for a monumental figure composition of sailors going to a bordello (gouache study, p. 97).

EARLY MARCH: Buys two Iberian sculptured heads from Apollinaire's secretary, Géry-Piéret, who has stolen them from the Louvre.

Evolving conception of the brothel composition with seven figures—five nude women, a sailor seated in the middle, and a medical student at the left (perhaps holding a skull) (p. 98, top). In another sketch, sailor figure appears unclothed and student carries a book (p. 98, middle).

MARCH 20: Opening of Salon des Indépendants, at which large Derain *Bathers* and Matisse *Blue Nude (Souvenir de Biskra)* are shown (the latter is bought

by the Steins); they offer further challenge to Picasso.

LATE APRIL–MAY: Begins work on large canvas later known as *Les Demoiselles d'Avignon*. Definitive watercolor study (p. 98, bottom) for canvas in its initial "Iberian" state shows five female figures; sailor has disappeared and student at left is displaced by nude woman lifting curtain. Watercolor of student (p. 98) in most advanced state before being dropped reflects stylized, scroll-like ear of stolen Iberian sculpture.

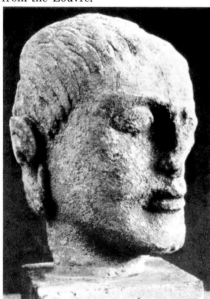

Head of a Man (Iberian sculpture). Museo Arqueológico Nacional, Madrid. One of two heads bought by Picasso from Géry-Piéret in March 1907

Self-Portrait.† Paris, early 1907. Ink, 12 x 9" (30.5 x 22.8 cm). Not in Zervos. Collection Margaret Mallory, Santa Barbara, California

Portrait of Max Jacob. Paris, early 1907. Gouache, 24⅜ x 18⅝" (62 x 47.5 cm). Present whereabouts unknown

African mask, Gabon. Wood whitened with clay, 18⅞ x 11¾″ (48 x 29.8 cm). Formerly collection André Derain

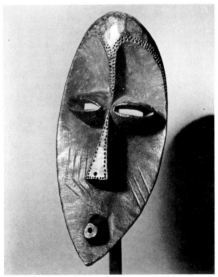

Babangi mask, French Congo. Wood, 14″ (35.5 cm) high. The Museum of Modern Art, New York

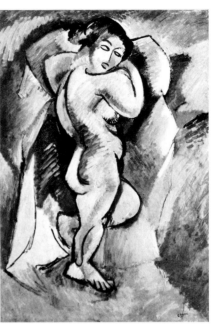

Georges Braque: *Large Nude.* 1907–08. Oil on canvas, 55¾ x 40″ (141.6 x 101.6 cm). Galerie Alex Maguy, Paris

Picasso with New Caledonian sculptures in the Bateau-Lavoir. Photograph by Gelett Burgess, 1908. From *Architectural Record* (New York), May 1910

MID-MAY: Studies individual motifs of large work (p. 94) ; moves toward greater schematization and flatter, more angular configurations, as in *Head and Shoulders of a Sailor* (p. 94). Similar tendencies demonstrated in *Self-Portrait* (p. 92) and *Bust of a Woman* (p. 93). *Woman in Yellow* (p. 84), painted about this time, contains Iberian references only in masklike face.

MAY OR JUNE: Visit to ethnographic museum at Palais du Trocadéro, where he has "revelation" about African sculpture. Although Derain and Matisse have already begun to collect it, Picasso has paid no attention to it until now.

JUNE 17–29: Cézanne retrospective of 79 watercolors at Bernheim-Jeune Gallery, Paris.

EARLY JULY: Final state of *Demoiselles d' Avignon* (p. 99). Two figures at right and one at left are repainted under influence of African sculpture (although Picasso later denies this). Painting seen by friends and acquaintances in studio during following months but is not exhibited until "Art Moderne en France" at Salon d'Antin, Paris, in 1916, when André Salmon gives it title by which it is known. Title emerges from Picasso's private joking with friends about a no-

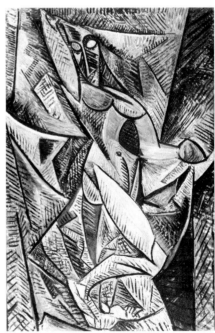

Nude with Drapery. Paris, Summer 1907. Oil on canvas, 59⅞ x 39¾″ (152 x 101 cm). Zervos II,¹ 47. Daix 95. The Hermitage Museum, Leningrad

torious brothel on the carrer d'Avinyo (Avignon Street) in Barcelona. Later professes to dislike title.

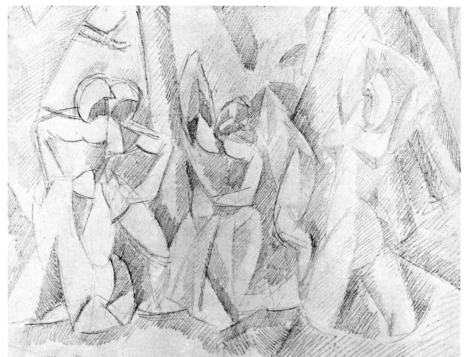

Study for Bathers in the Forest.† Paris, Spring 1908. Pencil, 12⅝ x 17⅛″ (32 x 43.5 cm). Zervos XXVI, 292. Musée Picasso, Paris

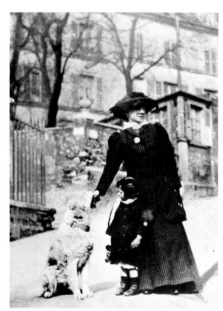

Fernande Olivier with Dolly van Dongen and the dog Frika, Place Ravignan

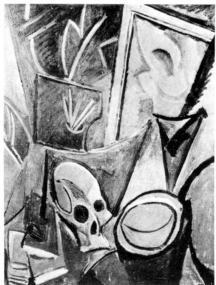

Still Life with Death's Head. Paris, Summer 1908. Oil on canvas, 45¾ x 35⅛″ (116 x 89 cm). Zervos II,¹ 50. Daix 172. The Hermitage Museum, Leningrad

SUMMER: Meets D.-H. Kahnweiler, who opened gallery at 28, rue Vignon in February. Kahnweiler visits the Bateau-Lavoir and sees *Demoiselles.*

SUMMER–AUTUMN: First postscript to *Les Demoiselles: Nude with Raised Arms (The Dancer of Avignon)* (p. 101). Paints brightly colored "African"

pictures: *Nude with Drapery* (p. 87; sketches, p. 103), second *Nude with Raised Arms* (p. 104), and *Vase of Flowers* (p. 105).

OCTOBER 1: Cézanne memorial retrospective at Salon d'Automne; catalog lists 56 works, most of them oils. Included are a group of late paintings, among them some nominally "unfinished" canvases.

OCTOBER OR NOVEMBER: Meets Braque, whom Apollinaire brings to studio in Bateau-Lavoir. Braque sees the *Demoiselles.* Soon after, he puts aside group of Cézanne-influenced landscapes and makes a monumental nude, in which influence of Picasso joins that of Cézanne and Matisse (final revision of *Large Nude* [p. 87] achieved at L'Estaque in early June of 1908).

1908

WINTER: Paints *Friendship* (p. 106), bought by Russian collector Sergei Shchukin in 1913.

SPRING: Numerous brightly colored "African" studies related to large compositions, involving alternately three and five female nudes in landscape setting (p. 112). Paints *version rhythmée* of *Three Women* (p. 113).

SUMMER: Suicide of a friend, German painter Wiegels, in Bateau-Lavoir. Perhaps in commemoration of his friend, paints *Still Life with Death's Head.*

Forgoes planned Spanish trip. Sometime before August, paints first version of very large composition *Three Women;* before being reworked in the fall, it appears in background of photograph of André Salmon.

Begins series of still lifes with simple geometrical forms (p. 107).

AUGUST: Leaves with Fernande for La Rue des Bois, sixty kilometers north of Paris, where he remains through early fall. Paints figures and landscapes (pp. 110, 111). Former reflect diminishing influence of African sculpture; latter, the influence of Rousseau and a primitive Cézannism.

Chez Kahn Weiler, 28, rue Vignon. — M. Braque est un jeune homme fort audacieux. L'exemple déroutant de Picasso et de Derain l'a enhardi. Peut-être aussi le style de Cézanne et les ressouvenirs de l'art statique des Egyptiens l'obsèdent-ils outre mesure. Il construit des bonshommes métalliques et déformés et qui sont d'une simplification terrible. Il méprise la forme, réduit tout, sites et figures et maisons, à des schémas géométriques à des cubes. Ne le raillons point, puisqu'il est de bonne foi. Et attendons.

Louis Vauxcelles

La Conquête de l'air

AU MANS

Wilbur Wright gagne le prix de la hauteur

Review of Braque exhibition at Galerie Kahnweiler, November 1908. Printed in *Gil Blas* (Paris), November 14, 1908

SEPTEMBER: Braque submits six Cézannesque but highly abstract landscapes of L'Estaque to the Salon d'Automne; all are refused. It is Matisse, sitting on the jury, who reportedly says that Braque is "making little cubes," perhaps the first use of the term to describe Braque's and Picasso's experiments.

FALL: Paints *The Dryad* (p. 114).

NOVEMBER 9: Braque shows the first Cubist pictures, his L'Estaque works, at Kahnweiler's gallery. In catalog preface Apollinaire writes: "Braque is evolving within himself a universal pictorial renaissance." Show is much talked about and visited by artists. Vauxcelles's review in *Gil Blas* (November 14) says: "[Braque] reduces everything, places and figures and houses, to geometric schemes, to cubes." Some months later he calls this type of painting "Cubist." (By end of 1909, term is common among painters and critics.)

NOVEMBER: Picasso and Fernande Olivier give banquet honoring the *Douanier* Rousseau, one of whose paintings, *Portrait of a Woman*, Picasso has bought from Père Soulier. Among poets and painters attending are Apollinaire and Marie Laurencin, Salmon, Braque, and Gertrude Stein. The old painter says to Picasso: "You and I are the greatest painters of our time, you in the Egyptian style, I in the modern."

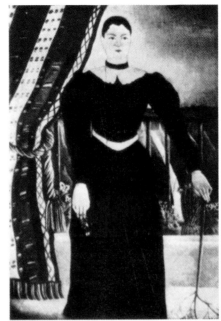

Henri Rousseau: *Portrait of a Woman* (Yadwigha). n.d., but bought by Picasso in 1908. Oil on canvas, 63 x 39½" (160 x 105 cm). Musée Picasso, Paris

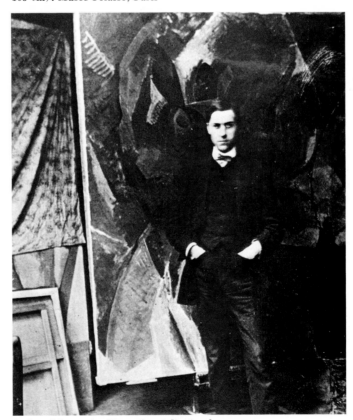

André Salmon in Picasso's studio in the Bateau-Lavoir, early Summer 1908. In background, first version of *Three Women*

Conception of *Carnival at the Bistro* (p. 124), which metamorphoses into composition of large still life *Bread and Fruit Dish on a Table* early in 1909 (p. 125).

WINTER 1908–09: Completes final version of *Three Women* (p. 115). African-influenced striations in earlier version are replaced with close-valued planes of earth tones, green, and gray in a shallow bas-relief space recalling the structure of Braque's L'Estaque paintings. Picasso and Braque become close friends.

Also paints *Seated Male Nude* (p. 116) and *Bather* (p. 117). Latter is first incidence of "double head" in Picasso's oeuvre—frontal head containing suggestion of interior profile.

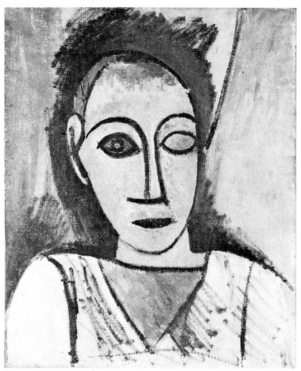

Bust of a Sailor. Paris, early 1907
Oil on canvas, 21¾ x 18⅛″ (55 x 46 cm)
Zervos XXVI, 12. Daix 22. Musée Picasso, Paris

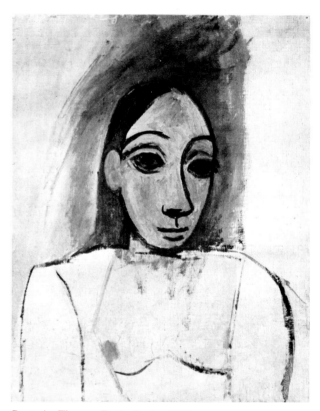

Bust of a Woman. Paris, Spring 1907
Oil on canvas, 23¼ x 18½″ (59 x 47 cm)
Zervos II,² 617. Daix 24. Musée Picasso, Paris

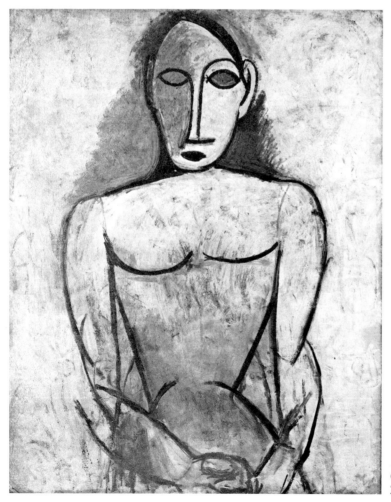

Woman with Joined Hands. Paris, early 1907
Oil on canvas, 35⅜ x 28″ (90 x 71 cm)
Zervos II,² 662. Daix 26. Musée Picasso, Paris

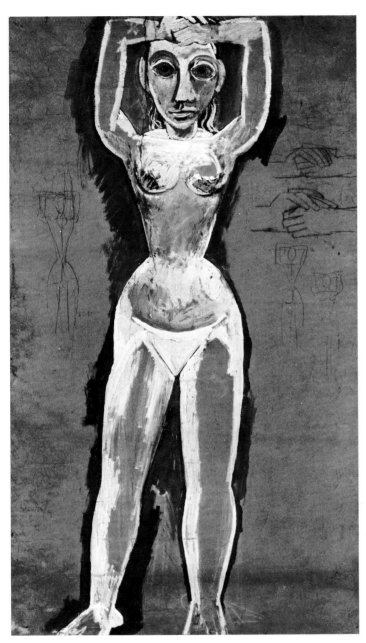

Nude with Raised Arms. Paris, Spring 1907
Oil, charcoal, and pencil on paper mounted on canvas,
52 x 31½″ (132 x 80 cm)
Zervos XXVI, 190. Daix 17. Musée Picasso, Paris

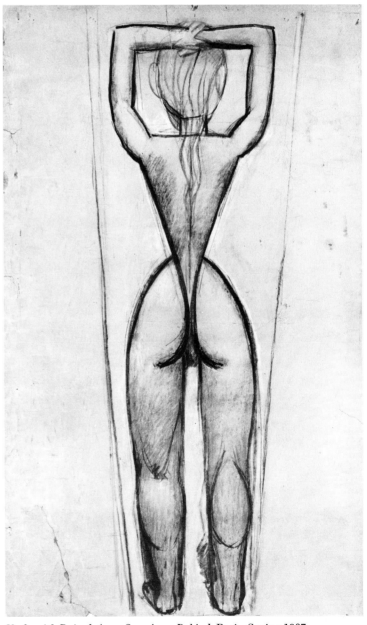

Nude with Raised Arms Seen from Behind. Paris, Spring 1907
Oil and charcoal on pasted paper mounted on canvas,
52¾ x 33¾″ (134 x 86 cm)
Zervos XXVI, 189. Daix 19. Musée Picasso, Paris

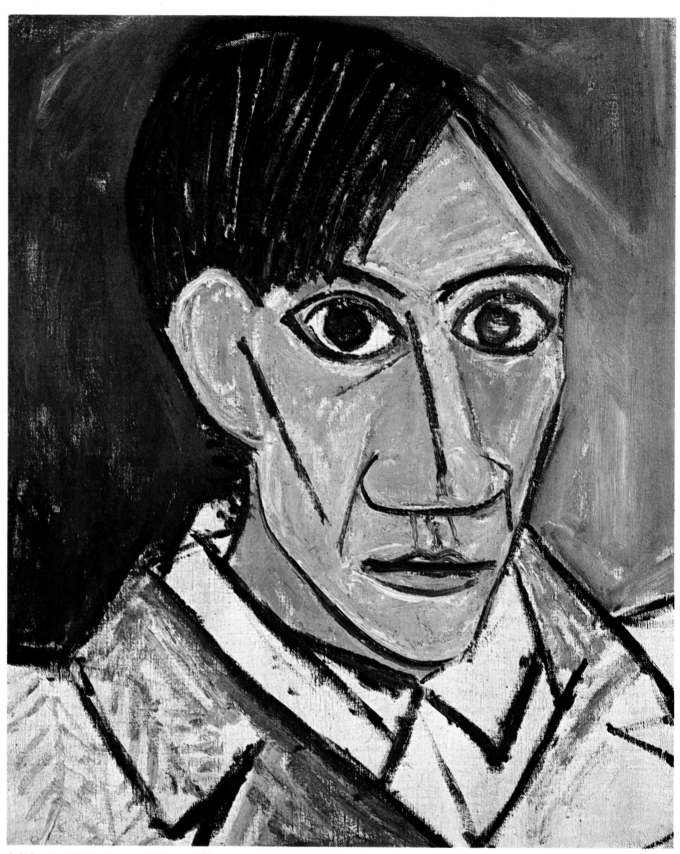

92 *Self-Portrait*. Paris, Spring 1907
Oil on canvas, 19¾ x 18⅛″ (50 x 46 cm)
Zervos II,¹ 8. Daix 25. National Gallery, Prague

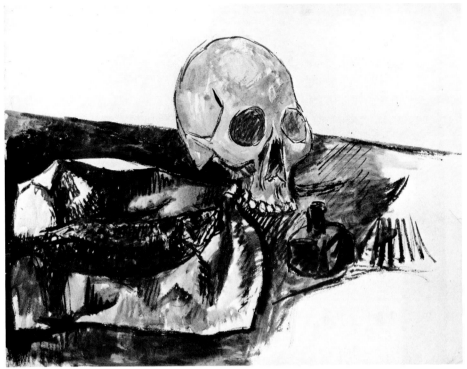

Still Life with Fish, Skull, and Inkwell. Paris, Spring 1907
India ink wash, 18¾ x 25″ (47.5 x 63.5 cm)
Zervos XXVI, 193. Musée Picasso, Paris

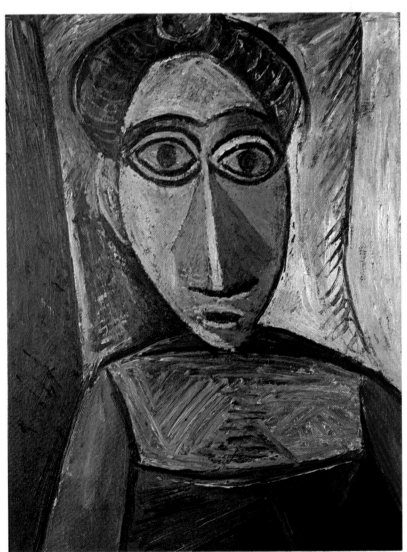

Bust of a Woman. Paris, Spring 1907
Oil on canvas, 25⅝ x 19⅞″ (64 x 50 cm)
Zervos II,¹ 16. Daix 33. National Gallery, Prague

93

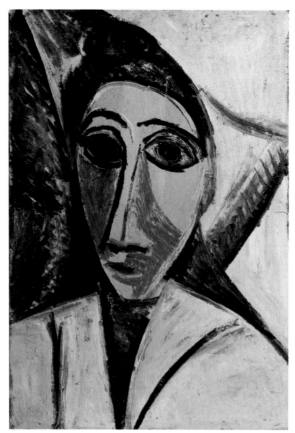

Head and Shoulders of a Sailor or of a Woman (Study for Les Demoiselles d'Avignon). Paris, Spring 1907
Oil on canvas, 21⅛ x 14⅜" (53.5 x 36.5 cm)
Not in Zervos. Daix 28. Musée Picasso, Paris

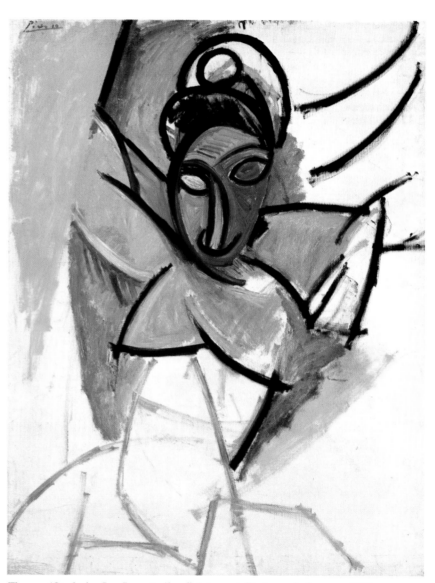

Woman (Study for Les Demoiselles d'Avignon). Paris, early Summer 1907
Oil on canvas, 46½ x 36⅝" (118 x 93 cm)
Zervos II,² 631. Daix 75. Collection H. and E. Beyeler, Basel

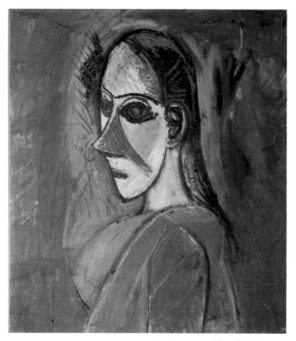

Bust of a Woman (Study for Les Demoiselles d'Avignon)
Paris, begun Spring 1907; reworked July 1907
Oil on canvas, 25⅝ x 22⅞" (65 x 58 cm)
Zervos II,¹ 23. Daix 38. Musée National d'Art Moderne,
Centre National d'Art et de Culture Georges Pompidou, Paris

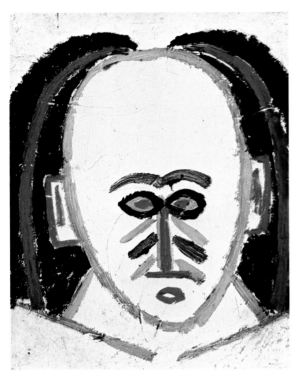

Striated Head. Paris, Summer 1907
Oil on canvas, 7 x 5⅝″ (17.8 x 14.3 cm)
Zervos XXVI, 270. Daix 73
Collection Claude Picasso, Paris

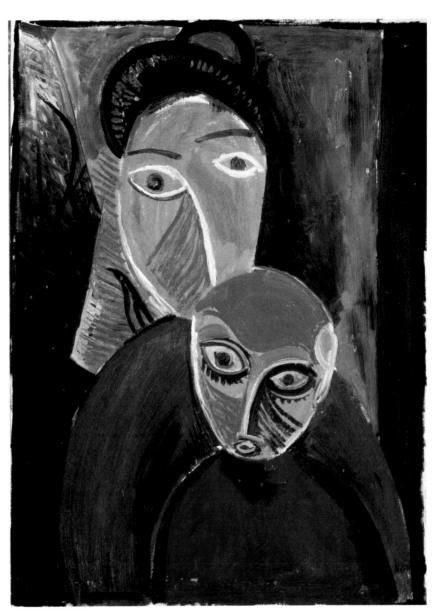

Mother and Child. Paris, Summer 1907*
Oil on canvas, 31⅞ x 23⅝″ (81 x 60 cm)
Zervos II,¹ 38. Daix 52. Musée Picasso, Paris

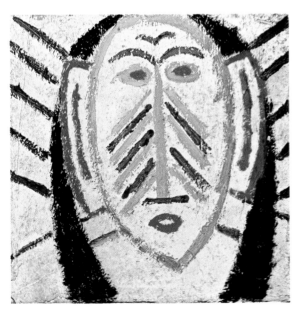

Head with Scarification. Paris, Summer 1907
Oil and sand on panel, 6⅞ x 5½″ (17.5 x 14 cm)
Zervos XXVI, 269. Daix 74. Collection Claude Picasso, Paris

95

Figure. Paris, 1907
Wood, 13⅞ x 4¾ x 4⅛″ (35.2 x 12.2 x 10.5 cm)
Zervos II,² 668. Spies 15. Musée Picasso, Paris

Standing Nude in Profile. Paris, Summer 1907
Pastel, gouache, and watercolor, 24¾ x 18⅞″ (63 x 47.8 cm)
Zervos XXVI, 275. Daix 72. Musée Picasso

Standing Man. Paris, 1907
Painted wood, 14½″ (37 cm) high
Zervos II,² 656–57. Spies 20. Private collection

Head. Paris, 1907*
Conté crayon and charcoal, 25⅝ x 19¾″ (65 x 50 cm)
Zervos VI, 905. Collection Bernard Picasso, Paris

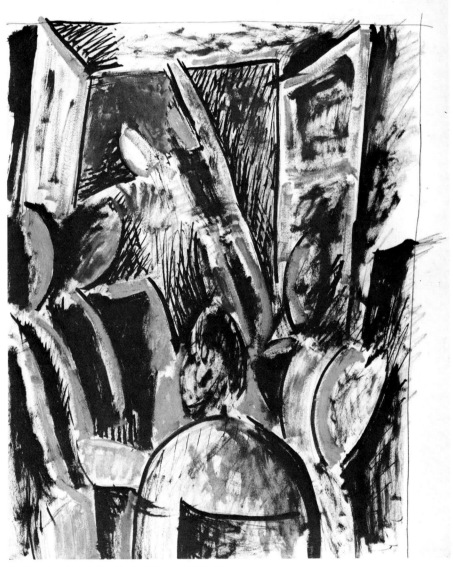

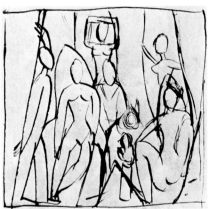

*Figures in a Bordello (Study for
Les Demoiselles d'Avignon)*
Paris, early Spring 1907
India ink on cut paper,
3¼ x 3½" (8.2 x 9 cm)
Zervos VI, 981. Musée Picasso, Paris

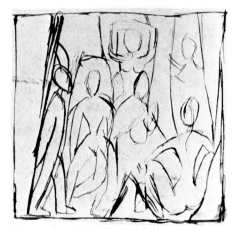

*Figures in a Bordello (Study for
Les Demoiselles d'Avignon)*
Paris, early Spring 1907
Pen and ink, 3½ x 3⅝" (8.7 x 9 cm)
Zervos VI, 980. Musée Picasso, Paris

Sailors in a Bordello. Paris, Winter 1906–07
Gouache and charcoal, 25¼ x 19½" (64.2 x 49.4 cm)
Zervos XXVI, 188. Daix 1. Musée Picasso, Paris

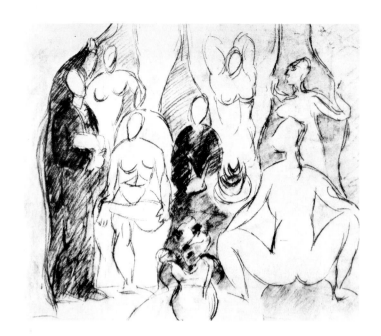

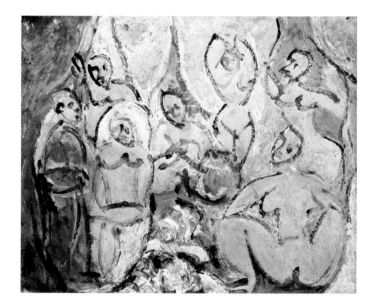

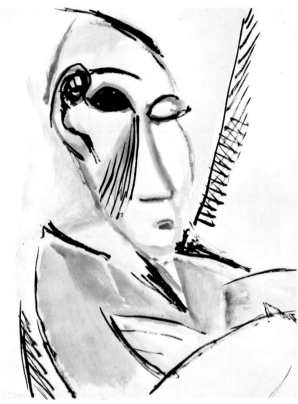

Head of the Medical Student (Study for Les Demoiselles d'Avignon). Paris, Spring 1907
Gouache and watercolor, 23¾ x 18½" (60.3 x 47 cm)
Zervos VI, 977. Daix 44. The Museum of Modern Art, New York. A. Conger Goodyear Fund

TOP RIGHT:
Medical Student, Sailor, and Five Nudes in a Bordello (Study for Les Demoiselles d'Avignon). Paris, early 1907
Charcoal and pastel, 18⅞ x 25" (47.7 x 63.5 cm)
Zervos II, 19. Daix 29. Kunstmuseum, Basel

CENTER RIGHT:
Medical Student, Sailor, and Five Nudes (Study for Les Demoiselles d'Avignon). Paris, March 1907
Oil on panel, 7⅜ x 9⅜" (18.7 x 23.8 cm)
Zervos II,¹ 20. Daix 30. Present whereabouts unknown

RIGHT:
Five Nudes (Study for Les Demoiselles d'Avignon)
Paris, May 1907
Watercolor, 6¾ x 8¾" (17.2 x 22.2 cm)
Zervos II,¹ 21. Daix 31. Philadelphia Museum of Art.
A. E. Gallatin Collection

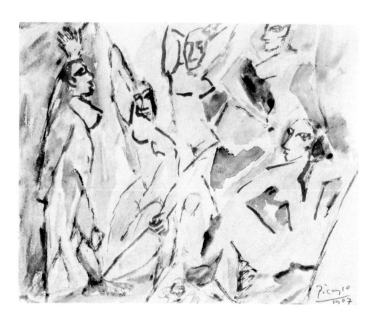

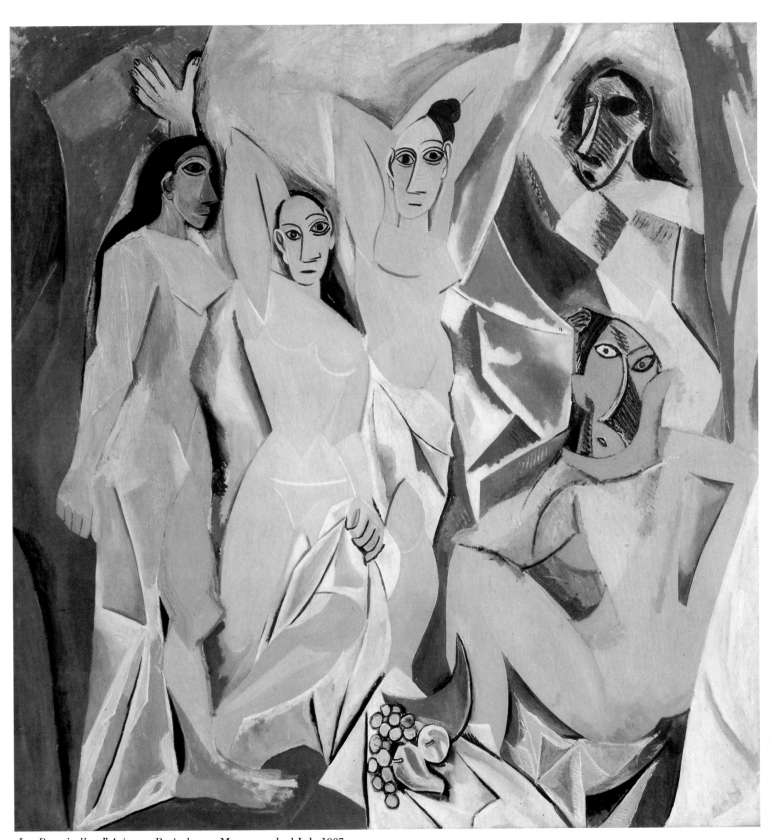

Les Demoiselles d'Avignon. Paris, begun May, reworked July 1907
Oil on canvas, 96 x 92″ (243.9 x 233.7 cm)
Zervos II,¹ 18. Daix 47. The Museum of Modern Art, New York.
Acquired through the Lillie P. Bliss Bequest

99

Landscape. Paris, Summer 1907
Oil on canvas, 36⅝ x 36¼″ (93 x 92 cm)
Zervos II,² 681. Daix 62. Musée Picasso, Paris

Nude with Raised Arms (The Dancer of Avignon)
Paris, Summer–Autumn 1907
Oil on canvas, 59⅛ x 39½″ (150.3 x 100.3 cm)
Zervos II,¹ 35. Daix 53. Private collection

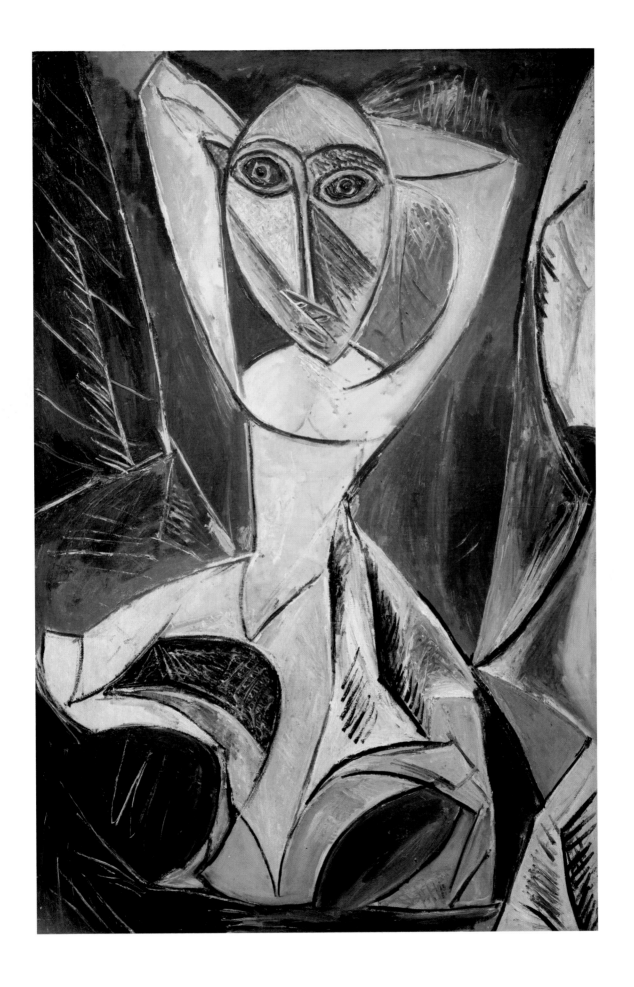

Sleeping Nude. Paris, Summer 1907
Pastel, 18⅞ x 24⅞″ (48 x 63.2 cm)
Zervos XXVI, 264. Daix 76. Musée Picasso, Paris

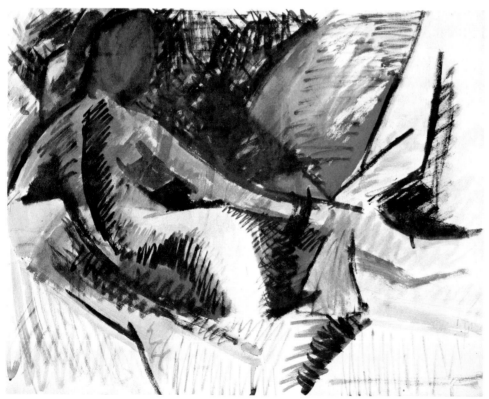

Odalisque, after Ingres. Paris, Summer 1907
Watercolor, gouache, and pencil, 19 x 24⅞″ (48 x 63 cm)

Zervos XXVI, 194. Musée Picasso, Paris

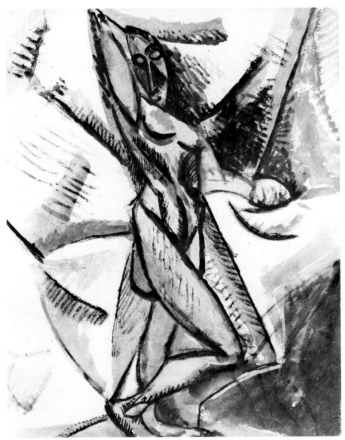

Study for Nude with Drapery. Paris, Summer 1907
Watercolor, 12¼ x 9½" (31 x 24 cm)
Zervos II,¹ 45. Daix 83. The Baltimore Museum of Art.
The Cone Collection, formed by Dr. Claribel Cone
and Miss Etta Cone of Baltimore, Maryland

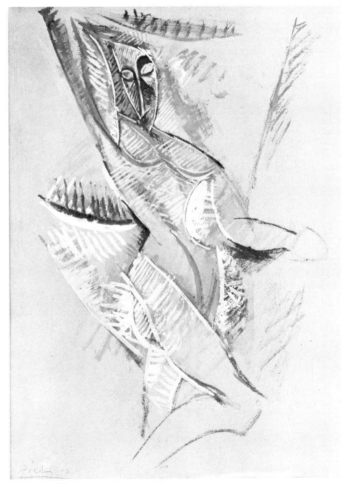

Study for Nude with Drapery. Paris, Summer 1907
Gouache on brown paper mounted on canvas,
12 x 9¼" (30.5 x 23.5 cm)
Zervos II,² 676. Daix 84. Collection
Mr. and Mrs. Sidney E. Cohn, New York

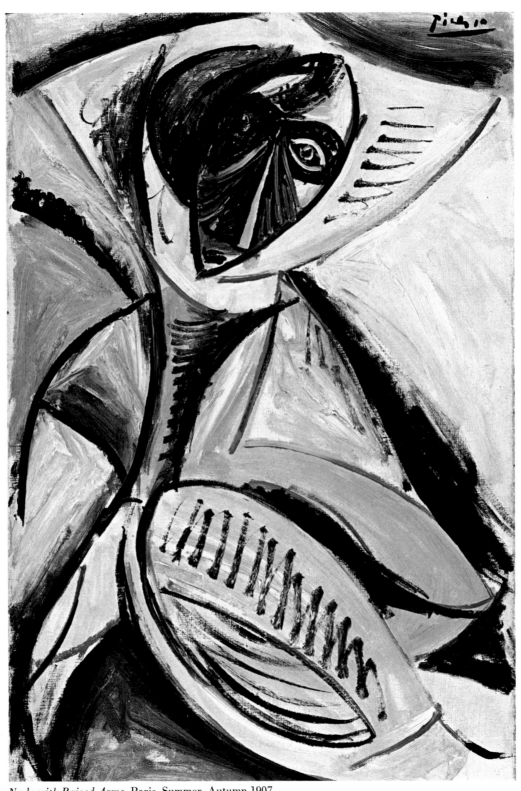

Nude with Raised Arms. Paris, Summer–Autumn 1907
Oil on canvas, 24⅞ x 16¾″ (63 x 42.5 cm)
Zervos II,¹ 36. Daix 54. Thyssen-Bornemisza Collection, Lugano, Switzerland

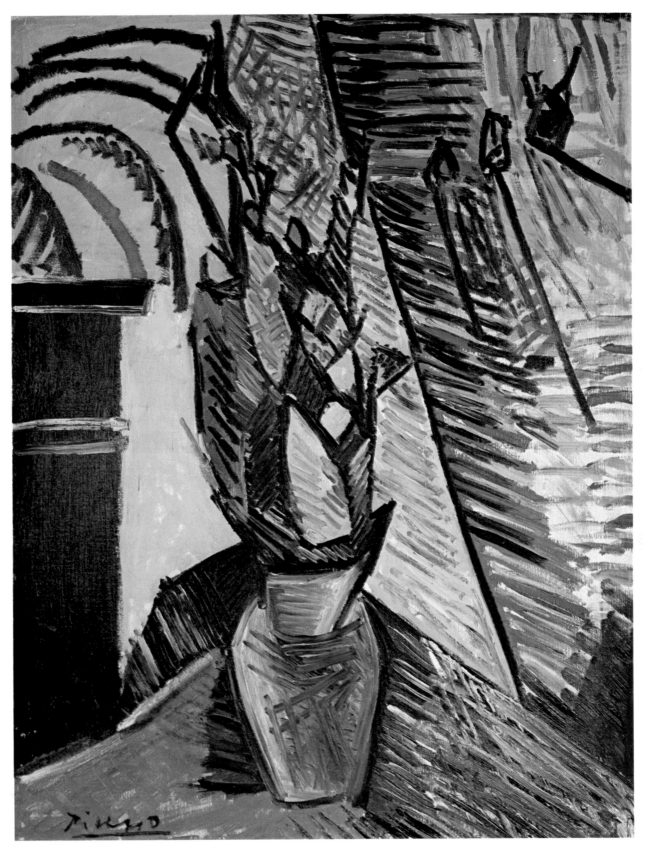

Vase of Flowers. Paris, Autumn 1907*
Oil on canvas, 36¼ x 28¾″ (92.1 x 73 cm)
Zervos II,[1] 30. Daix 70. The Museum of Modern Art, New York.
Gift of Mr. and Mrs. Ralph F. Colin, the latter retaining life interest

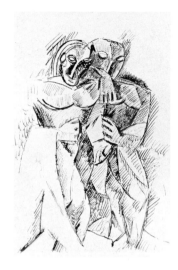

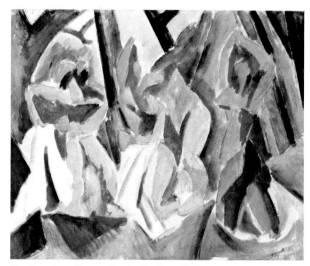

Study for Friendship. Paris, early 1908
Pen and India ink, 19 x 12⅞"
(48.2 x 32.6 cm)
Zervos VI, 1011. Musée Picasso, Paris

Bathers in a Forest. Paris, Spring 1908
Watercolor and pencil on paper mounted on canvas,
18¾ x 23⅛" (47.6 x 58.7 cm)
Zervos XXVI, 291. Daix 126. The Museum of Modern
Art, New York. Hillman Periodicals Fund

Repose. Paris, Spring 1908
Oil on canvas, 32 x 25¾" (81.2 x 65.4 cm)
Zervos XXVI, 303. Daix 170. The Museum of Modern
Art, New York. Acquired by exchange through the
Katherine S. Dreier Bequest and the Hillman Periodicals,
Philip Johnson, Miss Janice Loeb, and Mr. and Mrs.
Norbert Schimmel Funds

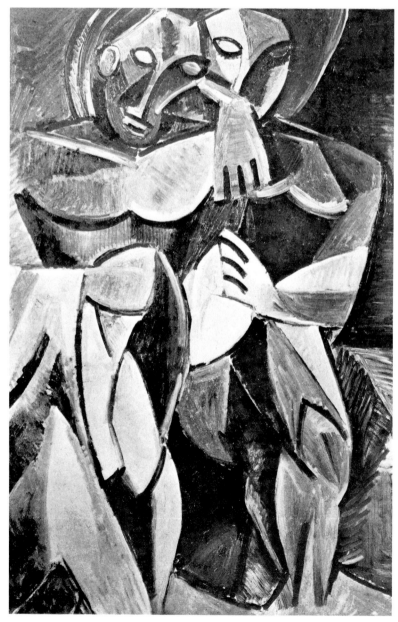

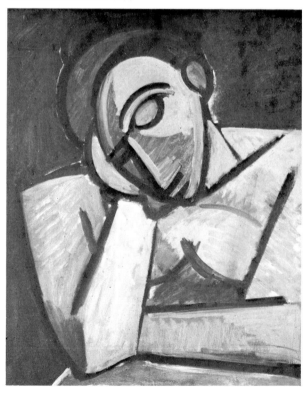

Friendship. Paris, early 1908
Oil on canvas, 59⅞ x 39¾" (152 x 101 cm)
Zervos II,¹ 60. Daix 104. The Hermitage Museum, Leningrad

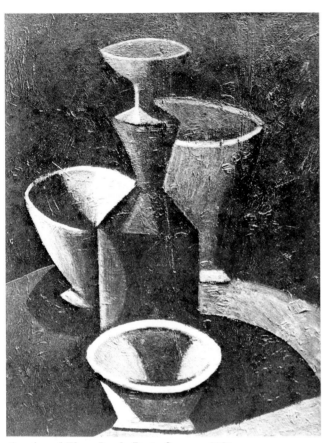

Carafe and Three Bowls. Paris, Summer 1908
Oil on cardboard. 26 x 19¾″ (66 x 50 cm)
Zervos II,¹ 90. Daix 176. The Hermitage Museum, Leningrad

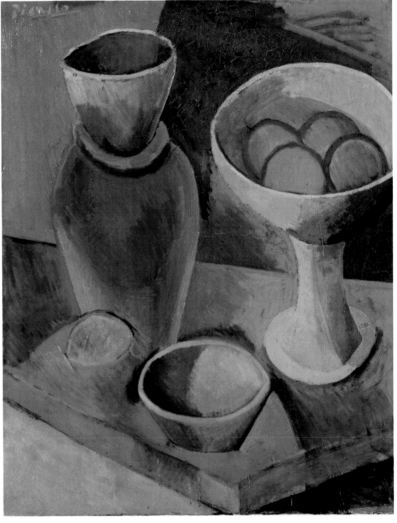

Bowls and Jug. Paris, Summer 1908
Oil on canvas, 31⅞ x 25⅝″ (81 x 65 cm)
Zervos II,¹ 63. Daix 177. Philadelphia Museum of Art.
A. E. Gallatin Collection

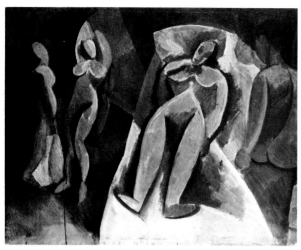

Sleeping Nude with Figures. Paris, Spring 1908
Oil on wood, 14¼ x 18⅜″ (36 x 46.5 cm)
Zervos II,² 688. Daix 164. Musée Picasso, Paris

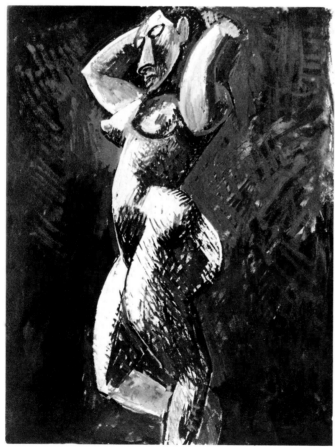

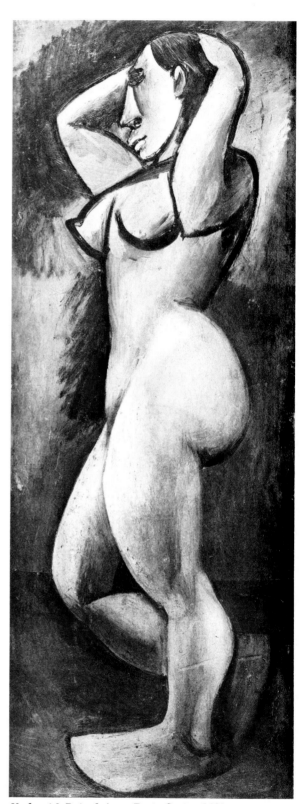

Nude with Raised Arms. Paris, Spring 1908
Gouache, 12⅝ x 9⅞″ (32 x 25 cm)
Zervos II,¹ 39. Daix 165. Musée Picasso, Paris

Nude with Raised Arms. Paris, Spring 1908
Oil on wood, 26⅜ x 10⅝″ (67 x 27 cm)
Zervos II,² 693. Daix 166
Collection Jacqueline Picasso, Mougins

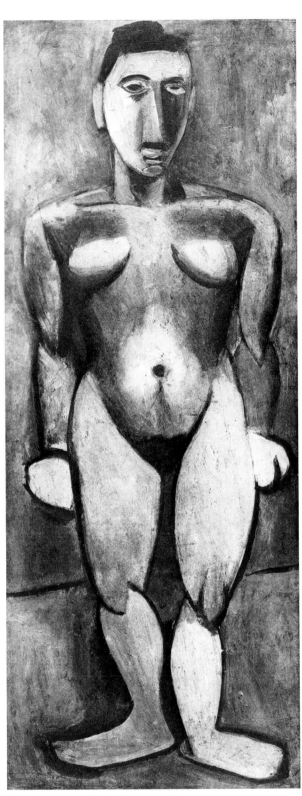

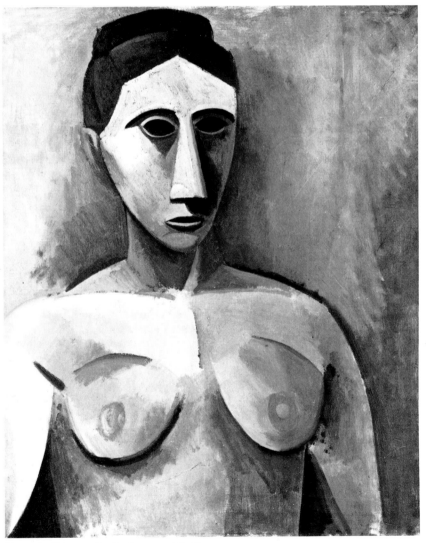

Standing Nude. Paris, Spring 1908
Oil on wood, 26⅜ x 10⅝″ (67 x 27 cm)
Zervos II,² 694. Daix 167
Collection Jacqueline Picasso, Mougins

Bust of a Woman. Paris, Summer 1908*
Oil on canvas, 28¾ x 23⅝″ (73 x 60 cm)
Zervos II,¹ 64. Daix 134. National Gallery, Prague

109

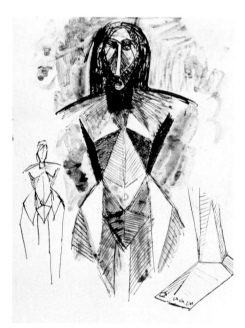

Standing Nudes and Study of Foot
La Rue des Bois, late Summer 1908*
Pen and India ink and wash, 11⅞ x 9″ (30 x 22.7 cm)
Zervos XXVI, 354. Musée Picasso, Paris

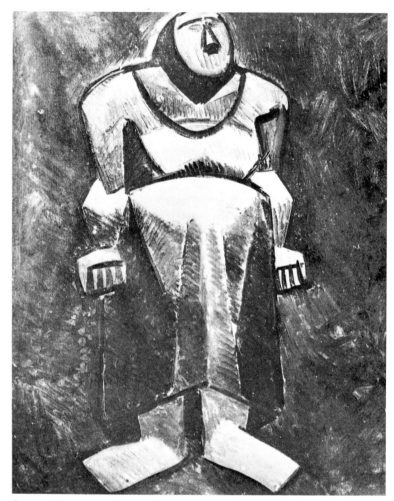

Peasant Woman. La Rue des Bois,
late Summer–early Autumn 1908
Oil on canvas, 32 x 25¾″ (81.2 x 65.3 cm)
Zervos II,' 91. Daix 193. The Hermitage Museum, Leningrad

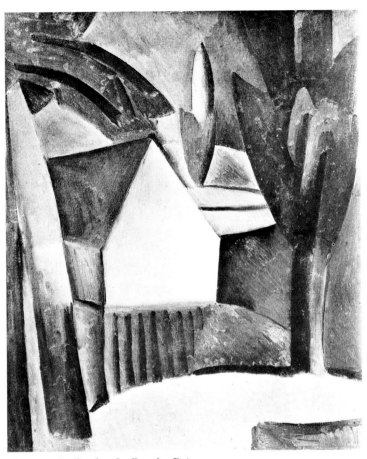

House in the Garden. La Rue des Bois,
late Summer— early Autumn 1908
Oil on canvas, 28¾ x 23⅝″ (73 x 60 cm)
Zervos II,¹ 80. Daix 189. The Hermitage Museum, Leningrad

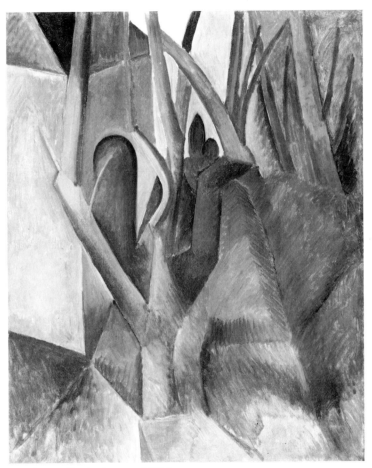

Landscape. Paris, Autumn 1908*
Oil on canvas, 39⅝ x 32″ (100.8 x 81.3 cm)
Zervos II,¹ 83. Daix 191. The Museum of Modern Art,
New York. Gift of David Rockefeller

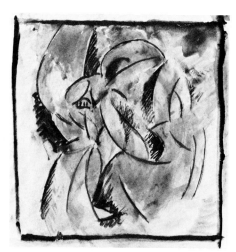

Study for Three Women. Paris, Spring 1908
Gouache, 9⅞ x 13″ (25 x 33 cm) (sheet)
Zervos XXVI, 328. Musée Picasso, Paris

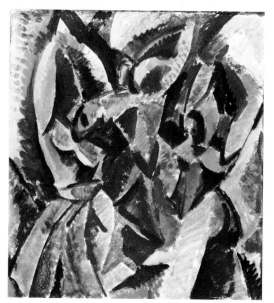

Study for Three Women. Paris,
Spring–Summer 1908
Gouache, 20⅛ x 19″ (51 x 48 cm)
Zervos II,¹ 104. Daix 124. Musée National d'Art
Moderne, Centre National d'Art et de Culture
Georges Pompidou, Paris

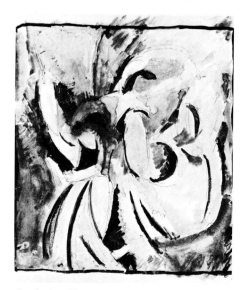

Study for Three Women. Paris, Spring 1908
Gouache and pencil, 13 x 9¾″ (33 x 24.7 cm)
(33 x 24.7 cm) (sheet)
Zervos XXVI, 336. Musée Picasso, Paris

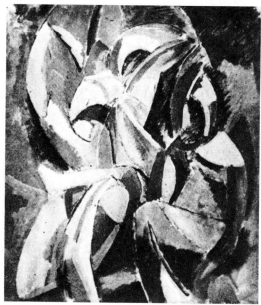

Study for Three Women
Paris, [Spring–Summer] 1908
Watercolor and gouache, 20⅞ x 18½″ (53 x 47cm)
Zervos II,¹ 106. Daix 120
The Pushkin State Museum of Fine Arts, Moscow

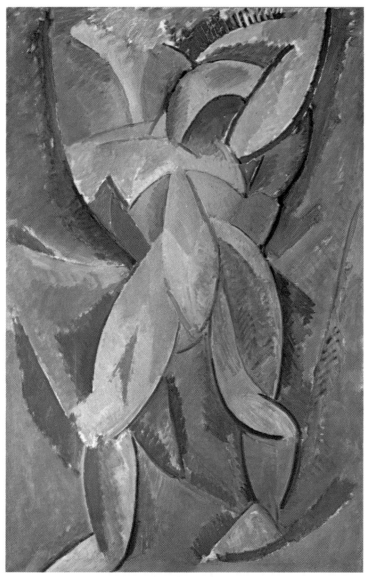

Standing Nude. Paris, Spring 1908
Oil on canvas, 59⅛ x 39⅜″ (150 x 100 cm)
Zervos II,¹ 103. Daix 116. Museum of Fine Arts, Boston

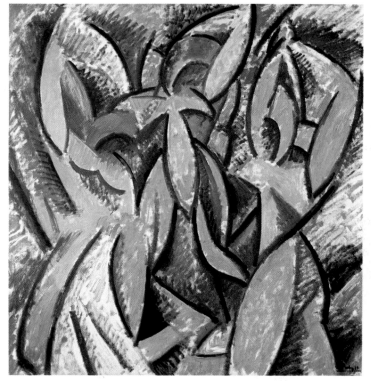

Three Women (version rhythmée). Paris, Spring–Summer 1908
Oil on canvas, 35⅞ x 35⅞″ (91 x 91 cm)
Zervos II,¹ 107. Daix 123
Kunstmuseum, Hanover. Sammlung Sprengel

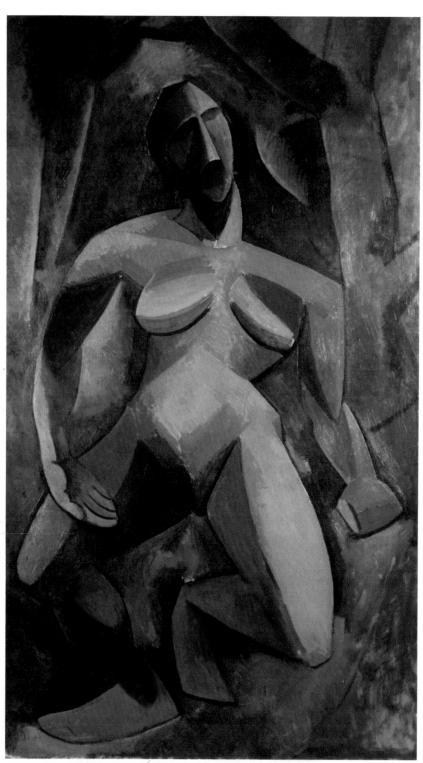

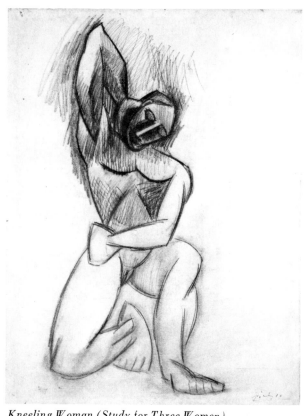

Kneeling Woman (Study for Three Women)
Paris, Autumn 1908
Charcoal, 25 x 18⅜" (63.2 x 47.9 cm)
Zervos II,[2] 707
Collection Mr. and Mrs. Jacques Gelman, Mexico City

The Dryad. Paris, Autumn 1908
Oil on canvas, 72⅞ x 42½" (185 x 108 cm)
Zervos II,[1] 113. Daix 133. The Hermitage Museum. Leningrad

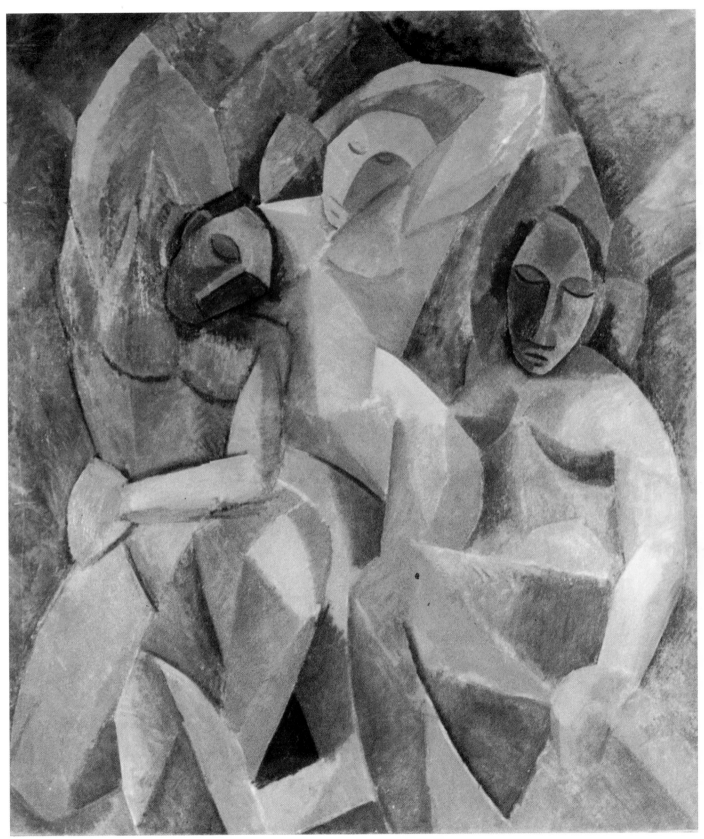

Three Women. Paris, begun Summer 1908;
reworked between November 1908 and January 1909
Oil on canvas, 78¾ x 70⅛″ (200 x 178 cm)
Zervos II,¹ 108. Daix 131. The Hermitage Museum, Leningrad

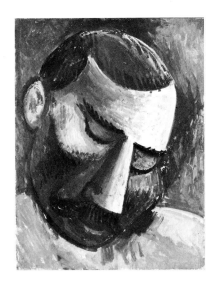

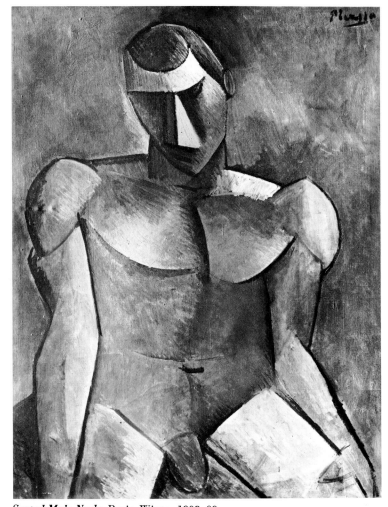

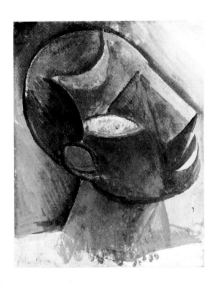

Seated Male Nude. Paris, Winter 1908–09
Oil on canvas, 36¼ x 28¾″ (92 x 73 cm)
Zervos II, 117. Daix 229. Musée d'Art Moderne du Nord, Villeneuve d'Ascq

TOP LEFT:
Head of a Man, late 1908*
Gouache on wood, 10⅝ x 8½″ (27 x 21.5 cm)
Zervos XXVI, 392. Daix 153.
Musée Picasso, Paris

ABOVE:
Head of a Man. Paris, late 1908*
Gouache on wood, 10⅝ x 8⅜″ (27 x 21 cm)
Zervos XXVI, 394. Daix 152.
Musée Picasso, Paris

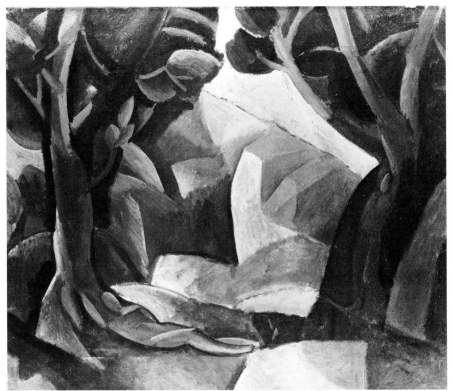

Landscape with Two Figures. Paris, late 1908*
Oil on canvas, 22⅞ x 28⅜″ (58 x 72 cm)
Zervos II,¹ 79. Daix 187. Musée Picasso, Paris

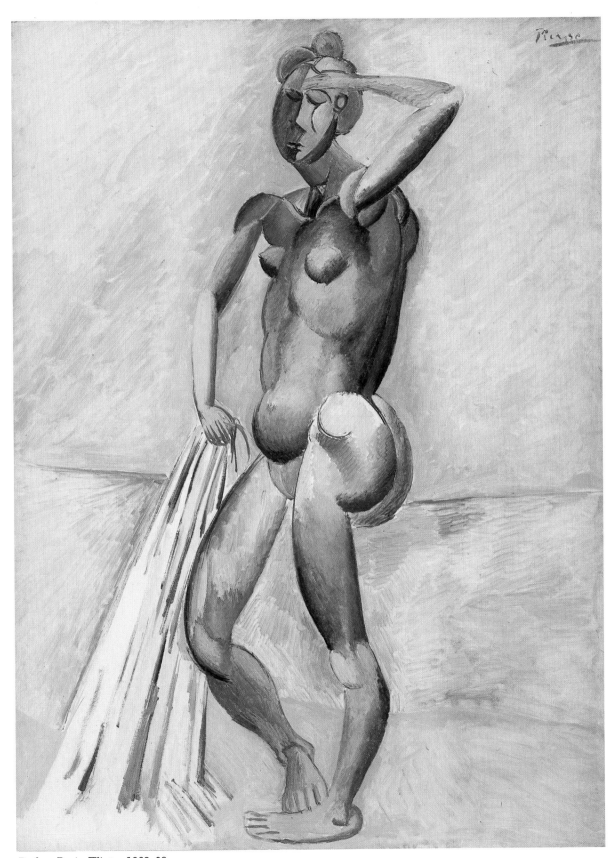

Bather. Paris, Winter 1908–09
Oil on canvas, 51¼ x 38⅛″ (130 x 97 cm)
Zervos II,¹ 111. Daix 239. Collection Mrs. Bertram Smith, New York

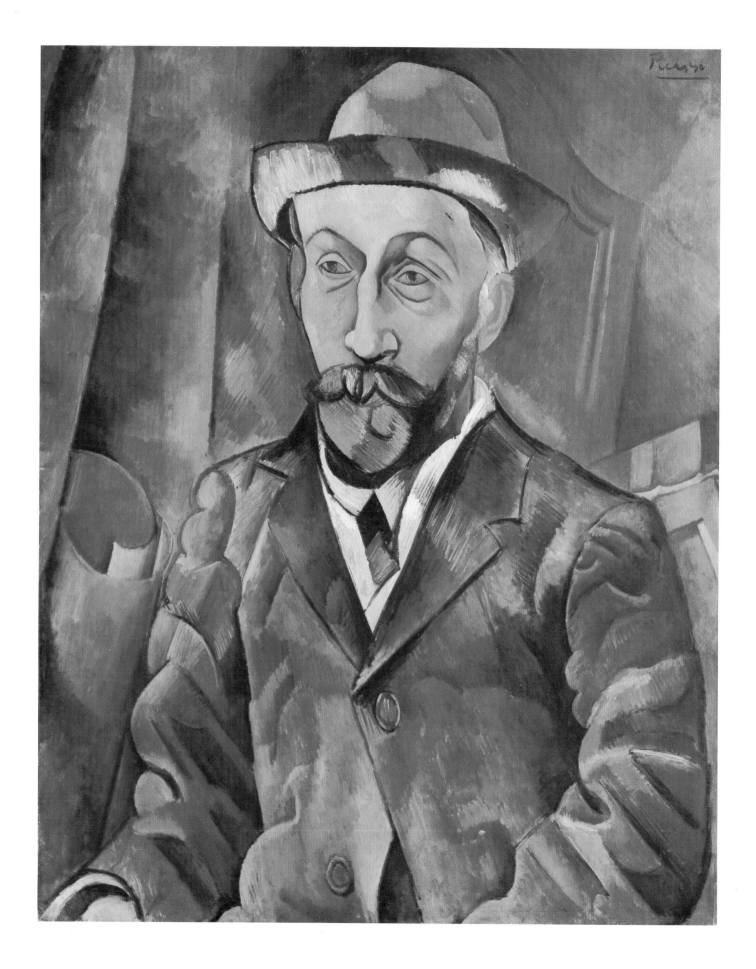

118

1909-1911

Houses of Horta de Ebro. Photographed by Picasso, Summer 1909. Photograph formerly in the collection of Gertrude Stein. Published in *Transition* (Paris), February 1928. RIGHT: Studio at Horta, with portraits of Fernande Olivier. Summer 1909

1909

BEGINNING OF YEAR: Final state of *Bread and Fruit Dish on a Table* (p. 125); shows monumental Cubism influenced by Rousseau as well as Cézanne.

Harlequin theme, reestablished in *Carnival at the Bistro* sketches (p. 124), persists in series of heads and in headdress of *Woman with a Fan* (p. 127). Paints portrait of Clovis Sagot (p. 118), himself an ex-circus clown before becoming an art dealer.

SPRING–SUMMER: Returns to Spain in May with Fernande, stopping briefly in Barcelona to visit his parents and see

old friends. While there, paints portrait of Pallarés (p. 128), whose studio he shares. Goes on to Horta de Ebro (now Horta de San Juan), first visited with Pallarés 11 years before.

Sojourn at Horta most crucial and productive of career. Begins series of landscapes, of which earliest, *Landscape (Mountain of Santa Bárbara)* (p. 129), frankly recalls Cézanne. *Houses on the Hill, Horta de Ebro* (p. 130), *Factory at Horta de Ebro* (p. 130), and *The Reservoir, Horta* (p. 131) constitute Picasso's first fully defined statements of Analytic Cubism (marked by "reverse perspective," bas-relief modeling, and consistent *passage*). Several por-

traits of Fernande (p. 132; series begun in Paris in spring, p. 128), culminating in *Woman with Pears* (p. 133). In the autumn, models sculpture of Fernande (p. 132) related to these portraits. Last picture at Horta, *Still Life with Liqueur Bottle* (p. 134), marked by faceting of planes into smaller units.

SEPTEMBER: Returns to Paris with large number of paintings.

SEPTEMBER OR OCTOBER: Leaves Bateau-Lavoir and moves to 11, boulevard de Clichy, near place Pigalle. Has studio with north light and apartment overlooking trees of avenue Frochot. In contrast with Bateau-Lavoir days, Picasso and Fernande have meals in a dining room "served by a maid in white apron," writes Fernande in *Picasso et ses amis* (Paris: Stock, 1933). Studio quickly becomes cluttered with things bought on walks: Louis-Philippe couch, low fireside chair, tapestries, musical instruments, and a small Corot of a figure of a woman. "In spite of all this. . . . Picasso was less happy here than he'd been before."

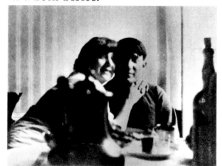

Fernande Olivier and Picasso, Paris, 1910

Picasso and Fernande begin to entertain on Sunday afternoons. They continue to visit Matisse on Fridays and attend Gertrude Stein's salons at rue de Fleurus on Saturday evenings.

AUTUMN–WINTER: Paints series of still lifes, among them *Fan, Salt Box, and Melon* (p. 135).

1910

BEGINNING OF YEAR: Ceases work on *Girl with Mandolin* (p. 137) when young model Fanny Tellier quits after

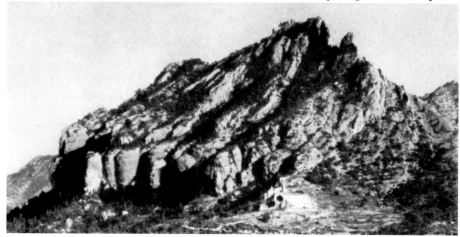

Mountain of Santa Bárbara, Horta de Ebro (now Horta de San Juan)

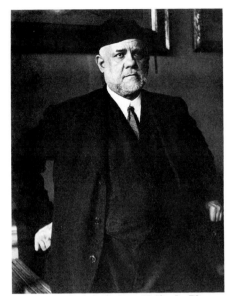

Picture dealer Ambroise Vollard. Photographed by Brassaï, 1932. The Museum of Modern Art, New York. David H. McAlpin Fund

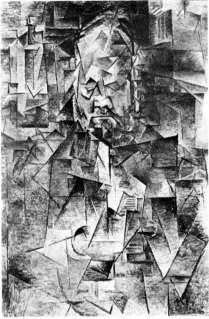

Portrait of Ambroise Vollard.† Paris, Spring 1910 (colorplate, p. 138)

MAY: Exhibition at Galerie Notre-Dame-des-Champs, Paris. Critic Léon Werth in *La Phalange* (Paris, June 10) describes two paintings, a "fruit-dish and glass, which display their structure, substructure, and superstructure and whose harmony, simplified as it is, is made up of the yellows and greens of certain Cézannes," and a "landscape of cubic roofs, cubic chimneys, and trees that are like the chimneys but decorated at the top with palms," probably *Bowls of Fruit with Wine Glass* of 1908 and *Factory at Horta* of 1909 (p. 130), bought by Shchukin.

LATE JUNE: With Fernande, travels to Cadaqués on the coast of Catalonia, where Pichot spends vacations. They take a house at the edge of the sea, and are joined shortly by Derain and his wife. Makes four etchings illustrating

House at Cadaqués (with auto in front) where Picasso and Fernande spend Summer of 1910

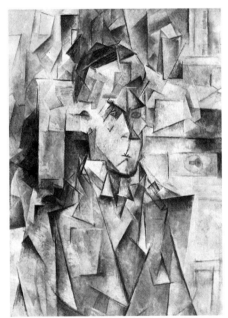

Portrait of Wilhelm Uhde.† Paris, Spring 1910 (colorplate, p. 139)

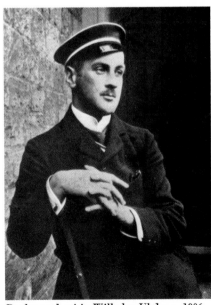

Dealer and critic Wilhelm Uhde, c. 1906

numerous sittings. Later Picasso says: "It may be just as well I left it as it is."

SPRING: Completes portraits of Ambroise Vollard (p. 138) and of dealer and critic Wilhelm Uhde (p. 139). Despite advanced Cubist segmentation, or "analysis," captures likeness of sitters. Portraits display lower-relief modeling;

space shifting from "sculptural" to "pictorial"; and increasing subdivision of more nuanced planes.

APRIL–MAY: Four works shown in group exhibition at gallery Müvészház, Budapest, among them *Woman with Mandolin* of 1909, later bought by Shchukin.

Saint-Matorel, a play by Max Jacob, which Kahnweiler publishes the next year. Continues to paint familiar subjects, now almost unrecognizable as style verges on nonfiguration; less "readable" than later Analytic Cubist pictures of 1911–12. *Woman with a Mandolin* (p. 140), *Nude Woman* (p. 141), and *The Rower* (p. 140) announce "high" Analytic Cubism; last traces of sculptural modeling dissolve in luminous shallow space; planes more fragmentary and increasingly "transparent."

121

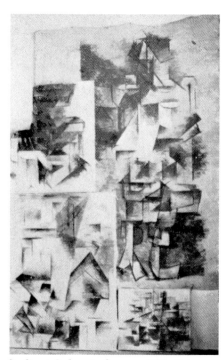

Studio at Cadaqués, Summer 1910. At upper left, *The Rower* (p. 140)

Daniel-Henry Kahnweiler. Photographed by Picasso at 11, boulevard de Clichy, Winter 1910–11

JULY 16–OCTOBER 9: Braque and Picasso are included in "Ausstellung des Sonderbundes Westdeutscher Kunstfreunde und Künstler," Düsseldorf; Picasso represented by one work, *Young Girl.*

SEPTEMBER 1–15: Braque and Picasso shown at Galerie Thannhauser, Munich. Three works by Picasso are included, among them *Head of a Woman*, painted Spring 1909.

Picasso in his studio at 11, boulevard de Clichy, Winter 1910–11. On wall above sofa is charcoal drawing *Nude Woman* (p. 141), shown at Gallery "291," New York, March 1911

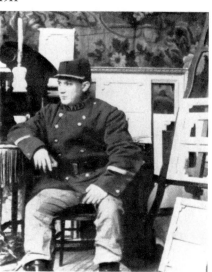

Picasso in Braque's army uniform. Photographed by Braque, 1909

EARLY SEPTEMBER: Returns to Paris with completed works and what Kahnweiler describes as "unfinished canvases." Paints portrait of Kahnweiler (p. 142), culmination of his series of Cubist portraits.

NOVEMBER 8–JANUARY 15, 1911: *Young Girl with a Basket of Flowers* of 1905 (p. 67), *Portrait of Clovis Sagot* (p. 118), and seven other works shown at

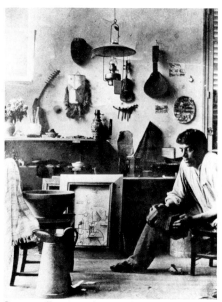

Georges Braque playing the concertina in his studio in the Hôtel Roma, rue Caulaincourt, Paris, 1910

Grafton Galleries, London, in exhibition organized by Roger Fry, "Manet and the Post-Impressionists."

DECEMBER 22: Review by André Salmon in *Paris-Journal* of recent exhibition, probably at Galeries Vollard.

1911

JANUARY–FEBRUARY: Represented by two works in group exhibition at Galerie Paul Cassirer, Berlin.

MARCH 28–APRIL 5: Exhibition of 83 watercolors and drawings at "291," Little Galleries of the Photo-Secession, in New York, first American exhibition of Picasso's work. Selections, which range from *Harlequin* of 1905 to works of 1910, are made by Edward Steichen, Marius de Zayas, and Frank Burty Havilland. Alfred Stieglitz, owner of the gallery, acquires the drawing *Nude Woman* (p. 141) of 1910 from show.

APRIL 21: Salon des Indépendants opens with Cubist manifestation, including Delaunay, Gleizes, Laurencin, La Fresnaye, Léger, Metzinger, Picabia, Le Fauconnier, Archipenko, and Marcel Duchamp. Picasso continues his policy of not showing in Salons.

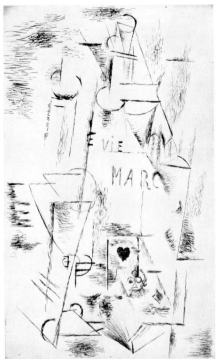

Still Life with Bottle of Marc. Céret, Summer 1911. Drypoint, 19¹¹⁄₁₆ x 12″ (50 x 30.5 cm). The Museum of Modern Art, New York. Acquired through the Lillie P. Bliss Bequest

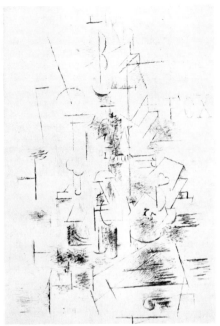

Georges Braque: *Fox.* Céret, Summer 1911. Drypoint, 21½ x 15″ (54.6 x 38 cm). The Museum of Modern Art, New York. Abby Aldrich Rockefeller Purchase Fund

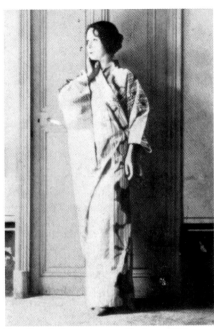

Eva Gouel in a kimono. Paris, c. 1911

MAY 1: Braque and Picasso represented in "Berliner Sezession," Picasso by four works from before 1907, among them *La Coiffure* of 1906 (p. 74).

EARLY JULY: Travels south to Céret, a small town in the French Pyrenees, where Manolo is living in an old villa, the Maison Delcros. Taking over first floor, works alone until early August, when Braque arrives with Fernande and Max Jacob joins them. Picasso paints *Still Life with Fan* (*L'Indépendant*) (p. 144), in which the use of lettering (introduced by Braque) further emphasizes Cubist ambiguities of surface and depth. Repeats this device in such paintings as *Bottle of Rum* (p. 143). Braque and Picasso work very closely together, Braque later describing their pioneering efforts as "rather like being roped mountaineers." Two drypoints, Picasso's *Still Life with Bottle of Marc* and Braque's *Fox*, illustrate extreme proximity of their work. Picasso paints *The Accordionist* (p. 145) and

Braque *The Portuguese*; in the latter Braque stencils his letters, an innovation taken up in the fall by Picasso. *The Accordionist* is the culmination of his Céret group. Its small-facet planes of single strokes reflect Neo-Impressionist interests; rendering of space is more luminous.

AUGUST 23: Picasso reads in newspaper that *Mona Lisa* has been stolen from Louvre. *Paris-Journal* offers ransom. An unidentified person, in hopes of receiving comparable ransom, turns over to *Journal* a Phoenician head stolen from Louvre the previous May and tells of similar robbery of two Iberian heads in 1907. Newspaper carries report of the event. Anonymous person is thief Géry-Piéret, who sold Picasso two Iberian heads four years before. Picasso returns to Paris.

SEPTEMBER 6: Picasso and Apollinaire return Iberian heads to Louvre via *Paris-Journal.* Newspaper carries headline: "Two new restitutions are made to *Paris-Journal.*" Police are apparently informed of Apollinaire's identity and his association with Géry-Piéret. Apol-

linaire arrested next day on charge of "harboring a criminal" thought to be connected with *Mona Lisa* theft. After four days of interrogation Apollinaire is cleared, though newspapers carry stories about "affair of the statues" for some time. As foreign resident, Picasso is frightened for his status but is never implicated.

OCTOBER 1: Opening of Salon d'Automne, which also has large Cubist section; again, Picasso and Braque do not enter. New York, Madrid, and Amsterdam press cover the event and refer constantly to the absent artist, Picasso.

OCTOBER 6–NOVEMBER 5: Braque and Picasso included in "Moderne Kunst Kring," Stedelijk Museum, Amsterdam. Picasso represented by nine works, among them *Portrait of Clovis Sagot* of 1909 (p. 118).

AUTUMN: Relationship with Fernande beginning to deteriorate. At the Steins', meets Eva Gouel (Marcelle Humbert), companion of the Polish painter Louis Markus (named Marcoussis by Apollinaire). Liaison develops between Picasso and Eva.

Paints *Mandolin Player* (p. 146) and completes *Man with Mandolin* (p. 147), moving toward high Analytic Cubism.

123

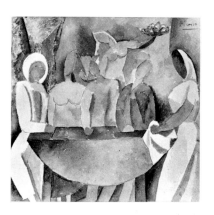

Study for Carnival at the Bistro. Paris, late 1908
Pen and India ink, 12⅝ x 19½" (32 x 49.5 cm)
Zervos VI, 1073. Musée Picasso, Paris

ABOVE RIGHT:
Study for Carnival at the Bistro. Paris, late 1908*
Watercolor and pencil, 8⅞ x 8¾" (22.5 x 22.3 cm)
Zervos II,¹ 62. Daix 218. Private collection

RIGHT:
Study for Carnival at the Bistro. Paris, Winter 1908–09
Gouache (sheet), 12⅝ x 19½" (32 x 49.5 cm)
Zervos VI, 1074. Daix 219. Musée Picasso, Paris

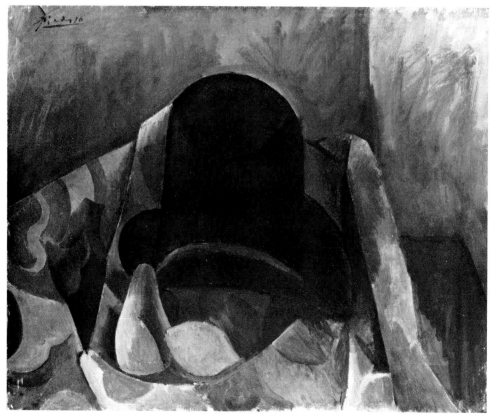

Still Life with Hat (Cézanne's Hat)
Paris, early 1909
Oil on canvas, 23⅝ x 28¾" (60 x 73 cm)
Zervos II,¹ 84. Daix 215. Private collection

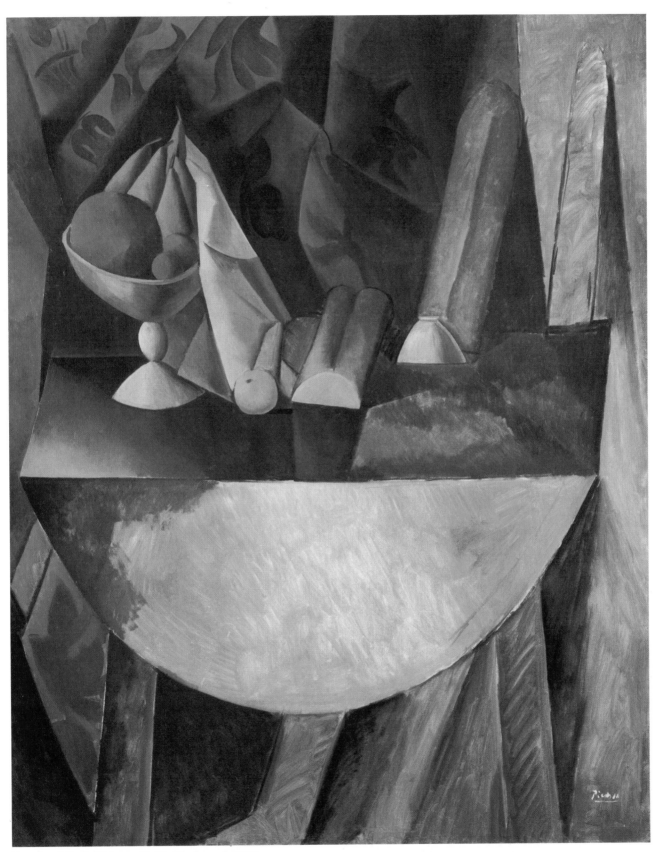

Bread and Fruit Dish on a Table. Paris, early 1909
Oil on canvas, 64⅝ x 52¼″ (164 x 132.5 cm)
Zervos II,¹ 134. Daix 220. Kunstmuseum, Basel

125

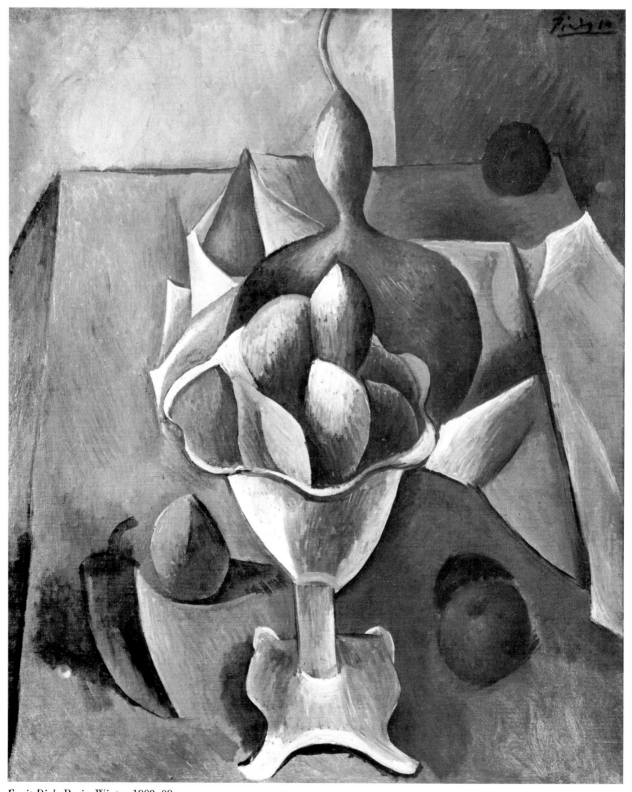

Fruit Dish. Paris, Winter 1908–09
Oil on canvas, 29¼ x 24″ (74.3 x 61 cm)
Zervos II,¹ 121. Daix 210. The Museum of Modern Art,
New York. Acquired through the Lillie P. Bliss Bequest

Woman with Fan. Paris, Spring 1909
Oil on canvas, 39⅜ x 31⅞″ (100 x 81 cm)
Zervos II,¹ 137. Daix 263
The Pushkin State Museum of Fine Arts, Moscow

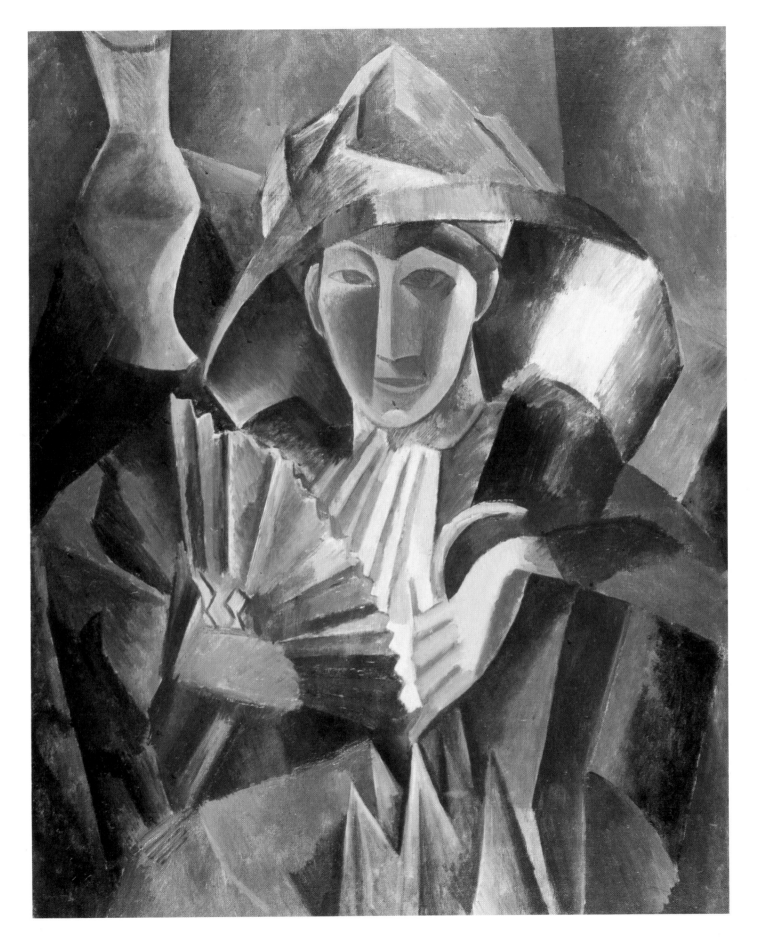

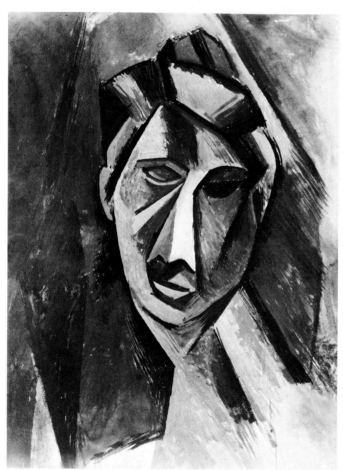

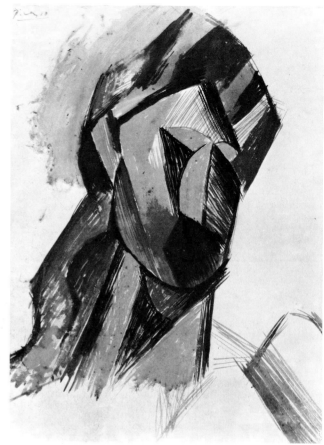

Head. Paris, Spring 1909
Gouache, 24 x 18″ (61 x 45.7 cm)
Zervos II,¹ 148. Daix 266. The Museum of Modern Art,
New York. Gift of Mrs. Saidie A. May

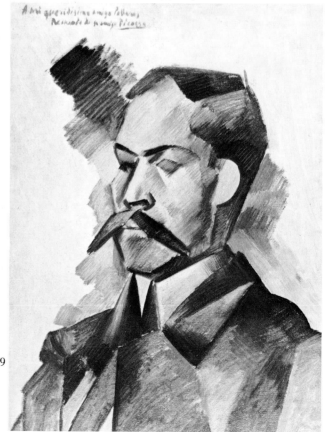

Head of a Woman (Fernande). Paris, Spring 1909
Gouache, 24⅝ x 18½″ (62.5 x 47 cm)
Zervos II,¹ 144. Daix 268. Acquavella Galleries, Inc., New York

Portrait of Manuel Pallarés. Barcelona, Spring 1909
Oil on canvas, 26¾ x 19½″ (68 x 49.5 cm)
Zervos XXVI, 425. Daix 274. Detroit Institute of
Arts. Gift of Mr. and Mrs. Henry Ford II

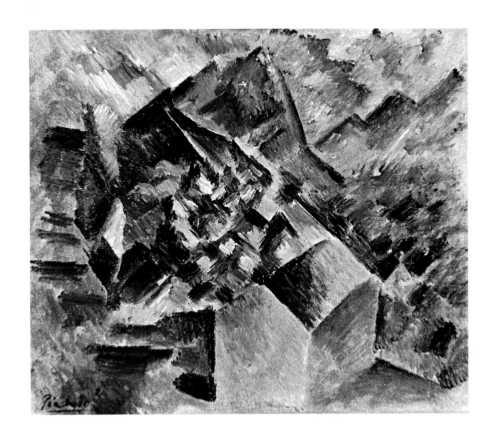

Landscape (Mountain of Santa Bárbara)
Horta de Ebro, Spring 1909
Oil on canvas, 15⅝ x 18⅝" (39 x 47.3 cm)
Not in Zervos. Daix 276. Private collection

Landscape with a Bridge. Paris, Spring 1909
Oil on canvas, 31⅞ x 39⅜" (81 x 100 cm)
Zervos XXVI, 426. Daix 273
National Gallery, Prague

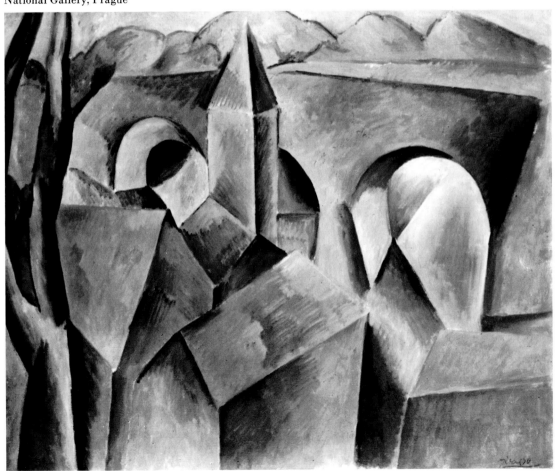

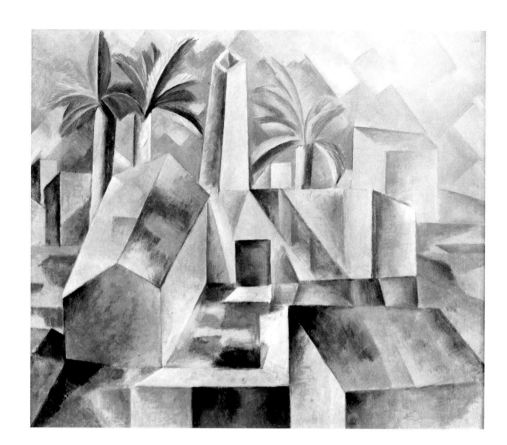

Factory at Horta de Ebro
Horta de Ebro, Summer 1909
Oil on canvas, 20⅞ x 23½″ (53 x 60 cm)
Zervos II,¹ 158. Daix 279. The Hermitage
Museum, Leningrad

Houses on the Hill, Horta de Ebro
Horta de Ebro, Summer 1909
Oil on canvas, 25⅝ x 31⅞″ (65 x 81 cm)
Zervos II,¹ 161. Daix 278
The Museum of Modern Art, New York
Nelson A. Rockefeller Bequest

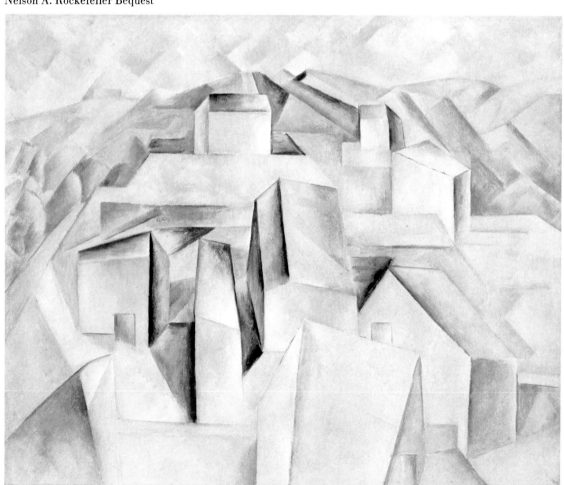

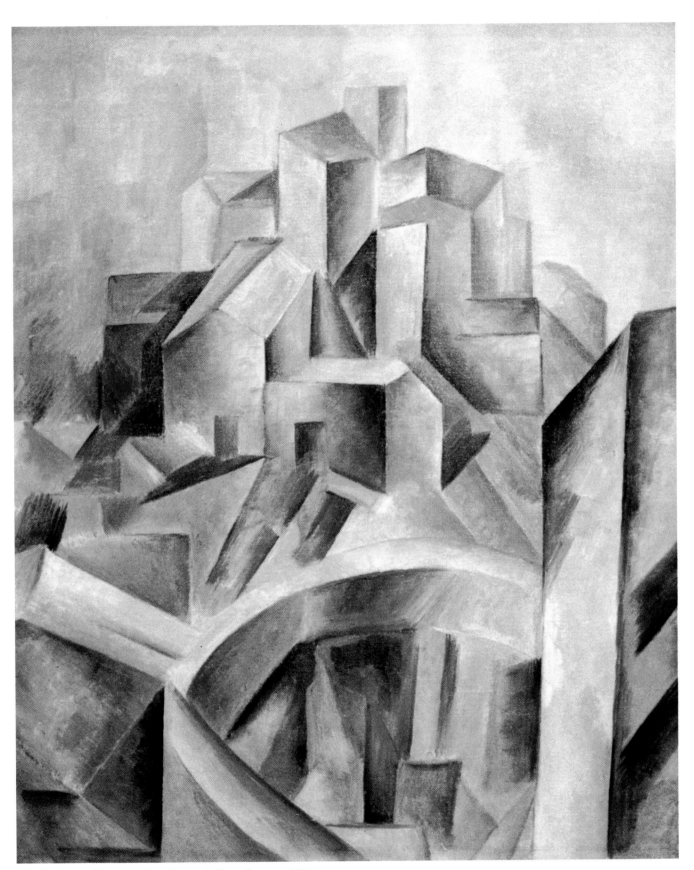

The Reservoir, Horta de Ebro. Horta de Ebro, Summer 1909
Oil on canvas, 23¾ x 19¾″ (60.3 x 50.1 cm)
Zervos II,[1] 157. Daix 280. Private collection, New York

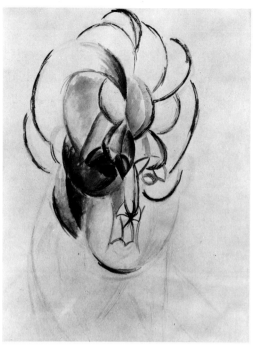

Head of Fernande. Horta de Ebro, Summer 1909
Brush and ink and watercolor,
13⅛ x 10⅛″ (33.3 x 25.7 cm)
Zervos XXVI, 413. Daix 289. The Art Institute of
Chicago. Gift of Alfred Stieglitz

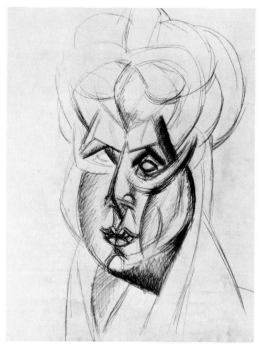

Head of Fernande (Study for Sculpture)
Horta de Ebro, Summer 1909
Charcoal, 24¾ x 19″ (62.8 x 48 cm)
Zervos XXVI, 414. Musée Picasso, Paris

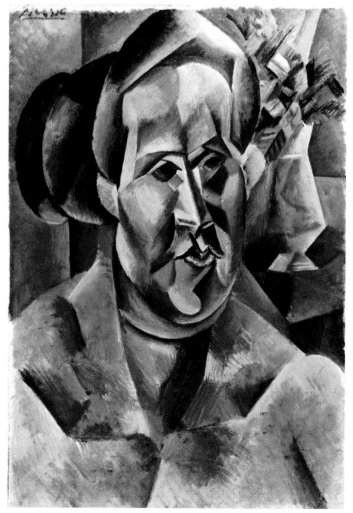

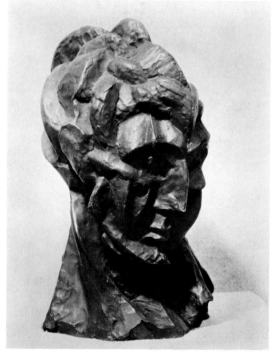

Head of a Woman (Fernande). Paris, Autumn 1909
Bronze, 16¼″ (41.3 cm) high
Zervos II,² 573. Spies 24
The Museum of Modern Art, New York. Purchase

Bust of Fernande. Horta de Ebro, Summer 1909
Oil on canvas, 24 x 16½″ (61 x 42.1 cm)
Zervos XXVI, 419. Daix 288. Kunstsammlung
Nordrhein-Westfalen, Düsseldorf

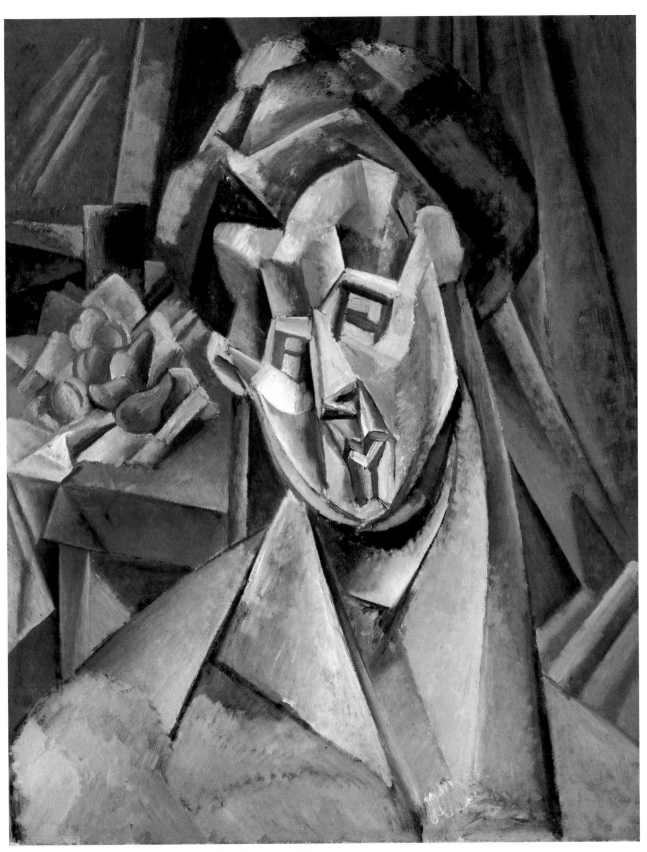

Woman with Pears (Fernande). Horta de Ebro, Summer 1909
Oil on canvas, 36¼ x 28⅞″ (92 x 73.1 cm)
Zervos II,¹ 170. Daix 290. Private collection

133

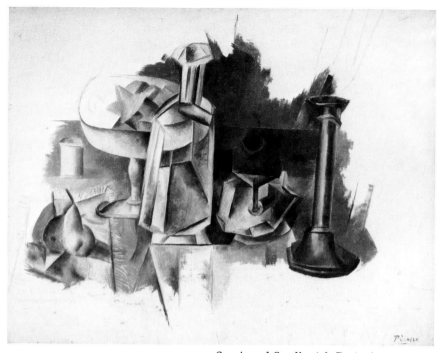

Carafe and Candlestick. Paris, Autumn 1909
Oil on canvas, 21½ x 28¾″ (54.5 x 73 cm)
Zervos II,¹ 187. Daix 316. Private collection

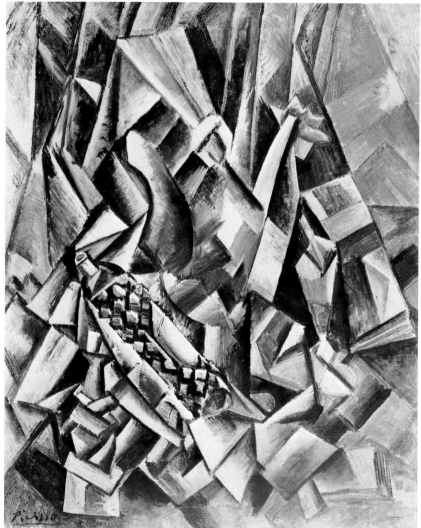

Still Life with Liqueur Bottle
Horta de Ebro, late Summer 1909
Oil on canvas, 32⅛ x 25¾″ (81.6 x 65.4 cm)
Zervos II,¹ 173. Daix 299. The Museum of Modern Art,
New York. Mrs. Simon Guggenheim Fund

OPPOSITE:
Fan, Salt Box, and Melon. Paris, Autumn 1909
Oil on canvas, 32 x 25¼″ (81.3 x 64 cm)
Zervos II,¹ 189. Daix 314. The Cleveland Museum of
Art. Purchase, Leonard C. Hanna, Jr., Bequest

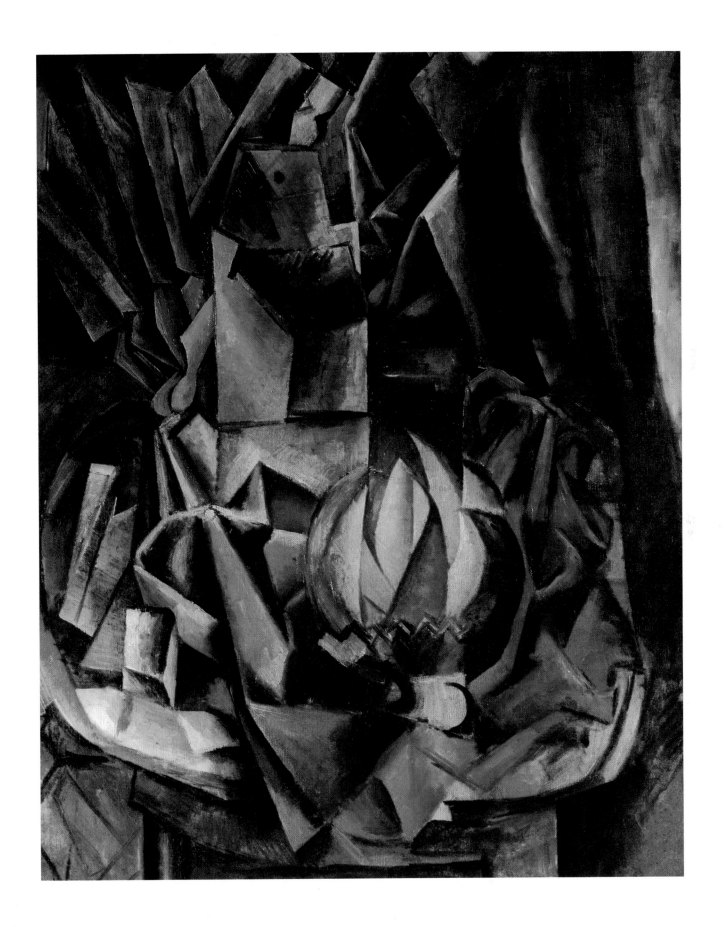

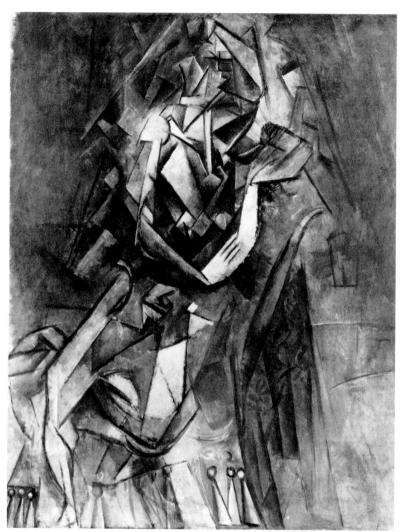

Woman in an Armchair. Paris, early 1910
Oil on canvas, 37 x 29½″ (94 x 75 cm)
Zervos II,¹ 213. Daix 344. National Gallery, Prague

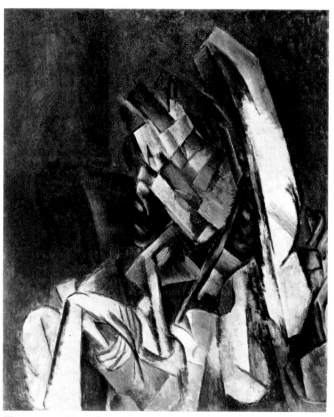

Woman in a Chair. Paris, early 1910
Oil on canvas, 28¾ x 23⅝″ (73 x 60 cm)
Zervos II,¹ 215. Daix 345. The Museum of Modern Art,
New York. Gift of Mr. and Mrs. Alex L. Hillman

Girl with a Mandolin (Fanny Tellier). Paris, early 1910
Oil on canvas, 39½ x 29″ (100.3 x 73.6 cm)
Zervos II,¹ 235. Daix 346. The Museum of Modern Art,
New York. Nelson A. Rockefeller Bequest

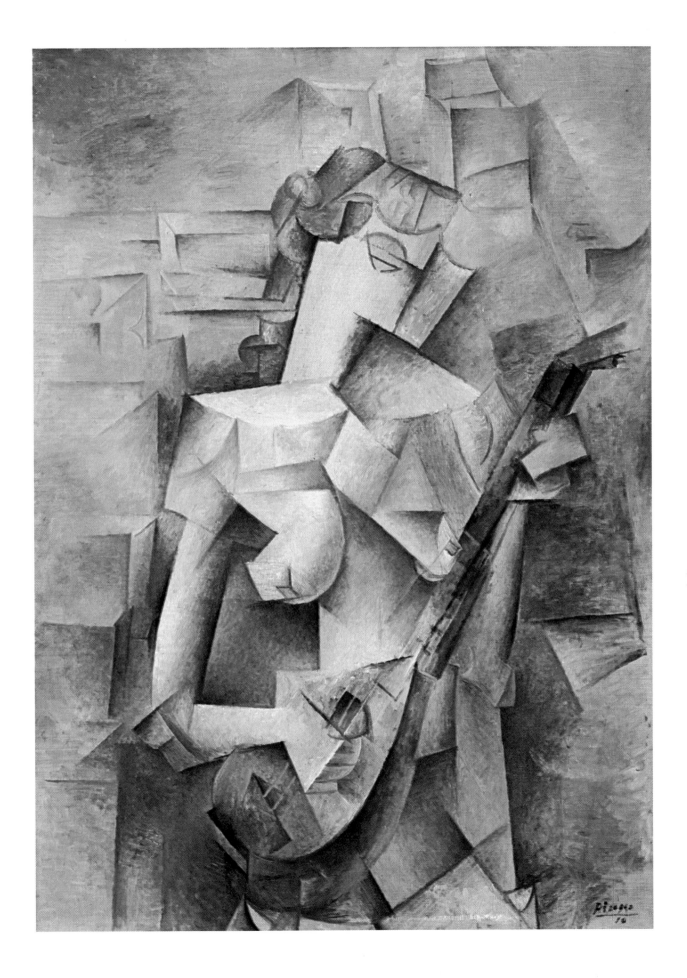

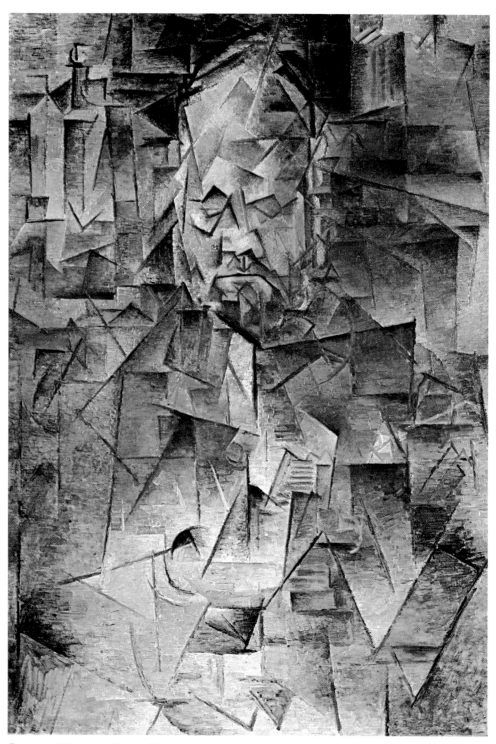

Portrait of Ambroise Vollard. Paris, Spring 1910
Oil on canvas, 36¼ x 25⅝" (92 x 65 cm)
Zervos II,¹ 214. Daix 337. The Pushkin State Museum of Fine Arts, Moscow

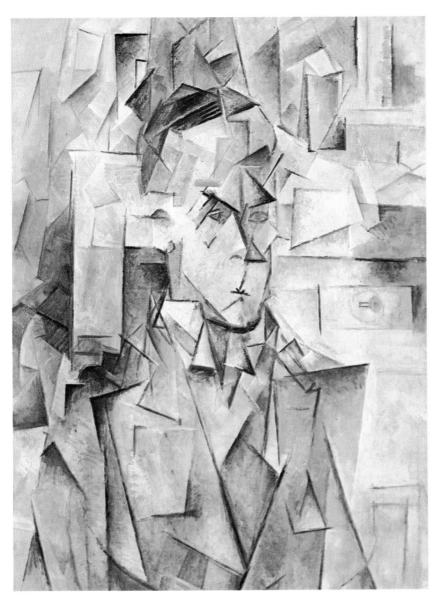

Portrait of Wilhelm Uhde. Paris, Spring 1910
Oil on canvas, 31⅞ x 23⅝″ (81 x 60 cm)
Zervos II,¹ 217. Daix 338. Private collection

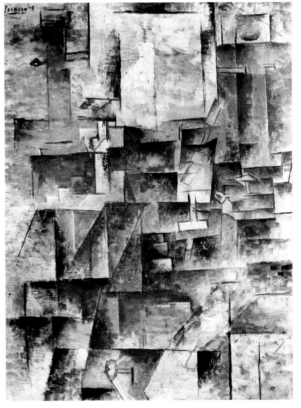

The Dressing Table. Cadaqués, Summer 1910
Oil on canvas, 24 x 18⅛″ (61 x 46 cm)
Zervos II,¹ 220. Daix 356
Collection Mr. and Mrs. Ralph F. Colin, New York

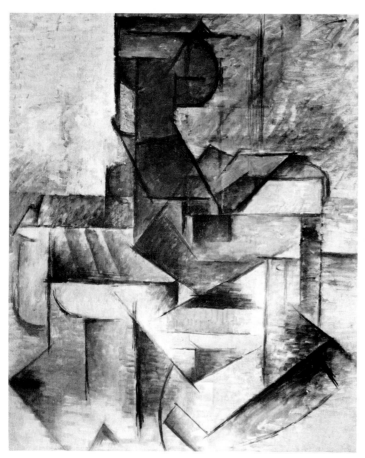

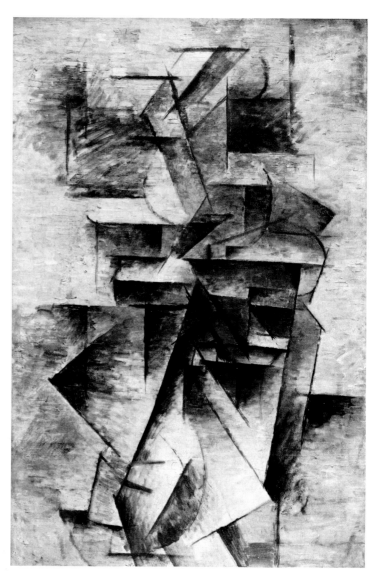

Woman with a Mandolin. Cadaqués, Summer 1910
Oil on canvas, 36 x 23¼″ (91.5 x 59 cm)
Zervos II,¹ 222. Daix 361
Museum Ludwig, Sammlung Ludwig, Cologne

The Rower. Cadaqués, Summer 1910
Oil on canvas, 28⅜ x 23⅜″ (72 x 59.3 cm)
Zervos II,¹ 231. Daix 360
Collection Mr. and Mrs. Ralph F. Colin, New York

Nude Woman. Cadaqués, Summer 1910
Oil on canvas, 73¾ x 24″ (187.3 x 61 cm)
Zervos II,¹ 233. Daix 363. National Gallery of Art,
Washington, D.C. Ailsa Mellon Bruce Fund

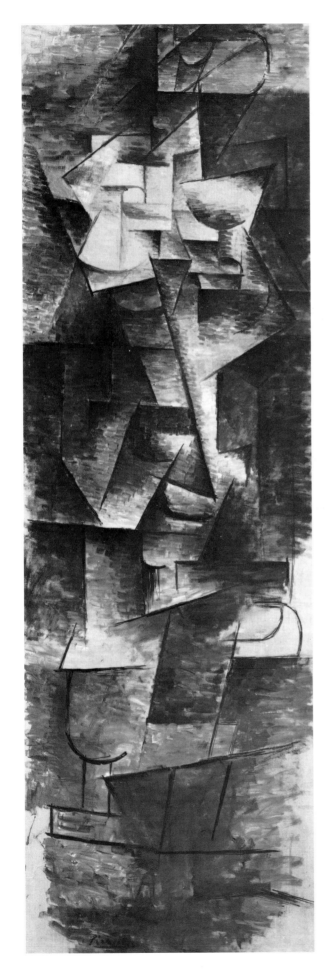

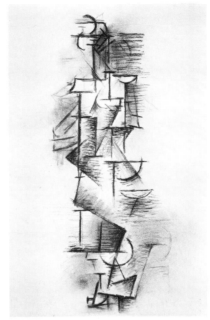

Nude Woman. Cadaqués, Summer 1910*
Charcoal, 19 x 12⅜″ (48.3 x 31.2 cm)
Zervos II,¹ 208. The Metropolitan Museum of Art,
New York. The Alfred Stieglitz Collection

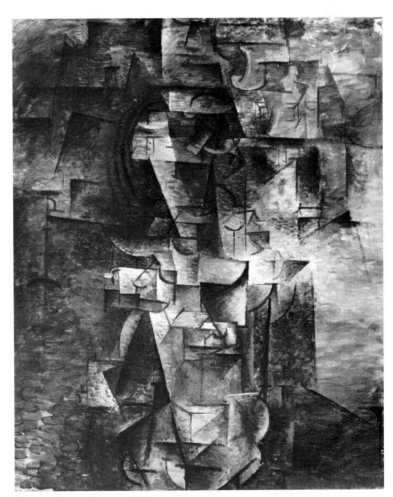

Woman. Paris, Autumn 1910
Oil on canvas, 39⅜ x 31⅞″ (100 x 81 cm)
Zervos II,¹ 234. Daix 367. Museum of Fine Arts, Boston.
Charles H. Bayley Fund and partial gift of Mrs. Gilbert W. Chapman

141

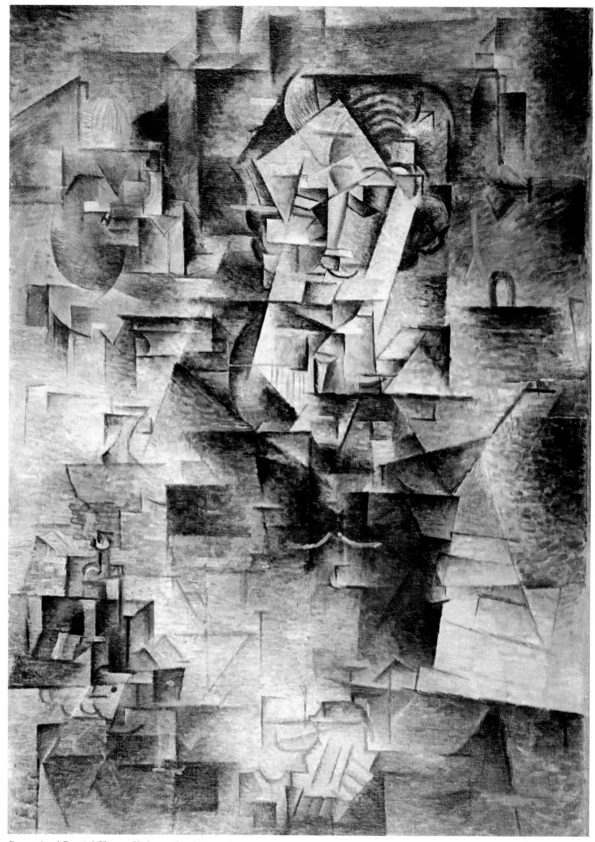

Portrait of Daniel-Henry Kahnweiler. Paris, Autumn 1910
Oil on canvas, 39⅝ x 25⅝" (100.6 x 72.8 cm)
Zervos II,¹ 227. Daix 368. The Art Institute of Chicago.
Gift of Mrs. Gilbert W. Chapman in memory of Charles B. Goodspeed

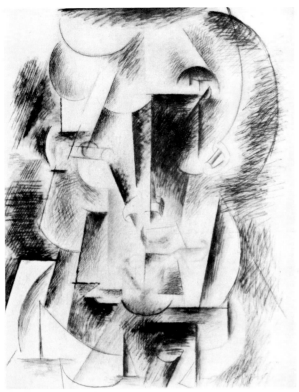

Head of a Man. Paris, 1910
Charcoal, 25¼ x 18⅞″ (64 x 48 cm)
Zervos XXVIII, 81. Collection Ernst Beyeler, Basel

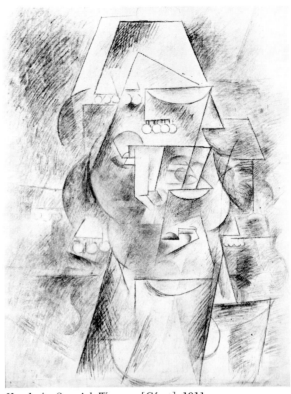

Head of a Spanish Woman. [Céret], 1911
Charcoal, 25⅜ x 19⅜″ (64.3 x 49 cm)
Zervos VI, 1126. Musée Picasso, Paris

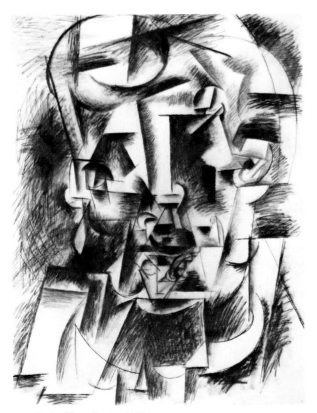

Head of a Man. Paris, 1910
Charcoal, 25¼ x 19⅛″ (64.2 x 48.6 cm)
Not in Zervos. Musée Picasso, Paris

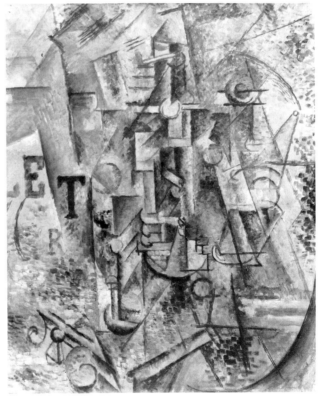

Bottle of Rum. Céret, Summer 1911
Oil on canvas, 23¾ x 19½″ (60.3 x 48.8 cm). Zervos II,¹ 267
Daix 414. Collection Mr. and Mrs. Jacques Gelman, Mexico City

143

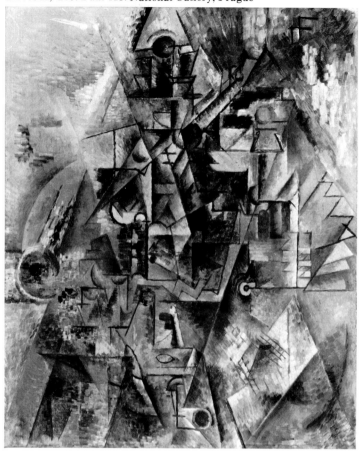

The Clarinet. Céret, Summer 1911
Oil on canvas, 24 x 19¾″ (61 x 50 cm)
Zervos II,[1] 265. Daix 415. National Gallery, Prague

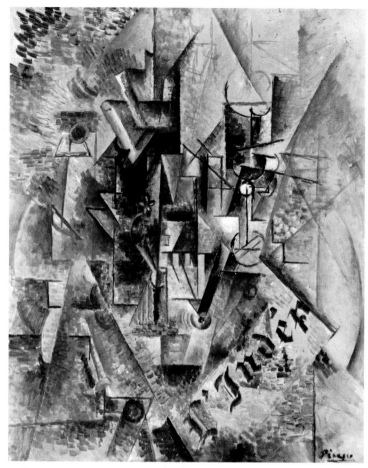

Still Life with Fan (L'Indépendant). Céret, Summer 1911
Oil on canvas, 24 x 19¾″ (61 x 50 cm)
Zervos II,[1] 264. Daix 412. Collection J. C. Koerfer, Bern

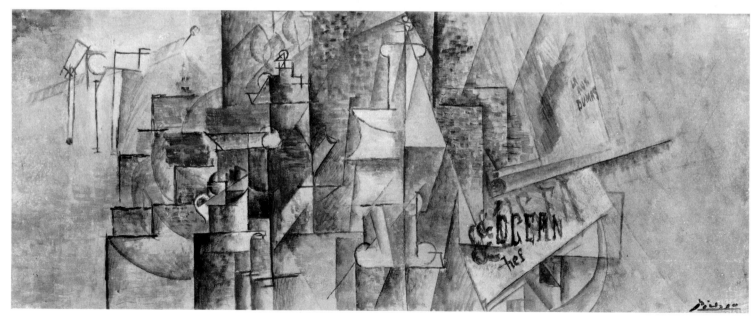

Still Life with Pipe Rack, Cup, Coffee Pot, and Carafe. Céret, Summer 1911*
Oil on canvas, 19¾ x 51¼″ (50 x 130 cm)
Zervos II,[2] 726. Daix 417. Perls Galleries, New York

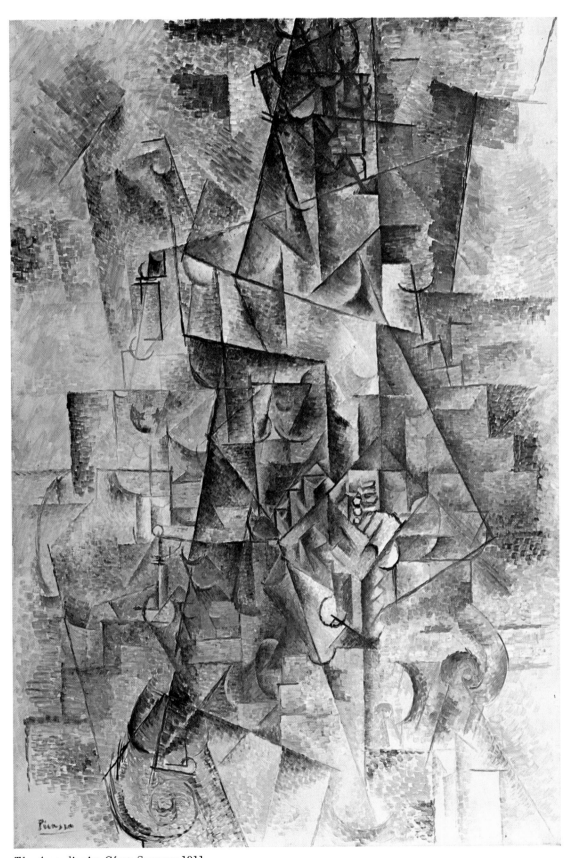

The Accordionist. Céret, Summer 1911
Oil on canvas, 51¼ x 35¼" (130.2 x 89.5 cm)
Zervos II,¹ 277. Daix 424. The Solomon R. Guggenheim Museum, New York

145

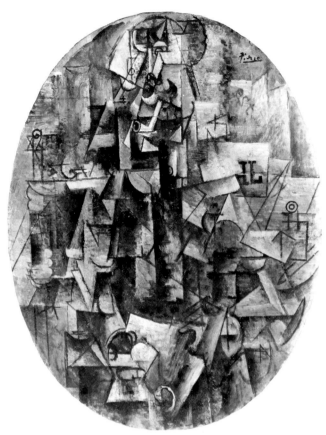

Man with a Pipe. Paris, Autumn 1911
Oil on canvas (oval), 35¾ x 27⅞" (90.7 x 70.8 cm)
Zervos II,² 738. Daix 422. Kimbell Art Museum, Fort Worth

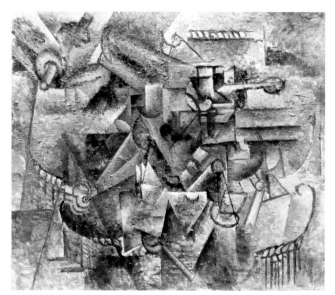

Glass of Absinth. Paris, Autumn 1911
Oil on canvas, 15⅛ x 18¼" (38.4 x 46.4 cm)
Zervos II,¹ 261. Daix 440. Allen Memorial Art Museum,
Oberlin College, Oberlin, Ohio. Mrs. F. F. Prentiss Fund

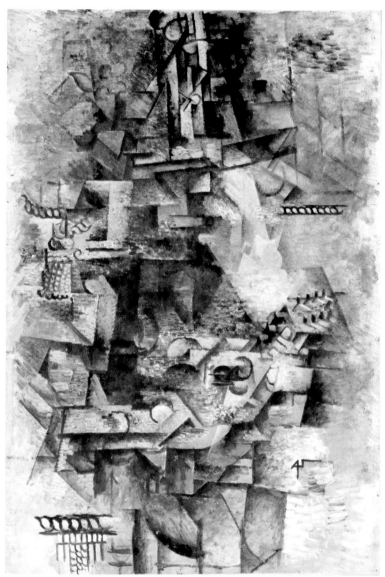

Mandolin Player. Paris, Autumn 1911*
Oil on canvas, 39⅜ x 25⅝" (100 x 65 cm)
Zervos II,¹ 270. Daix 425. Collection Ernst Beyeler, Basel

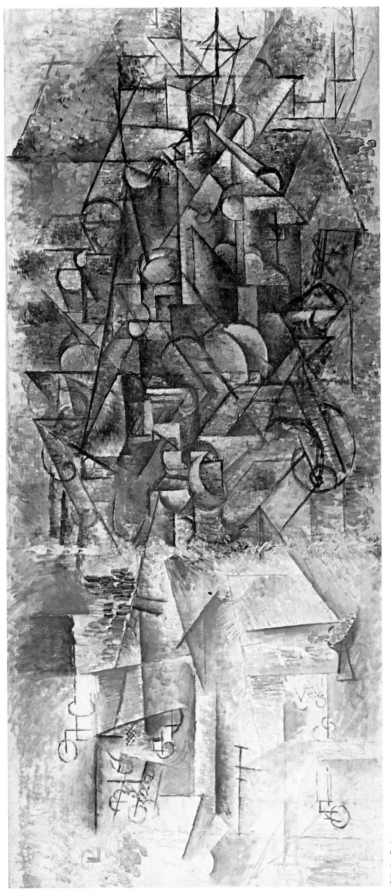

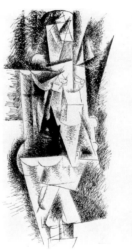

Standing Woman. [Paris, 1911]
Ink, 12½ x 7½″ (31.8 x 19 cm)
Zervos XXVIII, 38
Collection Mrs. Bertram Smith, New York

Man with Mandolin. Begun Céret, Summer 1911;
completed Paris, Autumn 1911
Oil on canvas, 63¾ x 28″ (162 x 71 cm)
Zervos II,¹ 290. Daix 428. Musée Picasso, Paris

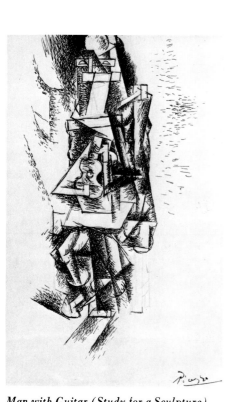

Man with Guitar (Study for a Sculpture)
Paris, early 1912
Ink, 12 x 7¾″ (30.5 x 19.5 cm)
Zervos XXVIII, 126
Private collection, Paris

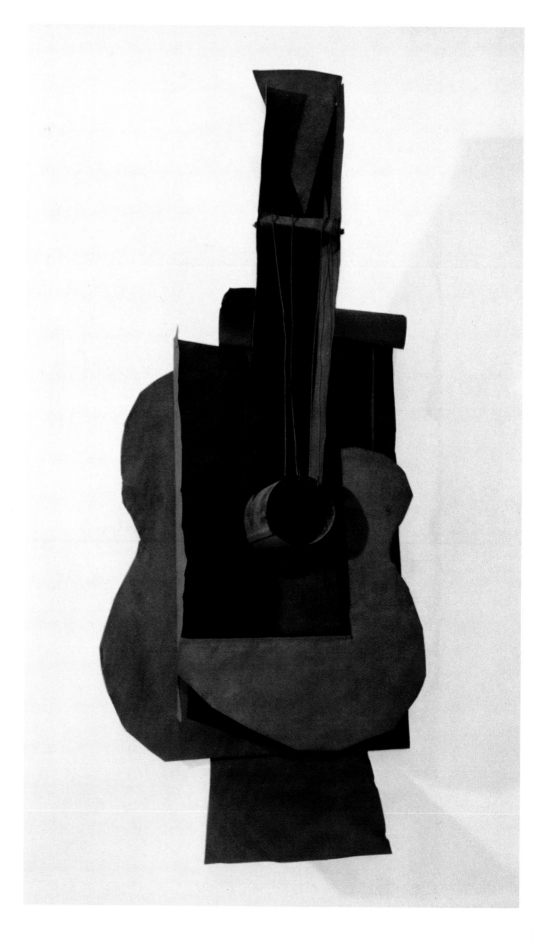

1912-1913

Guitar. Paris, early 1912
Sheet metal and wire, 30½ x 13¾ x 7⅝" (77.5 x 35 x 19.3 cm)
Zervos II,[2] 773. Spies 27. Daix 471. The Museum of Modern Art, New York. Gift of the artist

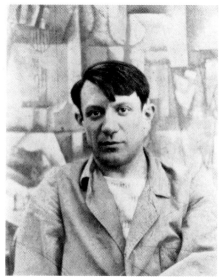

Picasso at Sorgues. Summer or early Autumn 1912. In background, *The Aficionado* (p. 161)

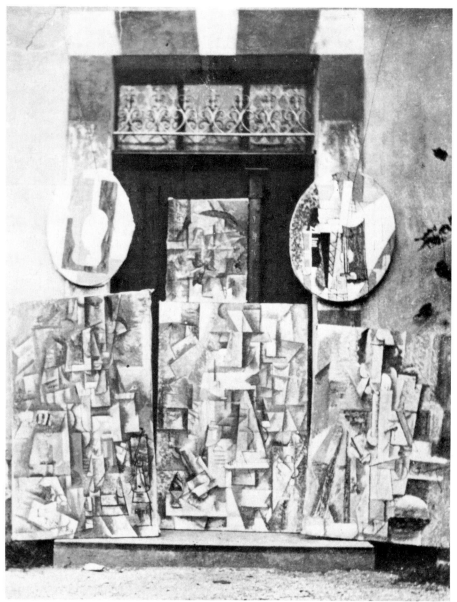

Paintings in front of villa "Les Clochettes." Sorgues, photographed in early Autumn 1912. From left: *The Aficionado* (p. 161), *Man with Guitar*, and *The Model*. Above: oval *Guitar*, *The Poet* (p. 160), and another oval *Guitar* (p. 159)

1912

WINTER: Paints *"Ma Jolie" (Woman with a Zither or Guitar)* (p. 155). Composition is dedicated to his new love, Eva. His pet name for her, "Ma Jolie," appears on canvas; words are from refrain of a contemporary popular song. "Chanson dernière": *O Manon, ma jolie, mon coeur te dit bonjour.*

In *"Ma Jolie,"* as in *Mandolin Player* (p. 146) and *Man with Mandolin* (p.

147) of the previous autumn, the mysterious, "metaphysical" quality of high Analytic Cubism, the painterliness of its impalpable, virtually abstract illusionism, is at its zenith.

JANUARY: Four works in "Jack of Diamonds" exhibition in Moscow.

FEBRUARY: Picasso and Braque included in second "Blaue Reiter" exhibition, Galerie Goltz, Munich; Picasso is rep-

resented by five works, among which are one from 1909, the *Bottle of Marc* (drypoint) from 1911 (p. 123), and *Saint-Matorel* (by Max Jacob), for which he prepared four etchings in 1910.

FEBRUARY 12: Exhibition of Picasso's early work at Dalmau gallery in Barcelona.

Still lifes are predominant motifs. Among paintings are three ovals: *Bottle, Glass, and Fork* (p. 154), *Violin, Glass, Pipe, and Inkstand* (p. 158), and *The Architect's Table* (p. 154). The latter, purchased by Gertrude Stein, contains her calling card and other recognizable motifs as Picasso veers away from the almost total abstraction of *"Ma Jolie."*

MARCH 20: Opening of Salon des Indépendants. Although Picasso does not enter, Apollinaire writes in *Le Petit Bleu* (Paris) that "Picasso's influence is most profound" and notes in *L'Intransigéant* (Paris) that Juan Gris is exhibiting *Homage to Picasso.*

SPRING: Creates *Guitar* (p. 148), a relief construction in sheet metal and wire (maquette in cardboard, p. 156) that is the three-dimensional planar counterpart of Cubist painting; its revolutionary departure from the traditional ap-

proaches, modeling and carving, opens way to twentieth-century constructed sculpture.

APRIL: Exhibition of 26 drawings at Stafford Gallery, London; almost all are prior to 1907.

APRIL 20–MAY 10: Cubist exhibition at Dalmau gallery in Barcelona, excluding both Picasso and Braque.

MAY: Room reserved for Picasso's work in the exhibition "Sonderbund," Cologne (May 25–September 30), including 16 works from periods 1901–05 and 1907–15. Also, 22 drawings and engravings, most from before 1907, are shown at Berlin Galerie "Der Sturm" earlier in the month.

Makes first collage, *Still Life with Chair Caning* (p. 157), by gluing onto surface of painted composition a piece of oilcloth printed with a caning pattern. This is first appearance of trompe l'oeil element in his painting.

MAY 18: Leaves with Eva for Céret. Barcelona press comments on his exclusion from Dalmau show and carries news of his arrival. Ramón and Germaine Pichot are there, and since they are in contact with Fernande, on June 21 Picasso leaves Céret with Eva, passing through Avignon on June 23 and stopping in nearby Sorgues-sur-l'Ouvèze. On June 25 sends Kahnweiler his address: "Les Clochettes," Sorgues. Braque and his wife Marcelle join them in July. On June 12, while still in Céret, writes to Kahnweiler about Eva: "…I love her very much and I shall write her name on my pictures." Not only writes her name, but he and Braque inscribe titles of newspapers, brand names of alcohol, and contemporary slogans on their canvases. During previous spring Picasso had written on three still lifes, *Notre avenir est dans l'air* ("Our future is in the air") (one, p. 157), a reference to contemporary excitement about pioneering feats of aviation. The two men are captivated by the Wright brothers, whose tandem efforts in aviation they see as paralleling theirs in painting. (Picasso had given Braque the nickname Wilbur.)

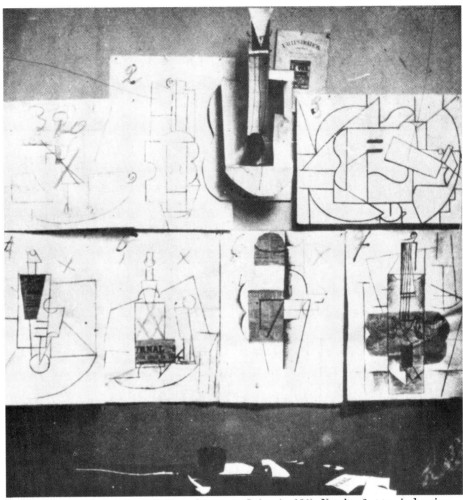

Studio at 242, boulevard Raspail, Paris, late Autumn 1912, with series of *papiers collés* in progress and cardboard *Maquette for Guitar* (p. 156). Number 2 at top is drawing for *Violin* of 1912 (p. 166)

EARLY SEPTEMBER: Returns to Paris to arrange for move to a new studio found for him by Kahnweiler at 242, boulevard Raspail. Gives up studio at Bateau-Lavoir, where works have been stored. During Picasso's absence Braque makes first *papier collé* (pasted-paper work), with simulated-woodgrain wallpaper.

SEPTEMBER 13: Back in Sorgues, works on *The Poet* (p. 160) and *The Aficionado* (p. 161). Hardening and flattening of high Analytic Cubist forms mark beginning of transition to Synthetic Cubism.

First and only issue of *La Section d'Or*, October 9, 1912, published on occasion of Salon

Numéro Spécial consacré à l'Exposition de la "Section d'Or"

Première Année — N° 1 recul exceptionnellement 0.50 9 Octobre 1912

LA SECTION D'OR

COLLABORATEURS

Guillaume Apollinaire
Roger Allard
Gabriele Buffet
René Blum
Adolphe Bassler
Marc Brésil
Max Goth
Ollivier Hourcade
Max Jacob
Pierre Muller
Jacques Nayral
Maurice Princet
Maurice Raynal
P. N. Roinard
Pierre Reverdy
André Salmon
Paul Villes
André Warnod
Francis Yard

Jeunes Peintres ne vous frappez pas !

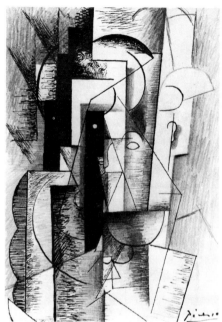

Completes transitional picture *Violin and Grapes* (p. 159), begun at Céret, which contains trompe l'oeil equivalent of simulated-wood wallpaper.

SEPTEMBER–OCTOBER: Included in several exhibitions outside France: Mánes Society of Prague (September–November; contents unknown) ; "Second Post-Impressionist Exhibition," Grafton Galleries, London (October 5–December 31; 13 paintings and three drawings include 13 lent by Kahnweiler, two by Leo Stein, and one by Vollard, among them still lifes from 1907 and 1908 and other works from 1910–12) ; "Moderne Kunst Kring." Stedelijk Museum, Amsterdam (October 6–November 7; includes 12 works dating from 1901–12).

OCTOBER: Returns to Paris with Eva, moving to new studio on boulevard Raspail.

OCTOBER 9: Opening of the Salon of "La Section d'Or," at the Galerie de la Boëtie, an exhibition of Cubist tendencies from which Picasso and Braque are absent. Jacques Villon, Marcel Duchamp, and Raymond Duchamp-Villon, along with Albert Gleizes, Jean Metzinger, Francis Picabia, and Apollinaire, are the principal organizers. Other painters included are Lhote, La Fresnaye, Léger, Marcoussis, and Gris.

AUTUMN: Makes his first *papiers collés*. This series contains only newsprint and flat painted planes in linear scaffolding, as in *Violin* (p. 166). Continues into following spring or summer, as in *Head* (p. 168). Photographs work in progress in boulevard Raspail studio (p. 151). First draws composition, then glues newspaper elements on top, redrawing charcoal lines where they were covered.

Second series of *papiers collés*, begun slightly later, contain large units of colored paper, often on colored grounds, as in *Violin and Sheet Music* (p. 165), *Guitar, Sheet Music, and Wine Glass* (p. 164), and *Bottle of Suze* (p. 164).

DECEMBER 18: Writes letter of agreement to Kahnweiler stating that for three years he will sell paintings to no one but him.

Head of Guillaume Apollinaire† (frontispiece for first edition of *L'Alcools*). Paris, early 1913. Ink, wash, and pencil, 8¼ x 5⅞" (21 x 15 cm). Zervos XXVIII, 214. Daix 579. Private collection, Paris

Guillaume Apollinaire before 1914

Picasso's first contract with D.-H. Kahnweiler, dated December 18, 1912, in which he makes a three-year arrangement and sets prices according to medium, dimensions, and format

1913

JANUARY–FEBRUARY: Represented by two drawings in exhibition "Die neue Kunst" at Galerie Miethke, Vienna.

FEBRUARY: First large retrospective, at Galerie Thannhauser, Munich. Includes 76 paintings and 38 watercolors, drawings, and etchings covering period 1901–12.

Cubist portrait of Apollinaire for frontispiece of Apollinaire's volume of poetry *L'Alcools* (Paris: Mercure de France), published April 20.

Publication of "Die moderne Malerei" by Apollinaire in *Der Sturm* (Berlin). Essay describes Picasso's collages and mentions cardboard reliefs; speaks of Cubism as "depicting new wholes with formal elements borrowed not from the reality of vision, but from that of conception."

FEBRUARY 17–MARCH 15: "International Exhibition of Modern Art" at 69th Regiment Armory, New York. Picasso represented by eight works: two still lifes lent by Leo Stein (one, *Vase, Gourd, and Fruit on a Table*, 1909); four works lent by D.-H. Kahnweiler (*Les Arbres*, *Mme Soler*, *Tête d'Homme*, and *Woman with Mustard Pot*); and a drawing (*Nude Woman*, 1910, p. 141) and a bronze (*Head of a Woman*, 1909, p. 132) lent by Alfred Stieglitz.

MARCH 3–APRIL 2: Represented by a gouache in third "Jack of Diamonds" exhibition in Moscow.

MID-MARCH: Departs for Céret with Eva. Max Jacob joins them.

MARCH 17: Publication of Apollinaire's *Les Peintres cubistes: Méditations esthétiques* (Paris: Eugène Figuière).

SPRING: Experiments with *papier collé* compositions, such as *Guitar* (p. 168), are more abstract and colorful than earlier ones. Another series, simplified and abstract, as in *Head* (p. 171), leads to oil painting *Geometric Composition: The Guitar* (p. 171).

MAY 3: Death of Picasso's father. Picasso goes to Barcelona for the funeral, returning to Céret before May 14. During the month, Max Jacob writes to

Apollinaire of the event and notes that Eva is not in good health. Speaks of the incessant rain, but says that they profited from a sunny day to attend a bullfight. Braque and his wife expected to visit in June en route to Sorgues.

MAY–JUNE: Included in international exhibition in Prague with 13 works, among them *Guitar Player ("Le Torero")*, 1911; *The Etagère*, 1911–12; and *Violin, Glass, Pipe, and Inkstand*, 1912 (p. 158).

SUMMER: In Céret completes *Man with a Guitar* (p. 172), which shows Synthetic Cubist style well developed: fragmented motifs of Analytic Cubism synthesized into large, flat, colorful shapes that are "signs" of objects. Gertrude Stein sells *Three Women* (p. 115) to purchase this picture.

On June 19, Eva writes Gertrude Stein from Céret that they will return to Paris next day. During July writes her several letters from Paris, saying that Picasso has "mild case of typhoid." Still in Paris on August 19, writes Miss Stein that she and Picasso have found new flat at 5, bis, rue Schoelcher. Soon after, they apparently return to Céret, where Juan Gris and his wife join them.

AUGUST–SEPTEMBER: Represented by five works in group exhibition at Galerie Goltz, Munich, among them *Head of a Woman*, 1907–08, and *Violin and Grapes*, 1912 (p. 159).

AUTUMN: Returns to Paris and paints *Woman in an Armchair* (p. 173),

Maison Delcros, "the Cubists' house," Céret. Picasso lives there in summers of 1911, 1912, and part of 1913

Studio at 242, boulevard Raspail, c. 1912, with suspended guitar "played" by newspaper arms; object now lost

unique work combining Analytic Cubist color with Synthetic Cubist schematic patterning. Vollard purchases group of 14 etchings and drypoints on Circus theme from 1904–05. He has them steelfaced and reprinted by Louis Fort in an edition of 270 under the title *Saltimbanques* (among them, *The Frugal Repast* of 1904, p. 52).

NOVEMBER 15: Apollinaire publishes photographs of four Picasso constructions (among them, *Guitar and Bottle of Bass*, p. 170), in periodical *Les Soirées de Paris*, of which he has become editor.

END OF YEAR: Russian artist Vladimir Tatlin arrives in Paris to see Picasso, whose Cubist work he knows from the Shchukin collection in Moscow. Spends month, paying frequent visits to Picasso's studio, where he sees constructions. Makes his own first constructions upon returning to Moscow.

Two whimsical versions of student wearing traditional *faluche*, or beret (p. 174). In *Student with a Pipe*, paper *faluche* is surrogate of integral object rather than constituent plane.

Paints *Card Player* (p. 175), finished early 1914, which contains many elements of trompe l'oeil collage and pointillist stippling.

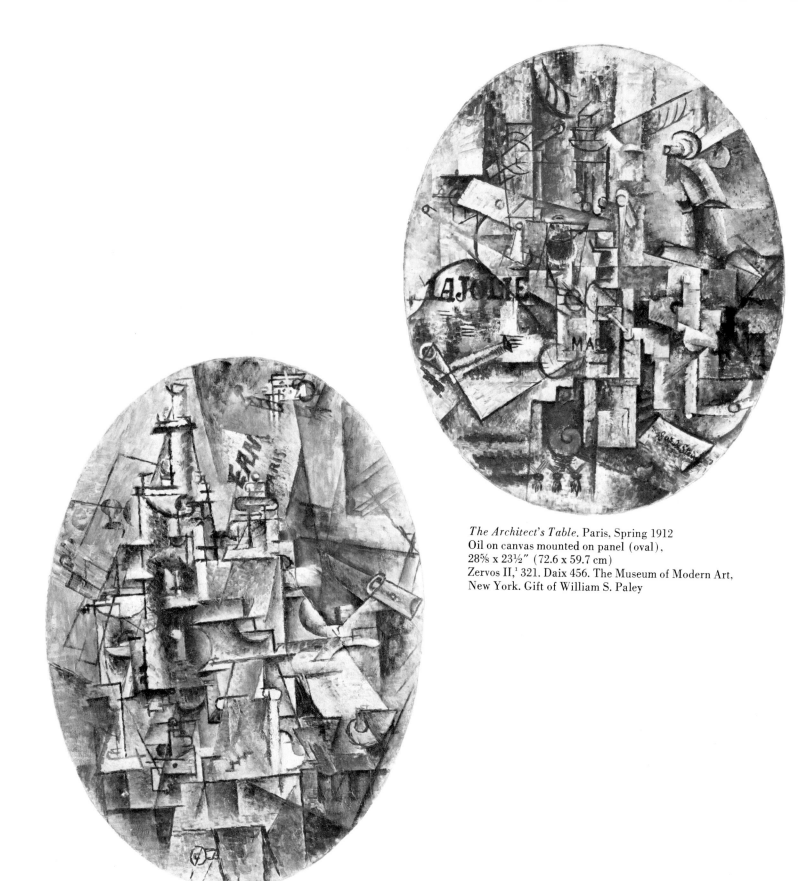

The Architect's Table. Paris, Spring 1912
Oil on canvas mounted on panel (oval),
28⅝ x 23½" (72.6 x 59.7 cm)
Zervos II,¹ 321. Daix 456. The Museum of Modern Art,
New York. Gift of William S. Paley

Bottle, Glass, and Fork. Paris, Winter 1911–12
Oil on canvas (oval), 28¼ x 21¼" (71.7 x 54 cm)
Zervos II,¹ 320. Daix 447. The Cleveland Museum of Art.
Purchase, Leonard C. Hanna, Jr., Bequest

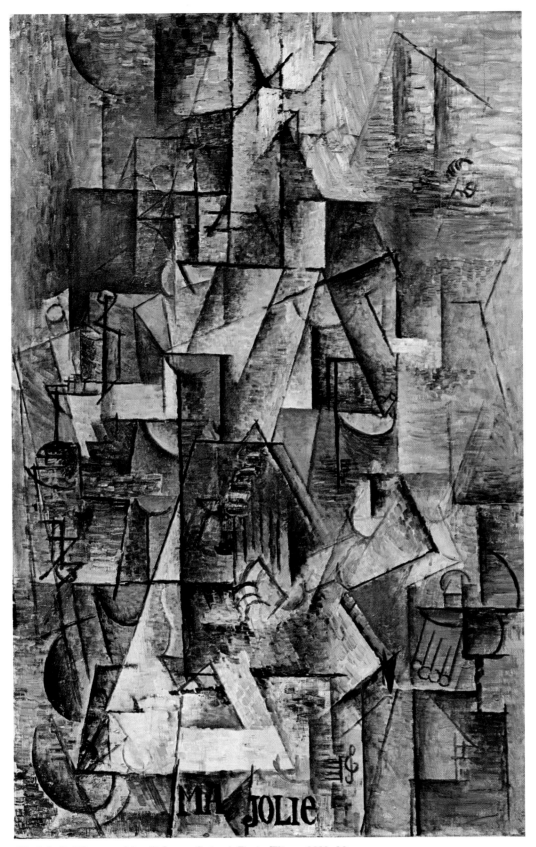

"Ma Jolie" (Woman with a Zither or Guitar). Paris, Winter 1911–12
Oil on canvas, 39⅜ x 25¾" (100 x 65.4 cm)
Zervos II,¹ 244. Daix 430. The Museum of Modern Art, New York.
Acquired through the Lillie P. Bliss Bequest

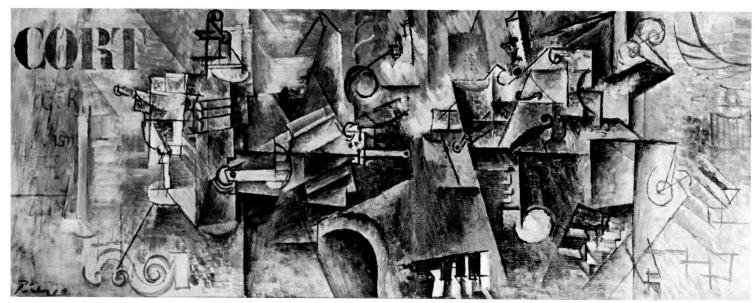

Still Life on a Piano. Paris, Spring 1912 (possibly begun in Céret, Summer 1911)
Oil on canvas, 19¾ x 51¼″ (50 x 130 cm)
Zervos II,² 728. Daix 462. Private collection, Switzerland

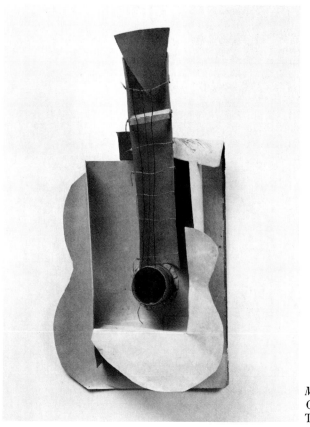

OPPOSITE, ABOVE:
Still Life with Chair Caning. Paris, May 1912
Collage of oil, oilcloth, and paper on canvas (oval),
surrounded with rope, 10⅝ x 13¾″ (27 x 35 cm)
Zervos II,¹ 294. Daix 466. Musée Picasso, Paris

OPPOSITE:
The Scallop Shell (Notre Avenir est dans l'air). Paris, Spring 1912
Oil on canvas (oval), 15 x 21¾″ (38 x 55.2 cm)
Zervos II,¹ 311. Daix 464. Collection Mr. and Mrs. Leigh B. Block, Chicago

Maquette for Guitar. Paris, early 1912
Cardboard and string (restored), 26⅛ x 13⅜ x 7⅝″ (66.3 x 33.7 x 19.3 cm)
The Museum of Modern Art, New York. (See *Guitar*, p. 148)

156

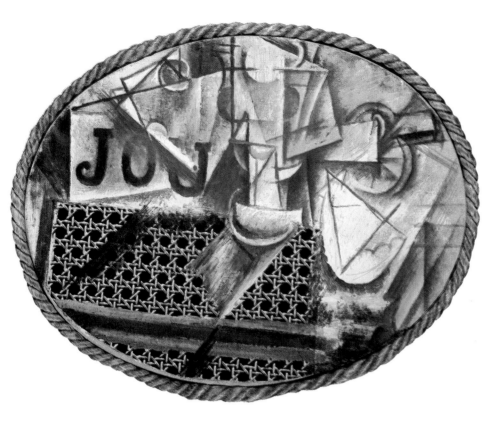

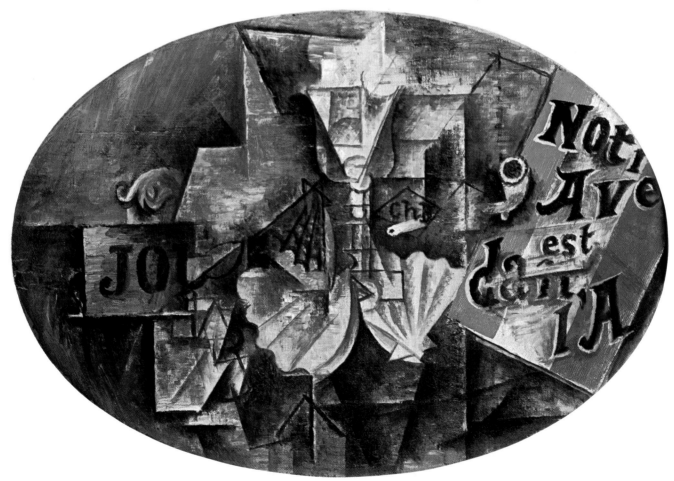

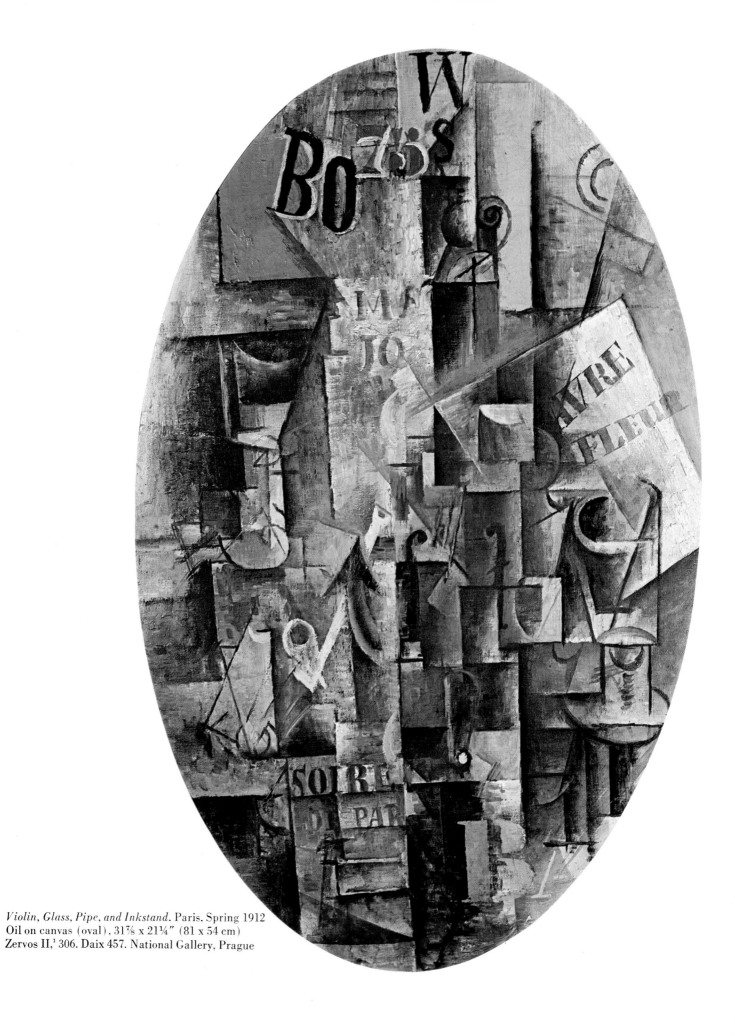

Violin, Glass, Pipe, and Inkstand. Paris. Spring 1912
Oil on canvas (oval), 31⅞ x 21¼″ (81 x 54 cm)
158 Zervos II,¹ 306. Daix 457. National Gallery, Prague

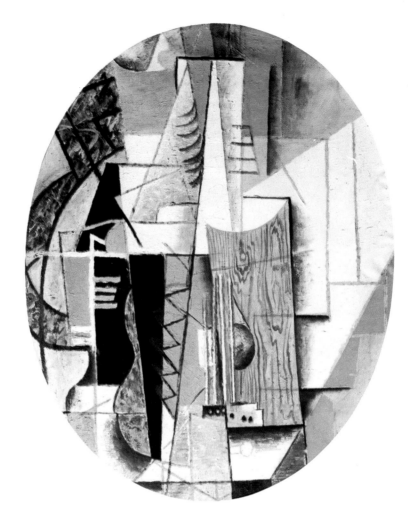

Guitar. Sorgues, early Autumn 1912
Oil on canvas (oval), 28⅜ x 23⅝″ (72 x 60 cm)
Zervos II,¹ 357. Daix 489
Nasjonalgalleriet, Oslo

L'Arlésienne. Sorgues, Summer 1912
Pen and gouache on paper mounted on canvas,
25½ x 8½″ (64.8 x 21.5 cm)
Zervos II,¹ 337. Daix 496
Private collection, U.S.A.

Violin and Grapes. Céret and Sorgues.
Spring–early Autumn 1912
Oil on canvas, 20 x 24″ (50.6 x 61 cm)
Zervos II,¹ 350. Daix 482
The Museum of Modern Art, New York.
Mrs. David M. Levy Bequest 159

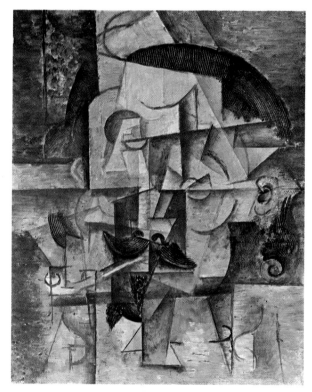

The Poet. Sorgues, Summer–Autumn 1912
Oil on canvas, 23⅝ x 18⅞″ (60 x 48 cm)
Zervos II,¹ 313. Daix 499. Kunstmuseum, Basel

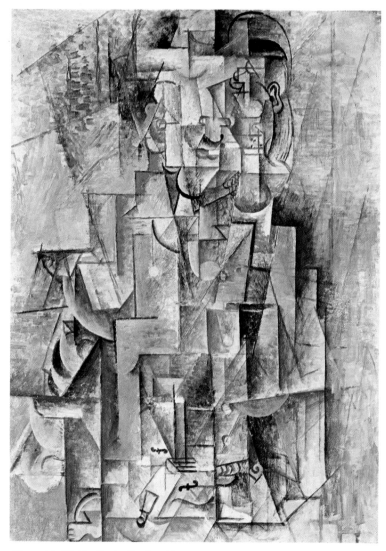

Man with Violin. Paris, Spring 1912
Oil on canvas, 39⅜ x 28¾″ (100 x 73 cm)
Zervos II,¹ 289. Daix 470. Philadelphia Museum of Art.
The Louise and Walter Arensberg Collection

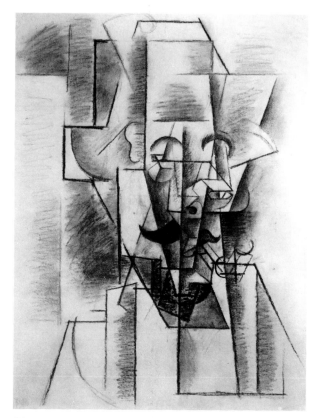

Man with Pipe. Sorgues, Summer–Autumn 1912
Charcoal, 24½ x 18⅛″ (62.2 x 47 cm)
Zervos VI, 1144. Collection Dr. and Mrs.
Israel Rosen, Baltimore, Maryland

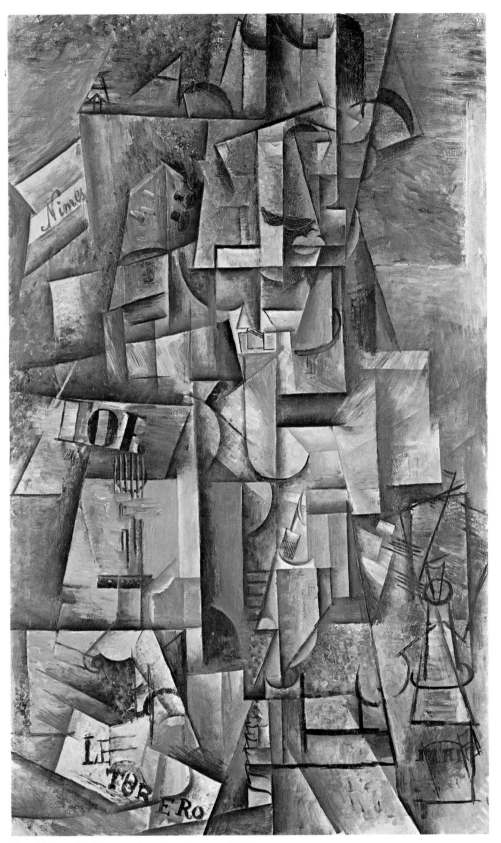

The Aficionado. Sorgues, Summer–Autumn 1912
Oil on canvas, 53⅛ x 32¼″ (135 x 82 cm)
Zervos II,¹ 362. Daix 500. Kunstmuseum, Basel. Gift of Raoul La Roche

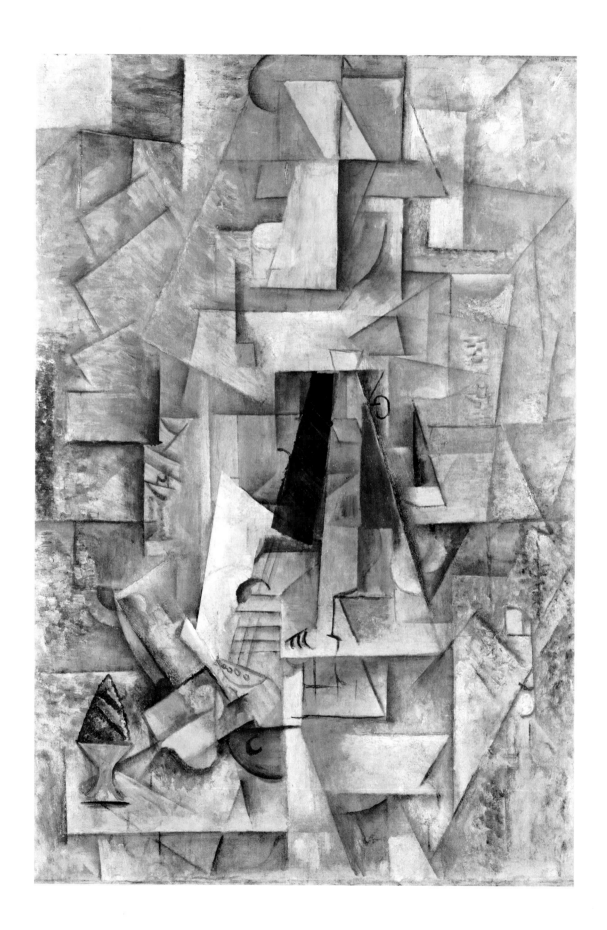

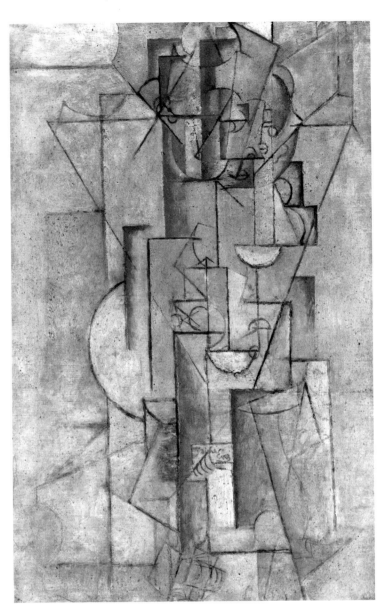

Nude Woman (J'aime Eva). Paris, Autumn 1912
Oil and sand on canvas, 39¾ x 26″ (101 x 66 cm)
Zervos II,¹ 364. Daix 541. Columbus Museum of Art,
Columbus, Ohio. Gift of Ferdinand Howald

OPPOSITE:
Man with Guitar. Sorgues, Summer 1912–Paris, Spring 1913
Oil on canvas, 51¾ x 38″ (131.5 x 96.3 cm)
Zervos II,¹ 354. Daix 495. Philadelphia Museum of Art.
The Louise and Walter Arensberg Collection

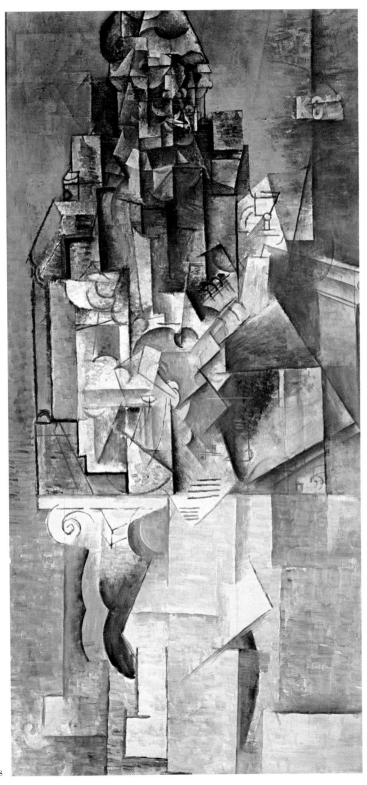

Man with Guitar. Paris, begun Autumn 1911,
reworked in 1912 and 1913
Oil on canvas, 61 x 30¼″ (155 x 77 cm)
Zervos XXVIII, 57. Daix 427. Musée Picasso, Paris

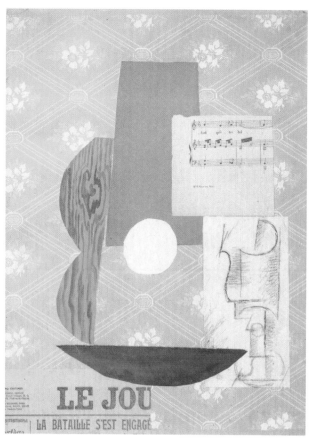

Guitar, Sheet Music, and Wine Glass. Paris, Autumn 1912
Charcoal, gouache, and pasted paper.
24⅝ x 18½″ (62.5 x 47 cm)
Zervos II,² 423. Daix 513. The McNay Art
Institute, San Antonio, Texas

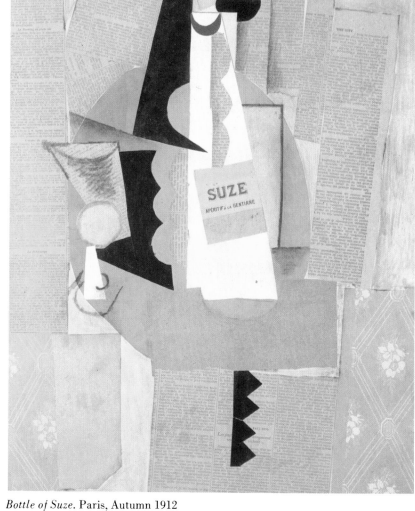

Bottle of Suze. Paris, Autumn 1912
Charcoal, gouache, and pasted paper, 25¼ x 19¾″ (64 x 50 cm)
Zervos II,² 422. Daix 523. Washington University, St. Louis

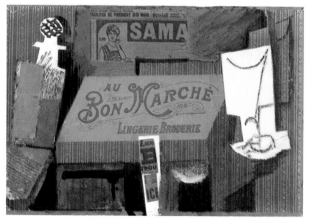

164

Au Bon Marché. Paris, Winter 1912–13
Oil and pasted paper on cardboard, 9⅜ x 14⅛″ (23.8 x 35.9 cm)
Zervos II,² 378. Daix 557. Ludwig Collection, Aachen

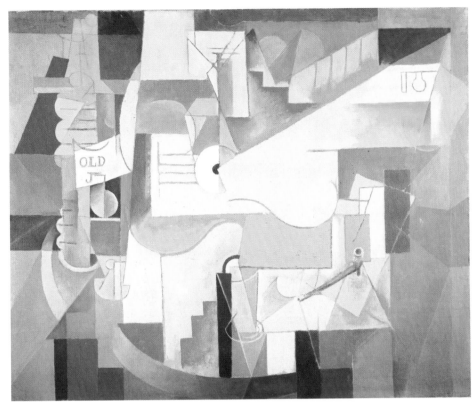

Bottle, Guitar, and Pipe. Paris, Autumn 1912
Oil on canvas, 23⅝ x 28¾" (60 x 73 cm)
Zervos II,² 377. Daix 510. Museum Folkwang, Essen

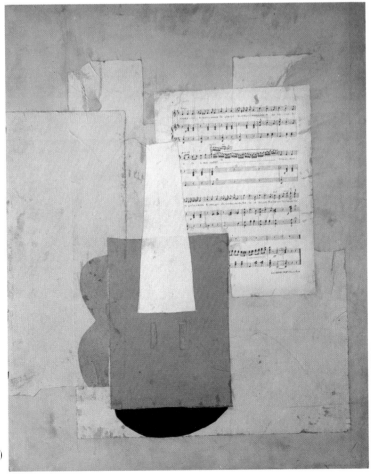

Violin and Sheet Music. Paris, Autumn 1912
Pasted paper on cardboard, 30¾ x 25⅝" (78 x 65 cm)
Zervos II,² 771. Daix 518. Musée Picasso, Paris

165

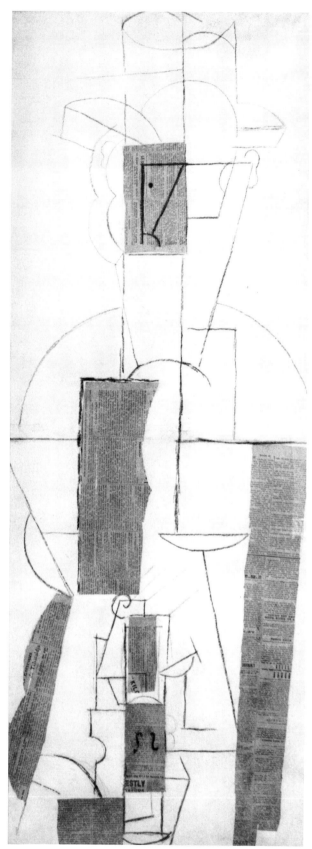

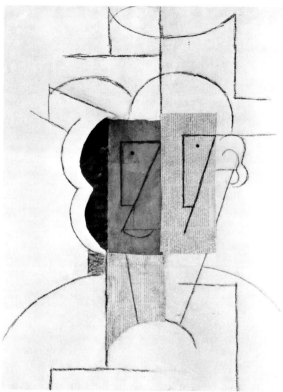

Man with a Hat. Paris, Winter 1912–13
Charcoal, ink, and pasted paper,
24½ x 18⅝" (62.2 x 47.3 cm)
Zervos II,² 398. Daix 534.
The Museum of Modern Art, New York. Purchase

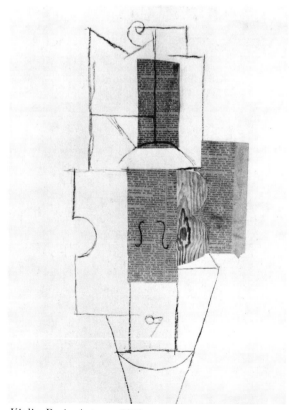

Man with a Violin. Paris, Winter 1912–13
Pasted paper and charcoal, 48⅝ x 18⅛" (123.5 x 46 cm)
Zervos II,² 399. Daix 535. Private collection, New York

Violin. Paris, Autumn 1912
Pasted paper, charcoal, and watercolor,
24⅝ x 19" (62.5 x 48 cm)
Zervos II,² 409. Daix 525. Alsdorf Foundation, Chicago

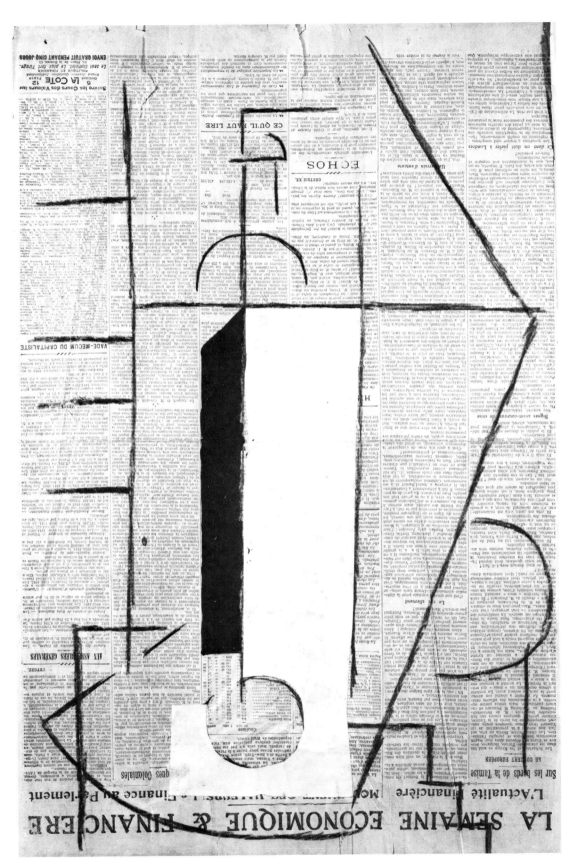

Bottle on a Table. Paris, Winter 1912–13
Pasted paper and charcoal on newspaper, 24⅜ x 17⅜" (62 x 44 cm)
Zervos II,² 782. Daix 551. Musée Picasso, Paris

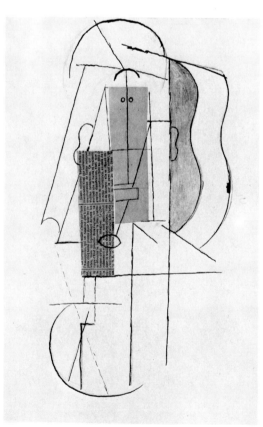

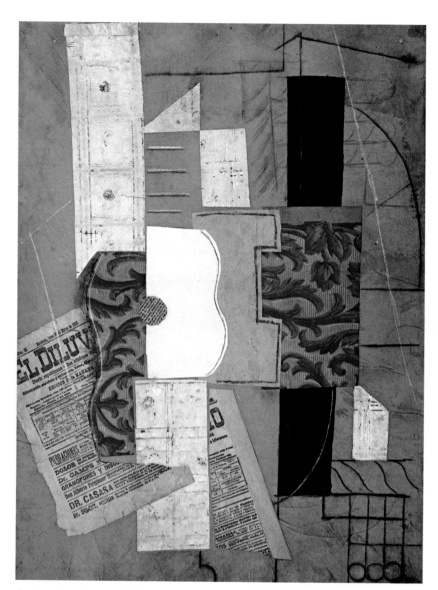

Guitar. Céret, Spring 1913
Charcoal, crayon, ink, and pasted paper, 26⅛ x 19½″ (66.3 x 49.5 cm)
Zervos II,¹ 348. Daix 608. The Museum of Modern Art,
New York. Nelson A. Rockefeller Bequest

Head. Céret, Spring 1913
Pasted paper, pen and ink, pencil,
and watercolor, 17 x 11⅜″ (43 x 28.8 cm)
Zervos II,² 403. Daix 592. The Museum of Modern Art,
New York. The Sidney and Harriet Janis Collection

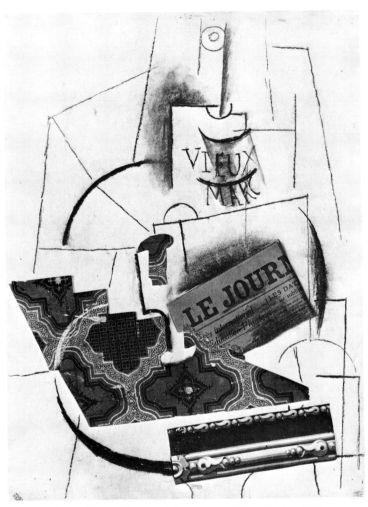

Bottle of Vieux Marc, Glass, and Newspaper. Céret, Spring 1913
Charcoal and pasted paper, 24⅝ x 18½″ (62.5 x 47 cm)
Zervos II,¹ 334. Daix 600. Musée National d'Art Moderne,
Centre National d'Art et de Culture Georges Pompidou, Paris

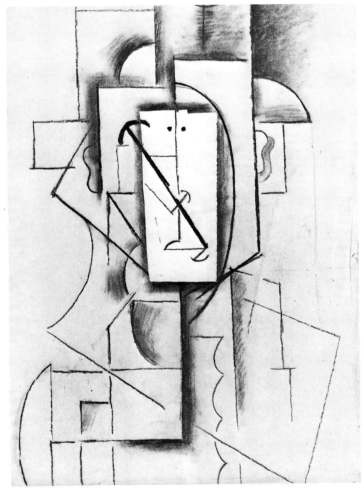

Head of a Harlequin. Céret, Spring–Summer 1913
Charcoal and pasted paper, 24⅝ x 18½″ (62.5 x 47 cm)
Zervos II,² 425. Daix 617. Musée Picasso, Paris

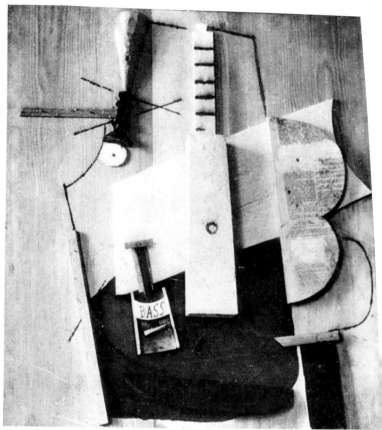

Guitar and Bottle of Bass (shown here complete in an
early photograph, now lacking certain pieces)
Paris, 1913. Construction of painted wood, pasted paper, charcoal, and nails,
35¼ x 31½ x 5½″ (89.5 x 80 x 14 cm)
Zervos II,² 575. Daix 630. Spies 33. Musée Picasso, Paris

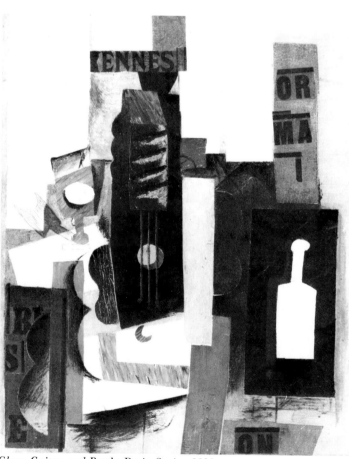

Glass, Guitar, and Bottle. Paris, Spring 1913
Oil, pasted paper, gesso, and pencil on canvas,
25¾ x 21⅛″ (65.4 x 53.6 cm)
Zervos II,² 419. Daix 570. The Museum of Modern Art,
New York. The Sidney and Harriet Janis Collection

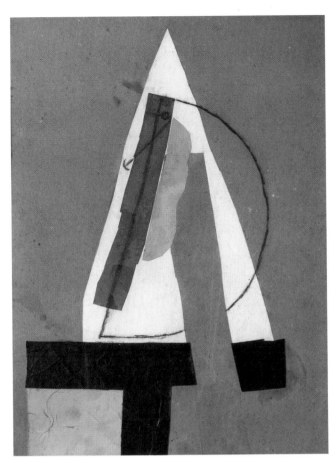

Head. [Paris or Céret], early 1913
Charcoal and pasted paper on cardboard, 16⅛ x 12⅝″ (41 x 32 cm)
Zervos II,² 414. Daix 595. Private collection, London

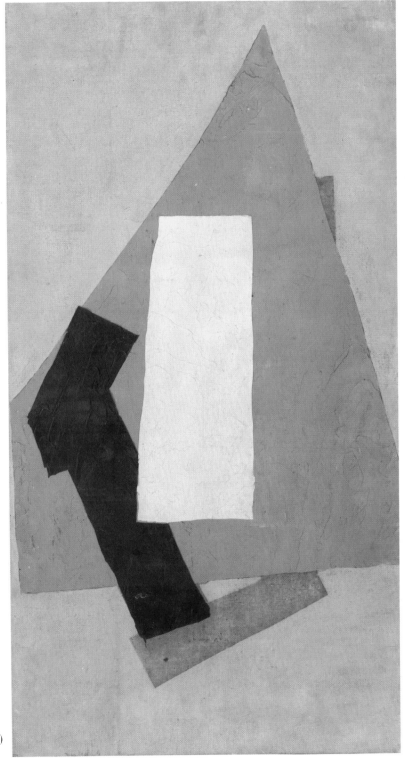

Geometric Composition: The Guitar. [Céret, Spring 1913]
Oil on canvas mounted on wood, 34¼ x 18¾″ (87 x 47.5 cm)
Not in Zervos. Daix 597. Musée Picasso, Paris

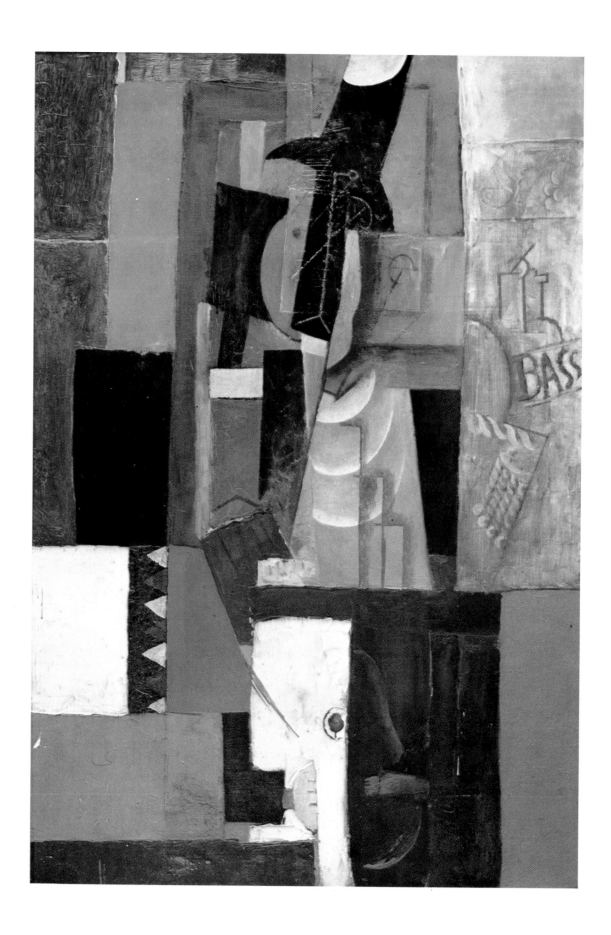

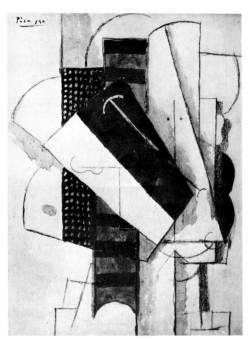

Head of a Man. Céret, Summer 1913
Oil, charcoal, ink, and pencil,
24¼ x 18¼″ (61.6 x 46.3 cm)
Zervos II,[2] 431. Daix 615
Collection Richard S. Zeisler, New York

Woman in an Armchair. Paris, Autumn 1913
Oil on canvas, 58¼ x 39″ (148 x 99 cm)
Zervos II,[2] 522. Daix 642. Collection Mr. and
Mrs. Victor W. Ganz, New York

OPPOSITE:
Man with a Guitar. Céret, Summer 1913
Oil and encaustic on canvas,
51¼ x 35″ (130.2 x 88.8 cm)
Zervos II,[2] 436. Daix 616. The Museum of
Modern Art, New York. André Meyer Bequest

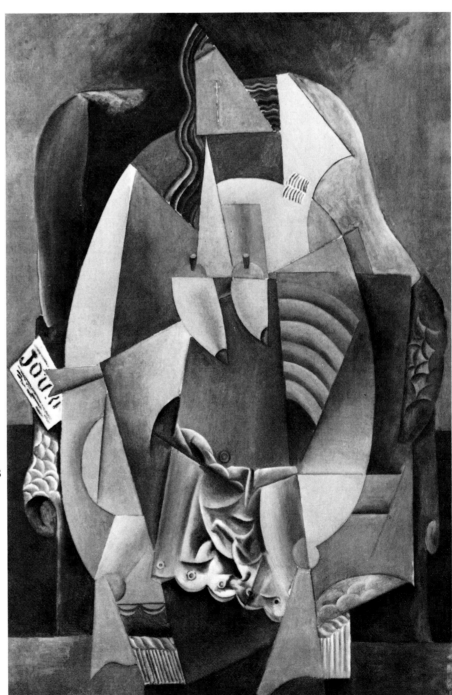

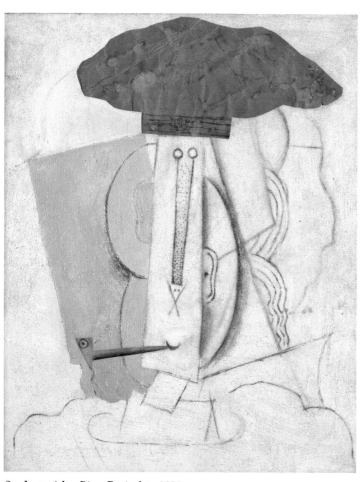

Student with a Pipe. Paris, late 1913
Oil, charcoal, pasted paper, and sand on canvas,
28¾ x 23⅛″ (73 x 58.7 cm)
Zervos II,² 444. Daix 620. The Museum of Modern Art,
New York. Nelson A. Rockefeller Bequest

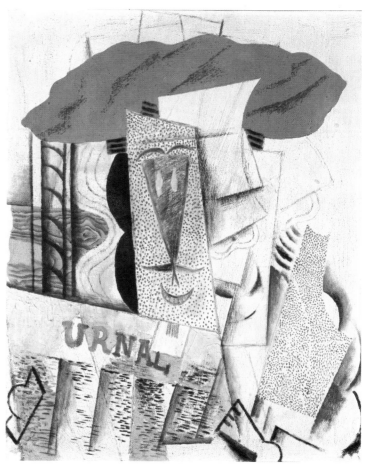

Student with a Newspaper. Paris, late 1913
Oil and sand on canvas, 28¾ x 23½″ (73 x 59.5 cm)
Zervos II,² 443. Daix 621. Private collection

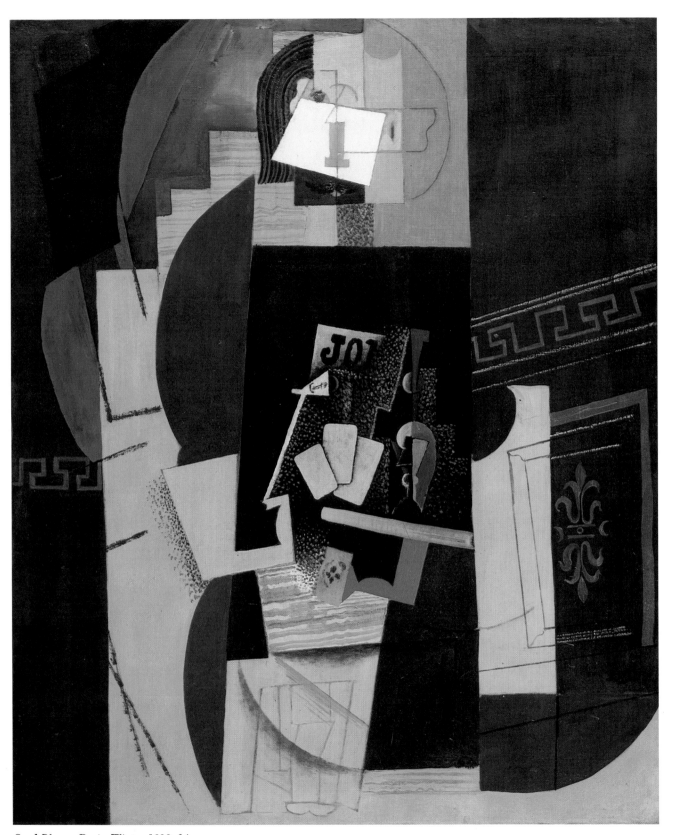

Card Player. Paris, Winter 1913–14
Oil on canvas, 42½ x 35¼″ (108 x 89.5 cm)
Zervos II,² 466. Daix 650. The Museum of Modern Art, New York. Acquired through the Lillie P. Bliss Bequest

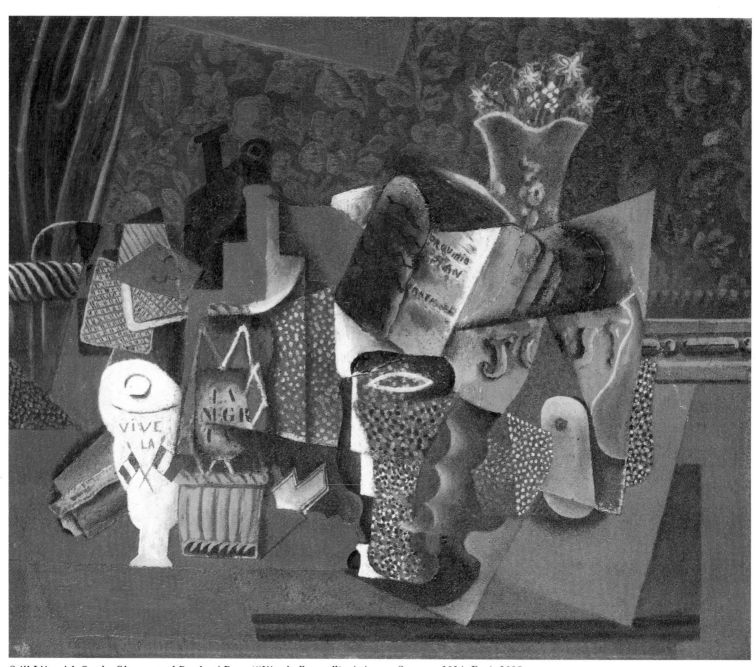

Still Life with Cards, Glasses, and Bottle of Rum (*"Vive la France"*). Avignon, Summer 1914–Paris 1915
Oil and sand on canvas, 21⅜ x 25¾" (54.2 x 65.4 cm)
Zervos II,² 523. Daix 782. Collection Mr. and Mrs. Leigh B. Block, Chicago

1914-1915

1914

JANUARY 14: Kahnweiler publishes *Le Siège de Jérusalem*, by Max Jacob, for which Picasso makes three etchings.

MARCH 2: Auction of Peau de l'Ours at Hôtel Drouot, Paris. Young Cubist painters are represented, but Picasso only by pre-Cubist works, of which 12 are included. *Family of Saltimbanques* sells for high price to Munich art dealer Thannhauser.

New group of *papiers collés*, such as *Pipe, Glass, Bottle of Rum* (p. 184).

SPRING: Makes relief construction *Still Life* (p. 185), a painted-wood snack on a half-circle tray with real upholstery fringe added. Also *Glass of Absinth* (p. 180), a sculpture in the round; the six casts, commissioned by Kahnweiler, are each differently painted, some highly colored, some with texture of sand.

JUNE: Departs for Avignon. The Derains and the Braques are nearby at Montfavet and Sorgues.

JUNE 23: Eva writes to Gertrude Stein of difficulty in finding a place to rent, adding that they are living in a hotel. Picasso continues his explorations with reliefs.

Produces more than a hundred drawings, many of them almost "Surrealist" in feeling (p. 185).

Happiness with Eva and financial success reflected in the lyricism of the summer's paintings, which tend to be richly colored and characterized by pointillist stippling. Works such as *Still Life with Cards, Glasses, and Bottle of Rum* ("*Vive la France*") (p. 176), *Green Still Life* (p. 182), and *Portrait of a Young Girl* (p. 183) are sometimes termed Rococo Cubist.

AUGUST: War declared on August 2. Braque and Derain are mobilized and Picasso sees them off at the station. Kahnweiler is in Rome, Gertrude Stein in England. Kahnweiler, a German citizen, remains in Italy until December 15, when he leaves for Switzerland, where he lives for duration of the war. His gallery on rue Vignon is soon sequestered with all his holdings, including

Still Life with Biscuits.† Avignon, Summer 1914. Pencil, 12⅛ x 19" (20.1 x 48.2 cm).

Zervos VI, 1238. Musée Picasso, Paris

works by Picasso and Braque. Stein is not allowed to return to Paris until mid-October. Apollinaire applies for French citizenship in order to join the army. Despite objections owing to the "affair of the statues," the government allows him to join the artillery.

AUTUMN: Still in Avignon, continues work on series of drawings of men leaning—on a balustrade, a table, a chair—in styles ranging from naturalism to Cubism. Canvas on Painter and Model theme (the model apparently being Eva) is left unfinished, but shows tendency that will resurface later in return to representational mode.

Returns to Paris in late October or early November. With most of its young men at war, the city is cheerless, and Picasso, young and robust, is viewed with mistrust. Somewhat ambivalent in his attitude toward the war, he is a foreigner with strong attachments to his German patrons Kahnweiler and Thannhauser (Cubism becomes associated with *les boches*). Adding to the sobriety of the scene is the aspect from his studio—the Montparnasse cemetery. Paintings such as *Still Life with Compotier and Glass* (p. 188) are somber in color. Makes relief construction *Mandolin and Clarinet* (p. 186).

Guillaume Apollinaire as Artilleryman.† 1914. Ink and watercolor, 9⅛ x 5" (23 x 12.5 cm). Zervos XXIX, 116. Private collection, Paris

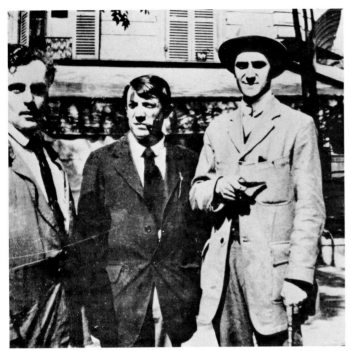 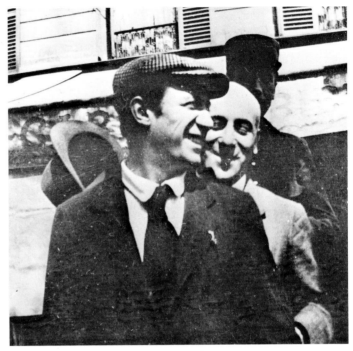

Picasso with Amedeo Modigliani (left) and André Salmon (right) in front of the Café de la Rotonde, boulevard du Montparnasse, c. 1915 RIGHT: Picasso with Max Jacob in front of the Rotonde, possibly the same day

1915

JANUARY 7: Max Jacob writes to Apollinaire at the front and talks of posing for a Picasso pencil portrait, in which he is "very much the old peasant." Also announces his impending baptism as a Catholic. Picasso is to be godfather and wants him to adopt "Fiacre" as his saint's name.

FEBRUARY 18: Baptism of Max Jacob. Picasso presents his new godson with a copy of *The Imitation of Christ* by Thomas a Kempis.

SPRING: Eva's health deteriorates.

MAY: Braque is wounded in the war.

AUGUST: Picasso makes a drawing of Vollard (p. 192), classical in technique and almost photographic in likeness.

NOVEMBER: Eva is taken to a hospital at Auteuil, a long distance from Picasso's studio.

In Kahnweiler's absence, Léonce Rosenberg begins to sell his pictures, although he does not have access to the sequestered paintings.

DECEMBER: Picasso writes to Gertrude Stein (who is in Majorca): "My life is hell. Eva becomes more and more ill each day. I go to the hospital and spend most of the time in the Métro. . . . However, I have made a picture of a Harlequin [p. 191] that, to my way of thinking and to that of many others, is the best thing I have ever done. M. Rosenberg has it." Starkly geometric, *Harlequin* is the major work in a long series (pp. 206–11) on this theme. Picture marks a redirection within Synthetic Cubism that will culminate in *Three Musicians* of 1921 (p. 231).

The young poet Jean Cocteau, on leave from the army, visits Picasso's studio with the composer Edgar Varèse; sees the *Harlequin* before it goes to Rosenberg.

DECEMBER 14: Eva dies. Small group of friends, among them Max Jacob and Juan Gris (who describes the funeral in a letter to Maurice Raynal at the front), accompanies Picasso to the cemetery. Writes Gertrude Stein three weeks later (January 8): "My poor Eva is dead." He speaks of his desire to see his old friend again.

Portrait of Max Jacob. Paris, early 1915. Pencil, 13 x 9¾" (33 x 23.5 cm). Private collection, Paris

179

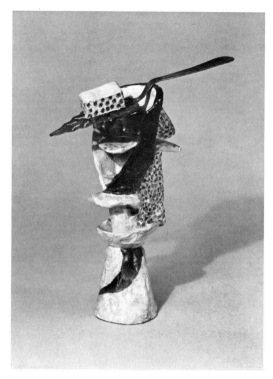

The Glass of Absinth. Paris, Spring 1914
Painted bronze with silver sugar strainer,
8½ x 6½″ (21.6 x 16.5 cm) ;
diameter at base, 2½″ (6.4 cm)
Zervos II,² 584. Spies 36. Daix 756. The Museum of
Modern Art, New York. Gift of Mrs. Bertram Smith

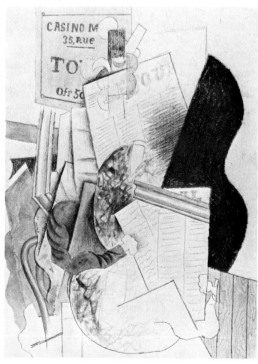

Man Reading a Newspaper
[Avignon, Summer] 1914
Pencil, watercolor, and charcoal,
12½ x 9⅜″ (31.7 x 23.7 cm)
Zervos XXIX, 66. Musée Picasso, Paris

Woman with a Mandolin. Paris, Spring 1914
Oil, sand, and charcoal on canvas, 45½ x 18⅝″ (115.5 x 47.5 cm)
Zervos II,² 448. Daix 646. The Museum of Modern Art,
New York. Gift of David Rockefeller

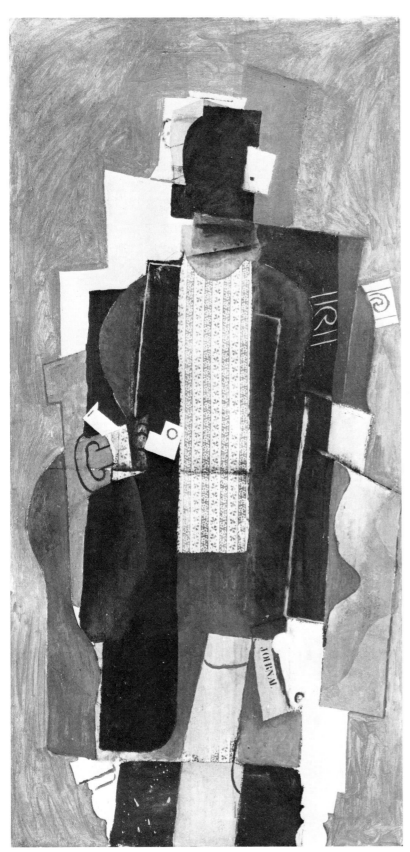

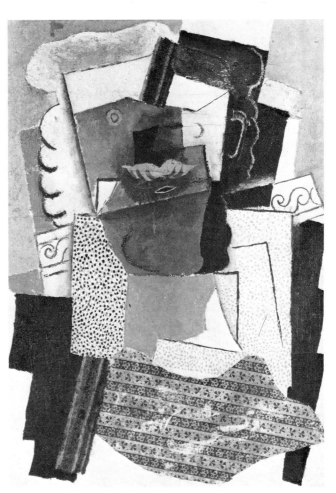

Man with a Mustache. [Paris, Spring 1914]
Oil, fabric, and pasted paper on canvas,
25¾ x 18¼" (65.4 x 46.2 cm)
Zervos II,² 468. Daix 759. Musée Picasso, Paris

The Smoker. [Paris, Spring 1914]
Pasted paper and oil on canvas, 54⅜ x 26⅜" (138 x 67 cm)
Zervos II,² 470. Daix 760. Musée Picasso, Paris

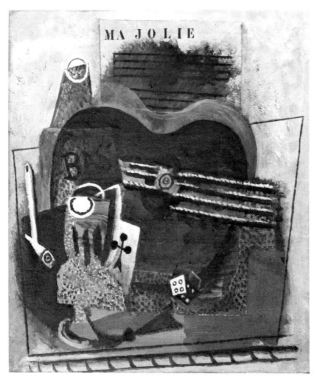

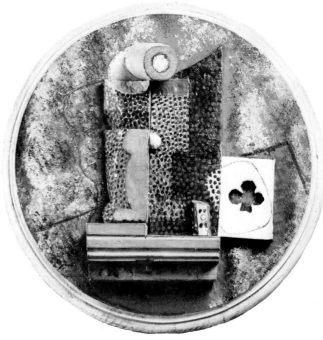

"Ma Jolie." Paris, late Spring, or Avignon, early Summer 1914
Oil on canvas, 17¾ x 15¾" (45 x 40 cm)
Zervos II,² 525. Daix 742. Private collection, Switzerland

Glass, Pipe, and Playing Card. Avignon, Summer 1914
Metal and painted wood,
13⅜ (34 cm) diameter, 3½" (8.6 cm) deep
Zervos II,² 830. Spies 45. Daix 788. Musée Picasso, Paris

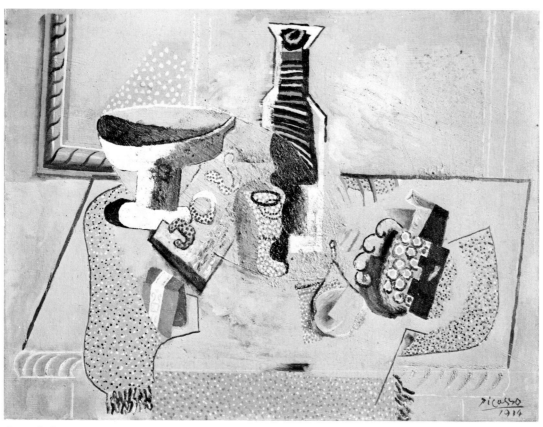

Green Still Life. Avignon, Summer 1914
Oil on canvas, 23½ x 31¼" (59.7 x 79.4 cm)
Zervos II,² 485. Daix 778. The Museum of Modern Art, New York. Lillie P. Bliss Collection

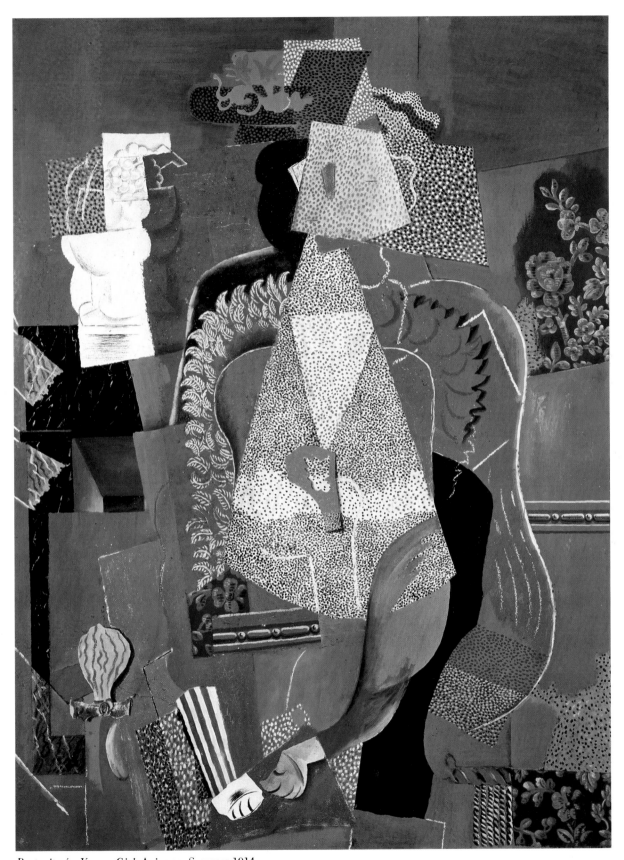

Portrait of a Young Girl. Avignon, Summer 1914
Oil on canvas, 51¼ x 38⅛″ (130 x 97 cm)
Zervos II,² 528. Daix 784. Musée National d'Art Moderne. Centre National d'Art et de Culture Georges Pompidou, Paris

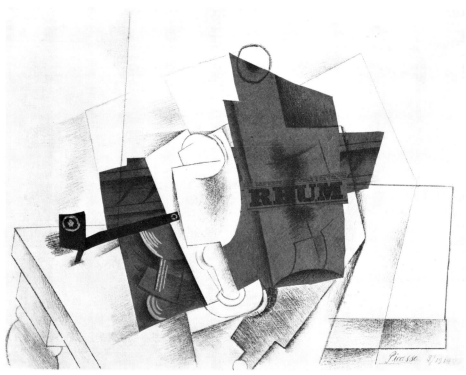

Pipe, Glass, Bottle of Rum. Paris, March 1914
Pasted paper, pencil, and gouache on cardboard, 15¾ x 20¾″ (40 x 52.7 cm)
Zervos II,² 787. Daix 663. The Museum of Modern Art, New York. Gift of Mr. and Mrs. Daniel Saidenberg

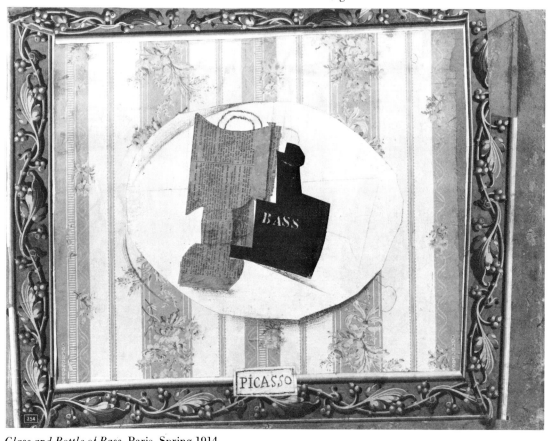

Glass and Bottle of Bass. Paris, Spring 1914
Pasted paper, charcoal, graphite, and paint on cardboard, 20½ x 26⅜″ (52 x 67 cm)
Not in Zervos. Daix 684. Private collection

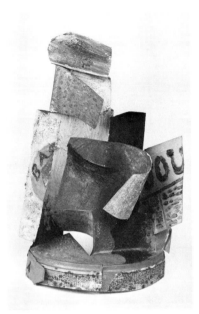

Bottle of Bass, Glass, and Newspaper. Paris, Spring 1914
Construction of sheet metal, oil, and paper, 10⅝ x 5½ x 3⅛″ (20.7 x 13.5 x 8 cm)
Zervos II,² 849. Daix 751. Spies 53. Musée Picasso, Paris

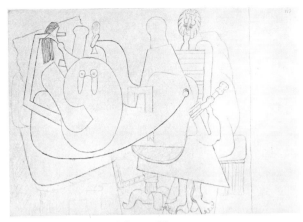

Reclining Woman and Guitar Player
Avignon, Summer 1914
Pencil, 7⅞ x 11¾″ (20 x 29.8 cm)
Zervos VI, 1151. Musée Picasso, Paris

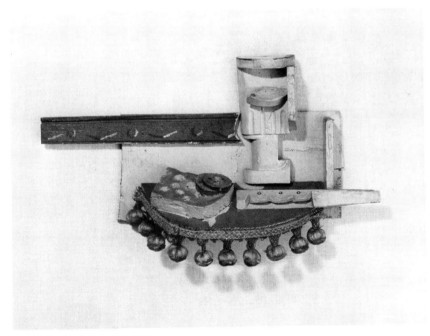

Still Life. Paris, Spring 1914
Painted wood with upholstery fringe, 10 x 18⅞ x 4″ (25.5 x 48 x 10 cm)
Spies 47. Daix 746. The Tate Gallery, London

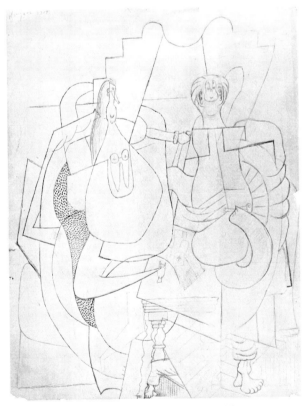

Couple Playing Cards. Avignon, Summer 1914
Pencil, 19½ x 15″ (49.5 x 38.1 cm)
Zervos II,² 841. Musée Picasso, Paris

185

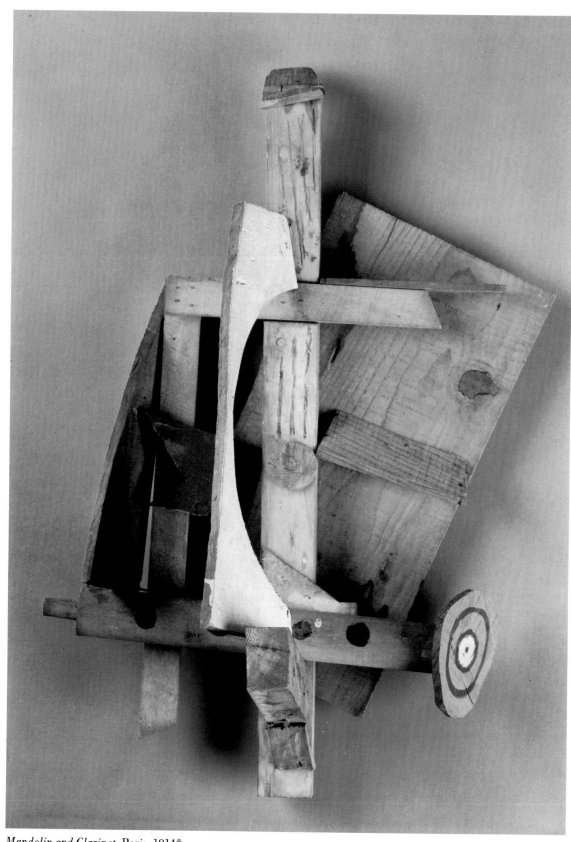

Mandolin and Clarinet. Paris, 1914*
Construction of painted wood and pencil, 22⅝ x 14⅛ x 9″ (58 x 36 x 23 cm)
Zervos II,² 853. Spies 54. Daix 632. Musée Picasso, Paris

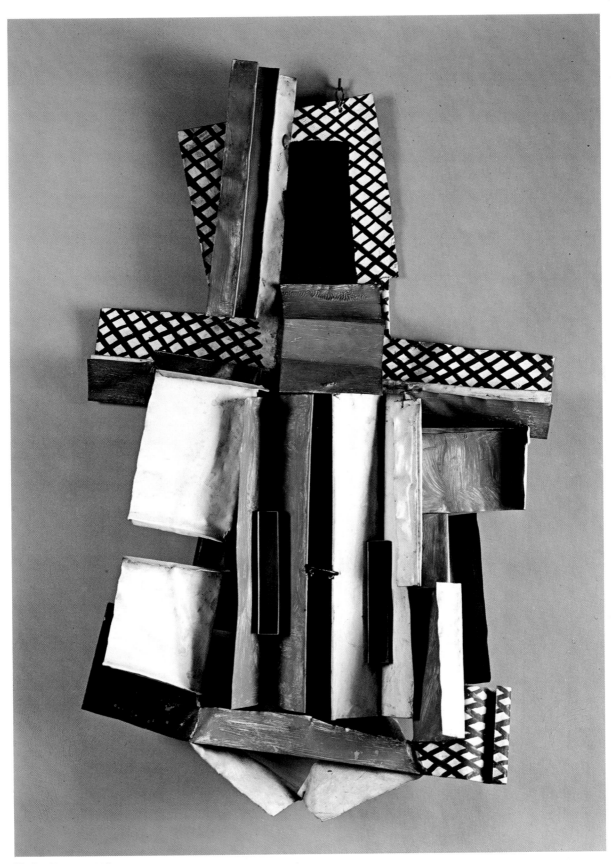

Violin. Paris, 1915*
Construction of painted metal, 37¼ x 25⅝ x 7½″ (94.5 x 65 x 19 cm)
Zervos II,² 580. Spies 55. Daix 835. Musée Picasso, Paris

187

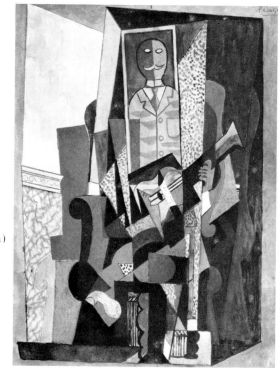

Man with a Guitar. Paris, Autumn 1915
Gouache and watercolor, 12¼ x 9½″ (31 x 24 cm)
Zervos II,² 549. Daix 875. Private collection

Still Life with Compotier and Glass. Paris, Winter 1914–15
Oil on canvas, 25 x 31½″ (63.5 x 80 cm)
Zervos II,² 537. Daix 805. Columbus Museum of Art. Columbus, Ohio. Gift of Ferdinand Howald

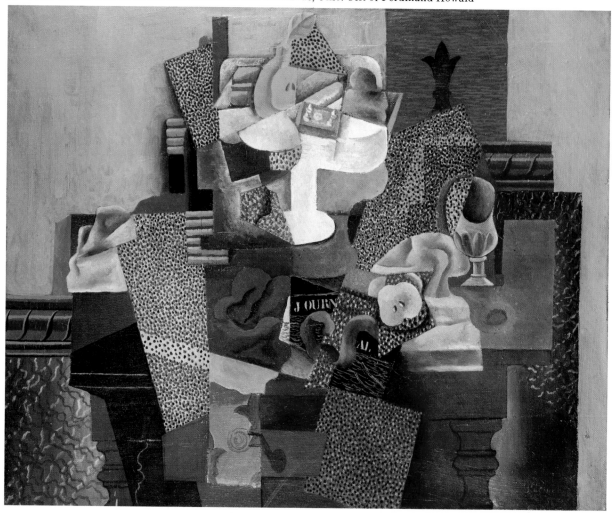

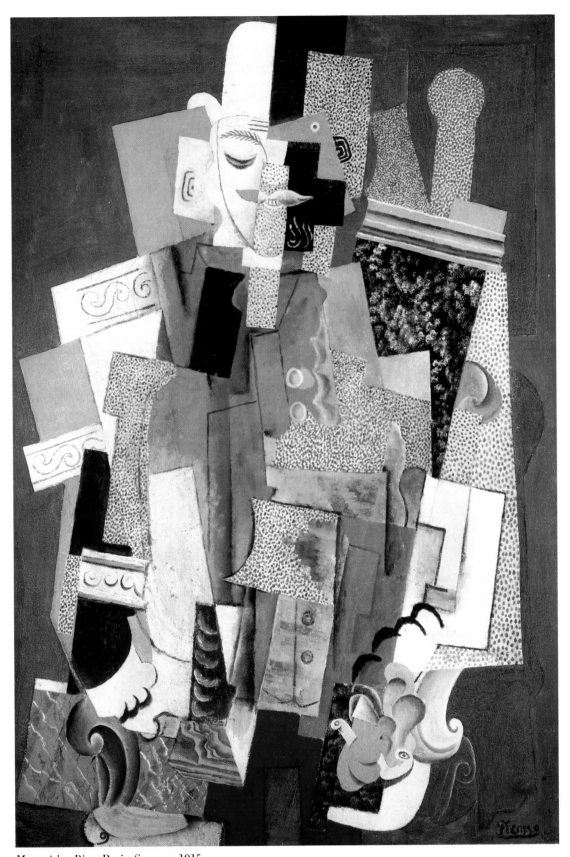

Man with a Pipe. Paris, Summer 1915
Oil on canvas, 51¼ x 35¼″ (130.2 x 89.5 cm)
Zervos II,² 564. Daix 842. The Art Institute of Chicago. Gift of Mrs. Leigh B. Block in memory of Albert D. Lasker

Dancing Couple. Paris, Autumn 1915
Gouache and pencil, 5½ x 4¾″ (14 x 12 cm)
Zervos II,² 556. Daix 848. Collection
Diane de Riaz, Val de l'Oise, France

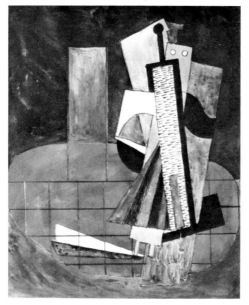

*Bottle of Anis del Mono and Compotier with
Bunch of Grapes.* Paris, [Autumn] 1915
Construction of wood, metal, and charcoal,
14¼ x 11 x 8½″ (36.2 x 28 x 21.5 cm)
Zervos II,² 927. Daix 834. Spies 58. Musée Picasso, Paris

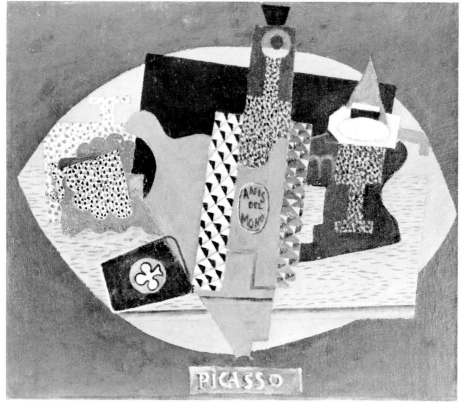

*Bottle of Anis del Mono, Glass, and Playing
Card on a Gueridon.* Paris, Autumn 1915
Oil on canvas, 18⅛ x 21⅝″ (46 x 55 cm)
Zervos II,² 552. Daix 838. Detroit Institute
of Arts. Bequest of Robert H. Tannahill

190

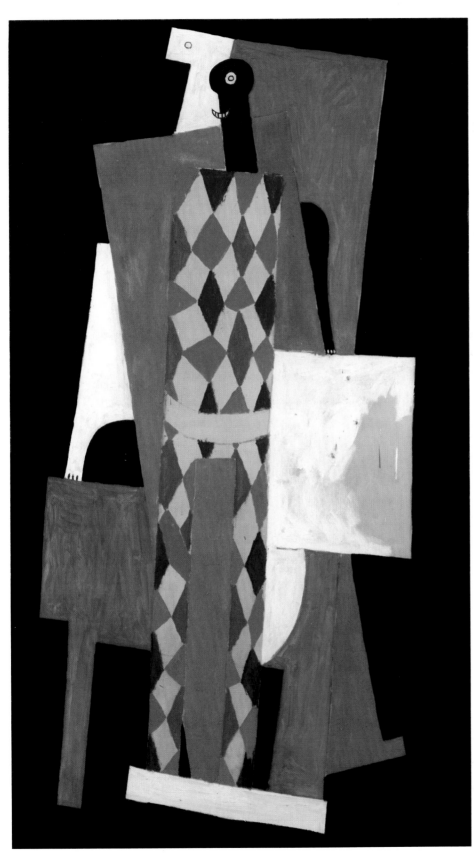

Harlequin. Paris, late 1915
Oil on canvas, 72¼ x 41⅜″ (183.5 x 105.1 cm)
Zervos II,² 555. Daix 844. The Museum of
Modern Art, New York. Acquired through
the Lillie P. Bliss Bequest

Portrait of Ambroise Vollard. Paris, 1915
Pencil, 18⅜ x 12⅝″ (46.7 x 32 cm)
Zervos II,² 922. The Metropolitan Museum of Art,
New York. Purchase, The Elisha Whittelsey Fund

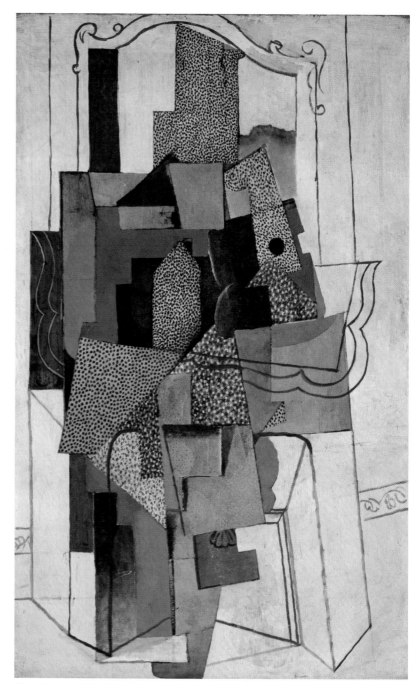

Man before a Fireplace. Paris, 1916
Oil on canvas, 50⅜ x 31⅞″ (128 x 81 cm)
Not in Zervos. Daix 891. Musée Picasso, Paris

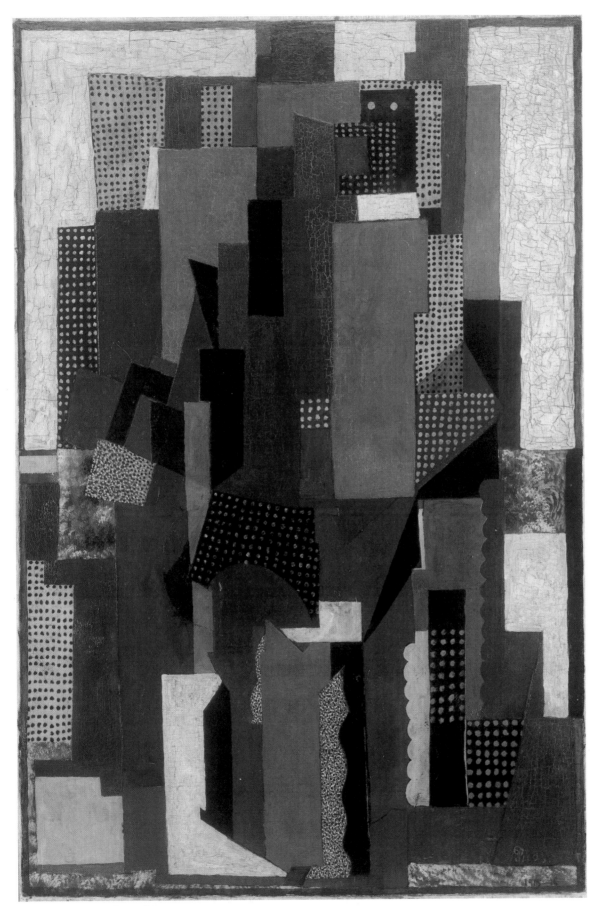

Man Leaning on a Table. Paris, 1916
Oil on canvas, 78¾ x 52″ (200 x 132 cm)
Zervos II,[2] 550. Daix 889. Private collection, Switzerland

193

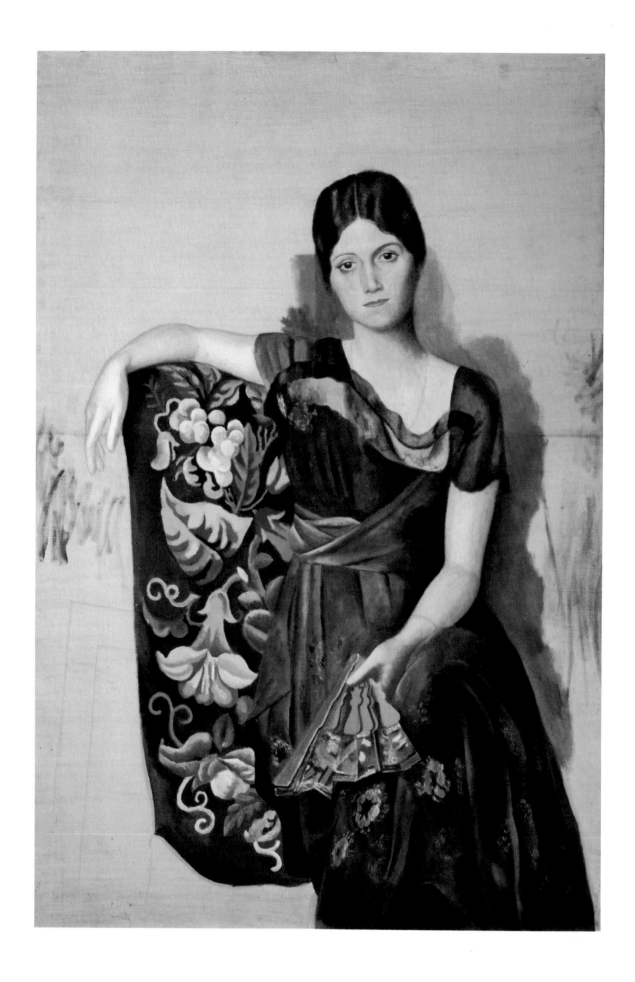

1916-1919

Picasso in his studio at 5, bis, rue Schoelcher, Paris, 1916. Large canvas in background is *Man Leaning on a Table* (p. 193).

1916

FEBRUARY 5: Opening of the Cabaret Voltaire in Zurich, founded by Hugo Ball; beginning of the Dada movement.

MARCH 17: Apollinaire receives a head wound and returns from the front. He is trepanned, and Picasso makes several drawings of him over the next three months (one, p. 201).

APRIL–MAY: Cocteau again visits Picasso, on one occasion wearing a Harlequin costume under his tunic, which he leaves behind (Picasso paints his friend Jacinto Salvado wearing the costume in 1923, pp. 240, 241). Paints Cocteau's portrait May 1. Cocteau is planning a ballet to be performed by the Ballets Russes directed by Serge Diaghilev. Cocteau will write the scenario and Erik Satie the music; Picasso is invited to design the decor.

LATE MAY: Cocteau brings Diaghilev to meet Picasso on rue Schoelcher. Discuss plans for the ballet, *Parade*. Picasso not yet decided to participate.

Completes *Man Leaning on a Table* (p. 193), culmination of many works on Seated Man theme and a developed example of his translation of collage syntax into painting. Also paints *Still Life: "Job"* and *Guitar Player* (both, p. 201).

JUNE: Publication of the first, and only, issue of *Cabaret Voltaire* (Zurich). The preface, written by Hugo Ball in May, uses the word "Dada" publicly for the first time. Picasso, one of the contributors, represented by four etchings and one drawing.

JUNE OR JULY: Moves to Montrouge, farther from Montparnasse. Continues to spend his evenings there, however, and frequently walks home with Satie, who lives in Arcueil. They discuss plans for the ballet.

JULY: First exhibition of the *Demoiselles d'Avignon* (p. 99) at the Salon d'Antin, Paris; show is organized by André Salmon.

AUGUST 24: Agrees to collaborate on *Parade*. Ballet's action to take place "in front of a fair-booth, on some Parisian boulevard, [where] a group of performers — an acrobat, a Chinese conjurer [p. 208], a little American girl — go through the routine of performing extracts from their repertory in order to attract the public to see the spectacle

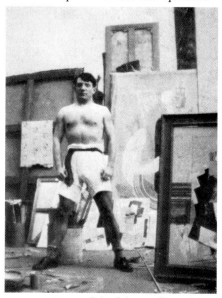

Picasso in his rue Schoelcher studio, c. 1916

inside." Cocteau plans to have voices (amplified through a megaphone) shriek gibberish and comment on the action. Picasso wants to eliminate the voiced sounds to make the production more visual, and Satie concurs. Picasso introduces three Managers wearing elaborate structures, which serve to dehumanize the figures and reduce the dancers to the proportions of puppets.

WINTER: Gertrude Stein has returned to Paris, and she exchanges visits with Picasso: "He had a marvelous rose pink silk counterpane on his bed," she writes in the *Autobiography of Alice B. Toklas*. "Where did that come from Pablo? . . . Ah ça, said Picasso with much satisfaction. . . . It was a well known chilean society woman [Mme Errazuriz] who had given it to him. . . . He was constantly coming to the house, bringing Paquerette a girl who was very nice or Irene a very lovely woman who came from the mountains and wanted to be free. He brought Erik Satie and the Princesse de Polignac and Blaise Cendrars."

DECEMBER 31: Is one of the organizers of banquet honoring Apollinaire on the occasion of publishing *Le Poète assassiné* (Paris: L'Edition Bibliothèque Curieux). Picasso is model for character of the artist (Bird of Benin) in the poem, which is about a poet who dies, after which the artist "sculpts him a profound statue out of nothing, like poetry and glory."

1917

JANUARY 16: Visits his family in Barcelona.

FEBRUARY 1: Writes Cocteau that he is working hard on the decor for *Parade*. Later Cocteau meets him in Paris, and they leave for Rome on February 17 to join Diaghilev and the Ballets Russes (they drop around to see Gertrude Stein before leaving so that Picasso may introduce the young poet to her).

Remaining in Rome for eight weeks, works in a studio on Via Margutta, making sketches for both the decor and the construction of the costumes. Spends considerable time in the company of

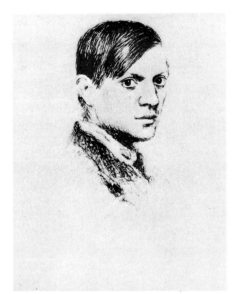

Self-Portrait.† Montrouge, 1917. Pencil, 13⅜ x 10¼″ (34 x 26 cm). Zervos III, 75. Private collection

Picasso and Olga.† 1917. Pencil, 10⅞ x 8⅛″ (27.5 x 20.5 cm). Zervos XXIX, 237. Collection Bernard Picasso, Paris

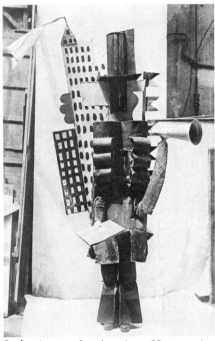

Statkewicz as the American Manager in first performance of ballet *Parade*; costume designed by Picasso

Diaghilev, Léonide Massine, Cocteau, Igor Stravinsky, and Léon Bakst; makes caricatures and portrait drawings of them. During this period, in which he attends rehearsals and performances of the troupe, meets a ballerina named Olga Koklova. Visits Naples and Pompeii (writes Gertrude Stein that he has "made Pompeiian fantasies and caricatures of Diaghilev, Bakst, and some dancers").

Company returns to Paris; personally supervises execution of costumes and works with company scene painters on painting of drop curtain.

MARCH 15: First issue of *Nord-Sud* appears; Pierre Reverdy is the editor.

MAY 18: Opening performance of *Parade* at Théâtre du Châtelet, Paris. At rise of curtain, audience is greeted by sounds of dynamos, sirens, express trains, airplanes, and typewriters, followed by rhythmic stomping. The French and American Managers appear, wearing ten-foot-high structures built up of angular Cubist agglomerations,

the back of the Frenchman outlined with shapes suggesting the trees of the boulevards and the figure of the American towering up like a skyscraper. The third Manager is a horse, two dancers hidden inside its body. In addition, there are four dancers: the Chinese conjurer, the little American girl, and two acrobats.

Some members of audience boo and shout *"Sales boches!"* ("Dirty Ger-

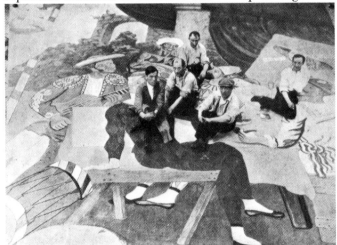

Picasso with scene painters for drop curtain of *Parade*, Paris, 1917.

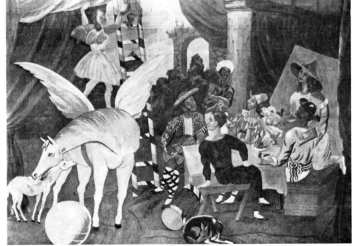

Final curtain for the ballet. Paris, 1917. Tempera, 35′3¼″ x 57′6″ (1060 x 1724 cm). Musées Nationaux, Paris

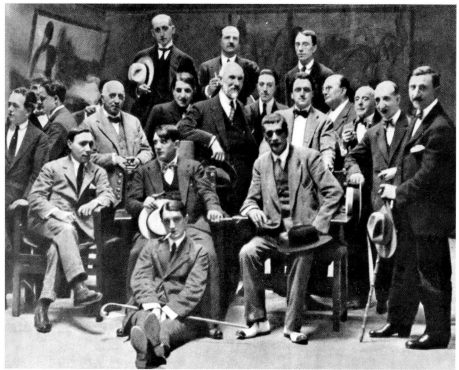

Picasso at Galerias Layetanas, Barcelona, July 1917. At his feet: Angel F. de Soto. Seated: Maeztu, Picasso, Iturrino. Standing, from left: Padilla, Feliu Elies, Román Jori, Xavier Nogués, Soglio, M. Humbert, Plandiura, A. Riera, G. Anyés, J. Colomer, Ricardo Canals. In top row: Miguel Utrillo, S. Segura, and Aragay

mans"), viewing the ballet as a Cubist manifestation and therefore un-French. Juan Gris praises it, however, writing to Maurice Raynal at the front that it is "unpretentious, gay, and distinctly comic." In his program note for the ballet, Apollinaire declares that the fusion of Picasso's designs and Massine's choreography achieves a "super realism [sur-réalisme], which is the manifestation of the new spirit."

BEGINNING OF JUNE: Picasso, in love with Olga, follows troupe to Madrid and to Barcelona, where it performs at Teatro de Liceo between June 23 and 30. Ernst Ansermet conducts and Picasso makes his portrait. When troupe leaves for South America, Olga remains behind with Picasso.

JULY 12: Picasso is given a homecoming celebration in Barcelona by fellow painters, including Miguel Utrillo, Angel F. de Soto, Ricardo Canals, and Iturrino. He is photographed seated among them in Galerias Layetanas.

JUNE–NOVEMBER: Paints ten works in both naturalistic and Synthetic Cubist styles: realistic portrait of a woman in a mantilla (for which Olga is model) (p. 204), and *Olga Picasso in an Armchair* (p. 194).

AUTUMN: Ballets Russes return to Barcelona; perform *Parade* on November 10. Poorly received.

NOVEMBER: Returns to Montrouge with Olga, invigorated by visit to Catalonia. Contact with the Ballets Russes leads to frequent social encounters with the haut-monde, resulting in change in life style.

Pointillist stippling appears frequently, as in *Harlequin and Woman with Necklace* (p. 206), *Harlequin* (p. 207), and *Woman in Spanish Costume* (*La Salchichona*) (p. 202). Paints entirely pointillist paraphrase (p. 203) of Le Nain's *Happy Family*.

1918

JANUARY 1: Apollinaire hospitalized with pulmonary congestion.

JANUARY 23–FEBRUARY 15: Matisse-Picasso exhibition at Galerie Paul Guillaume, 118, rue La Boëtie; Picasso work all pre-Cubist. Catalog preface written by Apollinaire.

SPRING: Moves to Hôtel Lutétia. New dealer, Léonce Rosenberg, is located on Right Bank near Faubourg Saint-Honoré. Continues friendship with wealthy Chilean, Mme Errazuriz, and meets others in high society.

Influence of theater prompts several works on Commedia dell'Arte theme. Paints realistic *Pierrot* (p. 208) and makes related etching as illustration for Max Jacob's *Phanérogame* (Paris: Privately printed), the story of a man who flew by flapping his thighs. In contrast to these classic treatments of Harlequin, paints the Synthetic Cubist *Harlequin Playing the Guitar* (p. 207) and *Harlequin with Violin* ("*Si tu Veux*") (p. 209).

MAY 2: Wedding of Apollinaire and Jacqueline Kolb; Picasso and Vollard are witnesses.

MAY 18: Attends performance of Stravinsky's *Renard*; at supper afterward, meets Marcel Proust and James Joyce.

JULY 12: Wedding of Picasso and Olga Koklova at Russian Orthodox church on rue Daru, Paris. Witnesses at the civil ceremony are Cocteau, Max Jacob, and Apollinaire. Couple spend honeymoon in Biarritz, staying at La Mimoseraie, home of Mme Errazuriz. During his stay, Picasso meets dealers Paul Rosenberg and Georges Wildenstein and draws portraits of their wives.

Picasso and Olga Koklova in Paris, 1917

Makes an Ingresque drawing, *Bathers*, and paints as well a small "Mannerist" version on that theme (both p. 205).

AUGUST 16: Writes to Apollinaire from Biarritz about the high life there; letter quotes from Apollinaire's *Seasons* and concludes on nostalgic note: "I have decorated a room here where I have put some of your verses."

MID-SEPTEMBER: Letter to Apollinaire from Biarritz, their last correspondence.

LATE SEPTEMBER: Olga and Picasso return to Paris.

NOVEMBER 9: Apollinaire dies of Spanish influenza, two days before the Armistice is signed. (Three years later a committee of friends of Apollinaire asks Picasso to design a monument for the dead poet's grave. The project drags on, money for the monument being raised over the course of the decade. During summers of 1927 and 1928, Picasso fills sketchbooks with drawings of Bathers, calling them studies for an imaginary monument [one, p. 265]. In 1928 or 1929 he offers three sculptures [two, pp. 267, 268] as maquettes for monument; the committee turns them down as too radical. In 1959 a monument is finally erected in church garden of St.-Germain-des-Prés. In 1972 Picasso gives The Museum of Modern Art a 13-foot enlargement of a 1928 maquette for its garden [frontispiece].)

MID-NOVEMBER: Picasso and his wife move to 23, rue La Boëtie. The second floor is given over to his studio and his

Publicity photograph for Ballets Russes on their New York tour, 1916. Three years later Picasso makes two drawings (pp. 217, 218). Olga is in the foreground

collection of paintings and African art, the first floor to their private apartment and the furnishings chosen by Olga.

Publication during the year of Cocteau's *Le Coq et l'arlequin* (Paris: Editions de la Sirène), for which Picasso provides three drawings.

1919

FEBRUARY: Cocteau publishes *Ode à Picasso* (Paris: Bernouard).

MARCH: First issue of *Littérature* (Paris), literary journal edited by Louis Aragon, André Breton, and Philippe Soupault.

MARCH 5–31: Braque exhibition at Léonce Rosenberg's Galerie de l'Effort Moderne. André Lhote writes that it sounds the death knell of Cubism.

About this time paints *Girl with a Hoop* and *Table, Guitar, and Bottle* (both, p. 211) in the Synthetic Cubist style.

APRIL OR MAY: Joan Miró visits Picasso in his studio and the latter buys a painting from his young fellow countryman.

MAY 15: Blaise Cendrars publishes "Pourquoi le 'Cube' s'effrite?" ("Why Is the 'Cube' Disintegrating?") in *La Rose rouge*, announcing the passing of Cubism.

EARLY MAY: Picasso leaves for London to design decor and costumes for *Le Tricorne*, a new Ballets Russes production based on the novel by Pedro de Alarcón, choreographed by Massine and set to music by Manuel de Falla. Spends three months in London, making numerous sketches for decor, costumes (p. 212), and drop curtain (motif from one sketch, p. 213, is enlarged and used in large work of oil, charcoal, and pinned paper entitled *Guitar*, p. 213). With assistance of Vladimir Polunin and his wife, paints drop curtain himself, signing it "Picasso Pinxit 1919."

During London sojourn, attends rehearsals and performances with Olga; makes drawings of dancers (pp. 217–19) and portrait drawings of Massine (p. 217), of Diaghilev and Alfred Seligsberg (p. 212), and of Derain (also in London, designing ballet decor).

Le Ménage Sisley, after Renoir.† Paris, Winter 1919. Pencil, 12¼ x 9⅜" (31.2 x 23.8 cm). Zervos III, 428. Musée Picasso, Paris

JULY 22: First performance of *Tricorne* at the Alhambra Theater, London.

LATE SUMMER: Vacations with Olga at Saint-Raphael, on the Riviera. Executes *Sleeping Peasants* (p. 215), which anticipates compositions in the "colossal" style of the following years.

OCTOBER 20: Opening of exhibition of drawings and watercolors at Paul Rosenberg's gallery at 21, rue La Boëtie. Designs invitation and catalog cover.

Works in both Cubist and realist modes. Invests some realist works, such as *Pitcher and Compotier with Apples* (p. 216), with sculptural weight and monumentality, a tendency that becomes more frequent during next three years.

NOVEMBER: Frontispiece for *Feu de joie* (Paris: Au Sans Pareil), collection of poems by Louis Aragon. (First printing is December 10, 1919, but volume is copyrighted 1920.)

DECEMBER: Invitation from Diaghilev to collaborate on *Pulcinella*, new ballet on Commedia dell'Arte theme set to music by Stravinsky. First sketches for decor vehemently rejected by Diaghilev as being too modern; Picasso later modifies them somewhat.

199

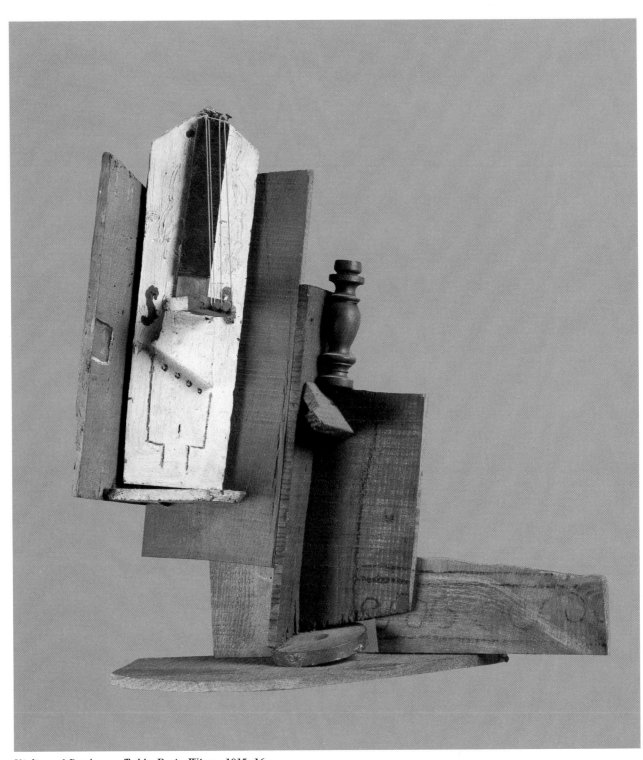

Violin and Bottle on a Table. Paris, Winter 1915–16
Construction of painted wood, tacks, string, and charcoal, 17⅞ x 16⅜ x 7½″ (45.5 x 41.5 x 19 cm)
Zervos II,² 926. Spies 57. Daix 833. Musée Picasso, Paris

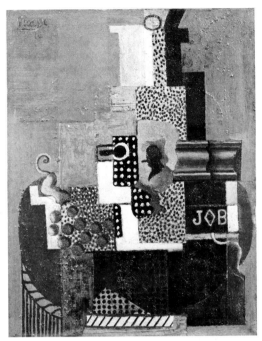

Still Life: "Job." Paris, 1916
Oil and sand on canvas, 17 x 13¾″ (43.3 x 35 cm)
Zervos XXIX, 168. Daix 885
The Museum of Modern Art, New York.
Nelson A. Rockefeller Bequest

Portrait of Guillaume Apollinaire. Paris, 1916
Pencil, 19¼ x 12″ (48.8 x 30.5 cm)
Zervos XXIX, 200. Private collection

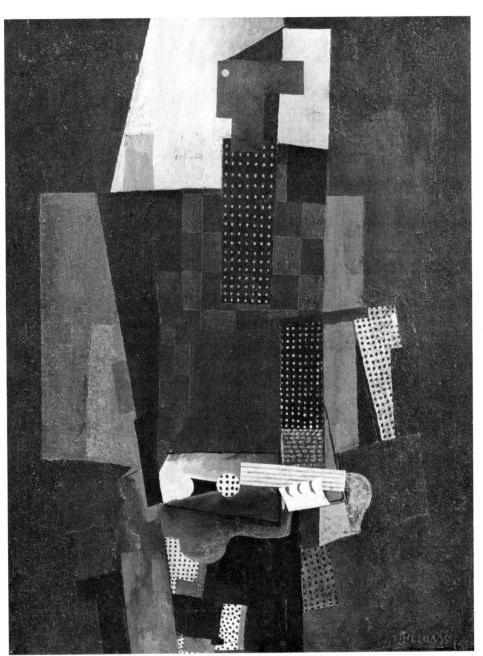

Guitar Player. Paris, 1916
Oil and sand on canvas, 51¼ x 38⅛″ (130 x 97 cm)
Zervos II.² 551. Daix 890. Moderna Museet, Stockholm

201

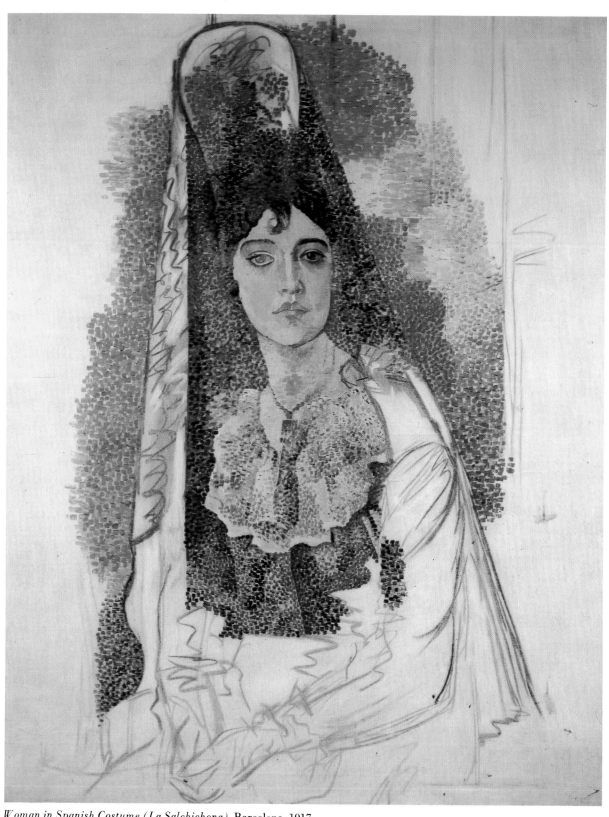

Woman in Spanish Costume (La Salchichona). Barcelona, 1917
Oil on canvas, 45⅝ x 35⅛″ (116 x 89 cm)
Zervos III, 45. Museo Picasso, Barcelona

The Happy Family, after Le Nain. [Paris]. 1917–18
Oil on canvas, 64⅝ x 46½″ (164 x 118 cm)
Zervos III, 96. Musée Picasso, Paris

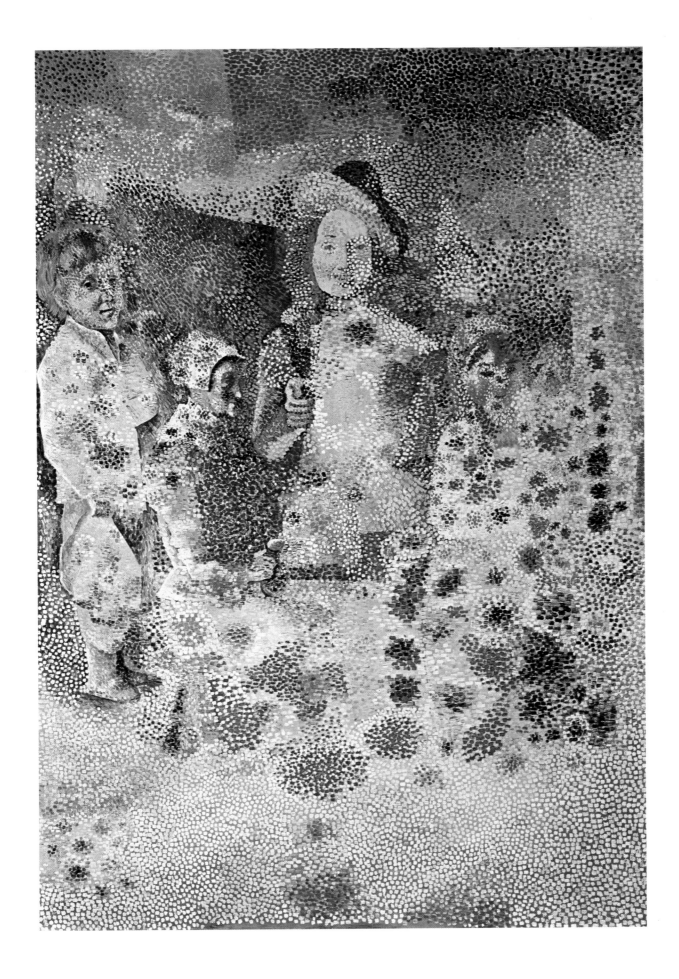

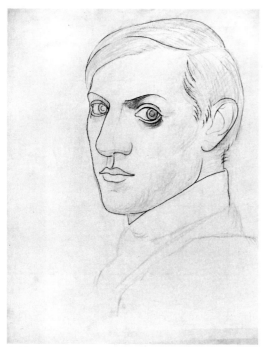

Self-Portrait. Paris, [1917]
Pencil, 25¼ x 19½" (64 x 49.5 cm)
Zervos XXIX, 309. Musée Picasso, Paris

Crucifixion. Paris, 1918*
Pencil, 14⅛ x 10½" (36 x 26.6 cm)
Zervos VI, 1331. Musée Picasso, Paris

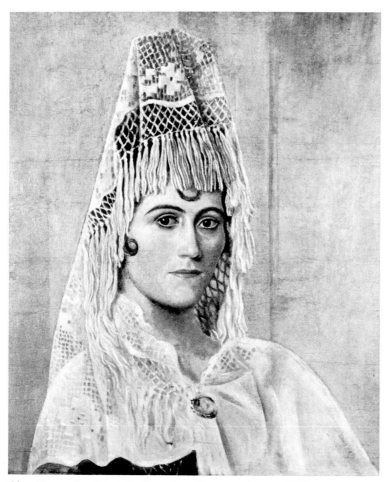

Olga Picasso in a Mantilla. Barcelona, Summer–Autumn 1917
Oil on canvas, 25¼ x 20⅞" (64 x 53 cm)
Zervos III, 40. Collection Mme Paul Picasso, Paris

Fisherman. Paris, 1918
Pencil, 13¾ x 10" (35 x 25.5 cm)
Zervos III, 250. Private collection

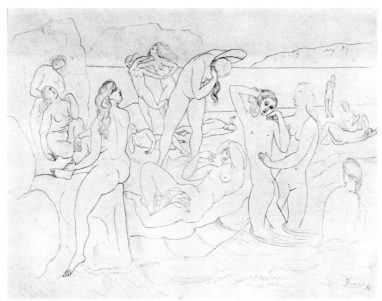

Bathers. Biarritz, Summer 1918
Pencil, 9½ x 12¼″ (24 x 31 cm)
Zervos III, 233. Fogg Art Museum, Harvard
University, Cambridge, Massachusetts.
Bequest of Paul J. Sachs.

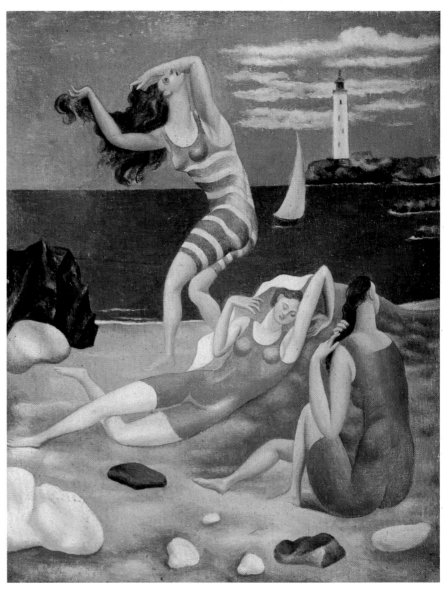

Bathers. Biarritz, Summer 1918
Oil on canvas, 10⅜ x 8⅝″ (26.3 x 21.7 cm)
Zervos III, 237. Musée Picasso, Paris

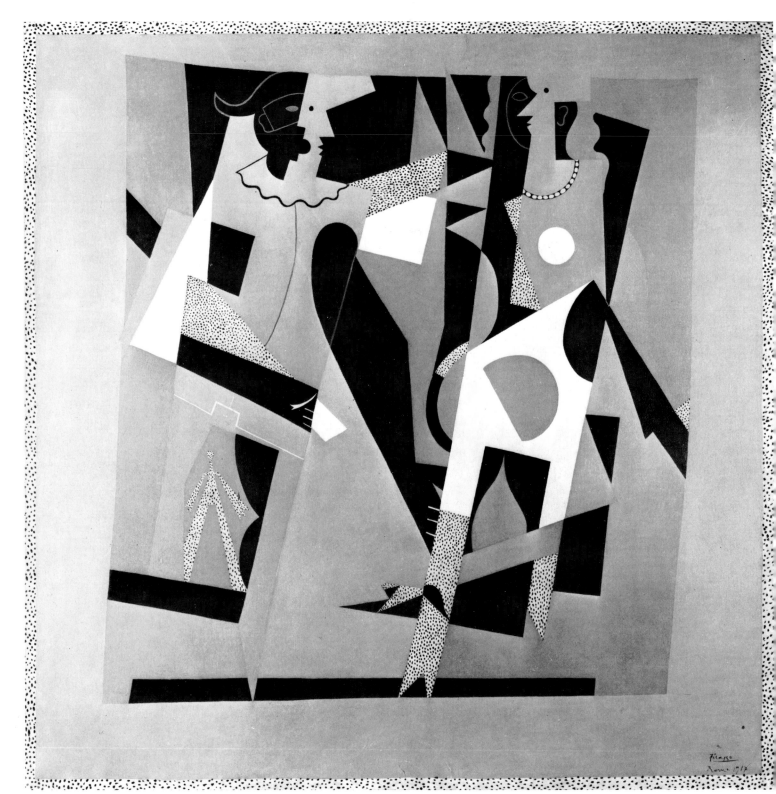

Harlequin and Woman with Necklace. Rome, 1917
Oil on canvas, 78¾ x 78¾" (200 x 200 cm)
Zervos III, 23. Musée National d'Art Moderne,
206 Centre National d'Art et de Culture Georges Pompidou, Paris

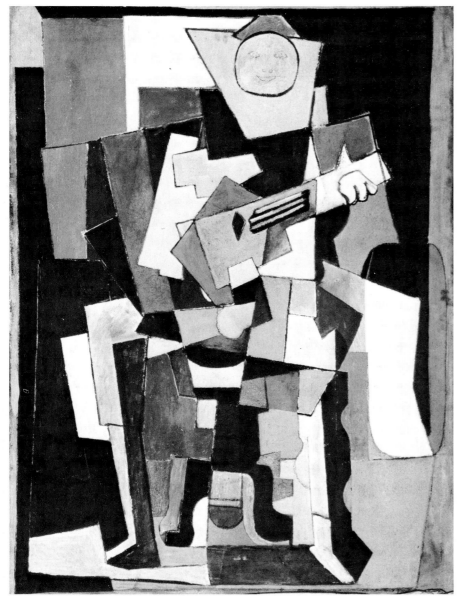

Harlequin Playing the Guitar. Paris, 1918
Oil and material on canvas, 57⅞ x 44½″ (147 x 113 cm)
Not in Zervos. Collection Jacqueline Picasso, Mougins

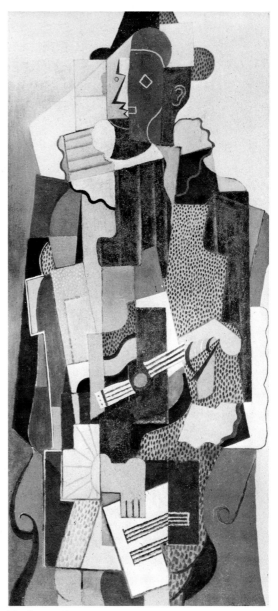

Harlequin. Paris, 1918
Oil on canvas, 57⅛ x 25⅝″ (145 x 65 cm)
Zervos III, 159. Private collection

207

The Chinese Conjurer
(Costume for ballet *Parade*). [Rome], 1917
Gouache, 10⅞ x 7⅞" (27.5 x 20 cm)
Zervos XXIX, 253
Collection Mr. and Mrs. Jacques Helft, Paris

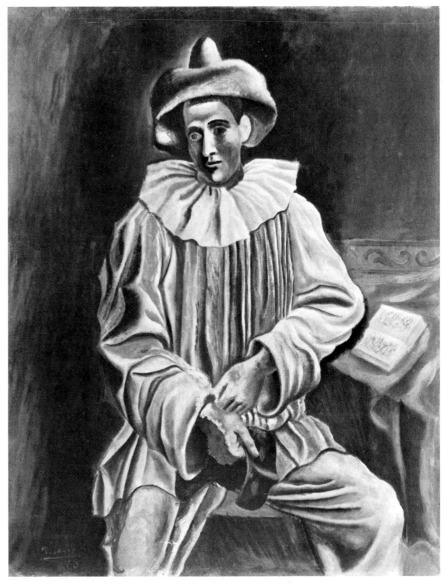

Pierrot. Paris, 1918
Oil on canvas, 36½ x 28¾" (92.7 x 73 cm)
Zervos III, 137. The Museum of Modern Art, New York. Sam A. Lewisohn Bequest

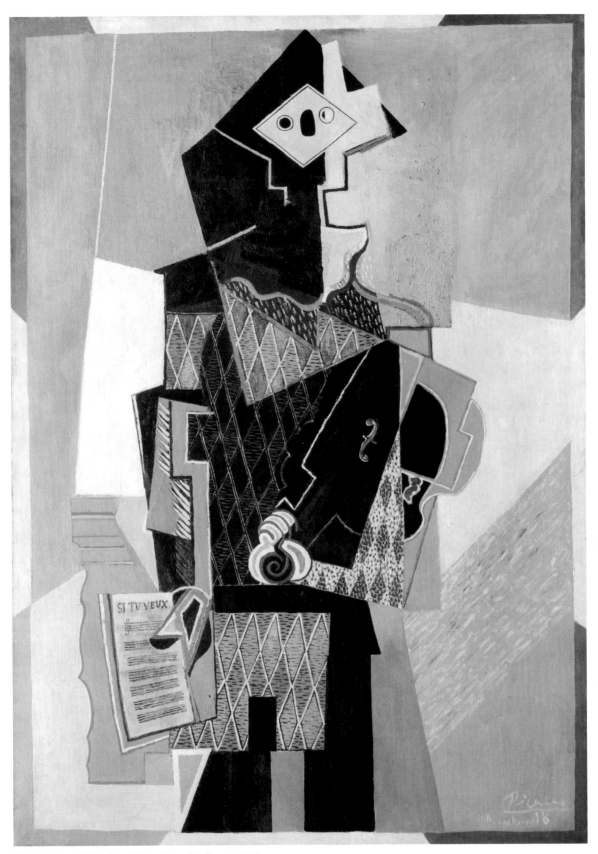

Harlequin with Violin ("Si tu Veux"). Paris, 1918
Oil on canvas, 56 x 39½" (142 x 100.3 cm)
Zervos III, 160. The Cleveland Museum of Art. Purchase, Leonard C. Hanna, Jr., Bequest

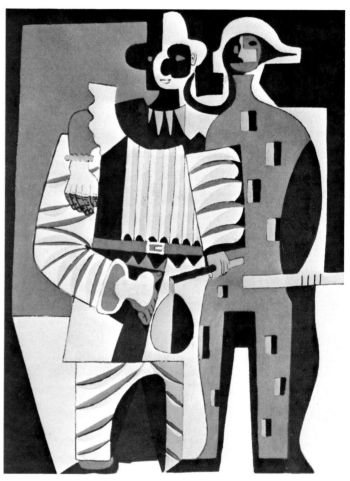

Pierrot and Harlequin. Juan-les-Pins, Summer 1920
Gouache, 10⅛ x 7¾″ (25.7 x 19.7 cm)
Zervos IV, 69. Collection Mrs. Gilbert W. Chapman, New York

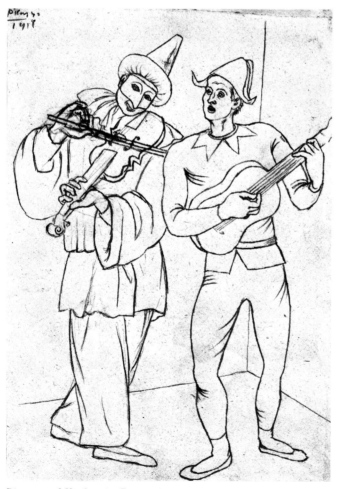

Pierrot and Harlequin. Paris, 1918
Pencil, 10¼ x 8½″ (26 x 21.6 cm)
Zervos III, 135. The Art Institute of Chicago.
Gift of Mrs. Gilbert W. Chapman

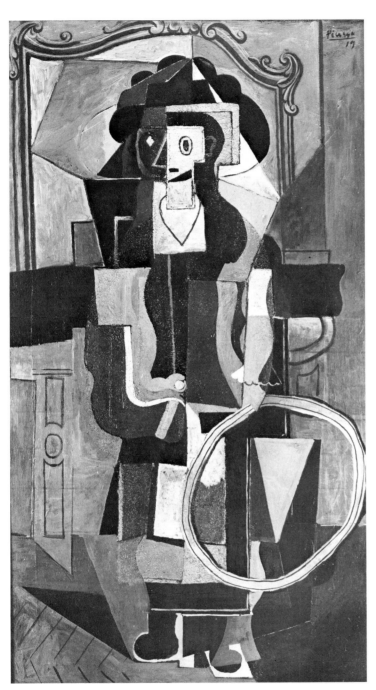

Girl with a Hoop. Paris, 1919
Oil and sand on canvas, 55⅞ x 31⅛″ (142 x 79 cm)
Zervos III, 289. Musée National d'Art Moderne, Centre
National d'Art et de Culture Georges Pompidou, Paris

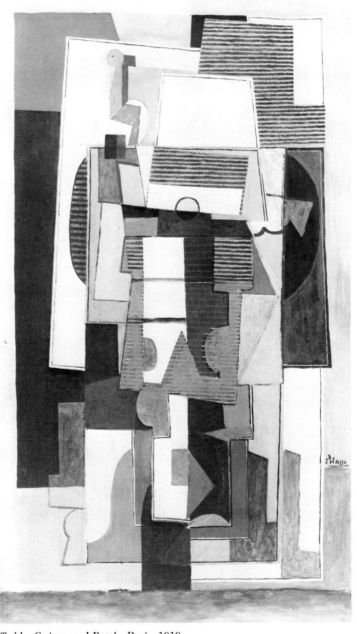

Table, Guitar, and Bottle. Paris, 1919
Oil on canvas, 50 x 29½″ (127 x 75 cm)
Zervos III, 437. Smith College Museum of Art,
Northampton, Massachusetts. Purchase

Bullfighter (Costume for ballet *Le Tricorne*)
London, Summer 1919
India ink and gouache, 10¼ x 7⅞″ (26 x 20 cm)
Zervos XXIX, 406. Musée Picasso, Paris

Serge Diaghilev and Alfred Seligsberg (after a
photograph). [London], Summer 1919
Charcoal and pencil, 25 x 19½″ (63.5 x 49.6 cm)
Zervos III, 301. Musée Picasso, Paris

Pulcinella (Costume and mask for ballet *Pulcinella*). Paris, February 1920
Watercolor and pencil, 13⅜ x 9¼″ (34 x 23.5 cm)
212 Zervos IV, 21. Musée Picasso, Paris

The Arena (Sketch for curtain of ballet
Le Tricorne). London, Summer 1919
Gouache on paper, 7¾ x 10½″ (19.5 x 26.5 cm)
Not in Zervos. Musée Picasso, Paris

Guitar. Paris, Autumn 1919
Oil, charcoal, and pinned paper on canvas, 85 x 31″ (215.9 x 78.7 cm)
Zervos II,² 570. The Museum of Modern Art,
New York. Gift of A. Conger Goodyear

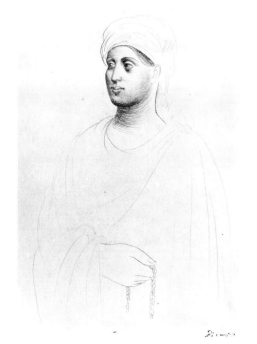

Woman with a Rosary. Paris, 1919
Pencil, 12½ x 8½″ (31.8 x 21.6 cm)
Zervos III, 360. Private collection

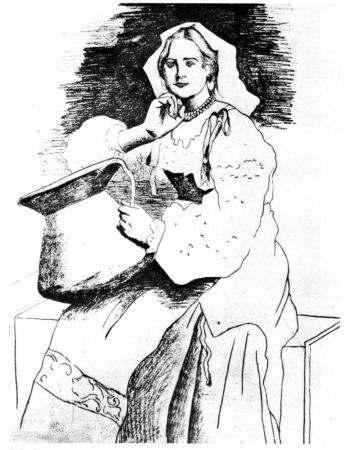

L'Italienne (after a photograph). Paris, 1919
Pencil, 24⅜ x 18⅞″ (62 x 48 cm)
Zervos III, 362. Private collection

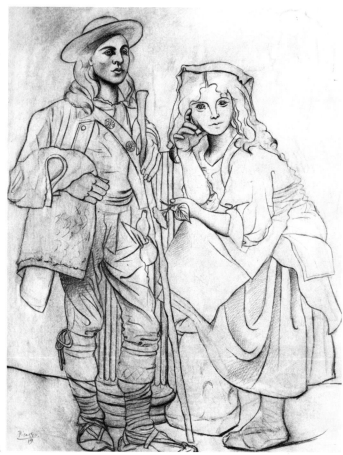

Italian Peasants (after a photograph). Paris, 1919
Pencil, 23¼ x 18¼″ (59 x 46.5 cm)
Zervos III, 431. Santa Barbara Museum of Art,
Santa Barbara, California. Gift of Wright Ludington

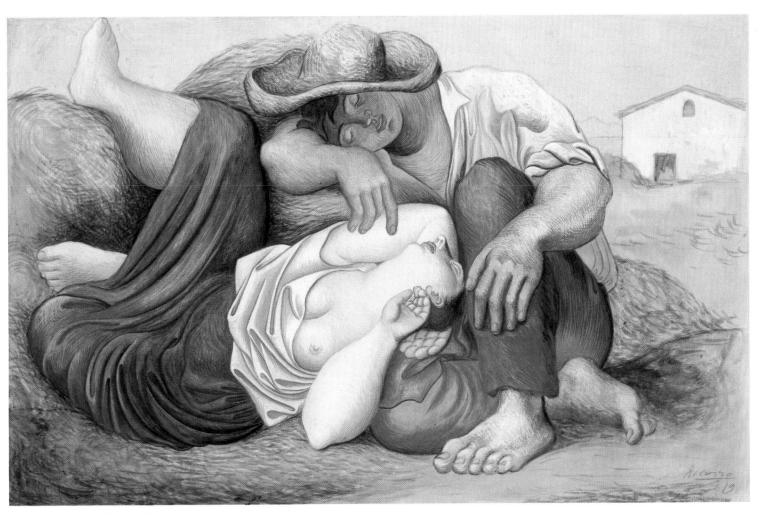

Sleeping Peasants. Paris, 1919
Tempera, watercolor, and pencil, 12¼ x 19¼″ (31.1 x 48.9 cm)
Zervos III, 371. The Museum of Modern Art, New York. Abby Aldrich Rockefeller Fund

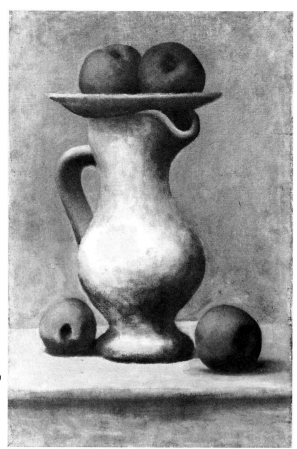

Still Life with Pitcher and Apples. [Paris], 1919
Oil on canvas, 25½ x 17⅛″ (65 x 43.5 cm)
Not in Zervos. Musée Picasso, Paris

Pitcher and Compotier with Apples. Paris, 1919
Pastel, 29½ x 39⅜″ (75 x 100 cm)
Zervos III, 276. Private collection

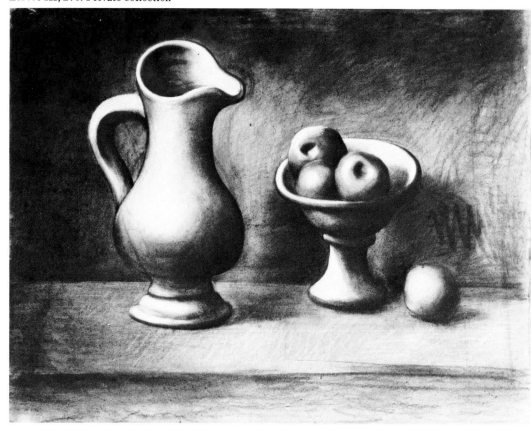

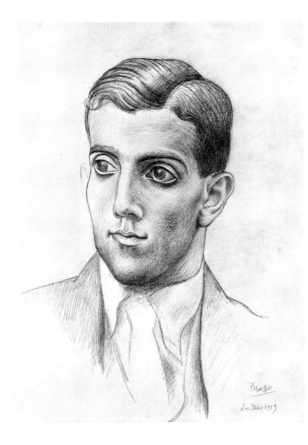

Portrait of Léonide Massine. London, Summer 1919
Pencil, 15 x 11⅜″ (38 x 29 cm)
Zervos III, 297. The Art Institute of Chicago.
Margaret Day Blake collection

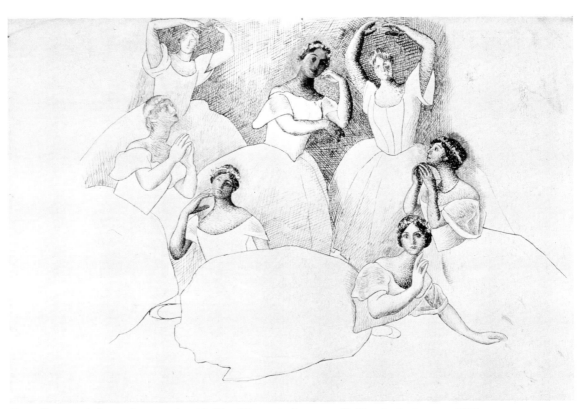

Seven Dancers (after a photograph, with Olga Picasso in foreground). [London], Summer 1919
India ink, 10⅜ x 15⅝″ (26.3 x 39.5 cm)
Zervos III, 355. Collection Jacqueline Picasso, Mougins

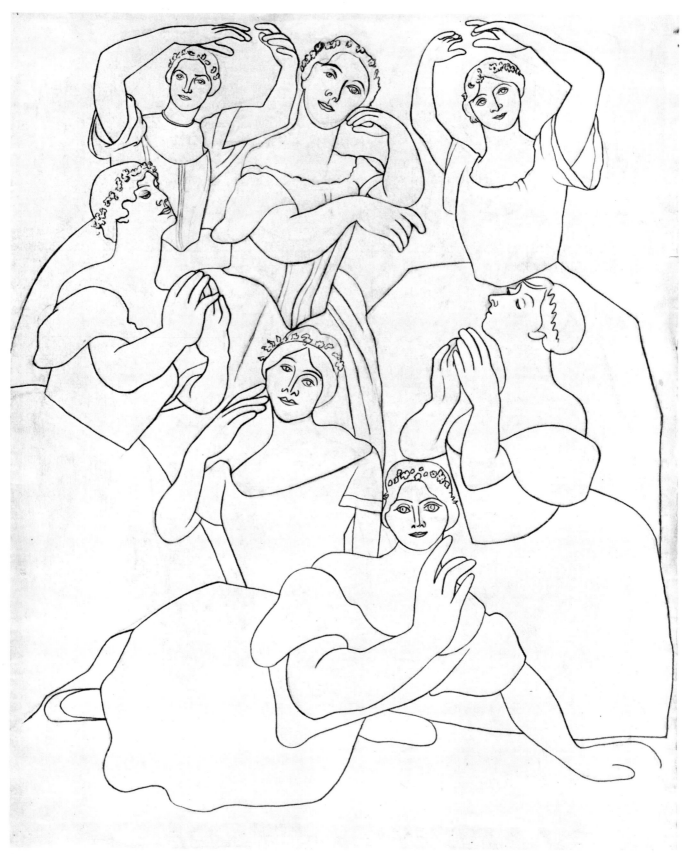

Seven Dancers (after a photograph, with Olga Picasso in foreground). [London], Summer 1919
Pencil, 24½ x 19¾″ (62.2 x 50 cm)
Zervos III, 353. Musée Picasso, Paris

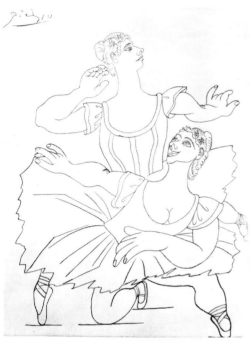

Two Dancers. London, Summer 1919
Pencil, 12¼ x 9½″ (31 x 24 cm)
Zervos III, 343. Collection Mr. and Mrs.
Victor W. Ganz, New York

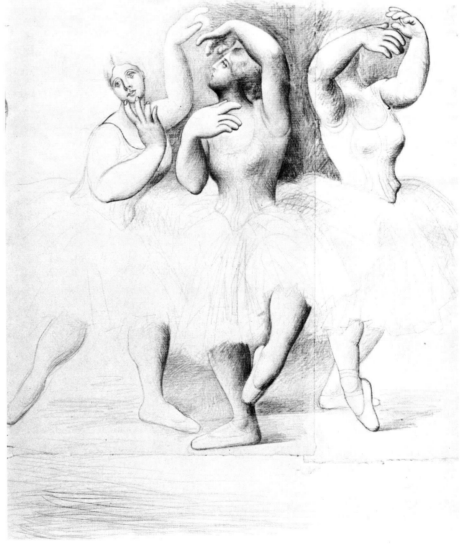

Three Dancers. [London], 1919
Pencil on paper (three sheets pasted together), 14⅝ x 12⅞″ (37 x 32.5 cm)
Zervos XXIX, 432. Musée Picasso, Paris

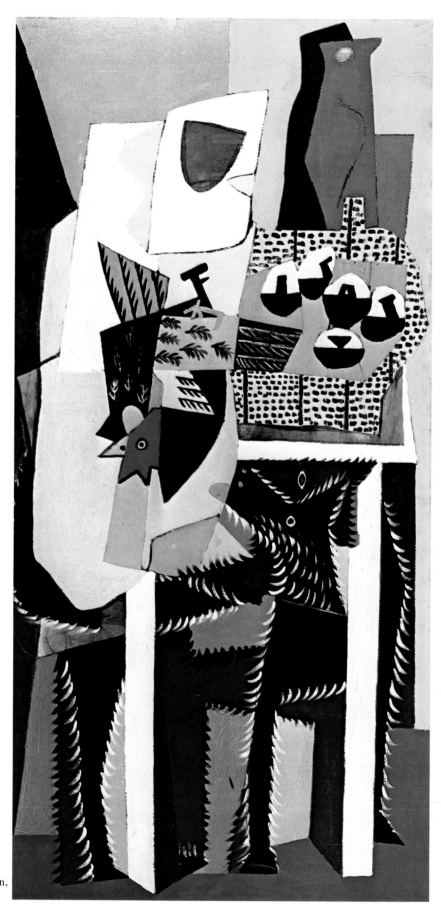

Dog and Cock. [Paris], 1921
Oil on canvas, 61 x 30¼″ (155 x 76.7 cm)
Zervos IV, 335. Yale University Art Gallery, New Haven,
Connecticut. Gift of Stephen C. Clark

1920-1924

1920

JANUARY: Dada poet Tristan Tzara arrives in Paris from Switzerland on January 18. Five days later a Dada manifestation, "Premier Vendredi de Littérature," takes place at the Palais des Fêtes, organized by literary journal *Littérature*. Many of Picasso's friends and acquaintances participate. Program lists a talk by André Salmon and poems written or read by Max Jacob, Aragon, Cocteau, Breton, and Tzara, among others.

FEBRUARY: Continues work on plans for *Pulcinella*. Invites Max Jacob to performance of *Tricorne* at the Opéra, but the poet is hit by an automobile on the way. Although Picasso visits him in the hospital, they see each other very seldom after that.

FEBRUARY 22: Kahnweiler returns to France from wartime exile. During year publishes *Der Weg zum Kubismus (The Rise of Cubism)* (Munich: Delphin) and in September opens a new gallery at 29 bis, rue d'Astorg, naming it for his friend and partner, André Simon.

MAY 15: First performance of *Pulcinella* at Paris Opéra, with decor and costumes by Picasso, choreography by Massine, music by Stravinsky (after Pergolesi), libretto by Massine and Diaghilev (after early Neapolitan texts). Final version of decor is Cubist, but costumes are closer to Italian comic opera (p. 212). Within a few weeks of the opening, Picasso makes portraits of his three musical collaborators, Satie, Stravinsky (both, p. 227), and Manuel de Falla.

Set design for ballet *Pulcinella*. Paris, 1920. Gouache. Present whereabouts unknown

MID-JUNE: Picasso and Olga leave for Juan-les-Pins, on the Riviera. Continues work on series of flat, geometric, highly colored gouaches (begun in Paris in May) using Commedia dell'Arte figures: Pierrot and Harlequin at a café table; Pulcinella reading *Le Populaire*; Pierrot and Harlequin standing side by side, the latter's arm draped over his companion's shoulders (p. 210). At same time, paints a few landscapes and works on paintings of nudes of monumental proportions, such as *Three Bathers* (p. 228), in which he distorts perspective in a humorous way.

SEPTEMBER: Still in Juan-les-Pins, produces series of drawings and a watercolor on theme of attempted rape of Hercules' bride Dejanira by the centaur Nessus (p. 226). Claims that mythological subjects come to him only in the South.

LATE SEPTEMBER: Returns to Paris.

Exhibitions during the year at Valori Plastici Gallery, Rome, and Galerie Paul Rosenberg, Paris.

1921

Published during the year are three volumes for which Picasso has executed portraits of the authors: Vincent Huidobro's *Saisons choisies* (Paris: La Cible), André Salmon's *Peindre* (Paris: Editions de la Sirène), and Paul Valéry's *La Jeune Parque* (Paris: La Nouvelle Revue Française).

FEBRUARY 4: Birth of son Paulo. Gertrude Stein (whose birthday is February 3) writes a birthday book for him. Picasso makes two self-portraits and portrait of a mother and child (p. 228).

MARCH 7–8: Four lithographs: *The Rider*, *The Wrestlers*, and *On the Beach* (two versions); issued by Galerie Simon under the title *Quatre Lithographies* in 1928.

APRIL: Publication of Maurice Raynal's *Pablo Picasso* (Munich: Delphin), the first monograph on the artist; published in France the following year (Paris: Crès).

MID-APRIL: Diaghilev, in need of decor

Self-Portrait (Profile).† [Paris], March 1921. Pencil, 10⅝ x 8¼" (27 x 21 cm). Zervos XXX, 149. Jan Krugier Gallery, Geneva

for a suite of Andalusian dances and songs, approaches Picasso about using an early version of his design for *Pulcinella*. He has first contacted Juan Gris, who, though recovering from a serious illness, meets with the director to discuss plans. Diaghilev apparently decides to go to Picasso instead, and to Gris's chagrin, Picasso agrees. Gris writes to Kahnweiler on April 29: "Picasso got away with it by producing a set of designs already made, saying that I would never be able to do it in so short a time."

MAY 22: First and only Paris performance of Diaghilev's *Cuadro Flamenco*, with decor and costumes by Picasso, folk music arranged by Manuel de Falla. Produced at Théâtre de la Gaîté-Lyrique, Paris.

MAY 30: Sale of Wilhelm Uhde's collection, sequestered by the French government during the war. Takes place at Hôtel Drouot. Contains 13 Picassos, including the Cubist portrait of Uhde (p. 139), *Girl with a Mandolin* of 1910 (p. 137), and an oval *Violin* of 1912. Event brings 247,000 francs, nearly three times the amount anticipated. Léonce Rosenberg, one of the sale's organizers, is slapped by Braque, who is outraged that a dealer would participate in an

Cover for program of ballet *Cuadro Flamenco*, with drawing by Picasso

event that might depress the artists' prices for their current work.

JUNE 13–14: First of four sales of works from Kahnweiler's gallery, sequestered by the government in 1914. Includes 36 paintings by Picasso, among them Cubist portrait of Kahnweiler (p. 142). The dealer buys back some of the works.

JUNE: Max Jacob writes to friends that he has retired to the country village of Saint-Benoît and is living in the rectory near a Romanesque cloister, in "a field of wheat at the edge of the Loire."

SUMMER: Picasso installs himself, Olga, and baby Paulo in a villa at Fontainebleau.

Paints two versions of *Three Musicians* (pp. 230, 231), both closely allied to Commedia dell'Arte gouaches of the previous summer. Maurice Raynal writes that they are "rather like . . . magnificent shop window[s] of Cubist inventions and discoveries."

Also paints the monumental *Three Women at the Spring* (p. 233), a neoclassic composition of three giant frieze-like figures. Monumental figures also appear in following months in pastel *Dancing Couple* (p. 234) and in paintings *The Reading of the Letter* (p. 234) and *Large Bather* (p. 235).

SEPTEMBER: Returns to Paris.

NOVEMBER 17–18: Second Kahnweiler sale at the Hôtel Drouot; includes 46 works by Picasso. (Third and fourth sales take place July 4, 1922, and May 7–8, 1923.) Picasso's Cubist paintings sell for far less than what his contemporary works are bringing.

1922

Publication of Pierre Reverdy's *Cravates de chanvre* (Paris: Editions Nord-Sud), for which Picasso makes three zinc etchings, including one of the author.

Portrait of Pierre Reverdy (frontispiece for *Cravates de chanvre*). 1922. Etching on zinc, 9⅛ x 6¼" (23.2 x 15.9 cm). The Museum of Modern Art, New York. Abby Aldrich Rockefeller Fund

BEGINNING OF YEAR: André Breton and Louis Aragon persuade collector and couturier Jacques Doucet to buy *Les Demoiselles d'Avignon*. He pays 25,000 francs.

APRIL: Tristan Tzara publishes a pamphlet, *Le Coeur à barbe: Journal transparent*, rebutting Dada declarations that Cubism is dead ("Cubists trying to keep Cubism alive are like Sarah Bernhardt"), and says: "As long as there are painters like Picasso, Braque, and Gris, . . . no one can speak of the death of Cubism without sounding like an idiot."

JUNE: Leaves for Dinard, in Brittany, with Olga and little Paulo. Paints *Women Running on the Beach* (p. 238) one of the last in series of monumental figure paintings. Image is used two years later on drop curtain for Diaghilev's *Train bleu*.

Invited by Diaghilev to design backdrop for new production of *L'Après-midi d'un faune*; submits a very simple design, which is rejected.

During summer, portrait of Olga and young Paulo, *Mother and Child* (p. 236).

LATE SEPTEMBER: Precipitous return to Paris: Olga has become ill and must have an operation.

AUTUMN: Exhibition at the Thannhauser gallery, Munich.

DECEMBER 20: First performance of Jean Cocteau's *Antigone* (after the play of Sophocles) at Théâtre de l'Atelier, Paris. Produced by Charles Dullin, with scenery by Cocteau and Picasso, costumes by Chanel. Set design not brought in by Picasso until a day or two before play opens. Dullin's assistant, Lucien Arnaud, describes that moment: "Picasso calmly produces from his pocket a scrap of white paper, deliberately crumpled. With his inimitable accent and an ironic expression he says: 'Here's the maquette.'"

1923

Catalan painter Jacinto Salvado, wearing costume Cocteau left behind during a visit to rue Schoelcher in 1916, poses for series of Harlequin portraits (pp. 240, 241), painted in neoclassic style.

Exhibition of drawings, Arts Club of Chicago.

MAY 19: Publication of Marius de Zayas's interview with Picasso in *The Arts* (New York). Interview takes place in Spanish and is published in English translation. Among other things, Picasso says that he can "hardly understand the importance given to the word *research* in connection with modern painting. . . . To find, is the thing."

JULY 7: "Soirée du 'Coeur à barbe,'" Dada event at the Théâtre Michel, with films by Hans Richter and Man Ray, music by Satie, Stravinsky, Darius Milhaud, and Georges Auric, and a performance of Tzara's *Coeur à gaz.* During course of evening someone shouts: "Picasso dead on the field of battle" (referring to the death of Cubism), which shocks Breton into jumping to the stage to come to his defense. Evening ends with the arrival of the police.

Portrait of André Breton (frontispiece for *Clair de terre*). 1923. Drypoint on copper, 12½ x 9⅜″ (31.8 x 23.8 cm). The Museum of Modern Art, New York. Gift of Victor S. Riesenfeld

SUMMER: Returning once more to the Riviera, takes family to Cap d'Antibes. Picasso's mother, Doña Maria, visits them, and he makes a portrait of her. The American painter Gerald Murphy has villa in Antibes, and Picasso is friendly with him and his beautiful wife (who appears in his drawings), as well as with Count Etienne de Beaumont. Meets Breton. Etches his portrait as frontispiece for the poet's *Clair de Terre* (Paris: Editions du Nord) later in year.

Paints *The Pipes of Pan* (p. 239).

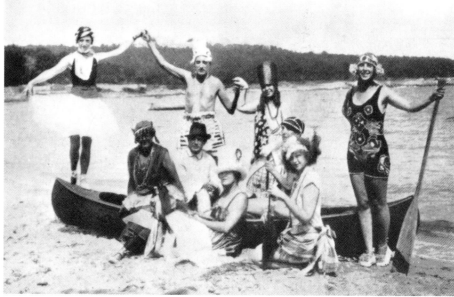

Party on beach at La Garoupe, Antibes, 1923. At left, Olga Picasso holding hand of Count Etienne de Beaumont; Picasso in center

Paulo on a donkey, 1923

SEPTEMBER: Returns to Paris.

NOVEMBER: 17: Exhibition of recent work at Paul Rosenberg/Wildenstein Gallery, New York; includes 16 works. Publication of Michel Georges-Michel's *Les Montparnos* (Paris: Arthème Fayard); 1920 gouache, *Pierrot and Harlequin* (p. 210), reproduced on cover of first edition.

Portraits of Paulo (on a donkey, after a photograph, p. 237; at a table drawing, p. 244) and of Olga in a pensive mood (p. 243).

Paulo on a Donkey (after a photograph).† Paris, 1923 (colorplate, p. 237)

1924

Makes large high-relief, painted metal construction, *Guitar* (p. 247).

Executes series of monumental still lifes in a bold, decorative Cubist mode, among them *The Red Tablecloth* (p. 248) and *Mandolin and Guitar* (p. 249).

Picasso with Gerald Murphy on beach at La Garoupe, Antibes, 1923

Bullfight.† [1922]. Oil and pencil on wood, 5⅜ x 7½″ (13.6 x 19 cm). Not in Zervos. Musée Picasso, Paris

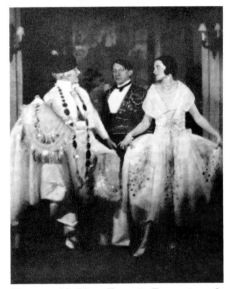

Picasso with Mme Eugenia Errazuriz and Olga Picasso at a ball given by Count Etienne de Beaumont, 1924, on occasion of first performance of *Mercure*. Photograph by Man Ray

APRIL: Exhibition at Paul Rosenberg's gallery on rue La Boëtie.

JUNE 18: First performance of the ballet *Mercure*, with decor and costumes by Picasso, music by Satie, and choreography by Massine; produced by Massine and Count Etienne de Beaumont as part of series of avant-garde programs entitled "Les Soirées de Paris." Performed at the Théâtre de la Cigale, Paris, the ballet, which is without plot, comprises three tableaux, "Night," "The Bath," and "Rape of Proserpine," for which Picasso creates *praticables,* movable scenery that can be manipulated by the dancers.

Several Surrealists protest Picasso's connection with event, describing it as a benefit for international aristocracy (program refers to it as benefit for Russian refugees); but Breton and other Surrealists, impressed with Picasso's innovative designs, publish a letter of apology in *Paris-Journal* of June 20. This "Hommage à Picasso" is signed by Aragon, Auric, André Boiffard, Breton, Robert Desnos, Joseph Delteil, Max Ernst, Francis Gérard, Max Morise, Pierre Naville, Benjamin Péret, Francis Poulenc, Soupault, and Roger Vitrac.

JUNE 20: First performance of *Le Train bleu* by Diaghilev's Ballets Russes, for which curtain is designed by Picasso (enlarged version of *Women Running on the Beach*, 1922, p. 238). Book is by Cocteau, with music by Milhaud, scenery by Henri Laurens, costumes by Chanel, and choreography by Bronislava Nijinska. Performed at Théâtre des Champs-Elysées, Paris.

SUMMER: Spends vacation with Olga and Paulo at Villa la Vigie, Juan-les-Pins. Fills sketchbook with some forty ink drawings of constellations of dots connected by networks of lines (pp. 248, 249). (Two pages are reproduced

in *La Révolution surréaliste* of January 15, 1925, and 16 pages are reproduced by woodcut for Balzac's *Le Chef-d'oeuvre inconnu,* published by Vollard in 1931.)

Portrait of Paulo as Harlequin (p. 245). (Following February, makes companion painting of Paulo as Pierrot; p. 244.)

OCTOBER: Publication of André Breton's *Manifeste du surréalisme* (Paris: Editions du Sagittaire), in which Surrealism is defined primarily in terms of automatism.

DECEMBER: Founding of the review *La Révolution surréaliste* (Paris), edited by Pierre Naville and Benjamin Péret. First issue reproduces the construction *Guitar* (p. 247) and a photo of Picasso by Man Ray.

Publication of Reverdy's *Pablo Picasso* (Paris: La Nouvelle Revue Française).

During year, publication of Reverdy's *Pablo Picasso* (Paris: La Nouvelle Revue Française) and of Cocteau's *Le Secret professional* (Paris: Stock), for which Picasso provides a portrait drawing of the author.

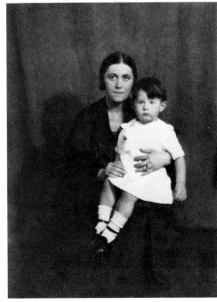

Olga Picasso and Paulo. Photograph by Man Ray, c. 1923

225

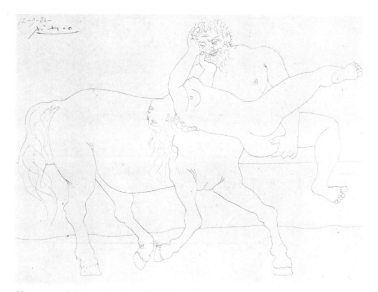

Nessus and Dejanira. Juan-les-Pins, September 12, 1920
Pencil, 8¼ x 10¼" (21 x 26 cm)
Zervos VI, 1394. The Museum of Modern Art, New York.
Acquired through the Lillie P. Bliss Bequest

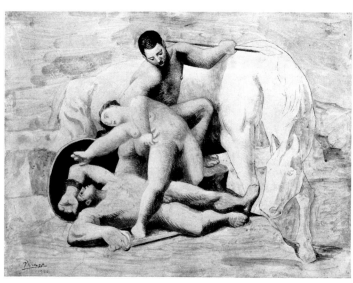

The Rape. Juan-les-Pins, 1920
Tempera on wood, 9⅜ x 12⅞" (23.8 x 32.6 cm)
Zervos IV, 109. The Museum of Modern Art, New York.
The Philip L. Goodwin Collection

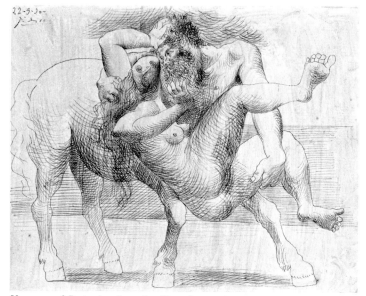

Nessus and Dejanira. Juan-les-Pins, September 22, 1920
Silverpoint on grounded paper, 8⅜ x 10⅝" (21.3 x 27 cm)
Zervos VI, 1395. The Art Institute of Chicago.
The Clarence Buckingham Collection

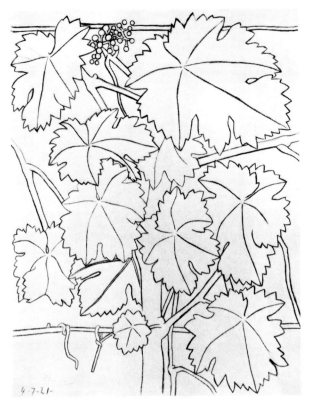

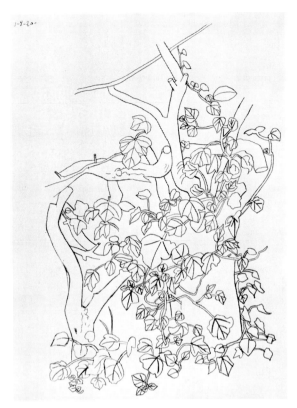

The Vine. Fontainebleau, July 4, 1921
Pencil and charcoal, 25¼ x 20¼″ (64 x 51.4 cm)
Zervos IV, 292
Collection Mr. and Mrs. Paul Osborn, New York

Branches and Leaves. Juan-les-Pins, August 1, 1920
Pencil, 19⅞ x 14½″ (50.5 x 36.7 cm)
Zervos IV, 129. Musée Picasso, Paris

Portrait of Erik Satie. Paris, May 19, 1920
Pencil on gray paper, 24½ x 18⅞″ (62.3 x 48 cm)
Zervos IV, 59. Musée Picasso, Paris

Portrait of Igor Stravinsky. Paris, May 24, 1920
Pencil on gray paper, 24⅜ x 19⅛″ (62 x 48.5 cm)
Zervos IV, 60. Musée Picasso, Paris

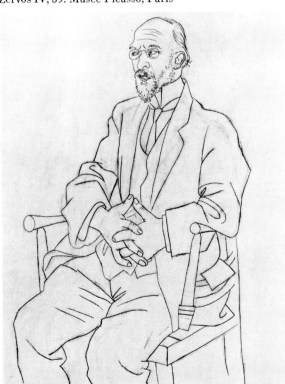

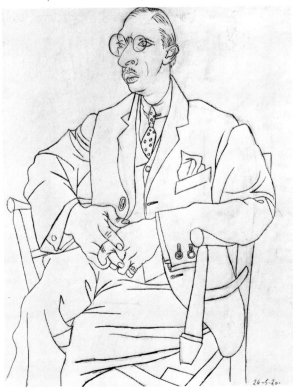

227

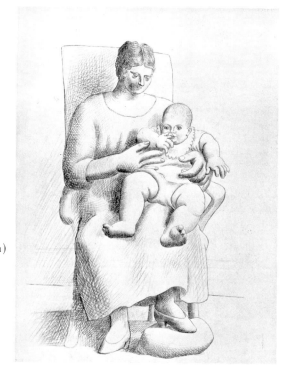

Mother and Child. Paris, 1921
Pencil, 25⅜ x 19½″ (64.5 x 49.5 cm)
Zervos IV, 294
Collection Bernard Picasso, Paris

Three Bathers. Juan-les-Pins, June 1920
(dated on painting 1923)
Oil and charcoal on wood, 31⅞ x 39⅜″ (81 x 100 cm)
Zervos IV, 169. Collection Stephen Hahn. New York

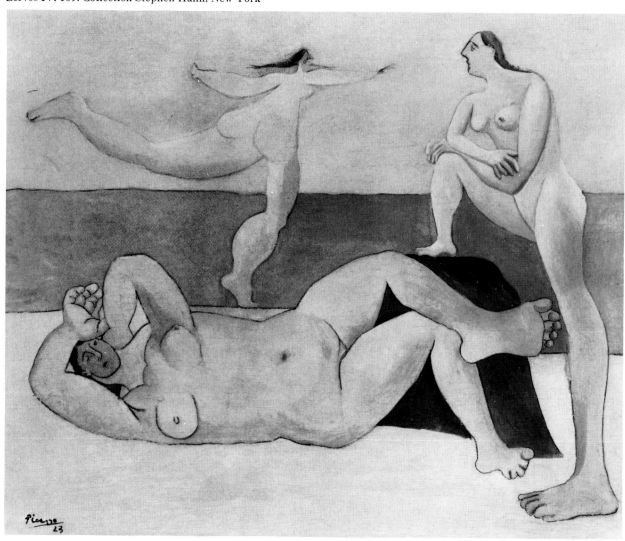

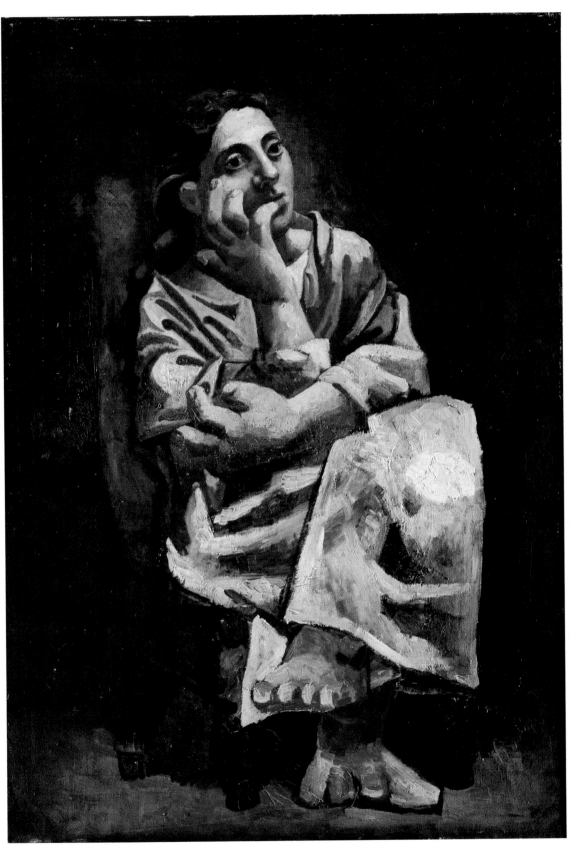

Seated Woman. Paris, 1920
Oil on canvas, 36¼ x 25⅝″ (92 x 65 cm)
Zervos IV, 179. Musée Picasso, Paris

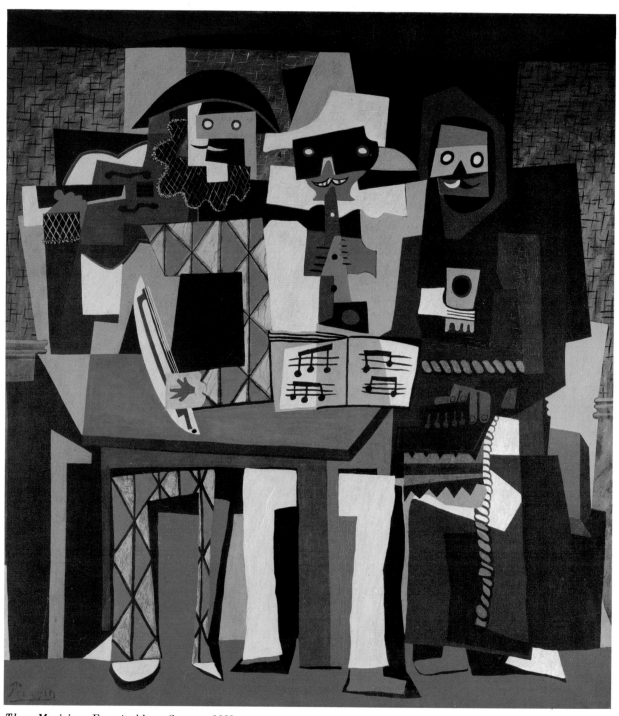

Three Musicians. Fontainebleau, Summer 1921
Oil on canvas, 80 x 74″ (203 x 188 cm)
Zervos IV, 332. Philadelphia Museum of Art. A. E. Gallatin Collection

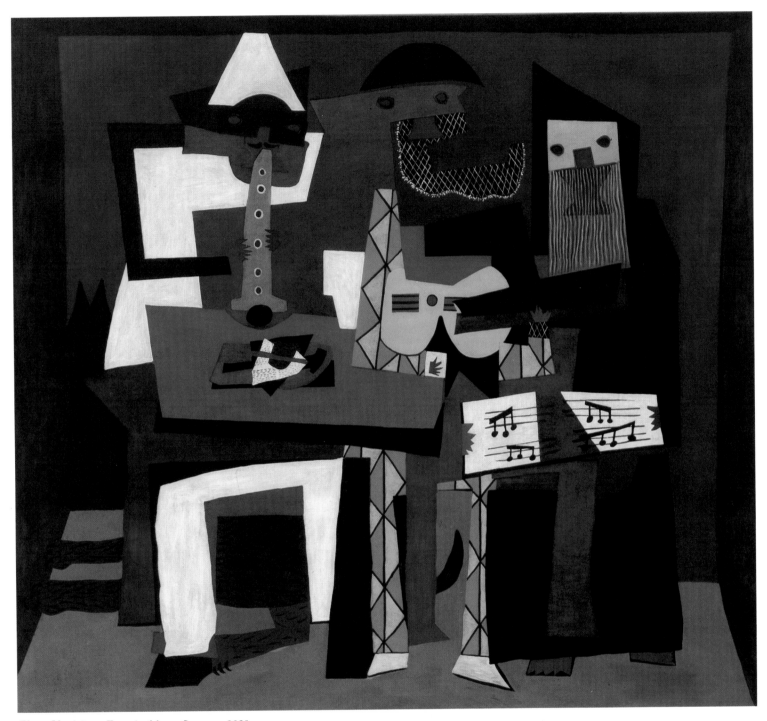

Three Musicians. Fontainebleau, Summer 1921
Oil on canvas, 79 x 87¾″ (200.7 x 222.9 cm)
Zervos IV, 331. The Museum of Modern Art, New York. Mrs. Simon Guggenheim Fund

Study for Three Women at the Spring
Fontainebleau, Summer 1921
Pencil on primed wood panel,
8½ x 10⅝″ (21.5 x 27 cm)
Not in Zervos. Musée Picasso, Paris

Hand Holding a Pitcher
(Study for Three Women at the Spring)
Fontainebleau, Summer 1921
Charcoal and sanguine,
12¾ x 9⅝″ (32.5 x 24.5 cm)
Zervos IV, 323. Musée Picasso, Paris

Hand Holding a Pitcher
(Study for Three Women at the Spring)
Fontainebleau, Summer 1921
Charcoal and sanguine,
9⅝ x 12⅝″ (24.5 x 32 cm)
Zervos IV, 326. Musée Picasso, Paris

Three Women at the Spring. Fontainebleau, Summer 1921
Sanguine and oil on canvas, 79⅛ x 63⅜″ (201 x 161 cm)
Not in Zervos. Musée Picasso, Paris

Hand (Study for Three Women at the Spring)
Fontainebleau, Summer 1921
Charcoal and sanguine,
9⅝ x 12⅝″ (24.5 x 32 cm)
Zervos IV, 325. Musée Picasso, Paris

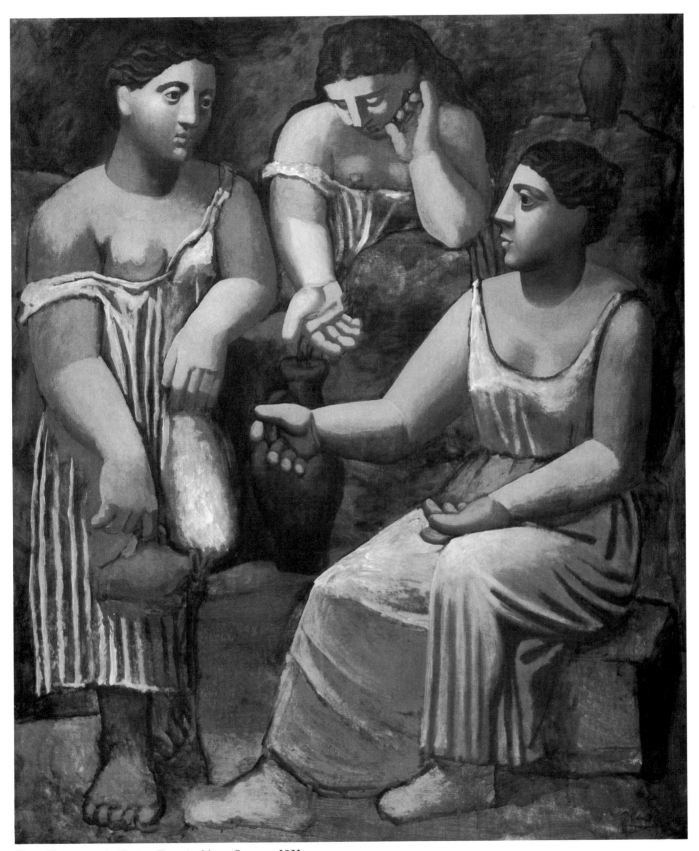

Three Women at the Spring. Fontainebleau, Summer 1921
Oil on canvas, 80¼ x 68½" (203.9 x 174 cm)
Zervos IV, 322. The Museum of Modern Art, New York. Gift of Mr. and Mrs. Allan D. Emil

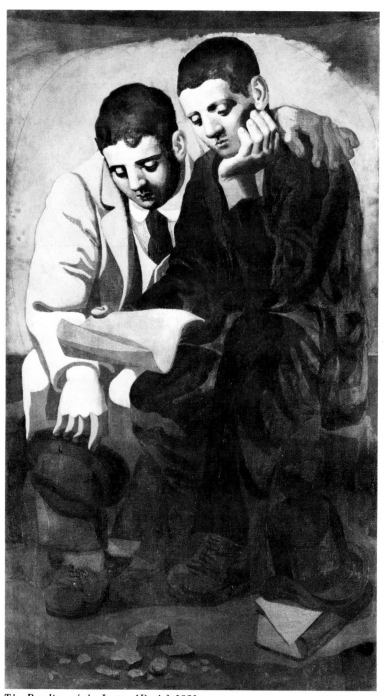

The Reading of the Letter. [Paris], 1921
Oil on canvas, 72½ x 41⅜″ (184 x 105 cm)
Not in Zervos. Musée Picasso, Paris

Dancing Couple. [Paris, 1921–22]
Pastel and oil on canvas, 55⅛ x 33⅝″ (140 x 85.5 cm)
Zervos XXX, 270. Musée Picasso, Paris

234

Large Bather
[Fontainebleau or Paris], 1921–22
Oil on canvas, 70⅞ x 38⅝″ (180 x 98 cm)
Zervos IV, 329. Musées Nationaux,
Paris. Ancienne Collection
Walter-Guillaume

Nude Seated on a Rock
Fontainebleau. Summer 1921
Oil on wood, 6¼ x 4⅜″
(15.8 x 11.1 cm)
Zervos IV, 309. The Museum of
Modern Art, New York.
James Thrall Soby Bequest

Nude with Drapery
Dinard, Summer 1922
Oil on panel, 7⅜ x 4⅞″
(18.8 x 12.2 cm)
Zervos IV, 382. Wadsworth
Atheneum, Hartford, Connecticut.
The Ella Gallup Sumner and Mary
Catlin Sumner Collection

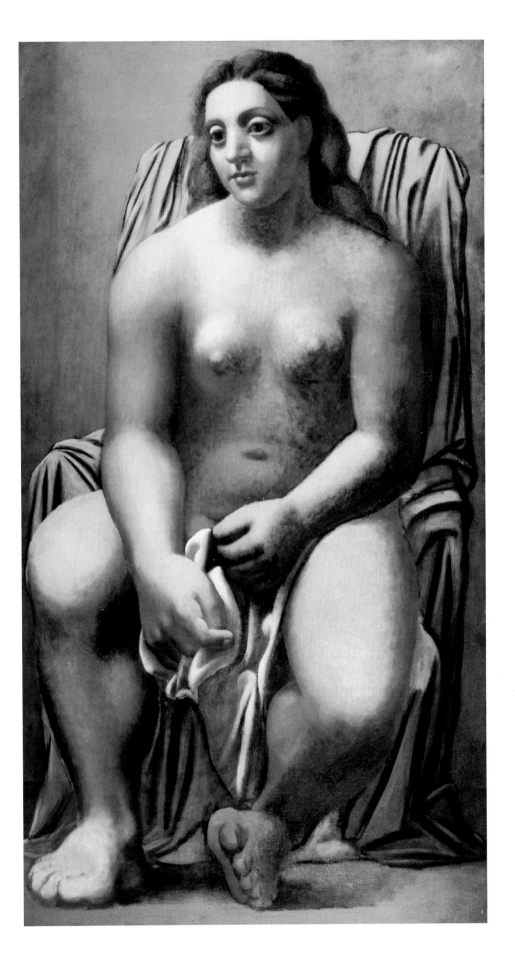

235

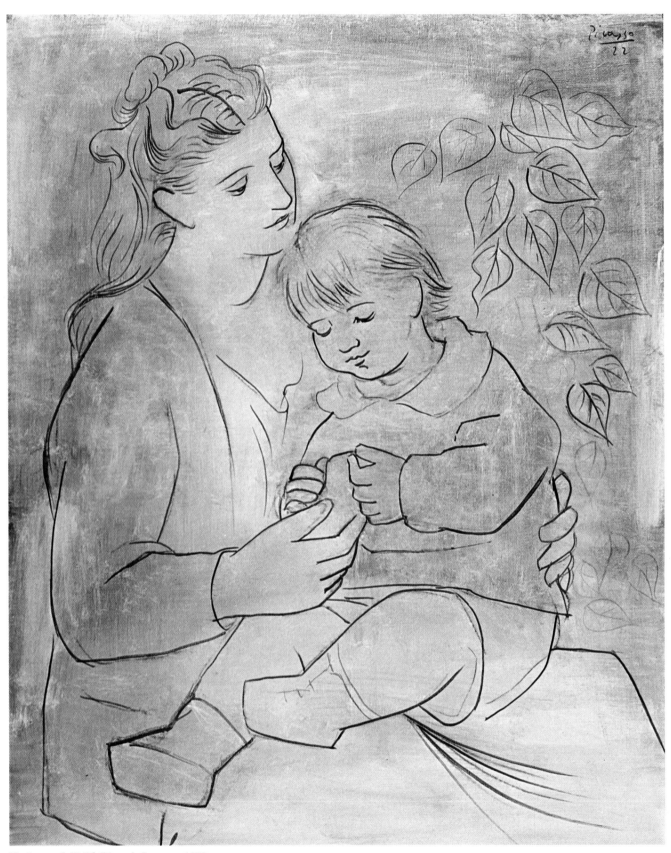

Mother and Child. Dinard, Summer 1922
Oil on canvas, 39⅜ x 32″ (100 x 81.1 cm)
Zervos IV, 371. The Baltimore Museum of Art. The Cone Collection,
formed by Dr. Claribel Cone and Miss Etta Cone of Baltimore, Maryland

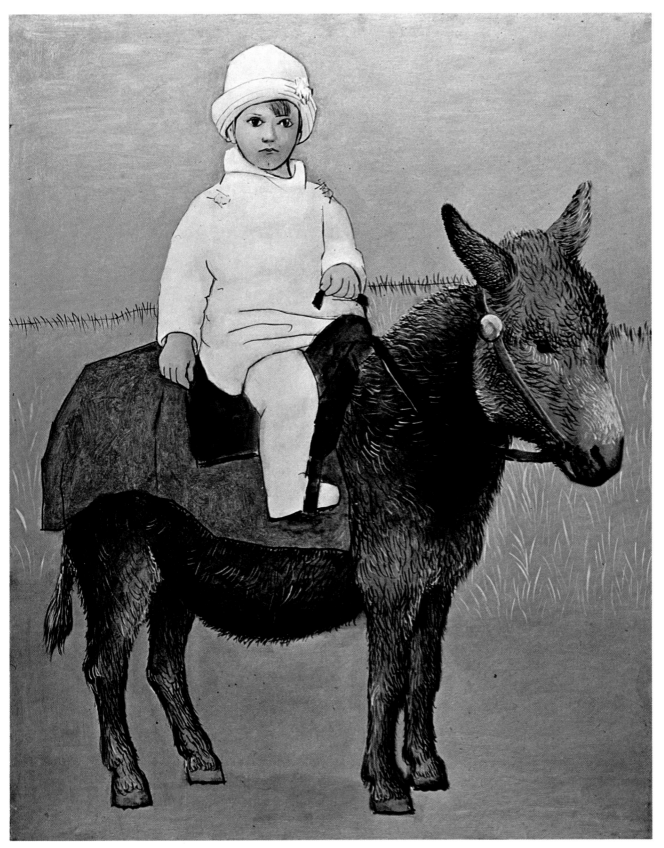

Paulo on a Donkey (after a photograph). [Paris], 1923
Oil on canvas, 39⅜ x 31⅞″ (100 x 81 cm)
Zervos VI, 1429. Collection Bernard Picasso, Paris

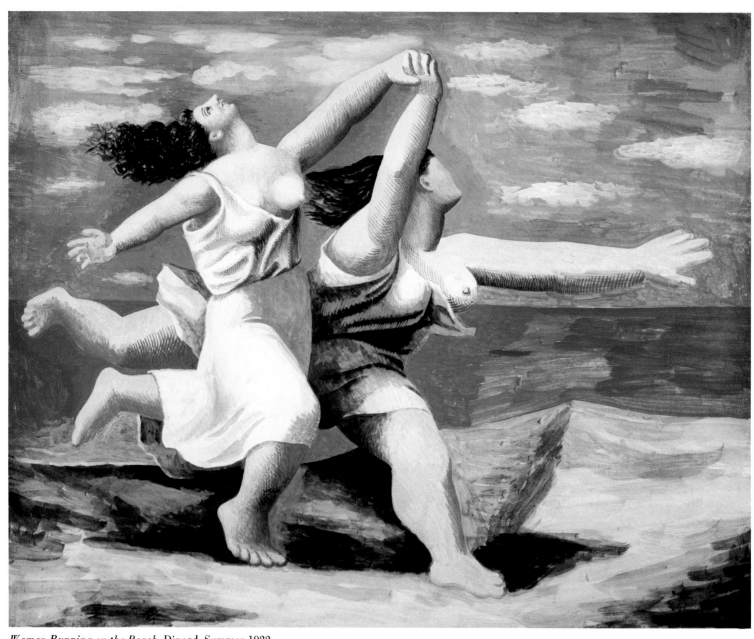

Women Running on the Beach. Dinard, Summer 1922
(used in 1924 for curtain of ballet *Le Train bleu*)
Oil on plywood, 13⅜ x 16¾" (34 x 42.5 cm)
Zervos IV, 380. Musée Picasso, Paris

238

The Pipes of Pan. Antibes, Summer 1923
Oil on canvas, 80¾ x 68¾" (205 x 174.5 cm)
Zervos V, 141. Musée Picasso, Paris

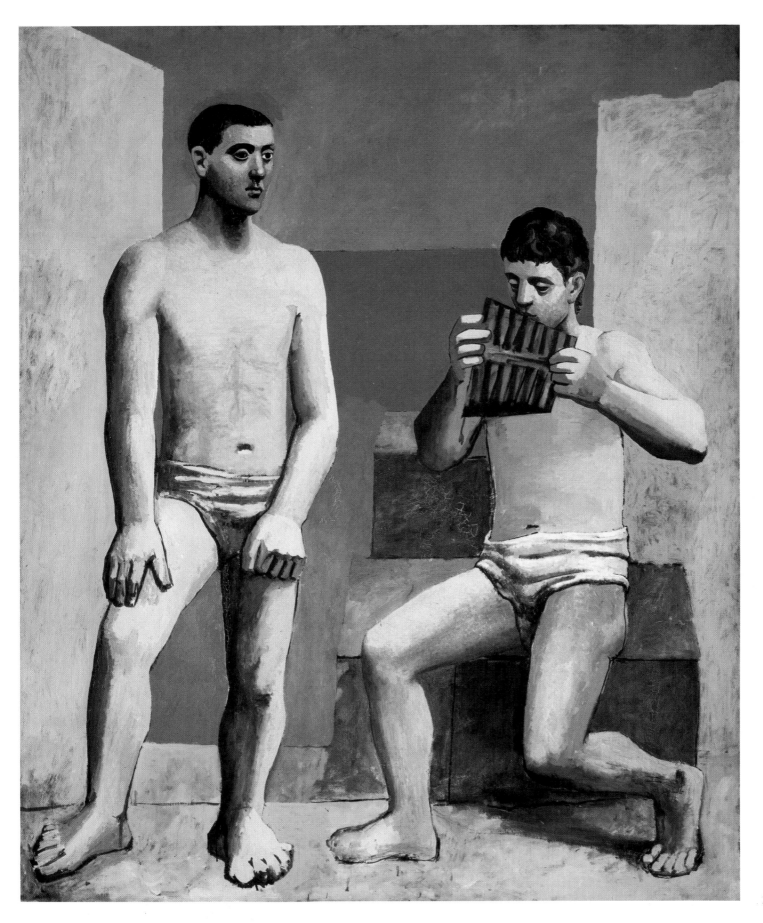

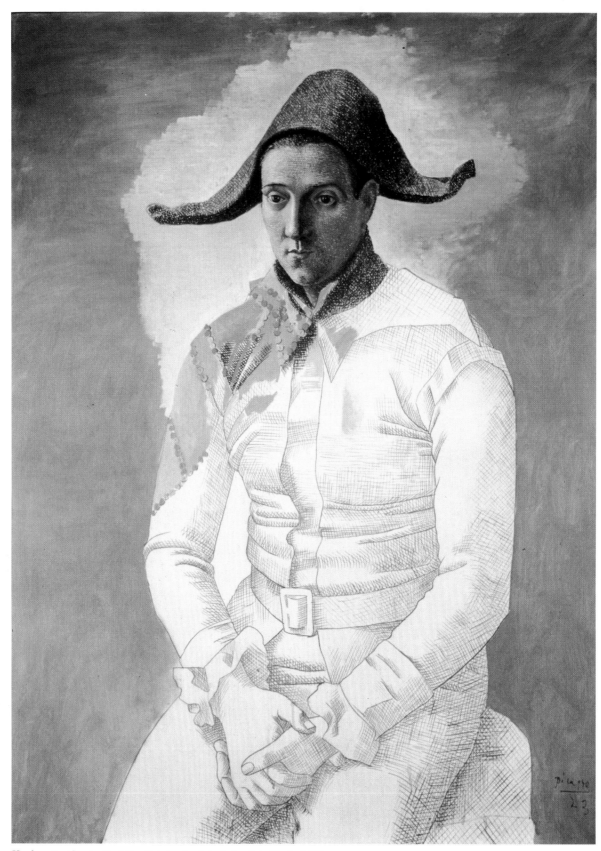

Harlequin (*Portrait of the Painter Jacinto Salvado*). Paris, 1923
Oil on canvas, 51¼ x 38¼″ (130 x 97 cm)
Zervos V, 17. Musée National d'Art Moderne, Centre National d'Art et de Culture Georges Pompidou, Paris

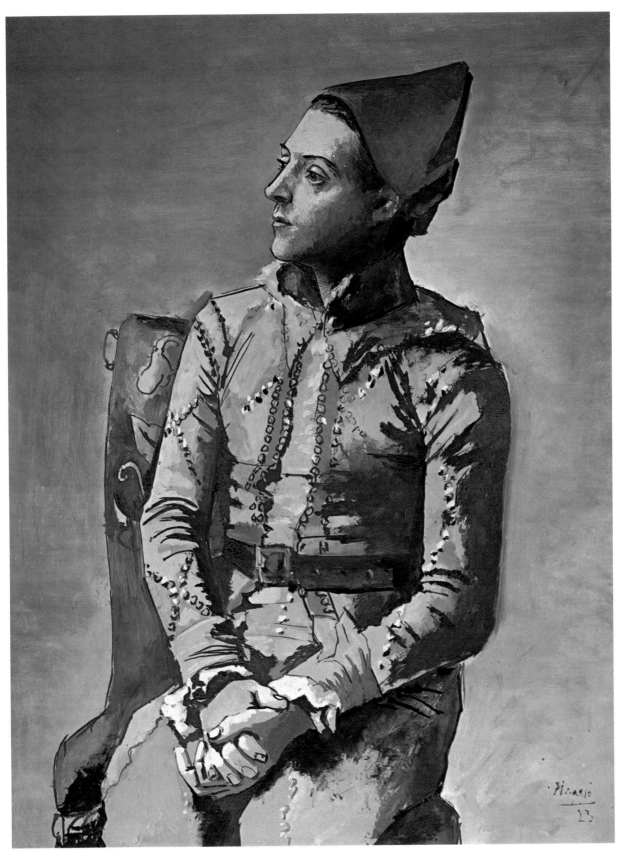

Seated Harlequin (Portrait of the Painter Jacinto Salvado). Paris. 1923
Tempera on canvas, 51⅜ x 38¼″ (130.5 x 97 cm)
Zervos V, 23. Kunstmuseum, Basel

Head of Young Man
[Paris or Antibes], 1923
Grease crayon,
24½ x 18⅝″ (62 x 47.3 cm)
Zervos V, 95. The Brooklyn Museum,
New York. Carll H. DeSilver Fund.

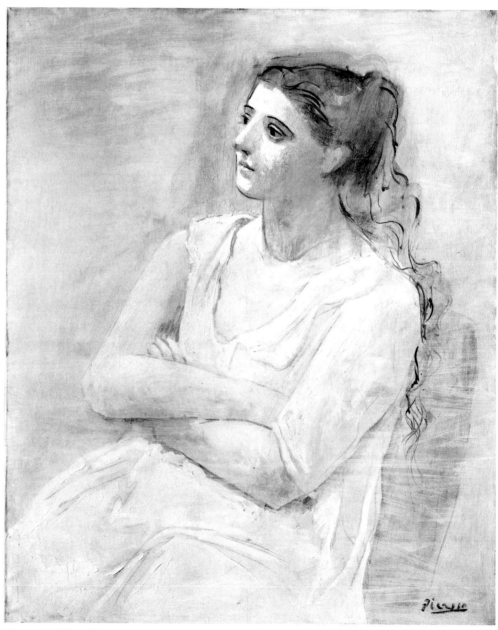

Woman in White. Paris, 1923
Oil on canvas, 39 x 31½″ (99 x 80 cm)
Zervos V, 1. The Metropolitan Museum of Art, New York.
Purchase, Rogers Fund

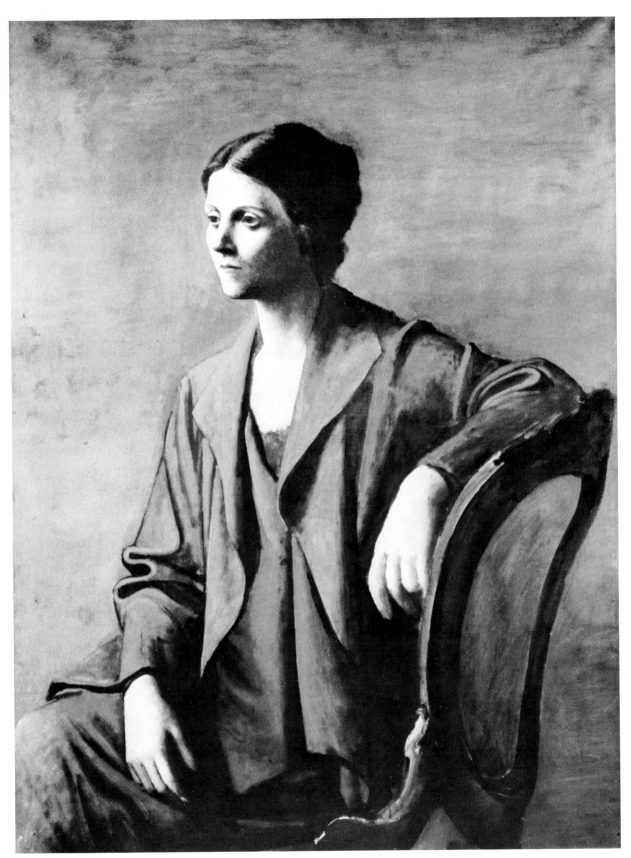

Olga Picasso. Paris, 1923
Oil on canvas, 51¼ x 38¼″ (130 x 97 cm)
Zervos V, 53. Private collection

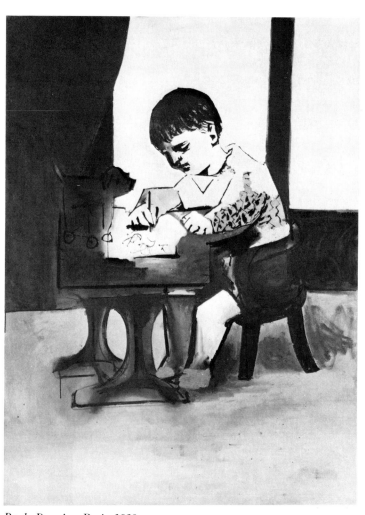

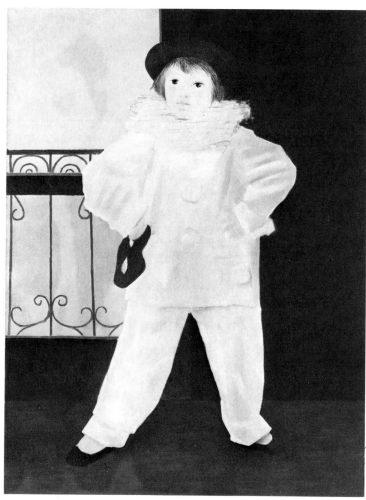

Paulo as Pierrot. Paris, February 28, 1925
Oil on canvas, 51¼ x 38⅛″ (130 x 97 cm)
Zervos V, 374. Musée Picasso, Paris

Paulo Drawing. Paris, 1923
Oil on canvas, 51¼ x 38⅜″ (130 x 97.5 cm)
Zervos V, 177. Musée Picasso, Paris

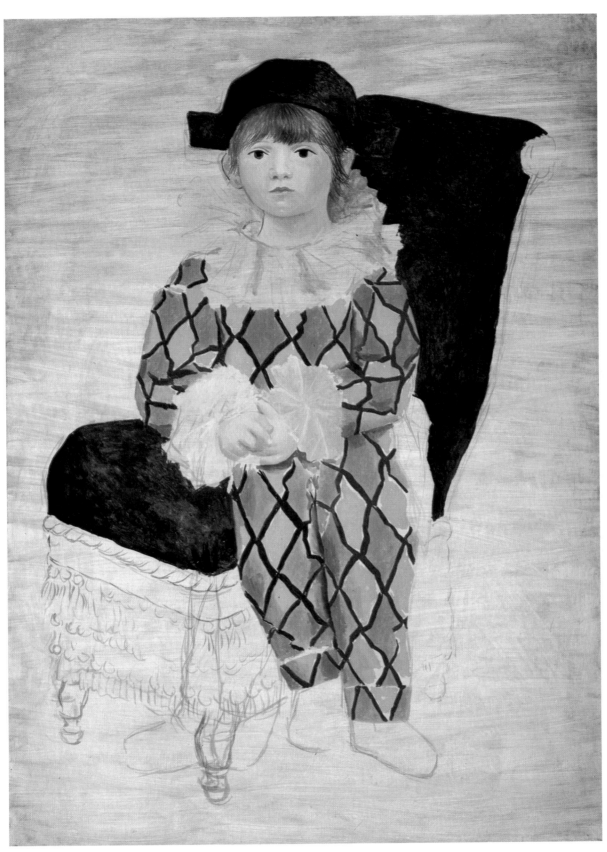

Paulo as Harlequin. Paris, 1924
Oil on canvas, 51¼ x 38⅜″ (130 x 97.5 cm)
Zervos V, 178. Musée Picasso, Paris

245

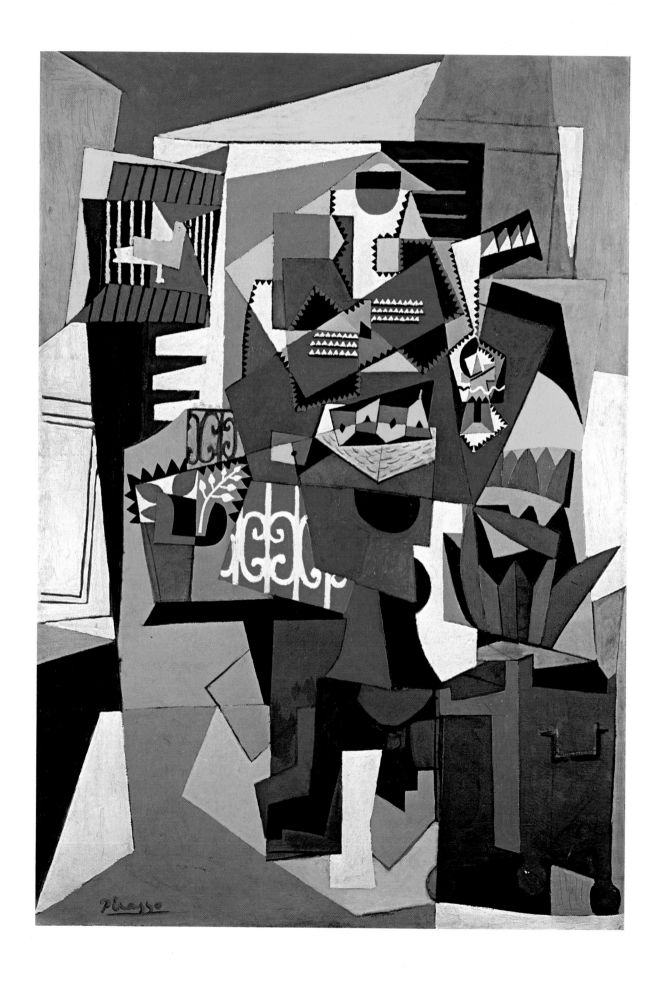

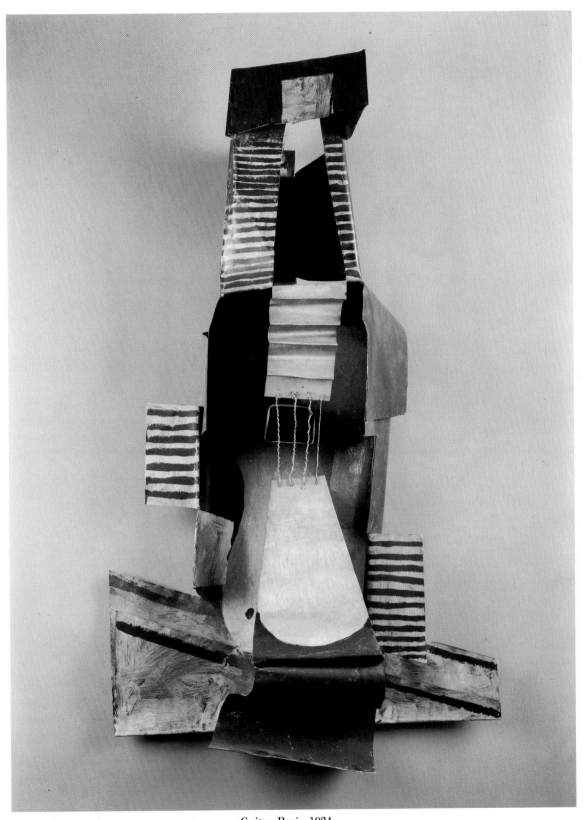

Guitar. Paris, 1924
Painted sheet metal and wire, 43¾ x 25 x 10½″ (111 x 63.5 x 26.6 cm)
Zervos V, 217. Spies 63. Musée Picasso, Paris

The Bird Cage. Paris, 1923
Oil and charcoal on canvas, 79⅛ x 55¼″ (200.7 x 140.4 cm)
Zervos V, 84. Collection Mr. and Mrs. Victor W. Ganz, New York

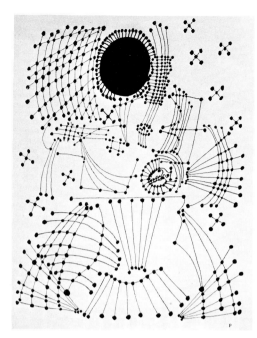

The Red Tablecloth. [Paris], 1924
Oil on canvas, 38¾ x 51¾" (98.5 x 131.5 cm)
Zervos V, 364. Private collection, New York

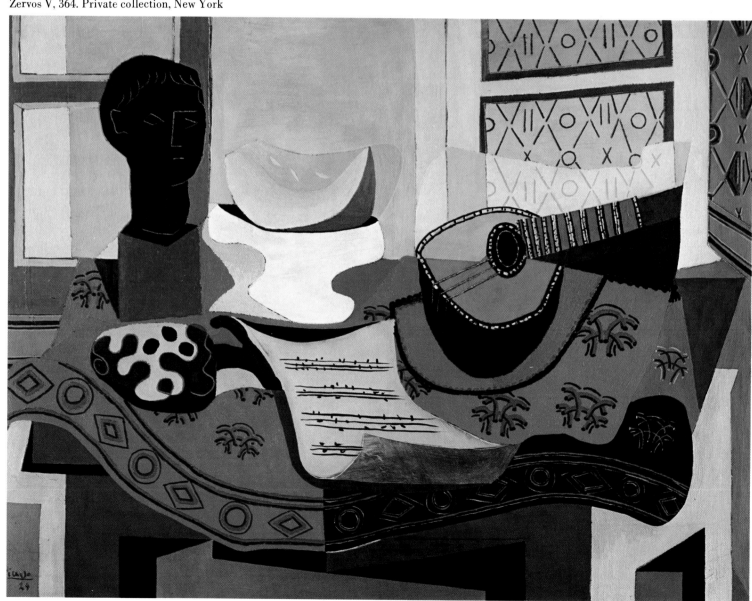

OPPOSITE AND LEFT:
Wood engraving after drawings of 1924,* from *Le Chef-d'oeuvre inconnu*,
by Honoré de Balzac. Published Paris, Ambroise Vollard, 1931
Each page, 13 x 10″ (33 x 25.5 cm)
The Museum of Modern Art, New York. The Louis E. Stern Collection

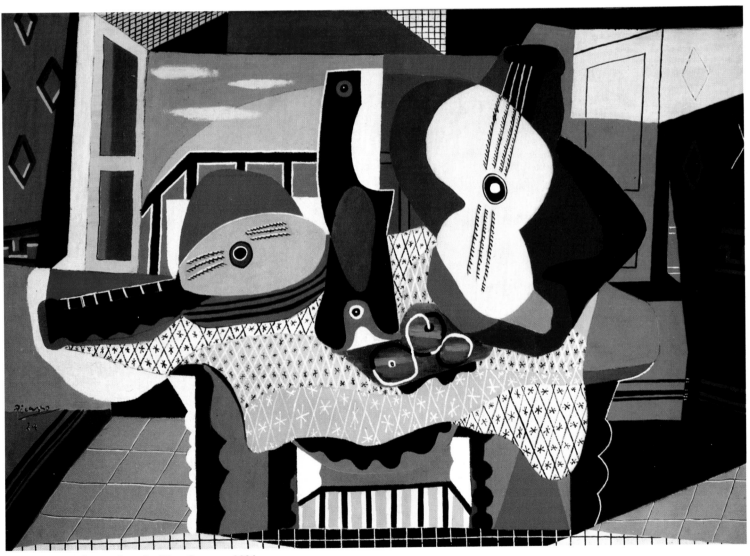

Mandolin and Guitar. Juan-les-Pins, Summer 1924
Oil and sand on canvas, 55⅝ x 78⅞″ (140.6 x 200.2 cm)
Zervos V, 220. The Solomon R. Guggenheim Museum, New York

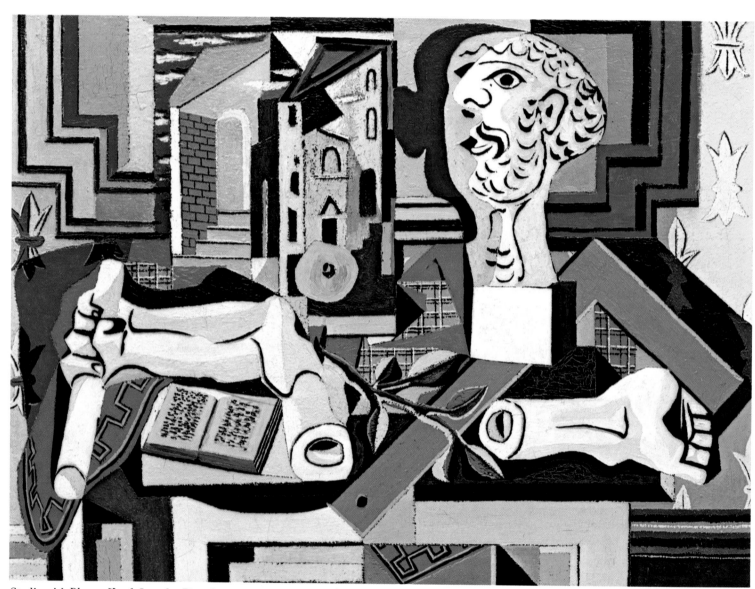

Studio with Plaster Head. Juan-les-Pins, Summer 1925
Oil on canvas, 38⅝ x 51⅝″ (98.1 x 131.2 cm)
Zervos V, 445. The Museum of Modern Art, New York. Purchase

1925-1929

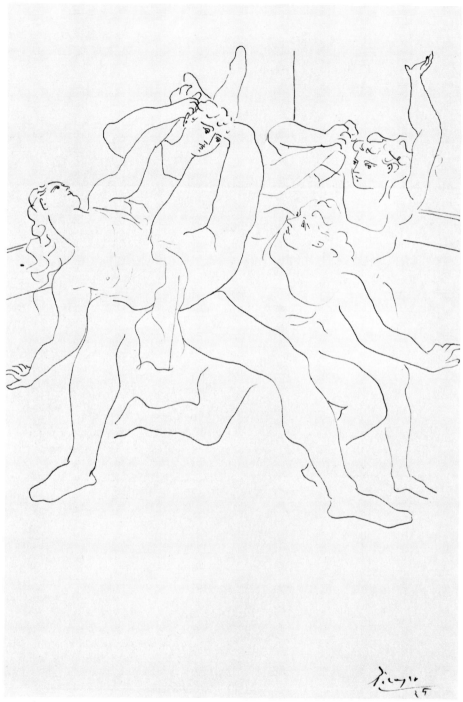

Four Dancers.† Monte Carlo, Spring 1925. Pen and ink, 13⅞ x 10″ (35.3 x 25.5 cm).

Zervos V, 422. The Museum of Modern Art, New York. Gift of Abby Aldrich Rockefeller

1925

JANUARY 15: Second issue of *La Révolution surréaliste* reproduces two pages of drawings from Juan-les-Pins sketchbook of previous summer.

SPRING: Begins work on *The Dance.*

MARCH–APRIL: Visits Monte Carlo with Olga and Paulo during Ballets Russes season. Makes drawings of dancers in classical style.

JUNE: Completes *The Dance* (p. 256). The antithesis of his classical drawings of dancers, the painting is strongly Expressionist in character. Painted at a time when marriage to Olga is becoming an increasing source of irritation and unhappiness, it is completed shortly after the death of his old friend Ramón Pichot, commemorated in profile in the window at right.

JULY 1: Death of Erik Satie.

JULY 15: Fourth issue of *La Révolution surréaliste* reproduces for first time *Les Demoiselles d'Avignon* (p. 99) as well as the recently completed *Dance.* Breton begins to publish sections of "Le Surréalisme et la peinture" in same issue, invoking name of Picasso in the cause of Surrealism: "We claim him as one of ours, even though it is impossible— and would be impudent, furthermore —to apply to his means the rigorous critique that elsewhere we propose to institute. Surrealism, if one must assign it a line of moral conduct, has but to pass where Picasso has already passed, and where he will pass in the future."

SUMMER: Vacations with Olga and Paulo at Juan-les-Pins. Paints *Studio with Plaster Head* (p. 250), complex composition built around Paulo's toy theater; motif of double head reappears in a sculptured head with segmented plaster arms. Head and arms anticipate fragmented soldier of *Guernica.* In *Woman with Sculpture* (p. 258), it is the woman who has the double head and not the sculpture. Also paints *The Embrace* (p. 257), the most expressionist and unleashed of Picasso's pictures and even more aggressive in spirit than *The Dance.*

NOVEMBER 14: Opening of the exhibition "La Peinture Surréaliste," first group exhibition of Surrealist painting, at Galerie Pierre, Paris. Picasso is represented, along with Jean Arp, Giorgio de Chirico, Ernst, Paul Klee, André Masson, Miró, Man Ray, and Pierre Roy. Shows Cubist pictures only.

Published during the year are Raymond Radiguet's *Les Joues en feu* (Paris: Bernard Grasset) and Reverdy's *Ecumes*

de mer (Paris: La Nouvelle Revue Française), both of which contain a portrait drawing of the author by Picasso.

1926

JANUARY: First issue of *Cahiers d'art* (Paris), subtitled "A Monthly Bulletin of Artistic Topics." Founded by Christian Zervos, marks beginning of long relationship with Picasso, whose work becomes the focus of Zervos's life. Early staff and contributors include Jean Cassou, Elie Faure, and E. Tériade.

BEGINNING OF YEAR: Paints *The Milliner's Workshop* (p. 262), grisaille work in which patterns of a curvilinear Cubism are exploited for their decorative, gestural rhythms. Later executes *Painter and Model* (p. 263), also in grisaille tones.

SPRING: Creates group of almost totally abstract collages on Guitar theme, one from an old shirt, another (p. 261) made from a coarse cloth used to wipe up the floor and perforated with nails pointing toward the viewer. Another (p. 260), in which a knitting needle pierces a cloth tacked on board, is illustrated in June 15 issue of *La Révolution surréaliste*.

JUNE: Exhibition at Paul Rosenberg's gallery, at which work of past twenty years is shown.

JULY: Waldemar George publishes 64 Picasso drawings in *L'Amour de l'art* (Paris). Published as separate volume, *Picasso dessins*, later in year (Paris: Editions des Quatre Chemins).

SUMMER: Vacations in Juan-les-Pins, where he paints large still life *Musical Instruments on a Table* (p. 259).

OCTOBER: Trip to Barcelona.

During year Diaghilev, in need of money, sells bullfight section from drop curtain of *Le Tricorne* and four sections of scenery from *Cuadro Flamenco*.

Publication of Cocteau's *Rappel à l'ordre* (Paris: Stock), collection of seven critical works, including essay "Picasso." Book becomes central document in Catholic neoclassic revival led by Jacques Maritain.

Picasso at Juan-les-Pins, 1926. Photograph by Man Ray. The Museum of Modern Art, New York. Gift of Mr. and Mrs. Alfred H. Barr, Jr.

1927

JANUARY: Meets seventeen-year-old Marie-Thérèse Walter in front of Galeries Lafayette, Paris. Many years later she recalls how he introduced himself: "Mademoiselle, you have an interesting face. I would like to make your portrait. I am Picasso." The name means nothing to her, but six months later they become lovers. First known painting of Marie-Thérèse dates only from 1932, perhaps because Picasso, still officially with Olga, does not wish liaison to become known; however, *Still Life on a Pedestal Table* of 1931 (p. 274) is a secret portrait.

MAY 11: Death of Juan Gris. Picasso pays condolence call on Gertrude Stein, who has remained close to him. Recollection from the *Autobiography of Alice B. Toklas*: "At one time Gertrude Stein said to him [Picasso] bitterly, you have no right to mourn, and he said you have no right to say that to me. You never realized his meaning because you did not have it, she said angrily. You know very well I did he replied."

JULY: Exhibition at Paul Rosenberg's gallery.

SUMMER: Vacations at Cannes with Olga and Paulo. Executes album of pen-and-ink drawings, *The Metamorphoses*, in which biomorphic bathers are given elephantine sculptural shapes, their sexual attributes reaching monumental proportions. Although probably intended as studies for a monument to Apollinaire, Zervos writes in 1929 that Picasso is proposing them as monuments to line the Croisette, the elegant promenade separating the beach from the great hotels in Cannes.

AUTUMN: Returns to Paris. Paints *Seated Woman* (p. 262), continuing a series begun in 1925. Explores double-head motif.

OCTOBER 16–NOVEMBER 10: Exhibition of drawings, watercolors, and pastels from 1902–27 at Galerie Alfred Flechtheim, Berlin. Also includes four bronzes and twenty prints.

WINTER: Begins work on *The Studio*.

Pursues Studio theme not only in paintings but in etchings as well. Commissioned by Vollard the year before to illustrate *Le Chef-d'oeuvre inconnu* by Balzac, makes first etchings for the book, which is published in 1931. One etching (p. 263) shows realistically drawn painter creating image of realistically drawn model in a highly abstract manner. (Dot-and-line drawings of 1924 were translated into woodcuts in 1926; pp. 248, 249.)

DECEMBER 27–FEBRUARY 28, 1928: One-man exhibition at Galerie Pierre, Paris.

1928

JANUARY 1: Executes large collage on canvas, *Minotaur* (p. 270), consisting of two legs emanating from a bull's head. It marks the first appearance of the Minotaur theme in his work, one he will pursue more and more frequently in the following years.

BEGINNING OF YEAR: Models the biomorphic *Bather (Metamorphosis I)* (p. 266), his first three-dimensional sculpture since 1914. Based on drawings from Cannes the previous summer, it is reproduced in *Cahiers d'art* later in the year.

Marie-Thérèse Walter, c. 1927 in a studio
photograph by an unidentified photographer

Study for Sculpture. Paris, March 20, 1928.
Pen and ink, 10⅜ x 14″ (26.5 x 35.5 cm).
Zervos VII, 140

from Barcelona whom he first met in
1902. Gonzalez has been living in Paris
since turn of century, earning his liveli-
hood primarily by making decorative
metalwork. Picasso perhaps approaches
him for assistance on Apollinaire mon-
ument project.

MARCH 20: Ink drawing leading to
painted metal sculpture *Head.*

MAY 14: Sends letter of condolence to
Gonzalez on occasion of his mother's
death. Has been frequenting Gonzalez's
studio on rue de Médéah to learn weld-
ing technique.

SUMMER: Vacations at Dinard, in Brit-
tany, with Olga and Paulo—and, clan-
destinely, with Marie-Thérèse, whom he
settles there as well. Continuing draw-

Study for Sculpture. Dinard, August 3, 1928.
Pen and ink, 11¾ x 8⅝″ (30 x 22 cm).
Zervos VII, 206

Completes *The Studio*, begun a few
months earlier (p. 268). Its linear
scaffolding of simple geometric forms
is echoed in drawings for wire sculpture
he makes later this year.

Reworking the Studio theme, executes
Painter and Model (p. 269), in which
an abstractly imaged painter draws an

abstractly imaged model as a realistic
profile, reversing situation of Balzac
etching of year before. Head of painter
bears close resemblance to painted metal
sculpture *Head* completed in the fall
(p. 269).

MARCH: About this time, renews ac-
quaintance with Julio Gonzalez, sculptor

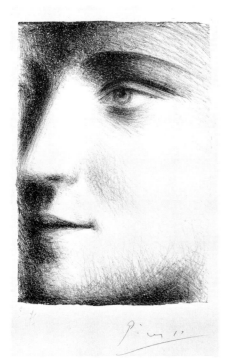

Visage (Face). 1928. Lithograph, 8 x 5½" (20.4 x 14.2 cm). The Museum of Modern Art, New York. Gift of Mrs. John D. Rockefeller

ings for imaginary monument, makes another series (one, p. 265), these even more volumetric than figures from 1927.

Beach inspires series of small canvases of Bathers at play (p. 265), leading to frolicsome *Swimmer* (p. 271) of the following year.

AUGUST 3: Executes drawing for a linear sculpture, which he makes after return to Paris.

OCTOBER: Working in Gonzalez's studio on rue de Médéah, completes metal sculpture *Head* (p. 269); also finishes *Wire Construction*, his first of four metal-rod sculptures (pp. 267, 268), which Kahnweiler likens to drawing in space. (He submits two of these sculptures, with accompanying drawings, as possible maquettes for the monument to Apollinaire, intending that it be a work over ten feet high; but the committee planning the monument turns them down as too radical.)

Zervos publishes "Sculptures des peintres d'aujourd'hui," in *Cahiers d'art*

(vol. 3, no. 7). Two versions of *Bather (Metamorphosis)* (p. 266), completed earlier that year, are reproduced along with three modeled sculptures from 1905–09, a construction of late 1913, and two versions of *Glass of Absinth* of 1914.

Publication of Wilhelm Uhde's *Picasso et la tradition française* (Paris: Editions des Quatre Chemins), in which he examines Picasso's role in French art.

NOVEMBER 26: Tériade, writing in *L'Intransigéant*, publishes "Visite à Picasso," recounting what artist told him on occasion of showing him wire sculptures and 1927 sketchbook from Cannes: "There is not a painting or drawing of mine that does not exactly reproduce a vision of the world. I would like some day to exhibit my synthetic-form designs alongside those of the same things I did classically. You would see my concern for exactness. . . ."

Publication of André Level's *Picasso* (Paris: Crès), for which the artist made the lithograph *Visage* the previous summer (probably modeled after the face of Marie-Thérèse Walter).

1929

WINTER: Continues to work in Gon-

zalez's studio. *Cahiers d'art* (vol. 4, no. 2–3) reproduces *Head* (p. 269) and *Wire Construction* (p. 267) from previous October. Begins work on the large metal sculpture *Woman in a Garden* (p. 282).

FEBRUARY: Paints *Bust of a Woman with Self-Portrait* (p. 272), in which a savage female head with voracious jaws is imposed against a classic profile of himself. Over following months produces many other works containing similarly aggressive women; images reflect tension in his marriage to Olga.

MAY: Paints *Nude in an Armchair* (p. 273). Makes the transfer lithograph *Figure*, one of his Metamorphic Bathers, for subscribers of review *Le Manuscrit autographe* (Paris).

Zervos publishes "Projets de Picasso pour un monument," in *Cahiers d'art* (vol. 4, no. 8–9), reproducing his drawings for an imaginary monument from the summer 1928 series.

SUMMER: Returns to Dinard for vacation. Paints *Bather with Beach Ball* (p. 272).

NOVEMBER: Opening of The Museum of Modern Art, New York.

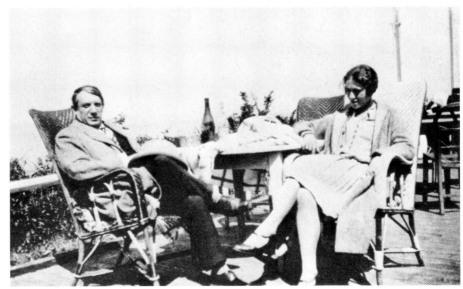

Picasso and Olga at Cannes, Summer 1927

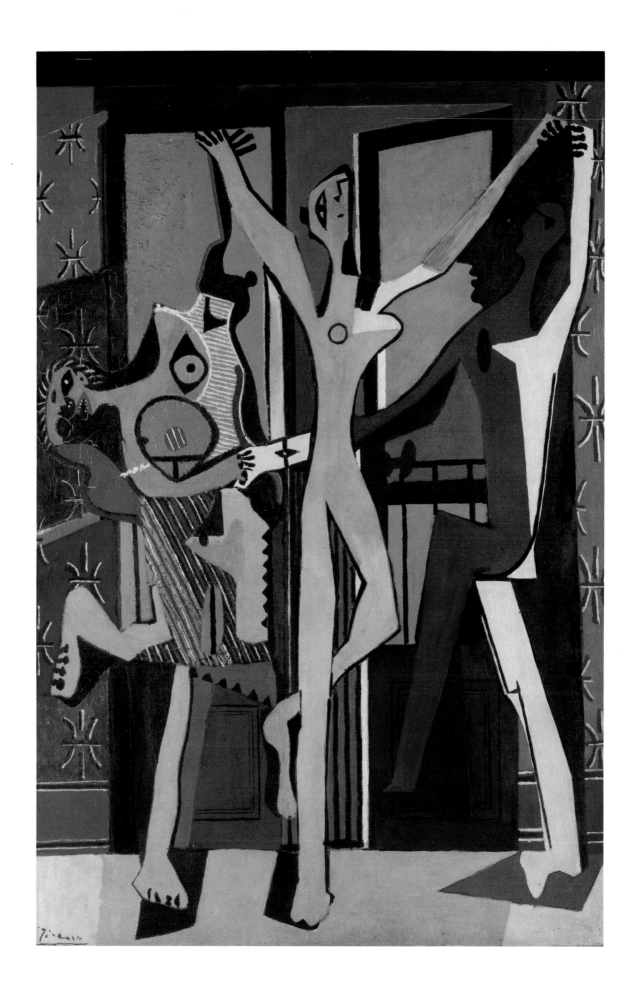

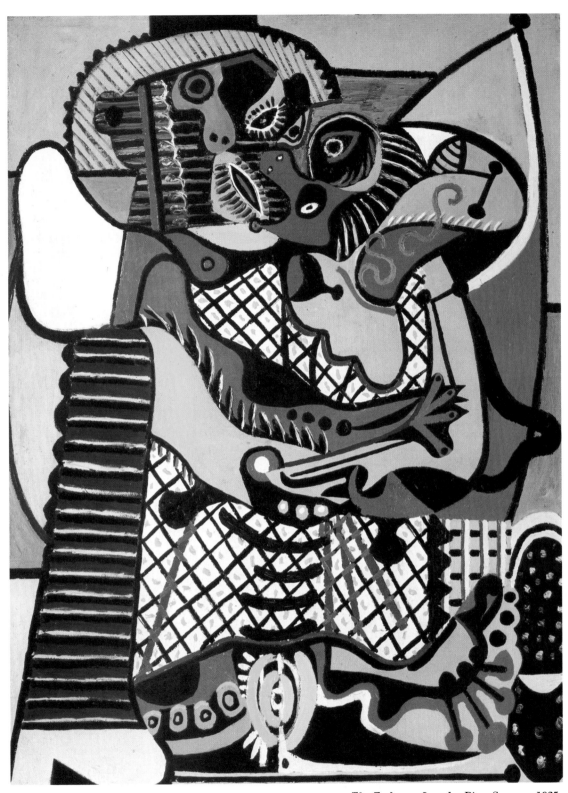

The Embrace. Juan-les-Pins, Summer 1925
Oil on canvas, 51¼ x 38⅛″ (130 x 97 cm.)
Zervos V, 460. Musée Picasso, Paris

The Dance. Monte Carlo, June 1925
Oil on canvas, 84⅝ x 55⅞″ (215 x 142 cm)
Zervos V, 426. The Tate Gallery, London

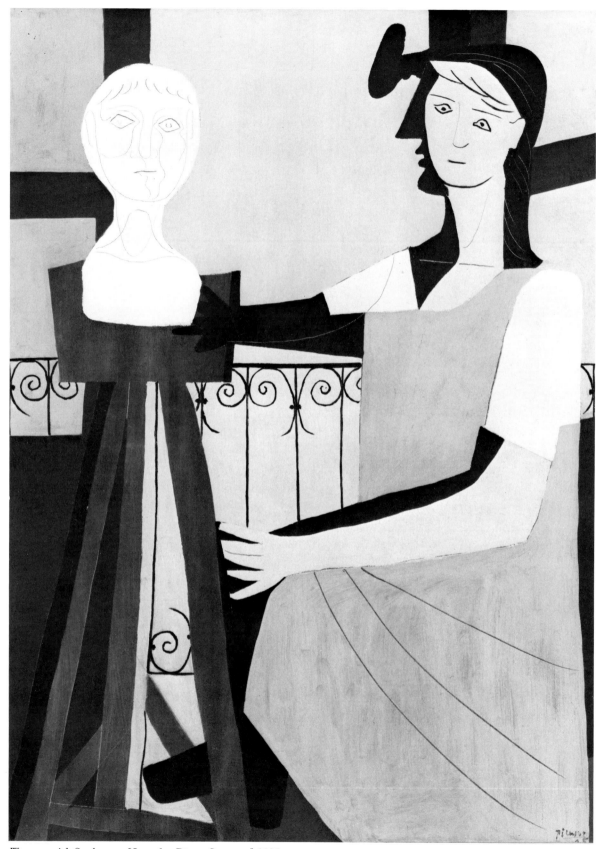

Woman with Sculpture. [Juan-les-Pins, Summer] 1925
Oil on canvas, 51⅝ x 38⅛" (131 x 97 cm)
Zervos V, 451. Collection Mr. and Mrs. Daniel Saidenberg, New York

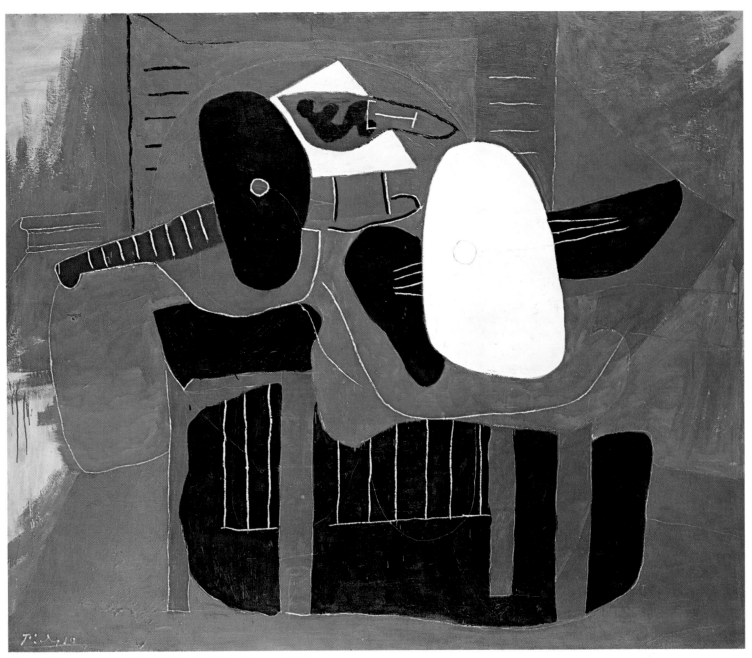

Musical Instruments on a Table. Juan-les-Pins, Summer 1926
Oil on canvas, 66⅛ x 80¾″ (168 x 205 cm)
Zervos VII, 3. Galerie Beyeler, Basel

ABOVE LEFT:
Guitar. Paris, April 3, 1926
Assemblage of tulle, cardboard, and string on
cardboard, 5¾ x 3¾″ (14.7 x 9.5 cm)
Not in Zervos. Musée Picasso, Paris

ABOVE RIGHT:
Guitar. Paris, May 1926
Assemblage of cardboard, tulle, and string with pencil
on cardboard, 4⅛ x 4¾″ (10.3 x 12 cm)
Not in Zervos. Musée Picasso, Paris

OPPOSITE, ABOVE LEFT:
Guitar. Paris, May 1926
Assemblage of string, button, and tulle with
pencil and oil on cardboard, 5⅝ x 4″ (14.2 x 10 cm)
Zervos VII, 21. Spies 65. Musée Picasso, Paris

OPPOSITE, ABOVE RIGHT:
Guitar. Paris, May 1926
Assemblage of string, nails, and button with pencil,
ink, and oil on cardboard, 9¾ x 4⅞″ (24.7 x 12.3 cm)
Not in Zervos. Musée Picasso, Paris

Guitar. Paris, Spring 1926
Assemblage of canvas, nails, string, and knitting
needle on painted wood, 51¼ x 38⅛″ (130 x 97 cm)
Not in Zervos. Musée Picasso, Paris

Guitar. Paris, Spring 1926
Assemblage of cloth, paper, string, and nails on painted canvas, 38⅜ x 51¼″ (97.5 x 130 cm)
Zervos VII, 9. Musée Picasso, Paris

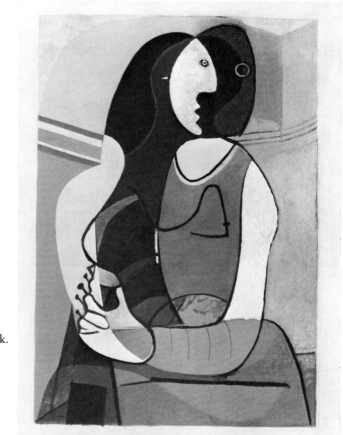

Seated Woman. Paris, 1927
Oil on wood, 51⅛ x 38¼″ (129.9 x 97.2 cm)
Zervos VII, 77. The Museum of Modern Art, New York.
James Thrall Soby Bequest

The Milliner's Workshop. [Paris], January 1926
Oil on canvas, 67¾ x 100⅞″ (172 x 256 cm)
Zervos VII, 2. Musée National d'Art Moderne, Centre
National d'Art et de Culture Georges Pompidou, Paris

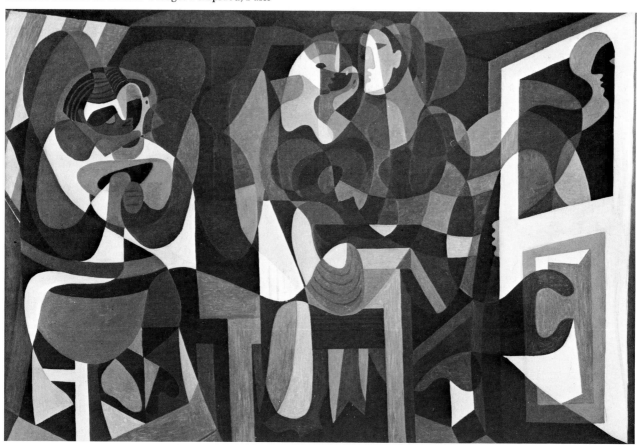

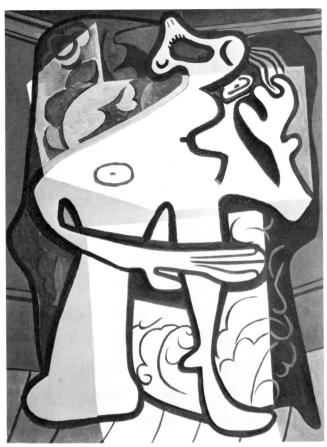

Woman in an Armchair. Paris, January 1927
Oil on canvas, 51⅜ x 38¼″ (130.5 x 97.2 cm)
Zervos III, 79. Private collection, New York

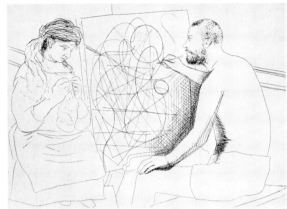

Painter with a Model Knitting, from *Le Chef d'oeuvre inconnu*, by Honoré de Balzac. Paris, 1927. Published Paris, Ambroise Vollard, 1931
Etching, 7⁹⁄₁₆ x 10⅞″ (19.2 x 27.7 cm)
Geiser 126. The Museum of Modern Art. New York. The Louis E. Stern Collection

Painter and Model. [Paris], 1926
Oil and charcoal on canvas, 54⅛ x 101⅛″ (137.5 x 257 cm)
Zervos VII, 30. Musée Picasso, Paris

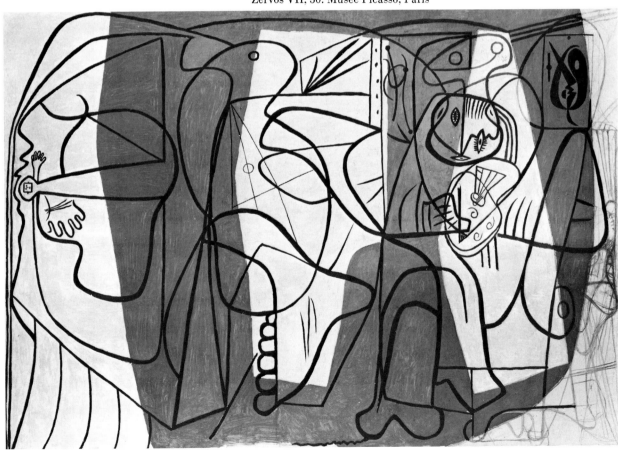

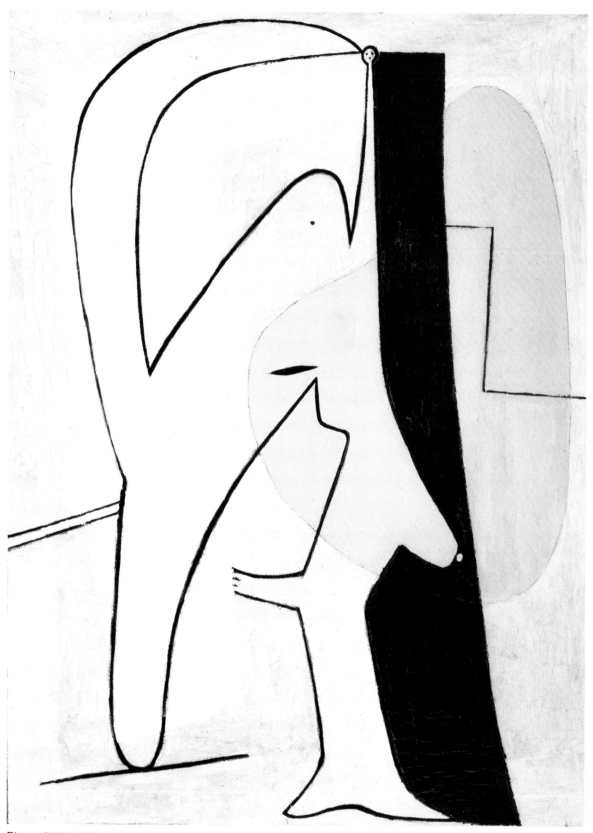

Figure. [1927–28]
Oil on plywood, 51¼ x 38⅛″ (130 x 97 cm)
Zervos VII, 137. Musée Picasso, Paris

Bather and Cabin. Dinard, August 9, 1928
Oil on canvas, 8½ x 6¼″ (21.6 x 15.9 cm)
Zervos VII, 211. The Museum of Modern Art,
New York. Hillman Periodicals Fund

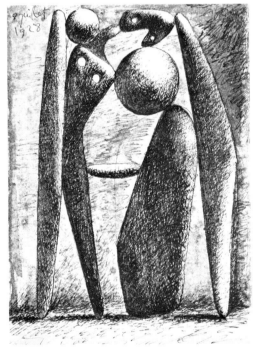

Bathers. Dinard, July 8, 1928
Pen, brush, and India ink,
11⅞ x 8¾″ (30.2 x 22 cm)
Zervos VII, 199. Musée Picasso, Paris

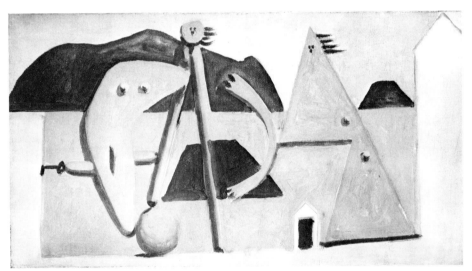

Bathers on the Beach. Dinard, August 12, 1928
Oil on canvas, 8½ x 17¾″ (21.5 x 40.5 cm)
Zervos VII, 216. Musée Picasso, Paris

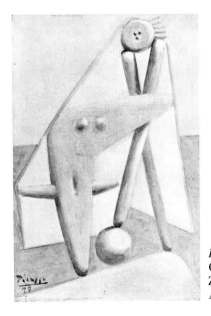

Bather. Dinard, Summer 1928
Oil on canvas, 9½ x 6½″ (24 x 16.5 cm)
Zervos VII, 209. Philadelphia Museum of Art
A. E. Gallatin Collection

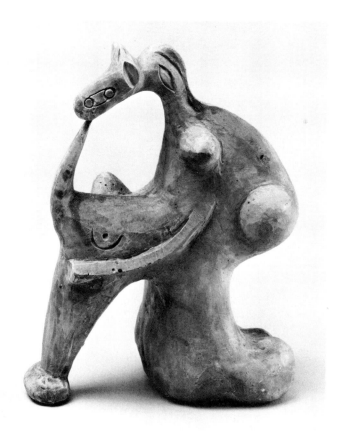

Bather (Metamorphosis II). Paris, 1928
Painted plaster original, 8⅞ x 7⅛ x 4½"
(22.6 x 18 x 11.5 cm)
Not in Spies. Musée Picasso, Paris

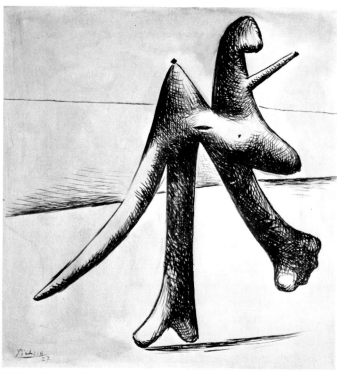

Bather. Cannes, Summer 1927
Oil on canvas, 23⅝ x 23¼" (59.9 x 58.7 cm)
Zervos VII, 87. Collection Norman Granz, Geneva

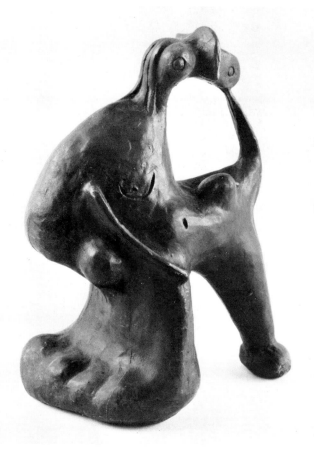

Bather (Metamorphosis I). Paris, 1928
Bronze, 8⅞ x 7⅛ x 4½" (22.6 x 18 x 11.5 cm)
Spies 67. Musée Picasso, Paris

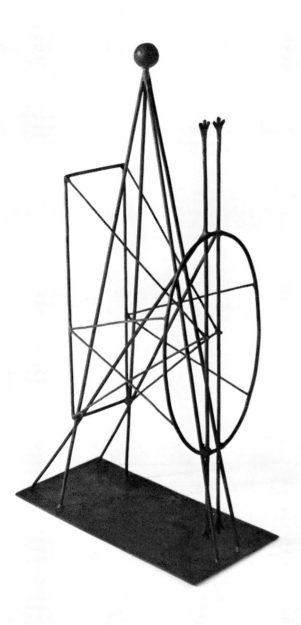

Wire Construction. Paris, October 1928*
Metal wire, 15 x 7¾ x 3⅞″ (38 x 19.6 x 10 cm)
Spies 71. Musée Picasso, Paris

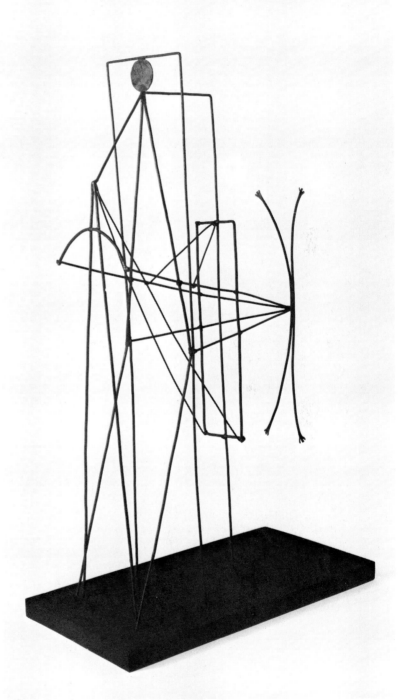

Wire Construction (offered as a maquette for a
monument to Guillaume Apollinaire). Paris, late 1928*
Metal wire, 23⅞ x 13 x 5⅞″ (60.5 x 33 x 15 cm)
Spies 69. Musée Picasso, Paris

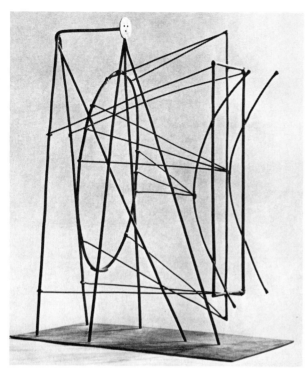

Wire Construction (offered as a maquette for a
monument to Guillaume Apollinaire). Paris, late 1928*
Metal wire, 19⅞ x 16⅛ x 7½″ (50.5 x 40.8 x 18.5 cm)
Spies 68. Musée Picasso, Paris

The Studio. Paris, Winter 1927–28
Oil on canvas, 59 x 91″ (149.9 x 231.2 cm)
Zervos VII, 142. The Museum of Modern Art,
New York. Gift of Walter P. Chrysler, Jr.

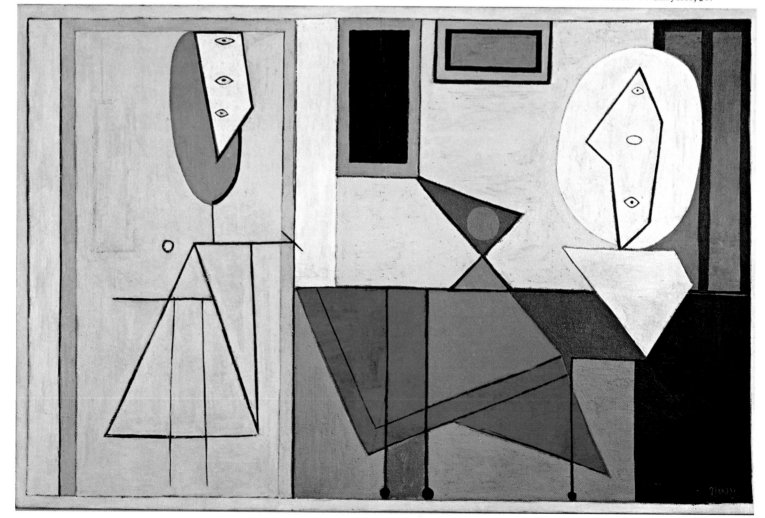

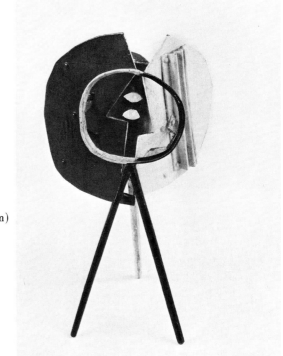

Head. Paris, October 1928
Painted metal, 7⅛ x 4⅝ x 3″ (18 x 11 x 7.5 cm)
Spies 66. Musée Picasso, Paris

Painter and Model. Paris, 1928
Oil on canvas, 51⅛ x 64¼″ (129.8 x 163 cm)
Zervos VII, 143. The Museum of Modern Art,
New York. The Sidney and Harriet Janis Collection

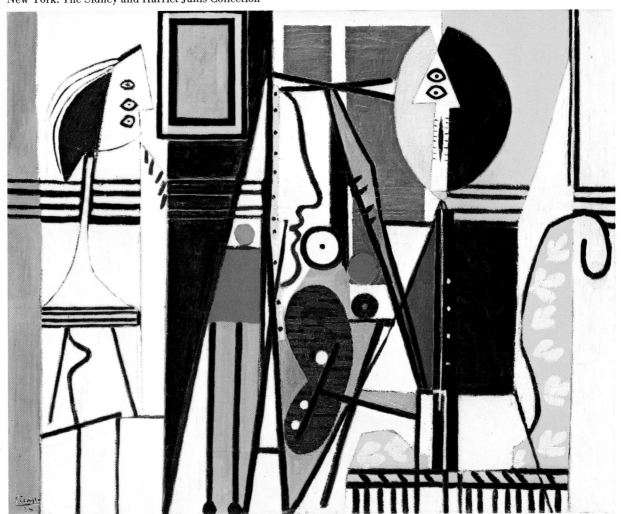

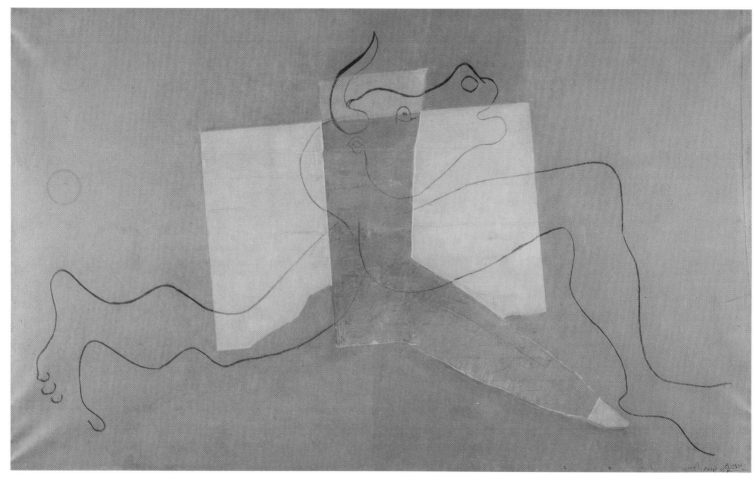

Minotaur. Paris, January 1, 1928
Charcoal and pasted paper on canvas, 54¾ x 90⅝″ (139 x 230 cm)
Zervos VII, 135. Musée National d'Art Moderne, Centre National d'Art et de Culture Georges Pompidou, Paris

The Swimmer. Paris, November 1929
Oil on canvas, 51¼ x 63⅜″ (130 x 161 cm)
Zervos VII, 419. Musée Picasso, Paris

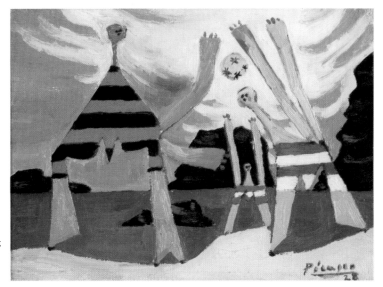

Bathers with Beach Ball. Dinard, August 21, 1928
Oil on canvas, 6¼ x 8⅝″ (15.9 x 21.8 cm)
Zervos VII, 226. Acquavella Galleries, Inc., New York

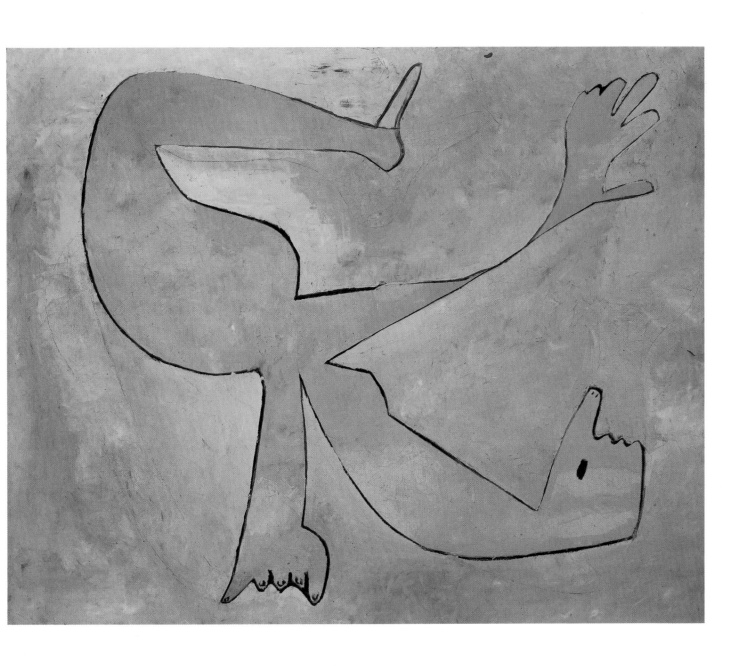

271

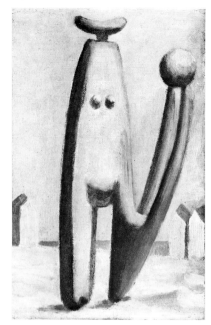

Bather with Beach Ball
Dinard, September 1, 1929
Oil on canvas, 8⅝ x 5½″ (21.8 x 14 cm)
Not in Zervos. Musée Picasso, Paris

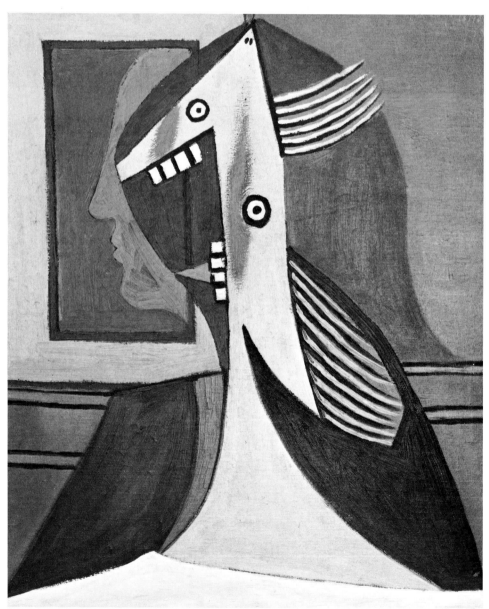

Bust of a Woman with Self-Portrait. Paris, February 1929
Oil on canvas, 28 x 23⅞″ (71 x 60.5 cm)
Zervos VII, 248. Private collection

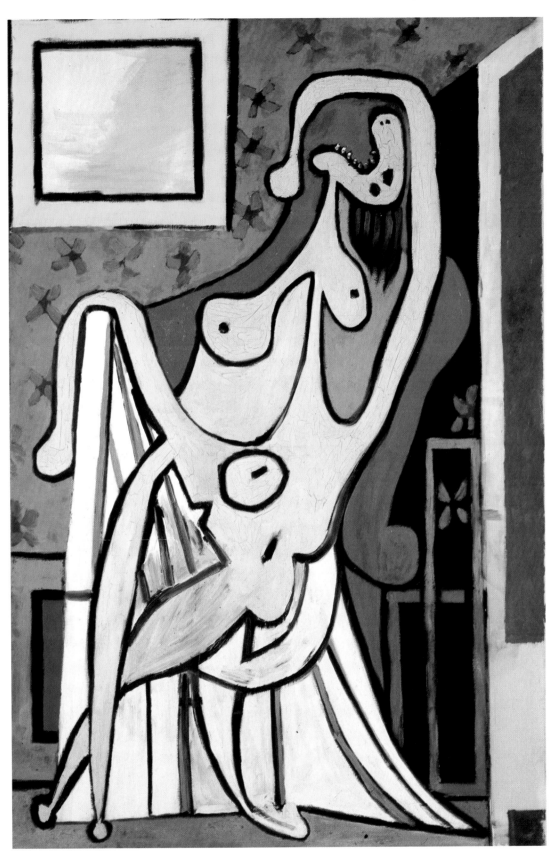

Nude in an Armchair. Paris, May 5, 1929
Oil on canvas, 76¾ x 51¼″ (195 x 130 cm)
Zervos VII, 263. Musée Picasso, Paris

273

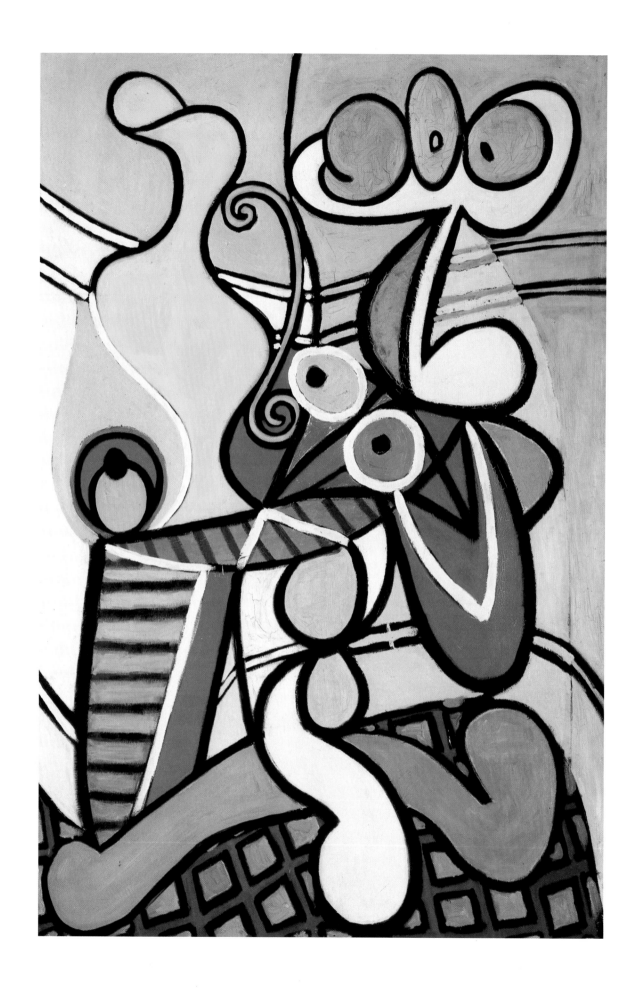

1930-1932

1930

WINTER: Working in Gonzalez's studio, completes two metal sculptures before end of year: *Head* (p. 283) and the large *Woman in a Garden* (p. 282).

Paints *Seated Bather* (p. 279), woman conceived in hard "bone structure" style, a menacing creature with mantis-like head (the mantis, a favorite Surrealist symbol, devours her mate in the course of the sexual act).

JANUARY 18–MARCH 2: "Painting in Paris," first exhibition at The Museum of Modern Art in which Picasso is represented; includes 14 works.

JANUARY 25–FEBRUARY 21: Retrospective of paintings by Picasso and Derain at Reinhardt Galleries, New York; includes 18 works from 1901 to 1928.

FEBRUARY 7: Completes *Crucifixion* (p. 278). Treatment of theme is devoid of religious significance but conveys pain and anguish of the event. Anticipates the violence and suffering manifest in *Guernica* and *The Charnel House*. The head of the Magdalen finds parallel in the menacing figure of Charlotte Corday in *Woman with Stiletto* (p. 278) of the following year.

MARCH: Exhibition of collages at Galerie Goëmans, Paris, in which Picasso is represented. Aragon pays homage to Picasso in catalog preface, "La Peinture au défi."

MARCH 26: Exhibition of 15 paintings at the Arts Club of Chicago.

APRIL: Special number of *Documents* (Paris) devoted to Picasso; contains 57 illustrations and articles by twenty contributors. One of them, Georges Bataille, writes "Soleil pourri" ("Putrefied Sun"), drawing analogies between Picasso's enthusiasm for the bullfight and primitive worship of the sun and, in Mithraic ritual, the bull.

JUNE: Buys country home, château de Boisgeloup, near Gisors, about forty miles northwest of Paris.

SUMMER: Leaves for vacation at Juanles-Pins. In August makes *Construction with Glove* (p. 281) and other sand reliefs.

AUTUMN: Returns to Paris and installs Marie-Thérèse at 44, rue La Boëtie, down the street from his and Olga's apartment at number 23.

SEPTEMBER: Accepts commission from Albert Skira for a series of etchings to illustrate Ovid's *Metamorphoses*. Between September 13 and October 25, prepares thirty etchings, of which all but one are classical in style; several evoke Marie-Thérèse. Edition is published in 1931.

OCTOBER 1–NOVEMBER 1: Exhibition of 22 drawings and gouaches from period 1907–28 at John Becker, New York, with catalog essay by Frank Crowninshield.

NOVEMBER 5: Represented by four works in group exhibition at Reinhardt Galleries, New York.

Published during the year are Eugenio d'Ors's *Pablo Picasso* (Paris: Editions des Chroniques du Jour), translated from Spanish into French and English; and Gertrude Stein's *Dix Portraits* (Paris: Editions de la Montagne), in which Picasso is one of the subjects. The volume is published in French and translated from the English by Georges Hugnet and Virgil Thompson. Picasso provides three drawings: of himself, Satie, and Apollinaire.

Marie-Thérèse Walter, c. 1930

1931

JANUARY: Valentine Gallery, New York, mounts exhibition "Picasso Abstractions," and Harvard Society for Contemporary Art, Cambridge, shows 15 etchings from commission for Ovid's *Metamorphoses*.

FEBRUARY: Tristan Tzara article on Picasso's *papiers collés* published in *Cahiers d'art* (vol. 6, no. 2).

Continues to work with Gonzalez. In *Head of a Woman* (p. 283) incorporates real objects (colanders) in his sculpture.

FEBRUARY 22–MARCH 11: Paints two very large, decorative still lifes in curvilinear Cubist style: *Pitcher and Bowl of Fruit* (p. 290) and *Still Life on a Pedestal Table* (p. 274). The first is executed with saturated colors and heavy black lines that recall medieval stained-glass tracery; the second, with richly colored organic forms that suggest the torso of Marie-Thérèse as it will later be realized in *Girl before a Mirror*.

APRIL: Major retrospective in London, "Thirty Years of Pablo Picasso," at the gallery Alex Reid & Lefèvre; includes 37 paintings.

MAY: Takes possession of the château de Boisgeloup. Converts a stable on the estate into sculpture studio. Not only continues to work in welded metal with Gonzalez but also returns to modeling in clay and plaster.

MAY 17–OCTOBER 6: Exhibition of the collection of the late Lillie P. Bliss at The Museum of Modern Art, New York; includes *Green Still Life* of 1914 (p. 182) and *Woman in White* of 1923 (p. 242). (Entire collection officially acquired by the Museum in 1934.)

JUNE: Paints *The Lamp* (p. 285) at Boisgeloup, where there is no electricity in the studio. (Brassaï photographs the studio by lamplight a year later.) A plaster head of Marie-Thérèse figures in this work. Picasso models several heads throughout this year and the next (pp. 284–86, 289, 298), sometimes recapturing them in charcoal and prints (pp. 287, 289).

SUMMER: Vacations again at Juan-les-Pins. Prepares series of lyrical and erotic engravings (later part of the Vollard Suite) inspired by his liaison with Marie-Thérèse.

AUTUMN: Work in sculpture continues. Along with major endeavors, whittles series of elongated miniature figures (p. 284), using frame molding found on his new estate at Boisgeloup.

DECEMBER 7: Paints *The Sculptor* (p. 284), the figure of the artist contemplating a bust of Marie-Thérèse (p. 285).

DECEMBER 16: Paints *The Red Armchair* (p. 288), employing the double-head motif to portray Marie-Thérèse.

During year, two major illustrated volumes are published. One, the Ovid *Metamorphoses* (Lausanne: Albert Skira), for which he completed thirty etchings in 1930–31 and Louis Fort printed the plates in Paris; and the other, the illustrated edition of Balzac's *Le Chef-d'oeuvre inconnu* (Paris: Ambroise Vollard), containing 13 etchings in the classical style and 67 wood engravings (executed by Georges Aubert), of which 16 pages are based on the calligraphic ink drawings from the 1924 sketchbook.

Exhibition at Paul Rosenberg's, Paris.

1932

JANUARY 5–27: Exhibition of illustrations for Ovid's *Metamorphoses* held at Harvard Society for Contemporary Art, Cambridge, Massachusetts.

JANUARY–MARCH: Paints series of portraits and scenes of sleeping women for which the model is Marie-Thérèse: *The Dream, The Dream (Reading)* (both, p. 292), *Nude on a Black Couch*, and *The Mirror* (both, p. 293). They culminate in *Girl before a Mirror* (p. 291) of March 14, which combines black tracery and organic forms of the two large still lifes of early 1931 (pp. 274, 290). Achieves metamorphosis of traditional Vanity image, in which a woman looking in the mirror sees herself as a death's head; here, figure with double head is reflected as somber-faced but voluptuous image.

Sculpture studio at Boisgeloup, 1933. Photographed by A. E. Gallatin

JUNE 16–JULY 30: Major retrospective at the Galeries Georges Petit, with selections made by Picasso himself. Listed in catalog are 236 works, ranging from such early canvases as *Evocation (Burial of Casagemas)* (p. 40) and *La Vie* (p. 44) to Horta pictures of 1908, *papiers collés*, the Ingresque portrait of Olga in an armchair (p. 194), and paintings of 1932. Also lists etchings and illustrated books and seven sculptures, among them *Woman in a Garden* and one other metal piece executed with Gonzalez. On occasion of show, Tériade interviews Picasso in *L'Intransigéant* (June 15): "One's work is sort of a diary. When the painter, on the occasion of an exhibition, sees some of his old canvases again . . . they seem like prodigal children—but they've come home wearing a shirt of gold. Pictures are made the way the prince gets children: with the shepherdess. One never paints the Parthenon's portrait. . . ."

Reaction of critics ranges from negative to guarded. Germain Bazin writes in *L'Amour de l'art:* "Picasso belongs to the past. . . . His downfall is one of the most upsetting problems of our era." Jacques-Emile Blanche writes: "It would seem that the latest avatars of the Protean creator of rue La Boétie give the key to the enigma. Taste, taste, always taste, manual dexterity, Paganini-like virtuosity. . . . He can do anything, he knows everything, succeeds at all he undertakes. . . . Child prodigy he was; prodigy he is in maturity; and prodigy of old age to come, I have no doubt."

Zervos publishes special Picasso issue of *Cahiers d'art* (vol. 7, no. 3–5) to coincide with the retrospective. Exhibition later travels to Kunsthaus, Zurich, where it is not well received. Jung publishes essay on Picasso, identifying stylistic traits as symptoms of schizophrenia (Picasso's so-called "lines of fracture" are a "series of psychic faults"); asserts that his pictures "immediately reveal their alienation from feeling."

SUMMER: Olga and Paulo vacation at Juan-les-Pins, probably without Picasso. Apparently spends summer at Boisgeloup, where he is visited by Kahnweiler, Raynal, Braque, Gonzalez, Leiris, and Zervos, along with their wives.

At Boisgeloup continues series of sculptured heads of women, all of them modeled after Marie-Thérèse.

OCTOBER: Zervos publishes the first volume of the Picasso catalogue raisonné (Paris: Cahiers d'Art), covering work from 1895 to 1906. Twenty-eight volumes will appear between 1932 and 1974. Also, in Spain, the government of Catalonia acquires the collection of Luis Plandiura for the Barcelona Museum. Among his holdings are some twenty paintings by Picasso, many of them early works from before 1903.

AUTUMN: Returning to Crucifixion theme, makes series of flat-patterned drawings (pp. 300–02) in his "bone" style of the 1929 monuments. These drawings are a metamorphosis of the Crucifixion from the Isenheim Altarpiece of Matthias Grünewald and are reproduced in 1933 in the first issue of *Minotaure.*

NOVEMBER 26–DECEMBER 30: Joint exhibition at Julien Levy Gallery, New York (etchings by Picasso shown along with objects by American artist Joseph Cornell).

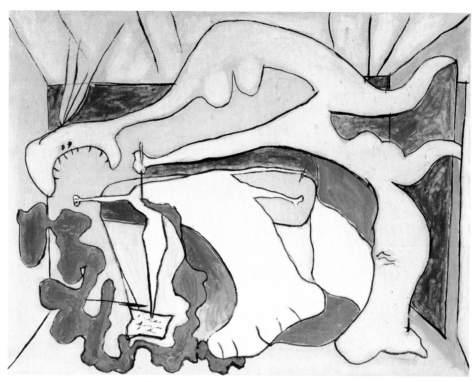

Woman with Stiletto (Death of Marat). [Paris], December 25, 1931
Oil on canvas, 18⅛ x 24″ (46 x 61 cm)
Not in Zervos. Musée Picasso, Paris

Crucifixion. Paris, February 7, 1930
Oil on wood, 19¾ x 25⅞″ (50 x 65.5 cm)
Zervos VII, 287. Musée Picasso, Paris

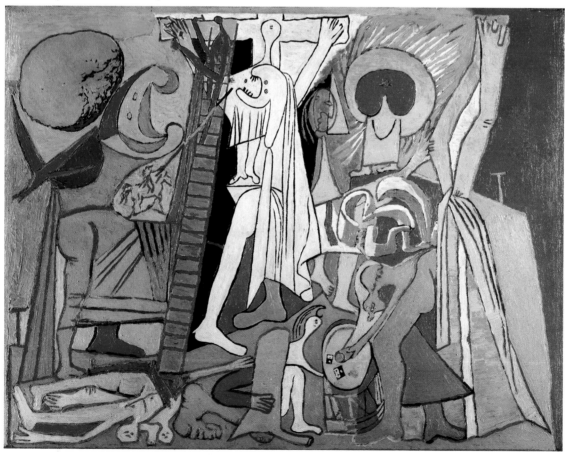

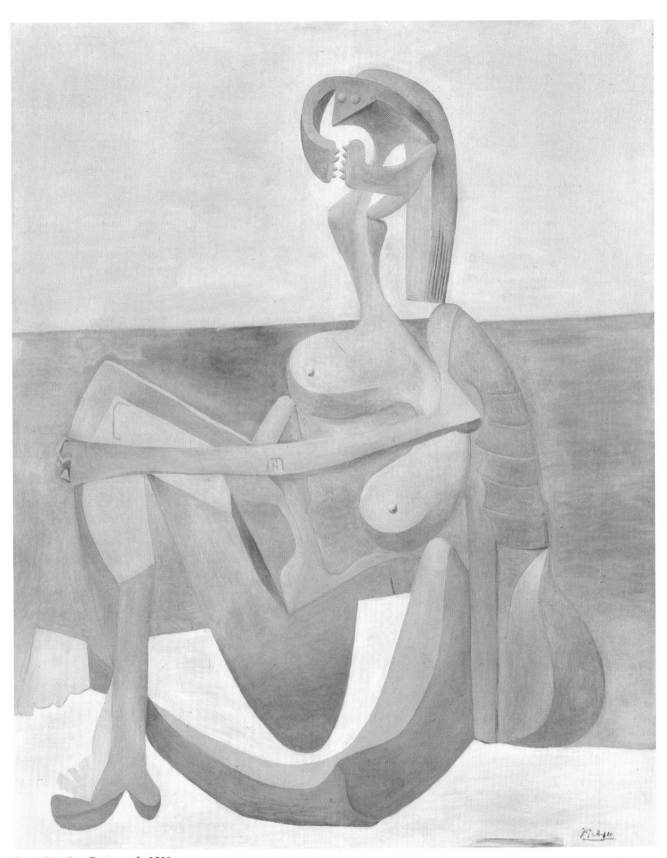

Seated Bather. Paris, early 1930
Oil on canvas, 64¼ x 51″ (163.2 x 129.5 cm)
Zervos VII, 306. The Museum of Modern Art, New York. Mrs. Simon Guggenheim Fund

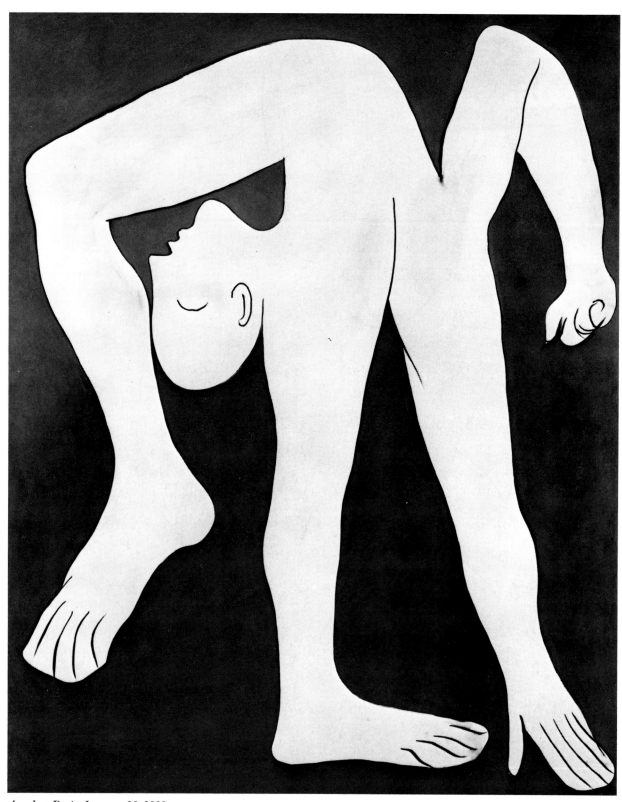

Acrobat. Paris, January 18, 1930
Oil on canvas, 63⅝ x 51¼″ (161.5 x 130 cm)
Zervos VII, 310. Musée Picasso, Paris

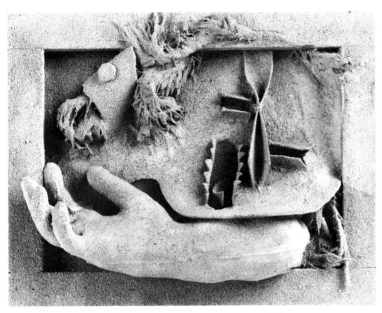

Construction with Glove. Juan-les-Pins, August 22, 1930
Cloth, cardboard, and vegetable matter sewn and glued on
rear of canvas stretcher and coated with sand,
10¾ x 13⅞ x ⅜″ (27.2 x 35.2 x 0.8 cm)
Spies 75. Musée Picasso, Paris

Figures by the Sea. Paris, January 12, 1931
Oil on canvas, 51⅜ x 77″ (130.5 x 195.5 cm)
Zervos VII, 328. Musée Picasso, Paris

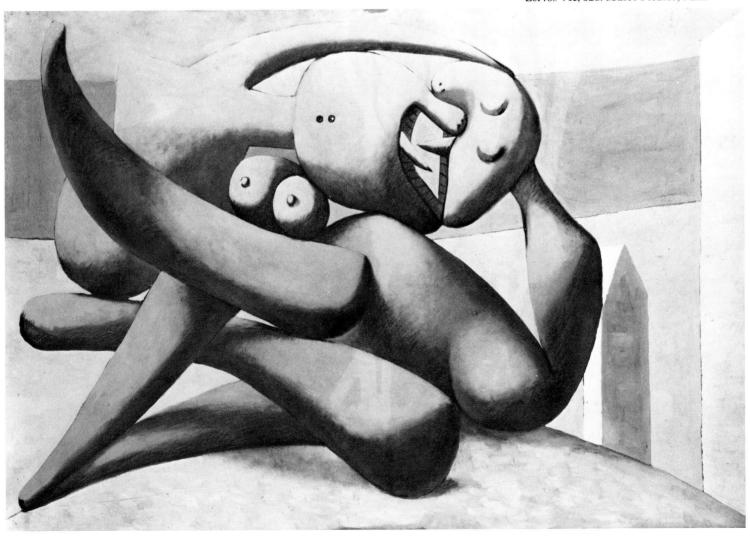

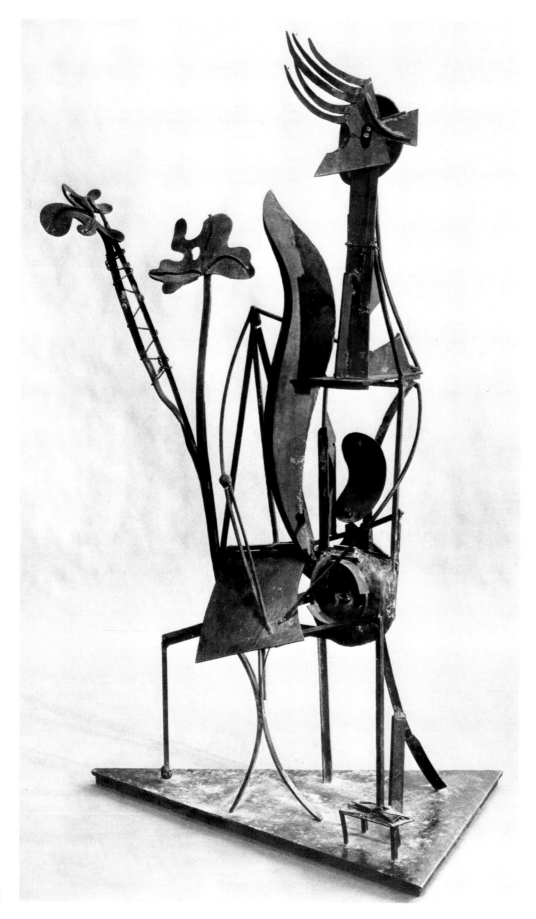

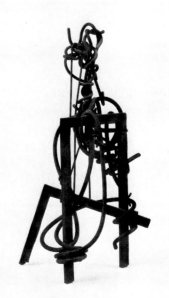

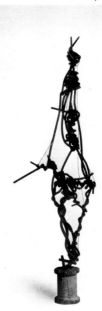

Construction. Paris, 1931
Metal and metal wire, 10¼ x 4½ x 4½″
(26 x 11.5 x 11.5 cm)
Spies 84. Musée Picasso, Paris

Figurine. Paris, 1931
Metal wire and spool, 12⅝″ (32 cm) high
Spies 83
Marina Picasso Foundation

Woman in a Garden. Paris, 1929–30
Bronze (after painted wrought iron),
82¾ x 46 x 32¼″ (210 x 117 x 82 cm)
Spies 72
Marina Picasso Foundation

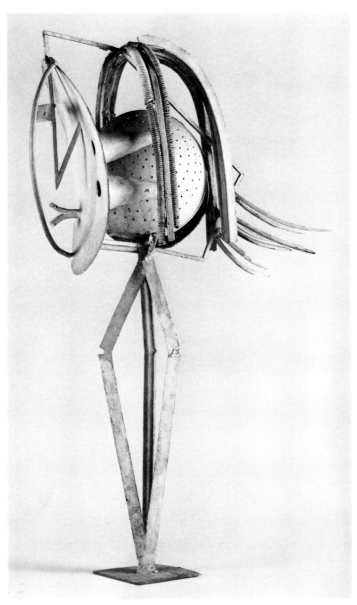

Head of a Woman. Paris, 1930–31
Painted iron, sheet metal, springs, and found objects (colanders),
39⅜ x 14½ x 23¼″ (100 x 37 x 59 cm)
Spies 81. Musée Picasso, Paris

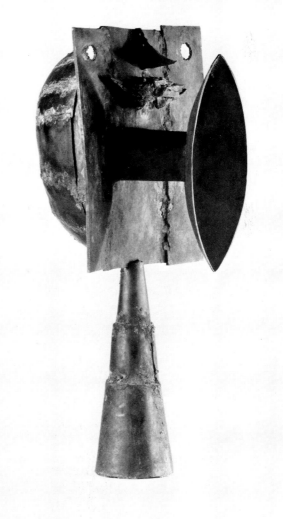

Head, Paris, 1930*
Iron, brass, and bronze, 32⅞ x 16 x 14″ (83.5 x 40.5 x 36 cm)
Spies 80. Musée Picasso, Paris

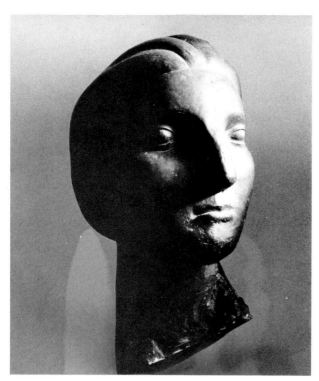

Head of a Woman. Boisgeloup, 1931*
Bronze, 19⅝ x 12⅜ x 10⅝″ (50 x 31 x 27 cm)
Spies 128. Private collection

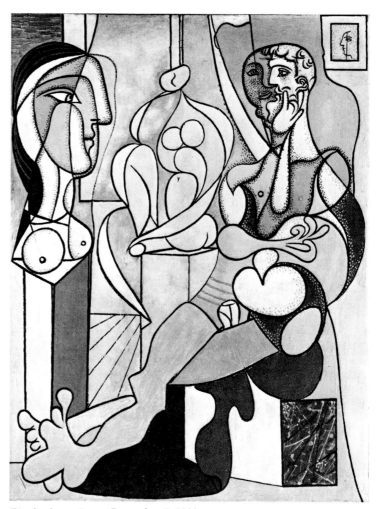

The Sculptor. Paris, December 7, 1931
Oil on plywood, 50⅝ x 37¾″ (128.5 x 96 cm)
Zervos VII, 346. Musée Picasso, Paris

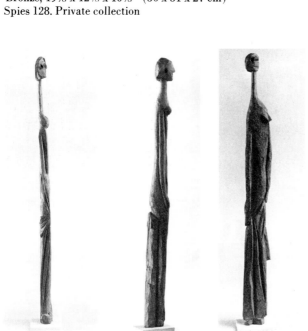

LEFT:
Standing Woman. Boisgeloup, 1931
Wood, 19⅛ x ⅞ x ⅞″ (48.5 x 2.3 x 2.3 cm)
Spies 93. Musée Picasso, Paris

CENTER:
Seated Woman. Boisgeloup, 1931
Wood, 22 x ¾ x 2″ (55.7 x 2 x 5 cm)
Spies 86. Musée Picasso, Paris

RIGHT:
Standing Woman. Boisgeloup, 1931
Wood, 18⅞ x 2 x 1″ (48 x 5 x 2.5 cm)
Spies 95. Musée Picasso, Paris

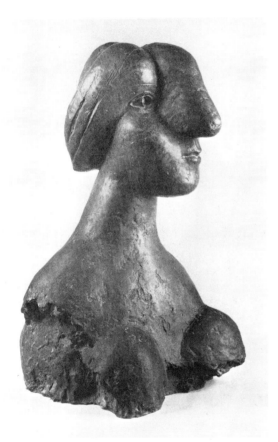

Bust of a Woman. Boisgeloup, 1931*
Bronze, 30½ x 16½ x 17⅛″ (77.5 x 42 x 43.5 cm)
Spies 131. Musée Picasso, Paris

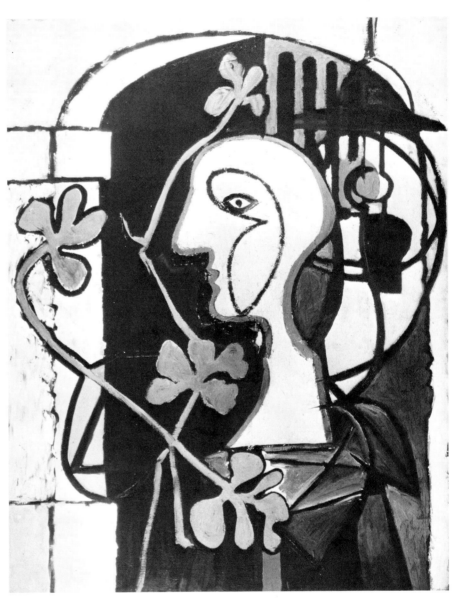

The Lamp. [Boisgeloup], June 1931
Oil on canvas, 63¾ x 51¼″ (162 x 130 cm)
Zervos VII, 347. Private collection

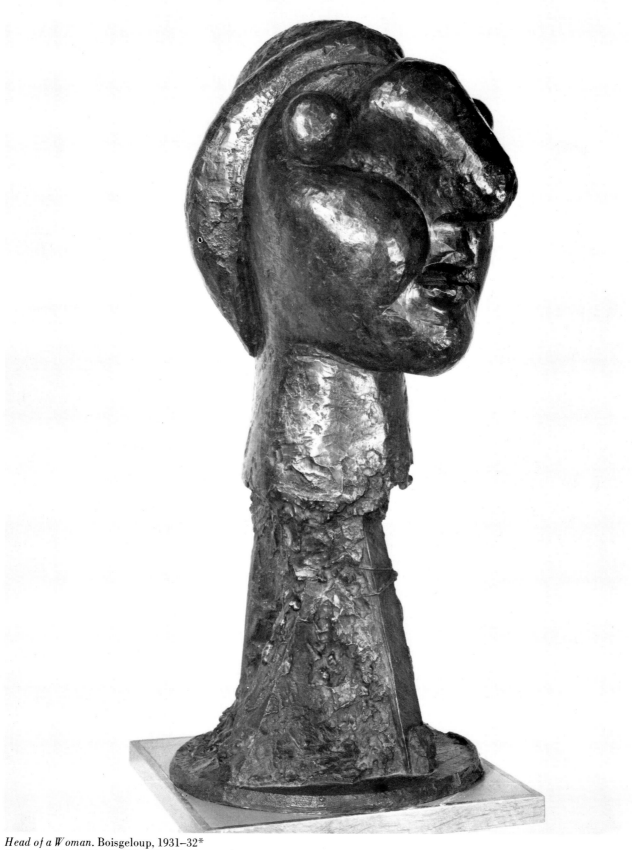

Head of a Woman. Boisgeloup, 1931–32*
Bronze, 33½ x 14½ x 17⅞″ (85 x 37 x 45.5 cm)
286 Spies 132. Galerie Louise Leiris, Paris

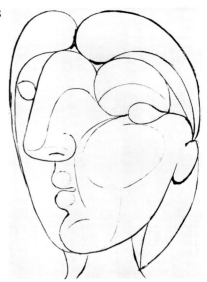

Head of a Woman, VII. [Paris], February 16, 1933
Monotype, 12½ x 9″ (31.7 x 22.9 cm)
Geiser 557. Musée Picasso, Paris

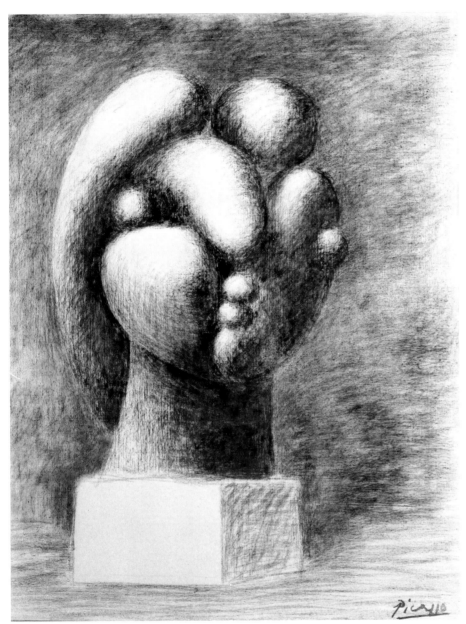

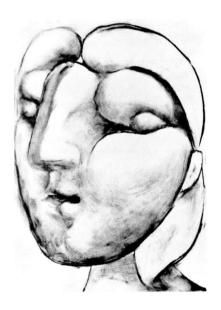

Sculptured Head. Boisgeloup, 1932
Charcoal on canvas, 36¼ x 28¾″ (92 x 73 cm)
Not in Zervos. Collection Ernst Beyeler, Basel

CENTER RIGHT:
Head of a Woman, VI. [Paris], February 16, 1933
Monotype, 12½ x 9″ (31.7 x 22.9 cm)
Geiser 556. Musée Picasso, Paris

RIGHT:
Head of a Woman. [Paris], February 1933
Drypoint, 12½ x 9″ (31.7 x 22.9 cm)
Geiser 288, XX. Musée Picasso, Paris

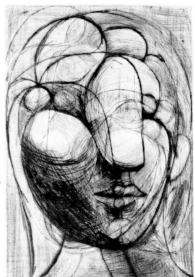

287

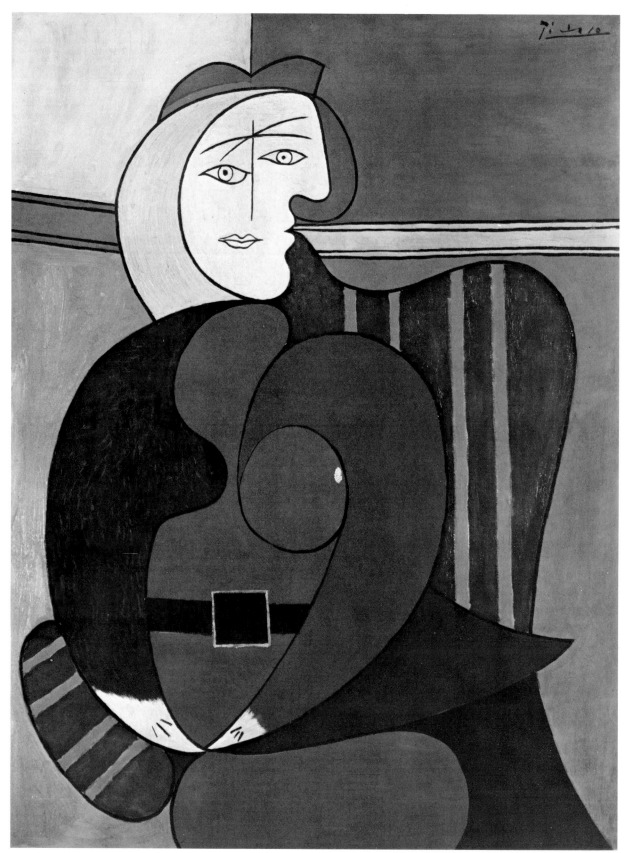

The Red Armchair. Paris, December 16, 1931
Oil and enamel on plywood, 51½ x 39″ (130.8 x 99 cm)
Zervos VII, 334. The Art Institute of Chicago. Gift of Mr. and Mrs. Daniel Saidenberg

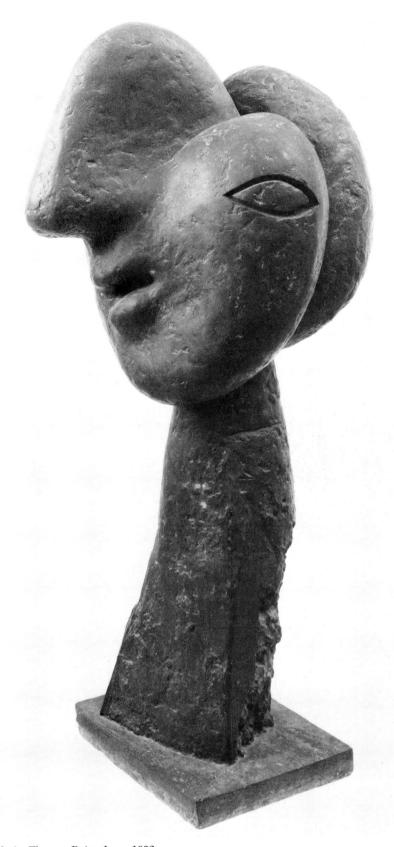

Head of a Woman. [Paris]
February 16, 1933
Drypoint, 12½ x 9″ (31.7 x 22.9 cm)
Geiser 288, IV. Musée Picasso, Paris

Head of a Woman, V. [Paris]
February 16, 1933
Monotype, 12½ x 9″ (31.7 x 22.9 cm)
Geiser 555. Musée Picasso, Paris

Head of a Woman. Boisgeloup, 1932
Bronze, 50⅝ x 21½ x 24⅝″ (128.5 x 54.5 x 62.5 cm)
Spies 133. Musée Picasso, Paris

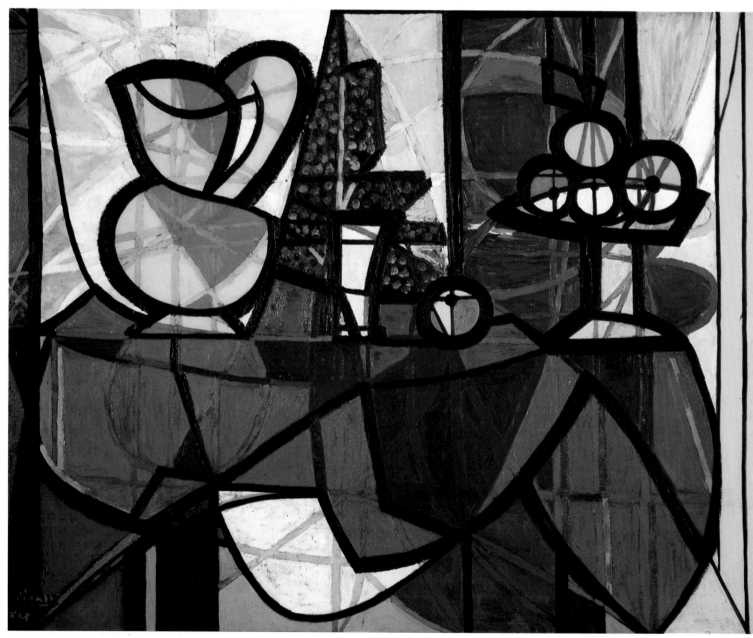

Pitcher and Bowl of Fruit. Paris, February 22, 1931
Oil on canvas, 51¼ x 63¾″ (130 x 162 cm)
Zervos VII, 322. The Museum of Modern Art, New York.
Nelson A. Rockefeller Bequest

Girl before a Mirror. Boisgeloup, March 14, 1932
Oil on canvas, 64 x 51¼″ (162.3 x 130.2 cm)
Zervos VII, 379. The Museum of Modern Art, New York.
Gift of Mrs. Simon Guggenheim

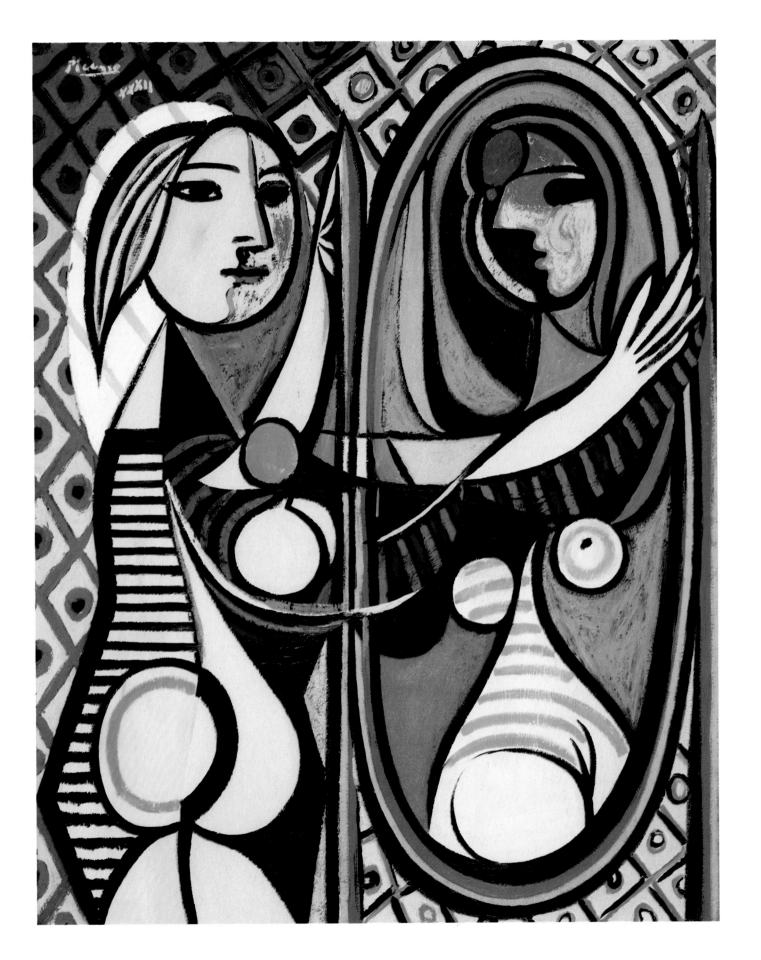

291

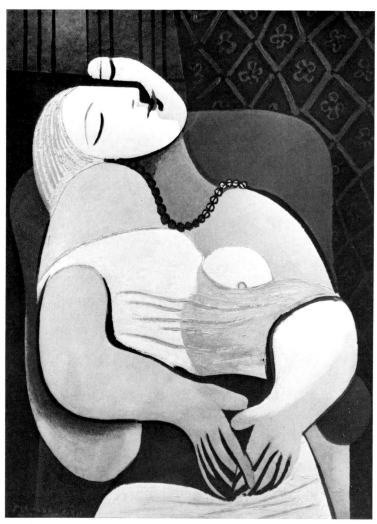

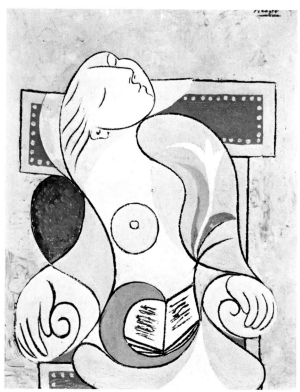

The Dream (Reading). [Boisgeloup], January 1932
Oil on canvas, 25⅞ x 19½″ (65.7 x 49.5 cm)
Zervos VII, 363
Collection Mr. and Mrs. James W. Alsdorf, Chicago

The Dream. [Boisgeloup], January 24, 1932
Oil on canvas, 51¼ x 38⅛″ (130 x 97 cm)
Zervos VII, 364. Collection Mr. and Mrs. Victor W. Ganz, New York

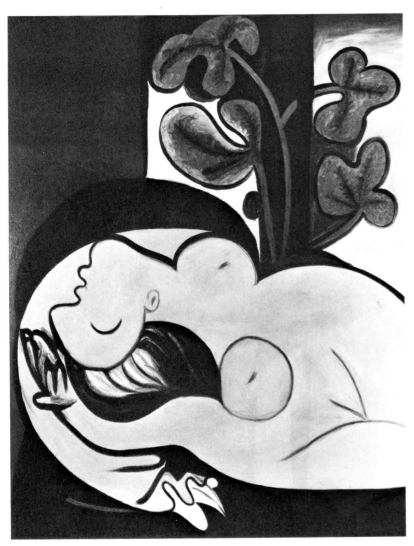

Nude on a Black Couch. Boisgeloup, March 9, 1932
Oil on canvas, 63¾ x 51¼″ (162 x 130 cm)
Zervos VII, 377. Private collection, San Francisco

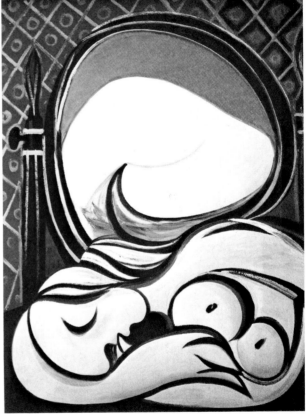

The Mirror. Boisgeloup, March 12, 1932
Oil on canvas, 51½ x 38⅛″ (130.7 x 97 cm)
Zervos VII, 378. Gustav Stern Foundation, Inc., New York

Women Playing at the Edge of the Sea
Paris, November 25, 1932
India ink, 9⅞ x 13¾″ (25 x 35 cm)
Zervos VIII, 58. Collection Mr. and Mrs.
Victor W. Ganz, New York

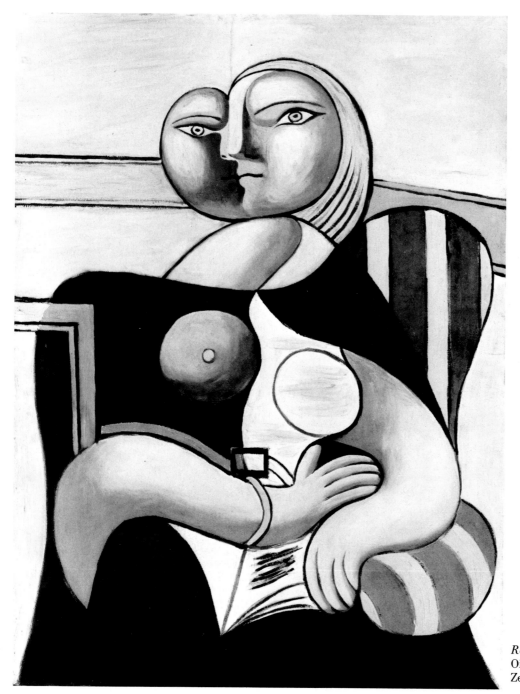

294

Reading. Boisgeloup, January 2, 1932
Oil on canvas, 51¼ x 38⅛″ (130 x 97 cm)
Zervos VII, 358. Musée Picasso, Paris

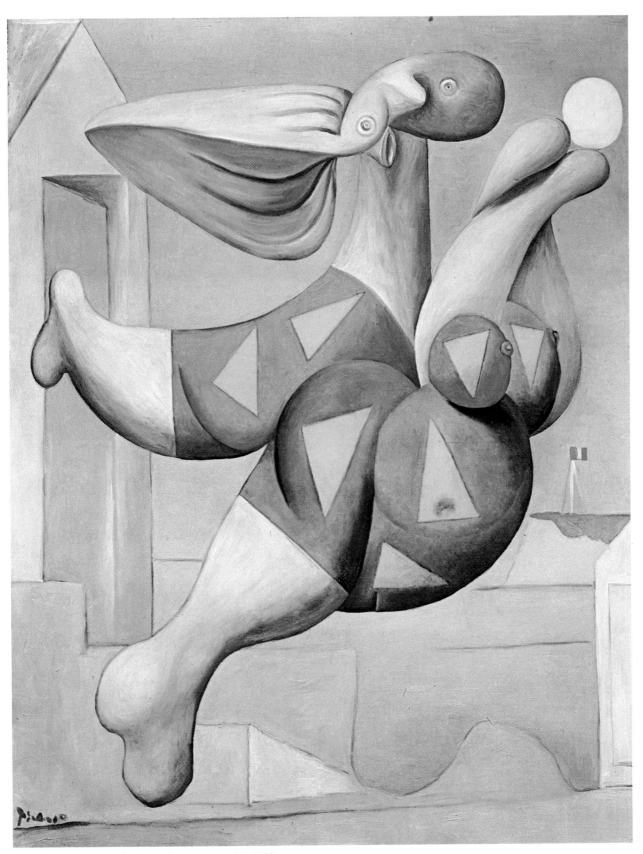

Bather with Beach Ball. Boisgeloup, August 30, 1932
Oil on canvas, 57⅝ x 45⅛″ (146.2 x 114.6 cm)
Zervos VIII, 147. The Museum of Modern Art, New York.
Mr. and Mrs. Joseph H. Lauder Collection

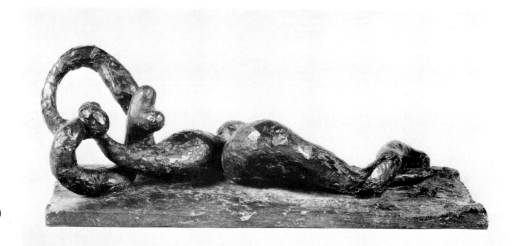

Reclining Woman. Boisgeloup, 1932
Bronze, 7½ x 27¾ x 12¼″ (19 x 70.5 x 31.3 cm)
Spies 109. Musée Picasso, Paris

Sleeping Nude. Boisgeloup, April 4, 1932
Oil on canvas, 51¼ x 63⅜″ (130 x 161 cm)
Zervos VII, 332. Musée Picasso, Paris

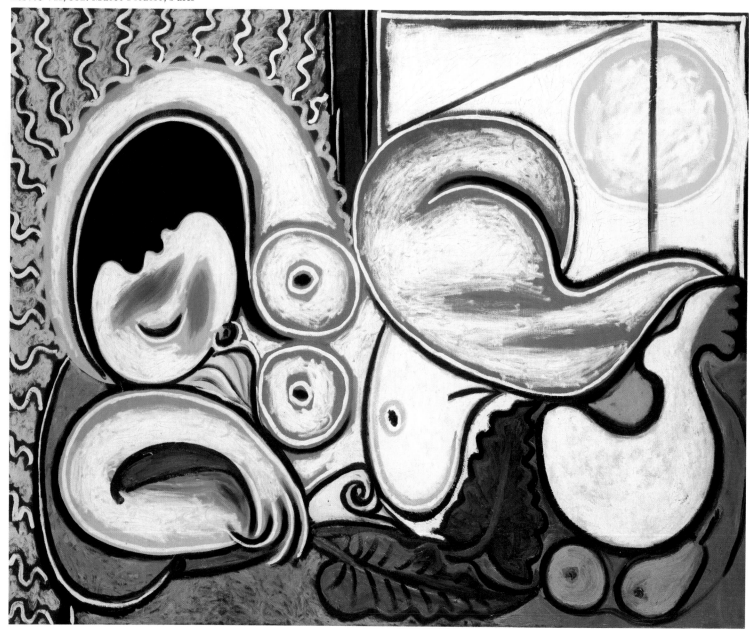

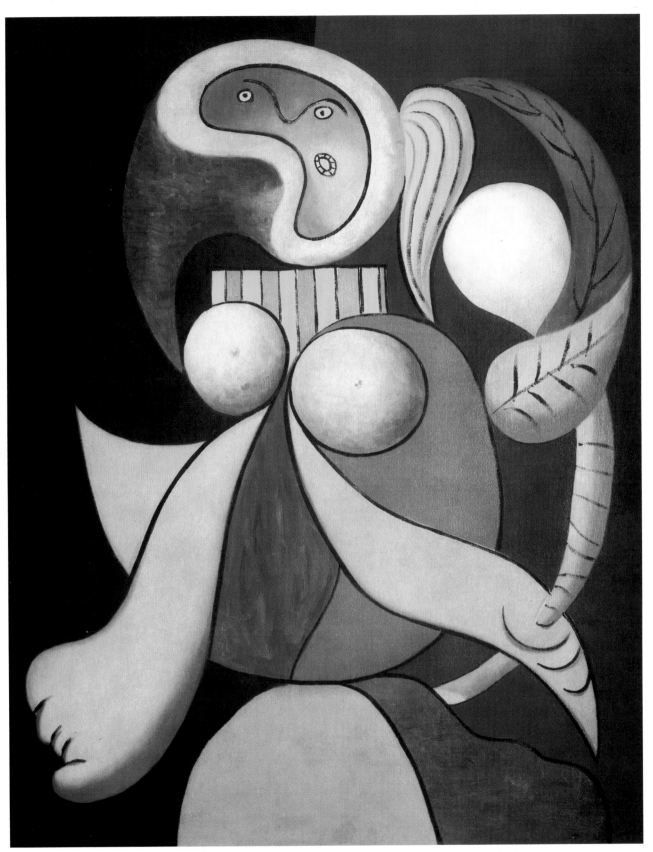

Woman with a Flower. Boisgeloup, April 10, 1932
Oil on canvas, 63¾ x 51¼″ (162 x 130 cm)
Zervos VII, 381. Collection Nathan Cummings, New York

Head of a Woman. Boisgeloup, 1932
Bronze, 27¾ x 16 x 12⅜″ (70.5 x 40.5 x 31.5 cm)
Spies 110. Musée Picasso, Paris

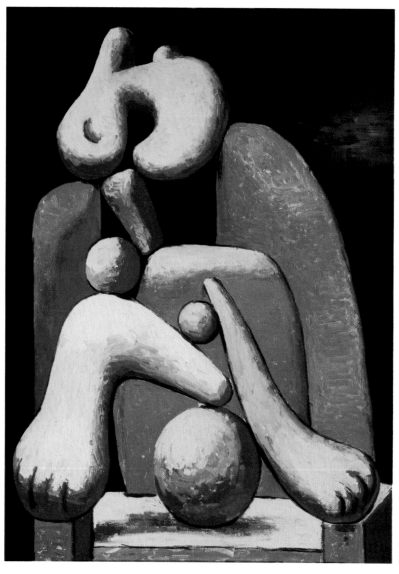

Woman in a Red Armchair. Boisgeloup, January 27, 1932
Oil on canvas, 51¼ x 38¼″ (130 x 97 cm)
Zervos VII, 330. Musée Picasso, Paris

Plaster Head and Bowl of Fruit. Paris, January 29, 1933
Oil on canvas, 27⅞ x 36¼″ (70.8 x 92 cm)
Zervos VIII, 84. Fogg Art Museum, Harvard University,
Cambridge, Massachusetts. Gift of Mr. and Mrs. Joseph Pulitzer, Jr.

Bather. Boisgeloup, 1932
Bronze, 27½ x 16½ x 12⅝″ (70 x 40.2 x 32 cm)
Spies 108. Musée Picasso, Paris

299

Crucifixion, after Grünewald. Boisgeloup, September 17, 1932
India ink, 13⅝ x 20″ (34.5 x 51.3 cm)
Zervos VIII, 49. Musée Picasso, Paris

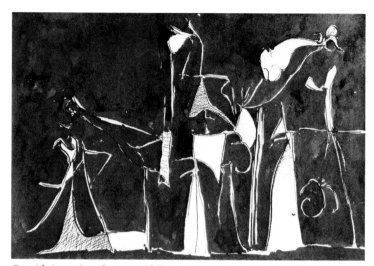

Crucifixion, after Grünewald. Boisgeloup, September 17, 1932
India ink, 13½ x 20¼″ (34.3 x 51.4 cm)
Zervos VIII, 51. Musée Picasso, Paris

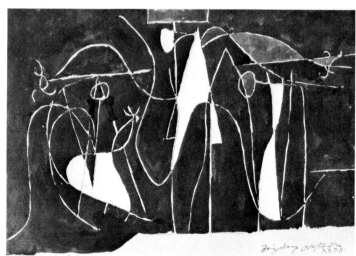

Crucifixion, after Grünewald. Boisgeloup, September 19, 1932
India ink, 13⅝ x 20⅛″ (34.5 x 51.3 cm)
Not in Zervos. Musée Picasso, Paris

Crucifixion, after Grünewald. Boisgeloup, September 17, 1932
India ink, 13⅝ x 20¼″ (34.7 x 51.5 cm)
Zervos VIII, 52. Musée Picasso, Paris

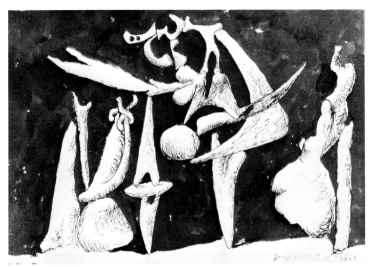

Crucifixion, after Grünewald. Boisgeloup, September 19, 1932
India ink, 13⅝ x 20¼″ (34.5 x 51.5 cm)
Zervos VIII, 55. Musée Picasso, Paris

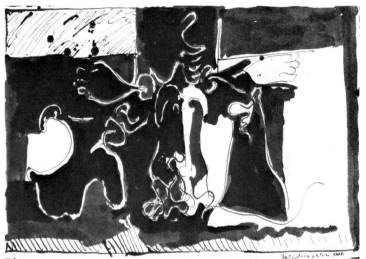

Crucifixion, after Grünewald. Boisgeloup, October 4, 1932
India ink, 13⅜ x 20⅛″ (34 x 51 cm)
Zervos VIII, 56. Musée Picasso, Paris

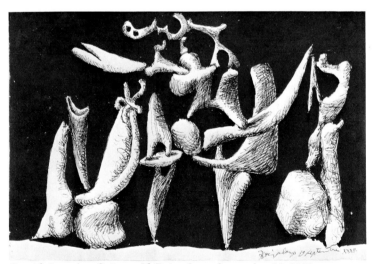

Crucifixion, after Grünewald. Boisgeloup, September 19, 1932
India ink, 13⅜ x 20⅛″ (34.1 x 51 cm)
Not in Zervos. Musée Picasso, Paris

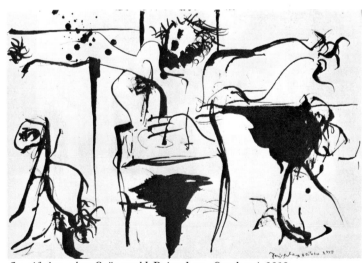

Crucifixion, after Grünewald. Boisgeloup, October 4, 1932
India ink, 13⅜ x 20⅛″ (34 x 51 cm)
Zervos VIII, 50. Musée Picasso, Paris

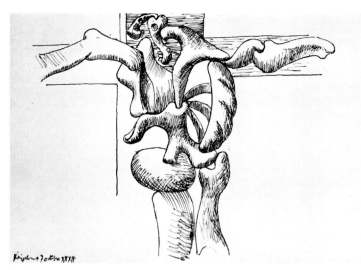

Study for the Crucifixion (Drapery with a Safety Pin)
Boisgeloup, October 7, 1932
India ink, 12¾ x 20⅛″ (35.2 x 51.2 cm)
Not in Zervos. Musée Picasso, Paris

Study for the Crucifixion, after Grünewald. Boisgeloup, October 7, 1932
India ink, 13⅝ x 19⅞″ (34.5 x 50.5 cm)
Not in Zervos. Musée Picasso, Paris

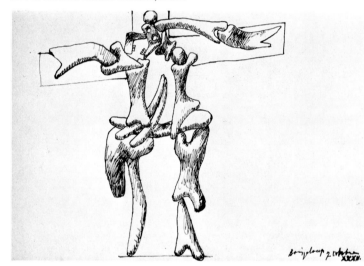

Study for the Crucifixion, after Grünewald. Boisgeloup, October 7, 1932
India ink, 13⅝ x 20⅛″ (34.5 x 51.2 cm)
Zervos VIII, 53. Musée Picasso, Paris

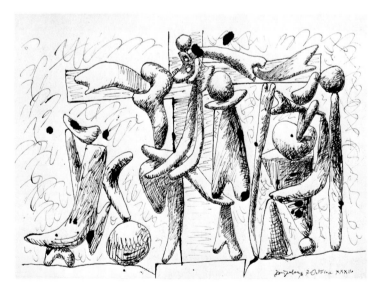

Crucifixion, after Grünewald. Boisgeloup, October 7, 1932
India ink, 13⅝ x 19⅞″ (34.5 x 50.5 cm)
Zervos *Dessins*, 101. Musée Picasso, Paris

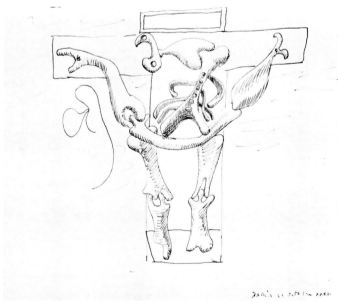

Study for the Crucifixion, after Grünewald
Paris, October 21, 1932
India ink, 10⅛ x 13⅛″ (25.7 x 33.3 cm)
Zervos VIII, 54. Musée Picasso, Paris

Bathers. Boisgeloup, April 18, 1933
India ink and pencil, 9⅛ x 13⅜″ (23 x 34 cm)
Zervos VIII, 127. Private collection

Two Figures on the Beach. Cannes, July 28, 1933
Pen and ink, 15¾ x 20″ (40 x 50.8 cm)
Zervos VIII, 124. The Museum of Modern Art,
New York. Purchase

On the Beach. Cannes, July 28, 1933
Watercolor, 15⅜ x 19⅝″ (39 x 49.8 cm)
Zervos VIII, 119. Perls Galleries, New York

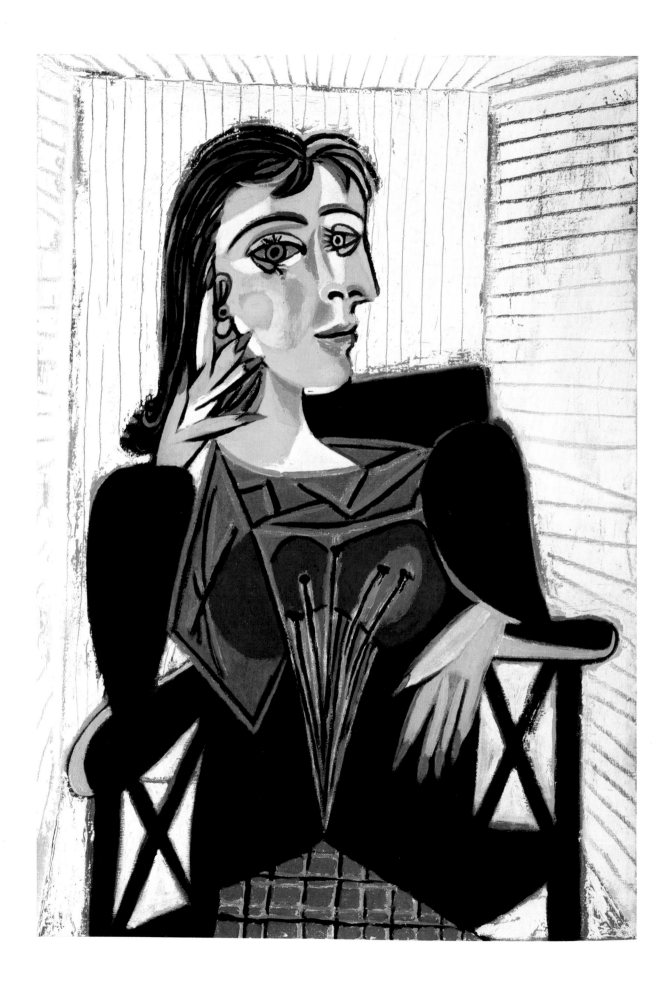

1933-1937

Dora Maar Seated. [Paris or Mougins], 1937
Oil on canvas, 36¼ x 25⅝″ (92 x 65 cm)
Zervos VIII, 331. Musée Picasso, Paris

1933

MARCH: Working in Paris, completes 57 etchings between March 14 and June 11, some forty of them on the theme of the Sculptor's Studio (*Model and Surrealist Sculpture*, p. 310). Although early scenes focus on a large sculpture of a female head like those in plaster from year before, later works in series relate to new subjects: acrobats, horsemen, a festive bull with revelers, a tauromachy, a centaur, a bust of an ancient god. Copperplates for these etchings are among a hundred acquired by Vollard between 1930 and 1937 and printed in Paris by master engraver Roger Lacourière. Become known as the Vollard Suite.

APRIL: At Boisgeloup, makes series of childlike drawings of couples making love (p. 311). Remarks that it took him many years to learn how to draw like a child.

JUNE 1: First issue of new magazine *Minotaure*, named by André Masson and Georges Bataille, published by Albert Skira, and edited by Tériade. (Second issue appears on same date.) Picasso makes a collage (p. 317) for first cover. Brassaï describes its creation: "On a wooden plank, he had thumbtacked a section of crushed and pleated pasteboard similar to [that] he often used for his sculptures. On top of this he placed one of his engravings, representing the monster, and then grouped around it some lengths of ribbon, bits of silver paper lace, and also some rather faded artificial flowers, which he confided to me had come from an outmoded and discarded hat of Olga's."

In first issue Breton hails collage-objects in "Picasso dans son élément," illustrated with Brassaï photographs of Paris and Boisgeloup studios as well as views of recent sculpture. Issue also reproduces series of Crucifixion drawings after Grünewald's Isenheim Altarpiece (pp. 300–02) and *An Anatomy*, suite of thirty images (p. 310) from February and March, in which Picasso "reinvents" the human anatomy by substituting chairs, cups, and other household objects for bodily parts.

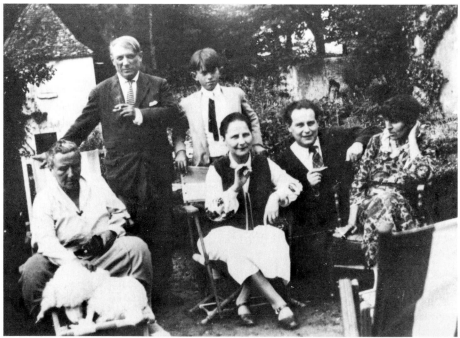

Gertrude Stein, Picasso, his son Paulo, an unidentified couple, and Alice B. Toklas

SUMMER: In July, vacations at Cannes with Olga and Paulo. Then, in great style, they travel on to Barcelona in Picasso's elegant Hispano-Suiza automobile, staying at the Ritz. The local newspaper, *La Publicidad*, reports on reunion there with old friends Manolo, the Soto brothers, and the Junyer-Vidal brothers. Picasso takes Paulo to the Barcelona Museum to see the recently acquired Plandiura collection of his Barcelona-period works.

EARLY SEPTEMBER: Returns to Paris. At Boisgeloup, paints *Bullfight: Death of the Female Toreador* (p. 314).

AUTUMN: Fernande Olivier publishes her memoirs, *Picasso et ses amis* (Paris: Stock), in which she describes life with Picasso in the early part of the century. He vainly attempts to prevent publication of the book to appease Olga, who is jealous of his former lover.

During year, publication of Tristan Tzara's *L'Antitête* (Paris: Editions de Cahiers Libres), containing an etching by Picasso, *Three Graces on the Beach*, dated December 1932.

Also published is Bernhard Geiser's *Picasso, peintre-graveur* (Bern: Published by the author), catalogue raisonné of engravings and lithographs, 1899–1931.

1934

WINTER: Continues to pursue Studio theme in his prints; introduces figure of Rembrandt in four.

FEBRUARY 6–MARCH 1: Exhibition "Pablo Picasso" at the Wadsworth Atheneum, Hartford, Connecticut; includes 79 works. Directed by James Thrall Soby.

MARCH: Paints Marie-Thérèse and a companion reading from a book. (Almost a year later takes up theme again in *Girl Reading*, p. 327.)

JUNE–SEPTEMBER: Series of bullfights (pp. 315, 318, 319), painted, drawn, and etched.

LATE AUGUST: Returns to Spain with Olga and Paulo, following the bulls from San Sebastian to Burgos and Madrid. They continue to Toledo and Saragossa, ending trip in Barcelona, where newspaper *La Publicidad* carries an ac-

count on September 6 of their visit to Museum of Catalan Art to see collection of Romanesque paintings removed from churches for preservation.

MID–SEPTEMBER: Returns with family to Paris.

SEPTEMBER–NOVEMBER: Completes four prints on theme of Blind Minotaur guided by a young girl (one, p. 323), part of Vollard Suite.

During year, publication of Gilbert Seldes's version of Aristophanes' *Lysistrata* (New York: Limited Editions Club), for which Picasso creates six etchings and 33 drawings (one each, p. 320).

Also published is Benjamin Péret's *De derrière les fagots* (Paris: José Corti), which includes etching *Death of Marat*, made in July.

1935

FEBRUARY: Completes *Interior with a Girl Drawing* (p. 326). Three months later, ceases painting until spring of following year.

FEBRUARY 20–MARCH 20: Exhibition of 1912–14 *papiers collés* at Galerie Pierre. Catalog written by Tristan Tzara.

MARCH–APRIL: Exhibition "Les Créateurs du Cubisme," at Galerie des Beaux-Art, Paris. Catalog prepared by Raymond Cogniat, preface by Maurice Raynal.

SPRING: Makes most ambitious etching to date, the *Minotauromachy* (pp. 328, 329), in which Minotaur and Bullfight themes are intertwined. Female bullfighter, introduced in painting of 1933 (p. 314), is here stretched across disemboweled horse that prefigures the one in *Guernica*.

JUNE: Pregnancy of Marie-Thérèse becomes known. Divorce from Olga contemplated, but proceedings are dropped because of complicated laws regarding community property. Olga moves with Paulo to Hôtel California. Marie-Thérèse stays with her mother. Picasso, who describes this period as "the worst time of my life," remains in Paris during the summer.

JULY 13: Writes to Sabartés in South America and invites him to move in with him and handle his business affairs.

OCTOBER 5: Marie-Thérèse Walter gives birth to María de la Concepción (after Picasso's sister who died as a child); known to the family as Maïa. Although city hall register shows "father unknown," Picasso is godfather at her baptism and assumes domestic chores in caring for the baby.

NOVEMBER 12: Jaime Sabartés returns to Paris with his wife, and writes some years later: "He [Picasso] awaited me behind the railing of the waiting room of the Gare d'Orsay. . . . From that day on the course of my life followed his." Sabartés moves to Picasso's apartment on rue La Boëtie, where he and Picasso carry on endless conversations that stretch far into the night. During this time Picasso "neither painted nor sketched and never went up to his studio except when it was absolutely necessary. . . . In order to occupy his imagination, he wrote—with a pen if he found one handy, or a small stub of pencil—in a little notebook which he carried about with him in his pocket."

Picasso's association with Surrealists leads him to compose a quantity of "automatic" poetry joined to illustration. (Following June writes poems illustrated with horse's head, and in September 1937 writes and illustrates *At the End of the Jetty* (both, p. 341). Some of his poems published in special issue of *Cahiers d'art* (vol. 10, no. 7–10). Adds colorful notations to his manuscripts, writing in Spanish and French, almost without punctuation.

1936

JANUARY 8: Portrait drawing of Surrealist poet Paul Eluard; marks beginning of long and enduring friendship between the two men.

FEBRUARY 18: Opening of retrospective exhibition at Sala Esteva, Barcelona, organized by the Amigos de las Artes Nuevas (ADLAN, Friends of New Art) under the direction of architect José-Luis Sert. ADLAN, which supports the

Marie-Thérèse with baby Maïa

Picasso with Maïa

leftist Popular Front, plans opening to coincide with national elections, which Popular Front wins. Sabartés, Gonzalez, Miró, and Dali attend, although Picasso does not. Eluard gives lectures the day before opening. Spanish press is hostile to exhibition.

MARCH 2–APRIL 19: Exhibition "Cubism and Abstract Art," The Museum of Modern Art, New York; organized by Alfred H. Barr, Jr. Contains 32 works by Picasso dating from 1907 to 1929, including oils, collage, photo of a

307

construction (1913), bronze, and photographs of decor for *Pulcinella* and Managers' costumes for *Parade*.

MARCH 3: Exhibition at Paul Rosenberg's of works from 1934 and 1935.

MARCH 25: Picasso and Marie-Thérèse depart in secret for Juan-les-Pins with their baby; live there under the name Ruiz. One month later paints Marie-Thérèse in *Sleeping Woman before Green Shutters* (p. 333).

APRIL: In Juan-les-Pins, begins series of drawings, watercolors, and gouaches on theme of Minotaur (pp. 323, 334, 335), which are continued in Paris.

EARLY MAY: Returns to Paris to work with Lacourière in his Montmartre studio on Vollard commission, illustrations for Buffon's *Histoire naturelle*. Completes the 31 plates at the rate of one a day (this edition of the bestiary is not published until 1942).

JUNE 3: Interrupts work to prepare an etching in tribute to Eluard, an illustration of his poem "Grand Air" (p. 341); poet writes text on the plate and the following day Picasso embellishes it.

EARLY SUMMER: In honor of electoral victory of Popular Front in France and ascension to power of the Léon Blum government, Picasso agrees to design a drop curtain for Romain Rolland's *14 Juillet*, to be presented at the Alhambra theater on July 14. Makes no new design but chooses a gouache (dated May 28) from the Minotaur series (p. 335).

JULY 18: Outbreak of Spanish Civil War. Picasso opposes General Franco and his takeover of the government. His support is recognized by the Republicans, and they name him director of the Prado Museum.

EARLY AUGUST: Departs for Riviera and, at Eluard's suggestion, chooses this time to stay in Mougins, a small village above Cannes. Among the many friends visiting there during summer are Zervos and his wife, Roland Penrose, Man Ray, Paul Rosenberg, the Eluards, René Char, and a young woman named Dora Maar, who is staying in St. Tropez for the summer. Picasso has first met her earlier in the year through Eluard

and has seen her frequently in the company of the Surrealists. The daughter of a Yugoslav architect, Dora Maar (born Markovitch) has lived with her family in Argentina and so speaks fluent Spanish. A photographer, she has already been invited by Picasso to photograph in his studio even before his trip to Juan-les-Pins at the end of March. Together they discover the town of Vallauris, where ceramics have been made since Roman times. In time she becomes his mistress.

Dora Maar, c. 1936. Photographed by Man Ray

AUTUMN: Abandons studio at Boisgeloup and, at Vollard's invitation, works at his house at Le Tremblay-sur-Mauldre, settling Marie-Thérèse and Maïa there. Spends weekends with them.

Paints portrait of Dora Maar, and with her assistance makes photographic shadow prints (a direct-exposure technique learned from Man Ray during the summer).

Published during year are two works by Paul Eluard for which Picasso has provided illustrations: *La Barre d'appui* (Paris: Cahiers d'Art), containing three etchings, and *Les Yeux fertiles* (Paris: G.L.M.), containing portrait drawing of the author, the three etchings from *La Barre d'appui*, and the decorated plate of "Grand Air" (p. 341).

Exhibition during the year in London at Zwemmer Gallery, containing 57 works.

1937

JANUARY 8–9: Etches the *Dream and Lie of Franco* (p. 340) and writes accompanying poem. The satirical work con-

sists of two plates, each divided into nine rectangular scenes which resemble the American comic strip or the Spanish *aleluya* but which read from right to left, owing to reversal from printing process. Work presents Franco as a grotesque, rather flaccid figure. (Last four scenes of second plate, finished June 7, are related to sketches for *Guernica*. Plates and separate sheet with poem are sold for benefit of the Spanish Republic.)

The poem catalogs images of war: ". . . cries of children cries of women cries of birds cries of flowers cries of timbers and of stones . . . cries of furniture of beds of chairs of curtains of pots of cats of papers cries of odours . . ."

With Dora Maar's help, finds new studio at 7, rue des Grands-Augustins, on second floor of seventeenth-century building. Their friend Georges Bataille has used space as meeting room for a group called Contre-attaque, and by coincidence the street is that on which the mad painter in Balzac's *Chef-d'oeuvre inconnu* lived.

Spanish Republican government invites Picasso to paint a mural for the Spanish Pavilion at the Paris World's Fair, scheduled to open in June.

JANUARY–MARCH: Paints series of portraits of Marie-Thérèse (two, pp. 336, 339).

FEBRUARY: Paints *Bather with Book* (p. 337); companion picture, *Two Nudes on the Beach* (p. 337), follows three months later.

APRIL 12–24: Exhibition at Valentine Gallery, New York: "Drawings, Gouaches, and Pastels by Picasso."

APRIL 26: German planes bombard Basque town of Guernica for three hours. Over course of next four days, *Ce Soir* and *L'Humanité* publish accounts of bombing; and from photographic coverage in *Ce Soir* of the death and destruction in the town, Picasso finds his theme for the Spanish Pavilion mural.

MAY: Begins *Guernica* sketches on May 1 in his new studio. Painting subsumes

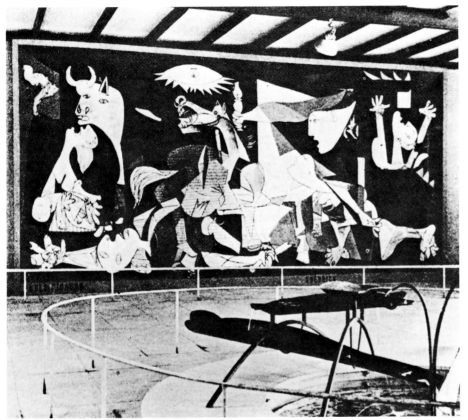

Guernica installed in the Spanish Pavilion of the Paris International Exposition, 1937.

In the foreground, Alexander Calder's Mercury Fountain

motifs from many early works, including *Dream and Lie of Franco* and *Minotauromachy*, as well as from bullfight series of 1933–35. More than fifty studies are made in all. Composition outlined on canvas by May 11. As work progresses, Picasso makes alterations and shifts position of figures and animals on the 26-foot composition. Dora Maar photographs the painting at seven stages over three-week period from May 11. Completed canvas (pp. 342–43) installed in Spanish Pavilion in mid-June.

JUNE: Opening of exhibition "Les Maîtres de l'art indépendant," held in connection with the International Exposition at the Petit Palais, Paris. *Les Demoiselles d'Avignon* (p. 99) is among 32 Picasso works on view.

JULY 12: Inauguration of the Spanish Pavilion of the International Exposition, designed by Luis Lacasa and José-Luis Sert. One of Picasso's sculptured heads of women is set up near the steps at the exit (p. 289), and his *Woman with Vase* (p. 313) is placed in the Pavilion.

SUMMER: Continues to be obsessed with motifs from *Guernica* and makes postscript sketches and paintings throughout the summer and autumn. Zervos publishes special issue of *Cahiers d'art* (vol. 12, no. 4–5) devoted to the painting, with Dora Maar's photographs of the work in progress and articles by Zervos himself as well as by Jean Cassou, Georges Duthuit, Michel Leiris, and Pierre Mabille; also includes poems by José Bergamin and Paul Eluard ("La Victoire de Guernica").

Departs for Mougins with Dora Maar, traveling in the Hispano-Suiza with his dog Kazbek and his painting equipment. Stays at Hôtel Vaste Horizon, where Paul and Nusch Eluard are also installed. Has the only room with balcony and works there each day. Paints portraits of Dora Maar (one, p. 304) and Nusch Eluard. Paul Rosenberg visits during their stay and chooses several canvases to be sold in his gallery.

SEPTEMBER: Returns to Paris.

MID-OCTOBER: Trip to Switzerland. While there, visits Paul Klee, who is critically ill.

OCTOBER–DECEMBER: Paints *Weeping Woman* (p. 344) and small gouache *Woman Crying* (p. 345), two of his final postscripts to *Guernica*.

NOVEMBER: Exhibition of 23 works in "Picasso from 1901 to 1937" at Valentine Gallery, New York.

NOVEMBER 1–20: Exhibition "20 Years in the Evolution of Picasso, 1903–1923" at Jacques Seligmann & Co., New York; includes *Les Demoiselles d'Avignon*; The Museum of Modern Art makes plans to acquire the painting, soon selling a Degas equestrian picture for $18,000 of the $24,000 purchase price. Remainder is contributed by Seligmann and Cesar de Hauke, co-owners of the gallery.

DECEMBER 19: *New York Times* publishes a statement by Picasso addressed to American Artists' Congress in New York, in which he defends actions of the Spanish Republican government and disputes Franco's propaganda about Republicans' supposed mistreatment of Spain's art treasures: ". . . as director of the Prado Museum, [I assure you] that the democratic government of the Spanish Republic has taken all the necessary measures to protect the artistic treasures of Spain during this cruel and unjust war. . . . Artists who live and work with spiritual values cannot and should not remain indifferent to a conflict in which the highest values of humanity and civilization are at stake."

During year, two exhibitions at Zwemmer Gallery, London: "Fifty Drawings by Pablo Picasso" and "Chirico and Picasso," which includes 19 works by the latter.

309

Three Women, VIII (from the suite *An Anatomy*)
[Paris], February 28, 1933
Pencil on vellum, 8 x 10⅝″ (19.8 x 27 cm)
Not in Zervos. Musée Picasso, Paris

Model and Surrealist Sculpture. Paris, May 4, 1933
Etching, 10⁹⁄₁₆ x 7⅝″ (26.7 x 19.4 cm)
Geiser 346, IIc. The Museum of Modern Art, New York.
Abby Aldrich Rockefeller Fund

Three Women, X (from the suite *An Anatomy*)
Paris, March 1, 1933
Pencil on vellum, 8 x 10⅝″ (19.8 x 27 cm)
Not in Zervos. Musée Picasso, Paris

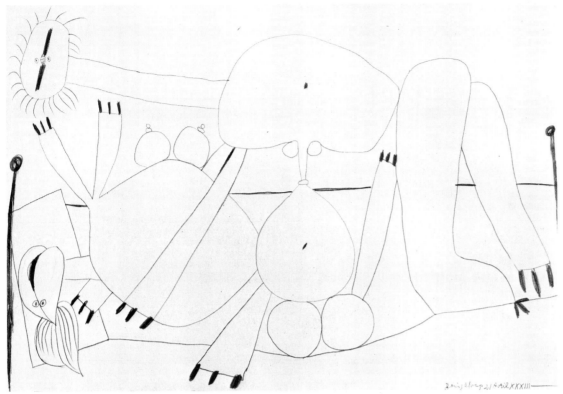

Figures Making Love, I. Boisgeloup, April 21, 1933
Pencil, 13⅝ x 20¼″ (34.5 x 51.5 cm)
Zervos VIII, 107. Musée Picasso, Paris

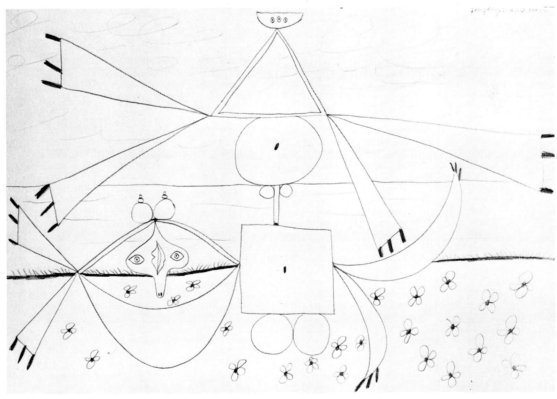

Figures Making Love, VI. Boisgeloup, April 21, 1933
Pencil, 13⅝ x 20⅛″ (34.5 x 51.2 cm)
Zervos VIII, 104. Musée Picasso, Paris

311

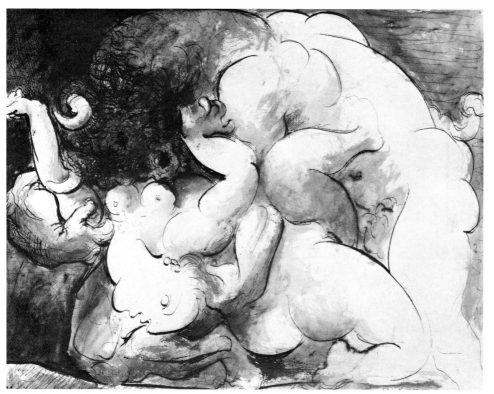

Minotaur and Nude. Boisgeloup, June 24, 1933
India ink on blue paper, 18½ x 24½″ (47 x 62 cm)
Zervos VIII, 112. The Art Institute of Chicago. Gift of Margaret Blake

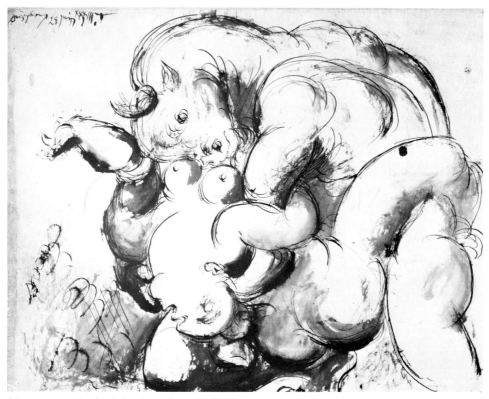

Minotaur and Nude. Boisgeloup, June 28, 1933
India ink and wash, 18½ x 24⅜″ (47 x 62 cm)
Not in Zervos. Musée Picasso, Paris

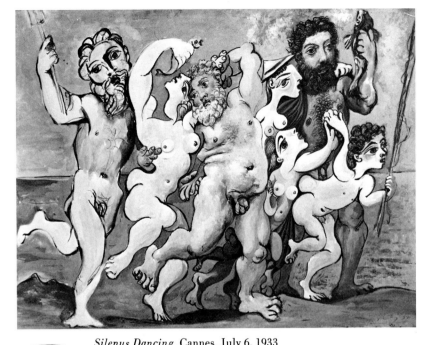

Silenus Dancing. Cannes, July 6, 1933
Ink and gouache, 13⅜ x 17¾″ (34 x 45 cm)
Not in Zervos. Private collection, Switzerland

The Sculptor and His Statue. Cannes, July 20, 1933
Pen and ink, watercolor, and gouache, 15⅜ x 19½″ (39 x 49.5 cm)
Zervos VIII, 120. Private collection, Switzerland

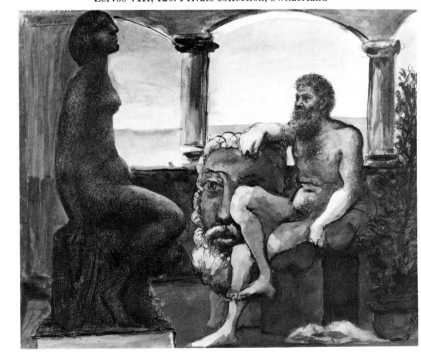

Woman with Vase. Boisgeloup, Summer 1933
Bronze, 86½″ (219.7 cm) high
Spies 135. Heirs of Pablo Picasso

313

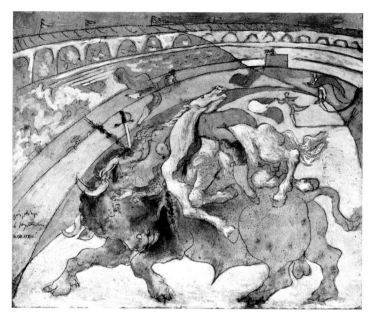

Bullfight: Death of the Female Toreador. Boisgeloup, September 6, 1933
Oil on wood, 8½ x 10⅝″ (21.7 x 27 cm)
Zervos VIII, 138. Musée Picasso, Paris

Bullfight: Death of the Toreador. Boisgeloup, September 19, 1933
Oil on wood, 12¼ x 15⅞″ (31.2 x 40.3 cm)
Zervos VIII, 214. Musée Picasso, Paris

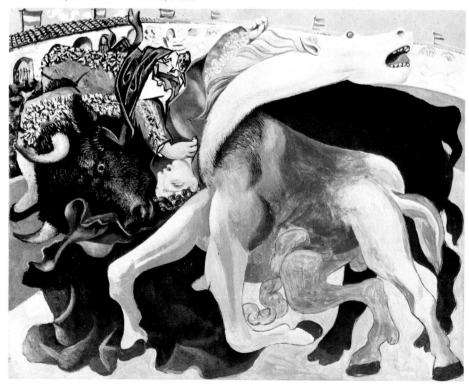

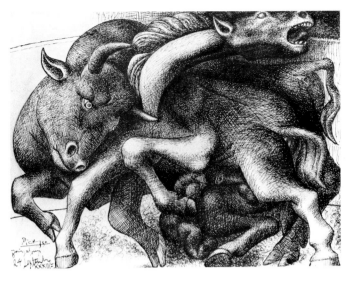

Bull Goring a Horse. Boisgeloup, September 24, 1933
India ink, 10¼ x 13¾″ (26 x 35 cm)
Not in Zervos. Private collection, Paris

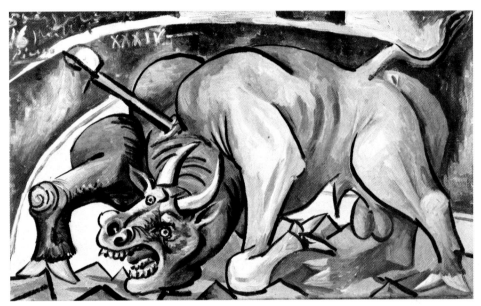

Dying Bull. Boisgeloup, July 16, 1934
Oil on canvas, 13 x 21⅝″ (33 x 55 cm)
Zervos VIII, 228. Private collection, Switzerland

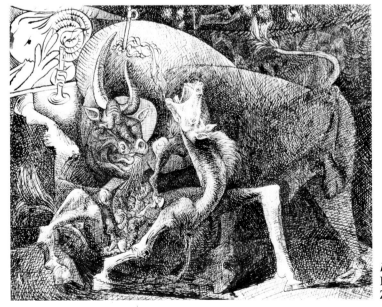

Bull Disemboweling a Horse. Boisgeloup, July 24, 1934
India ink on wood, 12⅜ x 16″ (31.5 x 40.7 cm)
Zervos VIII, 215. Musée Picasso, Paris

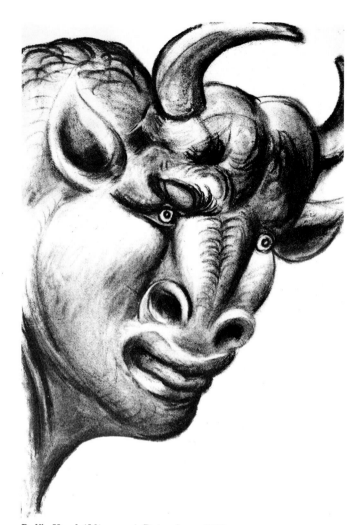

Bull's Head (Minotaur). Boisgeloup, 1933
Charcoal, 20⅛ x 13⅜" (51 x 34 cm)
Zervos VIII, 137. Musée Picasso, Paris

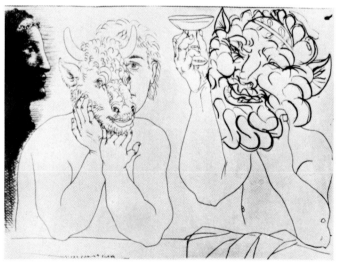

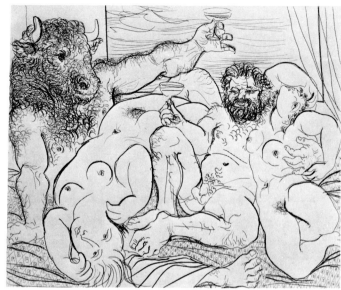

Bacchanal with Minotaur. Paris, May 18, 1933
Etching, 11¹¹⁄₁₆ x 14⅜" (29.7 x 36.5 cm)
Geiser 351, IV
The Museum of Modern Art, New York. Purchase Fund

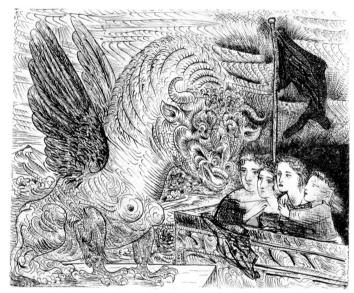

Winged Bull Observed by Four Children. Paris, December 1934
Etching, 9⁵⁄₁₆ x 11⅝" (23.7 x 29.5 cm)
Geiser 444, II
The Museum of Modern Art, New York. Purchase Fund

OPPOSITE:
Maquette for the cover of *Minotaure*. [Paris], May 1933
Collage of pencil on paper, corrugated cardboard, silver foil, ribbon, wallpaper painted with gold paint and gouache, paper doily, burnt linen leaves, tacks, and charcoal on wood, 19⅛ x 16⅛" (48.5 x 41 cm). Not in Zervos. The Museum of Modern Art, New York. Gift of Mr. and Mrs. Alexandre P. Rosenberg

Young Man with Bull's Mask, Faun, and Profile of a Woman. Paris, March 7, 1934
Etching, 8¾ x 12⁵⁄₁₆" (22.2 x 31.3 cm)
Geiser 422. Musée Picasso, Paris

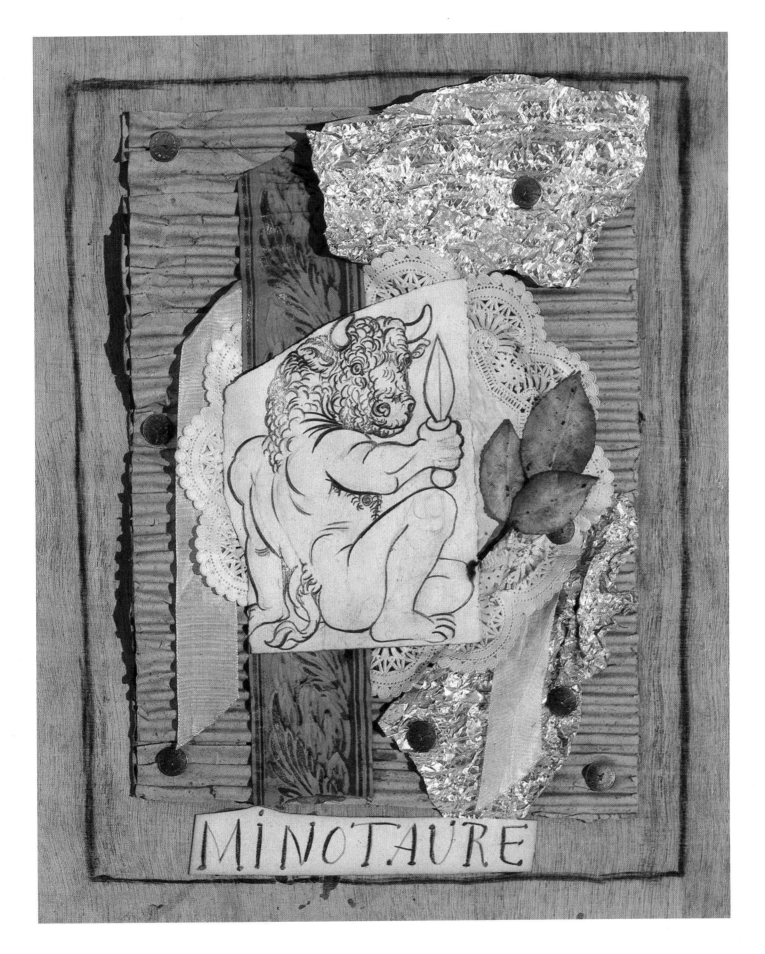

Vanquished Minotaur. Paris, May 29, 1933
Etching, 7⅝ x 10⁹⁄₁₆″ (19.3 x 26.8 cm)
Geiser 365, II. The Museum of Modern Art,
New York. Purchase Fund

Bullfight. Boisgeloup, July 22, 1934
Oil on canvas, 38¼ x 51¼″ (97 x 130 cm)
Zervos VIII, 229. Private collection

Female Bullfighter, I. Paris, June 12, 1934
Etching, 18⅞ x 26¾″ (48 x 68 cm)
Geiser 425 B,b. The Museum of Modern Art, New York.
Acquired through the Lillie P. Bliss Bequest

Bullfight. Boisgeloup, September 8, 1934
Etching, 19⁷⁄₁₆ x 27¹⁄₁₆″ (49.4 x 68.7 cm)
Geiser 433. The Museum of Modern Art, New York.
Acquired through the Lillie P. Bliss Bequest

319

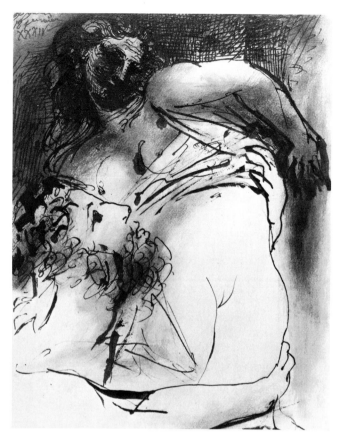

Myrrhina and Kinesias, from *Lysistrata,*
by Aristophanes. Paris, January 18, 1934
India ink, 12½ x 9¾″ (31.7 x 24.7 cm)
Zervos VIII, 163. Saidenberg Gallery, New York

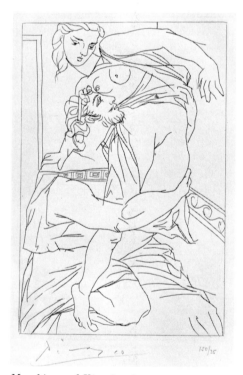

Myrrhina and Kinesias, from
Lysistrata, by Aristophanes
Paris, January 17, 1934
Published New York, The Limited Editions Club, 1934
Etching, 8⅝ x 6″ (22 x 15.2 cm)
Geiser 389. The Museum of Modern Art,
New York. The Louis E. Stern Collection

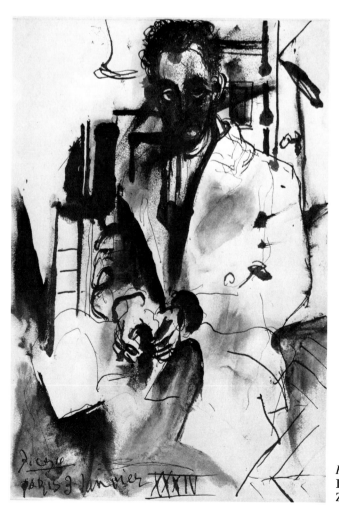

Portrait of Man Ray. Paris, January 3, 1934
India ink, 13⅝ x 9¾″ (34.7 x 24.8 cm)
Zervos VIII, 165. Collection Paul Kantor, Beverly Hills

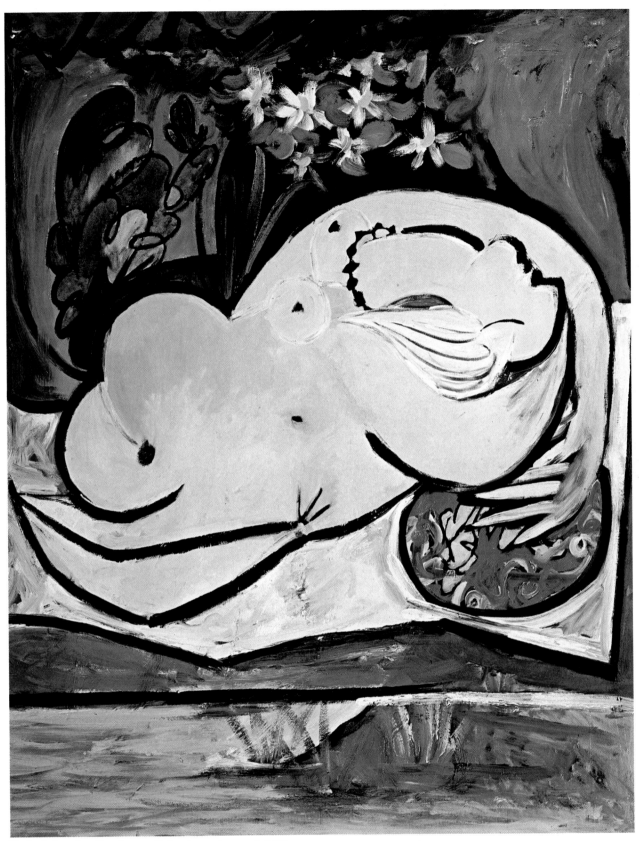

Nude Asleep in a Landscape. Boisgeloup, August 4, 1934
Oil on canvas, 63¾ x 51¼″ (162 x 130 cm)
Not in Zervos. Musée Picasso, Paris

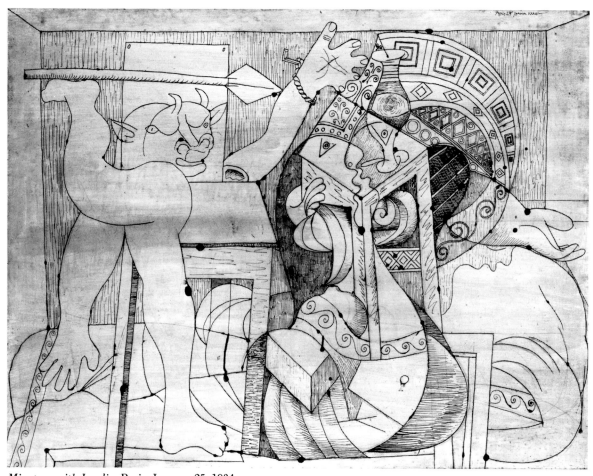

Minotaur with Javelin. Paris, January 25, 1934
India ink on wood, 38⅛ x 51¼" (97 x 130 cm)
Zervos VIII, 167. Musée Picasso, Paris

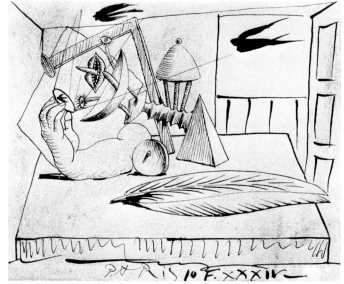

Construction with Swallows. Paris, February 10, 1934
India ink, 10¼ x 12⅞" (26 x 32.5 cm)
Zervos VIII, 173. Musée Picasso, Paris

Construction with Swallows. Paris, February 10, 1934
India ink, 10¼ x 13" (26 x 33 cm)
Zervos VIII, 175. Musée Picasso, Paris

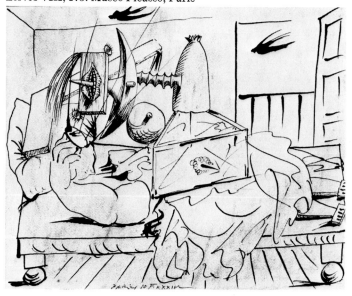

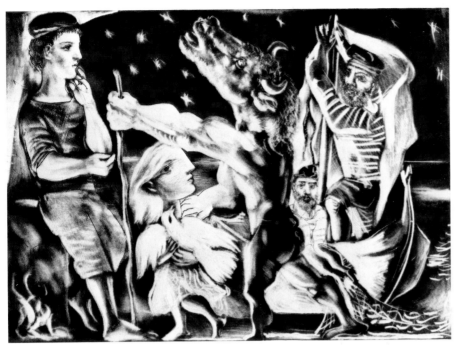

Blind Minotaur Guided by a Little Girl in the Night. Paris, November 1934
Aquatint, drypoint, and scraper, 9¹¹⁄₁₆ x 13⅝″ (24.6 x 34.6 cm)
Geiser 437, IV. The Museum of Modern Art, New York. Abby Aldrich Rockefeller Fund

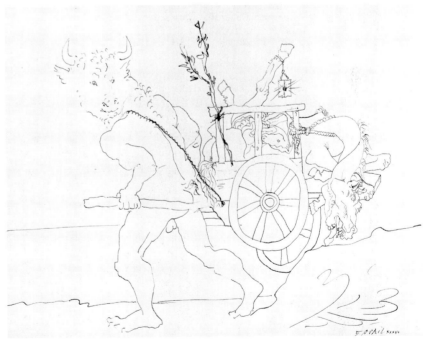

Minotaur Carting a Mare and its Foal. Juan-les-Pins, April 5, 1936
India ink, 19⅞ x 25¾″ (50.5 x 65.3 cm)
Zervos VIII, 276. Musée Picasso, Paris

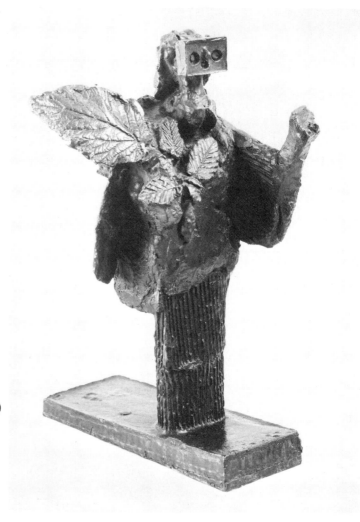

Woman with Leaves. [Boisgeloup], 1934
Bronze, 15 x 7⅜ x 10¼″ (38 x 18.7 x 25.8 cm)
Spies 157. Musée Picasso, Paris

Woman at a Mirror. Paris, April 1934
Ink, watercolor, and colored chalk, 17⅞ x 22″ (45.4 x 55.8 cm)
Not in Zervos. Los Angeles County Museum of Art.
Mr. and Mrs. William Preston Harrison Collection

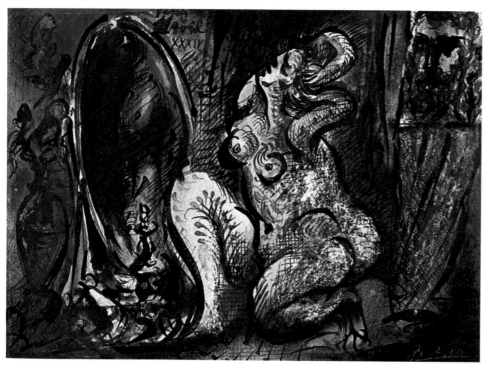

OPPOSITE:
Woman in a Red Hat. [Paris], 1934
Oil on canvas, 64 x 51″ (162.5 x 129.5 cm)
Zervos VIII, 238. Collection Mr. and Mrs.
Victor W. Ganz, New York

324

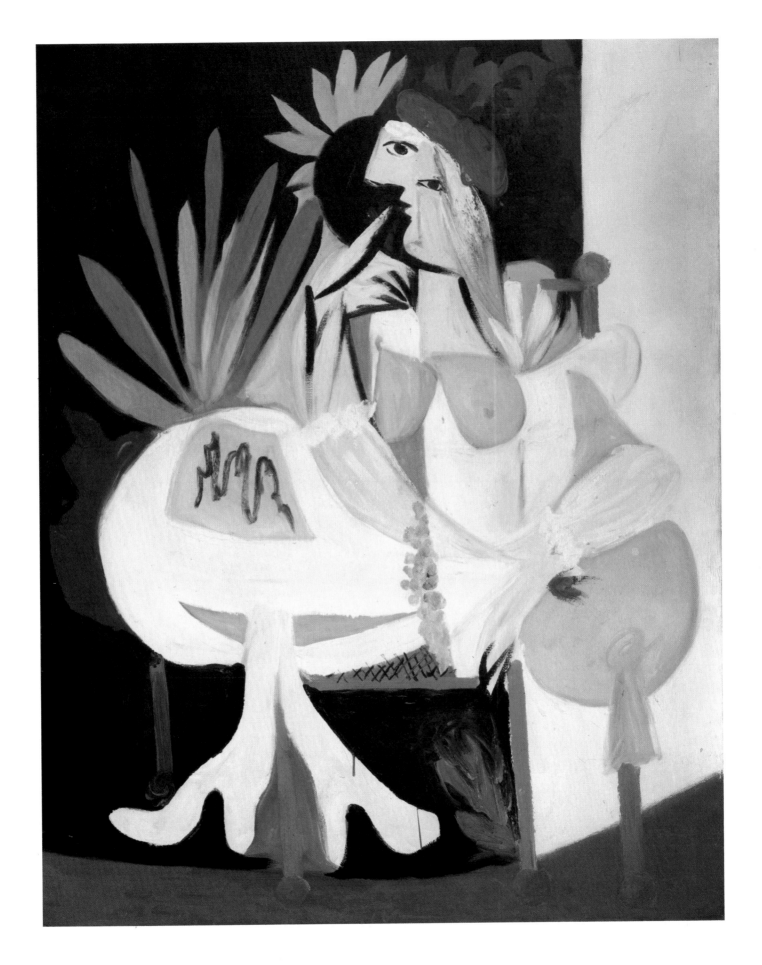

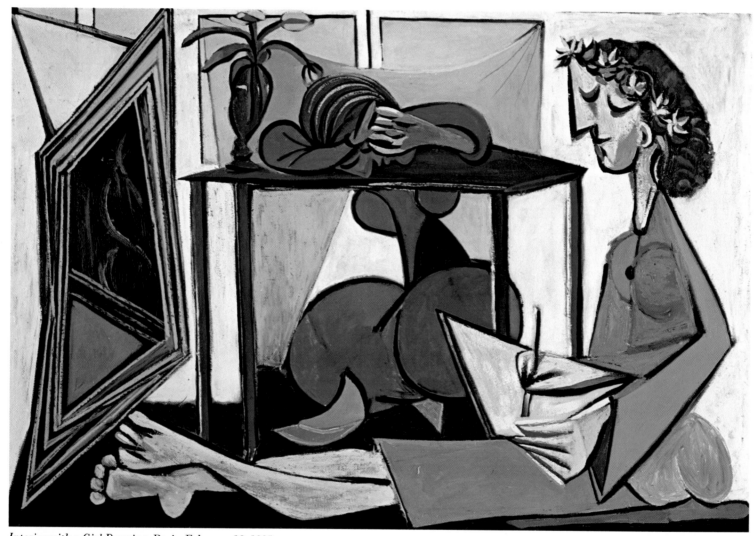

Interior with a Girl Drawing. Paris, February 12, 1935
Oil on canvas, 51¼ x 76⅝″ (130 x 195 cm)
Zervos VIII, 263. The Museum of Modern Art, New York. Nelson A. Rockefeller Bequest

Girl Reading. Paris, January 9, 1935
Oil and enamel on canvas, 63⅝ x 51″ (161.5 x 129.5 cm)
Zervos VIII, 260. Musée Picasso, Paris

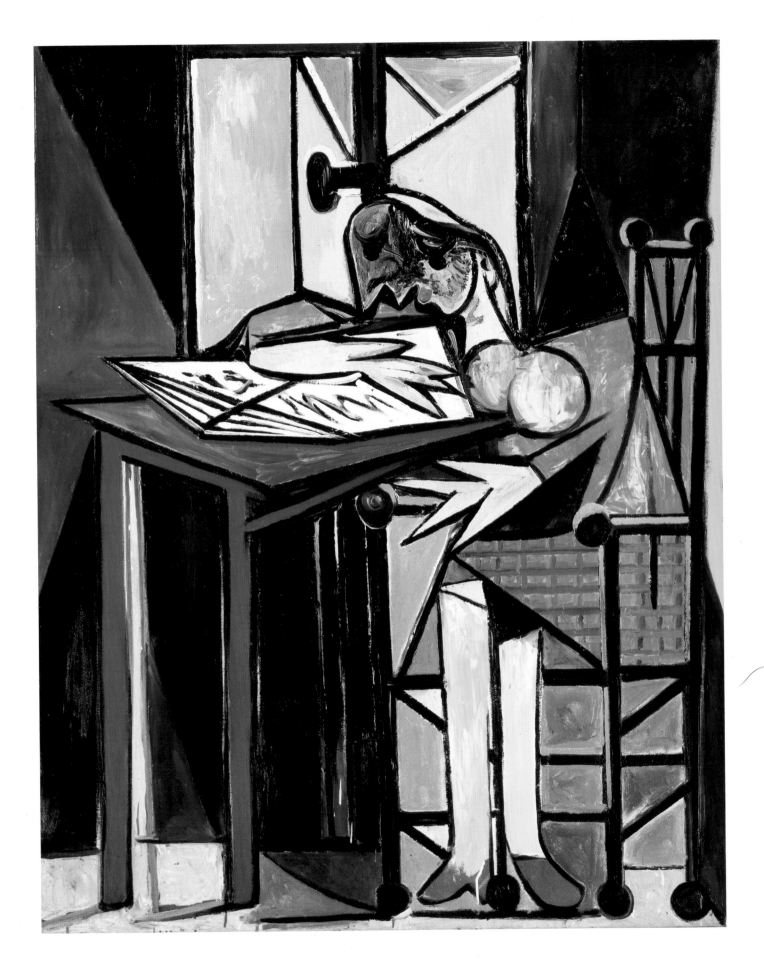

327

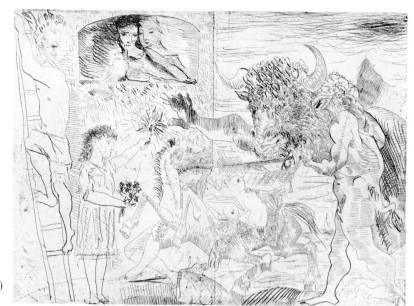

Minotauromachy. Paris, Spring 1935
Etching and scraper, 19⅝ x 27¼″ (49.8 x 69.3 cm)
Bloch 288, I. Musée Picasso, Paris

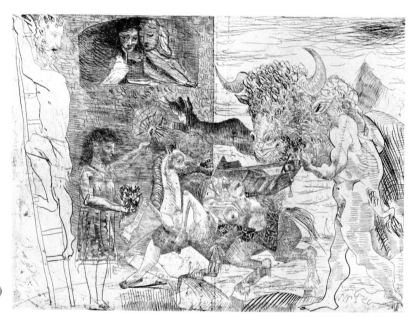

Minotauromachy. Paris, Spring 1935
Etching and scraper, 19⅝ x 27¼″ (49.8 x 69.3 cm)
Bloch 288, II. Musée Picasso, Paris

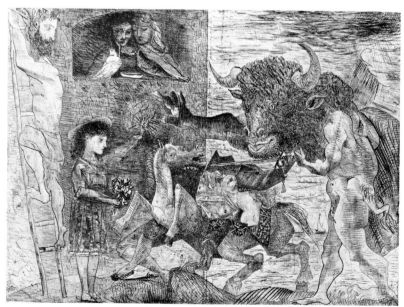

Minotauromachy. Paris, Spring 1935
Etching and scraper, 19⅝ x 27¼″ (49.8 x 69.3 cm)
Bloch 288, III. Musée Picasso, Paris

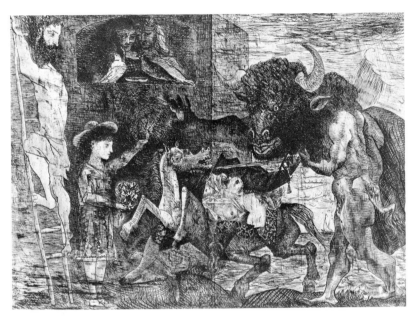

Minotauromachy. Paris, Spring 1935
Etching and scraper, 19⅝ x 27¼″ (49.8 x 69.3 cm)
Bloch 288, IV. Musée Picasso, Paris

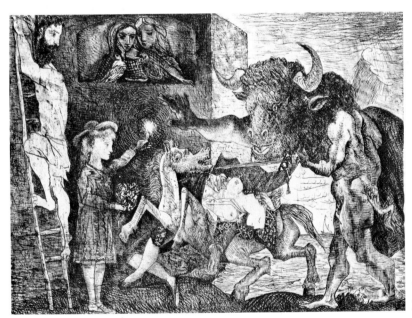

Minotauromachy. Paris, Spring 1935
Etching and scraper, 19½ x 27⁷/₁₆″ (49.5 x 69.7 cm)
Bloch 288, V. The Museum of Modern Art, New York. Purchase

329

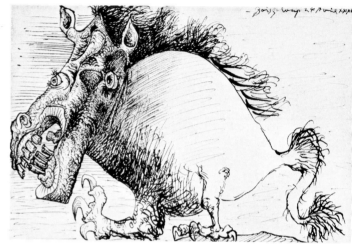

Monster. Boisgeloup, April 24, 1935
Pen and ink, 6¾ x 10″ (17 x 25.5 cm)
Not in Zervos. Collection Bernard Picasso, Paris

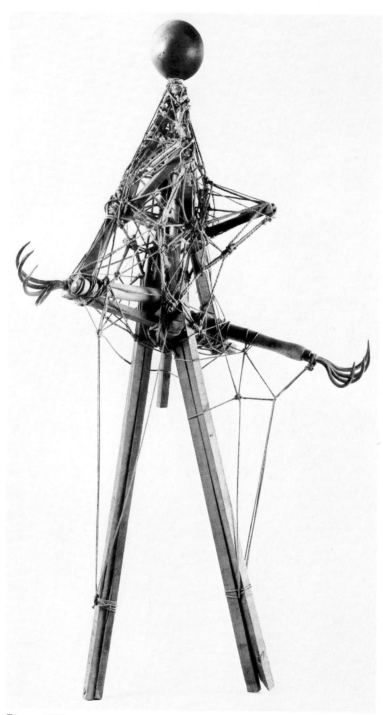

Figure. 1935
Wood, string, ladle, and rakes, 44⅛ x 24⅜ x 11¼″ (112 x 62 x 28.5 cm)
Spies 165. Musée Picasso, Paris

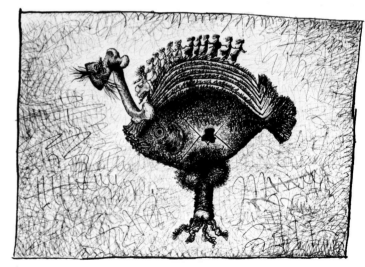

April Fool. [Juan-les-Pins], 1936
Pen and ink, 9¾ x 13¾″ (24.8 x 34.9 cm)
Not in Zervos. Private collection, London

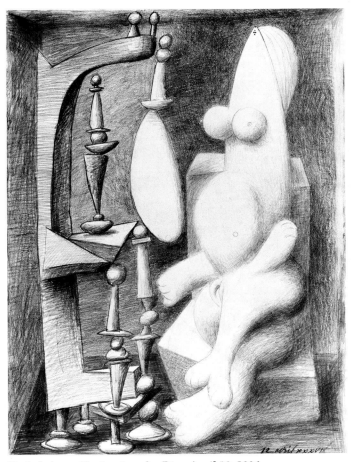

Nude before a Vanity. Juan-les-Pins, April 12, 1936
Pencil, 25¼ x 18⅞" (64 x 48 cm)
Zervos VIII, 275. Musée Picasso, Paris

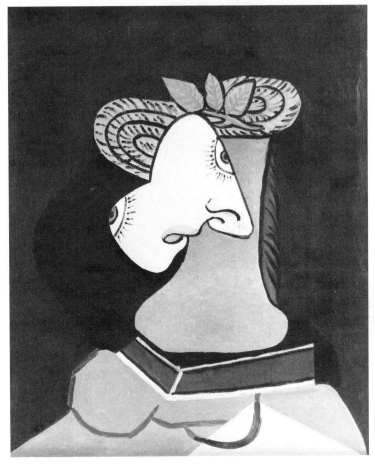

Lady in a Straw Hat. Juan-les-Pins, May 1, 1936
Oil on canvas, 24 x 19¾" (61 x 50 cm)
Not in Zervos. Musée Picasso, Paris

Bull and Horses. Paris, January 15, 1936
India ink, 6¾ x 10⅛" (17 x 25.5 cm)
Not in Zervos. Jan Krugier Gallery, Geneva

Faun Unveiling a Woman. Paris, June 12, 1936
Etching and aquatint, 12⁷⁄₁₆ x 16⁷⁄₁₆" (31.6 x 41.7 cm)
Bloch 230
The Museum of Modern Art, New York. Purchase

Circus Horse. Paris, October 23, 1937
India ink and pastel, 11½ x 17" (29 x 43 cm)
Zervos IX, 83. Private collection, Switzerland

Sleeping Woman before Green Shutters (Marie-Thérèse Walter). Juan-les-Pins, April 25, 1936
Oil on canvas, 21¼ x 25⅝" (54 x 65 cm)
Not in Zervos. Musée Picasso, Paris

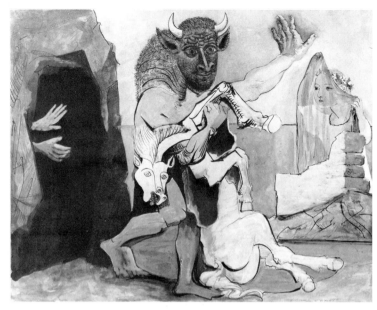

Minotaur and Dead Mare before a Grotto
Juan-les-Pins, May 6, 1936
India ink and gouache, 19¾ x 25¾″ (50 x 65.5 cm)
Not in Zervos. Musée Picasso, Paris

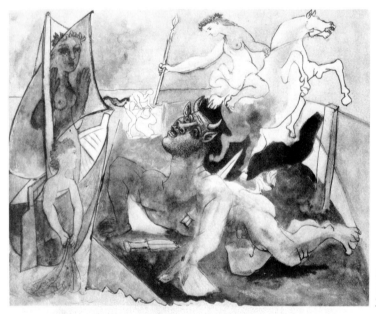

Composition with Minotaur (Curtain for *Le 14 Juillet* of Romain Rolland). Paris, May 28, 1936
India ink with gouache, 17¼ x 21½″ (44 x 54.5 cm)
Zervos VIII, 287. Musée Picasso, Paris

Composition with Minotaur. Paris, May 9, 1936
India ink and gouache, 19¾ x 25⅝″ (50 x 65 cm)
Zervos VIII, 286. Jan Krugier Gallery, Geneva

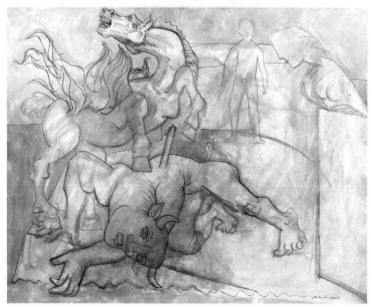

Minotaur, Horse, and Bird. Paris, August 5, 1936
India ink, watercolor, and gouache, 17⅜ x 21½″
(44.2 x 54.4 cm)
Not in Zervos. Musée Picasso, Paris

334

Composition with Wounded Minotaur, Horse, and Couple
Paris, May 10, 1936
India ink and gouache, 19¾ x 25⅝″ (50 x 65 cm)
Zervos VIII, 288. Musée Picasso, Paris

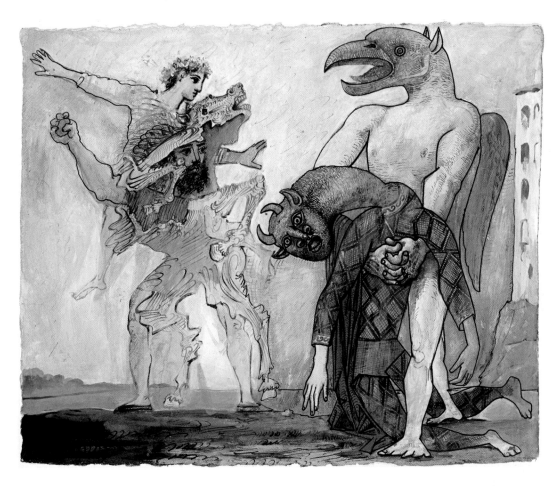

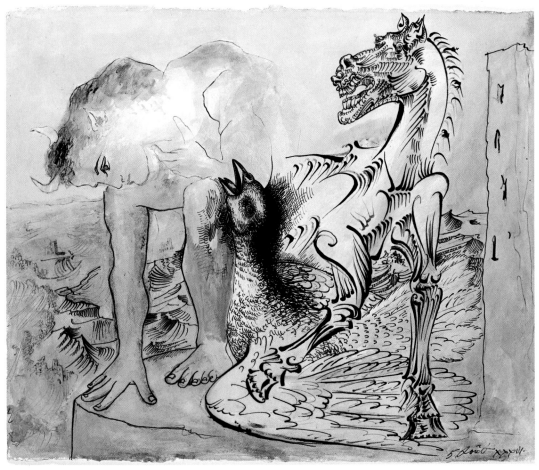

335

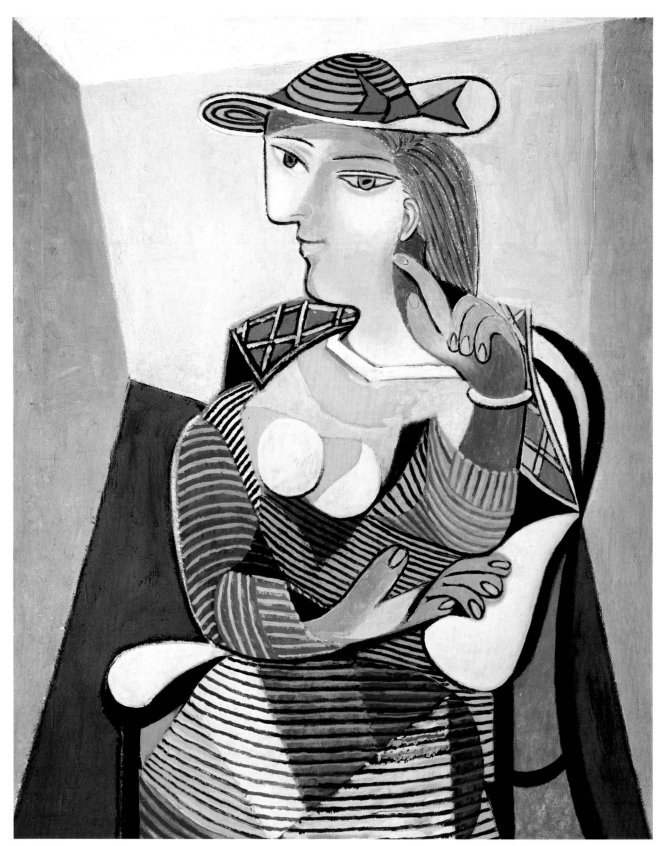

Seated Woman (Marie-Thérèse Walter). [Paris], January 6, 1937
Oil on canvas, 39⅜ x 31⅞″ (100 x 81 cm)

Zervos VIII, 324. Musée Picasso, Paris

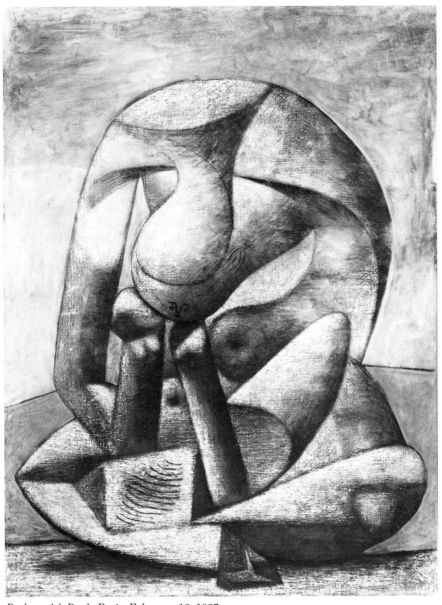

Bather with Book. Paris, February 18, 1937
Oil, pastel, and charcoal on canvas, 51¼ x 38⅜″ (130 x 97 cm)
Zervos VIII, 351. Musée Picasso, Paris

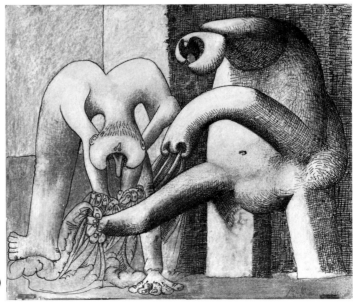

Two Nudes on the Beach. Paris, May 1, 1937
India ink and gouache on wood, 8⅝ x 10⅝″ (22 x 27 cm)
Zervos IX, 217. Musée Picasso, Paris

The Table. 1937
Steel wool, wooden knife, corrugated paper, cardboard,
piece of tablecloth, and oil on canvas, 19¾ x 25½″ (50 x 65 cm)
Spies 170. Collection Paloma Picasso Lopez, Paris

Seated Woman (Marie-Thérèse Walter). [Le Tremblay-sur-Mauldre], March 11, 1937
Oil and pastel on canvas, 51⅛ x 38⅛″ (130 x 97 cm)
Not in Zervos. Musée Picasso, Paris

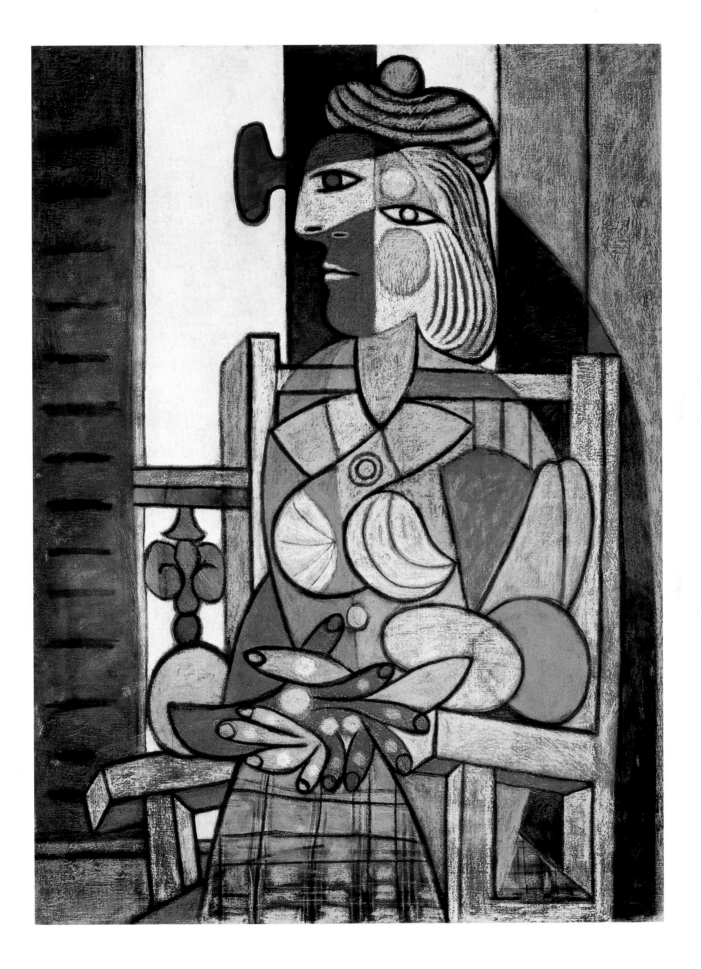

Dream and Lie of Franco, I. January 8, 1937
Etching and aquatint, 12⅜ x 16⁹⁄₁₆″ (31.4 x 42.1 cm)
Bloch 297. The Museum of Modern Art, New York. The Louis E. Stern Collection

Dream and Lie of Franco, II. January 8–9, June 7, 1937
Etching and aquatint, 12⅜ x 16⁹⁄₁₆″ (31.4 x 42.1 cm)
Bloch 298. The Museum of Modern Art, New York. The Louis E. Stern Collection

Poems and Horse's Head. Paris, June 1934
(Poems dated June 7, 1936, and June 15, 1936)
India ink and gouache, 13 x 6¾″ (33 x 17 cm)
Not in Zervos. Musée Picasso, Paris

At the End of the Jetty. Mougins, September 12, 1937
Pen and ink, 11¼ x 8¼″ (28.5 x 21 cm)
Not in Zervos. Collection Mr. and Mrs. Lee V. Eastman, New York

Grand Air, from *Les Yeux fertiles,* by Paul Eluard
Paris, June 3–4, 1936. Published Paris, G.L.M., 1936
Etching, 16⁷/₁₆ x 12½″ (41.7 x 31.8 cm)
Bloch 289. The Museum of Modern Art, New York.
A. Conger Goodyear Fund

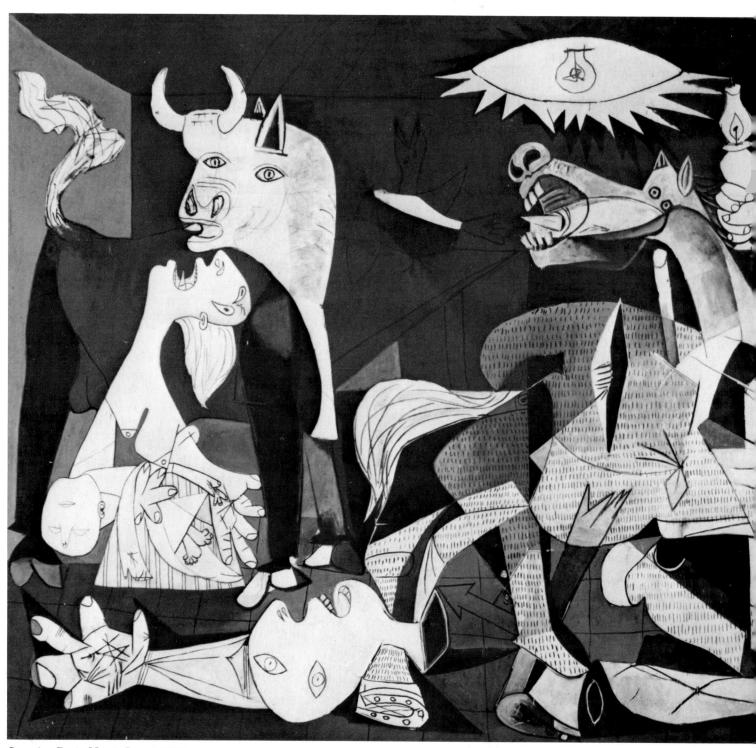

Guernica. Paris, May 1–June 4, 1937
Oil on canvas, 11' 5½" x 25' 5¾" (349.3 x 776.6 cm)
Zervos IX, 65. On extended loan to The Museum of Modern Art, New York

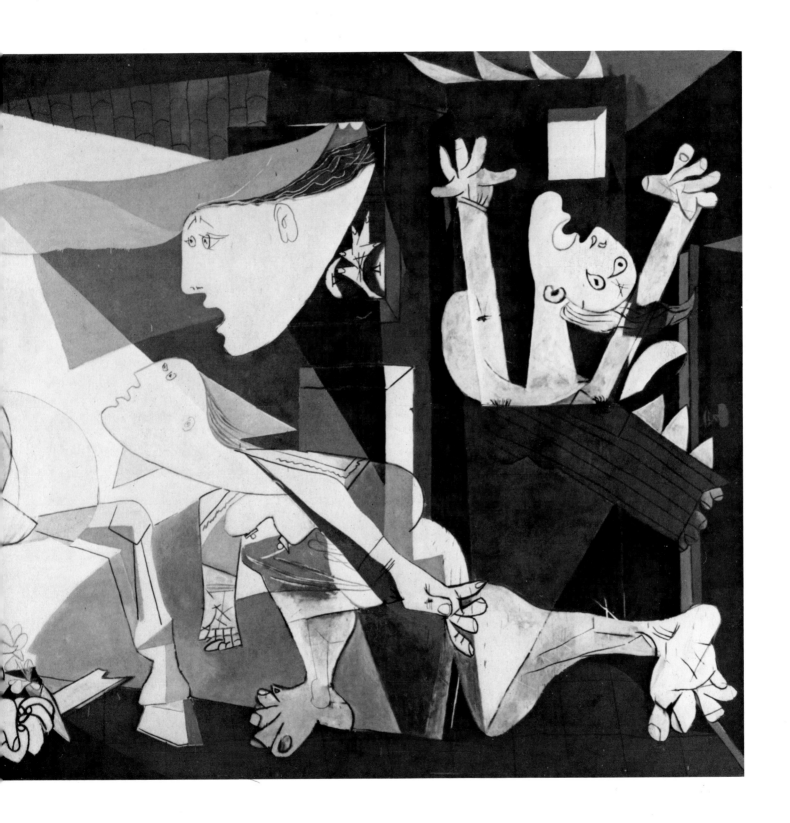

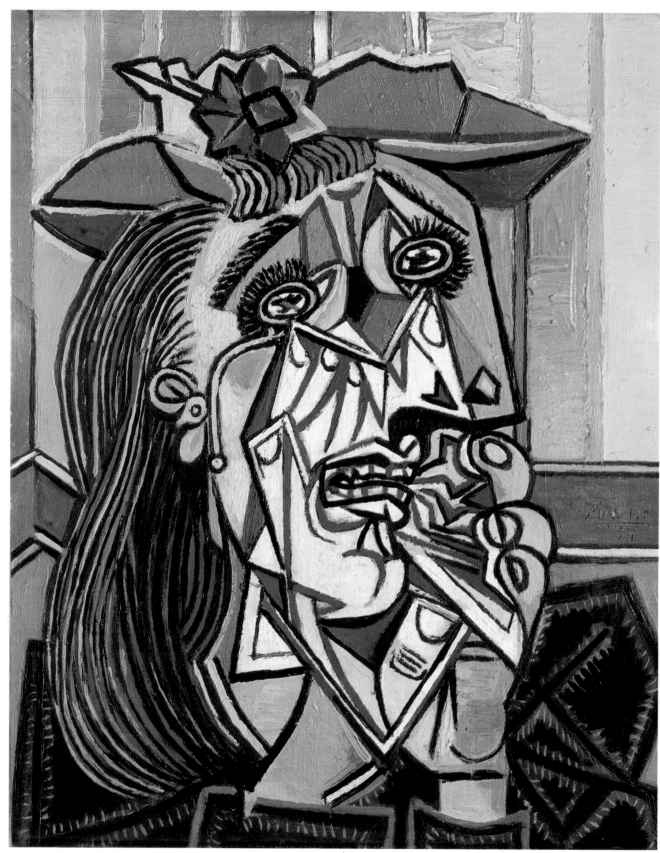

Weeping Woman. Paris, October 26, 1937
Oil on canvas, 23⅝ x 19¼″ (60 x 49 cm)
Zervos IX, 73. Private collection, England

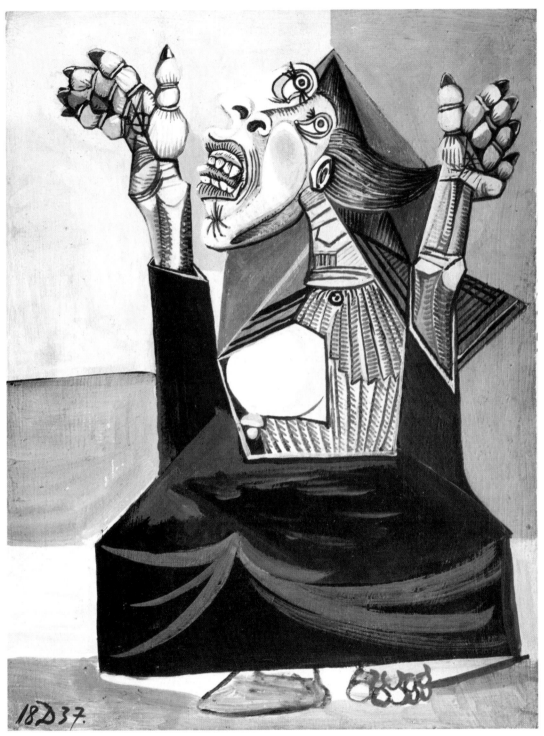

Woman Crying. Paris, December 18, 1937
Gouache and India ink on panel, 9½ x 7¼″ (24 x 18.5 cm)
Not in Zervos. Musée Picasso, Paris

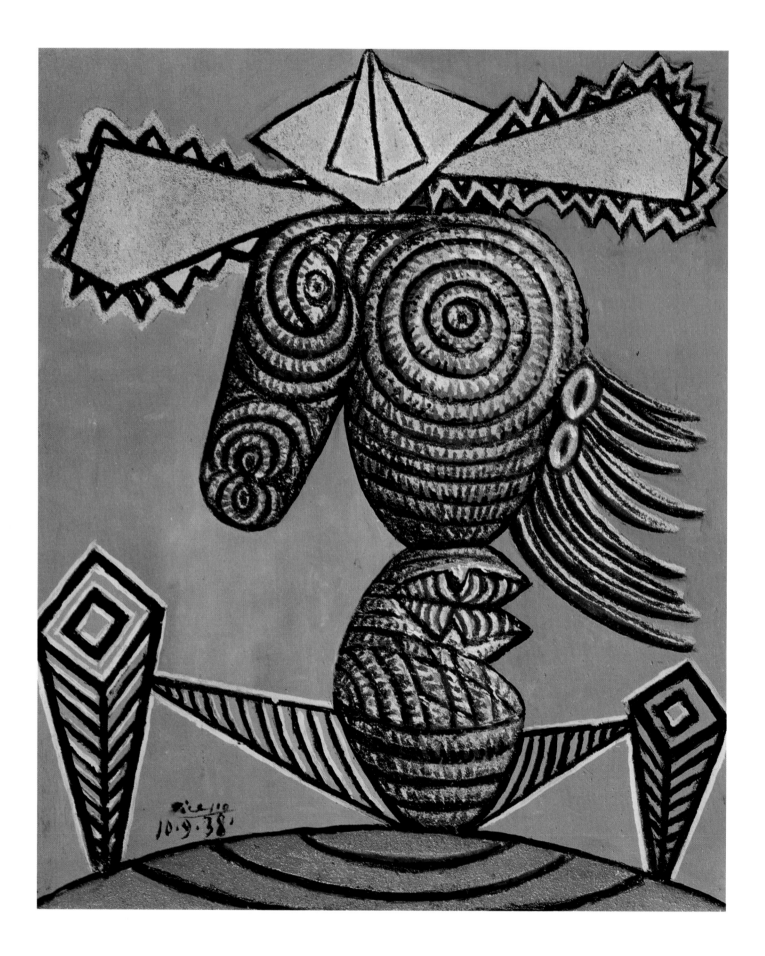

346

1938-1944

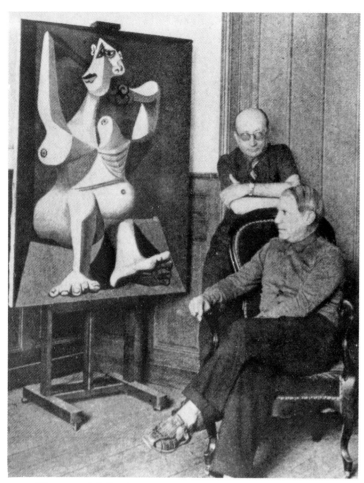

LEFT: Picasso and Sabartés in Royan, 1940. On the easel, *Woman Dressing Her Hair* (p. 366). RIGHT: *The Artist before His Canvas.* Paris, March 22, 1938. Charcoal on canvas, 51¼ x 37″ (130 x 94 cm). Not in Zervos. Musée Picasso, Paris

1938

JANUARY 22: Paints his daughter Maïa with her doll (p. 354).

MARCH: The cock begins to appear in a series of drawings and pastels (p. 354). When a young American painter asks Picasso about them, he replies: "Cocks, there have always been cocks, but like everything else in life we must discover them—just as Corot discovered the morning and Renoir discovered girls."

MARCH 11: The *Anschluss*: Austria is annexed by the German Reich.

SPRING: Makes a wall-size collage, *Women at Their Toilette* (p. 357), of wallpaper and oil on canvas.

APRIL: Begins to decorate forms with small lines that suggest chair caning or basketwork. Over next nine months, uses this device in series of paintings on theme of Seated Woman: *Seated Woman* (p. 358), *Seated Woman with Hat* (p. 346), and *Woman Seated in a Garden* (p. 359). Also makes drawings (p. 355), in which the entire page is covered with tracery like a fantastic spider's web.

MAY 24: Paints Dora Maar as *Seated Woman* (p. 356), incorporating a basketwork hat and drawing the face in profile yet with both eyes, ears, and nostrils fully visible. Uses double-face device in many portraits over the next two years.

SUMMER: Returns to Mougins with Dora Maar, again staying at Hôtel Vaste Horizon with Paul and Nusch Eluard. Paints portraits of Nusch and Dora, as well as of a young woman named Ines who works at the hotel. In the autumn, she returns with Picasso and Dora to Paris as housekeeper.

In Mougins, makes paintings and drawings of men with ice cream cones and lollipops (two, p. 360), continuing the series of basketwork figures.

LATE SEPTEMBER: Returns to Paris.

In Munich, Great Britain and France sanction the dismemberment of Czechoslovakia.

OCTOBER: Visits Zervos and his wife at Vézelay.

OCTOBER 4–29: Exhibition of *Guernica* and more than sixty studies at New Burlington Galleries in London, under

auspices of the National Joint Committee for Spanish Relief. Roland Penrose and a committee of politicians, scientists, artists, and poets make the arrangements. After show closes, the works are put on view in Whitechapel Gallery in London's East End; workers crowd the gallery. Two more exhibitions are arranged in Leeds and Liverpool before the works leave England.

OCTOBER 19–NOVEMBER 11: Exhibition "Picasso and Matisse" at Museum of Modern Art, Boston; includes 24 works by Picasso dating from 1901 to 1937.

NOVEMBER: Paints *Still Life with Red Bull's Head* (p. 362); another version with a black head executed a week earlier.

NOVEMBER 7–26: Exhibition "21 Paintings—1908 to 1934" at Valentine Gallery, New York.

WINTER: Picasso confined to bed with severe attack of sciatica. Sabartés visits daily and asks Picasso to make his portrait as a sixteenth-century gentleman wearing a ruff; despite his pain, Picasso obliges with a drawing (some months later makes a painting of him in this costume). Confinement continues until after Christmas.

1939

JANUARY 13: Death of Picasso's mother in Barcelona. Thirteen days later, city surrenders to Franco. Picasso's nephews, Fin and Javier Vilato, fight on the Republican side.

JANUARY 17: Exhibition of 33 recent works at Paul Rosenberg's gallery, Paris; 32 of these are shown in London in March, at Rosenberg & Helft.

JANUARY 21: On same day, paints Marie-Thérèse and Dora Maar in same pose, each woman inspiring a different morphology.

JANUARY 30–FEBRUARY 18: Represented by ten works in exhibition "Figure Paintings" at Marie Harriman Gallery, New York.

MARCH: Hitler enters Prague, and later in the month Madrid is taken by Franco.

MARCH 27–APRIL 29: Exhibition "Picasso before 1910" at Perls Galleries, New York.

APRIL 1: Paints *Head of a Woman with Two Profiles* (p. 362), in which facial dislocation appears at its most extreme.

During month, paints two versions of *Cat and Bird* (one, p. 363).

MAY 5–29: *Guernica* and related studies placed on exhibition in America at the Valentine Gallery, New York, under the auspices of the American Artists' Congress for the benefit of the Spanish Refugee Relief Campaign. Sidney Janis is chairman of the organizing committee. Works then sent to Stendahl Gallery, Los Angeles, for August 10–21 exhibition sponsored by Motion Picture Artists Committee. Subsequently on view at Arts Club of Chicago and San Francisco Museum of Fine Arts before being returned to New York in November for Picasso retrospective at The Museum of Modern Art.

MAY–JUNE: Exhibition "Picasso in English Collections" at London Gallery, London. Catalog published in *London Bulletin* (May 15) and edited by E.L.T. Mesens and Roland Penrose.

EARLY JULY: Dora Maar and Picasso travel by Train Bleu to Antibes, where they rent an apartment from Man Ray.

JULY 22: Death of Ambroise Vollard, Picasso's long-time friend and dealer, in an automobile accident. Picasso hurries back to Paris for funeral.

JULY 28: Invites Sabartés to accompany him on his return South. The chauffeur, Marcel, drives them in the Hispano-Suiza, stopping en route in Fréjus, where they attend a bullfight. During

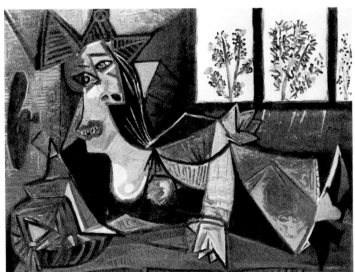

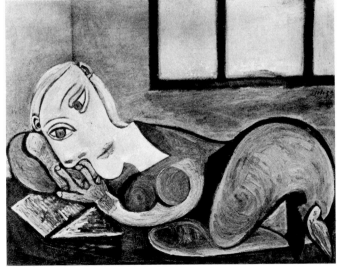

LEFT: *Woman Reclining on a Couch* (Dora Maar). Le Tremblay-sur-Mauldre, January 21, 1939. Oil on canvas, 38¼ x 51¼ (97 x 130

cm). Zervos IX, 252. Collection Julian Aberbach, and Family, New York. RIGHT: *Reclining Woman with a Book* (Marie-Thérèse Walter). Paris, January 21, 1939. Oil on canvas, 38 x 51⅜″ (96.5 x 130.5 cm). Zervos IX, 253. Musée Picasso, Paris

the first days after their arrival in Antibes, shows Sabartés the towns along the coast—Monte Carlo, Nice, Cannes, and Mougins. Settles into rented apartment and prepares to paint, clearing away furniture and bric-a-brac and covering walls with lengths of canvas. Spends mornings at the beach with Sabartés, Dora, his nephews from Barcelona, Penrose, and other friends.

AUGUST: Paints *Night Fishing at Antibes* (p. 365). Motif found in course of evening walks with Dora Maar, in the sight of fishermen using acetylene lamps to attract their catch. In the painting, Dora Maar appears on the jetty holding her bicycle and eating a double ice cream cone; Jacqueline Lamba, André Breton's wife, stands at her side. Palais Grimaldi (later to be Picasso Museum of Antibes) is in background.

AUGUST 23: Signing of German-Soviet Nonaggression Pact. War is threatened and guns are set up along the southern beaches.

AUGUST 25: Sabartés, Picasso, and Dora Maar return to Paris by train, leaving the chauffeur to drive back with Picasso's work of the summer.

SEPTEMBER 1: Germany invades Poland. Two days later, Britain and France declare war on Germany. Picasso leaves Paris for Royan, on the Atlantic coast near Bordeaux. Travels in the Hispano-Suiza with chauffeur Marcel, Dora Maar, Sabartés and his wife, and his dog Kazbec. Takes room at Hôtel du Tigre for Dora Maar and himself; Marie-Thérèse and Maïa are already at the villa Gerbier de Joncs. The two women soon become aware of the arrangement, leading to great difficulty for Picasso. A foreigner in the eyes of the law, he is harassed by local authorities. On September 7, returns to Paris for a day to obtain residence permit for Royan sojourn.

In Royan, continues to work throughout September and into October: in September, images of both Dora Maar and Marie-Thérèse; on September 17, *Bust of a Man in a Striped Shirt* (p. 361);

October 1–4, series of sketches of a sheep's head.

MID-OCTOBER: Again returns to Paris, this time for two weeks, to look for painting supplies and to store paintings in a bank vault. On assignment for *Life Magazine*, Brassaï photographs him visiting the cafés—the Flore and Brasserie Lipp—and posing in his studio (he would not allow Brassaï to watch him paint).

OCTOBER 22: Back in Royan, paints Sabartés wearing ruff of a Spanish gentleman.

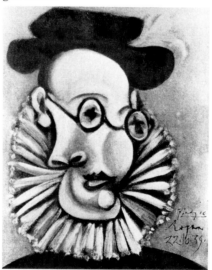

Jaime Sabartés. Royan, October 22, 1939. Oil on canvas, 18½ x 15" (45.7 x 38 cm). Zervos IX, 366. Museo Picasso, Barcelona

NOVEMBER 15–JANUARY 7, 1940: Major retrospective, "Picasso: Forty Years of His Art," at The Museum of Modern Art, New York. Organized by Alfred H. Barr, Jr., in collaboration with Art Institute of Chicago, it contains 344 works, many from the artist's own collection. *Guernica* and its studies are included. Exhibition later travels in different versions to The Art Institute of Chicago, City Art Museum of St. Louis, Museum of Fine Arts, Boston, San Francisco Museum of Art, Cincinnati Art Museum, Cleveland Museum of Art, Isaac Delgado Museum of Art, New Orleans, Minneapolis Institute of Arts, and Carnegie Institute, Pittsburgh.

DECEMBER 5: Returns to Paris, remaining there through December 21, when he returns to Royan.

Published during the year is *Pour la Tchécoslovaquie, hommage à un pays martyr* (Paris), edited by "the group of Czechoslovakian artists"; includes linocut by Picasso and texts by Paul Claudel, Paul Valéry, and F. Langer.

1940

BEGINNING OF YEAR: Takes studio in Royan on fourth floor of villa Les Voiliers, overlooking the sea and the Belle Epoque houses of the town.

FEBRUARY 5–29: Leaves Royan for a sojourn in Paris. Returns at end of month.

MARCH 4: *Life* Magazine (New York) publishes "Spanish Painter's Big Show Tours the Nation" on occasion of the tour of The Museum of Modern Art exhibition.

MID-MARCH: Again returns to Paris, where he will remain through mid-May. Sees those friends who are not in the army: Brassaï, Georges Hugnet, Man Ray, the Zervoses. Eluard has been mobilized, as have Breton and Aragon.

MARCH 14: Working in Paris, fills sketchbook with drawings for major composition *Woman Dressing Her Hair*. (Sketchbook published by Zervos in 1948 under title *Carnet de dessins de Picasso*.) Late in month paints series of still lifes inspired by the fish market at Royan (*The Eels, The Sea Spider*, etc.)

APRIL 19: Opening of exhibition of watercolors and gouaches at Yvonne Zervos's Galerie M.A.I., Paris.

MAY 10–13: Germans invade Belgium, crossing border into France May 12. Imminent appearance of Germans in Paris precipitates plans to return to Royan. The day before he leaves, runs into Matisse on the street; to his surprise, learns that Matisse is on the way to his tailor. When he reminds Matisse that German forces might arrive the next day. latter asks: "But what about our generals, what are they doing?" Picasso wryly responds: "Oh, they're from the Ecole des Beaux Arts."

MAY 16: Returns to Royan with Dora Maar and finds town filled with refugees from Belgium and the north.

JUNE: Fills another sketchbook with studies for *Woman Dressing Her Hair*. Working in Royan studio, completes the canvas (p. 366) by second or third week of month.

JUNE 14: Germans enter Paris. Eight days later Pétain signs Armistice with Germany. On June 23, German troops enter Royan.

AUGUST 15: Paints *Café at Royan* (p. 364), view from window of studio.

AUGUST 25: Finds presence of German troops threatening. With Sabartés, returns to Paris by car, carrying paintings and dog Kazbek. Dora travels by train at same time. Marie-Thérèse and Maïa remain behind.

AUTUMN: Abandons apartment at rue La Boëtie for duration of war, living in the studio at rue des Grands-Augustins. Frequents the cafés, which are warm. Installs magnificent stove in studio, but as shortages develop, there is no fuel for it. Refuses offers of special favors from Germans, reportedly saying: "A Spaniard is never cold." Gives out souvenir photographs of *Guernica* to German officers who call on him to see his work; looking at photo, one asks: "Did you do this?" Picasso replies: "No, you did."

Picasso's dealer, Paul Rosenberg, is in the United States, but the Nazis have confiscated his collection. Kahnweiler leaves Paris, taking up residence in the free zone in Limousin. Picasso learns that French soldiers have entered Boisgeloup studio and damaged some sculptures, most of which are in original plaster. During this period, receives invitations to live abroad—in Mexico, in the United States. Prefers to remain in France.

Published during year is Iliazd's *Afat* (Paris: Published by the author), with six etchings by Picasso.

1941

JANUARY 14–17: Writes a farce, *Le Désir attrapé par la queue* (Desire

Caught by the Tail) (published in 1944 in *Messages II*; Paris: Risques, Travaux et Modes). Its characters are obsessed by cold, hunger, and love, and their attempts to avoid the first two and satisfy the third inevitably end in disappointment. Hero is Big Foot, who lives in "artistic" studio. Onion is his rival for the affection of the heroine, Tart. She has a Cousin and two friends, Fat and Thin Anguish. Other characters are Round Piece, Two Bow-Wows, Silence, and Curtain. Picasso embellishes script with three drawings that introduce three of the six acts and a frontispiece, *Portrait of the Author*, in which he is viewed from the ceiling sitting at his table, glasses protruding from his forehead and pen in hand.

In continuing experiments with automatic poetry, makes page of imaginary calligraphy.

SPRING: Marie-Thérèse and Maïa return to Paris, moving to an apartment on boulevard Henri-IV, where Picasso visits each weekend. Draws scenes to amuse his daughter.

JUNE: Paints *Woman in an Armchair* on June 9 and *Child with Lobster* on June 21 (both, p. 367). During summer paints related work, *Woman with Artichoke* (p. 368).

LATE IN YEAR: Since he cannot leave Paris to work at Boisgeloup, converts bathroom of "les Grands-Augustins" into sculpture studio, explaining to Brassaï that "it's the only place warm enough in this great barracks." Makes numerous small sculptures, but also models large, classic *Head of a Woman* (p. 369) after Dora Maar (in 1959, it is placed in the ancient graveyard of Saint-Germain-des-Prés, Paris, in memory of Apollinaire).

During "phony war," Germans decree that all statues are to be melted down in order to recover the metal for military purposes. Nevertheless, Picasso has bronzes made of various sculptures at insistence of Sabartés, who tells him that "plaster is perishable . . . bronze is forever." Friends help transport original plaster versions to the foundry at night in handcarts.

Imaginary Script. 1941. Pen and ink. Not in Zervos. Private collection

1942

MARCH 27: Death of the sculptor Julio Gonzalez. Picasso attends funeral.

APRIL 5: Paints *Still Life with Steer's Skull* (p. 372), one of a series of works on that theme.

MAY 4: Completes *L'Aubade* (p. 370), a painting of two women, one seated and holding a guitar (perhaps preparing to play a "morning song"), the other sleeping. (Gives work to French national museums after the war.)

JUNE 6: Writing in *Comoedia* (Paris), Maurice de Vlaminck, a frequent guest of German officers, denounces Picasso, declaring him "guilty of having dragged French painting into the most fatal dead end, into indescribable confusion," and attacks both critics and public who have supported him. André Lhote's reply in support of Picasso appears in *Comoedia* a week later.

JULY: First of a long series of drawings on the theme Man with Sheep.

SUMMER: Eluard rejoins Communist party (having formerly been a member in the twenties) and works with the Resistance movement.

SEPTEMBER 20: First issue of *Les Lettres françaises*, underground paper supported by young painters and intellectuals. Eluard is associated with it and brings Picasso into contact with staff.

OCTOBER 9: *Portrait of Dora Maar* (p. 369) wearing a striped blouse. Some time later, Brassaï tells Picasso that he finds this a beautiful piece of painting—particularly the blouse. Picasso replies: "It pleases me that you've noticed that blouse. I invented it entirely. Dora never wore it. . . . Despite what they say of my facileness, I've also labored for a long time on a canvas—how I sweated over this blouse. . . . Over the months I painted and repainted it."

During the year, publication of the Comte de Buffon's *Histoire naturelle* (Paris: Fabiani), with 31 aquatints of animals by Picasso. Commissioned by Vollard, it was published despite the difficulty of finding production materials during the war years. Also published is Georges Hugnet's *Non vouloir* (Paris: Jeanne Bucher), to which Picasso contributes four wood engravings.

1943

JANUARY: Visits Dora Maar's studio on rue de Savoie to present her with a copy of the Buffon *Histoire naturelle*. While there, decorates and embellishes the pages—some forty in all—with bearded men and imaginary animals. On frontispiece, draws Dora as a bird and inscribes pages opposite, "per Dora Maar tan rébufond" ("for Dora Maar so very nice"), a pun in Catalan on the name of the author. (In 1957, Fabiani publishes a facsimile edition of these pages.)

FEBRUARY–MARCH: Working in Grands-Augustins sculpture studio, fashions assemblages from found objects, among them *The Flowering Watering Can* (p. 374), made from real watering can with the addition of pipes and nails, and *Head of a Bull* (p. 373), created from the saddle and handlebars of a derelict bicycle. Both are later cast in bronze. Simultaneously continues to model in plaster, creating *Death's Head* (p. 373).

Drawings on theme of Man with Sheep continue (p. 376), now more clearly

pointing to a large sculpture. About this time has seven-foot-high armature made, and sometime during the next year completes *Man with Sheep* (p. 377) in one or two days, working in wet plaster. (Brassaï, invited by Picasso to photograph all his sculptures for a proposed book, visits in advance of first shooting in late September and reports seeing the sculpture on arriving at the studio.)

MAY: Meets young painter Françoise Gilot, who visits him in his studio over the next two months. In summer she leaves for the South.

Returns to painting.

All Jews are required by Germans to wear yellow star, which affects many of his old friends, among them Max Jacob.

MAY 21: Paints *First Steps* (p. 375), modeled after his housekeeper Ines's daughter, as is the *Child with Pigeons* (p. 374) painted three months later, on August 24.

NOVEMBER: Françoise Gilot returns to Paris and resumes visits to Picasso's studio. Soon appears in his drawings.

Continues to see old friends, either in his studio or at bistros such as Le Catalan, his favorite at the time. Zervos's apartment is taken over by Germans, and he is in hiding.

1944

FEBRUARY 22: Arrest of friend Robert Desnos. He is sent to camp in Germany, where, soon after being liberated, he dies of typhus.

FEBRUARY 28: Arrest of Max Jacob at Abbey of Saint-Benoît-sur-Loire. Placed in concentration camp at Drancy. Picasso writes to him but never sees the poet again, as Jacob dies of pneumonia in the camp on March 5.

MARCH 19: Michel and Louise Leiris hold reading of Picasso's *Le Désir attrapé par la queue*. Albert Camus directs, and parts are played by Zanie and Jean Aubier, Louise and Michel Leiris, Simone de Beauvoir, Jean-Paul Sartre, Dora Maar, Germaine Hugnet, Raymond Queneau, and Jacques-Laurent

Portrait of the Author, from the published version of *Le Désir attrapé par la queue*, 1944

SOCIÉTÉ DU SALON D'AUTOMNE
Reconnue d'Utilité Publique

CATALOGUE
DES OUVRAGES
DE

Peinture, Sculpture, Dessin, Gravure, Architecture et Art Décoratif

EXPOSÉS

au Palais des Beaux-Arts de la Ville de Paris
Avenue de Tokio et Avenue du Président Wilson

DU 6 OCTOBRE AU 5 NOVEMBRE 1944

Siège social et Secrétariat général :
Grand Palais des Champs-Elysées, porte B. Téléphone Elysées 48-07.
Secrétariat du Salon pendant la durée de l'Exposition :
Palais des Beaux-Arts de la Ville de Paris, Avenue de Tokio.
Téléphone : Passy 92-93.

IMPRIMERIE E. DURAND
5, RUE SÉGUIER, PARIS

1944

Catalog of the 1944 Salon d'Automne, the first in which Picasso ever participated

Bost. Georges Hugnet prepares the musical accompaniment. Audience includes Brassaï, Braque and his wife,

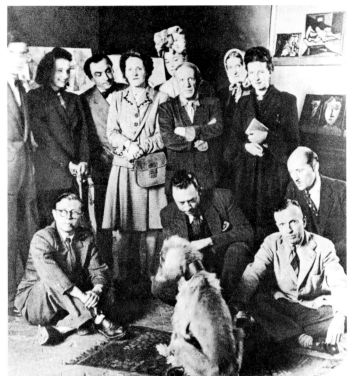

In Picasso's studio after a reading of his play *Le Désir attrapé par la queue*, March 1944. Standing, from left: Jacques Lacan, Cecile Eluard, Pierre Reverdy, Louise Leiris, Zanie Aubier, Picasso, Valentine Hugo, Simone de Beauvoir. On the floor:

Jean-Paul Sartre, Albert Camus, Michel Leiris, Jean Aubier, and Kazbek the dog. Photographed by Brassaï

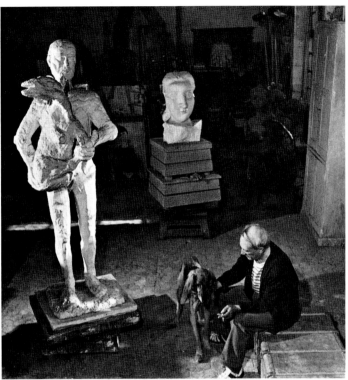

Picasso in his rue des Grands-Augustins studio after the Liberation, September 1944. Photographed by Robert Capa. At left, *Man with a Sheep* of 1944 (p. 377) and in background, *Head of a Woman* (Dora Maar) of 1941 (p. 369).

Valentine Hugo, Jacques Lacan, Paul Eluard's daughter Cecile, and Sabartés. After the performance, Picasso brings everyone, including the audience, to his studio, where he pulls out original manuscript of Alfred Jarry's *Ubu cocu*, calling it the "source" of his work.

SUMMER: Paints landscapes of Paris and several still lifes with a tomato plant.

MID-AUGUST: Street fighting between the Resistance and government intensifies as Germans retreat and Allies move toward Paris. Picasso moves to boulevard Henri-IV to be with Marie-Thérèse and Maïa. Between August 24 and 29, paints watercolor and gouache after Poussin's *Bacchanal*; gouache later disappears from his studio. He also makes realist charcoal portrait of Maïa.

AUGUST 25: Liberation of Paris. Returns to studio on rue des Grands-Augustins.

AUTUMN: Reunited with Eluard, Aragon, and other friends from the Resistance. Visitors from the United States and England flood studio, as do old friends. Photographers such as Robert Capa and Lee Miller record work of the time.

OCTOBER 5: Announcement in *L'Humanité* that Picasso has joined Communist party.

OCTOBER 7: Opening of Salon d'Automne ("Salon de la Libération"). Special gallery set aside to show Picasso's work, which numbers 74 paintings and five sculptures. Catalog notes that exhibition "has been prepared during the enemy occupation . . . [and] it opens in full independence." The first Salon in which Picasso has ever shown, it constitutes first official recognition he has received from his French colleagues.

Violent manifestations against Picasso take place in gallery. Some demonstra-

tors are Beaux-Arts students objecting to his art, some are conservatives condemning his new political stance. National Writers' Committee circulates petition in support of Picasso; signatories include Aragon, Eluard, François Mauriac, Paul Valéry, Jean-Paul Sartre, and Georges Duhamel.

OCTOBER 24: Interviewed by Pol Gaillard in *New Masses* (New York), Picasso explains why he joined Communist party: ". . . [it is] the logical conclusion of my whole life, my whole work. . . . I have always been an exile, now I no longer am; until the day when Spain can welcome me back, the French Communist Party opened its arms to me, and I have found in it those that I most value, the greatest scientists, the greatest poets, all those beautiful faces of Parisian insurgents that I saw during the August days; I am once more among my brothers."

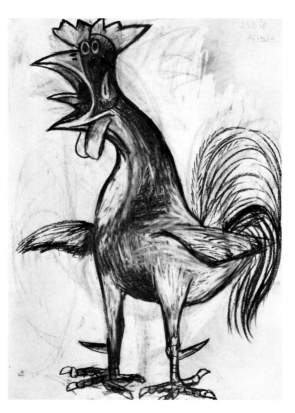

The Cock. Paris, March 23, 1938
Charcoal, 30¼ x 22⅜" (76.9 x 56.9 cm)
Zervos IX, 114. Private collection, New York

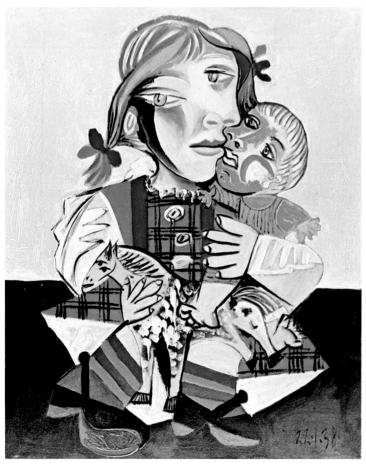

Maïa with a Doll. Paris, January 22, 1938
Oil on canvas, 28¾ x 23⅝" (73 x 60 cm)
Zervos IX, 101. Private collection

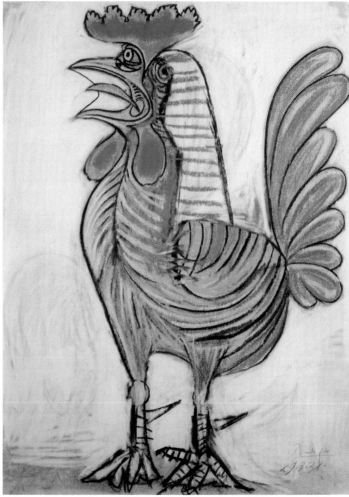

The Cock. Paris, March 29, 1938
Pastel, 30½ x 21¼" (77.5 x 54 cm)
Zervos IX, 113. Collection
Mr. and Mrs. Ralph F. Colin, New York

Two Seated Women. [Paris], October 8, 1938
India ink, 17¾ x 21⅛″ (45 x 53.5 cm)
Zervos IX, 227. Musée Picasso, Paris

Seated Woman. Paris, April 27, 1938
Ink, gouache, and colored chalk, 30¼ x 21⅝″ (76.5 x 55 cm)
Zervos IX, 133. Collection Ernst Beyeler, Basel

Seated Woman. Paris, April 29, 1938
Ink, pastel, and wash, 30⅛ x 21¾″ (76.5 x 55 cm)
Zervos IX, 132. Private collection, New York

355

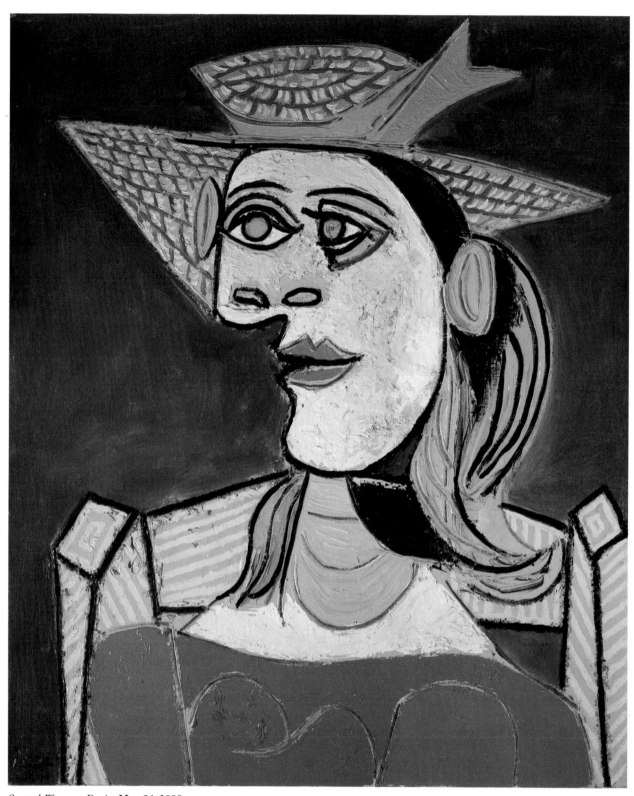

Seated Woman. Paris, May 24, 1938
Oil on canvas, 28¾ x 23⅝" (73 x 60 cm)
Zervos IX, 157. Acquavella Galleries, Inc., New York

356

Women at Their Toilette (Cartoon for a tapestry). Paris, Spring 1938
Oil and pasted paper on canvas, 117¾ x 176⅜″ (299 x 448 cm)
Zervos IX, 103. Musée Picasso, Paris

Seated Woman. [Mougins], August 29, 1938
Oil on canvas, 25⅝ x 19¾″ (65 x 50 cm)
Zervos IX, 211. Collection Norman Granz, Geneva

Woman Seated in a Garden. Paris, December 10, 1938
Oil on canvas, 51½ x 38¼″ (131 x 97 cm)
Zervos IX, 232. Collection Mr. and Mrs. Daniel Saidenberg, New York

Man with an Ice Cream Cone. Mougins, August 6, 1938
Oil on canvas, 24 x 19¾″ (61 x 50 cm)
Zervos IX, 190. Collection Jacqueline Picasso, Mougins

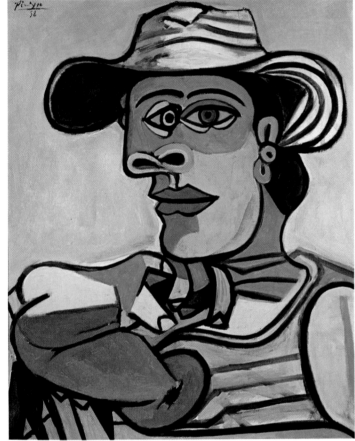

Sailor. Mougins, July 31, 1938
Oil on canvas, 23 x 18⅞″ (58.5 x 48 cm)
Zervos IX, 191. Private collection, Switzerland

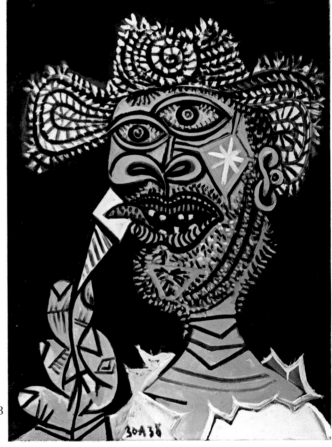

Man with an Ice Cream Cone. [Mougins], August 30, 1938
Oil on canvas, 24 x 18⅛″ (61 x 46 cm)
Zervos IX, 205. Musée Picasso, Paris

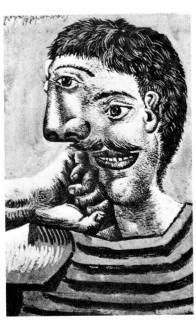

Bust of a Man in a Striped Shirt
Royan, September 17, 1939
Gouache, 8¼ x 5⅛" (21 x 13 cm)
Zervos IX, 330
Collection Bernard Picasso, Paris

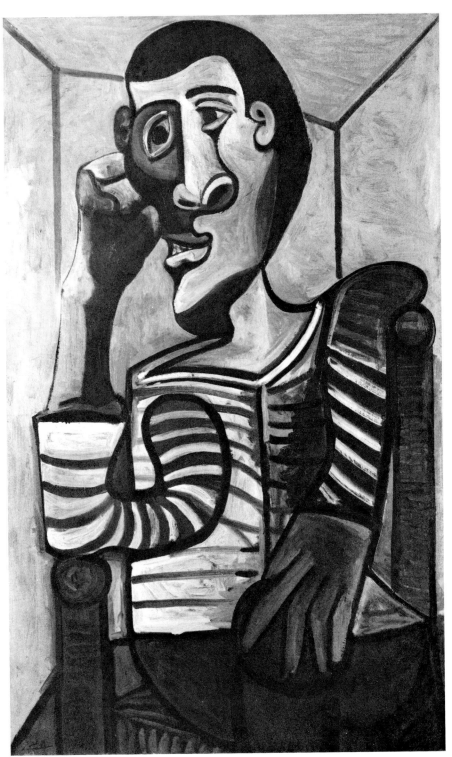

Sailor. Paris, October 28, 1943
Oil on canvas, 51¼ x 31⅞" (130 x 81 cm)
Zervos XIII, 167. Collection Mr. and Mrs. Victor W. Ganz, New York

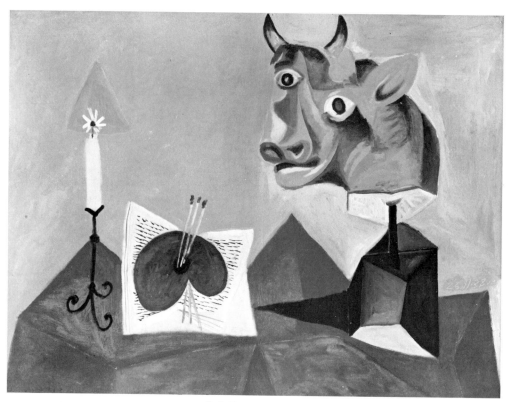

Still Life with Red Bull's Head. [Paris], November 26, 1938
Oil and enamel on canvas, 38⅛ x 51¼″ (97 x 130 cm)
Zervos IX, 239
Collection Mr. and Mrs. William A. M. Burden, New York

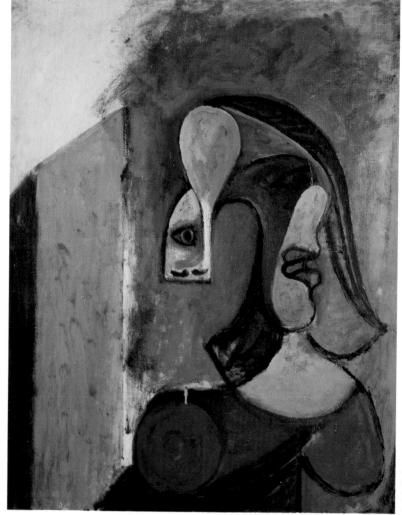

Head of a Woman with Two Profiles. Paris, April 1, 1939
Oil on canvas, 36¼ x 28¾″ (92 x 73 cm)
Zervos IX, 282
Collection Mr. and Mrs. Edwin A. Bergman, Chicago

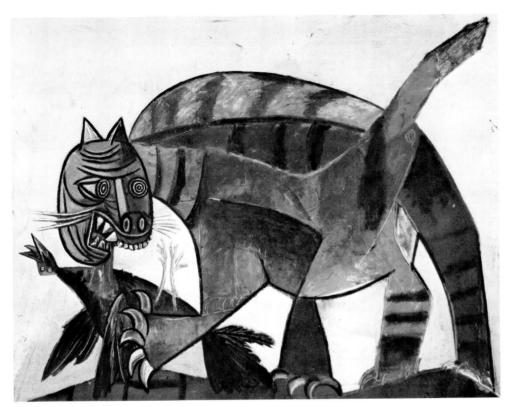

Cat and Bird. Le Tremblay-sur-Mauldre, April 1939
Oil on canvas, 38¼ x 50¾″ (97 x 129 cm)
Zervos IX, 297
Collection Mr. and Mrs. Victor W. Ganz, New York

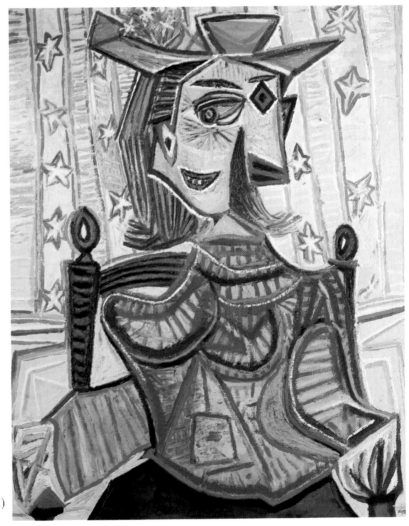

Dora Maar Sitting. [Paris or Royan], 1939
Oil on canvas, 28⅝ x 23½″ (72.5 x 59. 7 cm)
Not in Zervos. Perls Galleries, New York

363

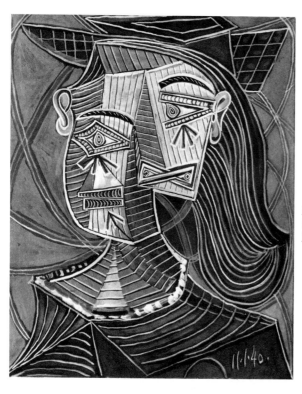

Head of a Woman. Royan, January 11, 1940
Gouache, 18⅛ x 15″ (46 x 38 cm)
Zervos X, 198. Private collection, London

Café at Royan. Royan, August 15, 1940
Oil on canvas, 38¼ x 51¼″ (97 x 130 cm)
Zervos XI, 88. Musée Picasso, Paris

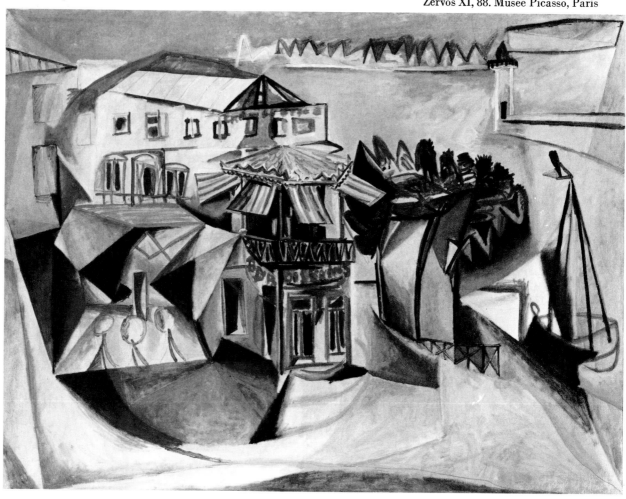

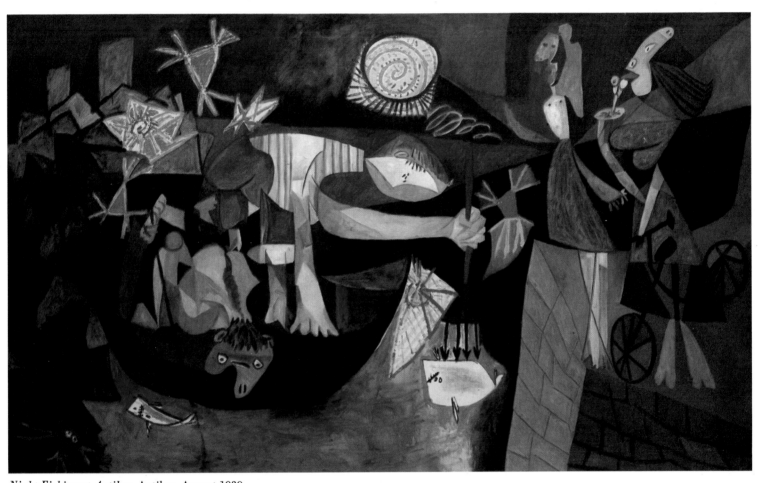

Night Fishing at Antibes. Antibes, August 1939
Oil on canvas, 81 x 136″ (205.7 x 345.4 cm)
Zervos IX, 316. The Museum of Modern Art, New York. Mrs. Simon Guggenheim Fund

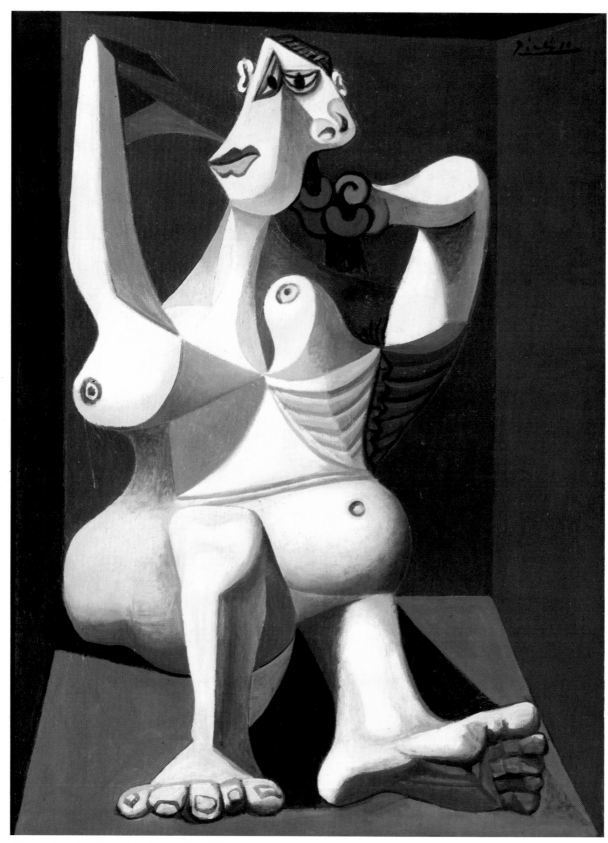

Woman Dressing Her Hair. Royan, June 1940
Oil on canvas, 51¼ x 38¼″ (130 x 97 cm)
Zervos X, 302. Collection Mrs. Bertram Smith, New York

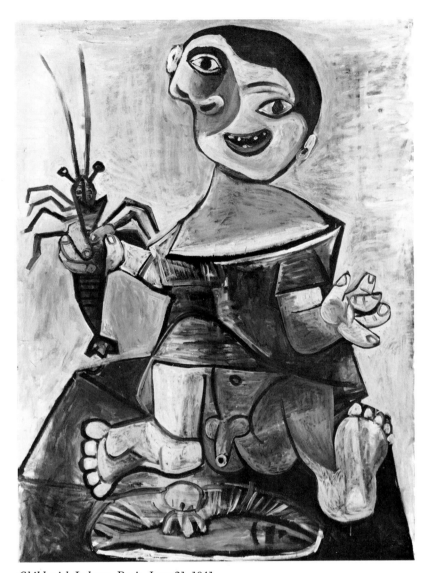

Child with Lobster. Paris, June 21, 1941
Oil on canvas, 51⅛ x 38″ (130.5 x 96.5 cm)
Zervos XI, 200. Musée Picasso, Paris

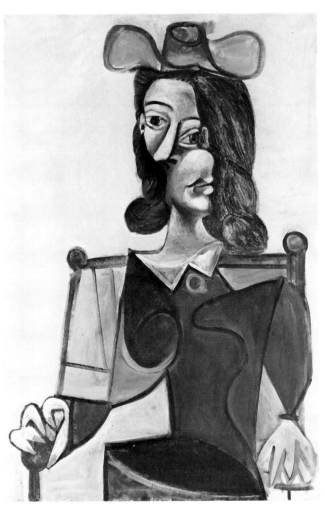

Woman in an Armchair. Paris, June 9, 1941
Oil on canvas, 35⅞ x 23⅝″ (92 x 60 cm)
Zervos XI, 155. Musée Picasso, Paris

367

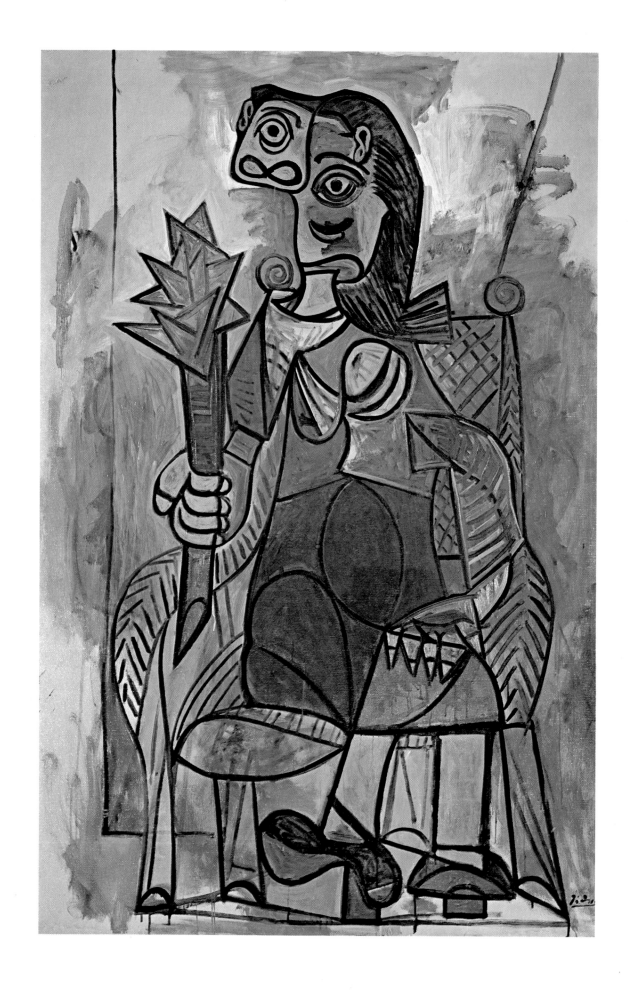

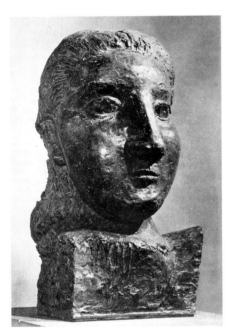

Head of a Woman. Paris, 1941
Bronze, 31½″ (80 cm) high
Spies 197. Private collection

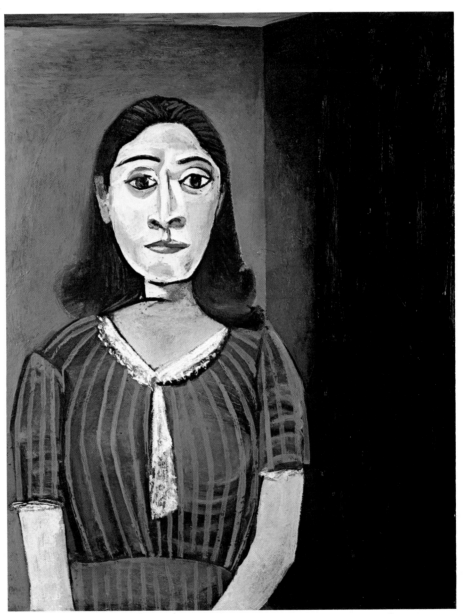

Portrait of Dora Maar. Paris, October 9, 1942
Oil on panel, 36¼ x 28¾″ (92 x 73 cm)
Zervos XII, 154. Collection Stephen Hahn, New York

Woman with Artichoke. Paris, Summer 1941*
Oil on canvas, 76¾ x 51¼″ (195 x 130 cm)
Zervos XII, 1. Museum Ludwig, Sammlung Ludwig, Cologne

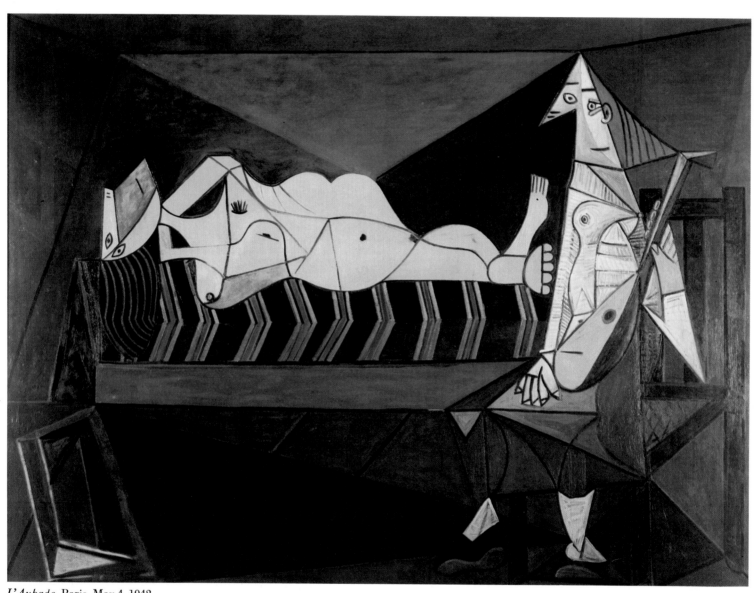

L'Aubade. Paris, May 4, 1942
Oil on canvas, 76¾ x 104⅜″ (195 x 265 cm)
Zervos XII, 69. Musée National d'Art Moderne, Centre National d'Art et de Culture Georges Pompidou, Paris

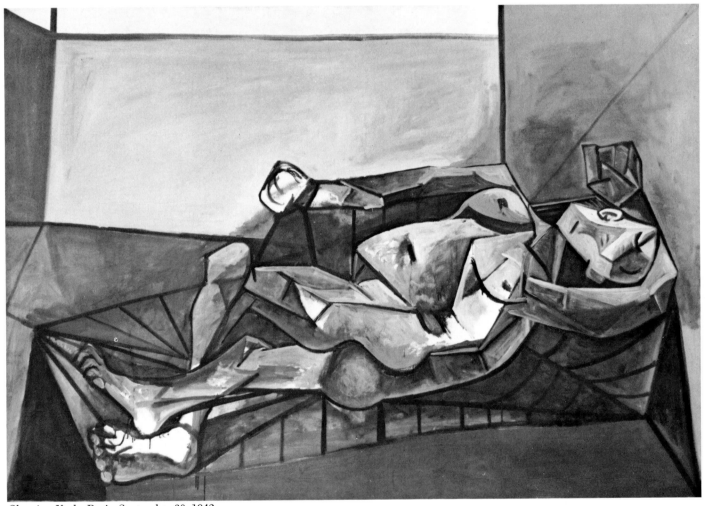

Sleeping Nude. Paris, September 30, 1942
Oil on canvas, 51¼ x 76¾″ (130 x 195 cm)
Zervos XII, 156. Collection Mr. and Mrs. Victor W. Ganz, New York

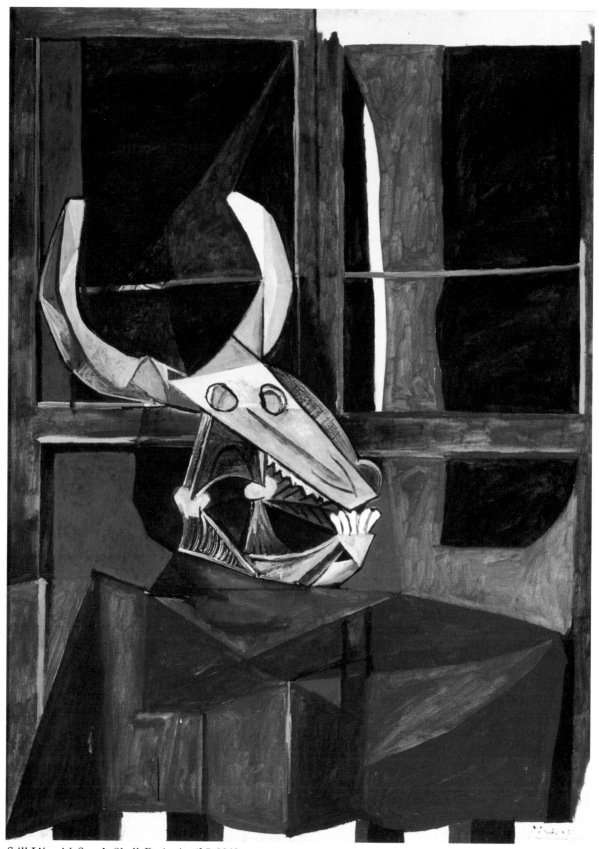

Still Life with Steer's Skull. Paris, April 5, 1942
Oil on canvas, 51¼ x 38¼″ (130 x 97 cm)
Not in Zervos. Kunstsammlung Nordrhein-Westfalen, Düsseldorf

372

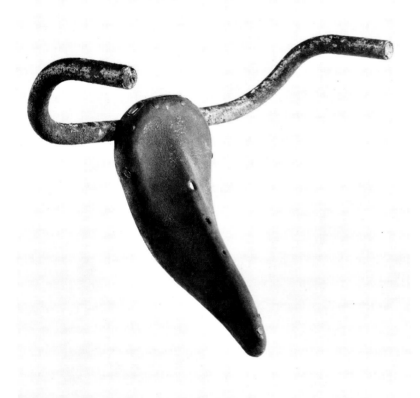

Head of a Bull. Paris, 1943
Assemblage of bicycle saddle and handlebars,
13¼ x 17⅛ x 7½″ (33.5 x 43.5 x 19 cm)
Spies 240. Musée Picasso, Paris

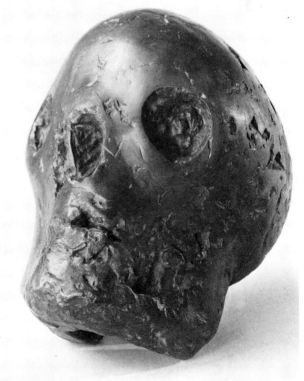

Death's Head. Paris, 1943
Bronze and copper, 9⅞ x 8¼ x 12¼″ (25 x 21 x 31 cm)
Spies 219. Musée Picasso, Paris

373

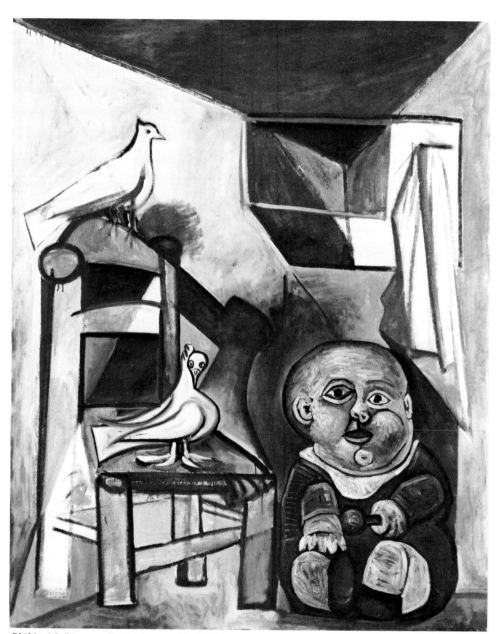

Child with Pigeons. Paris, August 24, 1943
Oil on canvas, 63¾ x 51¼″ (162 x 130 cm)
Zervos XIII, 95. Musée Picasso, Paris

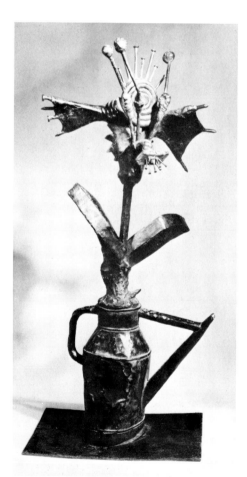

The Flowering Watering Can. Paris, 1943
Bronze (after assemblage of plaster, metal,
and watering can),
33⅛ x 17 x 15¾″ (84 x 43 x 40 cm)
Spies 239. Ludwig Collection, Aachen

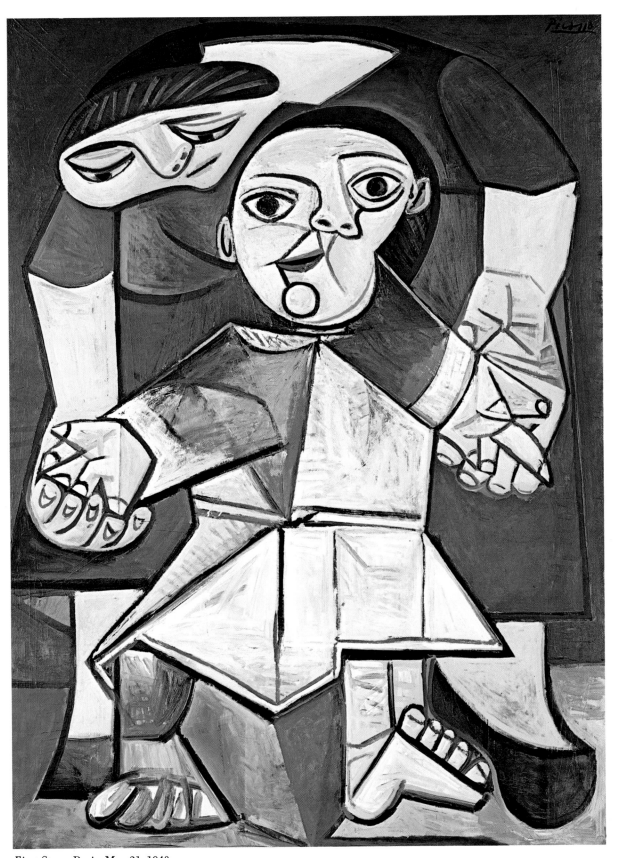

First Steps. Paris, May 21, 1943
Oil on canvas, 51¼ x 38¼" (130 x 97 cm)
Zervos XIII, 36. Yale University Art Gallery, New Haven, Connecticut. Gift of Stephen C. Clark

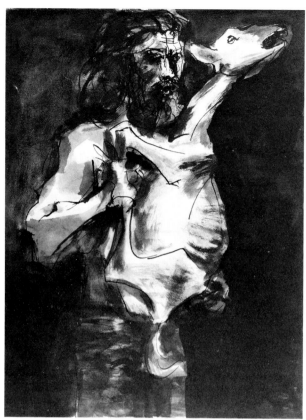

Study for Man with Sheep. [Paris], February 19, 1943
India ink, 25¾ x 19¾″ (65.5 x 50.2 cm)
Zervos XII, 238. Musée Picasso, Paris

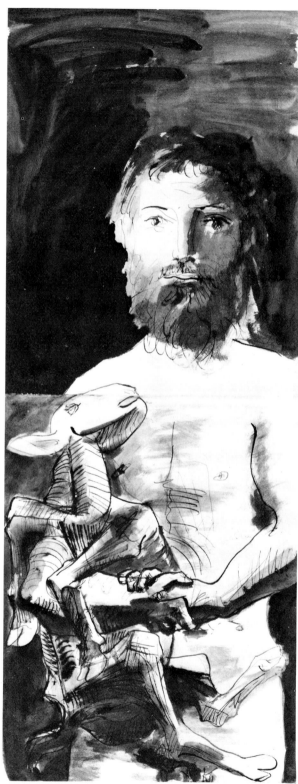

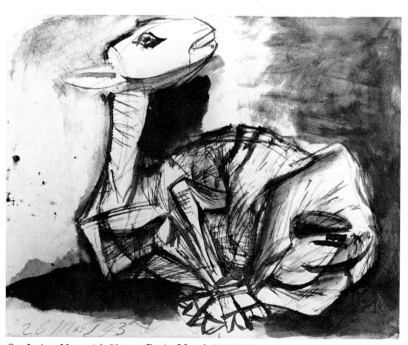

Study for Man with Sheep. Paris, March 26, 1943
India ink, 19⅞ x 25⅝″ (50.5 x 65 cm)
Zervos XII, 299. Musée Picasso, Paris

Study for Man with Sheep. Paris, March 30, 1943
India ink and wash, 51⅜ x 20″ (130.5 x 50.7 cm)
Zervos XII, 241. Musée Picasso, Paris

Man with Sheep. Paris, 1944
Bronze, 86⅝ x 30¾ x 28⅜″ (220 x 78 x 72 cm)
Spies 280. Philadelphia Museum of Art.
Gift of R. Sturgis and Marion B. F. Ingersoll

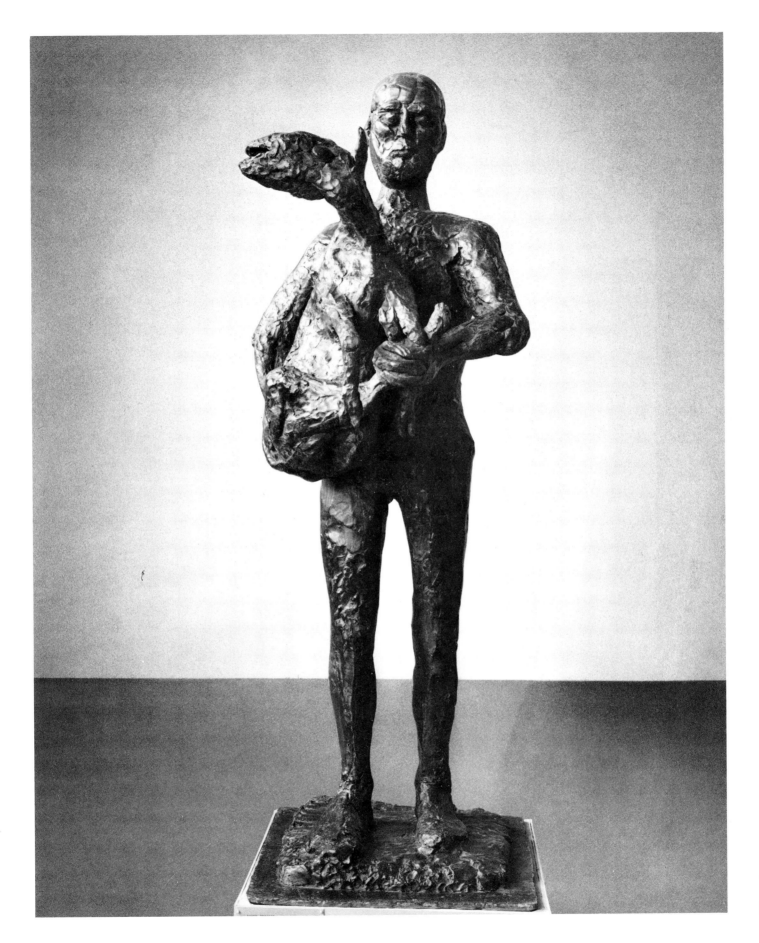

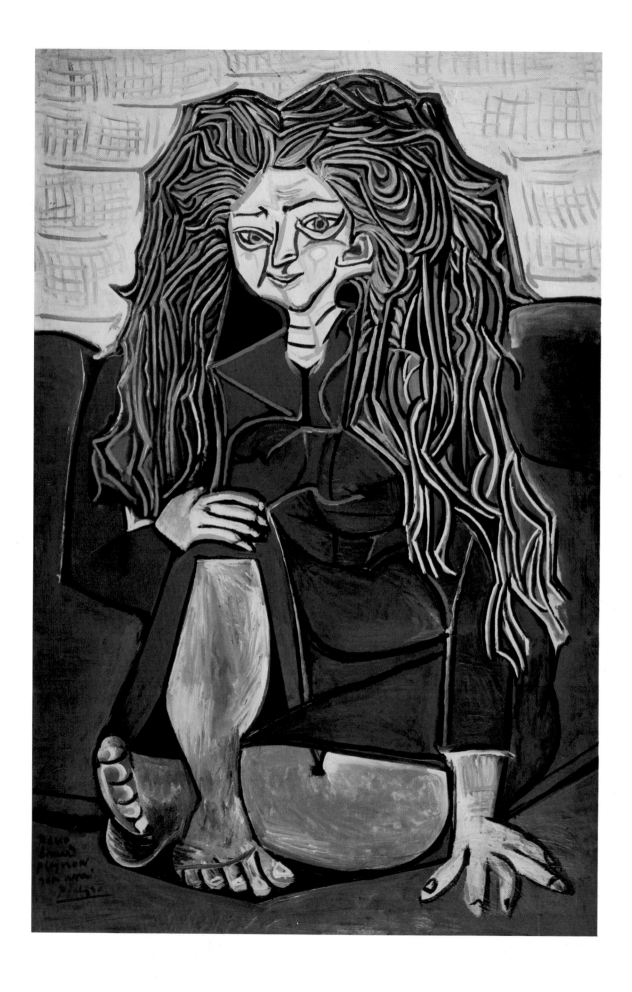

1945-1953

1945

Publication of Paul Eluard's tribute *A Pablo Picasso* (Geneva and Paris: Editions des Trois Collines), containing poetry of Eluard and reproductions of works by Picasso. Translated into English in 1947. Two other works by Eluard published this year contain frontispieces by Picasso: *Une Longue Réflexion amoureuse* (Neuchatel-Paris: Ides et Calendes) and *Au Rendez-vous Allemand* (Paris: Editions de Minuit).

BEGINNING OF YEAR: Begins second antiwar painting, *The Charnel House*, an expressionist image in Cubist armature, limited to grisaille tones. Constitutes a pendant to *Guernica*.

FEBRUARY: Zervos photographs *Charnel House* (p. 388) in early state. Dora Maar later recalls that image is based on contemporary Spanish film showing the annihilation of a family in its kitchen. Picasso continues to work on painting. Over next two months executes series of still lifes alluding to privations and fears of the Occupation, such as *Pitcher, Candle, and Casserole* of February 16 (p. 386) and *Still Life with Skull, Leek, and Pottery* of March 16 (p. 387).

FEBRUARY 27–MARCH 17: Exhibition at Buchholz Gallery, New York, of paintings and drawings from a private collection.

LATE APRIL: American armies enter concentration camp at Dachau on April 24. First photographs published short time later. On April 30, Hitler dies. One week later, Germany capitulates.

APRIL–MAY: Continues work on *Charnel House*. Details of composition shift. Zervos photographs progress each month (p. 388). In May, still life composition with pitcher and casserole is added at top. Picasso later alludes to photographs of concentration camps as a source of inspiration, but composition is well developed before they become known.

MAY: André Malraux visits Picasso in the Grands-Augustins studio. Arrives wearing uniform, and is invited by Picasso to describe events of the war. Shows him paintings, scenes of Paris made during the Occupation. They are joined by Brassaï and Nusch and Paul Eluard.

MAY 23: Makes three realistic portraits of Maurice Thorez, head of Communist party in France.

JUNE: At its Tenth Congress, French Communist party salutes Picasso, at same time calling for adherence to realism in matters of art.

JUNE 15: Ballets des Champs-Elysées produces *Le Rendez-vous*, for which Picasso designs the curtain. Choreography by Roland Petit, book by Jacques Prévert, music by Joseph Kosma, and decor by Brassaï. Opens at Théâtre Sarah Bernhardt, Paris.

JUNE 20–JULY 18: Exhibition "Picasso Libre," containing 21 paintings from 1940 to 1945, at Galerie Louis Carré, Paris.

JULY: Leaves for Cap d'Antibes with Dora Maar, who has been in ill health. Françoise goes to Brittany, although Picasso has arranged a room for her in the South, at Golfe-Juan, at the house of printer Louis Fort. With Dora, visits the fortified village of Ménerbes, in the Vaucluse; buys old house built into the ramparts of the town, trading a still life for the property. Turns deed over to Dora Maar.

AUGUST: Returns to Paris.

SEPTEMBER 28–OCTOBER 29: Two paintings exhibited in Salon d'Automne, of which one is *Still Life with Skull, Leek, and Pottery* (p. 387).

NOVEMBER 2: In studio of Fernand Mourlot, whom he meets through Braque, makes first of more than two hundred lithographs he will do here over next three and a half years. Discovers the intricate pleasures of creating prints with materials and techniques of lithography: transfer paper, crayon, tusche, washes, scraping, transferring images from plate to stone. He is particularly fascinated with possibility of preserving "metamorphoses of a picture," as he once told Zervos, by printing successive states of an image on the way to the final composition. First lithograph is a portrait of Françoise.

NOVEMBER 26: Reunited with Françoise, who visits his studio for first time since July.

DECEMBER: Exhibition of paintings by Picasso and Matisse at Victoria and Albert Museum, London. Includes 24 paintings lent by Picasso and one, *Night Fishing at Antibes* (p. 365), lent by a private collector. Works date from 1939 to 1945. Foreword by Zervos.

DECEMBER 5–JANUARY 17, 1946: Prints 11 states of a lithograph of a bull (pp. 390–91), gradually abstracting the image in successive states until nothing is left but an outline.

END OF YEAR: Begins *Monument aux Espagnols* (p. 393).

1946

FEBRUARY 15–MARCH 15: Participates in exhibition "Art et Résistance" sponsored by Amis des Francs-tireurs et Partisans Français and held at Musée National des Arts Modernes, Paris. Grisaille composition *Charnel House* (p. 389) and *Monument aux Espagnols* (latter not included in catalog) both shown.

MID-MARCH: Françoise, convalescing from broken elbow, leaves for the Midi, where she stays at home of printer Louis Fort at Golfe-Juan. Picasso joins her. They visit Matisse in Nice.

LATE APRIL: Picasso and Françoise return to Paris. She begins to live with him.

MAY 5: Paints portrait of Françoise, *Woman-Flower* (p. 394), first in series of paintings using that motif.

JUNE 14: With Mourlot, makes ten lithographs of head of Françoise, culminating in the eleventh, *Françoise en Soleil*, which follows the next day.

JUNE 14–JULY 14: Exhibition "Dix-neuf Peintures" at Galerie Louis Carré, Paris.

SUMMER: Publication of Alfred H. Barr's *Picasso: Fifty Years of His Art*, (New York: The Museum of Modern Art), greatly revised and expanded edi-

tion of 1939 exhibition catalog for "Picasso: Forty Years of His Art." Surveys the early period as well as decade following the exhibition.

EARLY JULY: Picasso and Françoise leave for Ménerbes, staying in house he has bought for Dora Maar. During evening walks in the village, becomes fascinated by owls circling in search of prey—theme will soon begin to appear in his work. Receives daily letters from Marie-Thérèse. Françoise finds situation uncomfortable and wishes to leave. After three weeks they move to Cap d'Antibes, where they stay with Marie Cuttoli, a collector and patron of the arts.

JULY 27: Death of Gertrude Stein, from whom Picasso has been estranged for some time.

EARLY AUGUST: Françoise and Picasso move to Louis Fort's at Golfe-Juan. Françoise becomes pregnant.

AUGUST: On the beach, meets Romuald Dor de la Souchère, curator of the Antibes museum (in the palais Grimaldi). He offers Picasso space in the museum for painting; Picasso decides instead to decorate the museum itself.

Picasso at palais Grimaldi, Antibes, c. 1946. In background, *Satyr, Faun, and Centaur.* Photographed by Robert Capa. The Museum of Modern Art, New York

Works intensively for two months, painting 22 panels (on plywood and wallboard). Subjects range from still lifes of creatures from the sea and studies of local people, such as *Woman Eating Sea Urchins,* to the Arcadian *Joie de Vivre,* which reflects his happiness with Françoise and for which he borrows title from Matisse. (Year later paints final panel, *Ulysses and the Sirens.*) About same time, palais Grimaldi is renamed the Musée Picasso by the Musées Nationaux.

Joined by Paul and Nusch Eluard, who are staying in Cannes to attend the Film Festival. Breton also arrives, recently returned from wartime exile in the United States; snubs Picasso because of his affiliation with the Communist party. They never see each other again.

Paul Eluard and Picasso on the beach at Antibes, 1946. Photographed by Michel Sima

LATE NOVEMBER: With Françoise, returns to Paris.

NOVEMBER 28: Old friend Nusch Eluard dies of cerebral hemorrhage. Paul Eluard is in Switzerland at the time, but on his return Picasso and Dora Maar call on him to comfort him. Picasso speaks fondly of Nusch, calling her a personage out of his Rose period (she was a wandering acrobat in her youth).

Publication of Jaime Sabartés's *Picasso: Portraits et souvenirs* (Paris: Louis Carré et Maximilien Vox).

1947

JANUARY: Takes up owl motif in both paintings and lithographs. In latter, makes prints of mythological creatures recalling themes from previous summer at Antibes, portraits of Ines and her child, and images of pigeons (anticipating the "Dove of Peace" of 1949).

MARCH 30: Makes six states of lithograph *David and Bathsheba, after Cranach the Elder* (three, p. 395). (Another state of this lithograph is pulled on May 29, 1949; p. 395.)

MAY: At suggestion of Jean Cassou, donates ten paintings to the Musée National d'Art Moderne, including *The Milliner's Workshop* of 1926 (p. 262), *L'Aubade* of 1942 (p. 370), and *Pitcher, Candle, and Casserole* of 1945 (p. 386). Aside from 1901 portrait of critic Gustave Coquiot (p. 37), which hangs in gallery of foreign artists in the Jeu de Paume, and two works in the Grenoble museum, these are Picasso's first works to enter a French public collection.

MAY 15: Birth of Claude, first child of Françoise and Picasso.

JUNE: With Françoise and the baby, leaves for Golfe-Juan.

AUGUST: Begins to make ceramics in Vallauris, at the Madoura pottery, the workshop of Georges Ramié, whom he met the summer before. Executes almost two thousand pieces over the next year (*Bull,* p. 397). Leads to a revitalization of the ceramics industry of the town, in a state of decline since World War I.

Publication of *Guernica: Pablo Picasso* (New York: Curt Valentin), with text by Juan Larrea, introduction by Alfred H. Barr, Jr., and photographs by Dora Maar.

DECEMBER: Production of Sophocles' *Oedipus Rex,* directed by Pierre Blanchar, with decor by Picasso and costumes designed by Françoise Ganeau; performed at Théâtre des Champs-Elysées, Paris.

Except for brief trip to Paris, spends winter months in Midi.

1948

Documentary film *Visite à Picasso* shot in Vallauris and at Musée Picasso in Antibes; produced by a Belgian filmmaker, Paul Haesaerts.

MARCH: Completes series of 125 lithographs illustrating Pierre Reverdy's *Le Chant des Morts* (Paris: Tériade), begun in 1946.

Completes 41 etchings for publication of Gongora's *Vingt Poèmes* (Paris: Les Grands Peintres Modernes et le Livre). Picasso writes text in Spanish and illuminates margins.

SUMMER: Françoise and Picasso move to La Galloise, villa in hills above Vallauris.

AUGUST 25: Accompanied by Eluard, flies to Wroclaw, Poland, for Congress of Intellectuals for Peace. Issues public declaration in behalf of Pablo Neruda, then persecuted in Chile. Visits Auschwitz, Krakow, and Warsaw. While there, makes portrait of old friend Ilya Ehrenburg, who is responsible for invitation to Congress. On September 2 receives decoration from president of Polish Republic. Remains in Poland two weeks.

EARLY SEPTEMBER: Returns to Vallauris.

OCTOBER: Returns to Paris.

NOVEMBER: Exhibition of 149 ceramics

Picasso at Congress of Intellectuals for Peace, Wroclaw, Poland, August 1948

at the Maison de la Pensée Française, Paris.

NOVEMBER 9: Paints *The Kitchen* (p. 397), a linear rendition of the utensils and furniture in his Grands-Augustins quarters in Paris. Another version, painted about same time, more clearly represents the Spanish tiles and birdcages alluded to in this image.

DECEMBER–JANUARY 1949: Prints 27 states of lithograph *Woman in an Armchair* (p. 396), in which Françoise wears embroidered coat Picasso brought her from Poland.

1949

JANUARY: Publication of *Les Sculptures de Picasso* (Paris: Editions du Chêne), with essay by Daniel-Henry Kahnweiler and photographs by Brassaï (additional photographs by Dora Maar, with others provided by Galerie Louise Leiris).

FEBRUARY: Aragon chooses lithograph of a pigeon or dove of January 9 as the image for poster announcing Peace Congress to open in Paris in April. Image quickly becomes known as "Dove of Peace."

FEBRUARY–MARCH: Publication of Mérimée's *Carmen* (Paris: La Bibliothèque Française), with 38 engravings by Picasso.

MARCH 8–APRIL 2: Exhibition "Pablo Picasso, Recent Work," at Buchholz Gallery, New York. Includes 1945–47 bronzes.

APRIL 19: Daughter born to Françoise and Picasso. They name her Paloma (Spanish word for "dove") after his "Dove of Peace" on posters throughout city.

Produces suite of lithographs interspersed with automatic writing.

SPRING: Returns to Vallauris. Rents old perfumery on rue du Fournas for sculpture and painting studios and for storage of ceramics.

About this time, fashions a female form from a long metal rod, affixing two arms at the top, two legs at the bottom, and a globular belly with two small

breasts in the middle. It is called *Pregnant Woman* (p. 398).

JULY: Exhibition of 64 recent works at Maison de la Pensée Française, Paris.

AUTUMN: Turns to sculpture in a more concentrated way; over the next year it occupies most of his time.

1950

WINTER: In celebration of Françoise's recent pregnancy, first major work in new studio is *Pregnant Woman*; Picasso models the body in clay and forms breasts and abdomen of clay water pots. (Two versions are cast in bronze: the first, p. 399, in 1955 and the second, with considerable reworking, in 1959.) Also makes terra-cotta *Woman with Arms Crossed*, later cast in bronze and reworked with etching (p. 399).

JANUARY 20: Paints *Claude and Paloma* (p. 400); not long after, paints *Claude and Paloma at Play* (p. 401).

FEBRUARY: Paints two paraphrases of earlier pictures: *Women on the Banks of the Seine, after Courbet* and *Portrait*

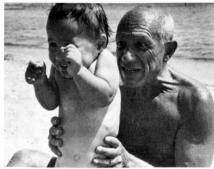

Picasso with baby son Claude, Golfe-Juan, 1948. Photographed by Robert Capa. The Museum of Modern Art, New York

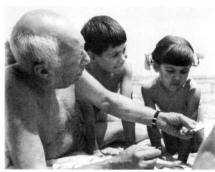

Picasso with Claude and Paloma, Vallauris, c. 1952. Photographed by Dorka

of a Painter, after El Greco (both, p. 403).

MARCH: Creates assemblages from objects found in field near studio and in walks through Vallauris. Makes *She-Goat* (p. 407), its back formed from a palm leaf, its rib cage from a wicker basket, and its udder from two ceramic flowerpots. The woman of *Woman with Baby Carriage* (p. 400) is erected from cake pans and stove plate, joined to the "ready-made," the stroller; also makes *Girl Jumping Rope* (p. 408), about which Françoise declared that he always wanted to "make a sculpture that did not touch the ground." "Found" elements are joined together with clay, and each work is later cast in bronze.

Continuing to work in ceramics, models a series of owls over the next few years (p. 402), returning to a subject that has fascinated him since his visit to Ménerbes with Françoise in 1946.

JUNE 25: Beginning of Korean War.

AUGUST 6: One of three casts of *Man with Sheep* is placed in main square in Vallauris. Laurent Casanova, a Communist party leader, presides.

OCTOBER: While Françoise remains in Vallauris, attends Second World Peace Conference in Sheffield, England; poster bears image of Dove in Flight, after Picasso's lithograph of July 9.

NOVEMBER: Receives the Lenin Peace Prize.

DECEMBER 22: Paints *Winter Landscape*, Vallauris (p. 406).

NOVEMBER–JANUARY 1951: Exhibition "Picasso: Sculptures, Dessins," at Maison de la Pensée Française, Paris; preface by Louis Aragon.

1951

JANUARY 18: Paints *Massacre in Korea* (p. 406), political statement about American intervention in that country.

FEBRUARY: Returns to Paris.

MAY: *Massacre in Korea* placed on exhibition in Salon de Mai, Paris.

JUNE 14: Eluard remarries; Picasso and Françoise attend ceremony in Saint-Tropez.

JUNE 25: Matisse Chapel dedicated in Vence, with much attendant publicity. Does not attend opening, but visits the bedridden Matisse.

SUMMER: Evicted from apartments at rue La Boétie, takes new space on rue Gay-Lussac. Sabartés takes on job of packing, sending seventy cases to the new apartment.

Returns to Vallauris.

Makes more sculptures from found objects: *Goat Skull and Bottle* (p. 407) and *Baboon and Young* (p. 408), latter incorporating two toy automobiles given to Claude.

SEPTEMBER 16: In Vallauris, paints *Nocturnal Landscape*.

Receives eviction notice on new apartment because it has been unoccupied; returns to Paris with Françoise, and they spend the winter there.

1952

FEBRUARY 19–MARCH 15: Exhibition of paintings, sculptures, and drawings at Curt Valentin gallery, New York.

APRIL: Outraged by war in Korea, decides to decorate a deconsecrated fourteenth-century chapel in Vallauris as a temple of peace. Plans to convey ideas in two panels, one depicting war, the other peace. Makes first sketches at this time. (Before September 14, fills two sketchbooks and a notebook with over 250 studies.)

APRIL 16: In Paris, paints *Goat Skull, Bottle, and Candle* (p. 407), relating to sculpture of year before.

SUMMER: In Vallauris, paints portrait of Hélène Parmelin (p. 378), wife of his friend the painter Edouard Pignon.

During year produces more sculptures: *The Crane* (p. 404) and *Priapus* (p. 412); begins *Woman Reading* (p. 404), completing it the following year.

LATE OCTOBER: Goes to Paris alone. Relationship with Françoise deteriorating.

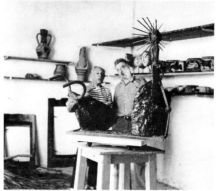

Picasso with Edouard Pignon, Vallauris, 1952. In foreground, *Goat Skull and Bottle* of 1951 (p. 407). Photographed by Robert Doisneau

Françoise Gilot and Picasso in their villa La Galloise, Vallauris, 1952. Photographed by Robert Doisneau

Françoise en Soleil (Françoise as the Sun). Paris, June 15, 1946. Lithograph, 25⅝ x 19¹¹⁄₁₆" (65 x 50 cm). Galerie Louise Leiris, Paris

NOVEMBER 18: Death of his old friend Eluard. Picasso attends funeral.

NOVEMBER 25: Series of lithographs of Balzac (pp. 410, 411); chooses one for frontispiece of an edition of Balzac's *Le Père Goriot* (Monte Carlo: André Sauret, 1952). Five years later, Michel Leiris publishes eight Balzac lithographs in *Balzacs en bas de casse et Picassos en majuscule* (Paris: Galerie Louise Leiris, 1957).

EARLY DECEMBER: Returns to Vallauris, where he completes the two great panels for the temple of peace (not installed until 1954). At La Galloise, writes *Quatre Petites Filles*, play in six acts (earlier version with same title begun in 1947 in Golfe-Juan).

DECEMBER–JANUARY 1953: Makes series of lithographs of Claude, Paloma, and Françoise at play, reading, asleep. Executes an elaborate drawing of Paloma over 13 days, from December 23 (p. 410). On December 28 paints *Paloma Asleep* (p. 409).

1953

MID-JANUARY: Leaves for Paris.

JANUARY 30–APRIL 9: Exhibition "Le Cubisme, 1907–1914," at Musée National d'Art Moderne, Paris; *Les Demoiselles d'Avignon* (p. 99) shown in Europe for first time since 1937.

MID-FEBRUARY: Returns to Vallauris.

MARCH: Françoise takes children to Paris, where she creates decor and costumes for a ballet. Picasso, working in Vallauris sculpture studio, creates group of small painted wooden dolls (p. 409).

Stalin dies on March 5, and Aragon asks Picasso to prepare a drawing for *Les Lettres françaises*. Portrait of Stalin appears in March 12 issue; to Picasso's puzzlement, his seemingly sympathetic treatment is received with great disapproval by French Communist party.

MAY–JULY 5: Major retrospective at the Galleria Nazionale d'Arte Moderna, Rome, in which 135 paintings, 32 sculptures, 39 ceramics, and 40 lithographs are exhibited. Catalog by Lionello Ven-

Les Lettres françaises, March 12–19, 1953, featuring Picasso's portrait of Stalin

turi. *The Charnel House* and War and Peace murals are included, and later, along with many other works in show, these travel to Milan for the large retrospective there in September. In Rome, Jean Cocteau is invited to speak in connection with exhibition; reminisces about his early acquaintance with Picasso.

JUNE: Retrospective at Musée de Lyon. Organized by Madeleine Rocher-Jauneau, includes 179 works dating from 1900 to 1953.

SUMMER: Françoise return to Vallauris with children. Picasso creates series of heads and busts inspired by her. Also paints *Seated Woman* (p. 413).

MID-AUGUST: With daughter Maïa, arrives in Perpignan at invitation of Jacques de Lazerme and his wife to attend bullfight at Collioure. Makes quick trip to Paris, then returns to the Lazermes' accompanied by Maïa, Paulo, and his nephew Javier Vilato. In Perpignan, meets young divorcée Jacqueline Roque.

SEPTEMBER 5: Communists of nearby Céret organize fete in Picasso's honor. He attends with Paulo and Edouard Pignon and his wife Hélène Parmelin.

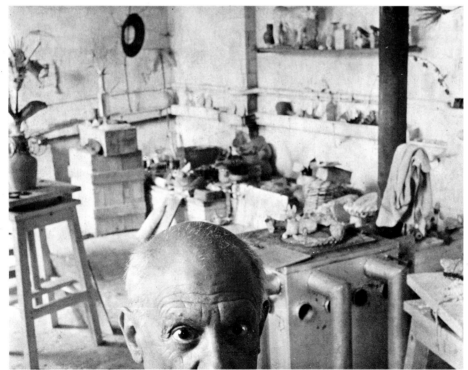

Picasso in his rue du Fournas sculpture studio, Vallauris, 1952. At left, *The Flowering Watering Can* of 1943 (p. 374). Photographed by Robert Doisneau. The Museum of Modern Art, New York. Gift of the photographer

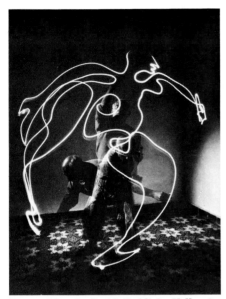

Picasso "drawing" with flashlight, Vallauris, 1949. Photographed by Gjon Mili. The Museum of Modern Art, New York

MID-SEPTEMBER: Returns to Vallauris. Françoise leaves him at the end of the month, taking Claude and Paloma to Paris, where they enter l'Ecole Alsacienne. She moves to new quarters on rue Gay-Lussac. Picasso goes to Paris for visit, taking up residence in his Grands-Augustins studio.

SEPTEMBER 20–NOVEMBER 20: Rome retrospective travels to Palazzo Reale, Milan, with many additions, notably *Massacre in Korea* (p. 406) and *Guernica* (pp. 342–43), the latter on view in Europe for first time since the war. Catalog is written by Franco Russoli.

NOVEMBER: Returns to Vallauris from Paris. On November 28, begins series of drawings on Painter and Model theme, completing 180 by the beginning of February.

DECEMBER 13–FEBRUARY 20, 1954: Major retrospective at the Museu de Arte Moderna, São Paulo, Brazil, in which *Guernica* is also shown. Catalog by Maurice Jardot.

During year, Sabartés donates to Museo de Málaga his library of books on Picasso, and to city of Barcelona, his works by Picasso.

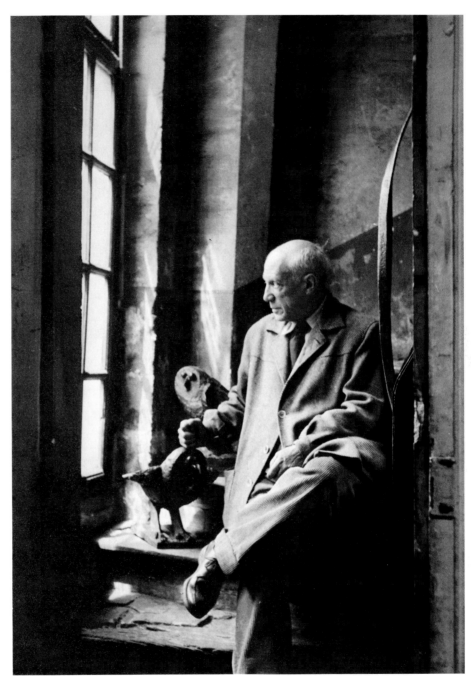

Picasso on steps of rue des Grands-Augustins studio, Paris. Photographed by Denise Colomb. At left, two *Owls* of 1953

385

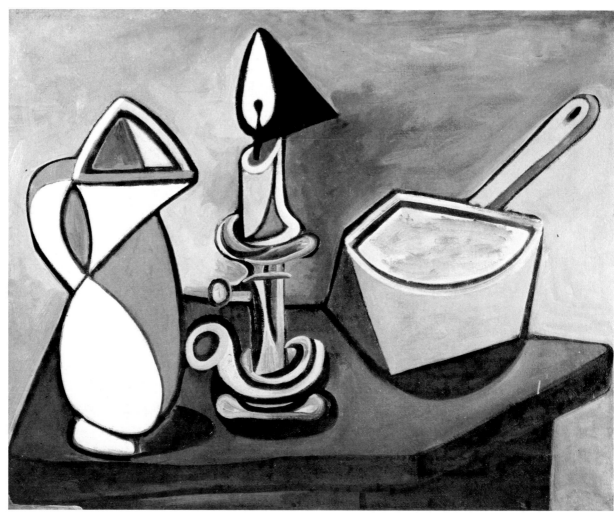

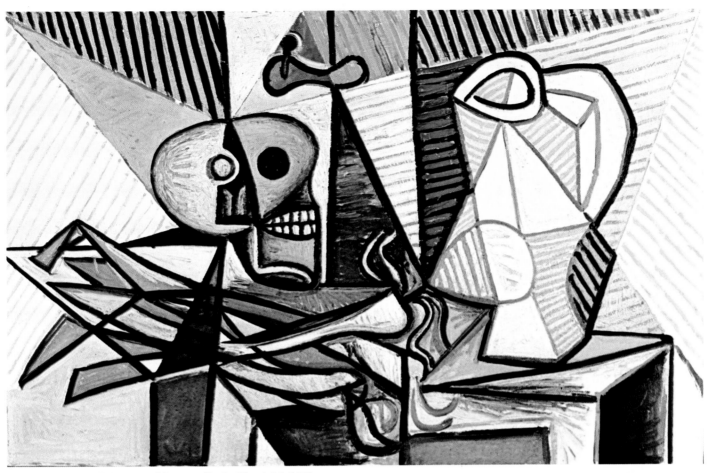

Still Life with Skull, Leek, and Pottery. Paris, March 16, 1945
Oil on canvas, 28¾ x 45¾″ (73 x 116 cm)
Zervos XIV, 97. Collection Paloma Picasso Lopez, Paris

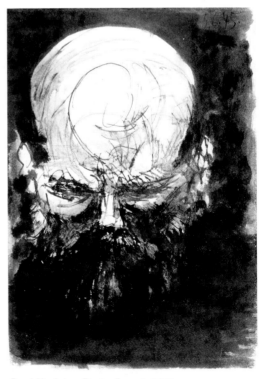

OPPOSITE, ABOVE:
Burning Logs. Paris, January 4, 1945
Crayon and pen and ink, 19½ x 23½″ (49.5 x 59.6 cm)
Zervos XIV, 59. The Museum of Modern Art, New York.
The Joan and Lester Avnet Collection

OPPOSITE:
Pitcher, Candle, and Casserole. Paris, February 16, 1945
Oil on canvas, 32¼ x 41¾″ (82 x 106 cm)
Zervos XIV, 71. Musée National d'Art Moderne, Centre
National d'Art et de Culture Georges Pompidou, Paris

Paul Verlaine. Paris, June 5, 1945
Wash and pen and ink, 11⅝ x 8¼″ (29.5 x 21 cm)
Not in Zervos. The Museum of Modern Art,
New York. Anonymous extended loan

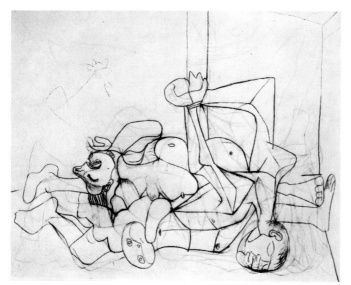

First, February 1945

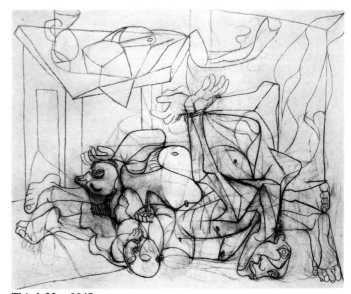

Third, May 1945

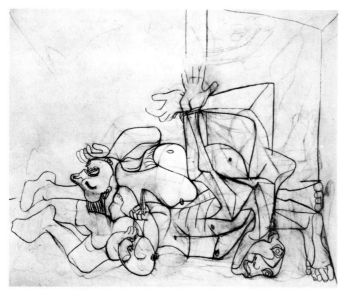

Second, April 1945

Progressive photographs of *The Charnel House* (opposite)
Zervos XIV, 72, 73, 75, 76

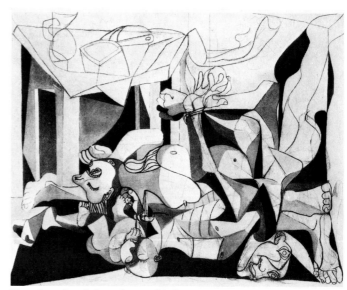

Fourth undated, but after mid-July 1945

The Charnel House. Paris, [1944]—1945
Oil and charcoal on canvas, 78⅝ x 98½″ (199.8 x 250.1 cm)
Zervos XIV, 76. The Museum of Modern Art, New York. Mrs. Sam A. Lewisohn Bequest (by exchange) and Purchase

Bull. Paris, December 5, 1945–January 17, 1946
Eleven progressive states of same lithograph, c. 11⅜ x 16⅛″ (28.9 x 41 cm)
Mourlot 17, States I–XI. Collection Bernard Picasso, Paris

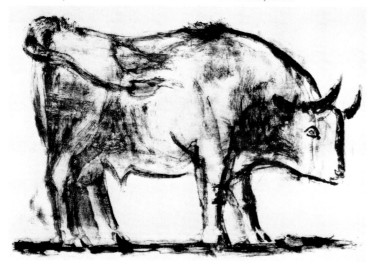

I. December 5, 1945

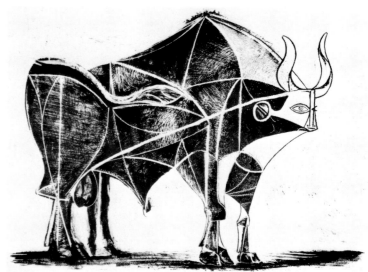

IV. December 22, 1945

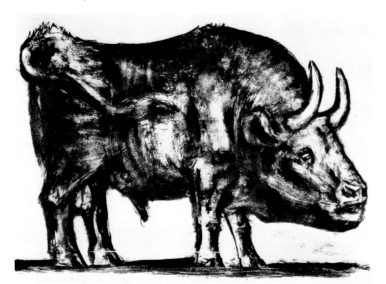

II. December 12, 1945

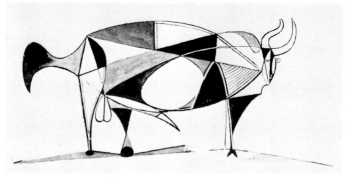

V. December 24, 1945

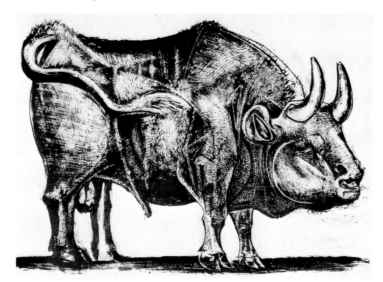

III. December 18, 1945

Bull. Paris, December 24–25, 1945
Watercolor, gouache, and India ink on cardboard,
5¼ x 11½″ (13.3 x 29.1 cm)
Zervos XIV, 130. Musée Picasso, Paris

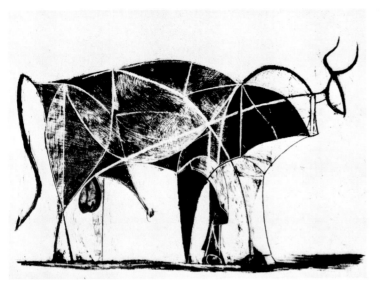

VI. December 26, 1945

IX. January 5, 1946

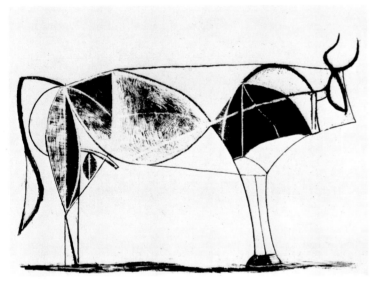

VII. December 28, 1945

X. January 10, 1946

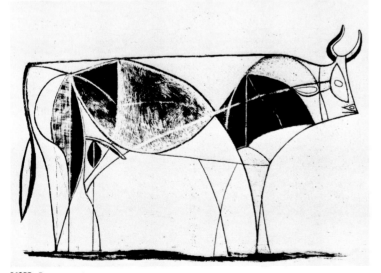

VIII. January 2, 1946

XI. January 17, 1946

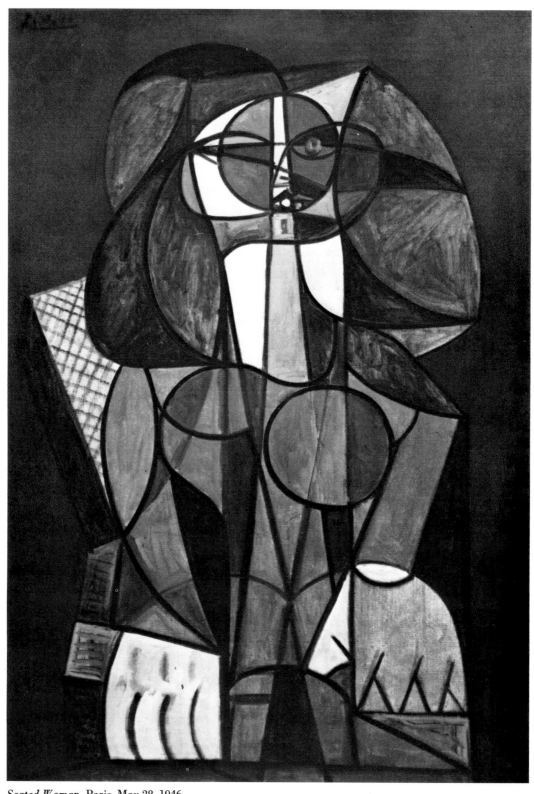

Seated Woman. Paris, May 28, 1946
Oil on canvas, 51¼ x 35⅛″ (130 x 89 cm)
Zervos XV, 13. Collection Mr. and Mrs. Victor W. Ganz, New York

Monument aux Espagnols. Paris, begun late 1945 and
exhibited February 1946; possibly altered before
being dated by artist, January 31, 1947
Oil on canvas, 76¾ x 51¼″ (195 x 130 cm)
Not in Zervos. Collection Jacqueline Picasso, Mougins

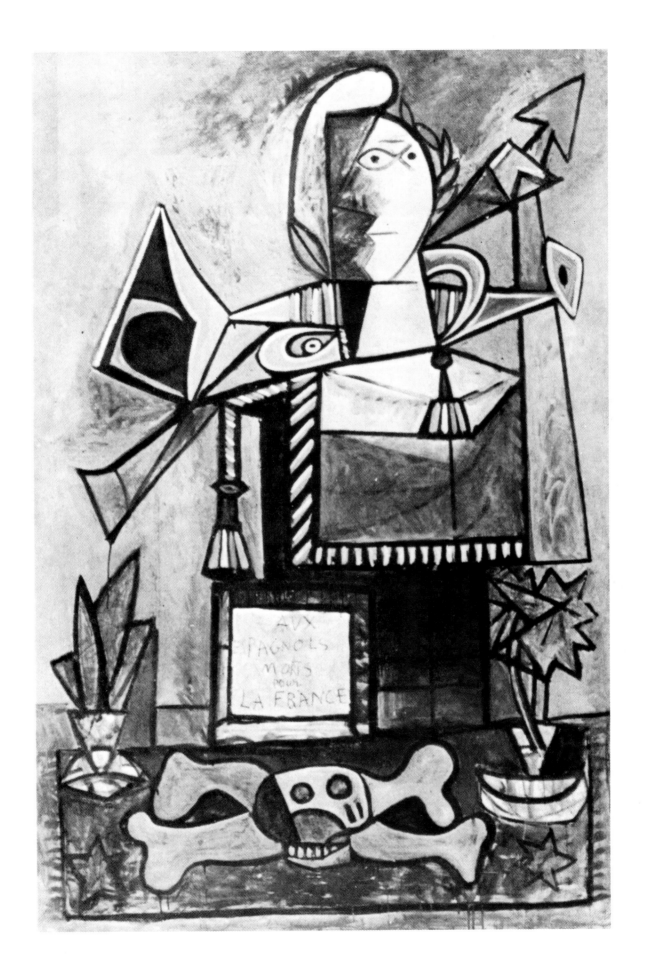

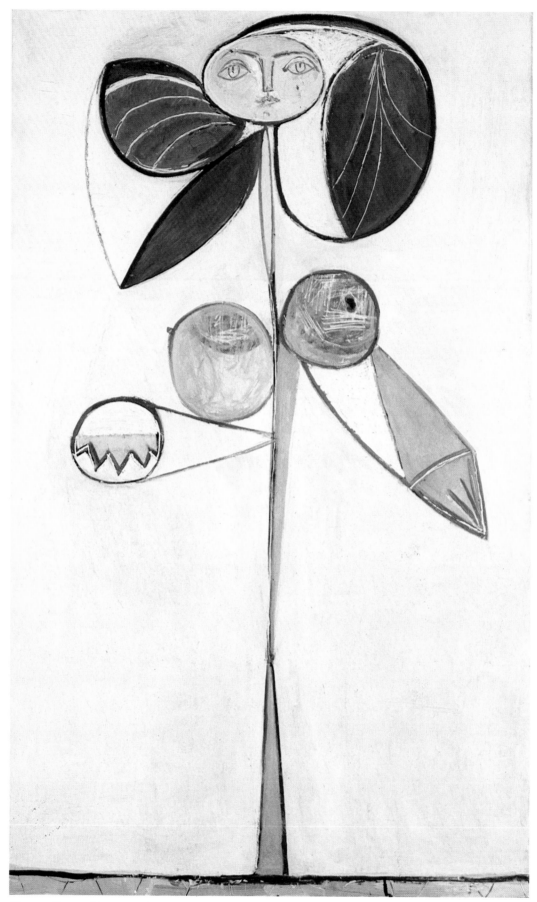

394 *Woman-Flower* (Françoise Gilot). Paris, May 5, 1946
Oil on canvas, 57½ x 34½″ (146 x 89 cm)
Zervos XIV, 167. Collection Ms. Françoise Gilot

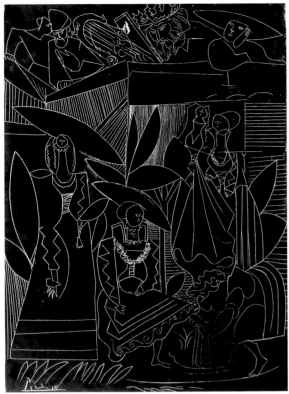

David and Bathsheba, after Cranach the Elder
Paris, March 30, 1947
Lithograph, 25½ x 19¼" (64.8 x 49 cm)
Mourlot 109, IV. The Museum of Modern Art, New York.
Acquired through the Lillie P. Bliss Bequest

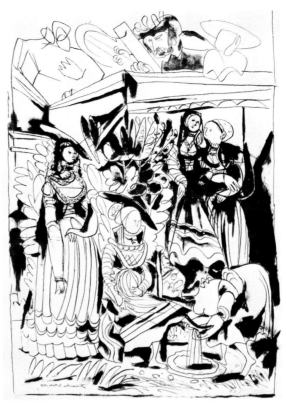

David and Bathsheba, after Cranach the Elder
Paris, March 30, 1947
Lithograph, 25⅝ x 19¼" (65.1 x 49 cm)
Mourlot 109, I. The Museum of Modern Art, New York.
Mrs. Bertram Smith Fund

David and Bathsheba, after Cranach the Elder
Paris, March 30, 1947
Lithograph, 25⅞ x 19¼" (65.7 x 49 cm)
Mourlot 109, II. The Museum of Modern Art, New York.
Acquired through the Lillie P. Bliss Bequest

David and Bathsheba, after Cranach the Elder
Paris, May 29, 1949
Lithograph, 25¹¹⁄₁₆ x 18¹⁵⁄₁₆" (65.3 x 48.1 cm)
Mourlot 109, bis. The Museum of Modern Art,
New York. Curt Valentin Bequest

Woman in an Armchair No. 1. Paris, December 17, 1948
Lithograph, 27³⁄₁₆ x 20⅛″ (69.1 x 51.1 cm)
Mourlot 134, IV

Woman in an Armchair No. 1. Paris, January 16, 1949
Lithograph, 27⅜ x 21½″ (69.5 x 54.6 cm)
Mourlot 134, 3rd state after transfer. The Museum of Modern Art,
New York. Mrs. Bertram Smith Fund

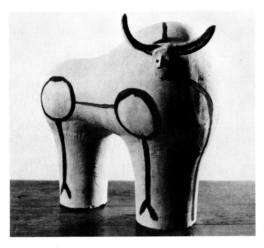

Bull. Vallauris, 1947
Ceramic, 14½ x 14½ x 9⅛″ (37 x 37 x 23 cm)
Ramié 258 and 260. Musée Picasso, Antibes

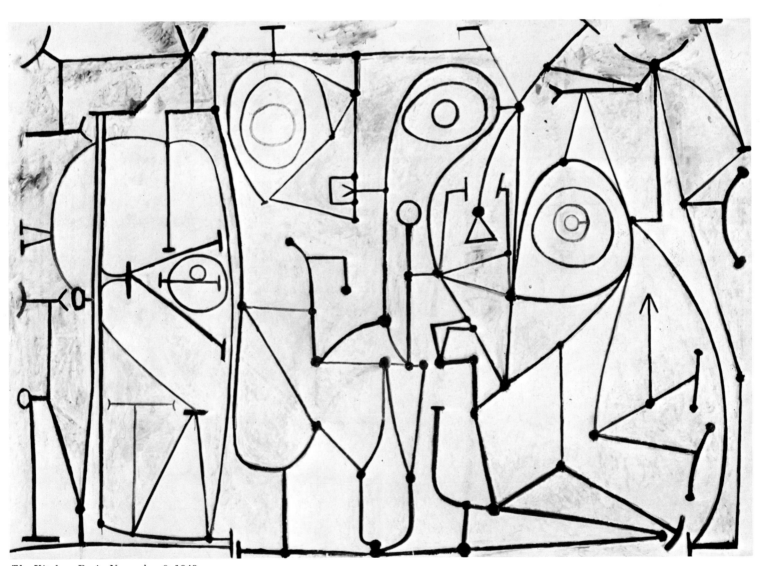

The Kitchen. Paris, November 9, 1948
Oil on canvas, 68⅞ x 98½″ (175 x 250 cm)
Zervos XV, 106. The Museum of Modern Art, New York.
Acquired through the Nelson A. Rockefeller Bequest

397

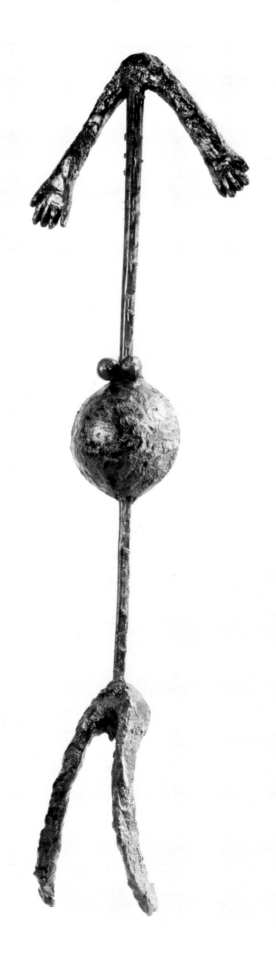

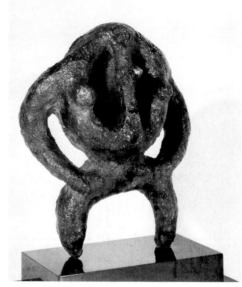

Woman. Vallauris, 1948
Bronze, 7⅜ x 6 x 3⅝″ (18.7 x 15.3 x 9.3 cm)
Spies 334. Perls Galleries, New York

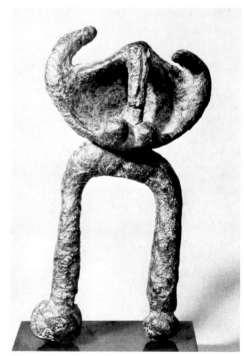

Woman. Vallauris, 1948
Bronze, 10″ (25.5 cm) high
Spies 333. Marina Picasso Foundation

Pregnant Woman. Vallauris, 1949
Bronze (after assemblage of plaster and iron bar),
51¼ x 14⅝ x 4½″ (130 x 37 x 11.5 cm)
Spies 347. Musée Picasso, Paris

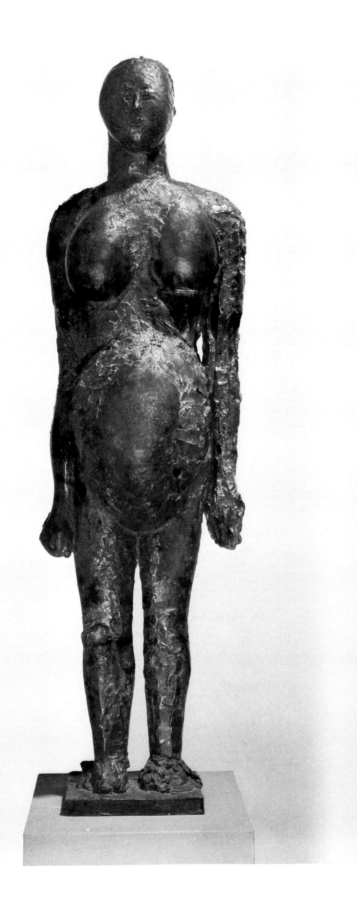

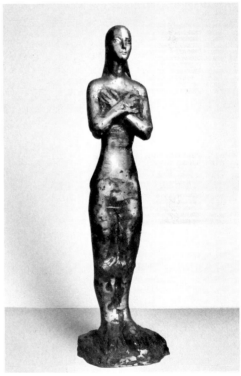

Woman with Arms Crossed. Vallauris, 1950
Bronze reworked with surface etching (unique),
13⅜ x 3⅞ x 3⅞″ (34 x 10 x 10 cm)
Spies 351. Collection Paloma Picasso Lopez, Paris

Pregnant Woman. Vallauris, 1950
Bronze, 41¼″ (104.8 cm) high;
at base 7⅝ x 6¼″ (19.3 x 15.8 cm)
Spies 349. The Museum of Modern Art,
New York. Gift of Mrs. Bertram Smith

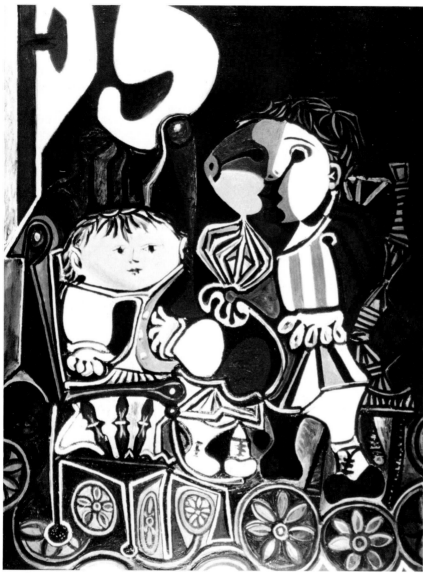

Claude and Paloma. Vallauris, January 20, 1950
Oil and enamel on plywood, 45¾ x 35⅛″ (116 x 89 cm)
Zervos XV, 157. Marina Picasso Foundation

Woman with Baby Carriage. Vallauris, 1950
Bronze (after assemblage of cake pans, terra-cotta, stove plate,
and stroller), 80⅛ x 57 x 24″ (203.2 x 144.7 x 60.9 cm)
Spies 407. Hirshhorn Museum and Sculpture Garden,
Smithsonian Institution, Washington, D.C.

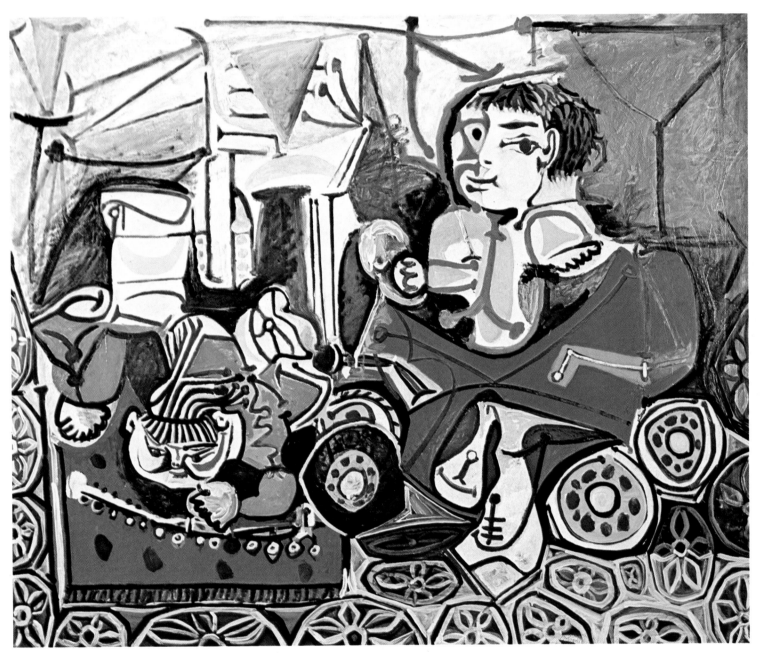

Claude and Paloma at Play. Vallauris, 1950
Oil and enamel on plywood, 46½ x 57⅛″ (118 x 145 cm)
Zervos XV, 163. Collection Bernard Picasso, Paris

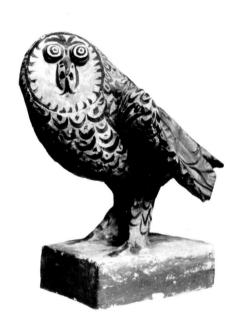

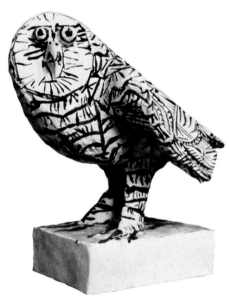

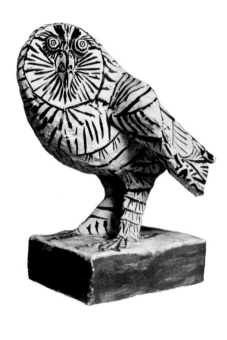

Three variants of *The Owl*. Vallauris, January 5, 1953
Painted ceramic, each 13⅜ x 13¾ x 8⅝″ (34 x 35 x 22 cm)
Spies 403. Collection Jacqueline Picasso, Mougins
(*left and center*) and Marina Picasso Foundation

Owl with the Head of a Woman. Vallauris, February 27, 1953
Painted terra-cotta, 13⅝ x 9¾ x 13⅝″ (34.5 x 24.7 x 34.5 cm)
Musée Picasso, Paris

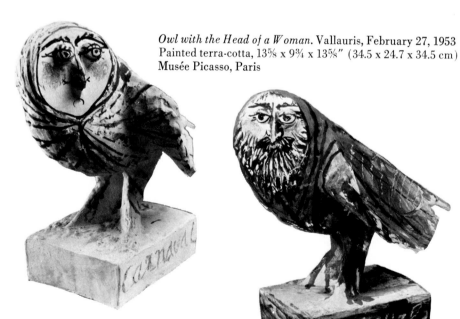

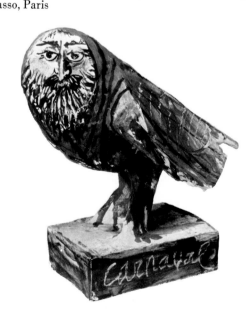

Owl with the Head of a Man. Vallauris, February 27, 1953
Painted terra-cotta, 13¾ x 9⅝ x 13″ (35 x 24.5 x 33 cm)
Musée Picasso, Paris

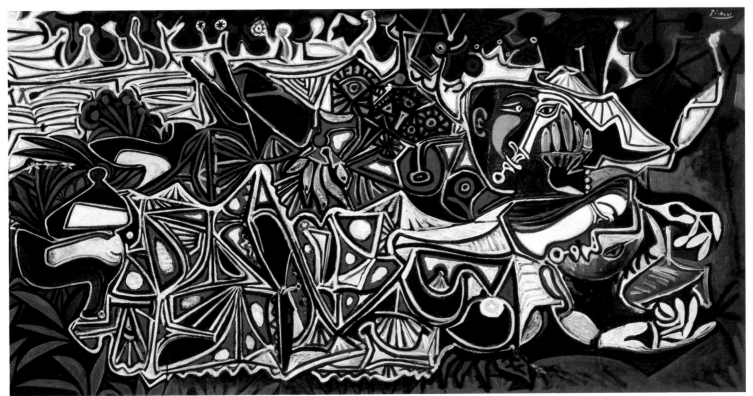

Women on the Banks of the Seine, after Courbet. Vallauris, February 1950
Oil on plywood, 39⅝ x 79⅛″ (100.5 x 201 cm)
Zervos XV, 164. Kunstmuseum, Basel

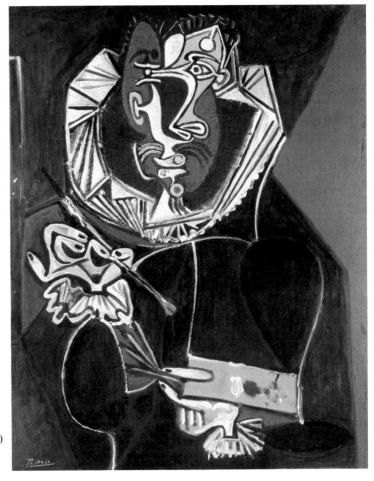

Portrait of a Painter, after El Greco. Vallauris, February 22, 1950
Oil on plywood, 39⅝ x 31⅞″ (100.5 x 81 cm)
Zervos XV, 165. Collection Angela Rosengart, Lucerne

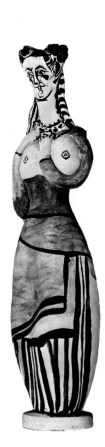

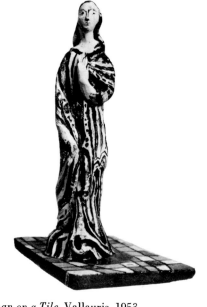

Woman on a Tile. Vallauris, 1953
Ceramic, 12 x 5⅞ x 9″ (30.5 x 15 x 23 cm)
Ramié 132. Collection Jacqueline Picasso, Mougins

Lady in Mantilla. Vallauris, 1949
Ceramic, 18½ x 4½ x 2¾″ (47 x 11.5 x 7 cm)
Ramié 101. Musée Picasso, Paris

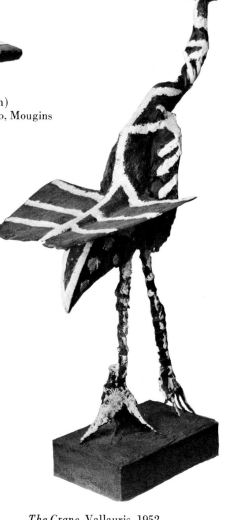

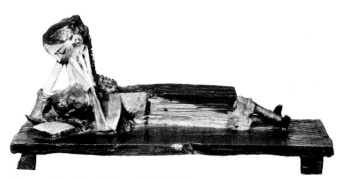

Woman Reading. Vallauris, 1952–53
Painted bronze (after original plaster with wood, nails, and screws),
6⅛ x 14″ (15.5 x 35.5 cm)
Spies 462. Private collection, Paris

The Crane. Vallauris, 1952
Painted bronze,
29½ x 11½ x 17″ (75 x 29 x 43 cm)
Spies 461. Collection Morton Neumann, Chicago

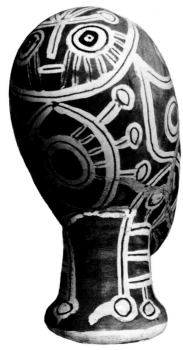

Large Owl
Painted ceramic,
18⅞ x 10¼″ (48 x 26 cm)
Private collection

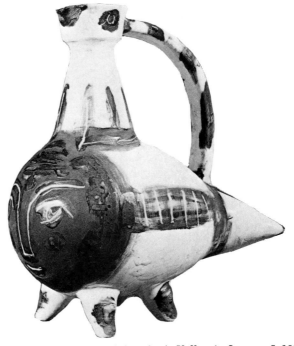

Jug (Animal form with four feet). Vallauris, January 5, 1954
Ceramic, 13⅞ x 6¾ x 11⅞″ (35 x 17 x 30 cm)
Ramié 286. Museo de Cerámica de Barcelona

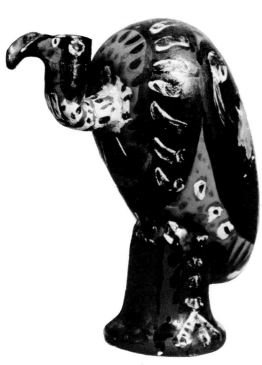

Condor. Vallauris, 1949
Terra-cotta, 16⅛ x 7⅞″ (41 x 20 cm)
Collection Jacqueline Picasso, Mougins

Plate with Fish. [Cannes], 1957
Ceramic, 17¼″ (44 cm) diameter
Marina Picasso Foundation

405

Winter Landscape. Vallauris, December 22, 1950
Oil on panel, 40½ x 49½″ (102.9 x 125.7 cm)
Not in Zervos. Collection Mr. and Mrs. Victor W. Ganz, New York

Massacre in Korea. Vallauris, January 18, 1951
Oil on plywood, 43⅛ x 82½″ (109.5 x 209.5 cm)

Zervos XV, 173. Musée Picasso, Paris

Goat Skull, Bottle, and Candle. Paris, April 16, 1952
Oil on canvas, 35⅛ x 41¾″ (89 x 116 cm)
Zervos XV, 198. The Tate Gallery, London

Goat Skull and Bottle. Vallauris, 1951
Painted bronze (after assemblage of bicycle handlebars, nails,
metal, and ceramic elements), 31 x 37⅝ x 21½″ (78.8 x 95.3 x 54.5 cm)
Spies 410. The Museum of Modern Art, New York.
Mrs. Simon Guggenheim Fund

She-Goat. Vallauris, 1950
Bronze (after assemblage of palm leaf, ceramic flowerpots,
wicker basket, metal elements, and plaster),
46⅜ x 56⅜ x 27¾″ (117.7 x 143.1 x 70.5 cm)
Spies 409. The Museum of Modern Art, New York.
Mrs. Simon Guggenheim Fund

407

Baboon and Young. Vallauris, 1951*
Bronze (after original plaster with metal,
ceramic elements, and two toy cars),
21 x 13¼ x 20¾″ (53.3 x 33.7 x 52.7 cm)
Spies 463. The Museum of Modern Art, New York.
Mrs. Simon Guggenheim Fund

Girl Jumping Rope. Vallauris, 1950
Bronze (after assemblage of metal frame, wicker basket, cake pans,
ceramic elements, and plaster), 60¼ x 25⅝ x 24⅜″ (153 x 65 x 62 cm)
Spies 408. Collection Paloma Picasso Lopez, Paris

Paloma's Dolls. Vallauris, c. 1953
Wood. Spies 481–87
Collection Paloma Picasso Lopez, Paris

Paloma Asleep. Vallauris, December 28, 1952
Oil on panel, 44⅞ x 57½″ (114 x 146 cm)
Zervos XV, 233. Collection Mrs. Bertram Smith, New York

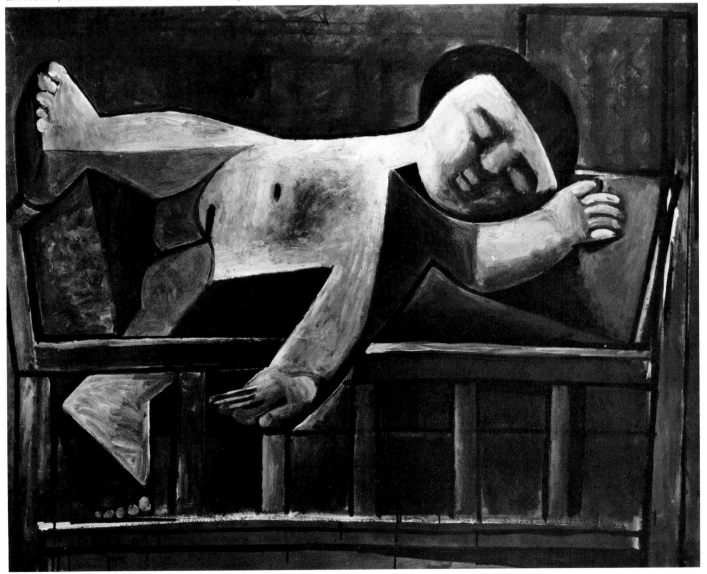

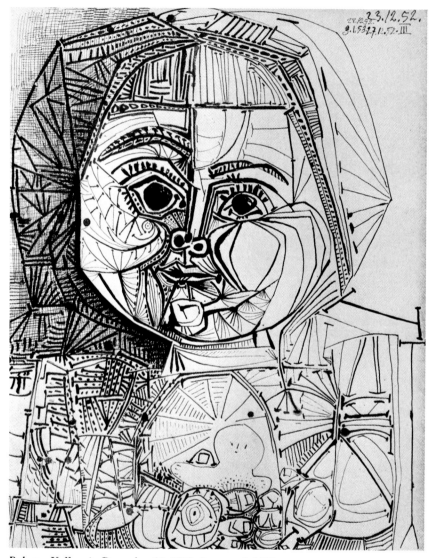

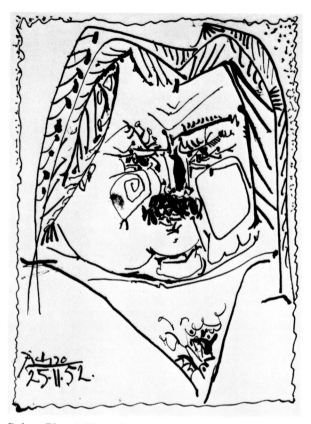

Balzac. Plate 7. November 25, 1952

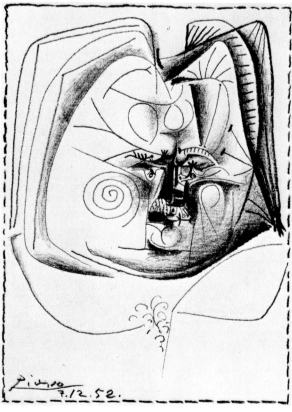

Paloma. Vallauris, December 23, 1952–January 3, 1953
India ink, 26 x 19⅞″ (66 x 50.5 cm)
Not in Zervos. Collection Jacqueline Picasso, Mougins

Portraits of Balzac. Plates 7 and 8 from *Balzacs en bas de casse et
Picassos sans majuscule,* by Michel Leiris. Paris, 1952
Published Paris, Galerie Louise Leiris, 1957
Lithograph, 13 x 9⅞″ (33 x 25.1 cm) (page size)
Mourlot 223, 224. The Museum of Modern Art, New York.
The Louis E. Stern Collection

410

Balzac. Plate 8. December 7, 1952

Balzac. Paris, November 25, 1952
Lithograph, 27½ x 20¹⁵⁄₁₆″ (69.9 x 53.2 cm)
Mourlot 226. The Museum of Modern Art,
New York. Purchase Fund

Balzac. Paris, November 25, 1952
Lithograph, 26⅝ x 20¼″ (67.6 x 51.5 cm)
Mourlot 227. The Museum of Modern Art. New York. Purchase Fund

Balzac, from *Le Père Goriot,* by Honoré de Balzac
Paris, November 25, 1952
Published Monte Carlo, André Sauret, 1952
Lithograph, 8⅝ x 6¼″ (21.9 x 15.9 cm)
Mourlot 216

411

Priapus. Vallauris, 1952
Bronze, 2 x 1⅛″ (5 x 2.9 cm)
Spies 458.
Collection Norman Granz, Geneva

Venus du Gaz. Mougins
Valve and burner from gas stove,
9⅞ x 3½″ (25 x 9 cm)
Private collection

Bird in Cage
Cage with painted cutout,
4¾ x 6¾″ (12 x 17 cm)
Collection Bernard Picasso, Paris

Personnage Serrure
Found lock mechanism, painted,
9½ x 7½″ (24 x 19 cm)
Collection Bernard Picasso, Paris

Women with a Mirror. Vallauris, December 12, 1950
Ink and gouache, 15⅛ x 22⅛" (38.5 x 56 cm)
Not in Zervos. Musée Picasso, Paris

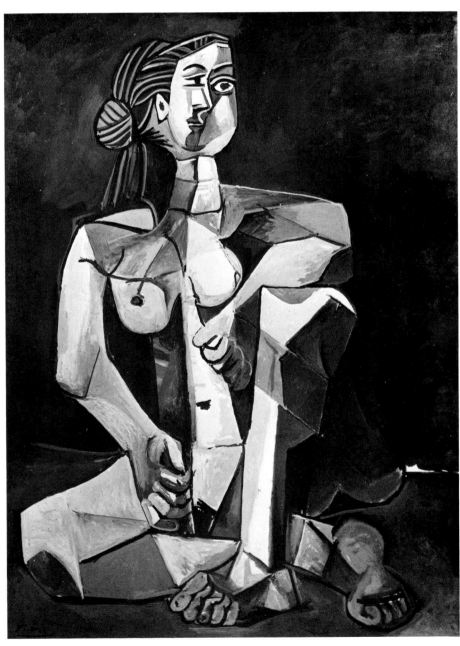

Seated Woman. Vallauris, July 9, 1953
Oil on canvas, 51¼ x 37¾" (130.2 x 95.9 cm)
Zervos XV, 292. The St. Louis Art Museum.
Gift of Mr. and Mrs. Joseph Pulitzer, Jr.

413

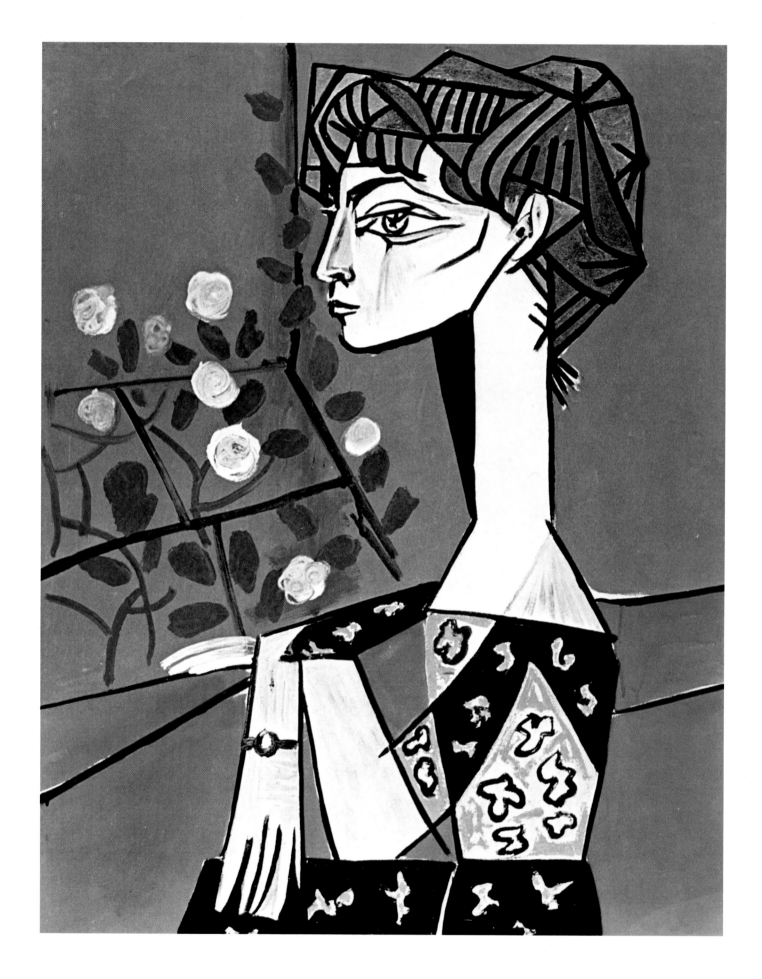

1954-1973

Jacqueline aux Fleurs. Vallauris, June 2, 1954
Oil on canvas, 39⅜ x 31⅞″ (100 x 81 cm)
Zervos XVI, 325. Collection Jacqueline Picasso, Mougins

1954

BEGINNING OF YEAR: Drawings in Painter and Model series continue through February 3, introducing, as well, Circus, mythological, and Harlequin themes. In an ink and wash drawing of January 21 (p. 422), both painter and model are women.

APRIL: Meets Sylvette David, twenty-year-old girl, who poses for him; in month's time, completes some forty drawings and oils of her.

JUNE 2–3: Three portraits of "Madame Z," Jacqueline Roque, whom he has met the previous summer in Perpignan (*Jacqueline aux Fleurs*, p. 414).

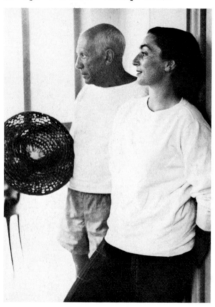

Picasso and Jacqueline Roque, 1955. Photographed by Man Ray

JULY: Exhibition "Picasso: Deux Périodes, 1900–1914, 1950–1954," at Maison de la Pensée Française, Paris, uniting works from Gertrude Stein's collection, held by Alice B. Toklas, with paintings from the Shchukin collection on loan from Russian museums. A Shchukin heir attempts to sequester works that Soviet government confiscated in 1917 revolution; attempt fails, but as a precaution, paintings are withdrawn by Soviet embassy. These pictures on view for only a few days, and

Picasso lends works from his own collection to replace them.

Attends bullfight at Vallauris, accompanied by Penrose, Cocteau, Prévert, Françoise and the children, and Jacqueline Roque. Later, takes Maïa to visit the Lazermes at Perpignan; Jacqueline joins them unexpectedly.

SEPTEMBER 8: Death of Derain, hit by an automobile on the road near his home at Chambourcy.

Picasso returns to Paris with Jacqueline, and they begin to live together at Grands-Augustins studio. Renews acquaintance with old friends.

OCTOBER 11: Paints *Jacqueline with Black Scarf* (p. 423).

NOVEMBER 3: Death of Matisse. Picasso is deeply touched by loss of old friend and rival, of whom he frequently said: "Au fond, il n'y a que Matisse" ("All things considered, there's only Matisse"). During year, Picasso has also lost two other old friends, Maurice Raynal and Henri Laurens.

DECEMBER 13: Perhaps as tribute to Matisse, whose Odalisque he admired, begins series of paintings based on Delacroix's *Women of Algiers*, one of whose figures struck him as resembling Jacqueline. Paints 15 canvases (pp. 424, 425) in two months.

1955

FEBRUARY 11: Death of Olga at Cannes, where she is later buried in Protestant cemetery.

MAY: Sojourn at Rousillon, in Provence, with Jacqueline.

MAY–JUNE: Exhibition "Picasso: 63 Drawings 1953–54, 10 Bronzes 1945–1953," at Marlborough Fine Art, Ltd., London.

JUNE–OCTOBER: Major retrospective, "Picasso: Peintures 1900–1955," at Musée des Arts Décoratifs, Paris; organized by Maurice Jardot, includes almost 150 works. (Between October 25 and April 1956, slightly modified version travels to Munich, Cologne, and Hamburg.)

La Californie, villa overlooking Cannes, bought in 1955. Photographed by Edward Quinn

SUMMER: Filming of Henri-Georges Clouzot's *Le Mystère Picasso* in Victorine studios, Nice. On film, paints two canvases entitled *Beach at La Garoupe*.

Buys La Californie, elaborate nineteenth-century villa overlooking Cannes, with views of Golfe-Juan and Antibes as well. Has large garden with eucalyptus and palm trees where he places sculptures. Goat Esmeralda and dog Yan are given run of estate. In room overlooking garden, sets up studio, which becomes subject of many pictures over ensuing months. Entertains many old friends, including Kahnweiler, Michel and Louise Leiris, and bullfighter Luis-Miguel Domínguín and his wife. Claude and Paloma visit.

OCTOBER 4: Makes portrait of Jacqueline as Lola de Valence (p. 432), after the Manet painting; a portrait drawing of the same month presents her in a more domestic guise (p. 422).

NOVEMBER 10: An old friend, Juan Vidal Ventosa, arrives with Sabartés from Barcelona, his first visit in twenty years. Brings along young Barcelona picture dealers Miguel and Juan Gaspar.

NOVEMBER 20: Paints *Jacqueline in a Turkish Vest* (p. 425).

Interior of La Californie, looking out toward garden. Motif of Art Nouveau doorway repeated in *The Studio* (p. 428). Photographed by Edward Quinn

Interior of La Californie, c. 1955. Photographed by Edward Quinn

1956

FEBRUARY: Lifelong fascination with Bathers reemerges: on February 16 paints large canvas *Two Women on the Beach* (p. 426), later acquired by Musée National d'Art Moderne, Paris.

APRIL 1: Paints *The Studio* (p. 428), one of a series of paintings of La Californie interior.

SEPTEMBER: Takes up Bather theme in another canvas, whose figures are realized as wood slat sculptures, later cast in bronze (p. 427).

OCTOBER 25: Seventy-fifth birthday celebrated in Vallauris by Madoura potters. Occasion also honored in Moscow, where Ilya Ehrenburg organizes exhibition of Russian State-owned pictures.

NOVEMBER 22: With Edouard Pignon, Hélène Parmelin, and seven others, writes to central committee of French Communist party protesting Russian intervention in Hungarian revolt; letter published in *Le Monde*.

1957

MARCH–APRIL: Opening exhibition at Kahnweiler's Galerie Louise Leiris, in new quarters at 47, rue de Monceau, Paris; includes paintings from 1955

Portrait of Jaime Sabartés with a Pinup.†
[Cannes], December 4, 1957. Colored heliograph with India ink, 14 x 10¼" (35.6 x 26 cm). Not in Zervos. Museo Picasso, Barcelona

and 1956. For occasion, makes series of portraits of his old friend.

MAY 4–SEPTEMBER 8: "Picasso: 75th Anniversary Exhibition" at The Museum of Modern Art, New York. Opens in two stages. On May 4 only paintings

and sculpture from 1898 through 1925 on view, along with drawings and watercolors from entire scope of show; on May 22, paintings and sculptures from years 1925 through 1956 are placed on view for duration of show. (Exhibition moves to Art Institute of Chicago from October 29 through December 8, and to Philadelphia Museum of Art from January 6 through February 23, 1958.)

JULY 6–SEPTEMBER 2: Exhibition of drawings, gouaches, and watercolors from 1898 to 1957 at Musée Réattu, Arles. Catalog by Douglas Cooper.

AUGUST 17–DECEMBER 30: Working in studio on top floor of La Californie, paints more than forty variations on Velázquez's *The Maids of Honor (Las Meninas)* (pp. 430, 431).

AUTUMN: Commissioned by UNESCO to decorate delegates' lounge of Paris headquarters. First gouache study of December 6 set in artist's studio, with canvas on easel showing representation of wooden Bathers from 1956. On December 15, begins to fill sketchbook with studio and bather figures, but on January 18 finally adopts theme of Fall of Icarus (title of work is suggested by Georges Salles).

417

1958

JANUARY 29: Final study for UNESCO mural shows Icarus in a seaside setting, plunging into the water like a bird or airplane while bathers watch from the beach. Work to be composed of series of panels covering over a hundred square meters of wall surface.

MARCH 8–JUNE 8: Exhibition of 150 original ceramics at Maison de la Pensée Française, Paris.

MARCH 29: Presentation of UNESCO murals in public schoolyard in Vallauris.

APRIL 19–JUNE 9: Paints *Bay of Cannes* (p. 434), view from window of La Californie; subject occupies him in several works from this period.

SEPTEMBER: Purchases fourteenth-century château de Vauvenargues, in the shadow of Mont Sainte-Victoire, located near Aix-en-Provence, where Cézanne lived. Fills rooms of château with paintings and sculptures brought from Paris.

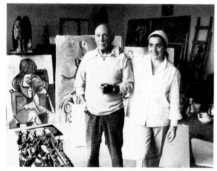

Picasso and Jacqueline. Photographed by Edward Quinn

1959

JANUARY 8: André Malraux appointed Minister of Cultural Affairs of France.

EARLY IN YEAR: At La Californie or shortly after moving to Vauvenargues, paints *Seated Woman* (p. 435).

FEBRUARY: Installed at Vauvenargues, where he will work off and on through Spring 1961.

APRIL 10–30: Paints 21 canvases at new estate, among them *El Bobo, after Velázquez and Murillo* (p. 433).

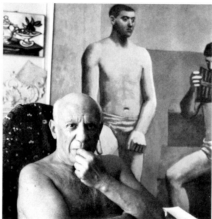

Picasso at La Californie, September 1958. In background, *The Pipes of Pan* (p. 239). Photographed by André Ostier

MAY 22–JUNE 27: Exhibition "Les Ménines, 1957," at Galerie Louise Leiris, Paris.

JUNE 5: Dedication of Monument to Apollinaire (sculptured head of Dora Maar from 1941, p. 369) in garden of Saint-Germain-des-Prés, Paris.

SUMMER: Spends time at La Californie.

AUGUST: At Vauvenargues, turns to another variation on a historical painting, Manet's *Luncheon on the Grass*. Makes many drawings and paintings on theme over next two years, working here, at La Californie, and, in 1961, at Notre-Dame-de-Vie.

AUTUMN: Experiments with linocuts, a medium he will repeatedly work with in 1962 and 1963.

During year, publication of *La Tauromaquia* (Barcelona: Ediciones La Cometa), by José Delgado (Pepe Illo); includes 26 aquatints and one etching by Picasso.

1960

FEBRUARY: Series of paintings of nudes, many bathing or washing their feet. These forecast his return to theme of Painter and Model, which will preoccupy him for next ten years.

APRIL 12: At Vauvenargues, paints *Bather with Sand Shovel* (p. 439), its flattened forms looking forward to metal cutout sculpture of following year.

Château de Vauvenargues, near Aix-en-Provence, bought in 1958. Photographed by Edward Quinn

Notre-Dame-de-Vie, Mougins, bought in 1961. Photographed by Edward Quinn. It is here that Picasso lives for most of the rest of his life

JUNE 15–JULY 13: Exhibition of 45 linocuts at Galerie Louise Leiris, Paris.

JULY 6–SEPTEMBER 18: Retrospective, 1895–1959, at Tate Gallery, London; organized by Arts Council of Great Britain. Contains 270 works, with catalog by Sir Roland Penrose.

JULY 27: Through intervention of Sabartés, Museo Picasso, Barcelona, given formal constitution (not open to public until March 1963).

AUGUST 20: At Vauvenargues, completes a version of *Luncheon on the Grass, after Manet* (p. 437), begun March 3.

OCTOBER 15: Begins cartoons for decoration of walls of Barcelona College of Architects. Designs, inspired by traditional Catalan dances and festivals, are later reproduced on concrete façade of building and incised into the surface by sandblasting, a technique perfected by young Norwegian artist Carl Nesjar. (Decorations are unveiled in April 1962.)

NOVEMBER: With the encouragement of dealer Lionel Prejger, designs large-scale sheet-metal sculpture, constructing maquettes from cut-and-folded paper or cardboard. Continues to work in medium over next three years.

NOVEMBER–DECEMBER: Exhibition at Sala Gaspar, Barcelona; includes thirty paintings.

1961

MARCH 2: Marries Jacqueline Roque at Vallauris.

JUNE: Moves into new villa, Notre-Dame-de-Vie, in hills above Cannes, near village of Mougins. June 6 through June 8, makes series of farewell drawings of La Californie before leaving.

OCTOBER 25: Picasso's eightieth birthday. Celebration at Vallauris three days later.

OCTOBER 25–NOVEMBER 12: Exhibition "Bonne Fête Monsieur Picasso" at UCLA Art Gallery, Los Angeles; includes more than 170 works.

During course of year, creates metal cutouts, folded and painted: *Woman with Hat* (p. 438), *The Chair* (p. 440), and *Woman with Outstretched Arms* (p. 438). (In 1962, collaborates with Carl Nesjar, who creates monumental cast-concrete version of latter for grounds of Kahnweiler's estate, Le Prieuré, at Saint-Hilaire.)

1962

JANUARY 2: Paints Jacqueline in *Seated Woman with Yellow and Green Hat* (p. 441).

JANUARY 26–FEBRUARY 24: Exhibition of paintings from Vauvenargues, 1959–61, at Galerie Louise Leiris, Paris.

APRIL 25–MAY 12: Exhibition "Picasso: An American Tribute," cooperative venture held at nine New York galleries: M. Knoedler and Co., Saidenberg, Paul Rosenberg & Company, Duveen Brothers, Perls Galleries, Staempfli Gallery, Cordier-Warren Gallery, The New Gallery, and Otto Gerson Gallery. Total of 309 works shown; catalog by John Richardson.

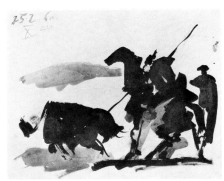

Bullfight. † [Vauvenargues], February 25, 1960. Wash, 18⅞ x 24½″ (48 x 62.3 cm). Not in Zervos. Private collection

Picasso at the bullfight at Vallauris, 1955. At his right, Jacqueline Roque and his daughter Maïa; at his left, his son Claude and Jean Cocteau. Photographed by Brian Brake

MAY 1: Awarded Lenin Peace Prize for second time.

MAY 14–SEPTEMBER 18: "Picasso 80th Birthday Exhibition: The Museum Collection, Present and Future," at The Museum of Modern Art, New York.

AUGUST: Serge Lifar, ballet master of Paris Opéra, visits Picasso in Mougins; asks him to design decor for ballet *Icare* (*Fall of Icarus*). Gouache design executed August 28.

NOVEMBER: Grisaille version of *Rape of the Sabines* (p. 444).

During year, executes over a hundred

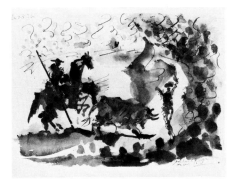

Bullfight. † Vauvenargues, August 23, 1960. Wash, 13¾ x 19⅜″ (35 x 49 cm). Zervos XIX, 373. Private collection, Paris

Picasso with the bullfighter Luis-Miguel Dominguín at La Californie, 1955. Photographed by Edward Quinn

engravings, mostly linocuts, as well as a series of sculptured female heads.

1963

MARCH 9: Museo Picasso, Barcelona, quietly opens in fifteenth-century Aguilar mansion on calle Montcada.

AUGUST 31: Death of Braque.

OCTOBER: At Mougins, begins to collaborate on engravings with Crommelynck brothers, Aldo and Piero, in their recently opened studio at Mougins. Had begun to work with Aldo in 1940s in Lacourière's workshop.

OCTOBER 11: Death of Cocteau.

1964

JANUARY 11–FEBRUARY 16: Retrospective "Picasso and Man" at Art Gallery of Toronto. Includes 273 works from period 1898–1961; organized by Jean Sutherland Boggs, with catalog by Boggs, John Golding, Robert Rosenblum, and Evan H. Turner. Exhibition moves to Montreal for a month.

JANUARY 15–FEBRUARY 15: Exhibition "Peintures 1962–1963" at Galerie Louise Leiris, Paris.

SPRING: Francoise Gilot, writing in collaboration with American art critic Carlton Lake, publishes intimate chronicle *Life with Picasso* (New York: McGraw-Hill). Picasso, outraged, tries to prevent publication of French edition, but to no avail. Book creates rift between him and their children, Claude and Paloma.

MAY 23–JULY 5: Retrospective, 1899–1963, at National Museum of Modern Art, Tokyo; travels to Kyoto and Nagoya.

During year, publication of Brassaï's reminiscences, *Conversations avec Picasso* (Paris: Gallimard). Later published in English under title *Picasso and Company*.

Also during year, completes model (p. 442) for giant sculpture to appear in Chicago's new Civic Center. Commissioned by architectural firm of Skidmore, Owings and Merrill in 1963, it is fashioned after a 1962 metal cutout, *Head of a Woman*. Final version, unveiled in 1967, is sixty feet high.

1965

JUNE 22–SEPTEMBER 15: Exhibition "Picasso et le théâtre" at Musée des Augustins, Toulouse. Organized by Denis Milhau, with catalog introduction by Jean Cassou and texts by Milhau, Robert Mesuret, and Douglas Cooper. In late June there is a special performance of ballets designed by Picasso: *Parade*, *L'Après-midi d'un faune*, and *Le Tricorne*.

JULY 15–AUGUST 18: Exhibition of paintings, tapestries, drawings, and en-

D.-H. Kahnweiler and Picasso strolling in the garden of La Californie. Photographed by Edward Quinn

gravings at Sala Gaspar, Barcelona (since 1961 there has been an annual exhibition at this gallery of recent works in various mediums).

NOVEMBER: Becomes ill and goes to Paris for an ulcer operation at the American Hospital in Neuilly. It is his last trip to Paris.

1966

SEPTEMBER 28: Death of Breton.

NOVEMBER: André Malraux opens exhibition "Hommage à Pablo Picasso," organized by French government under direction of Jean Leymarie. Major retrospective of over seven hundred works, with paintings shown at the Grand Palais and drawings, sculpture, and ceramics at the Petit Palais. Part of this exhibition, but organized separately, is "Pablo Picasso Gravure," a showing of 171 prints at the Bibliothèque Nationale, directed by Jean Adhémar. Sculpture presents a particular revelation, for much of it is from the artist's own collection and has never been seen before. Picasso does not attend.

1967

JANUARY 20: Some two hundred Catalan students and intellectuals render homage to Picasso in Barcelona.

Refuses French Legion of Honor.

SPRING: After absence of 12 years, evicted from studio on rue des Grands-Augustins, Paris.

JUNE 9–AUGUST 13: Major exhibition of Picasso sculpture and ceramics held at the Tate Gallery, London. Directed by Sir Roland Penrose, exhibition travels to The Museum of Modern Art in New York, where it is on view from October 11 through January 1, 1968.

1968

FEBRUARY 13: Death of Sabartés. Picasso donates Las Meninas series to Barcelona Picasso museum in his memory.

FEBRUARY 28–MARCH 23: Exhibition at Galerie Louise Leiris, Paris; includes drawings from 1966 and 1967.

MARCH 16–OCTOBER 5: At Mougins, during course of seven months makes 347 engravings (p. 458) containing rich mixture of motifs from the circus, bullfight, theater (Commedia dell'Arte), and Spanish literature (a series of the works are based on *La Celestina*, the play by Fernando de Rojas). Series culminates in a group of erotic scenes of lovemaking—explicit but full of humor. Engravings are printed by Aldo and Piero Crommelynck in their Mougins studio.

NOVEMBER 14: Continuing to paint, produces *Still Life with Umbrella* (p. 454).

DECEMBER 18–FEBRUARY 1, 1969: Exhibition of the 347 engravings at Galerie Louise Leiris, Paris.

1969

MARCH 4: At Mougins, completes portrait of Jacqueline (p. 446).

APRIL: Sixteen of the Celestina engravings from the 347 Series published in *El Entierro del Conde de Orgaz* (Barcelona: Editorial Gustavo Gili), for which he composes the text as well.

1970

JANUARY: Picasso family in Barcelona donates all paintings and sculptures in its possession to Museo Picasso, Barcelona.

JANUARY 20: Death of Yvonne Zervos.

MAY 1–OCTOBER 1: Exhibition of recent work at Palais des Papes d'Avignon, organized before her death by Yvonne Zervos and with catalog by Christian. Includes 167 oils and 45 drawings made between January 1969 and end of January 1970.

MAY 12: Bateau-Lavoir destroyed by fire.

SEPTEMBER 12: Death of Christian Zervos from a heart attack.

OCTOBER 15–NOVEMBER 29: Major retrospective, "Picasso: Master Printmaker," at The Museum of Modern Art, New York. Directed by Riva Castleman.

DECEMBER 15–FEBRUARY 21, 1971: Exhibition "The Cubist Epoch," Los Angeles County Museum of Art; later shown at Metropolitan Museum of Art, New York, from April 7 through June 7, 1971. Organized by Douglas Cooper.

DECEMBER 16–MARCH 1, 1971: Exhibition "Four Americans in Paris: The Collections of Gertrude Stein and Her Family," The Museum of Modern Art, New York. Directed by Margaret Potter. Catalog texts by Irene Gordon, Lucile M. Golson, Leon Katz, Douglas Cooper, and Ellen B. Hirschland.

At Gertrude Stein's death in 1946, her collection had been left in custody of Alice B. Toklas. Following latter's death in 1967, collection passes to heirs of Miss Stein, who sell it to a consortium of collectors, John Hay Whitney, Nelson and David Rockefeller, William S. Paley, and André Meyer (some 47 works, 38 by Picasso). Each member

Picasso with *Guitar* of 1912 (p. 148), given to The Museum of Modern Art, New York. Photographed in 1971 by Jacqueline Picasso

of the group pledges to bequeath at least one painting, of the Museum's choosing, to The Museum of Modern Art. These works, plus many others once owned by Miss Stein, are placed on view at the Museum.

1971

WINTER: The Museum of Modern Art is given 1912 *Guitar* (p. 148), Picasso's first constructed metal sculpture. In subsequent months, William Rubin, Chief Curator of Painting and Sculpture at the Museum, has extended con-

versations wih the artist. They discuss plans for a major exhibition and book on the Museum's Picasso holdings.

APRIL 23–JUNE 5: Exhibition of 194 drawings made between December 15, 1969, and January 12, 1971 at Galerie Louise Leiris, Paris.

OCTOBER 25: Picasso's ninetieth birthday. In honor of the occasion, selection of works is placed on exhibit at Grand Gallery of the Louvre.

1972

During year, continues working at Mougins, chiefly producing drawings and prints.

JANUARY 23–APRIL 2: Exhibition "Picasso in the Collection of The Museum of Modern Art," organized by William Rubin. Catalog includes additional texts by Elaine Johnson (on drawings) and Riva Castleman (on prints).

DECEMBER 1–JANUARY 3, 1973: Major exhibition of 172 drawings from November 21, 1971, through August 8, 1972, at Galerie Louise Leiris, Paris.

During course of year, The Museum of Modern Art acquires as gift of the artist a six-foot-high version of a 1928 *Wire Construction* (p. 268) conceived as a monument to Apollinaire. Picasso also authorizes and chooses materials for a 13-foot-high version, the size, he asserts, that he had originally intended the monument to be. This version is placed in the Museum's Sculpture Garden.

1973

JANUARY 24–FEBRUARY 24: Exhibition of 156 engravings realized between end of 1970 and March 1972 at Galerie Louise Leiris, Paris.

APRIL 8: Death of Pablo Picasso at Mougins.

APRIL 10: Burial on grounds of the château de Vauvenargues. Over his grave, Mme Picasso places bronze of *Woman with Vase* (p. 313).

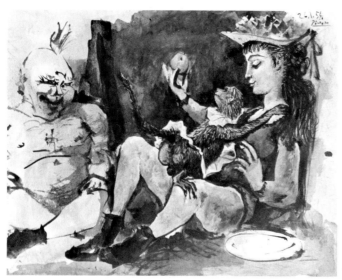

The Monkey and the Apple. Vallauris, January 26, 1954
Gouache, 9½ x 12⅝″ (24 x 32 cm)
Zervos XVI, 229. Private collection, Zurich

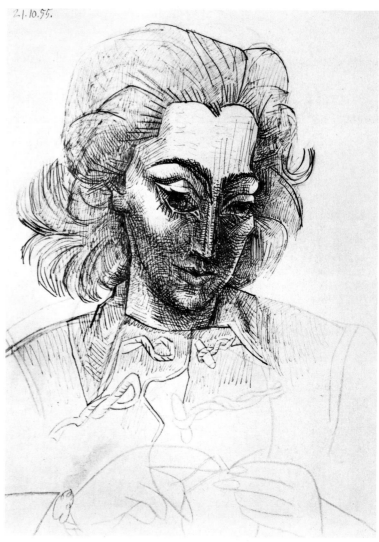

Jacqueline. [Paris], October 21, 1955
India ink and pencil, 25⅝ x 19¾″ (65 x 50 cm)
Zervos XVI, 485. Private collection

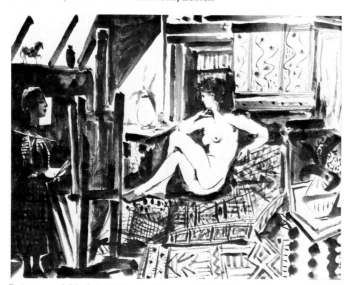

Painter and Model. Vallauris, January 21, 1954
Ink and wash, 9¼ x 12¼″ (23.5 x 31 cm)

Not in Zervos. Collection Mr. and Mrs. Daniel Saidenberg, New York

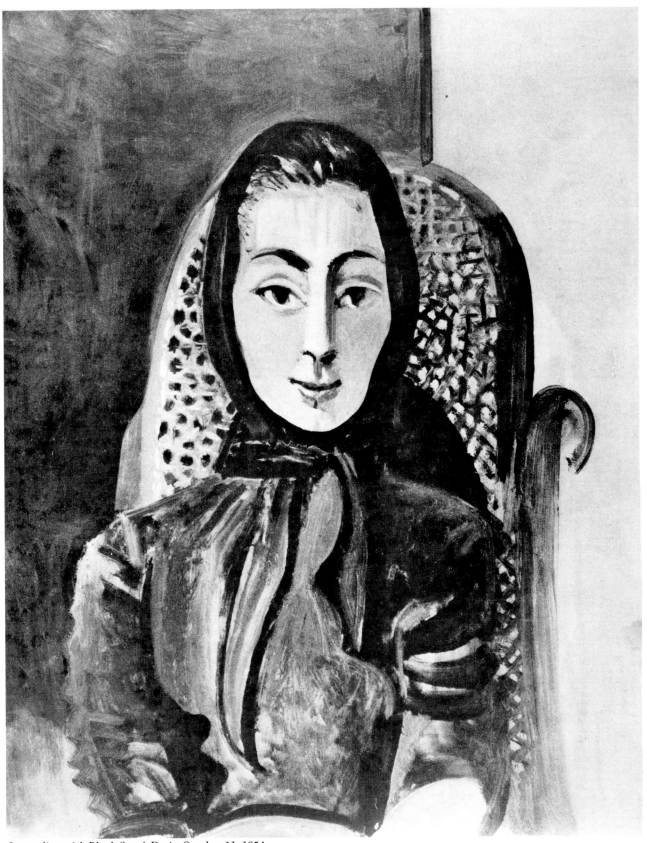

Jacqueline with Black Scarf. Paris, October 11, 1954
Oil on canvas, 36¼ x 28¾" (92 x 73 cm)
Zervos XVI, 331. Collection Jacqueline Picasso, Mougins

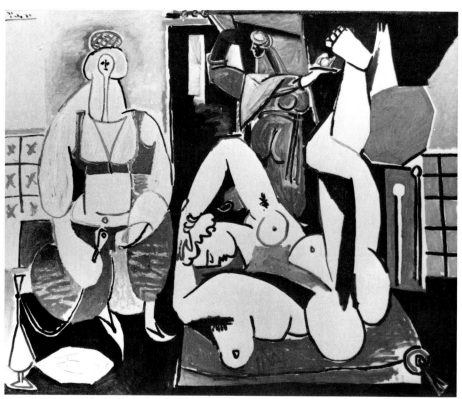

Women of Algiers, after Delacroix (H). Paris, January 24, 1955
Oil on canvas, 51¼ x 63¾″ (130 x 162 cm)
Zervos XVI, 356. Collection Mr. and Mrs. Victor W. Ganz, New York

Women of Algiers, after Delacroix (M). Paris, February 11, 1955
Oil on canvas, 51¼ x 76¾″ (130 x 195 cm)
Zervos XVI, 357. Collection Mr. and Mrs. Victor W. Ganz, New York

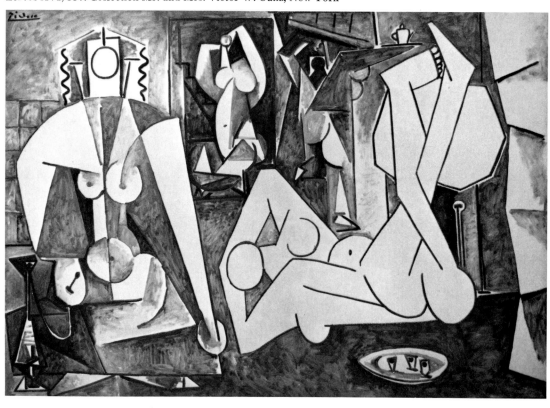

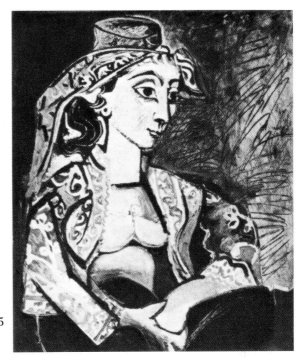

Jacqueline in a Turkish Vest. Cannes, November 20, 1955
Oil on canvas, 39⅜ x 31½″ (100 x 80 cm)
Not in Zervos. Collection Jacqueline Picasso, Mougins

Women of Algiers, after Delacroix (O, final version). Paris, February 14, 1955
Oil on canvas, 44⅞ x 57½″ (114 x 146 cm)
Zervos XVI, 360. Collection Mr. and Mrs. Victor W. Ganz, New York

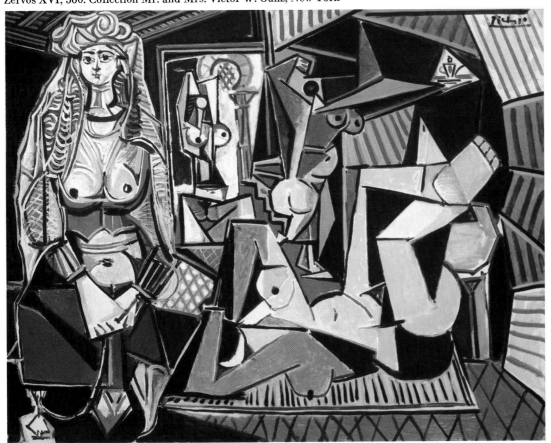

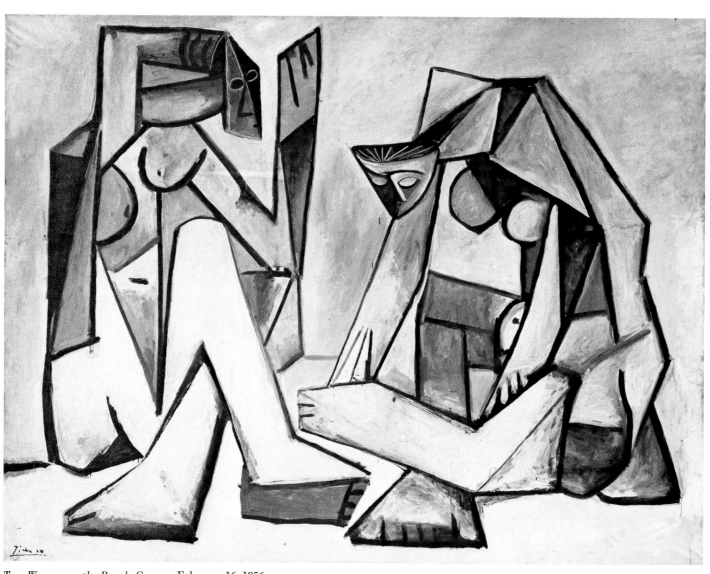

Two Women on the Beach. Cannes, February 16, 1956
Oil on canvas, 76¾ x 102⅜″ (195 x 260 cm)
Zervos XVII, 36. Musée National d'Art Moderne, Centre National d'Art et de Culture Georges Pompidou, Paris

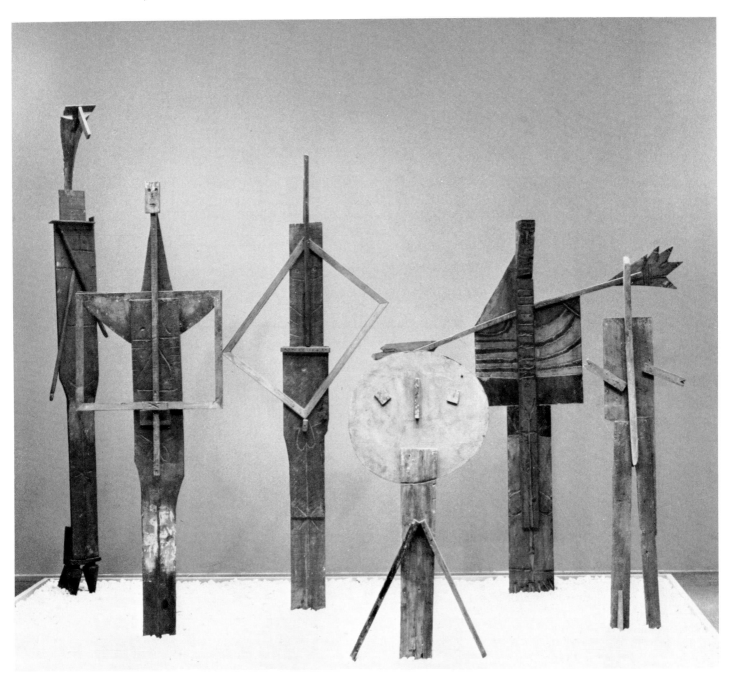

The Bathers. Cannes, 1956
Carved wood, 103″ (261.7 cm) high, 96¾″ (245.7 cm) high, 84¼″ (214 cm) high,
53½″ (135.9 cm) high, 78½″ (199.4 cm) high, and 69¾″ (177 cm) high
Not in Spies. Marina Picasso Foundation

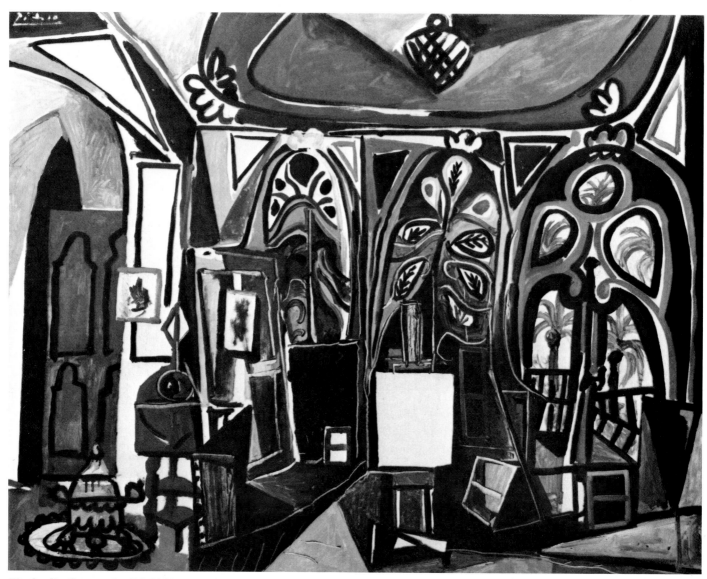

The Studio. Cannes, April 1, 1956
Oil on canvas, 35⅛ x 45¾″ (89 x 116 cm)
Zervos XVII, 57. Collection Mr. and Mrs. Victor W. Ganz, New York

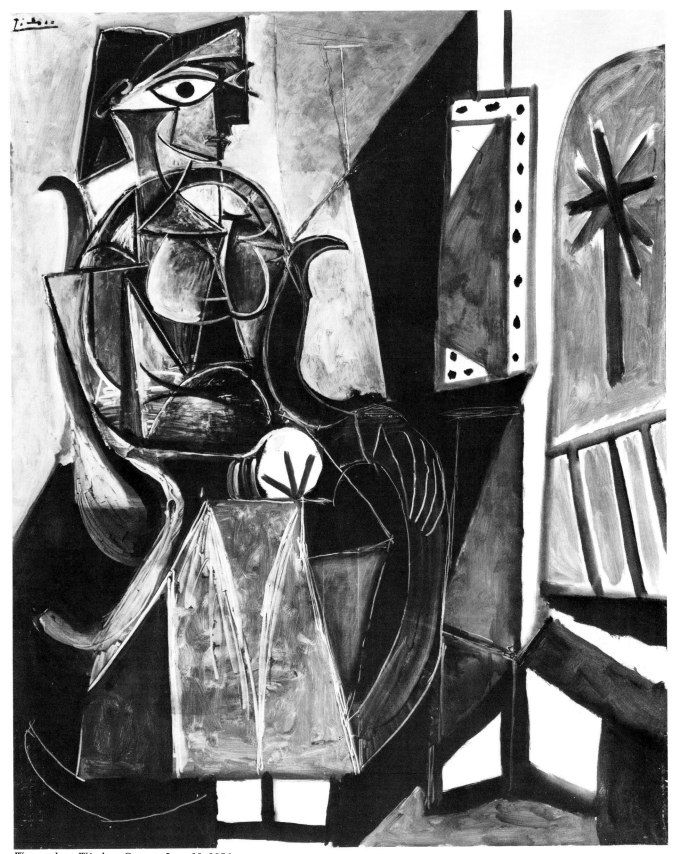

Woman by a Window. Cannes, June 11, 1956
Oil on canvas, 63¾ x 51¼″ (162 x 130 cm)
Zervos XVII, 120. The Museum of Modern Art, New York. Mrs. Simon Guggenheim Fund

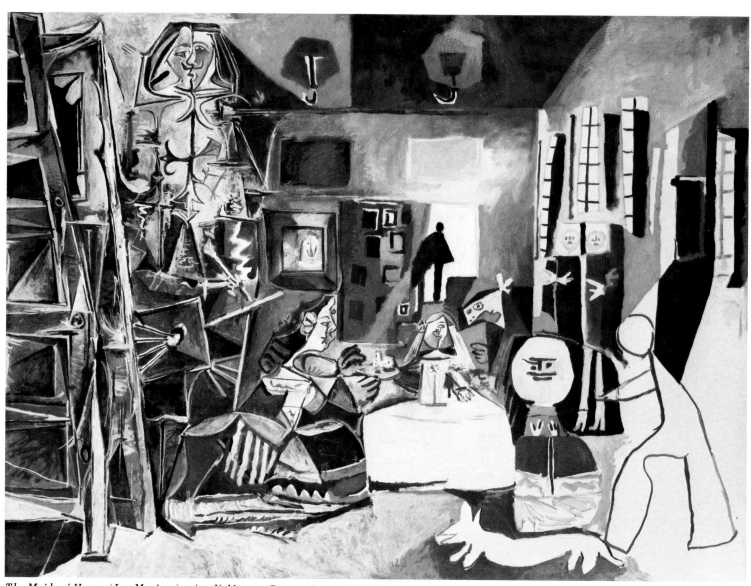

The Maids of Honor (*Las Meninas*), *after Velázquez*. Cannes, August 17, 1957
Oil on canvas, 76⅜ x 102⅜″ (194 x 260 cm)
Zervos XVII, 351. Museo Picasso, Barcelona

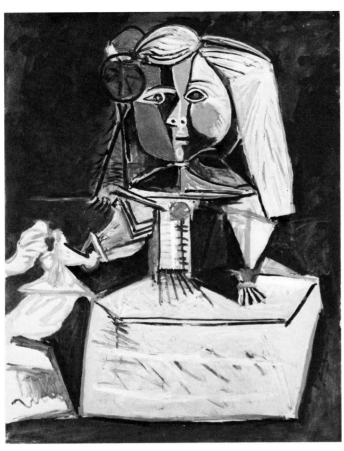

*The Infanta Margarita María, from The Maids of Honor
(Las Meninas), after Velázquez.* Cannes, September 14, 1957
Oil on canvas, 39⅜ x 32″ (100 x 81 cm)
Zervos XVII, 368. Museo Picasso, Barcelona

The Maids of Honor (Las Meninas), after Velázquez
Cannes, September 18, 1957
Oil on canvas, 50¾ x 63⅜″ (129 x 161 cm)
Zervos XVII, 372. Museo Picasso,.Barcelona

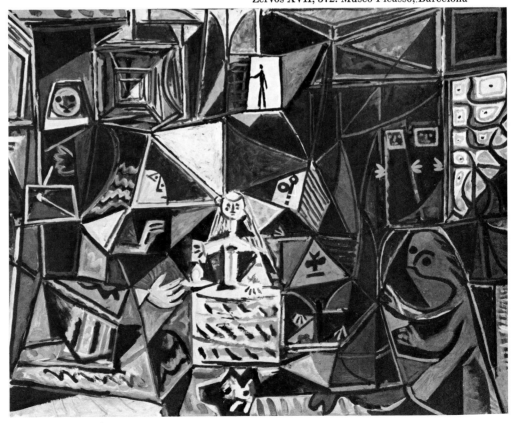

Helmeted Figure, after Rembrandt
[Cannes], 1956
Pen and India ink, 17 x 13″ (43 x 33 cm)
Not in Zervos
Private collection

Jacqueline as Lola de Valence, after Manet
[Paris or Cannes], October 4, 1955
India ink, 12⅝ x 9½″ (32 x 24 cm)
Zervos XVI, 479
Collection Jacqueline Picasso, Mougins

Jacqueline as an Equestrian, after Velázquez
Cannes, March 10, 1959
India ink and colored pencil,
14½ x 10⅝″ (37 x 27 cm)
Zervos XVIII, 367
Collection Jacqueline Picasso Mougins

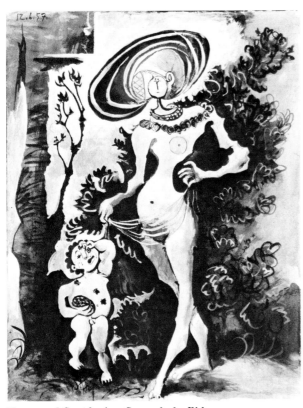

Venus and Cupid, after Cranach the Elder
[Cannes], June 12, 13, 1957
Ink and gouache, 25¾ x 19⅞″ (65.5 x 50.5 cm)
Zervos XVII, 339. Collection Jacqueline Picasso, Mougins

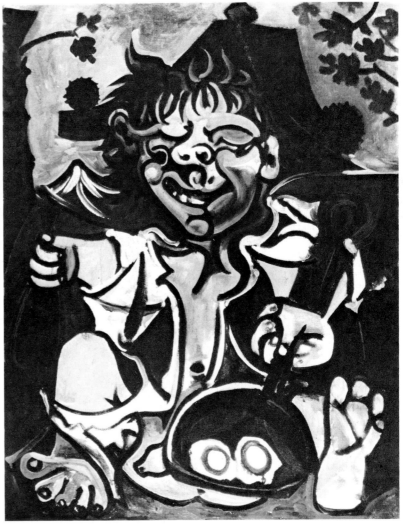

El Bobo, after Velázquez and Murillo. Vauvenargues, April 14, 15, 1959
Oil and enamel on canvas, 36¼ x 28¾″ (92 x 73 cm)
Zervos XVIII, 484. Private collection

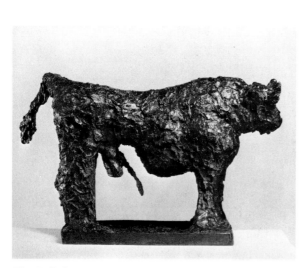

The Bull. Cannes, 1957
Bronze, 15¾ x 26 x 8½″ (40 x 66 x 21.5 cm)
Spies 512. Paul Rosenberg and Co., New York

The Bay of Cannes. Cannes, April 19–June 9, 1958
Enamel on canvas, 50¼ x 76¾″ (130 x 195 cm)
Zervos XVIII, 83. Musée Picasso, Paris

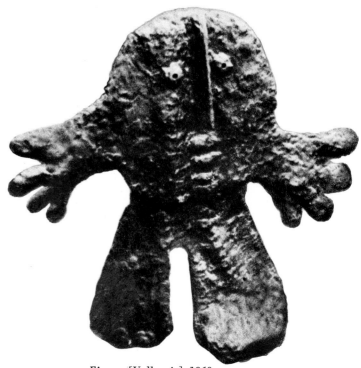

Figure. [Vallauris], 1960
Bronze, c. 37″ (94 cm) high
Spies 559. Collection Bernard Picasso, Paris

Seated Woman. [Vauvenargues or Cannes], 1959
Oil on canvas, 57½ x 45″ (146 x 114.2 cm)
Zervos XVIII, 308. Collection Mr. and Mrs. Victor W. Ganz, New York

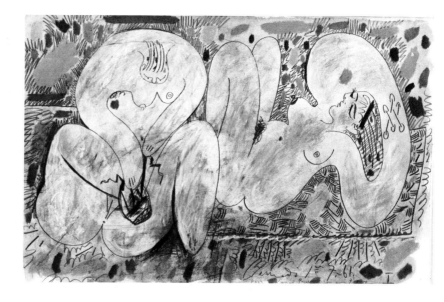

The Arm. [Cannes], March 15, 1959
Bronze, 22¾ x 6½ x 6¼″ (57.8 x 16.5 x 16 cm)
Spies 555. Hirshhorn Museum and Sculpture Garden,
Smithsonian Institution, Washington, D.C.

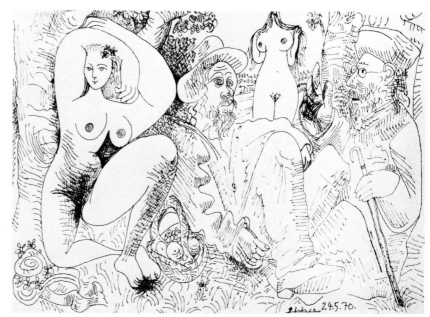

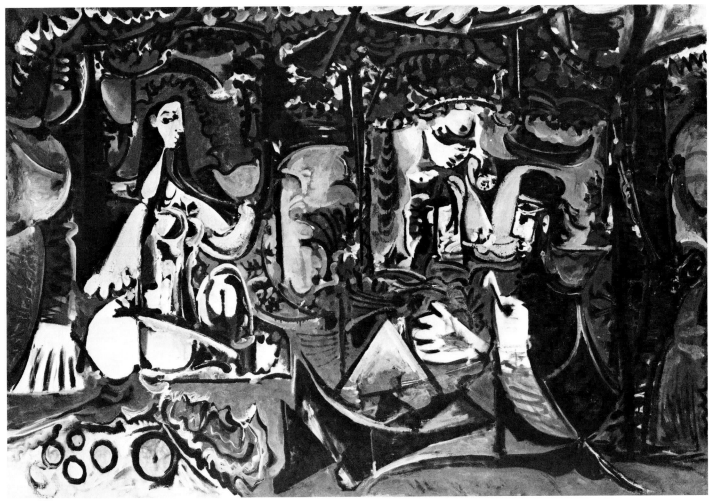

Luncheon on the Grass, after Manet. Vauvenargues, March 3–August 20, 1960
Oil on canvas, 50⅞ x 76¾″ (129 x 195 cm)
Zervos XIX, 204. Musée Picasso, Paris

OPPOSITE, TOP:
Luncheon on the Grass, after Manet. Mougins, August 22, 1961
Pencil, 10⅝ x 16¼″ (27 x 41.3 cm)
Zervos XX, 120. Collection Mr. and Mrs. Daniel Saidenberg, New York

OPPOSITE, CENTER:
Bathers (Study after Luncheon on the Grass, by Manet). Mougins, July 1, 1961
Colored pencil, 12⅞ x 19½″ (32.5 x 49.5 cm)
Zervos XX, 52. Private collection, Paris

OPPOSITE:
Luncheon on the Grass, after Manet. Mougins, May 24, 1970
India ink, 7 x 9⅞″ (17.8 x 25.2 cm)
Zervos XXXII, 84. Private collection

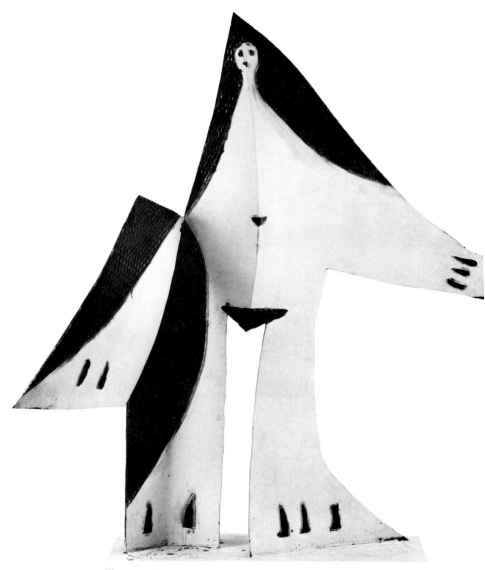

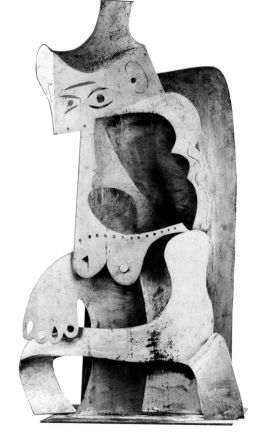

Woman with Outstretched Arms. Cannes, 1961
Metal cutout, folded and painted, 72 x 69⅝ x 28½″ (183 x 177.5 x 72.5 cm)
Spies 596. Musée Picasso, Paris

Woman with Hat. Cannes, 1961 (painted Mougins, 1963)
Metal cutout, folded and painted, 50 x 29⅛ x 15¾″ (127 x 74 x 40 cm)
Spies 626. Musée Picasso, Paris

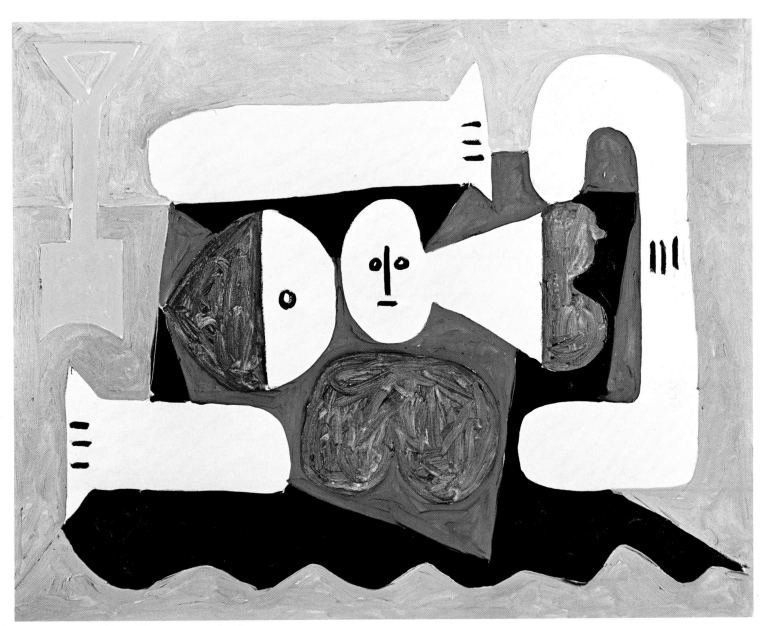

Bather with Sand Shovel. Vauvenargues, April 12, 1960
Oil on canvas, 44⅞ x 57½″ (114 x 146 cm)
Zervos XIX, 236. Collection Bernard Picasso, Paris

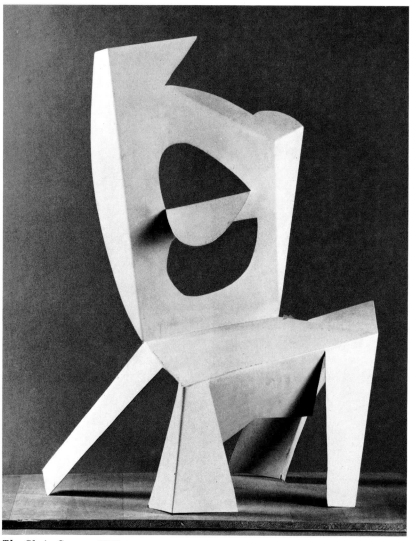

The Chair. Cannes, 1961
Metal cutout, folded and painted, 43⅞ x 45⅛ x 35″
(111.5 x 114.5 x 89 cm) (wooden base by artist)
Spies 592. Musée Picasso, Paris

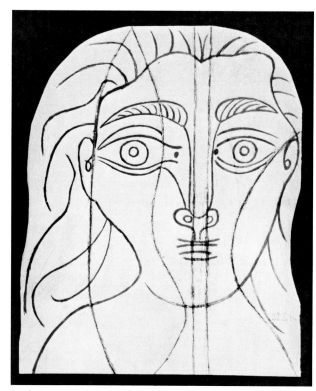

Study for Head. Cannes, May 22, 1961
Colored pencil on yellow cardboard,
31½ x 25⅝″ (80 x 65 cm)
Not in Zervos
Collection Jacqueline Picasso, Mougins

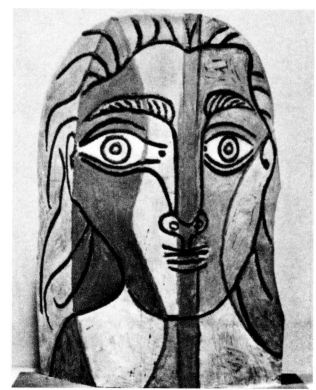

Head. Cannes, 1961
Painted sheet metal, 31½ x 21⅝″ (80 x 55 cm)
Spies 620. Collection Jacqueline Picasso, Mougins

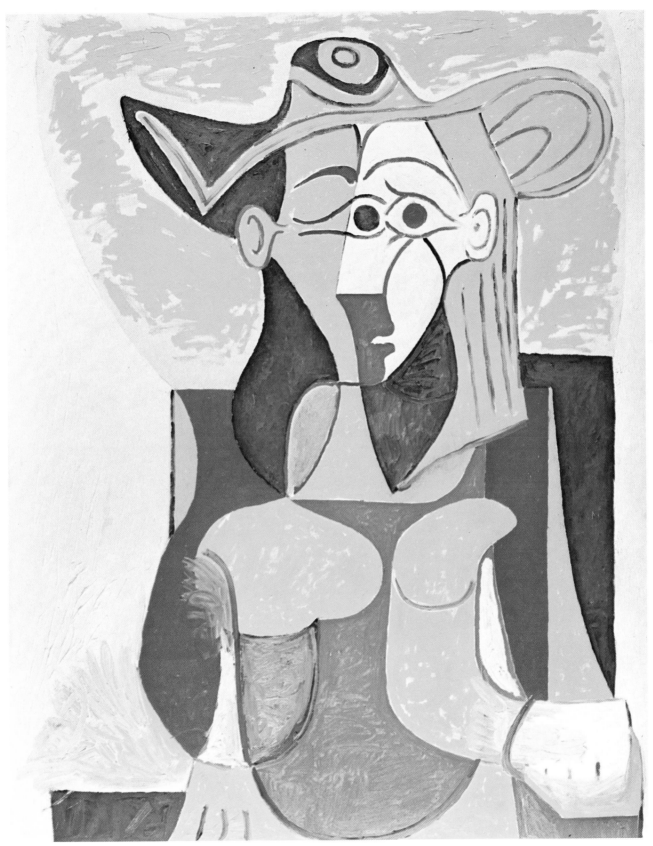

Seated Woman with Yellow and Green Hat. [Mougins], January 2, 1962
Oil on canvas, 63¾ x 51¼″ (162 x 130 cm)
Zervos XX, 179. Collection Jacqueline Picasso, Mougins

441

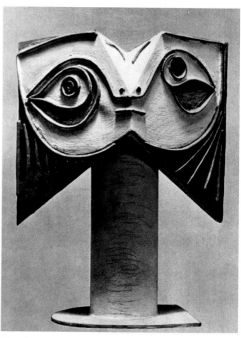

Head of a Woman. Mougins, 1962
Pipe and metal cutout, folded and painted,
12⅝ x 10″ (32 x 25.5 cm)
Spies 637. Collection Jacqueline Picasso, Mougins

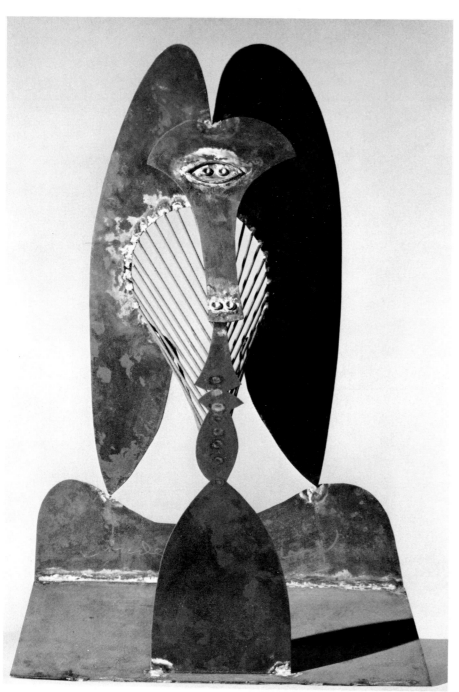

"Head of a Woman" (Kazbec) (Maquette for sculpture in Civic
Center, Chicago). Mougins, 1964
Welded steel, 41¼ x 27½ x 19″ (104.7 x 69.9 x 48.3 cm)
Spies 643. The Art Institute of Chicago. Gift of the artist

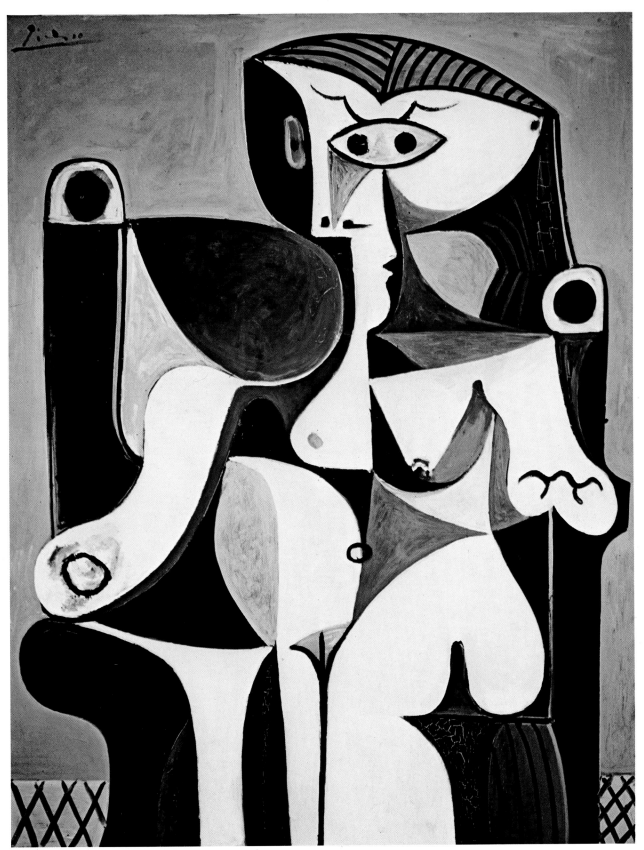

Seated Woman. Mougins, May 13–June 16, 1962
Oil on canvas, 57½ x 44⅞″ (146 x 114 cm)
Zervos XX, 227. Collection M. and Mme Claude Laurens, Paris

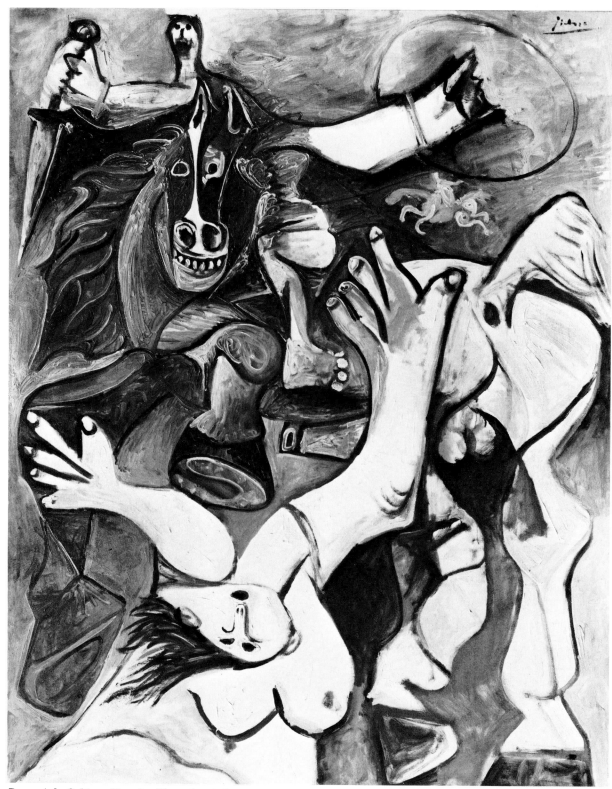

Rape of the Sabines. Mougins, November 2, 4, 1962
Oil on canvas, 63¾ x 51¼″ (161.8 x 130.2 cm)
Zervos XXIII, 71. Collection Norman Granz, Geneva

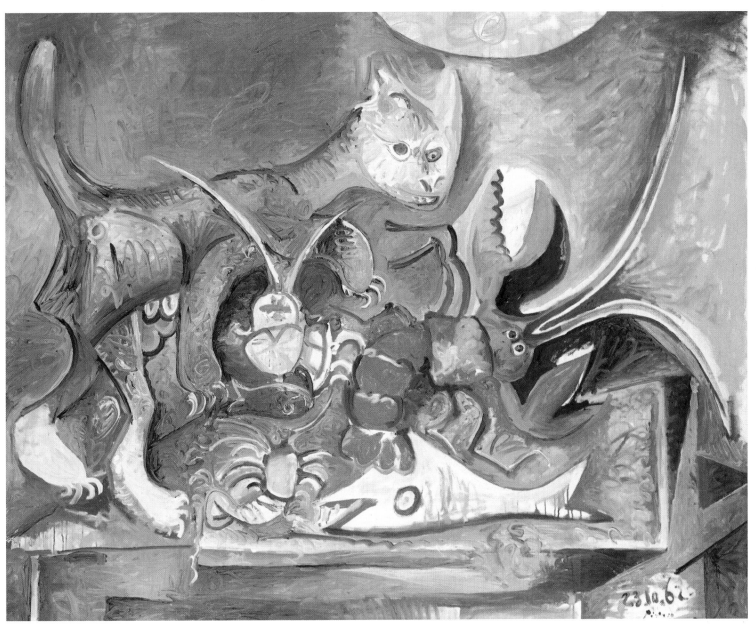

Cat and Lobster. Mougins, October 23, November 1, 1962
Oil on canvas, 51¼ x 63¾″ (130 x 162 cm)
Zervos XX, 356. Private collection, Switzerland

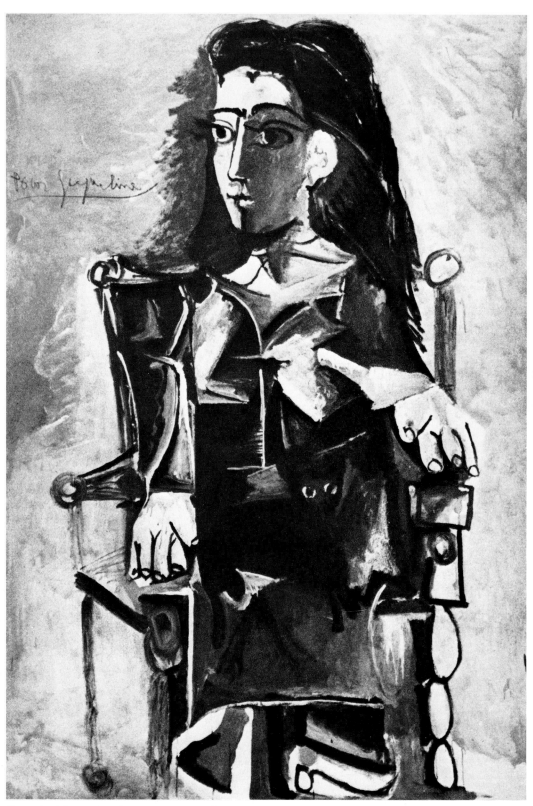

Portrait of Jacqueline. Mougins, February 26–28, March 1–3, 1964
Oil on canvas, 76¾ x 51¼″ (195 x 130 cm)
Zervos XXIV, 101. Collection Jacqueline Picasso, Mougins

446

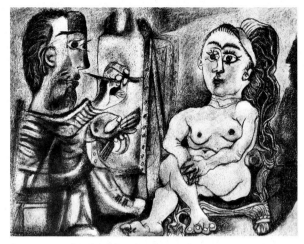

Painter and Model. Mougins, December 21, 28, 1963
Crayon, 20¼ x 26″ (51 x 66 cm)
Zervos XXIII, 382. Private collection

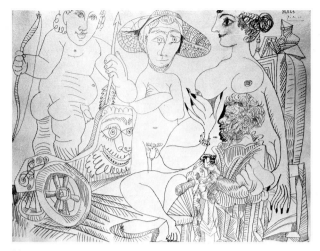

Mythological Scene. Mougins, August 30, 1967
Pencil, 22¼ x 29½″ (56.5 x 74.9 cm)
Zervos XXVII, 509. Perls Galleries, New York

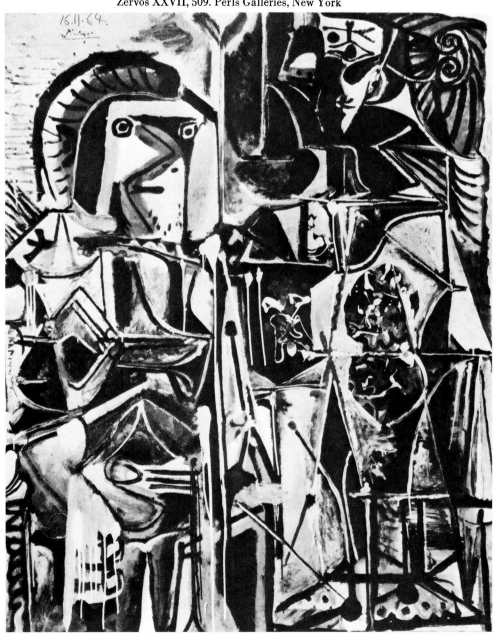

Painter and Model. Mougins,
November 16–December 9, 1964
Oil on canvas, 63¾ x 51⅛″ (162 x 130 cm)
Zervos XXIV, 312. Nationalgalerie
Berlin–DDR, Ludwig Collection, Aachen

447

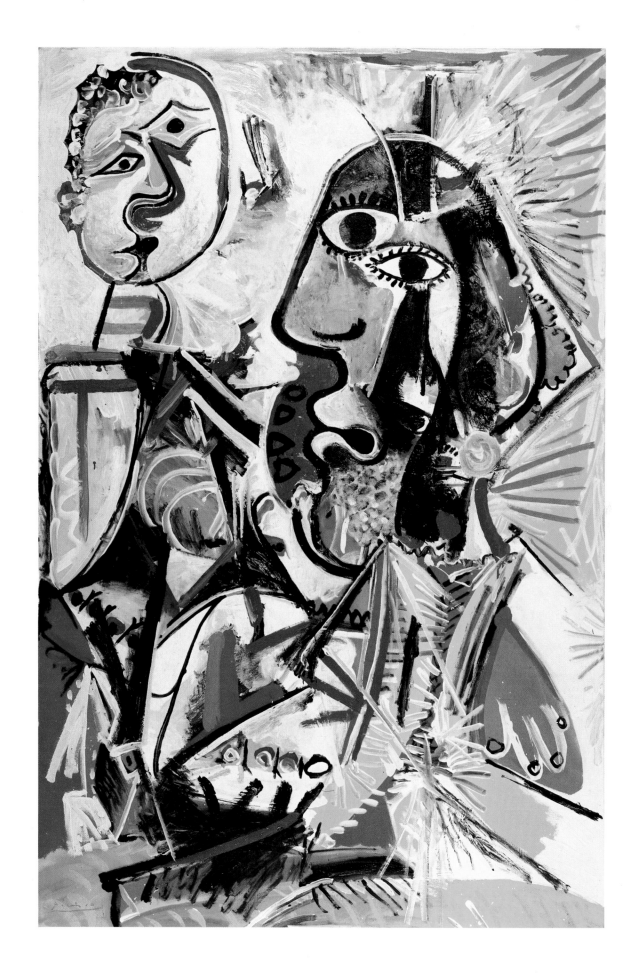

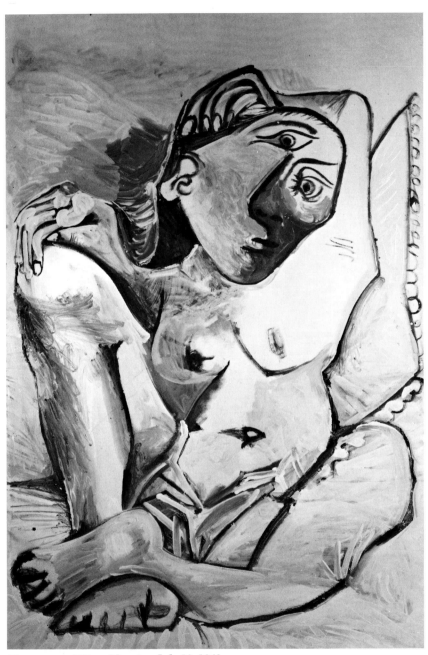

Woman on a Pillow. Mougins, July 10, 1969
Oil on canvas, 76¾ x 51¼″ (195 x 130 cm)
Zervos XXXI, 315. Galerie Louise Leiris, Paris

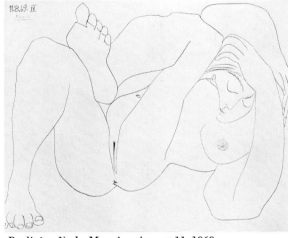

Reclining Nude. Mougins, August 11, 1969
Pencil, 19⅞ x 25¾″ (50.5 x 65.5 cm)
Zervos XXXI, 369. Galerie Louise Leiris, Paris

OPPOSITE:
Large Heads. Mougins, March 16, 1969
Oil on canvas, 76⅝ x 50⅞″ (194.5 x 129 cm)
Zervos XXXI, 102. Nationalgalerie Berlin–DDR, Ludwig Collection, Aachen

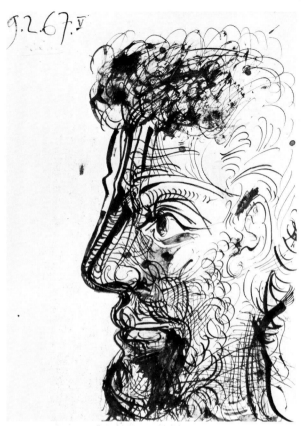

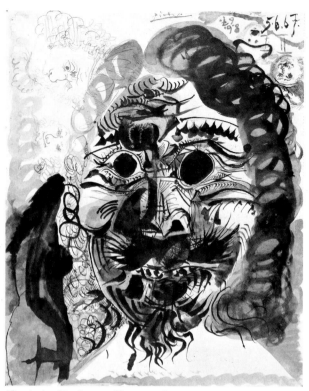

Head of a Musketeer. Mougins, June 5, 1967
India ink, 23⅞ x 19½″ (60.5 x 49.5 cm)
Zervos XXVII, 9. Galerie Louise Leiris, Paris

Head of a Man. Mougins, February 9, 1967
India ink, 25⅝ x 19¾″ (65 x 50 cm)
Zervos XXVII, 447. Collection Ms. Sandra Rotman, Toronto

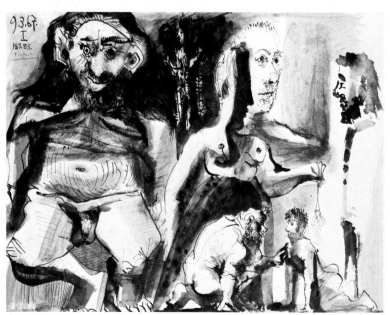

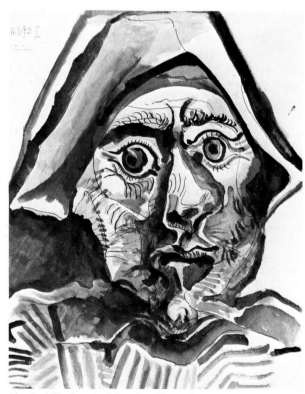

Figures. Mougins, March 9, 14, 15, 1967
Wash, brush, and pen and ink, 19⅜ x 25½″ (49.2 x 64.8 cm)
Zervos XXV, 294. The Museum of Modern Art, New York.
450 Gift of Mrs. Joan Avnet in honor of William S. Lieberman

Head of Harlequin. Mougins, November 14, 1970
Watercolor and India ink, 25⅝ x 20½″ (65 x 52 cm)
Zervos XXXII, 302. Sala Gaspar, Barcelona

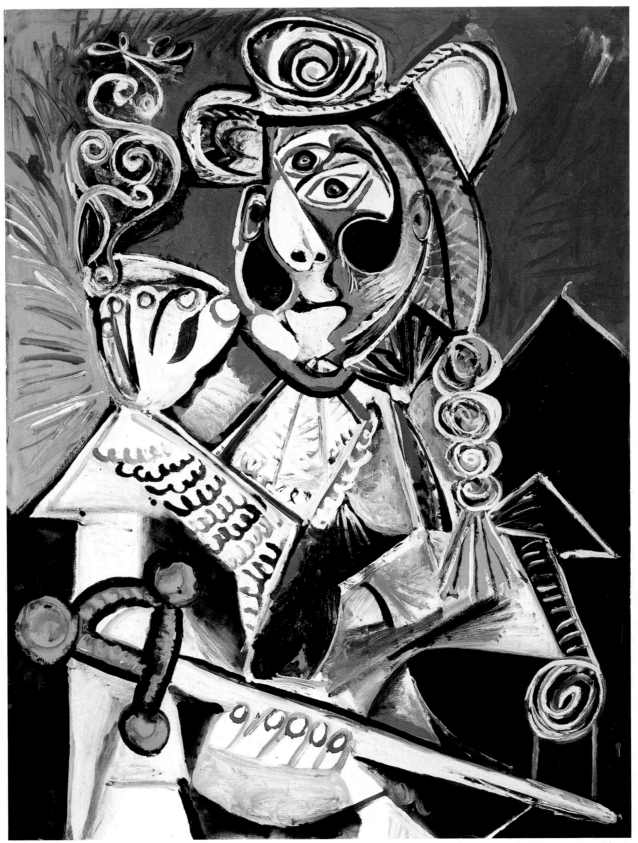

Cavalier with Pipe. Mougins, October 4, 1970
Oil on canvas, 57⅛ x 44⅞" (145 x 114 cm)
Zervos XXXII, 273. Musée Picasso, Paris

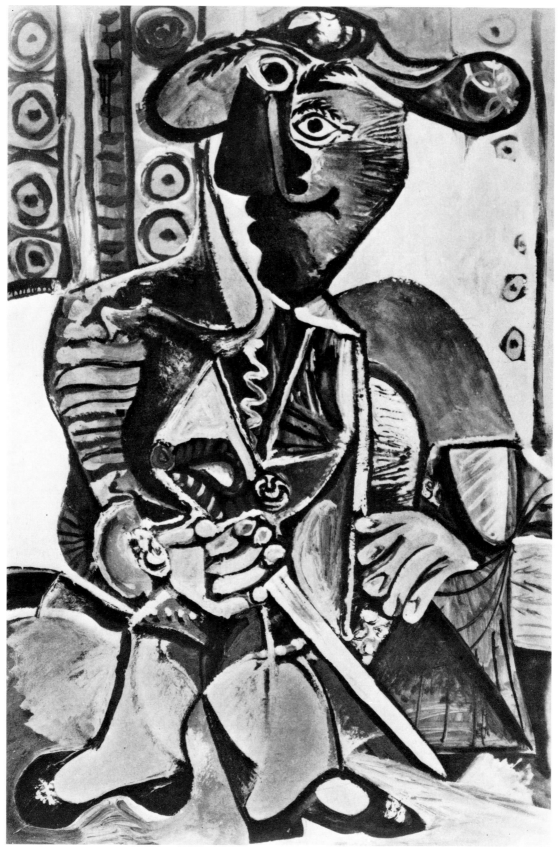

The Matador. Mougins, October 14, 1970
Oil on canvas, 76¾ x 51¼″ (195 x 130 cm)
Zervos XXXII, 276. Collection Jacqueline Picasso, Mougins

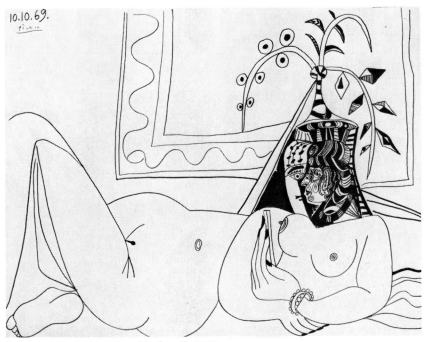

Reclining Nude. Mougins, October 10, 1969
Pencil, 20 x 25½″ (50.7 x 64.8 cm)
Zervos XXXI, 455. Saidenberg Gallery, New York

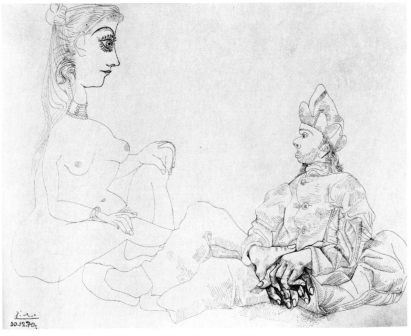

Man and Seated Nude. Mougins, December 30, 1970
Ink, 19⅞ x 25⅝″ (50.3 x 65 cm)
Zervos XXXII, 347. Ludwig Collection, Aachen

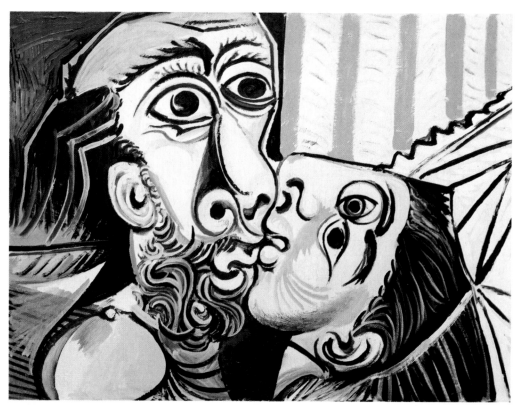

The Kiss. Mougins, October 26, 1969
Oil on canvas, 38⅛ x 51¼″ (97 x 130 cm)
Zervos XXXI, 484. Musée Picasso, Paris

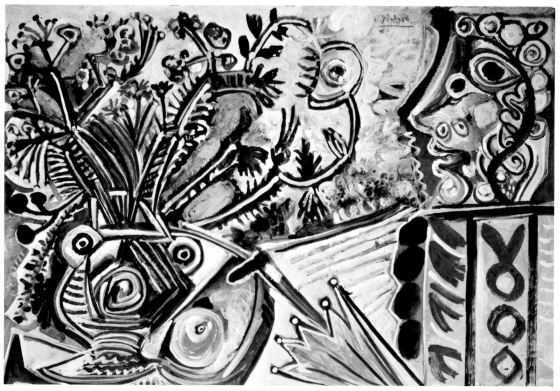

Still Life with Umbrella. Mougins, November 14, 1968
Oil on canvas, 38¼ x 57½″ (97 x 146 cm)
Zervos XXVII, 373. Galerie Louise Leiris, Paris

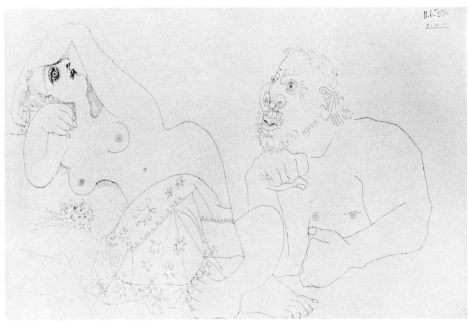

Contemplation. Mougins, June 11, 1970
Ink, 12½ x 19¼″ (31.6 x 49 cm)
Zervos XXXII, 118. Private collection, New York

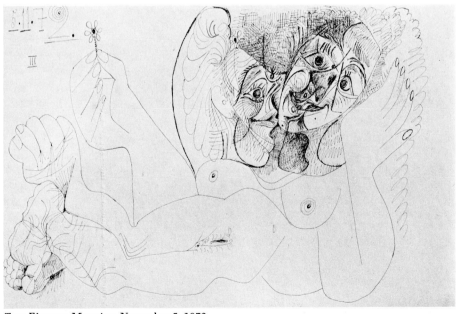

Two Figures. Mougins, November 5, 1972
India ink, 13 x 19¾″ (33 x 50 cm)
Zervos XXXIII, 531. Collection Bernard Picasso, Paris

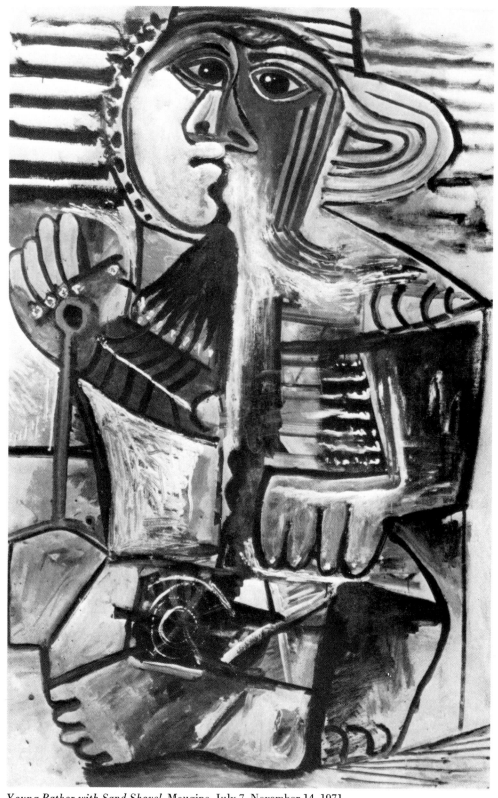

Young Bather with Sand Shovel. Mougins, July 7, November 14, 1971
Oil on canvas, 76¾ x 51¼″ (195 x 130 cm)
Zervos XXXIII, 229. Collection Bernard Picasso, Paris

Mother and Child. Mougins, August 30, 1971
Oil on canvas, 63¾ x 51¼″ (162 x 130 cm)
Zervos XXXIII, 168. Musée Picasso, Paris

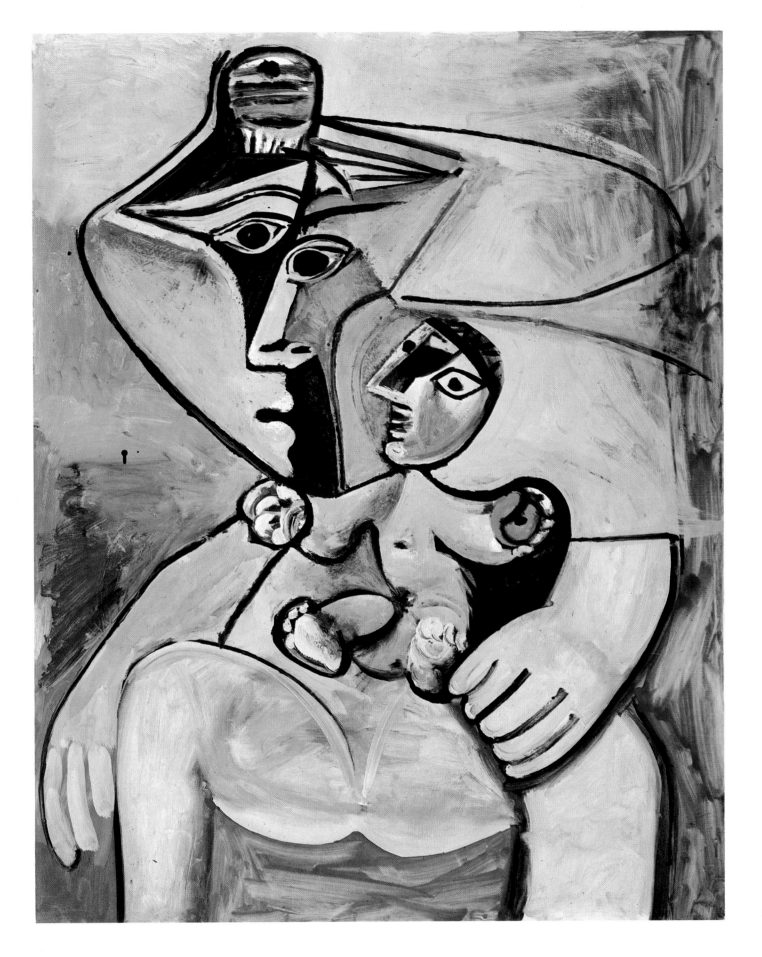

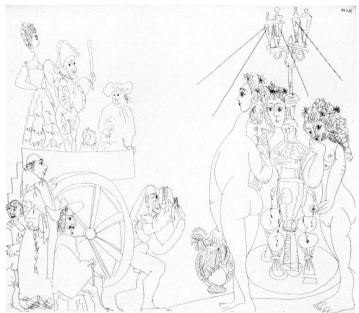

Plate 81 from *347 Series* (image of the artist
holding mask in center). Mougins, May 13, 1968
Etching, 16⁵⁄₁₆ x 19½″ (41.4 x 49.5 cm)
Bloch 1561. Reiss-Cohen Inc., New York

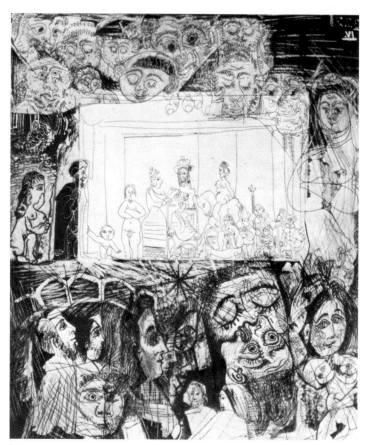

Picasso's Stage. Plate 10 from *156 Gravures récentes,*
by Michel Leiris. Mougins, February 3, 1970
Etching, aquatint, and scraper, 19¹¹⁄₁₆ x 16½″ (50 x 42 cm)
Galerie Louise Leiris, Paris

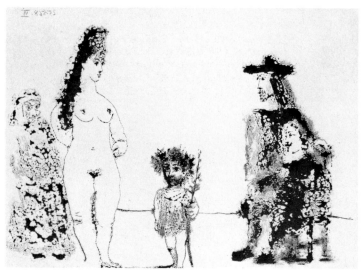

Plate 111 from *347 Series* (image of the artist
as a child in center). Mougins, May 25, 1968
Aquatint, 9¼ x 13⅛″ (23½ x 33.4 cm)
Bloch 1591. Reiss-Cohen Inc., New York

KEY TO VARIANT DATES

As has long been known, many of the dates in Christian Zervos's pioneering catalog are incorrect. Insofar as the work of 1900 to 1916 is concerned, almost all of these have been corrected in the two catalogues raisonnés of which Pierre Daix is coauthor: *Picasso: The Blue and Rose Periods* (with Georges Boudaille and Joan Rosselet) and *Picasso: The Cubist Years, 1907–1916* (with Joan Rosselet). A similarly careful review of problems of dating has been made by Werner Spies in *Sculpture by Picasso*.

There are, nevertheless, instances where my own dates differ significantly from even these recent catalogers'. In such instances, I have asterisked the date, and the reader will find the contrary opinions below. Where relevant, the list gives the variant opinions of the catalogers of major retrospective exhibitions and of other respected scholars.

William Rubin

VARIANT DATES

P. 71 *Woman with a Comb.* ZERVOS: Paris, 1906; D.B.: Paris, Summer–Autumn 1906

P. 72 *Woman with Loaves.* ZERVOS: 1906; D.B.: Summer 1906; LEYMARIE 36: Summer 1906; BARR p. 46–47: Summer 1906. (Sometime after the painting was completed, Picasso erroneously dated it 1905)

P. 95 *Mother and Child.* DAIX: Spring 1907; MUSEE PICASSO 25: Spring 1907

P. 96 *Head.* LEYMARIE 30: 1908

P. 105 *Vase of Flowers.* ZERVOS: Summer 1907; DAIX: Summer 1907

P. 109 *Bust of a Woman.* DAIX: early 1908

P. 110 *Standing Nudes and Study of Foot.* MUSEE PICASSO 414: Paris, 1908

P. 111 *Landscape.* DAIX: La Rue des Bois, August 1908; JARDOT 15: La Rue des Bois, 1908

P. 116 *Head of a Man.* ZERVOS: 1908–09; DAIX: [Spring] 1908; MUSEE PICASSO 38: [Spring] 1908

P. 116 *Head of a Man.* ZERVOS: 1908–09; DAIX: [Spring] 1908; MUSEE PICASSO 37: [Spring] 1908

P. 116 *Landscape with Two Figures.* ZERVOS: Summer 1908; DAIX: Summer 1908; LEYMARIE 54: Summer 1908; MUSEE PICASSO 40: [Paris], Summer 1908; BARR p. 62: Summer or Autumn 1908

P. 124 *Study for Carnival at the Bistro.* ZERVOS: Summer 1908; DAIX: early 1909

P. 141 *Nude Woman.* ZERVOS: Paris, Spring 1910; BARR p. 72: Paris, Spring 1910

P. 144 *Still Life with Pipe Rack, Cup,*

Coffee Pot, and Carafe. ZERVOS: Winter 1910–11

P. 146 *Mandolin Player.* ZERVOS: Spring 1911; LEYMARIE 74: Spring 1911; MEYER 20: early 1911

P. 186 *Mandolin and Clarinet.* DAIX: [Autumn 1913]; MUSEE PICASSO 68: [Autumn 1913]

P. 187 *Violin.* ZERVOS: 1914; SPIES: 1914; LEYMARIE 224: 1914

P. 204 *Crucifixion.* ZERVOS: 1915

Pp. 248–49 Drawings from which wood engravings were made for *Le Chef-d'oeuvre inconnu,* by Honoré de Balzac. BARR pp. 144–45: 1926. (As noted in GOLDING, these drawings can be dated 1924. They are executed in Juan-les-Pins as part of a summer sketchbook, of which two pages were reproduced in the January 1925 issue of *La Révolution surréaliste*)

P. 267 *Wire Construction.* SPIES: 1928–29; MUSEE PICASSO 163: 1928–29. (Reproduced and dated October 1928 in CAHIERS D'ART)

P. 267 *Wire Construction.* SPIES: 1928–29; MUSEE PICASSO 162: 1928–29

P. 268 *Wire Construction.* SPIES: 1928–29; LEYMARIE 230: 1930; MUSEE PICASSO 161: 1928–29; BARR p. 153: Autumn 1928; KAHNWEILER pl. 21: 1930

P. 283 *Head.* SPIES: 1931; LEYMARIE 233: 1931; MUSEE PICASSO 186: 1931; KAHNWEILER pl. 27–28, 1931. (The 1930 date given the work is based on its reproduction that year in D'ORS)

P. 284 *Head of a Woman.* SPIES: 1932; LEYMARIE 243: 1931–32; BARR p. 181: [1932]; KAHNWEILER pl. 46: 1931–32

P. 285 *Bust of a Woman.* SPIES: 1932; LEYMARIE 251: 1932; BARR p. 180: 1932; MUSEE PICASSO 225: 1932; KAHNWEILER pl. 64: 1932

P. 286 *Head of a Woman.* SPIES: 1932; LEYMARIE 252: 1932; KAHNWEILER pl. 59–60: 1932

P. 368 *Woman with Artichoke.* ZERVOS: 1942. (MEYER convincingly dates the painting Summer 1941)

P. 408 *Baboon and Young.* SPIES: 1952; LEYMARIE 305: 1952

SOURCES REFERRED TO IN CAPTIONS AND LIST OF VARIANT DATES

BARR Barr, Alfred H., Jr. *Picasso: Fifty Years of His Art.* New York, The Museum of Modern Art, 1946; paperbound, 1974.

BLOCH Bloch, Georges. *Pablo Picasso: Catalogue de l'oeuvre gravé et lithographie, 1904–1969.* 2 vols. Bern, Kornfeld and Klipstein, 1968–71.

CAHIERS D'ART Zervos, Christian. "Picasso

à Dinard, été 1928," *Cahiers d'art,* vol. 4, no. 2–3, Paris, 1929.

D.B. Daix, Pierre; Boudaille, Georges; and Rosselet, Joan. *Picasso: The Blue and Rose Periods, A Catalogue Raisonné of the Paintings.* Greenwich, Connecticut, New York Graphic Society, 1966.

DAIX Daix, Pierre, and Rosselet, Joan. *Picasso: The Cubist Years, 1907–1916, A Catalogue Raisonné of the Paintings and Related Works.* Boston, New York Graphic Society, 1979.

GEISER Geiser, Bernhard. *Picasso, peintre-graveur: Catalogue illustré de l'oeuvre gravé et lithographie, 1899–1931.* 2 vols. Vol. 1 published in Bern by the author, 1933; vol. 2 published in Bern by Kornfeld and Klipstein, 1968.

GOLDING Golding, John. "Picasso and Surrealism," from *Picasso in Retrospect.* New York, Praeger, 1973.

JARDOT "Picasso Peintures: 1900–1955." Exhibition catalog. Musée des Arts Décoratifs, Paris, June–October 1955. Directed by Maurice Jardot.

KAHNWEILER Kahnweiler, Daniel-Henry (photographs by Brassaï). *Les Sculptures de Picasso.* Paris, Editions du Chêne, 1948.

LEYMARIE "Hommage à Pablo Picasso." Exhibition catalog. Grand Palais (paintings), Petit Palais (drawings, gouaches, *papiers collés,* sculpture), Paris, November 1966–February 1967. Directed by Jean Leymarie.

MEYER "Picasso aus dem Museum of Modern Art, New York, und schweizer Sammlungen." Exhibition catalog. Kunstmuseum, Basel, June 15–September 12, 1976. Catalog by Franz Meyer and William Rubin.

MOURLOT Mourlot, Fernand. *Picasso Lithographe: 1919–1963.* 4 vols. Monte Carlo, André Sauret, Editions du Livre, 1949–64.

MUSEE PICASSO "Picasso: Oeuvres reçues en paiement des droits de succession." Exhibition catalog. Grand Palais, Paris, October 11, 1979–January 7, 1980. Directed by Dominique Bozo. (Dates given in this publication are provisional pending the appearance of the Musée Picasso catalog—D.B.)

D'ORS Ors, Eugenio d'. *Pablo Picasso.* Paris, Editions des Chroniques du Jour, 1930.

RAMIE Ramié, Georges. *Picasso's Ceramics.* New York, The Viking Press, Inc., 1976.

SPIES Spies, Werner. *Sculpture by Picasso, with a Catalogue of the Works.* New York, Harry N. Abrams, 1971.

ZERVOS Zervos, Christian. *Pablo Picasso.* 33 vols. Paris, Cahiers d'Art, 1932-1978.

ZERVOS DESSINS Zervos, Christian. *Dessins de Pablo Picasso, 1892–1948.* Paris, Editions Cahiers d'Art, 1949.

459

PHOTOGRAPH CREDITS

The following list, keyed to page numbers, applies to photographs for which a separate acknowledgment is due:

Acquavella Galleries, Inc., New York: 36 right, 101. David Allison, New York: 279, 263 top right. The Art Institute of Chicago: 157 bottom. Eric Baudouin, Paris: 204 bottom left. Cahiers d'Art: 16 bottom left, 120 top right, 122 top left, 150 right, 151 top, 153 top, 309. Geoffrey Clements, New York: 297. Prudence Cuming Assoc., Ltd., London: 256, 407 top. Sonia Delaunay Collection, Paris: 121 bottom center. Doisneau/Rapho, Paris: 383 top and middle. Walter Dräyer, Kunsthaus, Zurich: 76 bottom right. Jacques Faujour, Musée National d'Art Moderne, Centre National d'Art et de Culture Georges Pompidou, Paris: 138. Fry, *Cubism*: 151 bottom, 152 bottom right. Mira Godard Gallery, Toronto: 450 top left. Hans Hinz, Basel: 77, 125, 160 top right, 161, 174 right, 241, 403 top. Sidney Janis, New York: 348 left. Bruce C. Jones, Centerport, New York: 248 bottom. © Luc Joubert, Paris: 254 left, 276, 307 both. Peter Juley, New York: 128 top right. Kate Keller, Staff Photographer, The Museum of Modern Art: 148 right, 174 left, 215, 233, 268 bottom, 272 bottom right, 291, 354 top right, 358, 365, 386 top, 396 right, 410 top right and bottom right, 412 top left. Ralph Kleinhempel, Fotografisches Atelier, Hamburg: 118. M. Knoedler & Co., New York: 41 left, 127. Kunsthaus, Zurich: 188 top right. Galerie Louise Leiris, Paris: 89 top left and bottom, 122 bottom left, 152 left, 307. Magnum Photos, New York: 353. Robert E. Mates, Mary Donlon, Paul Katz, and Aida Mates, New York: 32 bottom, 60 right, 66 right, 145, 258, 320 top left, 359, 434 top left, 436 top right. James Mathews, New York: 52 right, 82 right, 98 left, 106 bottom right, 111 right, 130 top and bottom, 147 right, 154 top, 387 bottom, 395 top right, 458 bottom left. The Metropolitan Opera Archives, New York: 199 bottom. The Museum of Modern Art Photo Archive: 28 left, 86 top and bottom left, 87 top left and top right, 122 bottom right, 197 top right and bottom left and right, 199 top, 222 bottom, 223 top left, 225 top left, 254 top right and bottom right, 277, 384 top, 421. National Gallery, London: 42. O. E. Nelson, New York: 105, 139 right, 140 left, 204 bottom right, 453 top. Mali Olatunji, Staff Photographer, The Museum of Modern Art: 137, 148 right, 156 bottom, 168 right, 250, 290, 326, 427. Palau i Fabre, *Picasso en Cataluña*: 19 (excepting bottom left), 47 bottom left, 120 bottom, 121 center right, 198 top. Courtesy Sir Roland Penrose, London: 16 top left and top center; 56 top left, top center, top right, and bottom left; 57 center right; 122 top center and right; 150 left; 190 top left; 196 both; 198 bottom; 224 top right and center; 225 center; 255 bottom right. Philadelphia Museum of Art: 38 top. Eric Pollitzer, New York: 143 bottom right, 173 right, 219 top left, 246, 292 left, 294 top, 295, 325, 354 bottom right, 363 top, 371, 392, 406 top, 424 top and bottom, 425 bottom, 428, 435, 455 top. George Roos, New York: 227 top left, 228 bottom, 369 right. Paul Rosenberg & Co., New York: 313 bottom right. Galerie Rosengart, Lucerne: 448. Sabartés, *Picasso: Documents iconographiques*: 17 bottom left, 28 bottom center, 123 top right, 153 bottom, 382 left. John D. Schiff, New York: 29 center, 422 bottom left. Adolph Studly, New York: 64 left, 160 bottom right, 310 left. Soichi Sunami: 61 right, 62 top right, 98 middle right, 106 top right, 126, 132 bottom right, 134 bottom, 136 left, 166 top right, 180 top right, 182 bottom, 184 top, 208 right, 210 right, 213 right, 226 left, 235 top left, 248 top, 252 left, 263 top left, 303 middle, 316 top right and bottom right, 318 top, 319 top and bottom, 323 top, 328 left, 332 middle, 340 top and bottom, 341 bottom left, 395 top left, bottom left and bottom right, 407 middle left and bottom right, 408 right, 409 bottom, 411 right and bottom left, 429. Joseph Szaszfai, Yale University Art Gallery, New Haven, Connecticut: 220, 375. The Tate Gallery, London: 419 top left. E. V. Thaw & Co., New York: 141 bottom right, 214 top right, 349 left. Jann and John F. Thomson, Los Angeles: 320 bottom left. Eileen Tweedy, London: 171 left. Charles Uht, New York: 114 right, 180 left, 201 top left, 362 top, 450 bottom left. Fotograf O. Vaering, Oslo: 159 top right. Malcolm Varon, New York: 37 top, 68, 75 right, 83, 99, 117, 133, 159 bottom, 175, 191, 231, 262 top, 269 bottom, 320 right, 342–3, 366. Jeanine Warnod, Paris: 88 bottom left, 120 center, 179 top left and right. Regine Zweig, Essen: 165 top.

ACKNOWLEDGMENTS

The preparation of this exhibition and catalog has required the assistance and collaboration of many people. I have been most fortunate in the help I have received and the good will with which it has been given.

Foremost among those to whom I owe a debt of gratitude are Hubert Landais, Director of the Musées de France, whose support was essential to the realization of this retrospective, and Dominique Bozo, with whom I have had the great good fortune to codirect it.

Many museums have made special concessions so that certain pictures might be in this exhibition. Franz Meyer, Director of the Kunstmuseum, Basel, has been a strong advocate of our cause, and largely through his efforts our audience is enabled to view paintings from the Kunstmuseum in an overall context that clarifies their importance in the development of Picasso's oeuvre. Jiri Kotalik, Director of the National Gallery, Prague, warmly endorsed the idea of this exhibition from the start and has been outstanding in his generosity. Over a protracted period of loan negotiations, I have worked with Rosa-Maria Subirana, Director of the Museo Picasso of Barcelona, and I extend to her my very warm thanks for her help in obtaining the generous participation of Barcelona. Norman Reid, former Director of The Tate Gallery, London, has made truly unusual efforts to enable us to have works vital to this retrospective. In his willingness to lend many important works, K. G. Pontus Hultén, Director of the Musée National d'Art Moderne, Centre National d'Art et de Culture Georges Pompidou, Paris, continues and enlarges the mutual cooperation existing between our two institutions. Thomas Messer, Director of The Solomon R. Guggenheim Museum, New York, Jean Sutherland Boggs, Director of the Philadelphia Museum of Art, and Anne d'Harnoncourt, Curator of Twentieth Century Art at the same museum, have made very special efforts on our behalf.

This undertaking has involved staff time at all of the participating institutions, and I should like here to register my gratitude to the many who have aided us. Most particularly I should like to thank Michèle Richet, Curator of the Musées Nationaux de France and a member of the staff of the Musée Picasso, Paris, whose expenditure of time, effort, and expertise on this project has contributed significantly to its realization. Irène Bizot, always a pleasure to work with, has employed her customary diplomacy and efficiency on our behalf. Germain Viatte has given generously of his time in helping assemble and prepare the loans from the Centre Pompidou. Marguerite Rebois has with skill and confidence overseen the intricate logistics of transportation of the works borrowed from the Réunion. We have often imposed heavy demands on Dominique Bozo's staff at the Musée Picasso, and we are deeply grateful to Philippe Thiébaut and Paule Mazouet, who have responded with good will, patience, and skill.

The very special generosity of all the Picasso heirs is pointed out by Mr. Oldenburg in his Foreword. I should like here to add my thanks to his. During the greater part of the preparation of this exhibition and catalog, many estate questions were still unresolved, consequently making loan negotiations extremely difficult. Without the aid of Pierre Zécri, Administrateur Judiciaire of the Picasso estate, we could not have hoped to include the many important works we are borrowing from Picasso's heirs. Maître Zécri selflessly spent much of his very valuable time on our behalf. I am deeply grateful to him. Because of the unsettled nature of the estate, unusual problems were involved in obtaining photographs and catalog information; in helping us to secure these, Claude Picasso spared no effort. It was a great pleasure to work with him, and his assistance was absolutely essential.

This undertaking has required the assistance of many Picasso experts, both scholars and dealers. I am especially indebted to Pierre Daix. He has given liberally of his time and profound knowledge of Picasso; additionally, his catalogues raisonnés of Picasso's Blue and Rose and of the Cubist periods have been invaluable reference tools. Maurice Jardot has also been most generous in sharing his knowledge of Picasso with us; his catalog of the Picasso retrospective at the Musée des Arts Décoratifs, Paris, in 1955, along with that of Jean Leymarie, for the retrospective at the Grand Palais, Paris, in 1966, have frequently been consulted. Whenever asked, Werner Spies has readily shared his knowledge and research with us; his catalogue raisonné of Picasso's sculpture was in constant service. Roland Penrose, Picasso's close friend and biographer, warmly supported our efforts and was unfailingly willing to answer inquiries. Joan Rosselet, Daix's collaborator on the recently published catalogue raisonné of Picasso's Cubist years, has clarified a multitude of questions regarding dates and provenance. Other Picasso scholars whose books and articles were frequently consulted are Alfred H. Barr, Jr., Douglas Cooper, Edward Fry, John Golding, and Robert Rosenblum.

Numerous dealers whose knowledge of Picasso's oeuvre is immense have come to our aid. Ernst Beyeler and Eugene Thaw devoted many days of their time to assisting us with problems related to securing U.S. Government indemnification, as well as helping in myriad other ways over the entire period of preparation of this exhibition and catalog. Heinz Berggruen was, as he has often been in the past, of great aid in his capacity as a Picasso expert, as well as in assisting us with other more practical matters. In certain difficult negotiations, William Acquavella was instrumental in helping to secure essential loans. Among the dealers to whom we are grateful are Jan Krugier, Klaus Perls, L. Prejger, Alexandre Rosenberg, and Eleanore Saidenberg.

For aiding us in contacting lenders, we are obliged to David Bathurst, Director, Elizabeth Shaw, and Christopher Burge of Christie, Manson, and Woods International; Thilo von Watzdorf of Sotheby & Co., London; David Somerset, Director of Marlborough Fine Art, London; and John Rewald.

Javier Tusell Gomez, the Director General of the National Patrimony of Art, Archives, and Museums of Spain, Rafael de los Casares, the Consul General of Spain in New York, José Luis Rosello, Cultural Attaché in New York, and Fernando Vijande of Madrid have all kindly aided us in loan negotiations.

Many of the works on loan from the future Musée Picasso of Paris will have been shown just prior to our retrospective at the Walker Art Center, Minneapolis. In arranging for these loans, I have had the pleasure of working with Martin Friedman, Director of the Walker Art Center, and I should here like to thank him for his never failing courtesy and spirit of cooperation.

On behalf of the Trustees of The Museum of Modern Art, I wish to express my thanks to all of the lenders whose names are listed on page 463. They have generously lent works from their collections knowing that they would be deprived of them for many months. Mr. and Mrs. Victor W. Ganz, involved with this project from its inception, have been particularly generous.

This exhibition and catalog are of such a scale that almost every member of the Museum staff has participated in one way or another. The debt owed to the staff of the Department of Painting and Sculpture is almost immeasurable. From the beginning of this project, Carolyn Lanchner, Research Curator, has been essential to every activity associated with it. If there is any one person who has been indispensable, it is she. Laura Rosenstock, Curatorial Assistant, has given hours of her own time and worked with an efficiency, a consistent energy, and

a thoroughgoing professionalism that I have seldom seen matched. Among her many talents is an unfailing memory that has often prevented time-consuming mistakes. Alicia Legg, Curator, has supervised the placing of sculpture in the exhibition as well as made important contributions to the planning of the overall installation. Monique Beudert, Curatorial Assistant, although heavily involved with other projects, has handled much of the work of obtaining photographs, and has, as well, supervised the complicated logistics of various loan exchanges. Cora Rosevear, Assistant Curator, has dealt with the responsibility of the temporary transfer of our collection to other museums and to storage areas. The services of my assistant, Sharon McIntosh, have been, as always, invaluable. By taking on increased responsibilities, she significantly lightened my workload at a time when the demands of this project were almost all consuming. Deborah Magid, Maria A. Le Monnier, and Diane Jablon, all recruited for the final phase of preparations, have each contributed significantly to the realization of this exhibition and catalog. My secretary, Ruth Priever, has been heroic in typing a large part of the immense volume of correspondence generated by this project. Sharing the typing load and handling quantities of other details have been Diane Gurien, Diane Farynyk, and Elizabeth Maynard. Judith Cousins, Researcher of the Collection, worked diligently in gathering much of the needed preliminary documentation.

The print section of this exhibition has been organized with talent and expertise by Riva Castleman, Director of the Department of Prints and Illustrated Books, in collaboration with Alexandra Schwartz, Assistant Curator in that department.

The patience and energy of Richard Palmer, Coordinator of Exhibitions, although sorely tried by the unprecedented scale of this project, have never failed, and I owe an incalculable debt to him for the expertise and professionalism with which he has supervised the intricate logistics involved in the organization of this project. I should here also like to thank Mr. Palmer's assistant, Rosette Bakish, who handled a greatly increased workload with her usual competence and good cheer. Ethel Shein, Executive Assistant to the Director, has contributed to the realization of this project in a variety of ways, not least by her advice and counsel often turned to, I fear, in moments of crisis. James Snyder has skillfully coordinated overall planning necessitated by the extraordinary nature of this exhibition. It has been a pleasure to have a continuing dialogue with him since the inception of this retrospective. His versatility and common sense have lightened the burden for everyone. John H. Limpert, Jr., Director of Membership and Development, has worked tirelessly to enlist support for this exhibition. Certain of the many legal questions that must inevitably come up with an international involvement such as this have been dealt with by John Koegel, the Museum's General Counsel. My appreciation also goes to William Burback, Director of the Department of Education, and Myrna Martin, Assistant Director, for making special arrangements for college and university groups. Luisa Kreisberg, Director, and Sharon Zane, Assistant Director, of the Department of Public Information have been tireless and effective in dealing with the many publicity requirements of this project. Through this department we secured the services of Kermit Love, theater-art historian and designer, who has reproduced Picasso's costumes for the American and French Managers from the 1917 ballet *Parade*. Special thanks are also due to Fred Coxen, Production Supervisor, Jerome Neuner, Assistant Production Manager, and Richard Tooke, Supervisor, Department of Rights and Reproductions. For much of the necessary photography for the exhibition and catalog we are indebted to Kate Keller and Mali Olatunji.

The magnitude of this enterprise has multiplied all the usual problems of mounting an exhibition. Two departments which have felt this increased burden particularly are Registrar and Conservation. Eloise Ricciardelli, Registrar, and Cherie Summers, Associate Registrar, have smoothly and skillfully coordinated a daunting volume of shipping and in-house transportation of works of art. John Bennett, Traffic Manager, has spent many long hours at various airports in supervising the loading and unloading of loans. Jean Volkmer, Chief Conservator, Tosca Zagni, Senior Conservator, Antoinette King, Senior Paper Conservator, Patricia Houlihan, Senior Sculpture Conservator, Henry Cohen, Senior Sculpture Conservator, and Terry Mahon, Conservator, have been called on again and again both here and on trips abroad for their unique expertise. In Paris we were fortunate to have Diane O'Neal, a paper conservator on temporary assignment with the Musée Picasso, volunteer her aid in making condition checks.

I should here like to insert my warmest thanks to Paolo Cadorin, Conservator of the Basel Kunstmuseum, who generously made a trip to New York in the early stages of planning to consult with us on special security, shipping, and conservation arrangements for this exhibition. His advice and counsel were invaluable to all concerned.

To the extent that the magnitude of this retrospective was reflected in its actual physical assembling, it was equally so in the preparation of this catalog. Almost the entire Department of Publications was mobilized. Martin Rapp, its Director, made extraordinary efforts to insure that the exhibition should have a catalog that a project of this dimension merits. Christopher Holme, Managing Editor and designer of this catalog, has done an outstanding job in spite of pressing deadlines and my own exigencies regarding chronological placement of illustrations. He has been endlessly patient and always professional, and has my most profound appreciation. The size of this book and its extraordinary number of colorplates have greatly intensified the usual trials and difficulties of production; Tim McDonough, Production Manager, has overseen this process with unusual skill, consistent good will, and thorough professionalism. Jane Fluegel deserves my very special thanks for the carefully researched chronology which she compiled under extreme pressure, as well as for assembling the documentary photographs. She most ably copy-edited this catalog as well, and I am deeply grateful to her. My thanks also go to several people not on the Museum's staff who aided us in putting this catalog together—Barbara Nagelsmith, who obtained many documentary photographs; John Shepley, who translated from the French the contributions of Hubert Landais and Dominique Bozo; and Eliza Woodward, who most professionally and skillfully assisted in the copy editing.

To Meyer Schapiro I owe a very special debt. The inspiration derived from his lectures on Picasso that I heard many years ago as a graduate student at Columbia had much to do with the formation of my understanding of Picasso's oeuvre. I am, therefore, particularly pleased that Professor Schapiro has consented to write on *Guernica* and its studies and postscripts (left by Picasso in the Museum's care just before World War II) for a book being published by the Museum as a companion to this.

I am particularly grateful to Edward L. Saxe, Deputy Director and General Manager, who has handled many of the broader issues concerning security and the timing of this exhibition as it relates to the Museum's building program.

To my colleagues, the Directors of the other Curatorial Departments in the Museum, goes my deep appreciation for their disinterested generosity in sacrificing their departmental gallery spaces for the duration of this exhibition.

Lastly, I should like to thank that individual to whom I owe the deepest gratitude, Richard E. Oldenburg, Director of The Museum of Modern Art, who has supported this complex project with enthusiasm and conviction from the beginning. All those who view this exhibition are in his debt.

William Rubin

LENDERS TO THE EXHIBITION

Musée Picasso, Antibes
The Baltimore Museum of Art
Museo de Cerámica de Barcelona
Museo Picasso, Barcelona
Kunstmuseum, Basel
Nationalgalerie Berlin–DDR, Ludwig
 Collection, Aachen
Museum of Fine Arts, Boston
Queensland Art Gallery, Brisbane,
 Australia
Albright-Knox Art Gallery, Buffalo,
 New York
Fogg Art Museum, Harvard University,
 Cambridge, Massachusetts
The Art Institute of Chicago
The Cleveland Museum of Art
Museum Ludwig, Cologne
Columbus Museum of Art, Columbus, Ohio
Detroit Institute of Arts
Kunstsammlung Nordrhein-Westfalen,
 Düsseldorf
Museum Folkwang, Essen
Kimbell Art Museum, Fort Worth, Texas
Göteborgs Konstmuseum, Göteborg,
 Sweden
Kunsthalle, Hamburg
Kunstmuseum. Hanover, Sammlung
 Sprengel
Wadsworth Atheneum, Hartford
Hiroshima Museum of Art
The Hermitage Museum, Leningrad
The Tate Gallery, London
Los Angeles County Museum of Art
Museo Nacional de Arte Moderno, Madrid
The Pushkin State Museum of Fine Arts,
 Moscow
Yale University Art Gallery, New Haven,
 Connecticut
The Brooklyn Museum, New York
The Solomon R. Guggenheim Museum,
 New York
The Metropolitan Museum of Art,
 New York
Smith College Museum of Art,
 Northampton, Massachusetts
University of East Anglia, Norwich,
 Robert and Lisa Sainsbury Collection
Allen Memorial Art Museum, Oberlin
 College, Oberlin, Ohio
Nasjonalgalleriet, Oslo
Rijksmuseum Kröller-Müller, Otterlo,
 Holland

The Ashmolean Museum, Oxford
Bibliothèque Nationale, Paris
Musée d'Art Moderne de la Ville de Paris
Musée National d'Art Moderne, Centre
 National d' Art et de Culture Georges
 Pompidou, Paris
Musée Picasso, Paris
Musées Nationaux (Musée de l'Orangerie),
 Paris. Collection Walter-Guillaume
Philadelphia Museum of Art
National Gallery, Prague
The St. Louis Art Museum
Washington University, St. Louis, Missouri
The McNay Art Institute, San Antonio,
 Texas
Santa Barbara Museum of Art,
 Santa Barbara, California
Moderna Museet, Stockholm
The Toledo Museum of Art, Toledo, Ohio
Musée d'Art Moderne du Nord, Villeneuve
 d' Ascq
Hirshhorn Museum and Sculpture Garden,
 Smithsonian Institution, Washington, D.C.
National Gallery of Art, Washington, D.C.
The Phillips Collection, Washington, D.C.
Worcester Art Museum, The Dial
 Collection, Worcester, Massachusetts

Alsdorf Foundation, Chicago
Mr. and Mrs. James W. Alsdorf, Chicago
Raymond Barbey, Geneva
Mr. and Mrs. Edwin A. Bergman, Chicago
Ernst Beyeler, Basel
H. and E. Beyeler, Basel
Léon Bloch, Paris
Mr. and Mrs. Leigh B. Block, Chicago
Henry Brandon, Washington, D.C.
Mr. and Mrs. William A. M. Burden,
 New York
Mrs. Gilbert W. Chapman, New York
Mr. and Mrs. Sidney E. Cohn, New York
Mr. and Mrs. Ralph F. Colin, New York
Nathan Cummings, New York
Mr. and Mrs. Lee V. Eastman, New York
Walter D. Floersheimer, Locarno,
 Switzerland
Mr. and Mrs. Victor W. Ganz, New York
Mr. and Mrs. Jacques Gelman, Mexico City
Ms. Françoise Gilot
Norman Granz, Geneva
Stephen Hahn, New York
Mrs. Melville Hall, New York

Joseph H. Hazen, New York
Mr. and Mrs. Jacques Helft, Paris
Paul Kantor, Beverly Hills, California
J. C. Koerfer, Bern, Switzerland
M. et Mme Claude Laurens, Paris
Ludwig Collection, Aachen
Margaret Mallory, Santa Barbara,
 California
Morton Neumann, Chicago
Mr. and Mrs. Paul Osborn, New York
Bernard Picasso, Paris
Claude Picasso, Paris
Jacqueline Picasso, Mougins
Marina Picasso Foundation
Paloma Picasso Lopez, Paris
Mme Paul Picasso, Paris
Edouard Pignon, Paris
Diane de Riaz, Val de l'Oise, France
Dr. and Mrs. Israel Rosen, Baltimore,
 Maryland
Angela Rosengart, Lucerne
Ms. Sandra Rotman, Toronto
Mr. and Mrs. Daniel Saidenberg, New York
Mr. and Mrs. Georges E. S.
Mrs. Bertram Smith, New York
Gustav Stern Foundation, Inc., New York
Thyssen-Bornemisza Collection, Lugano,
 Switzerland
Mr. and Mrs. John Hay Whitney, New York
Mrs. John Wintersteen, Haverford,
 Pennsylvania
Richard S. Zeisler, New York
Gustav Zumsteg, Zurich
37 anonymous collectors

Acquavella Galleries, Inc., New York
Galerie Beyeler, Basel
Sala Gaspar, Barcelona
Isselbacher Gallery, New York
Jan Krugier Gallery, Geneva
Galerie Louise Leiris, Paris
Ruth O'Hara Fine Arts, New York
Perls Galleries, New York
Reiss-Cohen, Inc., New York
Paul Rosenberg & Co., New York
Galerie Rosengart, Lucerne
Saidenberg Gallery, New York
E. V. Thaw and Co., Inc., New York
Irving Zucker Art Books, New York